D0206598

About Island Press

Island Press is the only nonprofit organization in the United States whose principal purpose is the publication of books on environmental issues and natural resource management. We provide solutions-oriented information to professionals, public officials, business and community leaders, and concerned citizens who are shaping responses to environmental problems.

In 2000, Island Press celebrates its sixteenth anniversary as the leading provider of timely and practical books that take a multidisciplinary approach to critical environmental concerns. Our growing list of titles reflects our commitment to bringing the best of an expanding body of literature to the environmental community throughout North America and the world.

Support for Island Press is provided by The Jenifer Altman Foundation, The Bullitt Foundation, The Mary Flagler Cary Charitable Trust, The Nathan Cummings Foundation, The Geraldine R. Dodge Foundation, The Charles Engelhard Foundation, The Ford Foundation, The German Marshall Fund of the United States, The George Gund Foundation, The Vira I. Heinz Endowment, The William and Flora Hewlett Foundation, The W. Alton Jones Foundation, The John D. and Catherine T. MacArthur Foundation, The Andrew W. Mellon Foundation, The Charles Stewart Mott Foundation, The Curtis and Edith Munson Foundation, The National Fish and Wildlife Foundation, The New-Land Foundation, The Oak Foundation, The Overbrook Foundation, The David and Lucile Packard Foundation, The Pew Charitable Trusts, The Rockefeller Brothers Fund, Rockefeller Financial Services, The Winslow Foundation, and individual donors.

About Scientific Committee on Problems of the Environment

Scientific Committee on Problems of the Environment (SCOPE) is an international nongovernmental interdisciplinary body of natural science expertise. Its scientific program is designed to cover environmental issues—either global or shared by several nations—in urgent need of interdisciplinary synthesis. SCOPE was established by the International Council for Science (ICSU) in 1969. SCOPE acts at the interface between the science and decision-making sphere, providing advisors, policy-planners and decision-makers with the analytical tools to promote sound management and policy practices. This book represents an output of the SCOPE Global Invasive Species Program that is being done in collaboration with The World Conservation Union (IUCN) and Commonwealth Agricultural Bureau International (CABI).

Invasive Species
in a Changing World

Invasive Species in a Changing World

EDITED BY

Harold A. Mooney and Richard J. Hobbs

A Project of SCOPE,
the Scientific Committee on Problems of the Environment

ISLAND PRESS

Washington, D.C. • Covelo, California

Library of Congress Cataloging-in-Publication Data
Mooney, Harold A.
 Invasive species in a changing world / Harold A. Mooney and Richard J. Hobbs.
 p. cm.
 "A Project of SCOPE: The Scientific Committee on Problems of the Environment."
 Includes bibliographical references and index.
 ISBN 1–55963–781–1 (cloth : alk. paper) — ISBN 1–55963–782–X (paper: alk. paper)
 1. Biological invasions. I. Hobbs, R. J. (Richard J.) II. Title.
 QH353 .M66 2000
 577′.18—dc21 00-008791
 CIP

Printed on recycled, acid-free paper ♽

Manufactured in the United States of America
10 9 8 7 6 5 4 3 2 1

Contents

Preface

This book is a part of a larger effort to examine and deal with the global invasive species problem. A number of international organizations, including SCOPE (Scientific Committee on Problems of the Environment), IUCN (International Conservation Union), and CABI (Commonwealth Agricultural Bureau International) have joined forces to develop a global invasives species strategy. This program—GISP (Global Invasives Species Project)—is synthesizing the available information on invasives and developing new tools to deal with them, including early warning systems, legal and economic instruments, more effective methods for control, as well as better education on this issue. GISP, part of an international program on biodiversity called DIVERSITAS, is providing input to the Convention on Biological Diversity for meeting the requirements of article 8(h) of the convention that calls for all nations to "prevent the introduction of, control or eradicate those alien species which threaten ecosystems, habitats or species."

This synthesis resulted from a meeting held in San Mateo, California, with financial support from NASA (National Aeronautical and Space Agency), GEF (Global Environmental Facility), and ICSU (International Council for Science). We are indebted to these organizations as well as to Anne Schram and Veronique Plocq-Fichelet for providing their usual excellent staff support.

Introduction

Harold A. Mooney and Richard J. Hobbs

Increasing attention is being directed toward the issue of biological invasions. Almost daily we read in newspapers about another outbreak of some organism that is new to our area. We are actually seeing a massive biotic homogenization of the Earth's surface as a result of the breakdown of the major biogeographic barriers that have historically kept the floras and faunas of the various continents quite distinctive. This mixing has resulted in many aggressive species having extraordinarily wide distributions across the globe, or locally very high population densities, and the consequent devastation of the endemic biota of specific regions. Native species, too, can become invasive under certain conditions, but normally, biotic controls keep their populations in check.

Not all species that are transported among continents are damaging, and in fact many are important to our welfare and economy. This book concentrates not on benign introductions but rather on alien species that are exacting a toll on ecosystem diversity or ecosystem processes or "services." Invasives—alien species that not only take hold in their new foreign habitat but also become aggressive, or invasive—are the focus here. The invaders go by many names—exotics, aliens, pests, weeds, introduced species, nonindigenous species—and the list is not short.

There are now a large number of technical and popular volumes discussing various aspects of the invasive species problem. These point to the nature of the problem, the invasion process, our capacity to predict which species

might become invasive, the damage that they are doing, and how to control them. Building on that base, this book takes a different tack: It examines the proposition that the invasive species problem will be getting worse as a result of global change. We are spending a lot of time and energy predicting what kinds of new climates we will see with an atmosphere that is increasing in the composition of greenhouse gases. We are also studying how climate change will impact biotic systems and how biotic changes will in turn feed back to atmospheric processes. In these studies it is more or less assumed that the biota that we see on the continents is essentially a constant and will simply be shuttled around with a changing climate. The premise here, however, is that invasives themselves are a global change element and that their extent and impact should be considered in global change scenarios.

So the focus is on what we see today in terms of invasive species, globally, and what we may expect to see in the next hundred years, given the changing climate, commerce, land-use patterns, fire regimes, and atmospheric composition, including CO_2 and nitrogen deposition. This book examines not only the many drivers of global change that can have an impact on invasives but also how invasives can affect our health, welfare, and economy today and in the future.

It is curious that more attention is paid to global climate change than to the other global changes that are occurring, such as land cover changes, and biotic change caused by invasives. The case can certainly be made that in many ways biotic change is of a similar nature to climate change. In both cases the rates of change are unprecedented in geological history. Further, both climate change and biotic changes are subject to international concern that is embedded in the Climate Convention on the one hand and in the Convention on Biological Diversity on the other. Although both climate change and biotic change have large economic consequences, the former probably has the potential to dwarf the latter in the future but certainly not at the present. Both changes have the capacity to alter the nature of ecosystems. This is already occurring for invasive species and to a limited extent for climate change. A big difference between these two issues is that even though it will be difficult, there is the possibility of reversing the trend of increasing CO_2 concentrations in the atmosphere through modification of energy use. At present there is no "recall" of alien invasive species once they become established in large numbers. Perhaps in the future with better biological control or new applications of biotechnology, more general control, and even eradication, of invasives will be possible.

The task of the land (or coastal) manager is a daunting one. Successful management depends on knowing the detailed characteristics of the biota of a given landscape and how that biota responds to climate variability and to land-use patterns. Both climate change and biotic change present even fur-

ther challenges to the stewards of the land because neither change respects nature reserve borders. Biotic change constantly introduces new biotic players into the landscape that will interact in an unknown manner with the existing biota and a changing climate.

It is easy to become pessimistic about dealing with the challenges of biotic change, but good science, adequate resources, and the proper tools can win the day. The resolve to develop the tools and to bring the resources needed to deal with invasives is becoming more widespread as the consequences of doing nothing are appreciated to an ever greater extent. It is hoped that this volume provides the incentive for us all to work harder to deal with the invasive species problem in an aggressive and successful manner. Clearly, however, we have a very difficult task ahead.

Part I first lays out the dimensions of the invasive species problem with a comprehensive look at the status of freshwater, marine, and terrestrial ecosystems in relation to invasive species. It then examines a number of physical factors that will influence the future success of invading species, including changing fire regimes and the changing composition of the atmosphere. It also looks at how these changing physical factors will influence the success of invasives as well as their evolutionary pathways. Finally, it discusses what tools we presently have to keep track of the changing patterns and movements of invasive species.

The human dimensions of invasive species, such as society's diverse views about them and how they affect human health as well as the crops upon which we depend, are discussed in Part II. This section concludes with an analysis of the not inconsiderable costs of invasives.

Part III looks at the problem of invasives in different parts of the world, showing their current global prevalence and large impacts, and makes projections for future.

Finally, Part IV summarizes what we have learned and proposes a plan for dealing with invasive species at the global level. The road ahead will not be an easy one, but there are many actions that can be taken that will give us more choices of how the new biotic world will look in the future.

Part I

Dimensions
of the Problem

Chapter 1

⁕

Freshwater Nonindigenous Species: Interactions with Other Global Changes

Cynthia S. Kolar and David M. Lodge

In most regions on earth, nonindigenous species (NIS) comprise the first or second most important anthropogenic impact on freshwater ecosystems (U.S. Congress 1993; Naiman et al. 1995; Lodge, in press). Thus, the spread of NIS itself constitutes a major global change. Most species introduced outside their native range do not become established, and only a small proportion of those that do establish self-sustaining populations cause a perceptible environmental impact (Lodge 1993a,b; Williamson 1996). Yet, the enormous number of species introduced results in a large number of high-impact species (Lodge 1993a; Williamson 1996; Lodge et al. 1998; Lodge, in press). Therefore, even in the absence of other environmental changes, the global effects of NIS on native freshwater biodiversity and ecosystem function would be large. This chapter emphasizes the often important ways in which other global changes increase the frequency of introduction, establishment, and impact of NIS in freshwater ecosystems.

Several global changes—especially globalization of commerce, construction of dams and canals, urbanization and conversion of land to agriculture, climatic and atmospheric changes, and some practices of fisheries manage-

Table 1.1. Trends in the effects of global changes on freshwater ecosystems, and how strongly each global change increases the number or impact of NIS. Patterns for some environmental changes in certain parts of the earth might differ from the global estimates represented here.

	Trend in global change	Positive interaction with NIS
Globalization of commerce	increasing	strong
Shipping	increasing	strong
Bait trade	increasing	strong
Aquarium and pond trade	increasing	strong
Aquaculture	increasing	strong
Waterway engineering	increasing	strong
Canals	increasing	strong
Dams	increasing	strong
Land-use changes	increasing	medium
Siltation, eutrophication, etc.	increasing	medium
Water withdrawal	increasing	weak
Climatic and atmospheric changes	increasing	weak
Intentional stocking	increasing	strong

ment (e.g., stocking NIS)—have important, long-lasting effects on freshwater biodiversity and ecosystem function (Lodge, in press; Table 1.1). Most of these global changes strongly increase the impact of NIS (Table 1.1). This chapter draws on recently published reviews to briefly summarize the nature of each major global change with respect to freshwaters (Table 1.1, first two columns). Most important, it then provides evidence and examples of how each global change interacts with NIS to produce an even greater effect on freshwater ecosystems (Table 1.1, third column).

The primary goal of this chapter is to document the impact of these interactions on freshwater biodiversity and ecosystem function. Although it is impossible to eradicate most established NIS, it is vital to recognize that most of the underlying interactions among global changes are reversible. The occurrence and impact of NIS could be dramatically reduced if appropriate decisions governing the human activities listed in Table 1.1 are made. Some recommendations are included at the end of this chapter.

Globalization of Commerce

Although the ranges of some freshwater species change on many temporal and spatial scales without human influence, the number, rate, and spatial scale of recent and ongoing range expansions far exceed anything that would

occur in the absence of human influence (Lodge 1993a; Lodge et al. 1998). With the increased globalization of commerce over the last few centuries, and especially in recent decades, humans have begun the homogenization of the world's freshwater biota. Future steps to halt this trend can and should be built on documentation (such as in this chapter) of how this homogenization is exacerbated by interactions among global changes.

Humans, their vehicles, and their goods are often direct vectors for the movement of species beyond historical range boundaries. For the thousands of freshwater and marine species moved in the ballast water of ships, this is unintentional, but certainly foreseeable and increasingly preventable with new practices and technologies. In other cases, the movement of live freshwater species (if not their release in natural environments) is central to the goals of commerce: live fish and invertebrate species are used extensively in the fish bait trade; fishes, invertebrates, and plants are central to the aquarium and garden pond trade; and many fish, invertebrate, and plant species are used in aquaculture worldwide. The numbers of species and individuals involved, and the distances being traversed in short times, are enormous (Lodge et al. 1998). For example, frequent releases (accidental and intentional) of tropical fishes made possible a recent series of articles in a leading aquarium hobbyist magazine documenting the numerous Florida locations where many exotic tropical fishes can now easily be collected by the amateur hobbyist (Ganley and Bock 1998).

Few of these species-moving forms of commerce are new, but their global scale and pace of development are increasing rapidly, along with most other forms of commerce. In many cases, little attention has been paid to the environmental and economic costs of NIS. The most striking exception in North America—where costs of NIS have prompted regulatory action—is in ballast water management, where Canadian and U.S. guidelines were adopted for the Laurentian Great Lakes in the wake of the invasion by zebra mussels. Similar regulatory programs have also been enacted in Australia and other parts of the world. Although these guidelines entail considerable expense for the shipping industry, the need to prevent NIS has been accepted, in part because moving species is incidental to the goal of shipping. Resistance to regulation may be greater from enterprises such as the bait, aquarium, garden pond, and aquaculture industries, where moving and selling live organisms is the heart of the business. While these latter industries are satisfying societal demands, they are also major global vectors of NIS. In other parts of the world, for example, Australia and New Zealand, tighter restrictions exist on a broader array of taxa. In much of the world, the NIS-associated costs of many vectors of NIS and other global changes that increase the impact of NIS require more careful scrutiny and perhaps more regulation on both national and international levels. Some specific steps toward those ends are suggested in the final section of this chapter.

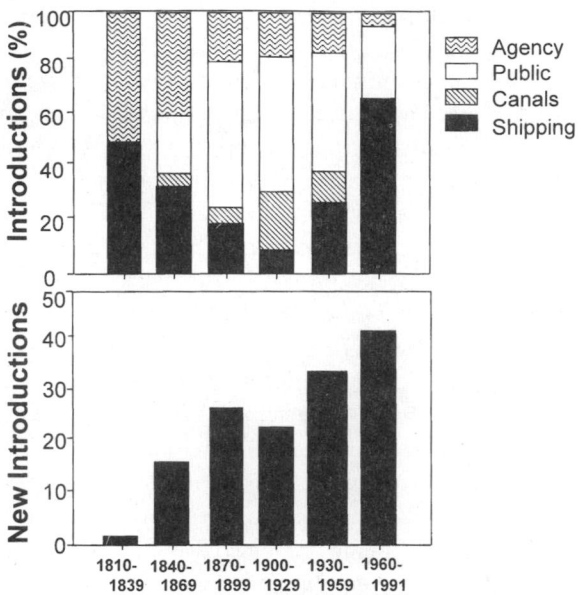

Figure 1.1. Top: Percentages of documented Laurentian Great Lakes NIS newly established during each 30-year interval that are attributable to other anthropogenic global changes: Agency = intentional stocking by state and federal agencies; Public=intentional and accidental releases by individual members or associations of the public; Canals = species that moved through a canal from one watershed to another; and Shipping = species transported in ballast. *Bottom:* The absolute number of documented NIS from 1810 to 1991, showing increasing trend of establishment. All data were taken from Mills et al. 1993.

The Laurentian Great Lakes provide an unusually well documented example of the importance of several global changes in increasing the numbers and impact of NIS (Fig. 1.1). At least 139 species of exotic algae, aquatic vascular plants, molluscs, and fishes have become established in the last 180 years, with the rate of species additions increasing with time (Fig. 1.1). Throughout the period, ship ballast (solid ballast earlier and water ballast more recently) has been an important vector, one that should be declining disproportionately since the implementation of ballast water regulations. Accidental and deliberate introductions by the public have been other significant sources of NIS in the Great Lakes, as they probably have been worldwide.

In addition, the Great Lakes data (Fig. 1.1) illustrate partially two of the remaining four types of global changes discussed in this chapter: waterway engineering (canals, locks, and dams) and stocking of NIS by governmental fisheries management agencies. For the Great Lakes, the relative importance of these sources of NIS has changed over time (Fig. 1.1), reflecting changing

patterns of shipping, and changing public attitudes (particularly driving the decline in NIS stocking by agencies) in North America. For most sources, however, even in the Great Lakes, the absolute number of introductions has continued to increase over time; this is certainly true on a global basis (Ruesink et al. 1995). The remainder of this chapter expands on the Laurentian Great Lakes example and uses examples from around the world to address systematically how each global change (Table 1.1) increases the impact of NIS in freshwater ecosystems.

Waterway Engineering

Humans have practiced various types of water management for thousands of years—from the 8,000-year-old irrigation canals on the eastern edge of Mesopotamia (McCully 1996) to the ongoing Three Gorges dam project in China. The number and size of completed water engineering projects— canals, locks, and dams—have greatly increased in the latter half of the twentieth century. Water management projects provide obvious, substantial benefits to humans, such as increased opportunities for commerce and transportation, electric power, and water for drinking and irrigation. However, these structures alter freshwater community structure in ways that reduce the abundance of native species and enhance the ability of NIS to become established, persist, and spread.

Canal and Lock Construction

Canals have been used for centuries to augment the transportation and trade possible on natural waterways. For example, segments of the 1,800 kilometer Grand Canal in southeastern China, begun in 486 B.C., are still used today (Qian 1994). Extensive, interconnected waterways were constructed throughout Europe, Russia, Canada, and the United States, particularly during the first half of the nineteenth century (Jackson 1997). One unintended consequence with enormous ecological implications is that canals and locks connecting previously unconnected waterways allow aquatic species to cross former geographic boundaries. In invaded watersheds, resident species may be vulnerable to predation or competition with NIS, or to diseases or parasites associated with NIS. Thus, species native to only one of two newly connected drainages may invade the other, or species nonindigenous to the region or the continent and present in only one drainage may invade the other.

Although many canals have existed for decades or centuries, they are becoming increasingly good conduits for species movement because of recent increases in water quality. In many canals, water quality has long been extremely poor—often lethal to many species—because they were typically

built in areas of industrialization or high human population. Throughout the United States and in many parts of the world, however, water quality has been steadily increasing as water pollution regulations were implemented. Canals that were formerly unusable by aquatic species are becoming important conduits of species movement. The canals that connect the Laurentian Great Lakes with one another and with other watercourses illustrate these points clearly.

Canals, NIS, and the Laurentian Great Lakes

Historically, fish assemblages of the upper Great Lakes were dominated by lake trout (*Salvelinus namaycush*), burbot (*Lota lota*), and ten species of whitefish (*Coregonus* spp., many endemic) (Fig. 1.2). The first high-impact NIS to enter the upper Great Lakes via canals, the sea lamprey (*Petromyzon marinus*), gained access via the Welland Canal (1829), which bypasses Niagara Falls, between Lakes Ontario and Erie. The sea lamprey, a parasitic fish that attaches to large fish and sucks their body fluids, was first found in Lake Erie in 1921. By 1946, it was established in all of the Great Lakes and had contributed to dramatic declines in lake trout populations; there were localized extinctions of lake trout in four out of the five lakes (Christie 1974). Sea lampreys also preyed heavily on burbot and larger whitefish species (a factor in the extinction of two endemic whitefish species) (Christie 1974).

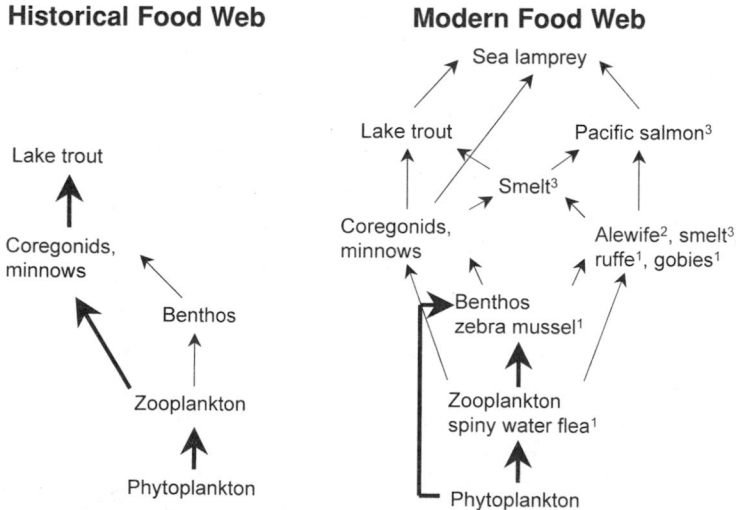

Figure 1.2. Major taxa in the historical and current food webs in the Laurentian Great Lakes, emphasizing the many NIS in the current food web. Bolded components show primary pools and flows (arrows) of energy, which have been transformed by NIS. Superscripts indicate global change that allowed introduction of NIS: 1 = shipping; 2 = canals; 3 = fisheries management.

In the 1930s, alewife (*Alosa pseudoharengus*) also invaded through the Welland Canal and quickly became abundant in the upper Great Lakes. Alewives removed large zooplankton from Lake Michigan (Wells 1970), competed with native prey fish (Crowder 1980), and were subject to large die-offs; several billions of alewives were estimated to have died in the spring of 1967 in Lake Michigan alone (Wells and McLain 1973). Alewife abundance was reduced by the deliberate introduction of several predacious Pacific salmonids (*Oncorhynchus mykiss, O. kisutch,* and *O. tshawytscha*). Thus, the sea lamprey and the alewife, both entering the Great Lakes through the Welland Canal, produced dramatic changes in the functioning of the Great Lakes, which in turn led to the deliberate introduction of exotic salmonid species to control alewife. The current state of the food web and ecosystem function is very unlike what existed before European settlement (Fig. 1.2), but more canal-driven changes are underway, particularly in the south of Lake Michigan.

During the latter part of the Pleistocene glaciation, proto-Lake Michigan drained to the south into what became the Mississippi River drainage. However, after the Pleistocene ice sheets receded, the Great Lakes basin and the Mississippi drainage remained independent for about 5,000 years (Underhill 1986). Then, about 130 years ago, they were artificially connected with the construction of three canals in the Chicago, Illinois, area; the first opened in 1873 (Changnon and Changnon 1996). Within 20 years of their opening, water quality in the canals (and in much of the upper Illinois and Des Plaines Rivers) was so poor, largely from sewage and industrial pollutants from Chicago, that species movement from one basin to the other was impeded. Since the passage of the Clean Water Act in 1976 and the construction of sewage treatment plants, however, water quality has improved (Changnon and Changnon 1996), and the canals are now conduits for species movement. In recent years, species movement from one basin to the other via canals has been documented for both fishes and invertebrates (Table 1.2).

Aided by normal and flood flow through the canals and river system, some species that spread to the Mississippi drainage from Lake Michigan have quickly colonized much of the Mississippi drainage. For example, zebra mussels (*Dreissena polymorpha*) colonized the southern basin of Lake Michigan by 1990, were collected in the Illinois River in 1991, and then quickly spread south for the entire length of the Mississippi River by 1993 (New York Sea Grant 1993).

Additional species are poised to move through the canals (Table 1.2). The potential impact of these canal-traveling NIS on the Mississippi drainage and the Great Lakes, respectively, is large (e.g., displacing native species and changing habitat conditions). The Chicago-area canals, along with others in the Great Lakes basin, will increasingly act as highways for other species to

Table 1.2. Aquatic fish and invertebrate species known to have used the Chicago-area canal system to expand their range from Lake Michigan to the Mississippi drainage, or vice versa. Also listed are species (*) that are likely to traverse the canals in the near future because their distributions have recently expanded to include the canals or the canals area. Species not native to North America are indicated ([+]).

Invaded Lake Michigan from the Mississippi drainage	Invaded Mississippi drainage from Lake Michigan
American eel (*Anguilla rostrata*)[1]	rainbow smelt (*Osmerus mordax*)[3]
gizzard shad (*Dorosoma cepedianum*)[2]	white perch (*Morone americana*)[4]
goldfish (*Carassius auratus*)[2+]	oriental weatherfish (*Misgurnus anguillicaudatus*)[4+]
yellow bass (*Morone mississippiensis*)[2]	
skipjack herring (*Alosa chrysochloris*)[2]	nine-spine stickleback (*Pungitius pungitus*)[3]
silver carp (*Hypophthalmichthys molotrix*)[*+]	zebra mussel (*Dreissena polymorpha*)[5+]
bighead carp (*Hypophthalmichthys nobilis*)[*+]	round goby (*Neogobius melanostomus*)[*+]
rudd (*Scardinius erhthrophthalmus*)[*+]	
water flea (*Daphnia lumholtzi*)[*+]	

[1] Cochran 1981; [2] Cudmore 1999; [3] Burr and Mayden 1980; [4] Burr et al. 1996; [5] Baskin 1998

move from one basin to the other. Inevitably, some of the invading species will cause substantial changes in the newly invaded ecosystem.

On a global basis, canal construction has declined in regions where many canals were built in the first half of the nineteenth century. In fact, many of these canals, built for trade over 100 years ago, were de-watered decades ago. There is, however, a growing trend in England, Canada, and the United States to restore de-watered and fragmented canals for recreational boating and angling. In addition, new canal systems are still being proposed and built worldwide, particularly in developing regions where water is a major means of transportation. For example, large projects are under consideration or construction in Brazil (to join a tributary of the Amazon River to the Paraguay River) and India (to create a huge string of reservoirs and canals linking the Ganges River to ten major river systems) (McCully 1996). On a global basis, canal and lock construction promise to increase in importance as conduits for NIS.

Dam Construction

Dams regulate river discharge, reduce flooding, and store water to meet fluctuating demands for water and energy (McCully 1996). These benefits were realized long ago; the earliest evidence of dam construction is from about 3000 B.C. in present-day Jordan (McCully 1996). Globally, the number of large dams (those over 15 meters high) has increased from just over 5,000 in

1950 to about 40,000 currently; and 85 percent of these have been constructed in the past thirty-five years (Postel and Carpenter 1997). Nearly 1,200 large dams (over 15 meters high) were under construction at the beginning of 1994 (Postel and Carpenter 1997). While dams will continue to be built in many places, some rivers, or sections thereof, in Sweden, Norway, and the United States are currently protected, making new dam construction very unlikely in these countries (McCully 1996).

While dams benefit human needs, they also cause dramatic ecosystem changes. Dams limit the movement of migratory species, alter temperature, alter flow and depth regimes, decrease habitat diversity, dampen high water flows, and change the system from a free-flowing (lotic) to a more static, lake-like (lentic) ecosystem (McCully 1996) (Table 1.3). Collectively, ecosystem changes caused by damming make the ecosystem less tolerable to native, lotic species and more vulnerable to colonization by NIS, or more susceptible to the spread and population growth of NIS already present.

Although the habitat changes that result from damming are important in enhancing NIS, probably the most important vector increasing NIS in associ-

Table 1.3. Unintended effects of species deliberately introduced into the Great Lakes by governmental agencies (from Mills et al. 1993).

Common name	Scientific name	Year of detection	Unintended effects of species
Curly pondweed	*Potamogeton crispus*	1879	Becomes overabundant; chokes out other species
Minor naiad	*Najas minor*	1932	Spreads rapidly; becomes overabundant
Faucet snail	*Bithynia tentaculata*	1871	Becomes overabundant; fouls surfaces
Oriental mystery snail	*Cipangopaludina japonica*	1940s	Becomes overabundant; crowds out other species
Chinook salmon	*Oncorhynchus tshawytscha*	1873	Ecological and genetic effects on native species
Rainbow trout	*Oncorhynchus mykiss*	1876	Ecological and genetic effects on native species
Common carp	*Cyprinus carpio*	1879	destroys habitat used by more favored fish and waterfowl
Brown trout	*Salmo trutta*	1883	Ecological and genetic effects on native species
Rainbow smelt	*Osmerus mordax*	1912	Excessive competition with and predation on juvenile native species
Western mosquitofish	*Gambusia affinis*	1923	Displacement of native species[1]
Coho salmon	*Oncorhynchus kisutch*	1933	Ecological and genetic effects on native species

[1] Mefee (1984)

ation with dams is intentional introductions by resource managers. Because fish species adapted to riverine conditions become less abundant or disappear from a system once it is impounded, fisheries managers often stock reservoirs with economically valuable fishes adapted to still waters: tilapia and carp in warm waters; and trout, bass, and catfish in cool waters (McCully 1996). Below dams, tailwater fisheries are also typically "enhanced" by stocking non-indigenous sport fish species. Such stocked species, for example, common carp (*Cyprinus carpio*) and gizzard shad (*Dorosoma cepedianum*), can proliferate in reservoirs and then move upstream in large numbers (Pringle 1997). A well-documented example of the complex indirect and direct ways in which damming enhances NIS is the Columbia and lower Snake Rivers, in the Pacific Northwest of the United States.

Dams, NIS, and the Columbia and Lower Snake Rivers (from Poe et al. 1994, Postel and Carpenter 1997)

Prior to settlement by Europeans, an estimated 10–16 million adult salmon and steelhead trout (*O. mykiss*) returned annually from the Pacific Ocean to spawn in the Columbia River basin. Since that time, about 130 dams have been built, mostly for hydroelectric development. Now only about 1.5 million salmon return annually (and 75 percent of those are hatchery-reared). Dam construction has resulted indirectly and directly in the establishment of many nonindigenous fish species. Dams converted the free-flowing rivers into a series of warmer, slow-flowing reservoirs, including shallow, warm backwater habitats with abundant aquatic plants. Conversely, downstream is usually colder than natural because water is typically released from the deeper, colder strata of reservoirs. Thus, both above and below the dam, conditions are very different from free-flowing conditions, reducing habitat suitability for native species and increasing invasibility by NIS.

Historically, two predator fish (northern pikeminnow [*Ptychocheilus oregonensis*] and prickly sculpin [*Cottus asper*]) and three omnivorous fish species (white sturgeon [*Acipenser transmontanus*], bull trout [*Salvelinus confluentis*], and cutthroat trout [*Oncorhynchus clarki*]) were at the top of the food web in the lower Columbia and Snake Rivers. Since the late 1800s, however, over twenty predacious fishes have been introduced (mostly centrarchids and percids). The upstream environmental changes caused by dams favored introduced centrarchids and percids, species that do better than natives in warmer, lentic environments. These species became more widespread after dam construction, although many had been introduced previously.

Food habit studies suggested that nonindigenous predatory fishes outcompeted northern pikeminnow for preferred prey. When nonindigenous predators were low in abundance, diets of northern pikeminnow were domi-

nated by insects (18 percent), crayfish (15 percent), and sculpins (14 percent). Despite high numbers of juvenile salmonids present, juvenile salmonids comprised only 2 percent of the northern pikeminnow diet. When nonindigenous predators were abundant, however, diets of northern pikeminnow were largely composed of juvenile salmonids (up to 70 percent).

The introduction of NIS thus has an ironic consequence: native northern pikeminnow appear to be thwarting efforts to save endangered salmonid stocks, even though it was the nonindigenous predatory fish species that caused the dietary shift of squawfish. As a result, the state of Washington put a bounty on northern pikeminnow. Since 1991, anglers have been paid $4–6 for each northern pikeminnow over 10 inches. Another, and likely more effective, means under consideration to restore endangered salmonid stocks is to modify or remove some of the dams obstructing return to their spawning grounds.

Dam Removal and Altering Dam Operation

Given the dramatic changes in riverine ecosystems after damming, support for removing smaller dams and changing the operating regime of larger dams is growing, particularly in the United States. Few dams of any size have yet been removed, but a number of dams have been denied relicensing and will likely be removed (McCully 1996). The draining of Lake Powell, the reservoir behind the Glen Canyon Dam on the Colorado River, was even discussed by the congressional House Resources Committee in 1997. Similarly, dam operating regimes are also being modified to more closely mimic natural systems (i.e., matching natural water temperatures and hydrographs). These trends are likely to continue in the United States and may also become important in other countries.

Removing dams and modifying dam operation—the reversal of earlier global changes—will reduce the relative abundance and impact of freshwater NIS. Restoring natural flood pulses may "wash out" NIS and help restore native species. In streams of the southwestern United States, which typically experience severe changes in discharge during flash flooding, nonindigenous fish species were unaffected by controlled, low-volume releases from dams. However, emergency releases of high volume, similar to the natural hydrograph, caused the disappearance from downstream of several NIS that were formerly abundant (Minckley and Mefee 1987). Similarly, many California streams have highly seasonal flow patterns, and some impounded systems are dominated by nonindigenous fishes. In unregulated systems, however, native fish species dominate and would-be colonists are regularly flushed downstream (Moyle and Light 1996). Removal of a dam in Minnesota allowed three native fishes—muskellunge (*Esox masquinongy*), flathead catfish (*Plylodictus olivaris*), and bowfin (*Amia calva*)—to move from the Mississippi

River, upstream of the former dam site where they had not been known for decades (Rebuffoni 1995). Thus, restorations of riverine communities by dam removal are not limited to arid regions with high natural variability in discharge.

Not only does dam removal have implications for freshwater NIS, but so do aspects of dam operation. Dam-induced changes in the timing of peak discharge can have devastating effects on native fish populations adapted to unregulated conditions. Dam operations that maintain flow regimes more similar to natural conditions often favor native species over NIS. A 1996 experimental flood release from the Glen Canyon Dam on the Colorado River more than doubled typical discharge for one week but was inadequate to remove nonindigenous fishes (Stevens 1997). Additional experimental floods are planned to restore native fish habitat and remove nonindigenous fish species.

Changing the depth in the reservoir from which water is released is an additional important aspect of dam operation. Dams can be designed to produce cold-, cool-, or warm-water systems below the dam. Because fish species composition depends largely on water temperature, native species are often lost below dams. For example, water temperature below Glen Canyon Dam is too cold for successful reproduction of native species as far as 400 kilometers downstream, although nonindigenous species adapted to the colder conditions have been stocked (McCully 1996). Thus, modifying the temperature of water released from dams to more closely mimic natural conditions may reduce the prominence of freshwater NIS.

Changes in Land Use

Urbanization and the conversion of natural habitats to agriculture are major global changes that affect the distribution and abundance of species (Dobson et al. 1997; Hobbs, this volume), and that enhance the importance of NIS. Over the past 280 years, the amount of nondomesticated land area has shrunk globally from about 95 percent to about 65 percent, mainly through the conversion of natural forests and grasslands into cropland and pasture (GEO 1997). In addition to ongoing intensification of agriculture, further conversion of forested and grassland areas to agriculture will be necessary to meet future increases in demand for food (GEO 1997). In most regions of the globe, habitat loss from changing land use is the first or second (after NIS) most important threat to freshwater biodiversity (Lodge, in press).

These land-use changes affect freshwaters by increasing runoff of silt, fertilizers, and pesticides, and by increasing water temperature (via decreased shading by natural vegetation). In addition, removal of large volumes of

water for irrigation often reduces habitat volume, and increases salinity (Pimentel et al. 1997). The combined effect of these ecosystem changes is to alter the amount and quality of habitat available to freshwater organisms. Native species, adapted to pre-development conditions, are sometimes lost, and the disturbed system is more vulnerable to the deliberate or accidental introduction of NIS.

Effects of Silt, Fertilizers, and Other Runoff

Increased nutrients in runoff cause eutrophication, one of the most serious and widespread global changes affecting lakes (Naiman et al. 1995). Eutrophication can lead to a number of negative impacts on freshwater ecosystems, including noxious blooms of blue-green algae, lower dissolved oxygen, and shifts in species composition of many taxa, including fishes (Lodge, in press).

Salmonid introductions in the southern Chilean Lake Region exemplifies how land-use changes can increase invasibility by NIS. This region of Chile contains large (50–870 km^2) and deep (up to 350 meter maximum depth) lakes with low nutrient content, even though their basins have deforested areas used for agriculture, human settlements, tourism, and salmon farming (Carpenter et al. 1996). At the beginning of the twentieth century, several salmonid species were stocked, but only rainbow trout and brown trout (*Salmo trutta fario*) were successful—probably because the lakes did not have sufficient nutrients for the other species (Carpenter et al. 1996). Since that time, land-use changes have continued and the lakes have become more nutrient-rich. Now, salmon that have escaped from salmon farming operations have become established in areas that were previously too nutrient-poor (Carpenter et al. 1996). Anthropogenic changes in Lake Victoria, East Africa, tell a similar but more devastating story of the interactions of land-use change and NIS.

Land-Use Changes and NIS in Lake Victoria (from Goldschmidt 1996, Bright 1998, Lodge, in press)

Lake Victoria, a large 12,000-year old lake in East Africa, is an essential source of water and protein from fish for its surrounding human population. A variety of global changes have affected the lake in the past century, but the best evidence suggests that the interaction of eutrophication and NIS has been especially important in changing the food web and function of the lake ecosystem. Eutrophication (mainly from changes in land use) and non-indigenous fishes and plants have changed Lake Victoria from a clear, well-oxygenated lake with incredible diversity of cichlid fishes (dominated by

planktivorous, herbivorous, and benthivorous species), to a murky, oxygen-deprived, weed-choked lake with diminished fish diversity (dominated by predators).

The human population in the Lake Victoria basin is growing at the annual rate of 3–4 percent, with a deforestation rate of 1–2 percent (both about twice the global average). Because of increased land use by humans, Lake Victoria began a marked eutrophication in the early decades of the twentieth century. Thirty years ago, the entire water column was usually oxygenated, but now at least 30 percent of the lake bottom is often without oxygen. Thus, less of the lake is available to fish and other organisms.

Before the 1950s, the commercial fishery depended on two native tilapia species. But by the early 1950s, they were overfished and three species of nonindigenous tilapia were introduced to refurbish the fishery. Also in the 1950s, Nile perch (*Lates nilotica*), which reach 2 meters and 200 kilograms, were stocked to convert the substantial biomass of smaller fish into large fish suitable for large-scale, higher capital investment and exploitation for human consumption. For the first few decades thereafter, Nile perch remained rare. But in the 1980s, well after eutrophication was underway, Nile perch quickly became abundant; in Ugandan waters (43 percent of the lake), for example, the total commercial catch of fishes increased from 17,000 tons in 1981 to 132,400 tons in 1989, with Nile perch and exotic tilapia constituting practically the entire catch. Preexisting eutrophication aided Nile perch by increasing overall productivity and by concentrating remaining prey in areas with sufficient dissolved oxygen for survival.

Now, since there are far fewer herbivorous fish, algae covers much of the lake, further driving down available oxygen and concentrating remaining prey, making them more vulnerable to predation. In 1990, Lake Victoria suffered a further blow with a population explosion of exotic water hyacinth (*Eichornia crassipes*), a floating Amazonian water plant considered one of the world's worst aquatic weeds; hyacinth now infests about 90 percent of the shoreline, chokes off harbors and clogs water supply pipes, provides habitat for disease-causing snails and mosquitoes, and inhibits navigation by fishing boats. Like Nile perch, water hyacinth has probably benefited from eutrophication. Thus, land use changes set the stage for the transformation of Lake Victoria by NIS. Not only has the unparalleled species flock of cichlids been imperiled, but the ability of the lake to meet human needs is now threatened.

Effects of Water Withdrawal for Irrigation and Other Human Needs

Freshwater is a largely nonsubstitutable natural resource for human uses, including agriculture, households, and industries (Postel and Carpenter

1997). Of these uses, agriculture consumes the most—about 82 percent of the water consumed per year globally (about 15 percent of the annual available runoff; Postel et al. 1996). Water withdrawals and extractions have tripled since 1950 to meet demand as human population has increased (Postel and Carpenter 1997). Although total water consumption is decreasing in the United States as a result of conservation efforts (USGS 1998), water consumption is expected to continue to increase in many parts of the world. For example, irrigated land in developing nations (excluding China) is expected to increase about 0.8 percent per year, with Egypt, Mexico, and Turkey anticipating particularly rapid expansions (World Resources Institute 1998). Removing large volumes of water from rivers and lakes often increases water temperature (because water becomes shallower), and increases salinity. Both of these changes can affect the distribution and abundance of NIS in the system.

Increases in salinity from water withdrawal can be especially dramatic. Mono Lake, California, has almost doubled in salinity in the sixty years since being tapped to supply water to Los Angeles (Mono Basin Ecosystem Study Committee 1987). The Aral Sea, central Asia, has fared much worse, and exemplifies the catastrophic effects that interactions between NIS and water withdrawal can have on native aquatic biota.

Water Withdrawal, NIS, and the Aral Sea (from Glazovsky 1995; Lodge, in press)

The Aral Sea, one of several large closed-basin, oligotrophic, fresh-saline lakes in the arid regions of central Asia, once had the world's fourth-largest surface area. Because of extensive water diversions for agriculture, however, the lake is literally disappearing. Beginning in the 1960s, both major inflows to the lake were diverted for irrigation. Between 1974 and 1986, the Syr Darya (one of the major inflowing rivers) did not even reach the lake. By the 1980s, river runoff that reached the sea had decreased from 560 km³/year to about 2 km³/year. Lake level dropped 31 percent from 1960 to 1993, during which time the lake split into two basins, and declined in surface area by 50 percent, and in volume by 72 percent. Over the same period, lake salinity increased from 10 grams/liter to 37 grams/liter (becoming more concentrated than seawater). Its predominantly freshwater species were replaced by predominantly saltwater organisms.

Although the ecology of the Aral Sea is poorly documented, these dramatic ecosystem changes have clearly decreased the abundance of native species and increased the relative abundance of NIS in the lake. Prior to 1927, when the first nonindigenous fish was introduced, the Aral Sea was home to 19 native fish species. By the 1960s, seventeen additional fishes had been intro-

duced (along with many invertebrate species). After that time, as salinity increased, the proportion of native species began to decline. Many freshwater fishes perished by 1975 when salinity increased to 12–14 grams/liter, and most others perished between 1985–1990 when salinity exceeded 23 grams/liter. By 1990, only five fish species remained—four of them nonindigenous. Now, no fishes remain. Thus, increasing water salinity, caused by diversion of water, led to a complete shift in the fish community to entirely nonindigenous species; salinity continued to increase so that the Aral Sea is now uninhabitable even to these NIS.

Climatic and Atmospheric Changes

Climatic warming from the accumulation of greenhouse gases, acid deposition from fossil fuel–derived oxides of sulfur and nitrogen, and increased exposure to UV-B radiation from stratospheric ozone depletion also have important effects on freshwater ecosystems (Schindler 1998) that interact with NIS. If present trends continue, most climatologists agree that global mean temperature may increase 2°C (relative to 1900) by 2100 (IPCC 1995). UV-B radiation is increasing, particularly at high latitudes. Although sulfur emissions in North America have decreased in recent decades, global acidification will continue and perhaps increase because of increases in fossil fuel consumption in other parts of the world (Schindler 1998).

Increasing water temperature, decreasing pH, and increasing UV-B exposure affect the distribution and relative abundance of freshwater organisms—and will likely alter invasibility of individual ecosystems by aquatic NIS. Though all three of these stressors have implications for aquatic NIS, we expect climatic change to have greater impact than pH and UV-B. Likely consequences of climatic change on lakes, summarized by Arnell et al. (1996), include drier conditions, changes in the abundance and species composition in individual lakes and regions, and altered nutrient loading to lakes. Similarly, water temperature of groundwater, surface runoff, streams, and rivers will increase; stream flow will decrease; some channels will become ephemeral, while others will dry. These types of ecosystem changes will alter the species composition of phytoplankton, zooplankton, bottom-dwelling invertebrates, and fishes in freshwater ecosystems (Magnuson et al. 1997). As a result, these systems may become more vulnerable to invasion by NIS, or NIS already present in the system may become more abundant.

Computer models simulating a 2–4°C increase of July air temperature reduced cold-water habitat in the Rocky Mountain region by 35–62 percent (Keleher and Rahel 1996). Many streams in the western United States contain both nonindigenous brook trout and native cutthroat trout; since brook trout are better adapted to warmer conditions than cutthroat (De Staso and Rahel 1994), climatic warming may help to further squeeze cutthroat trout out of

their native range. Also in the United States, cool-water species such as smallmouth bass and yellow perch may move northward 500 kilometers via canals and rivers, and warmer water species such as common carp and largemouth bass (*Micropterus salmoides*) may move up to 600 kilometers (Magnuson et al. 1997). Though many of these northward range expansions will be from fishes native to more southern regions, some of them will certainly be from species not native to the region or continent (as in the case of the carp).

In addition, human responses to climate warming will have further direct impacts on the distribution and abundance of aquatic NIS. Stream sections and lakes that are newly isolated by dropping water tables will be seen as opportunities to stock warmer water fishes, and fisheries management agencies will probably be pressured to augment these communities (Magnuson et al. 1997).

Although the interaction with NIS of changing UV-B and pH may be minor compared to the effects of changing climate, they will not be inconsequential. Even current levels of UV-B radiation produce strong biological effects. In clear waters, ambient UV-B reduces zooplankton survival, and lowers abundance and production of phytoplankton and periphyton (Lodge; in press). Future increases in UV-B radiation will increase water clarity and decrease habitat for cold-water fishes (Schindler 1998). Such ecosystem changes alter the distribution and relative abundance of aquatic species, including NIS.

Lake acidification is a major driver of biodiversity losses from the boreal lakes of North America, Europe, and Scandinavia because these lakes are naturally low in buffering capacity (Schindler 1998). As pH decreases, sensitive freshwater taxa, including bottom-dwelling invertebrates and some fishes, are lost (Sutcliffe and Hildrew 1989). In Lake 223 within the Experimental Lakes Area, northwestern Ontario, Mills (1984) found replacement of fathead minnows (*Pimephales promelas*) by pearl dace (*Margariscus margarita*) as pH declined. The persistence of predators, in similar circumstances, therefore, would depend on the prey fish community present prior to acidification. In Lake 223, for example, lake trout would have been eliminated if the community had not originally contained pearl dace. As with climatic warming, however, many changes in species assemblages in response to changing UV-B or pH will be from regional flora and fauna.

Stocking and Harvesting

People have stocked and cultured fish for millenia, and human use of aquatic organisms will continue to affect the distribution and relative abundance of freshwater NIS. Common carp, for example, were first transplanted by the Chinese over 3,000 years ago, and by the Romans 2,000 years ago (Li and Moyle 1993). Fish and invertebrate species are often introduced for a variety of reasons: as a food source; because of cultural and aesthetic desires; to

enhance sport and commercial fisheries; and to control problem species (Li and Moyle 1993). Introducing nonindigenous fishes has long been an important tool for fisheries managers; approximately 25–50 percent of the freshwater fishes caught by anglers in the continental United States are from populations established through intentional introductions (Moyle et al. 1986).

Activities associated with harvesting aquatic resources also lead to the unintentional spread of NIS. For example, a number of species have been spread in the Laurentian Great Lakes region via intentionally or accidentally released live bait by anglers: goldfish (*Carassius auratus*), ghost shiner (*Notropis buchanani*), suckermouth minnow (*Phenacobius mirabilis*), rudd (*Scardinius erythrophthalmus*) (Mills et al. 1993), and rusty crayfish (*Orconectes rusticus*) (Lodge et al. 1998). Bait-bucket spread has also been implicated in the spread of the Asian freshwater clam (*Corbicula fluminea*) throughout the United States (Carlton 1992). Species can also be spread from the live wells and trailers of boats, as in the cases of the zebra mussel and Eurasian water milfoil (*Myriophyllum spicatum*) (Mills et al. 1993).

As human population increases and the quality of sport and commercial fishing declines, additional pressure will be put on fisheries resource managers to introduce freshwater NIS for human exploitation. There will certainly be increased accidental introductions associated with stocking and harvesting fishes. The response of resource managers to increasing harvest and outside pressure to introduce additional species will greatly influence the interaction of NIS with other global changes.

The impacts of even deliberately introduced species, however, are not always predictable, and a number of negative effects, including habitat alteration, competition for food or space, predation, genetic effects, and introduction of disease and parasites have resulted. NIS usually alter the structure of a freshwater ecosystem irrevocably, because species can seldom be eliminated. Altered ecosystems can be more vulnerable to invasion to NIS. For example, Hill and Lodge (1999) found that lakes with overexploited predatory fishes were probably more successfully invaded by rusty crayfish. Thus, introducing NIS and harvesting either native or nonindigenous aquatic species may increase the invasibility of the system to future NIS. Flathead Lake, Montana, is a striking example of large and unanticipated responses to a deliberate, intensive introduction effort, while the Laurentian Great Lakes illustrate how harvesting fish and introducing NIS can interact to affect the subsequent invasibility of aquatic systems.

Unintended Consequences of NIS, Flathead Lake, Montana (from Li and Moyle 1993; Williamson 1996)

Flathead Lake is the largest lake in the Flathead River-Lake catchment (22,241 km^2), in northwest Montana. The highly modified fish community includes

introduced kokanee (*Oncorhynchus nerka*, landlocked sockeye salmon) and fourteen other introduced fishes. In 1949, it was found that introducing freshwater opossum shrimp (*Mysis relicta*) greatly improved growth of kokanee in Kootenay Lake, British Columbia. Between 1968 and 1975, this shrimp was therefore stocked into the Flathead catchment. *Mysis* reached Flathead Lake by 1981, and thereafter virtually eliminated some species of zooplankton from the lake, which was not anticipated.

Instead of including *Mysis* in their diets, as expected, kokanee competed with them for zooplankton. By 1989, the kokanee population crashed, seriously affecting species such as bald eagles (*Haliaeetus leucocephalus*), ducks, gulls, grizzly bears (*Ursus arctos*), and other mammals that fed heavily on the spawning kokanee, kokanee carcasses, and eggs. Bald eagles declined from hundreds observed during earlier kokanee spawning runs to only twenty-five in 1989. To compensate for this loss of food resources, eagles included more road-killed animals in their diet, which increased eagle mortality. Thus, introducing a small freshwater shrimp led to unpredictable and complex changes in both the aquatic and terrestrial ecosystems, and destroyed a spectacular display of grizzly bears and eagles that had previously attracted over 46,000 tourists annually.

Unintended Consequences of NIS: Laurentian Great Lakes (from Christie 1974)

As discussed earlier in this chapter, the historic food web of the Great Lakes was fairly simple, with energy flowing primarily from phytoplankton to zooplankton, planktivorous fish, and then predatory fish (Fig. 1.2). As emphasized earlier, unintentional species invasions via canals caused important changes in the food web, but large unanticipated changes also resulted from NIS that were deliberately stocked for a variety of reasons, including to replace native species that had been overexploited earlier and/or reduced by interactions with earlier NIS (Fig. 1.2, Table 1.3).

Exploitation of fisheries resources resulted in a noticeable reduction of some species (particularly whitefish) soon after the establishment of commercial fishing in the 1840s (causing the extinction of the largest whitefish, *Coregonus nigripinnis*, around the turn of the century). By the 1930s, sturgeon (*Acipenser fulvescens*) and two deepwater whitefish were depleted. Rainbow smelt was stocked, and became very abundant in Lakes Huron and Michigan. Smelt competed with and preyed on native prey fish species, but their effect was not detected until after the sea lamprey invaded the upper Great Lakes in the 1940s. After sea lampreys severely depleted lake trout and burbot populations, and predation pressure was relaxed, smelt became established in Lakes Ontario and Superior. Thus, the abundance of exotic smelt was indirectly enhanced by lampreys, another NIS.

Invasion and increased abundance of alewives during this period was probably made possible by the prior overharvest of lake trout and of potential zooplanktivorous competitors (*Coregonus* spp.), and by the invasion of sea lampreys (which further reduced lake trout). Overharvest of whitefish stocks continued, and some time after the invasion of alewives, two additional endemic species of whitefish became extinct. Exact causes for whitefish extinctions cannot be known, but degradation of spawning habitat, overfishing, competition, and predation by NIS (smelt and alewife) were probably all contributing factors.

As reviewed earlier (Fig. 1.2), fisheries managers introduced millions of Pacific salmonids to reduce the abundance of alewives. Alewife numbers declined and the Great Lakes fishery, primarily for nonindigenous salmonids (commercial and sport combined) is currently valued at $4.5 billion per year (Glassner-Shwayder 1996). While stocking the Great Lakes with salmonids is generally seen as a success story, some side effects cause concern. It is doubtful that current levels of harvest are sustainable (because of prey depletion). The current food web differs vastly from what existed historically (Fig. 1.2), stocked salmonid species have hybridized with and otherwise impaired native salmonids (Table 1.3), and the introduction and invasion of freshwater NIS increased the risk of invasion by additional NIS.

Conclusions and Recommendations

While some ebb and flow of species across terrestrial and aquatic landscapes would occur without human intervention, human activities greatly increase the rate and spatial scale of species introductions. In freshwater ecosystems, human activities have directly altered the distribution and relative abundance of NIS through the accidental escape of species transported (either accidentally or intentionally) in commerce, canal and dam construction, and the intentional stocking of aquatic species outside their native range. Other human activities have indirectly altered the distribution and relative abundance of freshwater NIS through changes in climate, atmosphere, and land use. All of these global changes that affect freshwater NIS are expected to continue. Most, if not all, will increase as global human population grows. Most—especially the globalization of commerce, waterway engineering, and the stocking of NIS by fisheries management agencies—strongly increase the problem of NIS (Table 1.1). Others, especially land use and climatic changes, will probably cause weaker and more localized interactions with NIS (Table 1.1).

Given the unpredictability of purposeful introductions and the devastation that can ensue from accidental introductions, increased measures should be taken worldwide to reduce the spread of aquatic NIS. The recommenda-

tions here focus on commerce that leads to accidental introductions, on waterway engineering, and on fisheries management because of their strong interactions with NIS.

Surprisingly, aquaculture, the aquarium and live bait trades, and recreational boating—vectors that together account for much of the spread of freshwater NIS—are only weakly regulated and often only at the state level in the United States. Experience has shown that complete containment of NIS in aquaculture facilities is nearly impossible, and that an introduction into an aquaculture facility should be considered a step toward its eventual release into the wild (Welcomme 1988). As of 1990, about 65 percent of the nonindigenous fish species established in the United States originated from the aquarium fish trade—over half of which escaped from culture facilities (Courtenay and Stauffer 1990). Simple, inexpensive measures to reduce escape from culture facilities and to reduce releases by aquarists are not often applied voluntarily. Yet few states mandate that culture facilities provide physical safeguards against escape of culture stocks (Courtenay and Stauffer 1990), and there is little effort to educate the public about the harm of releasing organisms. Virtually no United States laws regulate live wells or boat trailers of recreational boaters—though some states have laws that require boats to be free of zebra mussels before launching in at-risk waters. Stronger state-by-state regulation would be helpful, but vectors associated with sport fishing need to be regulated on larger geographic scales because watershed boundaries do not often correspond with political boundaries.

The shipping industry, responsible for about one-third of the NIS introductions in the Great Lakes (Mills et al. 1993), is a vector for which regulations are being developed. Most NIS spread by ships come from the release of ballast water. A single ship may carry between hundreds of gallons and tens of millions of gallons of ballast water (Carlton et al. 1995). Though aquatic species have been established via ballast water introduction for at least forty years, it was not until the invasion of the Laurentian Great Lakes by the zebra mussel, and of Tasmanian waters by toxic red tide dinoflagellates, that regulatory action was taken. Voluntary ballast water guidelines were passed for vessels entering the Great Lakes by Canada in 1989 (the Great Lakes Ballast Water Control Guidelines) and by the United States in 1990 (included in the Nonindigenous Aquatic Nuisance Prevention and Control Act). These voluntary guidelines were expanded to include all coastal waters of the United States in 1996 (the National Invasive Species Act). Similar guidelines have been passed in Australia and Chile. Though these guidelines are still voluntary, the International Maritime Organization has developed mandatory regulations to control ballast water discharge, which will likely be adopted sometime after the turn of the century (Baskin 1996).

Regulatory recognition that canals and dams (and the way they are oper-

ated) play a very important role in exacerbating NIS-associated problems increasingly exists in some parts of the world; for example, the United States and Scandanavia, where most waterway engineering was completed decades ago. In these countries, the role that assessment of environmental impact (including that of NIS) plays in decisions regarding waterway engineering should be encouraged and expanded, and should apply in plans to re-open long-closed canals. In other parts of the world, NIS should be included in the cost-benefit evaluation of existing and planned waterway engineering projects.

In all parts of the world, plans for deliberate species introductions by governmental agencies or private natural resource management groups should include a much more thorough consideration of the costs of NIS. Some NIS can provide enormous benefit to society, but often at a considerable cost: reduced abundance of native species; a lack of appreciation for the sport, food, and aesthetic value of native species; and the need for continual management of unstable, NIS-dominated communities (Moyle et al. 1986). Examples of ecological disasters caused by the introduction of freshwater NIS abound, and fisheries management agencies should be urged to avoid stocking NIS and to learn from past mistakes in North America and elsewhere.

When stocking fishes, even native species, is warranted, greater attention should be focused on protecting locally adapted stocks of native species by using brood stock from the same area in which the progeny are to be stocked (Philipp et al. 1986). Also, when introducing nonindigenous aquatic species, standards such as the International Council for the Exploration of the Seas (ICES) Code of Practice Concerning Introductions and Transfers of Marine Species should be used to reduce adverse effects of freshwater NIS (ICES 1995; Fig. 1.3).

Regarding research on NIS, aquatic ecologists should be challenged not only to work to reduce the number of NIS, but also to deepen their understanding of invasion ecology so that useful guidelines and recommendations for screening species may be developed for use by resource managers and policy makers. One such method begins with the quantitative determination of whether invading organisms and invaded ecosystems are different from non-invading organisms and noninvaded habitats. Many lists of characteristics purporting to describe NIS (e.g., wide environmental tolerances, single-parent reproduction, large native range, high rate of population increase), or to describe habitats that tend to be invaded (e.g., disturbed systems and low predator numbers), have been published, but with little or no quantitative analysis (reviewed in Lodge 1993b). If such patterns exist, they could be used to predict and therefore prevent future invasions and reduce risk to ecosystems. Such research has begun for terrestrial systems (Richardson and Bond 1991; Rejmanek and Richardson 1996; Veltman et al. 1996; Williamson and

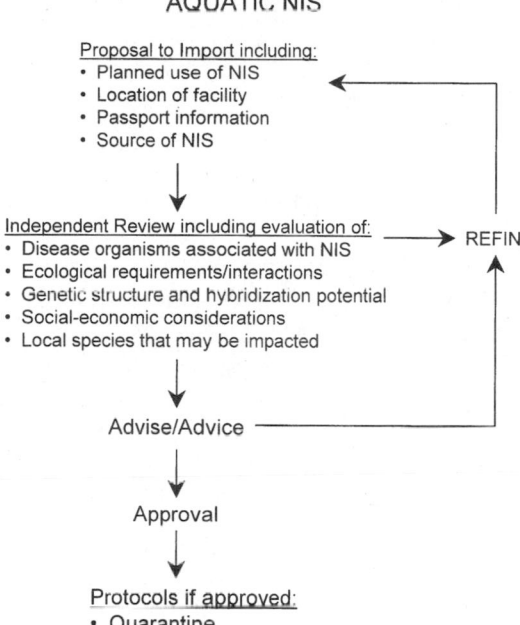

CODE OF PRACTICE FOR INTRODUCING AQUATIC NIS

Proposal to Import including:
• Planned use of NIS
• Location of facility
• Passport information
• Source of NIS

Independent Review including evaluation of:
• Disease organisms associated with NIS
• Ecological requirements/interactions
• Genetic structure and hybridization potential
• Social-economic considerations
• Local species that may be impacted

→ REFINE

Advise/Advice

Approval

Protocols if approved:
• Quarantine
• Confinement
• Monitor

Figure 1.3. Code of practice that should be completed when introducing an aquatic species is warranted (modified from ICES 1995).

Fitter 1996; Reichard and Hamilton 1997), but no similar work has yet been done on aquatic systems. Such analyses could be used, for example, to determine the relative probability that a given species would become problematic after introduction.

Finally, the general regulatory approach regarding NIS that exists in many countries requires consideration. Currently, for example, the United States allows all aquatic species into the country except those on a brief list of "dirty" species. This policy allows entry to many potentially problematic species that have never been screened in any way for potential environmental impact. Alternatively, the importation of all species could be prohibited except those screened and found unlikely to be sources of environmental problems. Such a "clean" list approach was proposed by the U.S. Fish and Wildlife Service in 1973 to restrict entry of fish and wildlife, but the policy was withdrawn after receiving over 5,500 negative comments (Reichard 1997). Nevertheless, the call by Reichard (1997) for the revival of such a policy should be supported. The

sorts of quantitative research prescribed above would lower the costs of implementing such a policy, and would better protect native ecosystems.

Acknowledgments

We thank Gary Lamberti for thoughtful discussions about lotic topics found within this chapter; and Ellen Marsden, Glenn Sandiford, Daniel Schneider, and Rip Sparks for many discussions about NIS in the Laurentian Great Lakes. We are also grateful to Hal Mooney for his patience. Bill Perry and the aquatic ecology discussion group at the Kaskaskia Biological Station of the Illinois Natural History Survey provided helpful reviews of an earlier version of this manuscript. Funding for this project was provided by Illinois-Indiana Sea Grant Program project number R/ANS-05-97 (to DML and others) and by a Clare Boothe Luce Memorial Fellowship (to CSK).

References

Arnell, N., B. Bates, H. Lang, J. J. Magnuson, and P. Mulholland. 1996. Hydrology and freshwater ecology. In *Climate Change 1995. Impacts, Adaptations, and Mitigation of Climate Change: Scientific-Technical Analyses*, ed. R. T. Watson et al., 325–364. Cambridge, Mass.: Cambridge University Press.

Baskin, Y. 1996. Curbing undesirable invaders. *BioScience* 46: 732–736.

Baskin, J. 1998. Winners and losers in a changing world. *BioScience* 48: 788–792.

Bright, C. 1998. *Life Out of Bounds: Bioinvasion in a Borderless World.* Worldwatch Institute Report.

Burr, B. M., D. J. Eisenhour, K. M. Cook, C. A. Taylor, G. L. Seegert, R. W. Sauer, and E. R. Atwood. 1996. Nonnative fishes in Illinois waters: What do the records reveal? *Transactions of the Illinois State Academy of Science* 89: 73–91.

Burr, B. M., and R. L. Mayden. 1980. Dispersal of rainbow smelt, *Osmerus mordax*, into the upper Mississippi River (Pisces: Osmeridae). *American Midland Naturalist* 104: 198–210.

Carlton, J. T. 1992. Dispersal mechanisms: A conceptual framework. Dispersal of living organisms into aquatic ecosystems as mediated by aquaculture and fisheries activities. In *Dispersal of Living Organisms into Aquatic Ecosystems*, ed. A. Rosenfield, and R. Mann, 13–46. College Park: The University of Maryland.

Carlton, J. T., D. M. Reid, H. van Leeuwen. 1995. Shipping study: The role of shipping in the introduction of nonindigenous aquatic organisms to the coastal waters of the United States (other than the Great Lakes) and an analysis of control options. The National Sea Grant College Program/Connecticut Sea Grant Project R/ES-6, Report No. CG-D-11-95 Final Report.

Carpenter, S., T. Frost, L. Persson, M. Power, and D. Soto. 1996. Freshwater ecosystems: Linkages of complexity and processes. In *Functional Roles of Biodiversity: A Global Perspective*, ed. H. A. Mooney et al., 299–325. New York: John Wiley and Sons.

Changnon, S. A., and J. M. Changnon. 1996. History of the Chicago diversion and future implications. *Journal of Great Lakes Research* 22: 100–118.

Christie, W. J. 1974. Changes in the fish species composition of the Great Lakes. *Journal of the Fisheries Research Board of Canada* 31: 827–854.

Cochran, P. A. 1981. An unusually small American eel (*Anguilla rostrata*) from the Lake Superior drainage. *Canadian Field-Naturalist* 95: 97–98.

Courtenay, W. R. Jr., and J. R. Stauffer, Jr. 1990. The introduced fish problem and the aquarium fish industry. *Journal of the World Aquaculture Society* 21: 145–159.

Crowder, L. B. 1980. Alewife, rainbow smelt and native fishes in Lake Michigan: Competition or predation? *Environmental Biology of Fishes* 5: 225–233.

Cudmore, B. C. 1999. Changing biodiversity and the theory of resistance to invasion: The Laurentian Great Lakes as a case study. M.Sc. dissertation. University of Toronto, Canada.

De Staso, J. III, and F. J. Rahel. 1994. Influence of water temperature on interactions between juvenile Colorado River cutthroat trout and brook trout in a laboratory stream. *Transactions of the American Fisheries Society* 123: 289–297.

Dobson, A. P., A. D. Bradshaw, and A. J. M. Baker. 1997. Hopes for the future: Restoration ecology and conservation biology. *Science* 277: 515–522.

Ganley, T., and R. Bock. 1998. Fish collecting in Florida: Collecting tropical fish without leaving the country. *Aquarium Fish Magazine*, November: 31–41.

GEO (Global Environment Outlook) 1997. *Global State of the Environment Report 1997*. United Nations Environment Programme.

Glassner-Shwayder, K. 1996. Biological invasions. Great Lakes Commission, Ann Arbor, Mich.

Glazovsky, N. F. 1995. Aral Sea. In *Enclosed seas and large lakes of Eastern Europe and Middle Asia*, ed A. F. Mandych, 119–154. Amsterdam: SPB Academic Publishing.

Goldschmidt, T. (translated by S. Marx-Macdonald). 1996. *Darwin's Dreampond: Drama in Lake Victoria*. Cambridge, Mass.: MIT Press.

Hill, A. M., and D. M. Lodge. 1999. Replacement of resident crayfishes by an exotic crayfish: The roles of competition and predation. *Ecological Applications* 9: 678–690.

ICES. 1995. ICES Code of Practice on the Introductions and Transfers of Marine Organisms, 1994. International Council for the Exploration of the Sea, Copenhagen, Denmark.

IPCC. 1995. Climate change 1995: A report to the IPCC. United Nations Environmental Programme, Intergovernmental Panel on Climate Change.

Jackson, J. N. 1997. *The Welland Canals and Their Communities: Engineering, Industrial, and Urban Transformation*. Toronto: University of Toronto Press.

Keleher, C. J., and F. J. Rahel. 1996. Thermal limits to salmonid distributions in the Rocky Mountain Region and potential habitat loss due to global warming: A Geographic Information System (GIS) approach. *Transactions of the American Fisheries Society* 125: 1–13.

Li, H. W., and P. B. Moyle. 1993. Management of introduced fishes. In *Inland Fisheries Management in North America*, ed. C. C. Kohler and W. A. Hubert, 287–307. Bethesda, Maryland: American Fisheries Society.

Lodge, D. M. 1993a. Biological invasions: Lessons for ecology. *Trends in Ecology and Evolution* 8: 133–137.

———. 1993b. Species invasions and deletions: Community effects and responses to

climate and habitat change. In *Biotic interactions and global change,* ed. P. M. Kareiva et al., 367–387. Sunderland, Mass.: Sinauer Associates Inc.

———. In press. Responses of lake biodiversity to global changes." In *Future Scenarios of Global Biodiversity.* New York: Springer-Verlag Publishers.

Lodge, D. M., R. A. Stein, K. M. Brown, A. P. Covich, C. Bronmark, J. E. Garvey, and S. P. Klosiewski. 1998. Predicting impact of freshwater exotic species on native biodiversity: Challenges in spatial scaling. *Australian Journal of Ecology* 23: 53–67.

Magnuson, J. J., K. E. Webster, R. A. Assell, C. J. Browser, P. J. Dillon, J. G. Eaton, H. E. Evans, E. J. Fee, R. I. Hall, L. R. Mortsch, D. W. Schindler, and F. H. Quinn. 1997. Potential effects of climate changes on aquatic systems: Laurentian Great Lakes and precambrian shield region. *Hydrological Processes* 11: 825–871.

McCully, P. 1996. *Silenced Rivers.* London: Zed Books.

Mefee, G. K. 1984. Effects of abiotic disturbance on coexistence of predator-prey fish species. *Ecology* 65: 1525–1534.

Mills, E. L., J. H. Leach, J. T. Carlton, D. L. Secor. 1993. Exotic species in the Great Lakes: A history of biotic crisis and anthropogenic introductions. *Journal of Great Lakes Research* 19: 1–54.

Mills, K. H. 1984. Fish population response to experimental acidification of a small Ontario lake. In *Early Biotic Responses to Advancing Lake Acidification,* ed. G. R. Hendrey, 117–131. Stoneham, Mass.: Butterworth Publishers.

Minckley, W. L., and G. K. Mefee. 1987. Differential selection by flooding in stream-fish communities of the arid American southwest. In *Community and Evolutionary Ecology of North American Stream Fishes,* ed. W. J. Matthews and D. C. Heins, 93–104. Norman: University of Oklahoma Press.

Mono Basin Ecosystem Study Committee. 1987. *The Mono Basin Ecosystem: Effects of Changing Lake Level.* Washington, D.C.: National Academy Press.

Moyle, P. B., H. W. Li, and B. A. Barton 1986. The Frankenstein effect: Impact of introduced fishes on native fishes in North America. In *Fish Culture in Fisheries Management,* ed. R. H. Stroud, 415–426. Bethesda, Maryland: American Fisheries Society, Fish Culture Section and Fisheries Management Section.

Moyle, P. B., and T. Light. 1996. Fish invasions in California: Do abiotic factors determine success? *Ecology* 76: 1666–670.

Naiman, R. J., J. J. Magnuson, D. M. McKnight, J. A. Stanford, eds. 1995. *The Freshwater Imperative: A Research Agenda.* Washington, D.C.: Island Press.

New York Sea Grant. 1993. North American range of the zebra mussel as of 15 December, 1993. *Dreisenna polymorpha* Information Review from the Zebra Mussel Information Clearinghouse 4: 6–7.

Philipp, D. P., J. B. Koppelman, and J. L. Van Orman. 1986. Techniques for identification and conservation of fish stocks. In *Fish Culture in Fisheries Management,* ed. R. H. Stroud, 323–337. Bethesda, Maryland: American Fisheries Society, Fish Culture Section and Fisheries Management Section.

Pimentel, D., J. Houser, E. Preiss, O. White, H. Fang, L. Mesnich, T. Barsky, S. Tariche, J. Schreck, and S. Alpert. 1997. Water resources: Agriculture, the environment, and society. *BioScience* 47: 97–105.

Poe, T. P., R. S. Shively, and R. A. Tabor. 1994. Ecological consequences of introduced piscivorous fishes in the Lower Columbia and Snake Rivers. In *Theory and Appli-*

cation in Fish Feeding and Ecology, ed. D. J. Strouder et al., 347–360. Columbia: University of South Carolina Press.

Postel, S., and S. Carpenter. 1997. Freshwater ecosystem services. In *Nature's Services: Societal Dependence on Natural Ecosystems,* ed. G. Daily, 195–214. Washington, D.C.: Island Press.

Postel, S. L., G. C. Daily, and P. R. Ehrlich. 1996. Human appropriation of renewable fresh water. *Science* 271: 785–788.

Pringle, C. M. 1997. Exploring how disturbance is transmitted upstream: Going against the flow. *Journal of the North American Benthological Society* 16: 425–438.

Qian, Z. ed. 1994. *Water Resources Development in China.* Beijing: China Water and Power Press.

Rebuffoni, D. 1995. Dam removal attracts fish species to Cannon. Minneapolis, Minn.: *Star Tribune,* 10 August, 5B.

Reichard, S. E. 1997. Prevention of invasive plant introductions on national and local levels. In *Assessment and Management of Plant Invasions,* ed. J. O. Luken and J. W. Thieret, 215–228. New York: Springer-Verlag Publishing.

Reichard, S. E., and C. W. Hamilton. 1997. Predicting invasions of woody plants introduced into North America. *Conservation Biology* 11: 193–203.

Rejmanek, M., and D. M. Richardson. 1996. What attributes makes some plant species more invasive? *Ecology* 77: 1655–1661.

Richardson, D. M., and W. J. Bond. 1991. Determinants of plant distribution: Evidence from pine invasions. *The American Naturalist* 137: 639–668.

Ruesink, J. L., I. M. Parker, M. J. Groom, and P. M. Karieva. 1995. Reducing the risks of nonindigenous species introductions: Guilty until proven innocent. *BioScience* 45: 465–477.

Schindler, D. W. 1998. A dim future for boreal waters and landscapes. *BioScience* 48: 157–163.

Stevens, W. K. 1997. A dam open, Grand Canyon roars again. *New York Times,* 25 February, C1, col. 3, Science Desk.

Sutcliffe, D. W., and A. G. Hildrew. 1989. Invertebrate communities in acid streams. In *Acid Toxicity and Aquatic Animals,* ed. R. Morris et al., 13–29. New York: Cambridge University Press.

Underhill, J. C. 1986. The fish fauna of the Laurentian Great Lakes, the St. Lawrence Lowlands, Newfoundland and Labrador. In *The Zoogeography of North American Fishes,* ed. C. H. Hocutt and E. O. Wiley, 105–160. New York: Wiley–Interscience.

U.S. Congress. 1993. *Harmful Non-indigenous species in the United States.* Office of Technology Assessment, OTA-F-565. Washington, D.C.: U.S. Government Printing Office.

USGS. 1998. *Estimated Use of Water in the United States in 1995.* United States Geological Survey Circular 1200.

Veltman, C. J., S. Nee, and M. J. Crawley. 1996. Correlates of introduction success in exotic New Zealand birds. *American Naturalist* 147: 542–557.

Welcomme, R. L. 1988. *International Introductions of Inland Aquatic Species.* Fisheries Technical Paper 294. Rome, Italy: Food and Agriculture Organization of the United Nations.

Wells, L. 1970. Effects of alewife predation on zooplankton populations in Lake Michigan. *Limnology and Oceanography* 15: 556–565.

Wells, L., and A. L. McLain. 1973. Lake Michigan: Man's effects on native fish stocks and other biota. Technical Report No. 20, Great Lakes Fishery Commission, Ann Arbor, Mich.

Williamson, M. 1996. *Biological Invasions.* London: Chapman and Hall.

Williamson, M., and A. Fitter. 1996. The varying success of invaders. *Ecology* 77: 1661–1666.

World Resources Institute. 1998. 1998–1999 world resources: A guide to the global environment. Environmental changes and human health. World Resources Institute, Oxford University Press.

Chapter 2

~

Global Change and Biological Invasions in the Oceans

James T. Carlton

There are multiple arenas and scales of human-induced global change that regulate the distribution, abundance, and diversity of species in the world's oceans. Recent work has identified five major categories of change that have, are now, or could in the future significantly alter marine biodiversity (National Research Council 1995; Lovel 1997; Ruckelshaus and Hays 1998; Carlton 1998; Ruiz et al. 1999):

1. Overfishing and its collateral impacts
2. Ocean- and land-derived input of either allochthonous chemicals or oversaturation of autochthonous chemical compounds (chemical pollution and eutrophication)
3. The physical obliteration and modification of coastal and near-coastal ecosystems, including the removal of marshes, the extirpation of other estuarine and coastal habitats, the dredging of bays, the trawling of shelves, and the alteration of freshwater flow (habitat destruction and fragmentation)

4. The introduction of nonnative (nonindigenous, alien, exotic) species (biological invasions)
5. Global climate change (GCC)

The potential range of responses of biological invasions to these changes (including invasions themselves) comprises a profound array across a kaleidoscope of temporal and spatial scales (Table 2.1; the range of responses

Table 2.1. Potential responses of biological invasions to the drivers of global change in the oceans

Phenomenon	*Examples of potential responses of bioinvasions (neutral responses are omitted)*
Fisheries: Overfishing and its collateral impacts	• *Enhance or depress invasions:* Reduction of keystone species reduces pressure on prey populations; resulting cascading effects (including shifts in abundance and diversity of multiple species) make community more or less susceptible to invasion, depending on resulting matrix of competitors, predators, resource availability, etc.
Chemicals: Chemical pollution and eutrophication (land- and ocean-derived)	• *Enhance invasions:* Local/regional extinction of species and depressed abundances of other species create opportunities for successful establishment of new invasions; eutrophic conditions specifically permit establishment of new invaders such as dinoflagellates and other phytoplankters. • *Depress invasions:* Native "weedy" species enhanced by eutrophic conditions prevent establishment of new invasions.
Physical destruction: Habitat destruction and fragmentation	• *Enhance invasions:* Local/regional extinction of species and depressed abundances of other species create opportunities for successful establishment of new invasions. • *Depress invasions:* Native "weedy"species enhanced by disturbed conditions prevent establishment of new invasions.
Biological invasions	• *Enhance or depress invasions:* New invasions either aid the establishment of other invasions (invasion facilitation) or lead to the establishment of a new competitor or predator that depresses the ability of additional new congeners, confamilials, or ecoequivalents to invade (invasion inhibition).

Global climate change	• *Enhance invasions under warmer conditions (A):* Warmer-water nonindigenous species become more abundant where established, and expand ranges to now warmer, higher latitudes. Invasions newly entering higher latitudes may interact with cold-adapted neogenotypes of nonindigenous species, leading to their extinction (genetic swamping) or continued existence only in yet higher latitude refugia.
	• *Enhance invasions under warmer conditions (B):* Conversely, lower-latitude nonindigenous populations may become extinct as waters become too warm, permitting new invasions of other warmer-water or eurythermal taxa.
	• *Enhance or depress invasions under changing patterns of primary production, altered salinity regimes from changing precipitation patterns, etc.:* New primary trophodynamic regimes, new patterns and processes of estuarine oceanography (e.g., relative to altered salinity dynamics, particularly the scale of horizontal intrusion of salt wedge), and other physicochemical conversions, either enhance or depress new invasions.

shown in the table are presented as *examples* only). A number of specific scenarios could lead to the enhancement of invasions, whereas other scenarios lead to equivocal outcomes where a driver of environmental change could result in the *depression or enhancement* of invasions (Table 2.1). Thus chemical pollution or habitat destruction could result in both the extinction of species and the depression in abundance of other species, phenomena that could then permit successful invasion by pollution-tolerant taxa because, in part, endemic "biotic resistance" had been relaxed or obliterated. Similarly, warming of coastal waters could enhance invasions by permitting the colonization and establishment of taxa previously restricted to lower latitudes. Alternatively, both pollution and habitat obliteration could depress invasions by favoring endemic weedy species to become abundant and inhibit the establishment of new invaders. One of the extraordinary difficulties in both empirical and theoretical invasion science is the challenge to relate the roles of these broader scale environmental changes to the rate and diversity of invasions.

One approach to framing this broad menu is to view these changes in terms of how *donor* and *recipient* regions may respond relative to their sus-

ceptibility or resistance to invasions. Intimately linked to this is the changing potential of species to be moved from one place to another, given that changes in dispersal vectors can in turn change the diversity and abundance of species transported.

Two aspects of invasion ecology are explored here as examples of the potential importance of global change to the understanding of invasion processes. The first is how changes in donor and recipient regions and in dispersal vectors could influence the rate of invasions. The second is an exploration of the potential responses of bioinvasions in the ocean to global climate change, and some of the inherent difficulties in detecting such responses as a correlate of temperature change.

Global Changes in Donor and Recipient Regions and in Dispersal Vectors

Carlton (1996a) has framed several scenarios that attempt to link various specific or general phenomena to an understanding of why invasions may occur when they do. Four of these phenomena, related to donor and recipient regions and to dispersal vectors, are used here to examine how global change could influence invasions. Some of the drivers of change shown in Table 2.1 can thus be sorted out in terms of where species may come from (donor areas) or go to (recipient areas). In addition, changes in vectors are also clearly a form of global change. Taken together, these form an interactive suite of processes that could directly alter the diversity, rate, and number of inoculations of potentially invasive species (Table 2.2).

Carlton (1996a) has explored in detail how changes in donor and recipient regions and the rise of new donor regions could enhance invasions. An example of a donor region change is the population increase (for any of a number of reasons) of a species that would then have greater potential to interface with a dispersal vector. An illustration of this may be the vast global increases in coastal populations of diatoms, dinoflagellates, and other phytoplankters, as a result of increased coastal nutrient loading (eutrophication), in the last quarter of the twentieth century (Hallegraeff 1993; Anderson 1994). Large standing stocks of these taxa in coastal embayments would inevitably be more frequently taken up by ships in ballast water, resulting in a remarkable global rise in the novel appearances of toxic phytoplankton (harmful algal) blooms around the world—which, indeed, appears to be exactly what occurred (Hallegraeff 1993; Horner et al. 1997).

Recipient region change captures many of the potential responses noted in Table 2.1. Thus, Cordell et al. (1992) suggested that the introduction of the Asian copepod *Pseudodiaptomus inopinus* in the Columbia River estuary

Table 2.2. Global changes in dispersal vectors and in donor and recipient regions that could alter the rate and timing of invasions in marine ecosystems (modified from Carlton 1996b).

Phenomenon	*Processes involved*
Dispersal vector changes	Vector size, speed, and quality increase lead to: • Increase in inoculant species diversity. • Increase in number of inoculated individuals per unit time. • Increase in number of post-transport individuals that are capable of initial survival and reproduction. New vector emerges from same donor region.
Changes in donor region	Environmental changes in DR* lead to: • Population increases of resident species making more individuals available for transport. • Range expansion of regional species into previously uninhabitable areas of DR, making these species available for transport (Resident and local species may be either native or introduced) New introductions of nonindigenous species occur within DR: • New species now available for transport.
New donor regions become available	New DRs become available: • New species available for transport. • New genomes with different adaptive regimes than previously transported populations of the same species (from other DRs) now become available for transport.
Changes in recipient region	Any environmental changes in RR+ that lead to altered ecological, biological, chemical, or physical states, thus changing the susceptibility of the RR to invasions. For example, altered water-quality conditions could lead to the increased ability of pollution-intolerant species to invade or the increased ability of pollution-tolerant species to invade.

*DR = Donor Region (dispersal hub in which a species interfaces with a transport mechanism)
¹RR = Recipient Region (endpoint of dispersal spoke where a species is released—the initial point of inoculation)

between Washington and Oregon in the United States "may have been encouraged by a synergism between increased ballast dumping, decrease in maximum flows due to regulation of the river, and the attenuation of extremely low temperatures in the estuary during the last decade" (p. 4). That is, this invasion may have been mediated by a combination of three different global change phenomena: a change in the vector, a physical alteration of the habitat, and global climate modification. Van den Brink et al. (1993) have suggested that the invasion of the Ponto-Caspian amphipod crustacean *Corophium curvispinum* in the Rhine River, the Netherlands, may have been

facilitated by the altered chemical and physical nature of the river due to industrial discharges.

Relative to the rise of new donor regions, while little has been done to formalize this concept in marine systems, potential examples abound—such as the rise in visits by military vessels to the harbors and ports of Southeast Asia during the Vietnam War, leading to the apparently novel supply of southern Asia taxa to harbors of, for example, southern California, and subsequently many new invasions (Carlton 1996b); and the opening of international trade between mainland China and the United States in the 1970s, leading to a suite of new invasions in estuaries such as San Francisco Bay (Carlton et al. 1990; Orsi and Walter 1991).

But perhaps one of the most profound examples of global change impacting the ocean has been the remarkable rise of one particular shipping-related vector throughout the twentieth century. While the carriage of ballast water in ships for stability purposes dates back to the 1840s (Carlton 1985), it has become a major global transport corridor for marine life only in the latter part of the twentieth century, due in large part to the increased scale of global trade and the concomitant need for increased product transport at greater and greater speeds. In terms of those phenomena identified in Table 2.2, the scaling up of ballast water as a vector has led to an increase in inoculant species diversity, a probable increase in the number of individuals released at a given place at a given time, and given this, a probable direct increase in the number of post-transported individual organisms that remain capable of survival and reproduction once released.

As a result, ballast water is now known to successfully carry a very large number of living marine organisms and, as a vector, has been directly linked to many specific successful invasions in the last quarter century (Carlton 1985 1996a; Carlton and Geller 1993; Hallegraeff 1993, 1998; McCarthy and Khambaty 1994; Galil and Huelsmann 1997; Pierce et al. 1997; Cohen and Carlton 1998; Smith et al. 1999). The modern scale of this transport is not precisely known, but, although ballast management strategies are coming slowly into play, the number of ships, their sizes, their speed, and the amount of water being transported with life in the water has been steadily increasing (National Research Council 1996). Carlton (1999) has proposed that 10,000 or more species may be transported *daily* around the world in the ballast water of ships. It is difficult to think of another human-mediated dispersal vector that now operates at such a scale so effectively.

A superb example of a ballast-mediated invasion has been the appearance of the American comb jelly fish (ctenophore) *Mnemiopsis leidyi* in the Black, Azov, and Mediterranean Seas. It is further an example of the stochastic nature of such transport: overall, ctenophores are almost never found in ballast plankton samples. No other mechanism, however, can account for the

arrival of this organism in the Black Sea. Since its first record in the Black Sea (1982) and a major population bloom in the late 1980s, followed by numerous fluctuations, the zooplankton and fish populations of the near surface waters of the Black Sea have declined profoundly (Shushkina et al. 1990; Malyshev and Arkhipov 1992; GESAMP 1997).

Ballast water is but one of a staggering array of means that humans now have at their disposal to move marine organisms from one ocean to another at great speed (Cohen et al. 1995; Carlton 1996; Cohen and Carlton 1997; Ruiz et al. 1997). Other vectors include the transport of marine organisms on the hulls and in the sea chests (compartments where water is drawn in) of vessels, with a wide variety of mariculture products, with bait worms and on semisubmersible exploratory drilling platforms, in addition to the frequency of direct release of a species for any of a number of purposes. Indeed, so many mechanisms may be available for some taxa that it is difficult to determine which transport vector may have operated to seed a given new population. In terms of global change, it is clear that the types of processes and phenomena framed in Tables 2.1 and 2.2 can impose themselves on almost any vector. In short, it is likely that we will see increasing numbers of invasions well into the twenty-first century before management strategies are able to apply sufficiently rigorous quarantine filters and barriers. When this multiplicity of vectors is combined with population surges or resurgences of invasive species (Crooks and Soule 1999), and thus the ability of these taxa to interface with dispersal vectors, or with the increased open-sea ranching in northern waters of species, such as seaweeds and oysters, outside of their normal reproductive ranges (Minchin 1993), the stage would appear to be set for a new invasive wave.

Detecting the Response of Marine Bioinvasions to Climate Change

Climate change and specifically global warming can have a complex and cascading set of effects in the marine environment (Table 2.1; Southward 1967; Ray et al. 1992; Paine 1993; Peterson et al. 1993; Culver and Buzas 1995; McGowan et al. 1998; Dayton et al. 1999; Sanford 1999). Changing atmospheric conditions leading to altered ultraviolet (UV) light penetration or to changing precipitation patterns can lead to altered patterns of primary production (induced, for example, by differential susceptibility to UV-B exposure [Behrenfeld et al. 1993; Smith 1995; Beardall et al. 1998], by increasing nitrogen inputs from land, or by favoring species that are more efficient at uptake of nutrients at different concentrations). Altered rainfall amounts could also create new patterns of estuarine salinity dynamics, favoring partic-

ular euryhaline species. Warming temperatures may lead to altered lengths of growing and reproductive seasons (influenced by, for example, the altered production of temperature-sensitive gonadotrophic hormones that promote egg protein synthesis in developing oocytes [Lawrence 1996]), or altered timing and length of feeding activity. Further, under a climatic scenario of increasing water temperatures, certain taxa (whether native or introduced) at a given location may become more abundant and some may become less abundant. Those that become more abundant may further impact those that are becoming rarer and may also interface more frequently and in larger numbers with dispersal vectors. Those that become less abundant may further create opportunities, due to their population declines, for new invaders if the former occupied unique trophic positions or unique microhabitats. Thus all of these processes could influence, in a given region, the ratios of native and introduced species, leading to altered species interactions (within or among three sets of interactive species pairs: native/native, native/introduced, and introduced/introduced species), and thus altered potentials for the enhancement or depression of invasions.

Two predictions that arise out of the phenomenon of warming trends in middle to higher-latitude ocean waters are that (1) previously lower latitude–restricted species will colonize higher latitudes for the first time (Mandrak 1989; Kennedy 1990; Nehring 1998), and (2) there will be an increase in abundance of species of evolutionarily warmer water affinity (specifically involving increased numbers of taxa that were already present, but existing only as marginal populations at what were cooler water middle to higher latitudes [Taylor et al. 1957; Minchin 1993; Barry et al. 1995]). Relative to the second case, Taylor et al. (1957) found significant shifts in the abundance of marine species (primarily commercial finfish) commencing in the 1930s in northern and southern New England that they linked to warming waters. Barry et al. (1995) examined faunal changes on the rocky intertidal shore of Monterey Bay, California, and documented increased abundances of species with southern affinities when population data from the 1930s and 1990s were compared. At Monterey annual mean shoreline ocean temperature increased by 0.75°C between the 1930s and the 1990s, and mean summer maximum temperatures from 1983 to 1993 were 2.2°C warmer than for the period 1921 to 1931 (Barry et al. 1995).

Relative to the first case, is there evidence for new invasions in the marine environment in the face of warming ocean temperatures? And if there is such evidence, can such shifts be clearly linked to climate change as opposed to other phenomena? This question is addressed here by using as a model system the changing ranges of certain species of nonindigenous marine invertebrates across a wide phyletic array on the Pacific coast of North America as a model system (Table 2.3).

By way of prefatory comment, it is worth noting that at the close of the twentieth century there is no close finger kept on the pulse of distributional shifts for most marine organisms. Range shifts in marine vertebrates are somewhat more likely to be noted and recorded, but with a steady decline in scholarly research in marine biogeography, natural history, and systematics (Carlton 1998), and with minimal publishing opportunities available to report significant new range data, the result is that fractions of the intertidal or shallow-water biota could be undergoing major geographic shifts and yet remain undetected, unreported, or both. New invasions, no matter how abundant, can thus be easily overlooked: The Caribbean barnacle *Chthamalus proteus* was first detected in the Hawaiian Islands by an amateur biologist in the 1990s, although it may have arrived and become common as much as twenty years earlier along the upper rocky intertidal shoreline (Southward et al. 1998). This situation thus potentially results in a massive underreporting and thus understatement of species responses to climate change, including the altered distributions of nonindigenous species.

The sample size to examine range shifts of nonindigenous species on the Pacific American coast is thus small (nine taxa; ten species counting an associated obligatory ectocommensal, but the latter is not further considered here because of the implied redundancy, although it is listed in Table 2.1). One species of hydroid, one bryozoan, three crustaceans, two bivalves, and two ascidians with origins in the western North Pacific, the North Atlantic, or the South Pacific Ocean, appear to have shifted to higher latitudes late in the twentieth century from previously long-established lower-latitude populations. Three species have moved from southern California into central California or southern Oregon; four species have moved from central California to northern California or the Pacific Northwest; one species has moved from northern California to southern Oregon, and one species has moved from southern Oregon to Puget Sound (Table 2.1). The clam *Gemma gemma* was established in central California by the 1890s, and has appeared in the 1990s, 100 years later, in northern California. Three species—the isopod *Sphaeroma*, the seasquirt *Styela*, and the shrimp *Palaemon*, all common in California by the 1930s, 1940s, and 1950s, respectively—arrived in Oregon and other points to the north only in the 1980s and 1990s. The bryozoan *Watersipora* and the clam *Theora*, both established by the 1960s in southern California, arrived in central California 20 years later. The hydromedusan *Blackfordia* in central California, the isopod *Sphaeroma walkeri* in southern California, and the seasquirt *Molgula manhattensis* in southern Oregon, all established in those regions in the 1970s, appear not to have experienced northward shifts to higher latitudes until the 1990s. Such movements (if real) are not phylogenetically linked (the set of species under consideration here represents a broad phyletic array), nor do

Table 2.3. Northward neo-range expansions of nonindigenous marine invertebrates along the Pacific coast of North America. (Dates indicates first collection[s], rounded to the decade.)

Taxon (native to)	Previous southern location (date)	Northward neo-range expansion (date)
CNIDARIA		
Hydrozoa (hydroids):		
Blackfordia virginica (Black Sea)	central California (1970s)	southern Oregon (1990s)
BRYOZOA (bryozoans):		
Cheilostomata:		
Watersipora "subovoidea" (Western Pacific?)	southern California (1960s)	central California (1980s), southern Oregon (1990s)
CRUSTACEA		
Isopoda (isopods):		
Sphaeroma walkeri (Indian Ocean)	southern California (1970s)	San Francisco Bay (1990s)
Sphaeroma quoyanum (New Zealand)	northern California (1930s)	southern Oregon (1990s)
Iais californica (New Zealand)	northern California (1930s)	southern Oregon (1990s)
Caridea (shrimp):		
Palaemon macrodactylus (western North Pacific)	central California (1950s)	southern Oregon (1980s)
MOLLUSCA		
Bivalvia (clams):		
Gemma gemma (western North Atlantic)	central California (1890s)	northern California (1990s)
Theora fragilis (western North Pacific)	southern California (1960s)	San Francisco Bay (1980s)
UROCHORDATA		
Ascidiacea (sea squirts):		
Styela clava (western North Pacific)	central California (1940s)	Pacific Northwest (1990s)
Molgula manhattensis (North Atlantic)	southern Oregon (1970s)	Puget Sound (1990s)

Geographic range definitions: southern California: south of Point Conception; central California: Point Conception to Bodega Bay; northern California: north of Bodega Bay; southern Oregon: south of Yaquina Head; Pacific Northwest: Oregon, Washington, and British Columbia

Notes on species: Blackfordia virginica. This Sarmatic hydroid was first collected in 1970 in San Francisco Bay, although it may not have become common there (perhaps as a result of reinoculations) until 1990 (Mills and Sommer 1995). It was first collected in Coos Bay, Oregon, in 1997 and was abundant by July 1999 (J. Carlton; identification by C. Mills).

Watersipora "subovoidea." A possibly western Pacific Ocean bryozoan that became established in southern California in the 1960s (review in Carlton 1979); collected in central California in the 1980s (Drakes Bay, J. Goddard, personal communication) and 1990s (San Francisco Bay,

J. Carlton, J. Chapman, A. Cohen, C. Mills, field collections), and in southern Oregon in the early 1990s (Coos Bay, C. Hewitt, personal communication) where it still persists (Coos Bay, J. Goddard, collection August 1998).

Sphaeroma walkeri. A southern hemisphere isopod well-established in southern California in the 1970s (Carlton and Iverson 1981) and unknown in central California (San Francisco Bay) until the 1990s (J. T. Carlton, J. Chapman, A. Cohen, C. Mills, field collections).

Sphaeroma quoyanum and its ventral ectocommensal isopod *Iais californica.* These New Zealand isopods became established in San Francisco Bay before the 1890s and arrived in northern California (Humboldt Bay) before the 1930s (Carlton 1979). They appeared in southern Oregon in the mid-1990s in Coos Bay (Carlton 1996b).

Palaemon macrodactylus. This Asian shrimp appeared in San Francisco Bay in the early 1950s (Newman 1963), and was first collected in the Pacific Northwest in Coos Bay, Oregon, in 1986, where populations remain (July 1999 collections, J. Carlton).

Gemma gemma. This small North Atlantic venerid clam was established in San Francisco Bay in central California by the 1890s. It was first found in Humboldt Bay in northern California in the 1990s (T. Miller, personal communication).

Theora fragilis. This small Asian semelid clam arrived in the 1960s in the bays of southern California and was absent in benthic collections in San Francisco Bay prior to 1982 (A. Navarret, personal communication; Carlton 1992, as *T. lubrica*).

Styela clava. This Asian solitary seasquirt was established on the warm margins of San Francisco Bay in central California by the 1940s, having occurred in southern California harbors since the early 1930s (Carlton 1979). It became established in southern Oregon (Coos Bay), Washington (Puget Sound) and British Columbia (Vancouver Island) in the 1990s (Kozloff 1996; Carlton 1996a; G. Lambert, C. Lambert, J. Carlton, J. Chapman, A. Cohen, C. Mills, field collections).

Molgula manhattensis. This North Atlantic seasquirt was established by the 1940s in central California (Carlton 1979) and by 1974 in Coos Bay, Oregon (J. T. Carlton records). It was first collected in the late 1990s in southern Puget Sound, Washington (G. Lambert, C. Lambert, J. Carlton, J. Chapman, A. Cohen, C. Mills, field collections).

they appear linked to any particular suite of reproductive strategies (which range from having planktotrophic larvae [the shrimp *Palaemon* and the clam *Theora*] to releasing lecithotrophic larvae [the bryozoan *Watersipora*], to brooders releasing live metamorphosed benthic young [the isopods and the clam *Gemma*]).

These northern expansions coincide in time with increased water temperatures along the Pacific coast of North America (Hayward 1997; Barry et al. 1995; J. Chapman, personal communication). The establishment of these taxa in these higher latitudes since the 1980s may also imply that while they were being consistently inoculated into more northern waters (respective to their previous northernmost limits), conditions—in particular, water temperature—have only become hospitable in recent times.

But do such records in fact indicate a northward shift of a previously estab-

lished and more southern nonindigenous faunal element due to climatic warming? I address five alternative explanations, other than GCC.

1. Geographic Expansions of Varied Time Lags Are Natural and Expected

Under this scenario, introduced species long established in one location may take variable lengths of time to initiate or control post-establishment spread. These lags may depend on a number of factors, including population size (and thus propagule abundance), reproductive strategies, and dispersal mechanisms. Punctuated post-establishment movement could indicate simply slower rates of spreading for some taxa as compared to others. In short, not all invasions are created equal.

Expansion is also not necessarily directional: A species in San Francisco Bay, albeit present in that system for some years or decades, might have the physiological repertoire to move north and to the south. Thus, expansions of nonindigenous species could be expected both to the north and to the south. No records appear to be available indicating southward movement of nonindigenous taxa along the American Pacific coast, although only limited surveys for selected taxa have been conducted in southern California waters during the 1980s and 1990s (e.g., Lambert and Lambert 1998). No surveys for nonindigenous taxa have been conducted, however, since the 1960s on the Mexican Baja California coastlines. Taylor et al. (1957) argued that in New England, "new northern records of southern species have been published with increasing frequency since about 1930 with no corresponding increase in records of extensions of the southern ranges of northern species, thus indicating these increases are real and not the result merely of an increased number of observers," (p.ii) implying that the data quality for southern records equals that of northern records.

It is important to note that the expansions of new invasions, in any direction along a coastline, are not necessarily germane to the present discussion. Thus the European shore crab *Carcinus maenas* and the New Zealand sea slug (opisthobranch snail) *Philine auriformis* spread both north and south along the Pacific coast after their initial appearance in central California (Grosholz and Ruiz 1995; Gosliner 1995). Such taxa will presumably first expand based upon their physiological breadth and available dispersal mechanisms. Although, as with all other species, such expansions are susceptible to altered environmental conditions, the fact that newly arriving species such as *Carcinus* and *Philine* spread to the south (as well as to the north) does not establish a southward-moving trend in the biota. Rather, it is the apparently novel movements of long-established species (whether native or introduced) that are of interest.

2. Inoculation Opportunity, Frequency, or Intensity Has Changed

This scenario relates to some of the phenomena discussed above and identified in Table 2.2. Establishment of previously southern taxa may have been dependent upon opportunity to move north or to inoculation frequency and intensity. Permutations here include a combination of new vectors, old vectors increasing in intensity, new or old vectors with directional bias, changes in source region inoculum pool, or any combinations of these. Possible examples of these scenarios and combinations include:

- New dispersal vectors are in play that are for the first time moving some or all of the species listed in Table 2.3 along the coast.
- New or old dispersal vectors are in play that differentially move species north instead of south.
- Old vectors are in play but have increased in intensity, thus altering inoculation intensity.
- Old vectors are in play and have not increased in frequency, but species inoculum pool has increased.

Relative to the first three, no novel vectors, human-mediated or natural, are known to have appeared on the Pacific coast for the dispersal of marine invertebrates in the 1980s or 1990s. However, whether well-known vectors (such as the movements of ships, and the fouling organisms thereon or the ballast organisms therein, or the movements of mariculture products) have changed in intensity or direction is not known.

Relative to the fourth example, the increased abundance of a species may permit it to more greatly interface with a dispersal vector, and thus change the size of a potential transported inoculum pool. Lag times in population explosions of introduced species have been reviewed by Crooks and Soule (1999). Carlton (1992) noted that the Japanese clam *Theora fragilis* had undergone a population surge in the Inland Sea of Japan in the 1970s, thus making it potentially more available for transport in ballast water to San Francisco Bay by the early 1980s. Crooks and Soule (1999) note the surge in populations of the Japanese mussel *Musculista senhousia* in southern California in the 1980s and 1990s, although it had been established there since the 1960s; inevitably, ships departing these harbors now carry more *Musculista* on their hulls or in their ballast than previously. Although first collected in 1970 in San Francisco Bay, the Sarmatic jellyfish *Blackfordia virginica* may not have become abundant until the 1990s (Mills and Sommer 1995), perhaps through reintroduction, and this increased California population may have led to its greater availability to be transported to Coos Bay. The possibility of increased inoculation frequency is not mutually exclusive with a scenario of altered climatic conditions (Ford 1996).

3. Colder-Water Genomes Have Evolved

Whether or not higher latitudes are slightly warmer, this hypothesis identifies the possibility that the now higher-latitude populations of the diverse taxa shown in Table 2.3 represent stocks that are in fact now tolerant of colder waters. The appearance of populations of warm-water nonindigenous species adapted to colder waters is a known phenomenon. Carlton and Scanlon (1985) note the rapid appearance in northern New England (Maine) of a cold-water stock of the Asian green alga *Codium fragile tomentosoides,* which was able to continue growing at temperatures at which southern New England populations (south of Cape Cod) of the same species had stopped growing and were indeed regressing. Shick (1991) noted the existence in Maine of cold-water-adapted Asian sea anemones (*Diadumene lineata* [= *Haliplanella luciae*]), which remain expanded and feeding at 0°C, while populations more than 1,000 kilometers south in Virginia undergo winter dormancy below 10°C. Ford (1996) has noted that colder-water-adapted populations of the oyster parasite *Perkinsus* could evolve since its arrival in the 1980s and 1990s in the northeastern United States.

It may be noted that if the species in question (Table 2.3) do not themselves represent such cold-adapted strains, that a possible consequence of warming-temperature-mediated invasions derived from lower-latitude populations could be the swamping of any previously restricted and allopatrically evolved cold-adapted populations of the same species. Thus, if southern populations of the sea anemone *Diadumene lineata* were to newly enter high latitudes, these could interact with cold-adapted "neogenotypes," leading to their extinction by genetic swamping.

4. Effects of ENSO or ENSO-Related Climatic Phenomena

El Niño—Southern Oscillation (ENSO) phenomena are well known to transport lower-latitude species to higher latitudes in the eastern Pacific Ocean on a regular basis. Species typically found in Mexico or California are thus regularly found as far north as Alaska during an intensive ENSO event. However, while these displaced individuals grow and mature (reaching several years in age), such "populations" do not become established, but rather disappear as the individuals age and die. The species listed in Table 2.3 are established, reproducing populations in their new northern localities. In addition, while these species have been available for two or more decades to the south, during which a number of ENSO events have occurred, no northern expansions of these species were previously recorded during those earlier episodes. This said, as with scenario 2, a new inoculation mediated by ENSO could "take" if the target (recipient) environment had changed. This scenario may not be entirely independent of a GCC invasions model if ENSO frequency is altered by GCC.

5. Possible Effects of Non-GCC Phenomena

Clearly, other environmental factors may be at play, such as donor region-specific water-quality amelioration, donor region–specific habitat alteration, donor-region-specific, land-based nutrient inputs to the nearshore system, and so forth (Table 2.2). In turn, individual species may be responding to specific phenomena. No reviews are available for the larger picture of the types and ranges of nonclimatic environmental conditions for the target environment (American Pacific coast from central California to British Columbia) used here to examine potential species range shifts.

To sort through these six alternative hypotheses (GCC and the five reviewed above) to explain the appearance of lower-latitude invasions in higher latitudes along the Pacific American coast will require the creation or excavation of pertinent data sets. For example, while warming near-coastal ocean water trends on the Pacific American coast are now identified (Barry et al. 1995; J. Chapman, personal communication), precise matching of minimum reproductive temperatures for the species shown in Table 2.3 with matching new temperature regimes for the sites where the species are newly recorded remains to be done.

Expected Additional Responses: Southern Contractions and Native Species Expansions

Two additional critical components of understanding the response of marine biota to climate change are (1) whether, as might be expected, there are corresponding and simultaneous southern contractions of taxa that appear to be moving further north, and (2) whether native taxa are responding to climate change as well by moving north (and contracting south) and becoming invaders as well.

Almost no data appear to be available in marine ecosystems relative to the southern contraction of the populations of the same species that are believed to be moving north, such as has been demonstrated in certain terrestrial ecosystems (e.g., Parmesan 1996). It could be that certain taxa may be unusually facile in the rapid selection for warmer-water genomes and thus would not appear to experience lower-latitude retreat. That potential aside, the rare data set available for the twentieth-century history of the marine intertidal snail *Littorina littorea* in Europe is of considerable interest. There appears to be some evidence that the northern range of this species has expanded while its southern range has contracted (Table 2.4). Once common as far south as 37° north latitude on the south coast of Portugal, by 1957 it had retracted to about 37° 45′ north, and some 30 years later was absent around and just north of Lisbon, between 38° 43′ and 39° 36.′ Indeed, the southernmost record, and

Table 2.4. The apparent northward retreat of the marine intertidal snail *Littorina littorea* along the Portugal Coast, circa 1900–1980s (assembled from data in Reid 1996).

Localities (south to north)	General region*	Date	Latitude+
"many localities around the coast of Portugal . . . as far south as the Algarve"	S coast, E of Cape San Vicente (E of Sagres)	at or before the beginning of the 20th century	37° 00′ Alg
south only to Vila Nova de Milfontes	SW coast, about halfway between Cape San Vicente and Cape Espichel	1956–1957	37° 45′ VNM
Lisbon area (Setubal, Sesimbra [Cezimbra], and Estoril) N to Peniche and Nazare	central W coast	absent in 1987, where formerly common at or before early 1900s	38° 43′ Lis 39° 21′ Pen 39° 36′ Naz
Porto	NW coast	1984[a]	41°11′ Por

+*Latitude Location Station Abbreviations:* Alg = Algarve; VNM = Vila Nova de Milfontes; Lis = Lisbon; Pen = Peniche; Naz = Nazare; Por = Porto

*N = North; S = South; E = East; W = West; SW = Southwest

[a] The Porto record is based on fifty live snails collected 18 February 1984 by I. Felix-Alves; the specimens are in the British Museum of Natural History, London (D. Reid, personal communication, October 1999).

one now 15 years old, occurs only at 41° 11′ north (Table 2.4). This often abundant snail may thus have retracted at least three degrees latitude in eighty years or less. In the meantime, the historical northern range of *Littorina littorea* has been the Kola Peninsula and White Sea region of northern Russia at about 70° north latitude (Reid 1996). However, Rózycki (1991) has extended the northern range to southern Spitzbergen (more than 75° north), where it was previously unknown. Rózycki's material was collected sometime between 1975 and 1989 (D. Reid, personal communication, October 1999).

Relative to native biotic responses, if there is an incipient latitudinal northward shift in long-introduced nonindigenous species from southern waters, a certain fraction of native organisms should be expected to be moving north as well, unless nonindigenous species (by the weedy, physiologically plastic nature of some taxa) are more eurythermal than the native biota. Here again, detection of this phenomenon will be slow in coming, given the now almost nonexistent publication of new range records of marine species, combined

with a hesitancy to report any such new records as being clearly independent of ephemeral events (such as ENSO-mediated dispersal). Nevertheless, documentation of such patterns will be essential to permit determining if biogeographic shifts are now occurring in the native as well as the introduced biota. Ford (1996) detailed the range expansion since 1982 of the oyster protozoan parasite *Perkinsus marinus* (a cryptogenic species of the Atlantic American coast) north of Chesapeake Bay that appears to be correlated with warming temperatures. Nehring (1998) has identified sixteen phytoplankton species that have become established in the North Sea pelagic ecosystem in the twentieth century, including ten thermophilic species from lower latitudes first recorded in the 1990s. Nehring speculates that the relatively mild winters in the 1990s may have aided the establishment of these species. Barry et al. (1995), while reporting increased abundances in central California of certain rocky intertidal marine invertebrates with warmer-water affinities, also reported the northward range expansion of two mollusks, the vermetid snail *Serpulorbis squamigerus* and the muricid snail *Ocinebrina circumtexta* [reported as *Ocenebra circumtexta*]. Both species, however, were previously known from Monterey Bay, albeit not in the 1930s transects that formed their comparative data set. *Serpulorbis* was reported from Monterey as early as 1887 (Kee 1887). The type locality of *O. circumtexta* is Monterey Bay (Stearns 1871), and it had been known north of Monterey, at Dillon Beach in Marin County at the north end of Tomales Bay (in central California) by at least the 1930s (Light 1941). However, the southern barnacle *Chthamalus fissus* appears not to have been found prior to the 1940s in Monterey Bay, where it is now common (S. Gilman, personal communication 1997; Barry et al. 1995). Another recent northern expansion in the northeast Pacific Ocean involves the large marine snail *Kelletia kelletii*, previously restricted to warm waters south of Point Conception, California, which established a large and permanent population in central California (Monterey Bay area) by 1980 (Herrlinger,1981; S. Lonhart, personal communication).

Species that are amenable to ENSO transport could serve as a possible pool of candidate species that are likely to either gradually shift north with GCC, or to now establish permanent populations (when they could not before) if transported north by ENSO phenomena. An example on the American Pacific coast is the rocky intertidal grapsid crab *Pachygrapsus crassipes*, which is normally found only as far north as Charleston and Cape Arago in southern Oregon (Morris et al. 1980) but which has been found occasionally along the central and northern Oregon coast (J. Goddard, personal communication) and during El Niño years as far north as Tatoosh Island, Straits of Juan de Fuca, Washington (R. T. Paine and M. Wonham, personal communication). Predation by *Pachygrapsus* has been proposed as one factor in setting the southern limit of the native periwinkle *Littorina sitkana* (Yamada 1977) at

Cape Arago, and thus the establishment of this crab well to the north of southern Oregon may have new implications for the southern distribution of that snail. Naturally, the expanded establishment of *Pachygrapsus*—or any species—may be sensitive to more factors than temperature alone (Davis et al. 1998).

As a general perspective, it is not, of course, the actual range expansions (a phenomenon that Paine [1993] has called "a relatively bland biotic response") themselves that are of interest here, but the potential and perhaps inevitable impacts on the structure of the recipient community. Some impacts may be fairly transparent, quantifiable, and experimentally tractable (such as the arrival of a new predator), while others may have cascading ecosystem reverberations that will be difficult to detect immediately, and may require considerable "teasing out" in experimental studies.

Conclusions

A complex kaleidoscope of changes greets the world's oceans at the dawn of the twenty-first century. Whether broadly viewed as a series of major global drivers well positioned to change general patterns of invasions (Table 2.1) or viewed more specifically in terms of how donor or recipient regions, combined with altered vectors, may respond in the face of change to influencing invasion patterns, it is clear that there is an unprecedented potential for a new era of global ocean invasions if management strategies to interface with human-mediated dispersal are not equally unprecedented. The combination of changes resulting from overfishing, chemical pollution, physical destruction, climate change, and invasions themselves, along with the unprecedented number of organisms now being moved around the globe hourly, will potentially favor a suite of species that can holistically capitalize (Dukes and Mooney 1999) on newly created environmental regimes.

Acknowledgments

For providing invaluable advice, comments, and records, I am grateful to John Chapman, Andrew Cohen, Sarah Gilman, Jeff Goddard, Chad Hewitt, Gretchen and Charles Lambert, Steve Lonhart, Todd Miller, Claudia Mills, Arleen Navarret, Robert Paine, David Reid, and Marjorie Wonham. Harold Mooney graciously provided the extended opportunity to prepare this essay.

References

Anderson, D. M. 1994. Red tides. *Scientific Amercian* 271: 62–68.
Barry, J. P., C. H. Baxter, R. D. Sagarin, and S. E. Gilman. 1995. Climate-related, long-

term faunal changes in a California rocky intertidal community. *Science* 267: 672–675.

Beardall, J., S. Beer, and J. A. Raven. 1998. Biodiversity of marine plants in an era of climate change: Some predictions based on physiological performance. *Botanica Marina* 41: 113–123.

Behrenfeld, M. J., J. W. Chapman, J. T. Hardy, and H. Lee. 1993. Is there a common response to ultraviolet-B radiation by marine phytoplankton? *Marine Ecology Progress Series* 102: 59–68.

Carlton, J. T. 1979. *History, biogeography, and ecology of the introduced marine and estuarine invertebrates of the Pacific coast of North America.* Ph.D. dissertation, University of California, Davis, 904 pp.

———. 1985. Transoceanic and interoceanic dispersal of coastal marine organisms: The biology of ballast water. *Oceanography and Marine Biology, An Annual Review* 23: 313–371.

———. 1992. Introduced marine and estuarine mollusks of North America: An end-of-the-20th-century perspective. *Journal of Shellfish Research* 11: 489–505.

———. 1996a. Marine bioinvasions: The alteration of marine ecosystems by non-indigenous species. *Oceanography* 9: 36–43.

———. 1996b. Pattern, process, and prediction in marine invasion ecology. *Biological Conservation* 78: 97–106.

———. 1998. Apostrophe to the ocean. *Conservation Biology* 12: 1165–1167.

———. 1999. The scale and ecological consequences of biological invasions in the world's oceans. In eds. Odd Terje Sandlund, Peter Johan Schei, and Auslaug Viken, *Invasive Species and Biodiversity Management*, 195–212. Dordrecht, The Netherlands: Kluwer Academic Publishers.

Carlton, J. T., and J. B. Geller. 1993. Ecological roulette: The global transport of non-indigenous marine organisms. *Science* 261: 78–82.

Carlton, J. T., and E. W. Iverson. 1981. Biogeography and natural history of *Sphaeroma walkeri* Stebbing (Crustacea: Isopoda) and its introduction to San Diego Bay, California. *Journal of Natural History* 15: 31–48.

Carlton, J. T., and J. A. Scanlon. 1985. Progression and dispersal of an introduced alga: *Codium fragile* ssp. *tomentosoides* (Chlorophyta) on the Atlantic coast of North America. *Botanica Marina* 28: 155–165.

Carlton, J. T., J. K. Thompson, L. E. Schemel, and F. H. Nichols. 1990. Remarkable invasion of San Francisco Bay (California, USA) by the Asian clam *Potamocorbula amurensis*. I. Introduction and dispersal. *Marine Ecology Progress Series* 66: 81–94.

Cohen, A. N., and J. T. Carlton. 1997. Transoceanic transport mechanisms: The introduction of the Chinese mitten crab, *Eriocheir sinensis*, to California. *Pacific Science* 51: 1–11.

———. 1998. Accelerating invasion rate in a highly invaded estuary. *Science* 279: 555–558.

Cohen, A. N., J. T. Carlton, and M. C. Fountain. 1995. Introduction, dispersal and potential impacts of the green crab *Carcinus maenas* in San Francisco Bay, California. *Marine Biology* 122: 225–237.

Cordell, J. R., C. A. Morgan, and C. A. Simenstad. 1992. Occurrence of the Asian

calanoid copepod *Pseudodiaptomus inopinus* in the zooplankton of the Columbia River estuary. *Journal of Crustacean Biology* 12: 260–269.

Crooks, J. A., and M. E. Soule. 1999. Lag times in population explosion of invasive species: Causes and implications. In *Invasive Species and Biodiversity Management,* ed. Odd Terje Sandlund, Peter Johan Schei, and Åuslaug Viken, 103–123. Dordrecht, The Netherlands: Kluwer Academic Publishers.

Culver, S. J., and M. A. Buzas. 1995. The effects of anthropogenic habitat disturbance, habitat destruction, and global warming on shallow water marine Foraminifera. *Journal of Foraminiferal Research* 25: 204–211.

Davis, A. J., L. S. Jenkinson, J. H. Lawton, B. Shorrocks, and S. Wood. 1998. Making mistakes when predicting shifts in species range in response to global warming. *Nature* 391: 783–786.

Dayton, P. K., M. J. Tegner, P. B. Edwards, and K. L. Riser. 1999. Temporal and spatial scales of kelp demography: The role of oceanographic climate. *Ecological Monographs* 69: 219–250.

Dukes, J. S., and H. A. Mooney. 1999. Does global change increase the success of biological invaders? *Trends in Evolution and Ecology* 14: 135–139.

Ford, S. E. 1996. Range extension by the oyster parasite *Perkinsus marinus* into the northeastern United States: Response to climate change? *Journal of Shellfish Research* 15: 45–56.

Galil, B. S., and N. Huelsmann. 1997. Protist transport via ballast water—biological classification of ballast tanks by food web interactions. *European Journal of Protistology* 33: 244–253.

GESAMP. 1997. Opportunistic settlers and the problem of the ctenophore *Mnemiopsis leidyi* invasion in the Black Sea. GESAMP Reports and Studies 58.

Gosliner, T. M. 1995. Introduction and spread of Philine auriformis (Gastropod: Opisthobranchia) from New Zealand to San Francisco Bay and Bodega Harbor. *Marine Biology* 122: 249–255.

Grosholz, E. D., and G. M. Ruiz. 1995. Spread and potential impact of the recently introduced European green crab, *Carcinus maenas,* in central California. *Marine Biology* 122: 239–248.

Hallegraeff, G. M. 1993. A review of harmful algal blooms and their apparent global increase. *Phycologia* 32: 79–99.

———. 1998. Transport of toxic dinoflagellates via ships' ballast water: Bioeconomic risk assessment and efficacy of possible ballast water management strategies. *Marine Ecology Progress Series* 168: 297–309.

Hayward, T. L. 1997. Pacific Ocean climate change: Atmospheric forcing, ocean circulation and ecosystem response. *Trends in Evolution and Ecology* 12: 150–154.

Herrlinger, T. J. 1981. Range extension of *Kelletia kelletii. Veliger* 24: 78.

Horner, R. A., D. L. Garrison, and F. G. Plumley. 1997. Harmful algal blooms and red tide problems on the U.S. west coast. *Limnology and Oceanography* 42: 1076–1088.

Keep, J. 1887. *West American Shells.* San Francisco: The Whittaker and Ray Co. Publishers.

Kennedy, V. S. 1990. Anticipated effects of climate change on estuarine and coastal fisheries. *Fisheries* 15: 16–24.

Kozloff, E. N. 1996. *Marine Invertebrates of the Pacific Northwest.* With Additions and Corrections. Seattle: University of Washington Press.

Lambert, C., and G. Lambert. 1998. Non-indigenous ascidians in southern California harbors and marinas. *Marine Biology* 130: 675–688.

Lawrence, A. J. 1996. Environmental and endocrine control of reproduction in two species of polychaete: Potential bio-indicators for global climate change. *Journal of the Marine Biological Association of the United Kingdom* 76: 247–250.

Light, S. F. 1941. *Laboratory and Field Text in Invertebrate Zoology.* Associated Students Store, University of California, Berkeley.

Lovel, G. L. 1997. Global change through invasion. *Nature* 388: 627–628.

Malyshev, V. I. and A. G. Arkhipov. 1992. The ctenophore *Mnemiopsis leidyi* in the western Black Sea. *Hydrobiological Journal* 28: 33–39.

Mandrak, N. E. 1989. Potential invasion of the Great Lakes by fish species associated with climatic warming. *Journal of Great Lakes Research* 15: 306–316.

McCarthy, S. A. and F. M. Khambaty. 1994. International dissemination of epidemic *Vibrio cholerae* by cargo ship ballast and other nonpotable waters. *Applied Environmental Microbiology* 60: 2597–2601.

McGowan, J. A., D. R. Cayan, and L. M. Dorman. 1998. Climate-ocean variability and ecosystem response in the northeastern Pacific. *Science* 281: 210–217.

Mills, C. E., and F. Sommer 1995. Invertebrate introductions in marine habitats: two species of hydromedusae (Cnidaria) native to the Black Sea, *Maeotias inexspectata* and *Blackfordia virginica,* invade San Francisco Bay. *Marine Biology* 122: 279–288.

Minchin, D. 1993. Possible influence of increase in mean sea temperature on Irish marine fauna and fisheries. In *Biogeography of Ireland: Past, Present, and Future,* ed. M. J. Costello and K. S. Kelly, 113–125. Occasional Publications of the Irish Biogeographical Society No. 2.

Morris, R. H., D. P. Abbott, and E. C. Haderlie. 1980. *Intertidal Invertebrates of California.* Stanford, Calif.: Stanford University Press.

National Research Council. 1995. *Understanding Marine Biodiversity: A Research Agenda for the Nation.* Washington, D.C.: National Academy Press.

————. 1996. *Stemming the Tide. Controlling introductions of nonindigenous species by ships' ballast water.* Washington, D.C.: National Academy Press.

Nehring, S. 1998. Establishment of thermophilic phytoplankton species in the North Sea: Biological indicators of climatic changes? *ICES Journal of Marine Science* 55: 818–823.

Newman, W. 1963. On the introduction of an edible Oriental shrimp (Caridea, Palaemonidae) to San Francisco Bay. *Crustaceana* 5: 119–132.

Orsi, J. J., and T. C. Walter. 1991. *Pseudodiaptomus forbesi* and *P. marinus* (Copepoda: Calanoida), the latest copepod immigrants to California's Sacramento–San Joaquin estuary. Proceedings of the Fourth International Conference on Copepoda. Bulletin of the Plankton Society of Japan. Special Volume (1991): 553–562.

Paine, R. T. 1993. A salty and salutary perspective on global change. In *Biotic Interactions and Global Change,* ed. P. M. Kareiva, J. G. Kingsolver, and R. B. Huey, 347–355. Sunderland, Mass.: Sinauer Associates Inc. Publishers

Parmesan, C. 1996. Climate and species' range. *Nature* 382: 765–766.

Peterson, C. H., R. T. Barber, and G. A. Skilleter. 1993. Global warming and coastal ecosystem response: How northern and southern hemispheres may differ in the Eastern Pacific Ocean. In *Earth System Responses to Global Change. Contrasts between North and South America,* ed. H. A. Mooney, E. R. Fuentes, and B. I. Kronberg, 17–34. New York: Academic Press, Inc.

Pierce., R. W., J. T. Carlton, D. A. Carlton, and J. B. Geller. 1997. Ballast water as a vector for tintinnid transport. *Marine Ecology Progress Series* 149: 295–297.

Ray, G. C., B. P. Hayden, A. J. Bulger, and M. G. McCormick-Ray. 1992. Effects of global warming on the biodiversity of coastal-marine zones, In *Global Warming and Biological Diversity,* ed. R. L. Peters and T. E. Lovejoy, 91–104. New Haven, Conn.: Yale University Press.

Reid, D. G. 1996. *Systematics and Evolution of Littorina.* Andover, Hampshire, England: The Ray Society.

Rózycki, O. 1991. Mollusca. In *Atlas of the Marine Fauna of Southern Sptizbergen,* ed. R. Z. Klekowski and J. M. Weslaski, 2: 358–541. Gdansk: Institute of Oceanology. Polish Academy of Sciences (as cited in Reid 1996).

Ruckelshaus, M. H., and C. G. Hays. 1998. Conservation and management of species in the sea. In *Conservation Biology: for the Coming Decade,* ed. P. L. Fiedler and P. M. Kareiva, 112–156. New York: Chapman and Hall.

Ruiz, G. M., J. T. Carlton, E. D. Grosholz, and Anson H. Hines. 1997. Global invasions of marine and estuarine habitats by non-indigenous species: Mechanisms, extent, and consequences. *American Zoologist* 37: 621–632.

Ruiz, G. M., P. Fofonoff, and A. H. Hines. 1999. Non-indigenous species as stressors in estuarine and marine communities: Assessing invasion impacts and interactions. *Limnology and Oceanography* 44: 950–972.

Sanford, E. 1999. Regulation of keystone predation by small changes in ocean temperature. *Science* 283: 2095–2097.

Shick, J. M. 1991. *A Functional Biology of Sea Anemones.* London: Chapman and Hall.

Shushkina, E.A., G. G. Nikolaeva, and T. A. Lukasheva. 1990. Changes in the structure of the Black sea planktonic community at mass reproduction of sea gooseberries *Mnemiopsis leidyi* (Agassiz). *Oceanology* 51: 54–60.

Smith, L. D., M. J. Wonham, L. D. McCann, G. M. Ruiz, A. H. Hines, and J. T. Carlton. 1999. Invasion pressure to a ballast-flooded estuary and an assessment of inoculant survival. *Biological Invasions* 1: 67–87.

Smith, R. C. 1995. Implications of increased solar UV-B for aquatic ecosystems. In *Biotic Feedbacks in the Global Climatic System,* ed. G. M. Woodwell and F. T. Mackenzie, 263–277. New York: Oxford University Press.

Southward, A. J. 1967. Recent changes in abundance of intertidal barnacles in southwest England: A possible effect of climatic deterioration. *Journal of the Marine Biological Association of the United Kingdom* 47: 81–95.

Southward, A.J., R. S. Burton, S. L. Coles, P. R. Dando, R. De Felice, J. Hoover, P. E. Parnell, T. Yamaguchi, and W. A. Newman. 1998. Invasion of Hawaiian waters by an Atlantic barnacle. *Marine Ecology Progress Series* 165: 119–126.

Stearns, R. E. C. 1871. Description of California shells. *American Journal of Conchology* 7: 171–173.

Taylor, C. C., H. B. Bigelow, and H. W. Graham. 1957. Climatic trends and the distribution of marine animals in New England. *U.S. Fishery Bulletin* 115.

van den Brink, F. W. B., G. van der Velde, and A. bij de Vaate. 1993. Ecological aspects, explosive range extension and impact of a mass invader, *Corophium curvispinum* Sars, 1895 (Crustacea: Amphipoda), in the Lower Rhine (The Netherlands). *Oecologia* 93: 224–232.

Yamada, S. B. 1977. Geographic range limitation of intertidal gastropods *Littorina sitkana* and *L. planaxis. Marine Biology* 39: 61–65.

Chapter 3

~

Land-Use Changes and Invasions

Richard J. Hobbs

The recent history of the world has been one of a dramatic increase in the incidence of human-induced disturbances as humans utilize an increasing proportion of the earth's surface in some way or another and appropriate an increasing amount of the earth's productive capacity and natural resources (Vitousek et al. 1986, 1997; Goudie 1990; Turner et al. 1991).

The extent of modification and predominance of different types of disturbance in any given area is determined by the prevalent land use. These uses can be summarized into major land-use categories, based on degree of alteration of the natural ecosystem (from Hobbs and Hopkins 1990):

1. Conservation (no deliberate modification)
 - wilderness areas
 - conservation reserves
 - uncommitted government-owned land
 - water catchment
2. Utilization (exploitation of native ecosystem)
 - nonplantation forestry
 - plant harvesting (fuelwood, medicines, etc.)

pastoralism
animal harvesting
recreation
3. Replacement (with intensively managed systems)
agriculture
horticulture
plantation forestry
4. Removal
urban development
mining
transport
industrial development

Conservation-oriented use will tend to limit the extent of human-induced disturbance, either by design or by default (for instance, in remote or harsh environments). Utilization of native ecosystems is a prevalent land use over large parts of the world, and includes the rangelands and other pastoral areas, forestry in native forest ecosystems, other extractive uses such as animal or plant harvesting and apiculture, and a growing utilization for recreation and tourism. Replacement, on the other hand, involves the removal of the native ecosystem and its replacement with a simpler system geared toward the production of particular crop or livestock species. Finally, complete removal results from destruction of the native ecosystem, such as occurs during surface mining or urban and industrial development. Each land use entails a suite of deliberate and inadvertent impacts of varying severity on the natural ecosystem.

Clearly, the extent of each of these various land uses varies geographically, and the removal category is relatively small compared to the others. Similarly, any particular area can have a mixture of these land-use categories, with, for instance, remnants of native ecosystems remaining (in a more or less altered state) within urban areas. Thus the interactions between different land uses, either on the same or adjacent areas, are also important.

Human modification has led in many cases to increasing degradation of ecosystem components, resulting in a decline in the value of the ecosystem, either for production or conservation purposes. This has been met with an increasing recognition that measures need to be taken to halt or reverse this degradation, and hence the importance of restoration or repair of damaged ecosystems is increasing (Dobson et al. 1997; Hobbs 1999).

This chapter explores the interactions between changing patterns of land use and biological invasions. Vitousek et al. (1997) have suggested that land transformation, while one of the predominant human impacts on ecosystems, is also probably the most difficult form of global change to quantify sensibly at a global scale. While changes can be measured at any given site, the

aggregation of these changes regionally and globally presents real challenges. There is no simple "land-use change" probe that can be mounted on a satellite. Thus, this chapter begins by attempting to simplify land-use changes into a series of categories that encompass the wide array of land transformations currently underway across the globe.

Land Transformation: A Complex Phenomenon

Many different land uses can be identified and categorized on the extent to which they modify the ecosystem. Discussion of land transformation thus has to capture the richness of the potential changes from one land use to another. Certainly, broad categories of change are apparent globally—for instance, increasing urbanization, deforestation, and ecosystem fragmentation, as well as agricultural intensification in some areas and abandonment of agricultural land in others. Such changes can be examined in relation to the effect they have on ecosystems, as illustrated in Figure 3.1. Here, a number of possible

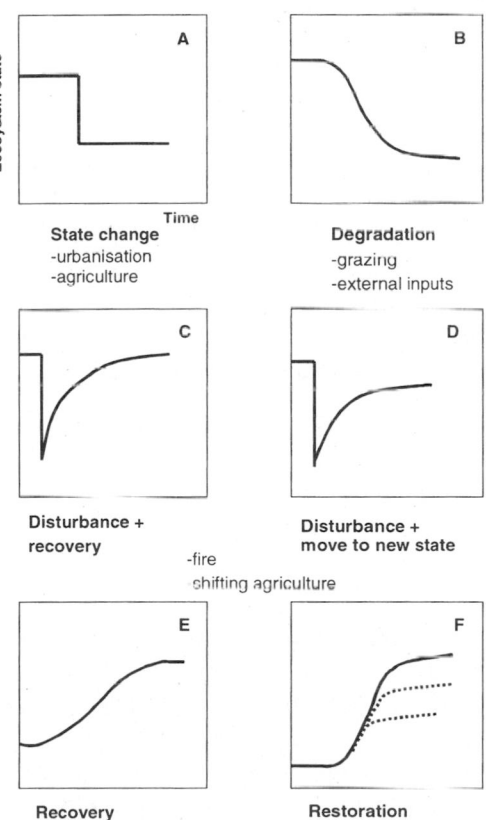

Figure 3.1. Different categories of land transformation, with examples of each.

types of transformation are identified, together with examples of each type. A land transformation is considered to represent a change in ecosystem "state," which may be defined in terms of ecosystem structure, composition, or function. Hence the relative importance of the change depends on which ecosystem components are valued—for instance, change in composition may be important in terms of conservation goals, whereas in terms of watershed management, functional aspects such as water uptake and flows may be more important.

In Figure 3.1, possible changes include both ecosystem decline and recovery. A particular human activity may result in a sudden or more gradual change in ecosystem properties. Hence, conversion by urban development or clearance for agriculture results in a sudden state change (A), whereas more chronic impacts from, for instance, livestock grazing or pollution, result in more gradual degradation (B). A further set of transformations results from the impact of individual disturbances such as fire or shifting agriculture. In this case, a sudden state change is followed either by a recovery to a similar state as was present pre-disturbance (C), or by a recovery to a different state (D). A wide array of such dynamics is possible, with numerous postdisturbance pathways, the exact nature of which are determined by a complex interaction between the ecosystem composition at the time of the disturbance and the subsequent biotic and abiotic conditions (Hobbs 1994; Pahl-Wostl 1995; Pickett and Ostfield 1995).

A final set of dynamics involves the recovery of ecosystems from a damaged or altered state following cessation of a disturbing factor or stressor. This may occur either as the result of normal succession or ecosystem development, such as in the case of old field dynamics (E), or through deliberate actions to encourage ecosystem restoration or repair (F). Here, too, numerous outcomes are possible, depending on the goals of the restoration efforts and the resources available to achieve them (Hobbs and Norton 1996; Hobbs 1999).

Land Transformation Enhances Invasion

Vitousek et al. (1997) illustrated the interrelationships between the various elements of global change, and suggested a two-way interaction between ecosystem transformation and invasions. This section explores both sides of this relationship—namely, the impact of land transformation on invasions, and the impact of invasions on land use.

Human-induced changes to ecosystems represent a special subset of the range of potential ecosystem dynamics. Ecologists are increasingly recognizing that ecosystems are dynamic entities in which change is the rule rather than the exception (Pahl-Wostl 1995; Pickett and Ostfield 1995; Fiedler et al. 1997). Rates of change will vary through time, with periods of relatively little

or slow change and other periods of rapid change (Holling 1986, 1995). The species making up ecosystems respond to such change in different ways, and hence through time the composition of any given ecosystem will not remain the same. Species come and go, depending on the current abiotic conditions and interactions with other species. Times of rapid system change, in particular, can represent opportunities for species to enter ecosystems and a reassortment of the biotic composition to occur.

If ecosystems are dynamic and species compositions are variable, the stage is set for species to appear and disappear in any given system, depending on the current abiotic conditions, the levels and types of disturbance, and the composition of the regional species pool. Such appearances and disappearances have been ongoing over millennia. However, two major changes have taken place relatively recently. One is the increasing levels of human transformation of ecosystems discussed earlier. The second is the dramatic increase in both the deliberate and the inadvertent transport of biota across the globe. The first change corresponds to a radical change in the levels and types of disturbance experienced by ecosystems. The second change corresponds to a marked increase in the regional species pool brought about as humans transport organisms around the globe and hence break down global biogeographic barriers. When both changes are put together, they produce the potential for a radical alteration of ecosystem dynamics.

In general, any change in ecosystem properties will provide opportunities for species colonization or population expansion. The types of system change illustrated in Figure 3.1 all provide such opportunities. Changes in ecosystem state are often accompanied by changes in amounts and flows of resources such as water, nutrients, and so on. For instance, removal of the native vegetation of a region and its replacement with agriculture or urban development can result in a much more "leaky" system, with greater flows of water and nutrients out of the system and less internal recycling (Hobbs 1993). These resources are then transported and become available elsewhere. Alternatively, activities such as building dams on rivers reduce environmental flows by trapping sediment and reducing flood levels.

I have argued elsewhere that any disturbance that acts to increase the supply of a limiting resource will provide an opportunity for invasion (Hobbs 1989). More generally, while disturbance is a natural part of ecosystem dynamics in many systems, human alteration of disturbance regimes and the introduction of novel disturbances produce changed system settings and increased opportunities for invasion (Hobbs and Huenneke 1992).

In any ecosystem there are species that can take advantage of disturbances to colonize or expand their populations. These are either disturbance specialists (e.g., species that germinate preferentially after a fire) or generalists that can tolerate a wide range of conditions. The disturbance provides a window of opportunity for such species, which generally lasts a relatively short time.

However, humans have transported species across the globe, both deliberately for agriculture, forestry, recreation, or horticulture and other pursuits, and inadvertently, for example, as seed contaminants. Disturbances and land transformations afford these new species opportunities to colonize and spread, and they are often able to do so as well or better than the species native to the area.

Indeed, land-use changes are often brought about by the use of introduced species—for example, new forage species, plantation trees, and the like. Such species have been transported around the globe with little attention being paid to their potential to spread and become problems elsewhere. A classic case is the extensive use of Northern Hemisphere pine species in the Southern Hemisphere, where they are undoubtedly producing valuable income as timber, but are also causing major problems when they invade adjacent systems and diminish their value in terms of either conservation or ecosystem services (Richardson et al. 1994; Van Wilgen et al. 1996).

Land transformation thus acts to encourage biotic change first by causing system changes that provide the opportunity for biological invasion, and second by bringing new species from different biogeographic regions into contact with these altered systems. The extent to which the biotic changes in any given area present a problem depends on the goals of management in that area. For example, radical biotic changes have taken place in urban areas throughout the world, both through removal of large proportions of the pre-existing ecosystems and through the introduction of domesticated and commensal plants and animals. This in itself is not a problem, unless such species pose threats to the conservation of remaining pockets of native vegetation in the urban area or act to impede essential ecosystem services.

Invasion Enhances Land Transformation

As well as being a result of land transformation, invasion by nonnative species can itself act as a driver of land transformation. This will occur when the invading species results in the sorts of ecosystem change indicated in Figure 3.1. Such changes are possible when an invading plant species becomes dominant and changes the type of vegetation present. For instance, invading trees can transform a grassland or shrubland into a forest, and invading grasses can, via land clearance and/or an altered fire regime, change a woody perennial system into an open grassland (Fig. 3.2; D'Antonio and Vitousek 1992; Richardson et al. 1994).

Less extreme changes caused by species that invade and alter system structure or function can also result in sometimes severe reductions in the value of land for current land uses. This then leads to the requirement to either develop alternative land uses or to increase the level of management required to maintain the existing land use. Examples include the invasion of rangeland

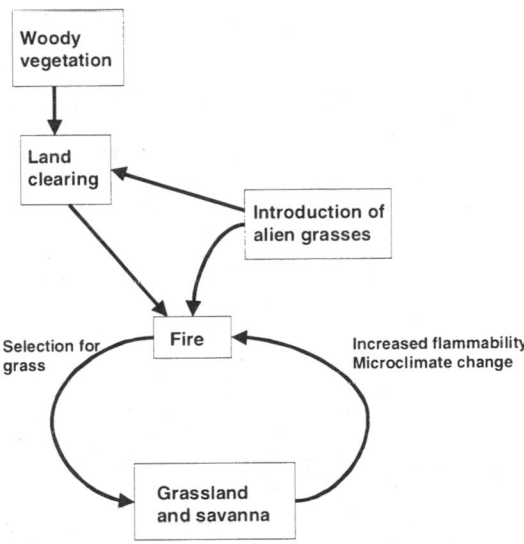

Figure 3.2. The interaction between land-use change and invasion, as exemplified by the conversion of woody vegetation (woodland, shrubland) to grassland, which may be initiated either by the purposeful clearing of land or after the invasion of the woody vegetation by introduced grasses. In either case, a grass-fire feedback system is initiated, which prevents the regeneration of woody species (modified from Vitousek et al. 1996).

systems by woody perennials (Brown and McIvor 1993; Ludwig et al. 1997), and the invasion of forest and shrubland by disease organisms (Wills 1993; Campbell and Schlarbaum 1994; Wills and Robinson 1994; Withers et al. 1994). In addition, nonnative species can pose problems for restoration projects, especially where nonnative species prevent the establishment of other desired species (Berger 1993; Hobbs and Mooney 1993). On the other hand, there are, of course, many invasions that have little or no impact on land use, and some invasions even prove beneficial from some perspectives. The net costs and benefits of particular invasions may often have to be assessed across a number of conflicting land uses (see Naylor, this volume).

Often, the causal link between land transformation and invasions is convoluted. A change in land use, or the continuation of an inappropriate land use or of inappropriate levels of use, often provides the conditions necessary for an invading species to become established. This is certainly the case in rangelands, where inappropriate grazing and/or fire regimes result in invasion by shrubs or grasses (Whisenant 1990; Ludwig et al. 1997). Thereafter, however, the invading species initiates further system change that precipitates the need for a change in land use or increased management to maintain the existing land use. Hence the change in system state initiated by the distur-

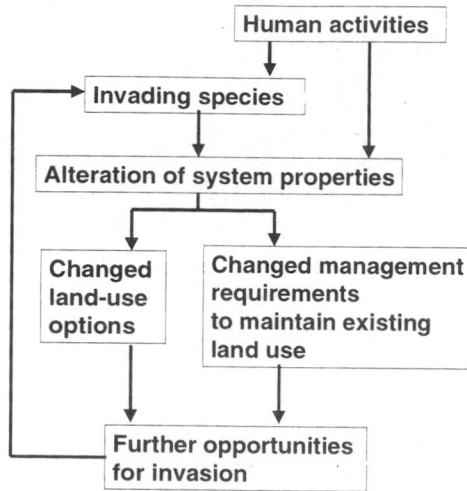

Figure 3.3. Interrelationships between human activities (management of ecosystems) and invasions.

bance or management regime is enhanced or speeded up by the invasion of nonnative species. The interlinkages between land transformation and invasions are illustrated diagrammatically in Figure 3.3.

Conclusions

Transformation of land from one type of system to another and change in land use is pervasive across the globe today. The areas involved in transformations such as deforestation are truly massive and are happening with considerable rapidity. While it is possible to obtain some estimates of the more obvious changes caused by deforestation and land clearing (e.g., Skole and Tucker 1993), it is more difficult to assess the totality of land-use changes. Also, if one starts considering the likely interactions between land-use change and climate change, predictions of future trends become difficult (Leemans and Zuidema 1995; Parry et al. 1996). In addition, many trends in land-use change are driven primarily by economic, political, and social, rather than biophysical, factors.

I have attempted to illustrate the interlinkages between land transformation and invasions. There seems to be a clear two-way street, with land transformation providing opportunities for invasion and, conversely, invasions enhancing and driving land transformations. At the moment, we seem to accept the situation as inevitable and hence are to some extent passively watching as our world is transformed and local diversity is replaced by glob-

al homogeneity. We urgently need debate at all levels of society as to whether this is really what we want. If it isn't, we urgently need to assess how we can set about retaining the systems and land uses that we want to retain, facilitating necessary changes in systems and land uses in an effective and nondegrading way, and preventing the transformation of local diversity by aggressive invasive species. This is quite a challenge, and we've a long way to go.

References

Berger, J. J. 1993. "Ecological restoration and non-indigenous plant species: a review." *Restoration Ecology* 1: 74–82.

Brown, J. R., and J. G. McIvor. 1993. "Ecology of woody weed invasions in the tropical woodlands of north-eastern Australia: implications for management." In *Proceedings of the 10th Australian Weeds Conference and 14th Asian Pacific Weed Society Conference. Vol. 1*, 471–774. Brisbane: Weed Society of Queensland.

Campbell, F. T., and S. E. Schlarbaum. 1994. *Fading Forests: North American Trees and the Threat of Exotic Pests.* National Resources Defense Council.

D'Antonio, C. M., and P. M. Vitousek. 1992. "Biological invasions by exotic grasses, the grass/fire cycle, and global change." *Annual Review of Ecology and Systematics* 23: 63–87.

Dobson, A. P. et al. 1997. "Hopes for the future: restoration ecology and conservation biology." *Science* 277: 515–22.

Fiedler, P. L. et al. 1997. "The paradigm shift in ecology and its implications for conservation." In *The Ecological Basis of Conservation: Heterogeneity, Ecosystems and Biodiversity*, edited by Pickett, S. T. A. et al., 83–92. New York: Chapman and Hall.

Goudie, A. 1990. *The Human Impact on the Natural Environment.* Cambridge, Mass.: MIT Press.

Hobbs, R. J. 1989. "The nature and effects of disturbance relative to invasions." In *Biological Invasions: A Global Perspective*, edited by Drake, J. A. et al., 389–405. New York: Wiley.

———. 1993. "Effects of landscape fragmentation on ecosystem processes in the Western Australian wheatbelt." *Biological Conservation* 64: 193–201.

———. 1994. "Dynamics of vegetation mosaics: can we predict responses to global change?" *Écoscience* 1: 346–56.

———. 1999. "Restoration of disturbed ecosystems." In *Ecosystems of the World 16. Disturbed Ecosystems*, edited by Walker, L. Amsterdam: Elsevier.

Hobbs, R. J., and A. J. M. Hopkins. 1990. "From frontier to fragments: European impact on Australia's vegetation." *Proceedings of the Ecological Society of Australia* 16: 93–114.

Hobbs, R. J., and L. F. Huenneke. 1992. "Disturbance, diversity and invasion: implications for conservation." *Conservation Biology* 6: 324–37.

Hobbs, R. J., and H. A. Mooney. 1993. "Restoration ecology and invasions." In *Nature Conservation 3: Reconstruction of Fragmented Ecosystems, Global and Regional Perspectives*, edited by Saunders, D. A. et al., 127–33. Chipping Norton: Surrey Beatty and Sons.

Hobbs, R. J., and D. A. Norton. 1996. "Towards a conceptual framework for restoration ecology." *Restoration Ecology* 4: 93–110.

Holling, C. S. 1986. "Resilience of ecosystems: local surprise and global change." In *Sustainable Development of the Biosphere*, edited by Clark, W. C., and R. E. Munn, 292–317. Cambridge: Cambridge University Press.

———. 1995. "What barriers? What bridges?" In *Barriers and Bridges to the Renewal of Ecosystems and Institutions*, edited by Gunderson, L. H. et al., 3–34. New York: Columbia University Press.

Leemans, R., and G. Zuidema. 1995. "Evaluating changes in land cover and their importance for global change." *Trends in Ecology and Evolution* 10: 76–81.

Ludwig, J. et al. (ed). 1997. *Landscape Ecology, Function and Management: Principles from Australia's Rangelands*. Melbourne: CSIRO Publishing.

Pahl-Wostl, C. 1995. *The Dynamic Nature of Ecosystems: Chaos and Order Entwined*. Chichester: Wiley and Sons.

Parry, M. L. et al. 1996. "Global and regional land-use responses to climate change." In *Global Change and Terrestrial Ecosystems*, edited by Walker, B., and W. Steffan, 466–83. Cambridge: Cambridge University Press.

Pickett, S. T. A., and R. S. Ostfield. 1995. "The shifting paradigm in ecology." In *A New Century for Natural Resources Management*, edited by Knight, R. L. and S. F. Bates, 261–78. Washington, D.C.: Island Press.

Richardson, D. M. et al. 1994. "Pine invasions in the Southern Hemisphere: determinants of spread and invadability." *Journal of Biogeography* 21: 511–27.

Skole, D., and C. Tucker. 1993. "Tropical deforestation and habitat fragmentation in the Amazon: satellite data from 1978 to 1988." *Science* 260: 1905–10.

Turner, B. L. I. et al. (ed). 1991. *The Earth as Transformed by Human Action*. New York: Cambridge University Press.

Van Wilgen, B. W. et al. 1996. "Valuation of ecosystem services. A case study from South African fynbos ecosystems." *BioScience* 46: 184–9.

Vitousek, P. M. et al. 1986. "Human appropriation of the products of photosynthesis." *BioScience* 36: 368–73.

———. 1996. "Biological invasions as global environmental change." *American Scientist* 84: 468–78.

———. 1997. "Human domination of Earth's ecosystems." *Science* 277: 494–99.

Whisenant, S. G. 1990. "Changing fire frequencies on Idaho's Snake River plains: ecological and management implications." In *Proceedings from the Symposium on Cheatgrass Invasion, Shrub Dieoff and Other Aspects of Shrub Biology and Management. USFS General Technical Report INT-276*, 4–10. Washington, D.C.: United States Forest Service.

Wills, R. T. 1993. "The ecological impact of *Phytopthora cinnamomi* in the Stirling Range National Park." *Australian Journal of Ecology* 18: 145–59.

Wills, R. T., and C. J. Robinson. 1994. "Threats to flora-based industries in Western Australia from plant disease." *Journal of the Royal Society of Western Australia* 77: 159–62.

Withers, P. C. et al. (ed). 1994. "Plant Diseases in Ecosystems; Threats and Impacts in South-western Australia." *Journal of the Royal Society of Western Australia* 77: 1–131.

Chapter 4

✑

Fire, Plant Invasions, and Global Changes

Carla M. D'Antonio

Fire has played an important role in human history and in the ability of humans to control the natural world. Nonetheless, in the last century, our ability to control plant growth with fire has begun to change as unwanted exotic species spread across the landscape and interact with fire in a way that may be both unpredictable and undesirable. Generalizations regarding the relationship between fire and the dynamics of invasive, exotic species have been elusive because of the diversity of ecosystems being invaded by introduced species and the variation in the frequency and importance of natural fire. Yet clarification of this relationship is essential if we are to predict how climate, land use, and other global-scale changes will influence the occurrence and outcome of wildfire. Because well-established invaders can themselves influence fire regimes (D'Antonio and Vitousek 1992; Mack and D'Antonio 1998), it is also important to begin identifying invader traits that might promote or suppress fire under current and changing climate.

There is clear evidence that many invasive nonnative species can be promoted by fire, but there is also evidence that many introduced species can be controlled by fire. For example, in the Hawaiian islands, fire in seasonally dry

ecosystems appears to promote exotic grasses to the detriment of native species (Smith and Tunison 1992; Hughes et al. 1991). Yet in the California coast and interior valleys, fire is used as a management tool to reduce exotic and promote native species (e.g., Parsons and Stohlgren 1989; Hastings and DiTomaso 1996). In addition, in some areas of the western United States, introduced European annual grasses increase fire frequency and respond positively to it (e.g., Whisenant 1990a; Young 1992; Brooks 1998) while in other parts of the western United States, fire is being used to control some of these same invaders. Clearly then, it is important to try to clarify the conditions under which fire suppresses versus promotes introduced species. In addition, many of the fire-promoted and fire-promoting invasive exotic species are grasses that were purposefully brought to or planted into the region where they are now naturalized. If these species promote fire to the potential detriment of native species, then we need the tools with which to evaluate the ecological versus cultural or socioeconomic trade-offs that arise from the grass-fire interaction.

In this chapter I will discuss recent literature examining the impacts of fire on introduced species and the impacts of introduced plants on fire regimes with the goal of finding generalizations that might be useful in a management framework. I will also briefly explore potential interactions between fire, invasion, and other elements of global environmental change. I used BIOSIS, an abstract service, and references cited in D'Antonio and Vitousek 1992 and D'Antonio et al. (1999) to survey for recent (past thirteen years) literature on the subject. I did not attempt to survey the extensive gray literature or older literature on use of fire as a management tool. Several caveats should be noted a priori regarding our ability to draw firm conclusions in this area: (1) Fire intensity and behavior is extremely variable even within a site, so variation in impacts should be expected at all scales. (2) Quantification of fire frequency and intensity is rarely done because it is difficult. Thus few data are available to look for numerical correlation between fire regime parameters and invasion intensity, and much of the information available is anecdotal. (3) There is no general consensus on what constitutes an invasion or what level of population increase or decrease after fire represents a biologically important change. In spite of these caveats, there is ample information available to begin to make reasonable predictions about the relationship between fire and invasions now and into the near future.

Role of Fire in Promoting Invasion of Native Ecosystems

Understanding the role of fire in promoting the invasion of native ecosystems is important because human contact with ecosystems often promotes accidental fire as well as provides a means for propagules of exotic species to enter

an ecosystem. In addition, many societies use fire to manage ecosystems both to promote or to discourage particular species. Lastly, several investigators (e.g., Torn and Fried 1992) have suggested that natural fire frequency and/or intensity should increase in many regions of the world as a result of climate changes predicted by recent global circulation models. Such changes may affect the abundance of invasive exotic species, which in turn might affect native biological diversity and the functioning of ecosystems.

Fire Often Promotes Invasion

Over the past two decades many studies have documented an increase, decrease, or no change in the abundance of an exotic species in response to fire. A sampling of these are detailed in Tables 4.1 and 4.2. In the vast majority of cases, fire resulted in an increase in introduced species; only in 20 percent of the cases did fire reduce or eliminate an invader. In very few cases did fire have no effect on the abundance of an invader. Ecosystems where fire had a positive effect on native species include (1) desert shrublands and woodlands of western North America, including the Great Basin and the Mojave and Sonoran Desert regions; (2) semiarid shrublands including heathlands and shrublands of Australia, the fynbos of South Africa, and California chaparral; (3) grassland/savanna ecosystems from eastern Australia, Venezuela, France, and California; and (4) more mesic but seasonally dry woodlands including Hawaii, western Australia, and parts of eastern Australia.

Despite a sizable literature on the role of recurrent "natural" fire in many ecosystems throughout the world, such as California mixed-conifer forest and interior chaparral, the garigue of Spain, monsoonal forests and savannas in northern Australia, and dry savannas of Africa (e.g., MacDonald and Frame 1988), there is very little mention of the occurrence of invasive exotic species in these systems. In the case of California chaparral, we know that the propagules of introduced species are sometimes close by, yet communities experiencing a more or less "natural" fire regime appear to be somewhat resistant to invasion (at least right now!). By contrast, South African shrublands, which have a long history of recurrent fire, are becoming heavily invaded by a few fire-tolerant woody species (e.g., Richardson et al. 1990, 1996). Although native species there can respond positively to fire, the introduced species appear to have more prolific seed production and more rapid regeneration, and fire provides a "window of opportunity" for the invaders. After successive fire cycles, invaders increase and native species richness declines (Holmes and Cowling 1997). This instructive example demonstrates that even communities where fire has been an historic occurrence can be invaded by fire-resistant or -responsive species.

In many studies, investigators conducted controlled burns specifically to try to reduce the abundance of an exotic pest plant (Table 4.2). The effective-

Table 4.1. Examples showing increase in exotic species after accidental or natural fire. Most studies are observational or correlative. Controlled burn studies are described in Table 4.2.

Study region (habitat)	Invader (common name)	Role of fire	Reference
California			
(riparian)	*Arundo donax* (giant reed)	Invasion occurs without fire but fire promotes thickening	Bell 1997
(maritime chaparral)	*Carpobrotus edulis* (highway iceplant)	Invades slowly without fire; germination reduced by fire but invasion enhanced by it	Zedler and Schied 1988 Hickson 1988; D'Antonio et al. 1993
(chaparral)	*Bromus* spp., *Schismus barbatus, Brassica nigra* (black mustard)	Enhanced by repeated burning	Haidinger and Keeley 1993
(Sierra foothills)	*Cytisus scoparius* (Scotch broom)	Germination promoted by fire	Bossard 1991
(Mojave Desert)	*Bromus rubens* (red brome), *S. barbatus*	Invade without fire; dominance promoted by fire	Brown and Minnich 1986; Brooks 1998
Western U.S.A.			
(Great Basin Desert)	*Bromus tectorum* (cheatgrass)	Slow invasion without fire; thickening and dominance promoted by fire	Klemmedson and Smith 1955; Sparks et al. 1990; Whisenant 1990a; Svejcar and Tausch 1991
	Taeniatherum asperum (medusahead)	Needs fire to invade some areas but not others	Young and Evans 1971; Young 1992
(desert riparian floodplain)	*Tamarix ramosissima* (salt cedar)	Invades without fire, increases with fire	Busch 1995
Nevada			
(Great Basin Desert)	*Bromus rubens* (red brome)	Invades without fire; enhanced by fire	Beatley 1966; Hunter 1991; Svejcar and Tausch 1991
Arizona			
(Sonora Desert grassland)	*Eragrostis lehmaniana* (Lehman's lovegrass)	Can spread without fire but may be enhanced by fire	Cable 1971; Anable et al. 1992
Sonora, Mexico			
(Sonoran Desert/ thornscrub)	*Pennisetum ciliare* (buffel grass)	Invades slowly without fire in several habitats; thickening enhanced by fire	Búrquez and Quintana 1994; A. Burquez, UNAM Hermosillo, personal communication

Study region (habitat)	Invader (common name)	Role of fire	Reference
Hawaii (seasonal sub-montane woodland)	*Schizachyrium condensatum* (beard grass), *Melinis minutiflora* (molasses grass)	Invade without fire, but some, particularly *M. minutiflora,* are promoted by fire	Hughes et al. 1991
NW Territories Canada (boreal forest)	European annuals/ biennials	Temporary invasion occurred after large natural fire	Wein et al. 1992
Venezuela (llanos)	*Hyparrhenia rufa* (thatching grass/ jaragua)	Invades without fire but is promoted by fire	Bilbao 1995
Brazil (cerrado)	*M. minutiflora* (molasses grass)	Can invade without fire but also promoted by fire	J. Augusto Santos, R. Oliviera, personal communication
France (grassland)	Exotic annual grasses	Temporary invasion occurs after fire	Trabaud 1990
W. Australia (*Eucalyptus* woodland)	Annual forbs and grasses	Enhanced by fire	Bridgewater and Backshall 1991
(open woodland, shrubland)	Perennial grasses, primarily *Ehrhardta calycina* (veldt grass)	Enhanced by fire	See MacDonald and Frame 1988
SW Australia (roadsides adjacent to sclerophyll wood-land)	*Eragrostis curvula* (weeping lovegrass), *E. calycina*	Invasion enhanced by fire	Milberg and Lamont 1995
South Africa (proteoid fynbos)	*Acacia* spp.	Invasion enhanced by fire	Holmes et al. 1987
(mountain fynbos)	*Pinus radiata* (Monterey pine), *P. halepensis, Banksia* (3 spp.)	Invasion slow with-out fire but enhanced by fire	Richardson and Brown 1986; Richardson 1988; Richardson et al. 1990

Table 4.2. Examples where invaders responded either positively or negatively to experimental burning. Examples organized by geographic proximity. Common names presented if available.

Location (habitat)	Invader (common name)	Invader life-form	Burn treatments	Species responses	Reference
California (Sierra foothill woodland)	Exotic grasses and forbs	Annuals	Season of burn	Grasses declined; forbs increased regardless of season	Parsons and Stohlgren 1989
(coast range grassland)	*Centaurea solstitialis* (yellow star thistle)	Thistle	Season of burn	*Centaurea* declined	Hastings and Di Tomaso 1996
(Central Valley prairie)	Eurasian annual grasses	Grasses	Season of burn	Grasses decline with spring burning but exotic forbs increase	Meyer and Schiffman in press
(coastal grassland)	*Genista monspessulana* (French broom)	Shrub	Repeated late-summer fire	Shrubs decline only with recurrent fire	D. Boyd, Calif. State Parks, D. Odion, Marin Water District, personal communication
Arizona (high Sonoran Desert)	*Eragrostis lehmanniana* (Lehmann's love grass)	Grass	Season of burn	All treatments favored love grass germination	Ruyle et al. 1988
South Dakota (short-grass prairie)	*Bromus japonicus* (Japanese bromegrass)	Grass	Spring burning	Reduced by fire	Whisenant 1990b Whisenant and Uresk 1990
Nebraska (tall-grass prairie)	*Bromus inermis* (smooth brome)	Grass	Season of burn	Target declines when fire occurs at tiller elongation	Willson and Stubbendieck 1997
Wisconsin (tall-grass prairie)	*Agropyron repens* (quack grass), *Phalaris arundinacea* (canary reed grass)	Perennial grasses	Season of burn	Both species increase with summer burning	Howe 1995

Illinois (woodland)	*Alliaria petiolata* (garlic mustard)	Perennial forb	Intensity	No decline with low-intensity fire, some with midintensity	Nuzzo 1991
Florida (woodlands)	*Schinus terebinthifolia* (pepper tree)	Small tree	Repeat burning; intensity	Very little reduction in any treatment	Doren and Whiteaker 1990
NE Alberta, Canada (wetland w/in boreal forest)	*Sonchus arvensis* (sow thistle), *Cirsium arvensis* (Canada thistle)	Forbs	Light versus "deep" versus no burning	No change in abundance with any fire intensity	Hogenbirk and Wein 1991
Victoria, Australia (temperate grassland)	Exotic grasses and forbs	Annual and perennial	One burn only	Most exotics increased	Lunt 1990
Western Australia (sand plain heath)	Exotic annuals	Grasses and forbs	One burn period	No effect	Hobbs and Atkins 1991
(shrubland)	Exotic annuals	Grasses and forbs	One burn period	No effect	Hester and Hobbs 1992
(*Eucalyptus* woodland)	Exotic annuals	Grasses and forbs	One burn period	Reduced exotics	Hester and Hobbs 1992
(*Banksia* woodland)	Exotic annuals	Grasses and forbs	Sept. low intensity, March higher intensity	Short-lived increase in exotics	Hobbs and Atkins 1990
NSW, Australia (dry rainforest)	*Lantana camara* (lantana)	Shrub	Propane torch; 2 intensities	All methods promoted invasion	Gentle and Duggin 1997; Duggin and Gentle 1998
Queensland, Australia (open sclerophyll forest)	*Lantana camara* (lantana)	Shrub	Repeated winter burning	Little effect—maybe slowed invasion small amount	Russell and Roberts 1996
(dry tropical forest)	*Cryptostegia grandiflora* (rubber vine), *Zizyphus mauritiana* (jujube)	Shrubs	One fire at end of dry season	*C. grandiflora* reduced by fire; no effect on *Z. mauritiana*	Grice 1997

ness of fire in killing nonnative species or reducing their population growth will depend on fire intensity, time of burning and prior and subsequent weather conditions. While fire intensity is likely to directly affect control, very few studies estimated it (but see Nuzzo 1991; Gentle and Duggin 1997). Several investigators found that timing of burning had a strong influence on the degree to which control was achieved (e.g., Parsons and Stohlgren 1989; Hastings and DiTomaso 1996; Willson and Stubbendieck 1997; Meyer and Schiffman, in press). While simulating the timing of "natural" fire seems like an intuitive thing to do (see Parsons and Stohlgren 1989; Howe 1995; Hastings and DiTomaso 1996), it is not always effective at reducing exotics. Howe (1995) measured substantial increases in abundance of two exotic perennial prairie grasses after midsummer (the lightning season) burns in a Wisconsin prairie. In two studies where the response of the entire community to fire was measured (Parsons and Stohlgren 1989; Meyer and Schiffman, in press), fire was used successfully to reduce exotic annual grasses but exotic forbs increased. The relative impact of the forbs compared to the grasses on native diversity or ecosystem function was not evaluated. Nonetheless, the results of these studies imply that if fire is to be used as a management tool, the benefits (reduction of one invader) must be weighed carefully against the costs (increase in another invader or decline of native species). In addition, past land-use history and availability of seed have a strong effect on the outcome of controlled burns even in vegetation types thought to have evolved with fire (see Lunt 1990). If the seedbank is full of exotic species and natives are depleted (e.g., Parsons and Stohlgren 1989; Lunt 1990), or if individuals of exotic species are resistant to fire (Johnson and Purdie 1981; Doren and Whiteaker 1990; Grice 1997), then fire has little effect on their control.

I found numerous studies where invasion of a native-dominated habitat could occur without fire but where subsequent fire promoted thickening or spread of the invader. These studies were largely in arid or semiarid ecosystems where introduced grasses invade the understory or intershrub spaces in largely woody vegetation. In many of these cases, disturbances such as cattle grazing and/or gopher activity may have preceded invasion, but Whisenant (1990a) and Svejcar and Tausch (1991) provide clear cases where invasion occurred without fire or livestock grazing. Also, in South Africa woody exotics can invade without fire but are promoted by it (e.g., Richardson 1988; Richardson et al. 1990).

I also attempted to assess whether the invaders that were promoted by fire were a long-term part of the community or whether they rapidly gave way to native species. In many cases, studies were very short term, so it was not possible to make this assessment. In the majority of cases, however, invaders appeared to be a persistent part of the community. These included

annual and perennial grasses, shrubs, trees, and succulents. The cases where exotics persisted for only a short time (<5 years) were all instances where invaders were annuals or biennials (Hobbs and Atkins 1990; Trabaud 1990; Wein et al. 1992) and fire was a part of the recent (<10,000 years) history of the sites.

Lastly, invasion due to fire suppression in an otherwise fire-prone ecosystem does not yet appear to be a common phenomenon, yet a few examples exist. In dry woodland fragments within an urban boundary near Sydney, Australia, fire suppression is practiced for the protection of houses and buildings. There, invasion by an introduced woody species appeared to increase with increasing time since previous fire (Rose and Fairweather 1997). Likewise, Putz (1998) suggests that fire suppression is leading to the replacement of native oaks by the exotic laurel oak in Florida woodlands. Fire is well known to control the invasion of grasslands by woody species, and in Texas prairies, fire suppression is partly responsible for widespread invasion by *Sapium sebiferum*, Chinese tallow tree (Bruce et al. 1995; Whisenant, personal communication).

Conclusions

Johnson and Purdie (1981) suggest that fire is rarely effective at controlling woody invaders in grassland and that fire alone may even encourage many troublesome invaders. Recent literature on fire and exotic species also suggests that fire in most ecosystems tends to promote rather than discourage introduced species. The exceptions to this are some ecosystems where fire has a long evolutionary history (e.g., California chaparral and mixed-conifer forest, Australia monsoonal forests, African savannas). Yet fire can favor exotics in many ecosystems where fire has been an important force prior to European colonization, including South African fynbos ecosystems and northcentral U.S. prairies (Howe 1995).

No two fires are alike, and the outcome of fire depends on its timing, intensity, recurrence interval, and subsequent weather. Thus, specifically predicting fire impacts is difficult. Nonetheless, examples accumulating from throughout the world suggest that, more often than not, fire promotes nonnative species, and that if fire is to be used for their control, it must be carefully applied and factors such as seed availability (of both natives and exotics), plant phenology, and fire intensity must be critically evaluated.

Impact of Invaders on Fire Regimes

One of the most potentially damaging impacts that an invading species can have on native biological diversity and ecosystem functioning is to alter the

disturbance regime (D'Antonio and Vitousek 1992; Mack and D'Antonio 1998). Introduced species can alter the rate of spread of fire, the probability of occurrence of fire, and the intensity of fire in an ecosystem. The nature of the evidence provided varies considerably among studies and is indicated in Table 4.3. I also include unpublished information from systems where invasions are well documented in published literature but impacts on fire regime are speculative but based on a firm understanding of the biology of the system (see *Myrica faya*).

Invaders Affect Frequency and Intensity of Fires

I found very few published studies where an introduced species had the potential to, or clearly did, decrease the spread of fire in the invaded systems. Nonetheless, I believe that this may become a more broadly recognized phenomenon as our awareness of the role of fire and invaders increases. Potential examples include (1) invasion of maritime chaparral in coastal California by the South African succulent *Carpobrotus edulis* (invasion documented by Zedler and Schied 1988; D'Antonio et al. 1993; impacts on fire = personal observation of author); (2) invasion of the nitrogen-fixing tree *Myrica faya* in Hawaii Volcanoes National Park (invasion documented by Vitousek and Walker 1989 and others; effects on fire = personal observation, T. Tunison, Hawaii Volcanoes National Park, Resources Management); (3) *Mimosa pigra* (nitrogen-fixing shrub) invasion in western Australia (Gill et al. 1990; Lonsdale and Miller 1993); (4) invasion by the tree *Schinus terebinthifolius* in Florida (Wade et al. 1980; Doren et al. 1991), (5) invasion by vines that blanket trees in Florida (Gordon 1998); and (6) invasion by leguminous shrubs such as French and Scotch brooms in California grasslands (personal observation). In the case of *Myrica faya* invasion into Hawaii, *Myrica*'s low flammability and lack of litter layer is expected to suppress the spread of fire in woodland ecosystems invaded by introduced grasses. *Myrica* is not necessarily suppressing an historic fire regime, but it could suppress the recent regime created by grass invasion of the forest understory. In four of the remaining examples, recurrent fire plays a role in stimulating native species regeneration in the ecosystems the invaders are entering. Hence fire suppression by the invaders could reduce regeneration of native species.

In contrast to the relatively small number of cases cited above, I found numerous cases where invaders had a significant effect on fire regime, enhancing some aspect of it (Table 4.3). In the majority of cases, invaders were suspected of increasing fire frequency while in a few cases (e.g., van Wilgen and Richardson 1985; Bilbao 1995; Lippincott, in press), invaders were suspected of increasing fire intensity. These latter cases were largely from the Americas and the fynbos of South Africa in places where fire has been a

Table 4.3. Examples of invaders that alter fire regimes in invaded ecosystem by increasing frequency and/or intensity of fire. Most examples are observational. Very few numbers are available on fire frequency or intensity changes. Examples organized by geographic proximity. Common name given if available.

Region (habitat)	Invader (common name)	Growth form	Invader = new life-form? *	Effect on fire	Reference
Hawaii (submontane dry forest & woodland)	*Andropogon virginicus* (broom sedge), *Schizachyrium condensatum* (beard grass), *Melinis minutiflora* (molasses grass)	Perennial grasses	Yes	Increase frequency size, intensity	Smith and Tunison 1992; Tunison et al. 1995
(coastal lowlands, shrubland)	*A. virginicus, S. condensatum, M. minutiflora, Hyparrhenia rufa* (thatching grass or jaragua)	Perennial grasses	Not always	Increase frequency and intensity	Smith and Tunison 1992; Tunison et al. 1994
(subalpine woodland)	*Holcus lanatus* (velvet grass), *Anthoxanthum odoratum* (sweet vernal grass)	Perennial grasses	No	Increase fire intensity	Smith and Tunison 1992
Western U.S.A. (Great Basin Desert)	*Bromus tectorum* (cheatgrass)	Annual grass	Yes	Increase frequency	Steward and Hull 1949; Whisenant 1990a
	Taeniatherum caput-medusae (medusahead)	Annual grass	Yes	Increase frequency	Menke 1989; Young 1992
(Mojave Desert)	*Bromus rubens* (red brome), *B. tectorum, Schismus* spp.	Annual grasses	Yes	Increase frequency	Beatley 1966; Brown and Minnich 1986; Brooks 1998

(*continues*)

Table 4.3. Continued

Region (habitat)	Invader (common name)	Growth form	Invader = new life-form? *	Effect on fire	Reference
California					
(riparian)	*Arundo donax* (giant reed)	Perennial grass	Yes	Increase frequency and intensity)	Bell 1997
(coastal chaparral)	*Lolium perenne* (perennial rye)	Perennial grass	Yes	Increase frequency	Zedler 1983
(chaparral)	Various annual grasses, forbs		Yes	Increase frequency	Haidinger and Keeley 1993
NW Mexico					
(Sonoran Desert)	*Pennisetum ciliare* (buffel grass)	Perennial grass	Yes	Increase frequency	Búrquez and Quintana 1994
Florida					
(pine sandhills)	*Imperata cylindrica* (cogongrass)	Perennial grass	No	Increase fire intensity	Lippincott, in press
(prairie)	*Melaleuca quinquinervia* (punk tree)	Tree	Yes	Increase fire intensity	Gordon 1998
Costa Rica					
(dry forest)	*Hyparrhenia rufa* (jaragua/thatching grass)	Perennial grass	Yes	Increase fire frequency	Janzen 1988
Venezuela					
(llanos)	*Hyparrhenia rufa* (thatching grass)	Perennial grass	No	Increase fire intensity	Bilbao 1995

South America (savannas)	*Hyparrhenia rufa, Melinis minutiflora, Panicum maximum* (guinea grass), *Brachiaria* spp. (Para)	Perennial grasses	*No*	Increase fire frequency and intensity	Blydenstein 1967; Medina 1987
Australia (riparian)	*Cenchrus* (=*Pennisetum*) *ciliare* (buffel)	Perennial grass	Yes	Increase fire frequency and area	Latz 1991
(woodland)	*Ehrhardta calycina* (veldt grass)	Perennial grass	Yes	Increase fire frequency	Baird 1977
(mesic forest)	*Melinis minutiflora* (molasses grass), *Pennisetum polystachum* (feathery pennisetum)	Perennial grasses	Yes	Increase fire frequency	Gill et al. 1990
South Africa (mountain fynbos)	*Pinus* spp.	Tree	Yes	Increase fire intensity; decrease fire frequency	van Wilgen and van Hensbergen 1992
(fynbos)	*Acacia saligna, Hakea sericea* (silky wattle)	Shrubs	No	Increase fire intensity; decrease frequency	van Wilgen and Richardson 1985; van Wilgen and van Hensbergen 1992

* Decision based either on investigators' comments or opinion of this author.

part of the recent (pre-invasion) disturbance regime and invaders more or less resemble natives in terms of life form. The former cases come largely from woodland ecosystems including desert and semiarid shrublands and dry or seasonally dry tropical forests.

Characteristics of Invaders That Alter Fire Regime

Can we predict on the basis of species characteristics, which invaders should lead to alterations in fire regime? Models of fire behavior such as BEHAVE, REFIRES (Davis and Burrows 1994), and others rely heavily on fuel characteristics such as live and dead fuel moisture, fuel packing density, biomass and vertical distribution of fine versus medium and coarse fuels, horizontal fuel distribution, and fuel energy content to predict rates of fire spread and intensity. When measured in the field, these parameters are based on community-wide or plotwide values. Yet they are strongly influenced by the species composition within the sample unit and thus by individual species traits. Invaders can have a strong influence on any of these parameters. In addition, fire behavior is also strongly influenced by wind and weather conditions. While these are ultimately controlled by regional climate, wind speed can be strongly affected by plant species composition. For example, when comparing wind speeds over two adjacent pieces of land, a fire-induced exotic grassland and a remnant patch of unburned woodland, Freifelder et al. (1998) found that wind speeds were consistently higher over the grassland regardless of season.

Several authors have attempted to sort out which fuel characteristics or species parameters will have the largest effect on fire spread rates and/or intensity. Using simulation models where one or more fuel parameters was manipulated while the others were held constant, van Wilgen et al. (1990) found that the variability in fuel energy content among vegetation patch types had little influence on fire spread rates. Likewise, van Wilgen and van Hensbergen (1992) found that fuel energy content was not responsible for observed variation in fire intensity in South African fynbos. Lippincott (in press) found that the variability in fuel energy content between native and exotic fuels in a Florida pineland was not large and probably had little to do with differences in fire severity among patch types. By contrast, alteration of characteristics such as fuel distribution, biomass, and structure of the fuel bed had a large effect on fire characteristics.

Van Wilgen and Richardson (1985) used runs of Rothermel's (1972) fire spread simulation model to examine the effect of altered fuel characteristics on fire spread rate and flame length (intensity) in invaded versus uninvaded fynbos shrublands in southern Africa. Their invaded sites were structurally similar to uninvaded sites in that all were shrub dominated. The main differ-

ence between the "native" and "exotic" fuels was a higher density and biomass of fine fuels per unit area of ground surface in invaded sites. For *Hakea*-invaded shrubland, the increased biomass of fine fuels and decreased fuel moisture did not lead to the expected increase in fire severity because they were counteracted by a densely packed fuel bed that presumably reduced oxygen to the fire. The increased fuel biomass of shrublands invaded by *Acacia* species also did not lead to increases in fire severity because of high fuel moisture in live tissue of the invader. Van Wilgen and van Hensbergen (1992) thus predict that the altered fuel bed characteristics will result in less-frequent fires because it will take more extreme weather conditions for fires to spread, but that fire severity will increase because of the altered fuel loads and extreme conditions under which they will burn. Fire intensity in woody vegetation is known to influence native species survival and regeneration (e.g., Moreno and Oechel 1994). Thus changes in fire severity can have important impacts, even when fire frequency is not changed.

Lippincott (in press) empirically examined alterations in fire intensity in Florida pine sandhills invaded by the Asian grass *Imperata cylindrica*, in contrast to pine sandhills patches containing only native grass fuels. She found that the exotic grass fuels were more continuously distributed and resulted in a more continuous fire. In addition, the *Imperata* fuels were more dense vertically, which resulted in higher fire intensity at 0.5 to 0.99 meters above the ground surface. This increased intensity resulted in greater mortality among saplings of the dominant native pine species.

In contrast to the studies described above, investigators examining the spread of fire in ecosystems where the invaders are structurally very different from native species have shown strong effects of changing fuel characteristics on fire frequency or spread rates. Using fuel and microclimate parameters estimated from field sampling, Freifelder et al. (1998) found that the most significant parameter affecting fire spread rates through seasonally dry grass-invaded sites in Hawaii was wind speed. This was much greater over a smooth grass canopy than over the native woodland canopy, and when these differences were entered into Rothermel's (1972) fire spread model, they resulted in enormous differences in fire spread rates. By contrast, variation among fuel types in moisture content or density did not have a large effect on fire characteristics. Thus it is the structural change from a heterogeneous to a smooth canopy that had the most profound effect on fire regime. The smooth grass canopy (see Figure 4.1) was the result of two sequential exotic-grass-fueled fires that eliminated the dominant trees and shrubs of the native woodland (see Hughes et al. 1991) and had a strong effect on plant species richness (D'Antonio and Dudley 1995).

Whisenant (1990a) empirically examined the horizontal frequency of fine

Figure 4.1. The introduced C_4 grasses *Schizachyrium condensatum* (beardgrass) and *Melinis minutiflora* (molasses grass) form a relatively smooth canopy in a site that used to be dominated by native woody species, including several shrub species and the native tree *Metrosideros polymorpha* (ohia). These introduced grasses invade the understory of the woodlands and fuel large and intense fires. Fires in turn alter the system from a diverse native woodland with a heterogeneous canopy to a simple low-diversity system dominated by grasses. Photo taken by author at 850-meter elevation in Hawaii Volcanoes National Park.

fuels in grass-invaded and burned Great Basin desert in western North America where, historically, fires were rare but are now common occurrences. He found that the horizontal frequency of fine fuels increased with grass invasion of sagebrush steppe by *Bromus tectorum* (cheatgrass) and that this relationship between fine-fuel frequency and grass species abundance does not exist for native grasses in this system. Biomass of *B. tectorum* fuels was not as important as frequency since it reached an asymptote as cheatgrass cover increased. He and others (Beatley 1966; Billings 1990) have surmised that the increase in fire frequency in the Great Basin ecosystems is the result of an increase in the horizontal continuity of fine fuels that persist during the summer lightning season compared to uninvaded vegetation. Beatley (1966) described characteristics of invaded desert shrublands in Nevada and found that the exotic grass *Bromus rubens* (red brome), unlike native annuals, can germinate with spring rains and then stalks persist throughout the summer drought when lightning strikes are common. Thus it appears to be a combination of phenology and horizontal distribution of fuels that promotes fire in these ecosystems. Fire in these habitats has severe effects on native species richness (Whisenant 1990a; Billings 1990).

Conclusions

Chapin et al. (1996) suggest that species with ecosystem impacts, including altering the disturbance regime of a site, are those that are qualitatively different from the rest of the species in a community. Mack and D'Antonio (1998) define "qualitatively different" invaders as species with no functional analogues in the invaded system. Functional analogy is further defined as sharing a suite of traits that influence a particular ecosystem function such as disturbance regime. The scant literature on fuel characteristics of native versus non-native species suggests that where invaders are similar in overall life-form to natives (see van Wilgen and Richardson 1985; Bilbao 1995; Lippincott, in press), they tend to alter primarily fuel biomass per unit area of ground. This in turn has the potential to influence fire intensity. By contrast, where invaders have no functional analogues in terms of fuel characteristics in the invaded system, such as in the case of annual or perennial grasses invading desert shrublands (see Whisenant 1990a; Burquez and Quintana 1994; Brooks 1998), they have the potential to alter fire frequency and indeed introduce fire to ecosystems where it had no evolutionary role. In other words, if an invader is simply more of the same (e.g., van Wilgen and Richardson 1985; Bilbao 1995; Lippincott, in press), it may alter fire intensity or slightly modify an existing fire regime. However, if an invader is something very new ("qualitatively different"), then it has the potential to introduce a novel type of disturbance to the ecosystem. But do the former invaders have less severe impacts than the latter? Both are impacts on fire regime, but the latter is a complete alteration rather than a modification. In terms of impacts on native species, invasive alien shrubs in South African fynbos clearly have a devastating effect on native species, although this effect is not solely through fire. However, the potential for restoration of these ecosystems may be higher (see Holmes and Cowling 1997) than in desert shrubland (see Whisenant 1990a), Hawaiian woodlands (see Hughes et al. 1991), or other sites where fire is a novel disturbance and the invaders have set in motion a fire cycle where none previously existed.

In spite of the large number of cases found where invaders promote fire, it is not appropriate to assume that the majority of invaders have the potential to do so. Many people have suggested that less than 20 percent of all invaders have important ecological impacts, and I suspect that less than 5 percent alter fire regime. These invaders should be easy to identify beforehand since many are grasses and/or woody species that come from fire-prone ecosystems, and we are already amassing a large database on them. What is difficult to predict is how fast they will move across the landscape and how abundant they must become before their impacts are felt. These issues are particularly important in light of the numerous ongoing global changes that are discussed in the following section.

Interaction of Fire and Biological Invasions with Other Aspects of Global Change

Land-Use/Land-Cover Change

Land-use/land-cover change is without a doubt the most profound impact that humans have had on the biosphere. In arid and semiarid ecosystems, livestock production has resulted in a reduction in native woody species and the introduction of grazing-tolerant grasses. Parsons (1972) documented the flow of grazing-tolerant, African pasture grasses to the New World. Their further spread there is the result of both land-use change (beef production) and natural spread. The impacts of this flow on the desire to preserve native ecosystems is now being manifested. For example, *Hyparrhenia rufa* (jaragua grass) was introduced to Costa Rica for livestock production and is now widespread throughout the Guanacaste province. In this same region, it is considered the largest single impediment to reforestation of tropical dry forest (Janzen 1988) because of its propensity to fuel large, intense fires. Likewise, in the state of Sonora, Mexico, the African grass *Pennisetum ciliare* has been planted widely for beef production at the expense of native lowland desert and thornscrub vegetation. It is spreading rapidly throughout the region, fueling repeated fires and leading to massive decline in native species over a very large area (Alberto Búrquez, personal communication, and see Figure 4.2). Clearly, the conversion of land for livestock production, combined with the introduction of fire-promoting grasses, will continue to cause spread of the grass-fire cycle in many regions of the world.

Forest fragmentation after logging or type conversion for livestock grazing is impacting enormous areas of tropical forest each year. In Australia, livestock grazing and fire in dry-open tropical forests has promoted invasion of wet-forest fragments that abut more open vegetation types by unwanted exotic woody species such as *Lantana camara* (Gentle and Duggin 1997; Duggin and Gentle 1998). While *Lantana* itself does not promote further fire, it does interfere with native species recruitment. Thus, the process of forest fragmentation in a fire-prone ecosystem with fire-responsive exotics will lead to the degradation of forest fragments.

Changes in land cover in many regions of the world have resulted directly from the construction of dams and the impoundment of rivers. In the western United States, the large-scale control of the Colorado River by successive impoundment has led to invasion of thousands of hectares of floodplain forest by the Eurasian saltcedar, *Tamarix ramosissima*. Fire, once a rare phenomenon in riparian areas in this region, is now quite common (Busch 1995). Busch believes this is the result of the buildup of woody fuels throughout these forests due to physiological stress caused by altered water table conditions for riparian trees. *Tamarix* itself does not promote the spread of fire

Figure 4.2. Top: Buffel grass (*Cenchrus ciliaris*), introduced to Mexico from Africa, has been widely planted for use as cattle forage. Today thousands of hectares of diverse Sonora plains and thornscrub vegetation have been replaced by this African grass. This photo shows a site purposefully converted to buffel pasture at 300-meter elevation in Sonora, Mexico. *Bottom:* Buffel grass invades away from planted areas into native vegetation. Here it can be seen growing in a desert riparian woodland near Hermosillo, Sonora, Mexico. Eventually, it carries fire into these unique and diverse sites that historically have not experienced fire. Photographs by author.

since its litter is largely nonflammable, but it responds positively to fire (Busch 1995). In turn, it can reduce water availability to native species, adding to the physiological stress they are already experiencing from human land-use activities (see Zavaleta, this volume).

Land-use change frequently brings with it the construction of roads that can serve as conduits for the spread of unwanted exotic organisms. Lonsdale and Lane (1994) found that tourist vehicles were vectors of weed seeds in a remote Australian national park. Others (e.g., Forcella and Harvey 1983; Milberg and Lamont 1995; D'Antonio et al. 1999) have demonstrated that roadsides are replete with nonnative species that then invade away from these corridors into adjacent native vegetation. Because fires also frequently begin along roadsides, fire-promoted exotics should be expected to spread from roadsides into adjacent habitat, and road construction should accelerate this phenomenon.

Other Global Changes

The impact of climate change on fire frequency will depend both on its impact on possible ignition sources as well as on the likelihood that an ignition will result in a fire. Very few investigators have attempted to evaluate how the anticipated global climate change over the next 1 to 200 years will affect possible ignitions and the actual frequency of fire. Fosberg et al. (1993) review some of the difficulties with making these sorts of predictions. Nonetheless, palynological evidence clearly shows that fire frequencies are higher under warmer, drier conditions (e.g., Clark 1988, 1990; Johnson and Larson 1991). Recently, there have been several attempts to evaluate how a doubled-CO_2 climate might affect fire spread rates, assuming that ignition has already occurred. For example, Torn and Fried (1992) found increases in area burned and frequency of escaped fires using four different versions of available general circulation models (GCMs) when comparing current to projected climate for northern California. They found that the magnitude of the increase in fire spread was dependent on the choice of GCM and fuel type. Further, they found that projected changes in wind speed were much more important than changes in temperature in driving fire spread. Changes in wind speed can occur both by external climate forcing and by changes in the vegetation canopy within a site. The latter may be a direct result of biological invasion.

The spread of introduced, fire-promoting exotic species such as grasses in North American deserts or tropical woodlands, regardless of changes in ignition frequency, should increase the ratio of possible ignitions to actual fires because of changes in fuel and canopy characteristics. Climate change alone or in combination with elevated atmospheric CO_2, may change the competitive relationship between native and exotic plant species in a way that favors

exotics. Alternatively, severe droughts associated with climate change may increase the fuel potential of vegetation by reducing fuel moisture or decomposition time, by promoting pathogen outbreaks that kill woody vegetation (e.g., Riggan et al. 1994) or increasing the amount of xerophytic habitat surrounding wetlands (Hogenbirk and Wein 1991). The latter authors experimentally simulated drought and fire in a seasonally flooded wetland ecosystem in Alberta, Canada, and found that both drought and fire enhanced invasion by Eurasian forbs (mainly thistles) in this system. On this basis, they predict that climate change will shift these systems from ones in which flooding controls species dynamics to ones in which drought and fire are important controlling forces. Thus even if climate change does not alter possible ignition frequencies within a region, it might alter real fire frequency solely by favoring growth of fire-promoting exotics or by causing fuel accumulation. Indeed, the frequency of drought is expected to increase, as is interannual variability in precipitation over North America under projected climate change (Rind et al. 1989, 1990). This should lead to an increase in conditions that favor fire.

Will an increase in the frequency of exotic-species-fueled fires contribute to increased trace gases in the atmosphere? Current knowledge suggests that this will not be the case. D'Antonio and Vitousek (1992) estimated that exotic-grass-fueled fires were responsible for less than 1.5 percent of the total increase in stable gases released from biomass burning on a global scale (see Crutzen and Andreae 1990). Even if exotic-grass-fueled fires double in occurrence, we do not anticipate their contribution to atmospheric trace gases to be large.

Several authors have shown that addition of nitrogen to ecosystems can result in the promotion of exotic species at the expense of natives (e.g., Huenneke et al. 1990; Maron and Connors 1996). Recently, Brooks (1998) and Brooks and Allen (personal communication) have suggested that atmospheric nitrogen deposition in parts of semiarid and arid southern California is responsible for a large increase in the abundance of introduced annual grasses. These grasses, in turn, have carried fire into shrubland sites in Riverside County, California, where it occurred at a much lower frequency, or into the Mojave Desert where fire was previously largely absent. The experimental evidence of Brooks (1998) and others (e.g., Hobbs et al. 1988; Huenneke et al. 1990) that added nitrogen can greatly increase the abundance of exotic grasses is largely on infertile soils. Thus, we can expect that atmospheric nitrogen deposition will strongly interact with the spread of fire-promoting exotic species in these sorts of situations and that low-fertility ecosystems are significantly at risk. Hobbs and Atkins (1988) showed that nutrient addition increased the abundance of exotic species, particularly an exotic annual grass, when combined with soil disturbance in a woodland in

Australia. The interaction of nitrogen deposition with land-use disturbance as it relates to subsequent invasion and the potential for fire should be further explored.

Conclusions

Most studies show that fire increases invasion by introduced species. Even in several studies where fire was specifically used to control an invasive exotic species, other nontarget exotics increased after fire or exotics were not effectively reduced by fire. Thus fire should be used with great caution as a management tool, and almost all fires should be viewed as creating a window of opportunity for exotics to invade an ecosystem.

Naturally fire-prone ecosystems, such as the fynbos of South Africa or coastal chaparral in California, can be heavily invaded by exotic species. Thus the occurrence of a "natural fire regime" will not guard against invasion if fire-responsive exotic propagules are available or if that natural fire regime is severely altered.

Examples are now extremely common of where invaders create conditions that favor the spread of fire. This occurs when invaders are different in their life-form or phenology from natives and thus increase both the continuity and biomass of fine fuels in a community where fire is a relatively novel event. The most common such invaders are grasses invading desert shrubland or dry forest ecosystems. These are formidable invaders that are difficult to control and are spreading rapidly throughout the world.

In ecosystems where fire has been a common part of the historic disturbance regime, invaders often change fuel biomass or vertical distribution, and by so doing tend to increase fire intensity. In these cases, invaders have the potential to have a negative impact on native species but do not convert the community entirely to exotics. Their impacts via changes in fire regime at this point are not as severe as those cases where invaders introduce fire into systems where it was previously uncommon.

The effect of climate change on the invader-fire interaction will depend on how climate affects the frequency of weather conditions that will either ignite vegetation or favor the spread of fire from an ignition source. Currently, there has been very little research on how climate change will affect fire frequency, and this will depend on the particular geographic region in question and the pool of potential invaders. From a modeling perspective, the particular GCM used will also affect the projected impact on fire independent of fuel type or species responses. Because of the enormous impact that grass-fueled fires can have on native biological diversity and ecosystem function, more research is needed into how fire regimes might change with climate change.

Exotic-grass-fueled fires will likely not affect the changing composition of

the atmosphere. Biomass burning does contribute significantly to the global rise in greenhouse gases, but exotic-grass-fueled fires are only a tiny fraction of this increase.

Atmospheric nitrogen deposition is expected to contribute to the spread of fast-growing exotic grasses that may introduce fire into areas where it was previously absent or increase the intensity of fire in places where it already existed. More data is needed to elucidate this potentially important interaction.

Acknowledgments

I thank Hal Mooney for encouraging me to delve into this literature, Dave Richardson for suggesting some relevant literature with which I was not familiar, and both Hal Mooney and Richard Hobbs for providing editorial comments. Salary support during manuscript preparation was provided by a fellowship from the Miller Institute for Basic Research in the Sciences, University of California, Berkeley.

References

Anable, M.E., et al. 1992. "Spread of Introduced Lehmann Lovegrass *Eragrostis lehmanniana* Nees. in Southern Arizona, USA." *Biological Conservation* 61:181–188.

Baird, A.M. 1977. "Regeneration After Fire in King's Park, Western Australia." *Journal of the Royal Society of Western Australia* 60:1–22.

Beatley, J.C. 1966. "Ecological Status of Introduced Brome Grasses (*Bromus* spp.) in Desert Vegetation of Southern Nevada." *Ecology* 47:548–554.

Bell, G.P. 1997. "Ecology and Management of *Arundo donax*, and Approaches to Riparian Habitat Restoration in Southern California." In *Plant Invasions: Studies from North America and Europe*, edited by J.H. Brock, 103–113. Leiden, The Netherlands.

Bilbao, B. 1995. *Impacto del regimen de quemas en las características edáficas, producción de materia orgánica y biodiversidad de sabanas tropicales en Calabozo, Venezuela.* Ph.D. Dissertation, Insituto Venezolano de Investigaciones Científicas (IVIC), 215 pp.

Billings, D.W. 1990. "*Bromus tectorum*, a Biotic Cause of Ecosystem Impoverishment in the Great Basin." In *The Earth in Transition: Patterns and Processes of Biotic Impoverishment*, edited by G.M. Woodell, 301–322. Cambridge University Press, Cambridge.

Blydenstein, J. 1967. "Tropical Savanna Vegetation of the Llanos of Colombia." *Ecology* 48:1–15.

Bossard, C.C. 1991. "The Role of Habitat Disturbance, Seed Predation and Ant Dispersal on the Establishment of the Exotic Shrub *Cytisus scoparius* (Scotch Broom) in California." *Madrono* 40:47–61.

Bridgewater, P.B., and D.J. Backshall. 1981. "Dynamics of Some Western Australian Ligneous Formations with Special Reference to the Invasion of Exotic Species." *Vegetatio* 46:141–148.

Brooks, M.L. 1998. *Ecology of a Biological Invasion: Alien Annual Plants in the Mojave Desert.* Ph.D. Dissertation, University of California, Riverside, 186 pp.

Brown, D.E., and R.A. Minnich, 1986. "Fire and Changes in Creosote Bush Scrub of the Western Sonoran Desert, California." *American Midland Naturalist* 116:411–422.

Bruce, K.A., et al. 1995. "Initiation of a New Woodland Type on the Texas Coastal Prairie by the Chinese Tallow Tree (*Sapium sebiferum* [L.] Roxb.)." *Bulletin of the Torrey Botanical Club* 122:215–225.

Búrquez, A., and M. Quintana. 1994. "Islands of Diversity: Ironwood Ecology and the Richness of Perennials in a Sonoran Desert Biological Reserve." *Occasional Papers in Conservation Biology* 1:22–27.

Busch, D.E. 1995. "Effects of Fire on Southwestern Riparian Plant Community Structure." *Southwestern Naturalist* 40:259–267.

Cable, D.R. 1971. "Lehmann Lovegrass on the Santa Rita Experimental Range, 1937–1968." *Journal of Range Management* 24:17–21.

Chapin, F.S., III, et al. 1996. "The Functional Role of Species in Terrestrial Ecosystems." In *Global Change in Terrestrial Ecosystems,* edited by B. Walker and W. Steffan, 403–430. Cambridge University Press, Cambridge.

Clark, J.S. 1988. "Effect of Climate Change on Fire Regimes in Northwestern Minnesota." *Nature* 334:233–235.

———. 1990. "Fire and Climate Change During the Last 750 Years in Northwestern Minnesota. " *Ecological Monographs* 60:135–159.

Cowie, I.D., and P.A. Werner. 1993. "Alien Plant Species Invasive in Kakadu National Park, Tropical Northern Australia." *Biological Conservation* 63:127–135.

Crutzen, P.J., and M.O. Andreae. 1990. "Biomass Burning in the Tropics: Impact on Atmospheric Chemistry and Biogeochemical Cycles." *Science* 250:1669–78.

D'Antonio, C.M., and T.L. Dudley. 1995. "Biological Invasions as Agents of Change on Islands Versus Mainlands." In *Islands: Biological Diversity and Ecosystem Function,* edited by P.M. Vitousek, L. Loope, and H. Adsersen, 103–121. Springer-Verlag, Berlin.

D'Antonio, C.M., et al. 1993. "Invasion of Maritime Chaparral by the Introduced Succulent *Carpobrotus edulis*: the Roles of Fire and Herbivory." *Oecologia* 95:14–21.

D'Antonio, C.M., and P.M. Vitousek. 1992. "Biological Invasions by Exotic Grasses, the Grass/Fire Cycle, and Global Change." *Annual Review of Ecology and Systematics* 23:63–87.

D'Antonio, C.M., et al. 1999. "Disturbance and Biological Invasions: Direct Effects and Feedbacks." In *Ecosystems of Disturbed Ground,* edited by L.R. Walker. Elsevier, in press.

Davis, F.W., and D.A. Burrows. 1994. "Spatial Stimulation of Fire Regime in Mediterranean-Climate Landscapes." In *The Role of Fire in Mediterranean-type Ecosystems,* edited by J.M. Moreno and W.C. Oechel, 117–139. Springer-Verlag, Berlin.

Doren, R.F., and L.D. Whiteaker. 1990. "Effects of Fire on Different Size Individuals of *Schinus terebinthifolius.*" *Natural Areas Journal* 10:107–113.

Doren, R.F., et al. 1991. "Evaluation of Fire as a Management Tool for Controlling *Schinus terebinthifolius* as Secondary Successional Growth on Abandoned Agricultural Ground." *Environmental Management* 15:121–130.

Duggin, J.A., and C.B. Gentle. 1998. "Experimental Evidence on the Importance of Disturbance Intensity for Invasion of *Lantana camara* L. in Dry Rainforest–Open Forest Ecotones in Northeastern NSW, Australia." *Forest Ecology and Management* 110:279–292.

Forcella, F. and S.J. Harvey. 1983. "Eurasian Weed Infestation in Western Montana in Relation to Vegetation and Disturbance." *Madrono* 30:102–109.

Fosberg, M.A., et al. 1993. "Climate Change–Fire Interactions at the Global Scale: Predictions and Limitations of Methods." In *Fire in the Environment: the Ecological, Atmospheric and Climatic Importance of Vegetation Fires*, edited by P. Crutzen and J.G. Goldammer, 123–137. Wiley & Sons, New York.

Freifelder, R., et al. 1998. "Microclimate Effects of Fire-Induced Forest/Grassland Conversion in Seasonally Dry Hawaiian Woodlands." *Biotropica* 30:286–297.

Gentle, C.B., and J.A. Duggin. 1997. "*Lantana camara* L. Invasions in Dry Rainforest–Open Forest Ecotones: The Role of Disturbances Associated with Fire and Cattle Grazing." *Australian Journal of Ecology* 22:298–306.

Gill, A.M., et al. 1981. *Fire and the Australian Biota.* Australian Academy of Science, Canberra, 582 pp.

———. 1990. "Fires and Their Effects in the Wet-Dry Tropics of Australia." In *Fire in the Tropical Biota: Ecosystem Processes and Global Challenges*, edited by J.G. Goldammer, 159–178. Springer-Verlag, Heidelberg.

Gordon, D.R. 1998. "Effects of Invasive, Non-indigenous Plant Species on Ecosystem Processes: Lessons from Florida." *Ecological Monographs* 8:975–989.

Grice, A.C. 1997. "Post-fire Regrowth and Survival of the Invasive Tropical Shrubs *Cryptostegia grandiflora* and *Ziziphus mauritiana*." *Australian Journal of Ecology* 22:49–55.

Haidinger, T.L., and J.E. Keeley. 1993. "Role of High Fire Frequency in Destruction of Mixed Chaparral." *Madrono* 40:141–147.

Hastings, M.S., and J.M. DiTomaso. 1996. "Fire Controls Yellow Star Thistle in California Grasslands." *Restoration and Management Notes* 14:124–128.

Hester, A.J., and R.J. Hobbs. 1992. "Influence of Fire and Soil Nutrients on Native and Nonnative Annuals at Remnant Vegetation Edges in the Western Australian Wheatbelt." *Journal of Vegetation Science* 3:101–108.

Hickson, D.E. 1988. *History of wildland fires on Vandenberg Air Force Base, California.* National Aeronautics and Space Administration, Kennedy Space Center, Florida, Technical Memo 100983, 65 pp.

Hobbs, R.J., and L. Atkins. 1988. "Effects of Disturbance and Nutrient Addition on Native and Introduced Annuals in Plant Communities in the Western Australian Wheatbelt." *Australian Journal of Ecology* 13:171–179.

———. 1990. "Fire-related Dynamics of a *Banksia* Woodland in Southwestern Western Australia." *Australian Journal of Botany* 38:97–110.

———. 1991. "Interactions Between Annuals and Woody Perennials in a Western Australian Nature Reserve." *Journal of Vegetation Science* 2:643–654.

Hobbs, R.J., et al. 1988. "Effects of Fertilizer Addition and Subsequent Gopher Disturbance on a Serpentine Annual Grassland Community." *Oecologia* 75:291–295.

Hogenbirk, J.C., and R.W. Wein. 1991. "Fire and Drought Experiments in Northern Wetlands: A Climate Change Analogue." *Canadian Journal of Botany* 69:1991–97.

Holmes, P.M., I.A. MacDonald, and J. Juritz. 1987. "Effects of Clearing Treatment on Seed Banks of the Alien Invasive Shrubs *Acacia saligna* and *A. cyclops* in the Southern and Southwestern Cape, South Africa." *Journal Applied Ecology* 24:1045–51.

Holmes, P.M., and R.M. Cowling. 1997. "The Effects of Invasion by *Acacia saligna* on the Guild Structure and Regeneration Capabilities of South African Fynbos Shrublands." *Journal of Applied Ecology* 34:317–332.

Howe, H. 1995. "Succession and Fire Season in Experimental Prairie Plantings." *Ecology* 76:1917–25.

Huenneke, L.F., et al. 1990. "Effects of Soil Resources on Plant Invasions and Community Structure in Californian Serpentine Grassland." *Ecology* 71:478–491.

Hughes, F., et al. 1991. "Alien Grass Invasion and Fire in the Seasonal Submontane Zone of Hawaii." *Ecology* 72:743–746.

Hunter, R. 1991. "*Bromus* Invasions of the Nevada Test Site: Present Status of *B. rubens* and *B. tectorum* with Notes on Their Relationship to Disturbance and Altitude." *Great Basin Naturalist* 51:176–182.

Janzen, D. 1988. "Management of Habitat Fragments in a Tropical Dry Forest." *Annals of Missouri Botanical Garden* 75:105–16.

Johnson, E.A., and C.P.S. Larson. 1991. "Climatically Induced Change in Fire Frequency in the Southern Canadian Rockies." *Ecology* 72:194–201.

Johnson, R.W., and R.W. Purdie. 1981. "The Role of Fire in the Establishment and Management of Agricultural Systems." In *Fire and the Australian Biota*, edited by A.M. Gill, R.H. Groves, and I.R. Noble, 497–528. Australian Academy of Science, Canberra.

Klemmedson, J.O., and J.G. Smith. 1955. "Cheatgrass (*Bromus tectorum* L.)." *Botanical Review* 30:227–262.

Latz, P.K. 1991. "Buffel and Couch Grass in Central Australian Creeks and Rivers." *Newsletter of the Central Australian Conservancy Council*, April: 5.

Le Maitre, D.C., et al. 1996. "Invasive Plants and Water Resources in the Western Cape Province, South Africa: Modeling the Consequences of a Lack of Management." *Journal of Applied Ecology* 33:161–172.

Lippincott, C.L. "Effects of *Imperata cylindrica* (cogongrass) Invasion on Fire Regime in Florida Sandhill." *Natural Areas Journal*, in press.

Lonsdale, W.M., and A.M. Lane. 1994. "Tourist Vehicles as Vectors of Weed Seeds in Kakadu National Park, Northern Australia." *Biological Conservation* 69:277–283.

Lonsdale, W.M., and I.L. Miller. 1993. "Fire as a Management Tool for a Tropical Woody Weed: *Mimosa pigra* in North Australia." *Journal of Environmental Management* 33:77–87.

Lunt, I.D. 1990. "Impact of an Autumn Fire on a Long-grazed *Themeda triandra* (kangaroo grass) Grassland: Implications for Management of Invaded, Remnant Vegetation." *Victorian Naturalist* 107:45–51.

MacDonald, I.A.W., and G.W. Frame. 1988. "The Invasion of Introduced Species into

Nature Reserves in Tropical Savannas and Dry Woodlands." *Biological Conservation* 44:67–93

Mack, M.C., and C.M. D'Antonio. 1998. "Impacts of Biological Invasions on Disturbance Regimes." *Trends in Ecology and Evolution* 13:195–198.

Maron, J.L., and P.G. Connors. 1996. "A Native Nitrogen-Fixing Shrub Facilitates Weed Invasion." *Oecologia* 105:302–312.

Medina, E. 1987. "Nutrient Requirements, Conservation and Cycles of Nutrients in the Herbaceous Layer." In *Determinants of Tropical Savannas,* edited by B.H. Walker, 39–65. IUBS Monograph, Paris.

Menke, J.W. 1989. "Management Controls on Productivity." In *Grassland Structure and Function: California Annual Grassland,* edited by L.F. Huenneke and H.A. Mooney, 173–199. Kluwer, Dordrecht.

Meyer, M.D., and P.M. Schiffman. "Fire Season and Mulch Removal in a California Grassland: A Comparison of Restoration Strategies." *Madrono,* in press.

Milberg, P., and B.B. Lamont. 1995. "Fire Enhances Weed Invasion of Roadside Vegetation in Southwestern Australia." *Biological Conservation* 73:45–49.

Moreno, J.M., and W.C. Oechel. 1994. "Fire Intensity as a Determinant Factor of Postfire Plant Recovery in Southern California Chaparral." In *The Role of Fire in Mediterranean-type Ecosystems,* edited by J.M. Moreno and W.C. Oechel, 26–45. Springer-Verlag, Berlin.

Nuzzo, V.A. 1991. "Experimental Control of Garlic Mustard (*Alliaria petiolata* [Bieb.] Cavara & Grande) in Northern Illinois Using Fire, Herbicide, and Cutting." *Natural Areas Journal* 11:158–167.

Parsons, J.J. 1972. "Spread of African Pasture Grasses to the American Tropics." *Journal of Range Management* 25:12–17.

Parsons, D.A., and T.J. Stohlgren. 1989. "Effects of Varying Fire Regimes on Annual Grasslands in the Southern Sierra Nevada of California." *Madrono* 36:154–168.

Putz, F.E. 1998. "Halt the Homogeocene." *The Palmetto* 18:7–9.

Richardson, D.M. 1988. "Age Structure and Regeneration After Fire in a Self-sown *Pinus halepensis* Forest on the Cape Peninsula, South Africa." *South African Journal of Botany* 54:140–144.

Richardson, D.M., and P.J. Brown. 1986. "Invasion of Mesic Mountain Fynbos by *Pinus radiata." South African Journal of Botany* 52:529–536.

Richardson, D.M., et al. 1990. "Assessing the Risk of Invasive Success in *Pinus* and *Banksia* in South African Mountain Fynbos." *Journal of Vegetation Science* 1:629–642.

———. 1996. "Current and Future Threats to Plant Biodiversity on the Cape Peninsula, South Africa." *Biodiversity and Conservation* 5:609–648.

Richardson, J.R., and T.T. Harris. 1995. "Vegetation Mapping and Change in the Lake Okeechobee Marsh Ecosystem." *Ergebnisse der Limnologie* 45:17–39.

Riggan, P.J., et al. 1994. "Perspectives on Fire Management in Mediterranean Ecosystems of Southern California." In *The Role of Fire in Mediterranean-type Ecosystems,* edited by J.M. Moreno and W.C. Oechel, 140–162. Springer-Verlag, Berlin.

Rind, D., et al. 1989. "Changes in Climate Variability in the 21st Century." *Climatic Change* 14:5–37.

————. 1990. "Potential Evapotranspiration and the Likelihood of Future Drought." *Journal Geophysical Research* 95:9983–10004.

Rose, S., and P.G. Fairweather. 1997. "Changes in Floristic Composition of Urban Bushland Invaded by *Pittosporum undulatum* in Northern Sydney, Australia." *Australian Journal of Botany* 45:123–149.

Rothermel, R.C. 1972. *A Mathematical Model for Predicting Fire Spread in Wildland Fires.* U.S.D.A. Forest Service Tech. Paper INT-115. Intermountain Research Station, Logan, Utah. 40 pp.

Russell, M.J., and B.R. Roberts. 1996. "Effects of Four Low-intensity Burns Over 14 Years on the Floristics of a Blackbutt (*Eucalyptus pilularis*) Forest in Southern Queensland." *Australian Journal of Botany* 44:315–329.

Ruyle, G.B., et al. 1988. "Effects of Burning on Germinability of Lehmann Lovegrass." Journal *of Range Management* 41:404–406.

Smith, C.W. 1985. "Impact of Alien Plants on Hawaii's Native Biota." In *Hawaii's Terrestrial Ecosystems: Preservation and Management,* edited by C.P. Stone and J.M. Scott, 180–250. Cooperative National Park Resources Study Unit, University of Hawaii, Honolulu.

Smith, C.W., and J.T. Tunison. 1992. "Fire and Alien Plants in Hawaii: Research and Management Implications for Native Ecosystems." In *Alien Plant Invasions in Native Ecosystems of Hawaii: Management and Research,* edited by C.P. Stone, T. Tunison and D.A. Stone, 394–408. University of Hawaii Press, Honolulu.

Sparks, S.R., et al. 1990. "Changes in Vegetation and Land Use at Two Townships in Skull Valley, Western Utah." United States Department of Agriculture, Forest Service, Intermountain Research Station, General Technical Report INT-276.

Stewart, G., and A.C. Hull. 1949. "Cheatgrass (*Bromus tectorum*): An Ecological Intruder in Southern Idaho." *Ecology* 30:58–74.

Svejcar, T., and R. Tausch. 1991. "Anaho Island, Nevada: A Relict Area Dominated by Annual Invader Species." *Rangelands* 13:233–236.

Torn, M.S., and J.S. Fried. 1992. "Predicting the Impacts of Global Warming on Wildland Fire." *Climatic Change* 21:257–274.

Trabaud, L. 1990. "Fire as an Agent of Plant Invasion? A Case Study in the French Mediterranean Vegetation." In *Biological Invasions in Europe and the Mediterranean Basin,* edited by F. di Castri, A.J. Hansen, and M. Debussche, 417–437. Kluwer Academic Publishers, Dordrecht.

Tunison, J.T., et al. 1994. *Fire Effects in the Coastal Lowlands Hawaii Volcanoes National Park.* Cooperative National Park Resources Study Unit Technical Report 96, Cooperative Agreement CA 8007-2-9003. U.H. Manoa.

————. 1995. *Fire Effects in the Submontane Seasonal Zone Hawaii Volcanoes National Park.* Cooperative National Park Resources Study Unit Technical Report 97, Cooperative Agreement CA 8007-2-9004. U.H. Manoa.

van Wilgen, B.W., and D.M. Richardson. 1985. "The Effects of Alien Shrub Invasions on Vegetation Structure and Fire Behaviour in South African Fynbos Shrublands: A Simulation Study." *Journal of Applied Ecology* 22:955–966.

van Wilgen, B.W., and H.J. van Hensbergen. 1992. "Fuel Properties of Vegetation in Swartboskloof." In *Fire in South African Mountain Fynbos,* edited by B.W. Van-

Wilgen, D.M. Richardson, F.J. Kruger, and H.J. van Hensbergen, 37–53. Ecological Studies 93. Springer-Verlag, Berlin.

van Wilgen, B.W., et al. 1990. "The Role of Vegetation Structure and Fuel Chemistry in Excluding Fire from Forest Patches in the Fire-prone Fynbos Shrublands of South Africa." *Journal of Ecology* 78:210–222.

Vitousek, P.M., and L.R. Walker. 1989. "Biological Invasion by *Myrica faya* in Hawaii: Plant Demography, Nitrogen Fixation and Ecosystem Effects." *Ecological Monographs* 59:247–265.

Wade, D., et al. 1980. *Fire in South Florida Ecosystems.* U.S.D.A. Forest Service Gen. Tech. Rep. SE-17, Asheville, North Carolina.

Wein, R.W., et al. 1992. "Northward Invading Non-native Vascular Plant Species in and Adjacent to Wood Buffalo National Park." *Canadian Field-Naturalist* 106:216–224.

Whisenant, S.G. 1990a. "Changing Fire Frequencies on Idaho's Snake River Plain: Ecological and Management Implications." United States Department of Agriculture, Forest Service, Intermountain Research Station, General Technical Report INT-276.

————. 1990b. "Postfire Population Dynamics of *Bromus japonicus.*" *American Midland Naturalist* 123:301–308.

Whisenant, S.G., and D.W. Uresk. 1990. "Spring Burning Japanese Brome in a Western Wheatgrass Community." *Journal of Range Management* 43:205–208.

Willson, G.D., and J. Stubbendieck. 1997. "Fire Effects on Four Growth Stages of Smooth Brome (*Bromus inermis* Leyss.)." *Natural Areas Journal* 17:306–312.

Young, J.A. 1992. "Ecology and Management of Medusahead (*Taeniatherum caput-medusa* ssp. *asperum* [Simk.] Melderis)." *Great Basin Naturalist* 52:245–252.

Young, J.A., and R.A. Evans. 1971. "Invasion of Medusahead into the Great Basin." *Weed Science* 18:89–97.

Zedler, P.H. 1983. "Vegetation Change in Response to Extreme Events: The Effect of a Short Interval Between Fires in California Chaparral and Coastal Scrub." *Ecology* 64:809–818.

Zedler, P.H. and G.A. Scheid. 1988. "Invasion of *Carpobrotus edulis* and *Salix lasiolepis* After Fire in a Coastal Chaparral Site in Santa Barbara County, California." *Madrono* 35:196–201.

Chapter 5

❧

Will the Increasing Atmospheric CO$_2$ Concentration Affect the Success of Invasive Species?

Jeffrey S. Dukes

Over the last two centuries, accelerating rates of fossil fuel use and forest clearing by humans have led to increasing concentratons of carbon dioxide (CO$_2$) in the atmosphere (Houghton et al. 1996). From a pre-industrial-era concentration of 280 parts per million (ppm), atmospheric CO$_2$ rose to 364 ppm in 1997 (an increase of 30 percent), and is likely to reach 560 ppm, double the preindustrial concentration, within the next century. Because the atmosphere is well mixed, this increase is fairly uniform over the entire surface of the planet. Plants, which need CO$_2$ to carry out photosynthesis, are directly affected. Animals, which are not directly dependent on CO$_2$, are primarily affected by changes in the plants that they use for food or shelter.

This chapter explores how plant and animal responses to elevated atmospheric CO$_2$ could affect the prevalence of invasive species. As CO$_2$ continues to rise, will alien species that are currently benign become invasive? Will ecosystem properties change, permitting new invasions? Will problems that are currently caused by invaders become worse, or disappear? To address any

of these questions, we must understand not only how different species and ecosystems respond to rising CO_2, but how these responses interact to favor one species over another—all in all, a complicated task.

Our understanding of the CO_2 responses of natural systems has grown quickly over the last two decades, as a number of (generally small-statured) ecosystems have been studied in depth. However, many important ecosystems remain to be studied. In these unstudied systems, we still cannot confidently predict which species will benefit from the rise in CO_2. Furthermore, few of the ecosystem-level experiments to date have focused attention on nonnative species. Thus, the predictions about alien species in this chapter are necessarily speculative, but they are based on a broad and rapidly expanding foundation of knowledge about the effects of elevated CO_2 on individual species and on ecosystems.

Because plant responses to rising CO_2 mediate the responses of ecosystems and animals, they are covered first in this chapter. Ecosystem-level responses are covered next. Some of these responses may alter the susceptibility of communities to invasion. Responses of animal species are covered last.

Responses of Plants to Increasing CO_2

The rise in CO_2 availability directly impacts photosynthetic processes, evoking a wide range of physiological and morphological responses in plants. These vary among species, depending on differences in photosynthetic pathways, intrinsic growth rates, and other properties. Common responses include changes in growth rates (Poorter 1993; Poorter et al. 1996), allocation patterns (Bazzaz 1990), water-use efficiency (Eamus 1991), and nutrient uptake rates (BassiriRad et al. 1996; Jackson and Reynolds 1996).

Without directly studying a plant species and the community in which it lives, it remains difficult to predict whether that species will benefit from elevated CO_2. We can, based on certain traits, usually predict whether an individually grown plant will increase its growth in response to CO_2 enrichment. Under these circumstances, most species that use the C_3 photosynthetic pathway respond favorably to increased atmospheric CO_2. Species that use the C_4 and CAM pathways are less predictable; many respond positively, but in general the response is less vigorous than that of C_3 plants (Poorter 1993; Poorter et al. 1996). C_3, C_4, and CAM designate different biochemical pathways for carbon fixation. C_3 and C_4 indicate the number of carbons in the initial CO_2 receptor during photosynthesis, and CAM refers to crassulacean acid metabolism, which is characteristic of certain succulent plants. Two categories of C_3 species tend to respond most strongly to elevated CO_2: fast-growing species and those that form symbioses with nitrogen-fixing microbes (Poorter 1993;

Poorter et al. 1996). Although fast-growing species are responsive when they are grown individually in resource-rich conditions, few studies of plant communities have investigated whether these species are equally responsive in competitive conditions. Nitrogen-fixers generally respond strongly to elevated CO_2 when grown individually, and often respond in communities, as well (Newton et al. 1994; Stewart and Potvin 1996; Hebeisen et al. 1997; Vasseur and Potvin 1998).

In competition-free environments, invasive species tend to respond strongly to elevated CO_2 (Table 5.1). However, these responses are statistically

Table 5.1. Stimulation of growth of invasive plant species by elevated CO_2. Data from Poorter 1993 and Poorter et al. 1996. A species was determined to be invasive if it appeared in the global natural area invaders data set compiled by Daehler 1998, was listed as not indigenous to, but common in North America by Whitson et al. 1996, or was one of the five most invasive pines listed by Rejmánek and Richardson 1996. Weight ratios are the dry weight of plants grown in elevated CO_2 divided by the dry weight of plants grown in the treatment closest to ambient CO_2.

Invasive species	Weight ratio	CO_2 References
HERBACEOUS C_3 SPECIES		
Abutilon theophrasti	1.43	Carlson and Bazzaz 1980, Patterson and Flint 1980, Patterson et al. 1988, Bazzaz et al. 1989, Dippery et al. 1995
Arrhenatherum elatius	1.50	Hunt et al. 1991, 1993, Poorter et al. 1996
Avena barbata	1.21	Poorter et al. 1996
Bromus hordaceus	3.60	Poorter 1993
Bromus inermis	1.03	Poorter et al. 1996
Bromus rigidus	1.49	Poorter et al. 1996
Bromus tectorum	1.72	Smith et al. 1987, Poorter 1993
Centaurea solstitialis	1.51	Poorter et al. 1996
Chenopodium album	1.26	Carlson and Bazzaz 1982, Hunt et al. 1991
Dactylis glomerata	1.39	Hunt et al. 1993
Datura stramonium	1.72	Carlson and Bazzaz 1980, Carlson and Bazzaz 1982
Digitalis purpurea	1.16	Hunt et al. 1991
Elytrigia repens	1.67	Tremmel and Patterson 1993
Holcus lanatus	1.68	Hunt et al. 1991, Campbell et al. 1993
Lolium multiflorum	1.61	Campbell et al. 1993
Phalaris aquatica	1.67	Morison and Gifford 1984, Campbell et al. 1993
Phleum pratense	2.09	Campbell et al. 1993

(continues)

Table 5.1. Continued

Invasive species	Weight ratio	CO_2 References
Plantago lanceolata	1.28	Fajer et al. 1991, Hunt et al. 1991, Campbell et al. 1993
Plantago major	1.48	Poorter et al. 1988, Den Hertog et al. 1993, Poorter 1993
Rumex acetosella	1.31	Hunt et al. 1991
Taraxacum officinale	2.30	Poorter 1993
Trifolium subterraneum	1.24	Campbell et al. 1993
WOODY C_3 SPECIES		
Acacia mangium	1.40	Ziska et al. 1991
Acacia melanoxylon	1.21	Poorter 1993
Alnus glutinosa	1.44	Norby 1987, Poorter 1993
Betula pendula	1.76	Petersson and McDonald 1992, Petersson et al. 1993, Mortensen 1994a, Silvola and Ahlholm 1995
Elaeagnus angustifolia	1.61	Norby 1987
Eucalyptus camaldulensis	2.11	Poorter 1993
Eucalyptus globulus	1.57	Poorter 1993
Eucalyptus grandis	2.03	Conroy et al. 1992, Poorter 1993
Lonicera japonica	2.35	Sasek and Strain 1991
Nerium oleander	1.46	Downton et al. 1980, Downton and Grant 1994
Pinus contorta	1.02	Mortensen 1994b
Pinus pinaster	1.67	Guehl et al. 1994
Pinus radiata	1.35	Conroy et al. 1986, Conroy et al. 1988, Conroy et al. 1990
Populus deltoides	1.65	Carlson and Bazzaz 1980
Prunus serotina	1.33	Bazzaz 1990
Pueraria lobata	1.20	Sasek and Strain 1988
Robinia pseudoacacia	1.32	Norby 1987
C_4 SPECIES		
Andropogon glomeratus	0.63	Bowman and Strain 1987
Andropogon virginicus	1.14	Wray and Strain 1986
Paspalum conjugatum	1.22	Ziska et al. 1991
Pennisetum clandestinum	1.15	Campbell et al. 1993
Sorghum halepense	1.10	Patterson et al. 1984, Tremmel and Patterson 1993
Spartina anglica	0.88	Campbell et al. 1993, Lenssen 1993, Lenssen et al. 1993
CAM SPECIES		
Opuntia ficus-indica	1.22	Nobel and Garcia de Cortazar 1991, Cui et al. 1993, Cui and Nobel 1994, Nobel et al. 1994

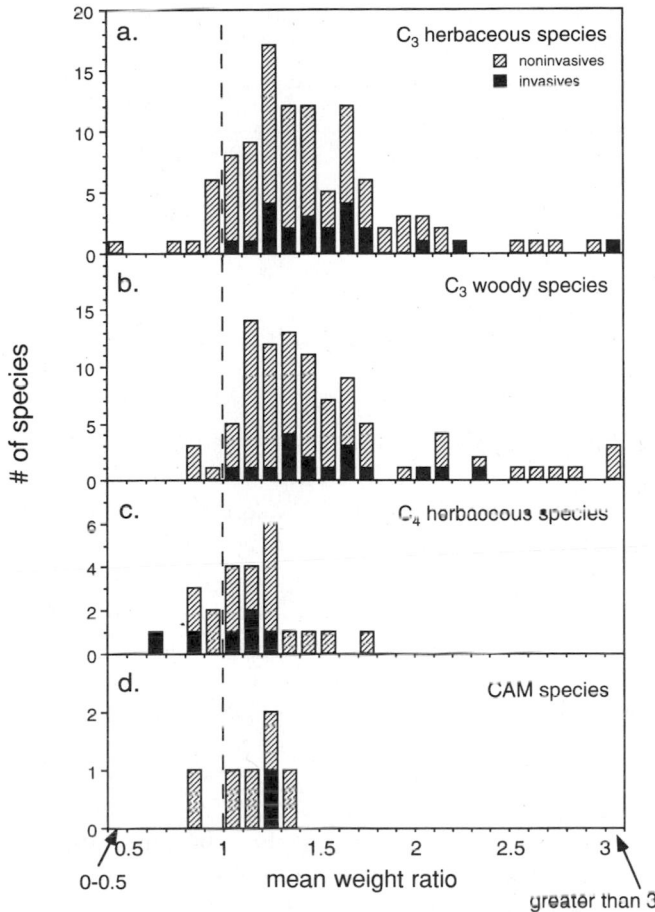

Figure 5.1. Distribution of mean weight ratios of species listed by Poorter et al. 1996, with species listed in Table 5.1 identified as invasive and all other species identified as noninvasive. The dashed line represents the border between positive and negative CO_2 responses.

indistinguishable from the responses of noninvasive species of the same physiological type (Fig. 5.1, Table 5.2).

One must be careful not to extrapolate the biomass response of a species grown individually or in monoculture to its future success as a part of a community for two reasons: First, the long-term CO_2 response of populations will depend on changes in seed quality and output, which are rarely measured (but see the 1998 study of North American desert invader *Bromus rubens* [red brome] by Travis Huxman and colleagues). Second, a

Table 5.2. Median weight ratios of invasive species from Table 5.1 and other species listed in Poorter et al. 1996, and *P*-values from Mann-Whitney U tests for differences between weight ratios of invasive and other species.

	Invasives		Others		
Species type	median	n	median	n	P-values
C_3 herbaceous	1.495	22	1.4	93	0.22
C_3 woody	1.46	17	1.4	80	0.30
C_4 herbaceous	1.12	6	1.16	18	0.24
CAM	1.22	1	1.14	5	0.55

species that responds strongly to elevated CO_2 when grown individually or in monoculture may respond quite differently when grown in competition with other species of plants (Bazzaz and McConnaughay 1992). Whereas growth of a solitary plant might be limited by the availability of CO_2, plants in communities are likely to be limited by the availability of light, water, and nutrients, for which they perceptibly compete with other plants. Thus, growth of plants in some communities might not directly respond to a rise in CO_2 availability (Reynolds 1996). Even in these situations, physiological responses of plants to elevated CO_2 might affect growth and competition by causing limitation of other resources to abate (or intensify). The species that best respond to the full suite of CO_2-driven changes in resource availability are most likely to benefit from the CO_2 increase. Identifying these species without studying them in communities can be difficult, as is illustrated by the European annual *Chenopodium album* (lamb's-quarters), a common weed throughout most of North America. Although the species responds positively to elevated CO_2 when grown individually (see Table 5.1), it did not respond when grown in a Canadian pasture community, even in disturbed (and thus low-density) sites (Taylor and Potvin 1997).

Despite the difficulties, some general principles may yet emerge. Experimental results from the same Canadian pasture community suggest that the rise in CO_2 may slow succession, or the development of plant communities, allowing "early-successional" species to persist in a community for longer than they do currently (Potvin and Vasseur 1997; Vasseur and Potvin 1998). If this turns out to be a general phenomenon, the abundance of invaders, many of which are considered early successional species, could increase.

Certain traits may help to predict "winning" and "losing" species in community settings. Plants that use the C_3 photosynthetic pathway tend to

respond more positively to elevated CO_2 than do C_4 plants in communities such as salt marsh (Curtis et al. 1989) and savanna (Johnson et al. 1993), as well as in experiments where C_3 crops are grown in competition with C_4 weeds (e.g., Alberto et al. 1996). However, results from mixed C_3-C_4 communities are not entirely clear-cut. In an experiment on tallgrass prairie (Owensby et al. 1993), CO_2 enrichment favored C_4 plants. Dominant C_4 grasses responded to an increase in water availability under elevated CO_2, while the CO_2 response of shorter C_3 grasses was limited by nutrient and light availability. Carbon dioxide enrichment similarly benefitted a C_4 annual more than a C_3 annual in a greenhouse-based competition experiment (Bazzaz et al. 1989). On the whole, results of competition experiments with C_3 and C_4 species suggest that where both types of species co-occur, the rise in CO_2 is likely to favor C_3 species in most, but not all, cases. In natural communities, this could translate to increased success of C_3 shrubs, forbs, and grasses that are invading C_4 grasslands, and decreased yield losses to C_4 weeds in fields of C_3 crops (Patterson 1995; Alberto et al. 1996). However, because high temperatures favor C_4 species over C_3 species, climate change may counteract these consequences of increasing CO_2.

In summary, research to date has not established a clear link between invasive and CO_2-responsive plant species. We can identify with some confidence general categories of plant species that are likely to benefit from the CO_2 increase in community settings. Within these categories, it is still difficult to predict which species will benefit the most. However, knowledge about ecosystem-level responses can lead to the identification of plant traits that will confer advantages under elevated CO_2.

Ecosystem-Level Responses to Increasing CO_2

Collectively, plant responses to CO_2 enrichment affect the availability of other resources, such as soil nutrients, water, and light, and could also alter fire regimes. These indirect changes will favor certain species over others (as was seen above with C_4 grasses in tall-grass prairie), and may increase the susceptibility of some ecosystems to invasion.

Most plants maintain a constant concentration of CO_2 in their stomata, the pores through which O_2 and CO_2 are exchanged and water vapor is lost to the atmosphere. Plants react to increased CO_2 availability by partially shutting their stomata, which increases the efficiency with which they use water. In some ecosystems, the increase in water-use efficiency leads to wetter soils (Bremer et al. 1996; Field et al. 1997; Fredeen et al. 1997). In plant communities such as these, alien species that are poised to take advantage of water availability increases could become more abundant.

Researchers working in California's sandstone annual grasslands have

observed that the plants in this ecosystem deplete soil moisture reserves more slowly when they are exposed to elevated CO_2 (Field et al. 1997; Fredeen et al. 1997). In these grasslands, CO_2 enrichment can cause summer-active species such as *Hemizonia congesta* ssp. *luzulifolia* to more than double their annual biomass production (Field et al. 1996). The annual forb appears to respond to the wetter soil left after the senescence of the dominant grasses, rather than to the CO_2 itself. Although *Hemizonia* is native to these grasslands, alien species that are active in the summer might also take advantage of increased water availability. For instance, the Mediterranean annual *Centaurea solstitialis* (yellow star thistle), which is invasive in the western United States and other mediterranean-climate regions, is summer-active. This species is also known to respond strongly to elevated CO_2 when grown in monoculture (J. Dukes, unpublished data).

Working on the same project in northern California, Nona Chiariello and Christopher Field (1996) studied the CO_2 response of serpentine grassland communities grown in microcosms with and without alien annual grasses. Nonnative grasses are known to respond to increases in water availability in this ecosystem (Hobbs and Mooney 1991), but water availability in the field (at least at shallow depths) appears to be only minimally affected by elevated CO_2. In the microcosm experiment, the annual grasses did not respond to increased CO_2, although one species responded strongly to fertilization. Interestingly, in this experiment and in the field, deep-rooted summer-active species did respond to CO_2 enrichment, indicating that deep reserves of soil moisture may be increased by elevated CO_2 or that the CO_2 increase allowed these species to grow root systems that more effectively exploited deepwater reserves.

Decreased water use by herbaceous dominants may allow invasions of woody species into some grassland ecosystems (Polley 1997). Grassland invaders mesquite (*Prosopis glandulosa*, Polley et al. 1996b) and huisache (*Acacia smallii*, Polley et al. 1997) both respond to elevated CO_2. As CO_2 rises, invading species such as these may become more abundant in their native ecosystems, as well as in ecosystems where they are aliens (e.g., in South Africa; see Richardson et al., this volume).

Several North American ecosystems become susceptible to invasion when water is unusually plentiful. For example, in Colorado short-grass steppe communities, long-term irrigation facilitated the establishment of alien plants that persisted long after watering treatments were stopped (Milchunas and Lauenroth 1995). Heavy-rainfall years favor invasive grasses in many arid and semiarid ecosystems, including Sonoran desert in Arizona (Burgess et al. 1991) and the transition between Great Basin and Mojave desert in Nevada (Hunter 1991). It is not known whether water availability will increase in

these systems under elevated CO_2, or whether any increase would be large enough to facilitate invasions.

Invasive species can also benefit from the addition of other resources to ecosystems. In nutrient-poor ecosystems, fertilization often spurs success of faster-growing species. These species are mostly nonnative in some North American ecosystems such as Minnesota grasslands (Wedin and Tilman 1996) and California's serpentine grasslands (Huenneke et al. 1990). In other ecosystems, including many in Europe, most of the responsive species are natives (Scherer-Lorenzen et al., this volume). The rise in CO_2 will indirectly alter nutrient availability in many, if not all, ecosystems. At this time, no experimental studies have identified invaders that are likely to benefit from changes in nutrient availability associated with rising CO_2. It is nonetheless worth briefly discussing the mechanisms by which increasing CO_2 alters nutrient availability.

A variety of plant responses to rising CO_2 can potentially lead to changes in nutrient availability. Increases in plant growth rates may increase competition for nutrients. Plant-mediated changes in soil moisture patterns may affect rates of litter and soil organic matter decomposition. Changes in litter chemistry can affect the rate at which nutrients that are bound in decomposing litter become accessible to plants and microbes. Some plant species respond to elevated CO_2 by increasing carbon inputs to soil from roots, which can in turn increase the size of microbial populations, and thus alter nutrient availability (Díaz et al. 1993; Zak et al. 1993). Because plant species differ in their responses to CO_2, changes in nutrient availability in a community may depend largely on the community's species composition (Hungate et al. 1996). Thus, CO_2-driven shifts in species dominance can also affect nutrient availability. An example: If the rise in CO_2 causes legumes to become more abundant in a community, atmospheric nitrogen would be captured and made available to microbes and other plant species more quickly (Zanetti et al. 1997). It is too early to predict whether such CO_2-driven changes in nutrient availability will alter the prevalence of biological invaders.

In ecosystems where the rise in CO_2 stimulates plant growth and litter accumulation, fire frequencies could increase. Because fire promotes biological invasion of many plant communities and can often increase the dominance of invasive species (D'Antonio and Vitousek 1992; D'Antonio et al. 1999; D'Antonio, this volume), it is appropriate to discuss conditions in which the rise in CO_2 could affect fire regimes.

The degree to which fire regimes of different grassland communities are accelerated or depressed by rising CO_2 will depend in large part on the timing of plant growth and senescence in those communities. For instance, in annual grasslands where senescence of the dominant grasses precedes a summer dry season, any increase in litter buildup or continuity would persist through the dry season, heightening the risk of fires for many months of the year. In contrast, the rise in CO_2 improves water relations in some perennial grasslands (Bremer et al. 1996), which could delay senescence of the dominant grasses during midseason droughts. This would decrease the flammability of the grasslands and increase the length of droughts required for the grassland to become susceptible to fires. If this phenomenon slowed the fire cycle, less-fire-tolerant species might invade. However, once the grasses did senesce, the increased litter buildup could trigger more intense fires (Sage 1996).

CO_2-driven changes in species dominance could also alter fire frequencies, possibly leading to further changes in species composition. Some invasive plant species might have already benefited from the 30 percent increase in CO_2, and might have consequently triggered changes in fire regimes that facilitated further invasions. Although one can only speculate about such a scenario, there exists a candidate species. *Bromus tectorum*, which has invaded millions of acres of land in western North America, is known to respond to elevated CO_2 (Table 5.1). If the rise in CO_2 stimulated growth of this annual grass, it may have also contributed to the increase in fire frequency and subsequent increase in *Bromus* dominance in the intermountain west, the region between the Sierra Nevada and the Rocky Mountains (Mayeux et al. 1994). An increase in the water-use efficiency of the grass that accompanied the rise in CO_2 may have also allowed *Bromus* to extend its range into regions that had previously been too arid to support its growth (Sage 1996).

Responses of Animals to Increasing CO_2

I expect that animal responses to the rise in CO_2 will be indirect, and based on the responses of plants. Changes in the tissue quality, phenology (timing of life stages), physiology, and distribution of plants are likely to have the most important consequences for animals (Cannon 1998). Responses of some animal species to CO_2-driven changes in plants have been recorded, but no studies have examined how the responses of alien animal species differ from those of native species. Here, I briefly summarize the known impacts of elevated CO_2 on animal species, and speculate about possible consequences for native versus alien animals.

Most of the experiments that have examined animal responses to elevated CO_2 have focused on insect species. Insect herbivores are directly affected by

changes in the quality of plant tissue that accompany elevated CO_2. The nitrogen concentration of leaves generally decreases when plants are grown in elevated CO_2, and this reduces their nutritive value. To compensate, insect larvae of many species increase leaf consumption. In most cases, larvae that eat high-CO_2-grown leaves nonetheless perform more poorly than larvae that eat leaves grown in ambient air (Cannon 1998). This is the case for gypsy moth (*Lymantria dispar*) larvae that are fed quaking aspen (*Populus tremuloides*) leaves. However, the response of these larvae to red oak (*Quercus rubra*) leaves illustrates that this phenomenon is dependent on the host plant species. Larvae that fed on oak leaves grown at elevated CO_2 performed better than larvae that consumed leaves grown in ambient air (Lindroth et al. 1993).

Some studies suggest that aphid populations could increase as CO_2 rises, as a consequence of increased fecundity (Awmack et al. 1996) and longer settling times (Smith 1996). As with insect larvae, this may depend on host plant species. The potato aphid (*Aulacorthum solani*) responds quite differently to elevated CO_2 when it is on bean (*Vicia faba*) than when it is on tansy (*Tanacetum vulgare*) (Awmack et al. 1997).

When plants are grown under elevated CO_2, litter quality does not decline as consistently as tissue quality (Norby and Cotrufo 1998). When litter quality does decline, detritavores respond. Francesca Cotrufo and colleagues (1998) grew rooted cuttings of ash (*Fraxinus excelsior*) in both ambient and CO_2-enriched air and fed leaf litter from these plants to *Oniscus asellus* individuals. Elevated-CO_2-grown litter had a higher lignin content and C:N ratio than ambient-grown litter, and the isopods consumed 16 percent less of the high-CO_2-grown litter.

Animals that live in the soil may be affected by changes in soil moisture, and in the quality and growth of roots. For instance, earthworms living in plots of Swiss grassland exposed to elevated CO_2 produced 35 percent more surface cast mass than earthworms living in plots exposed to ambient air (Zaller and Arnone 1997). The increase in cast production was probably stimulated by an increase in soil moisture in the high-CO_2 plots.

As CO_2 rises, an accompanying decrease in forage quality is likely to affect eating habits of grazing and browsing animals, but little research has been done on this topic. Ranchers may be able to maintain growth of livestock at current levels by adding nutritional supplements to their animals' diet, but growth and reproduction of wild species is likely to decrease (Owensby et al. 1996).

Elevated CO_2 alters the development rates of some plant species, which will cause some species to flower and fruit at slightly different times of year (Reekie 1996). If these changes are extreme, the rise in CO_2 could lead some plant species to flower at a time when pollinators are not available. This could

lead to a decline of both plant and animal populations. Such a dissociation between flowering time and pollinator availability is less likely to occur between "generalist" species than between "specialist" species that rely on few species for pollination or for their food supply. Invasive insect species tend to be generalists, and thus are unlikely to encounter such problems.

It is not clear that elevated CO_2 will affect the success of alien animal species. One can speculate that changes in the phenology of native plant species will adversely affect some native pollinators without substantially affecting alien pollinators, resulting in an increase in the relative abundance of the aliens. However, for most plant species, phenological changes under elevated CO_2 appear to be slight. Changes in tissue and litter quality are likely to affect many herbivores and detritivores, but it is unclear that these changes would favor either natives or aliens. Similarly, changes in soil moisture may affect earthworms and other soil-living organisms, but will not necessarily alter the prevalence of invasive species.

Conclusions and Predictions

The rise in CO_2 will probably alter the prevalence of invasive species, but the nature of this change is difficult to predict. Whereas alien species may benefit from higher CO_2 in some regions, native species may benefit in others. Plants with certain CO_2-responsive traits are likely to benefit from the rise in CO_2, especially if they are growing in ecosystems where those traits are rare. For instance, C_3 species growing in C_4-dominated ecosystems are likely to benefit from the rise in CO_2 (but under some circumstances may not). Invasiveness and CO_2-responsiveness are not clearly linked.

As with plants, ecosystems differ in their responses to elevated CO_2. In those ecosystems where the rise in CO_2 increases the availability of other resources or causes a change in the fire regime, new, possibly alien species could take advantage of the novel conditions. Animal species will also be affected by the changes in plant and ecosystem qualities, but it is difficult to predict whether native and alien species will be affected differently.

Given the uncertainties, what specific changes might we expect to see in the future as CO_2 continues to rise? It seems likely that increases in plant water-use efficiency will allow some species, particularly annual grasses, to extend their ranges further into arid regions (as may already have happened). In some deserts that are dominated by widely spaced, fire-intolerant perennial species, interactions of these invasions with fire could lead to the loss of the native perennials, as has already occurred in parts of North America.

In more mesic areas, increases in the water-use efficiency of grassland dominants is likely to increase deep water percolation, which would benefit shrubs and other species with deep rooting patterns. Leguminous shrubs

might become especially invasive as rising CO_2 stimulates nitrogen fixation. In contrast, C_4 grasses might become less competetive, rendering C4 grasslands especially invasible. Although C_4 species benefit from increasing water availability, most do not respond strongly to elevated CO_2 in wet conditions. Periodic droughts, which may currently limit some species from invading these grasslands, will become less frequent as CO_2 rises. As a consequence, some of the species that are presently excluded may survive and invade (Polley et al. 1996a).

The future success of any single alien species depends on many factors other than the response of that species to elevated CO_2. Other elements of global change, such as those discussed in this book, will also affect species' success. Interactions among the many elements of global change will undoubtedly be important in shaping the future composition of natural communities. Research projects that are designed to discover how these interactions will affect the earth's ecosystems are just getting underway.

References

Alberto, A. M. P., L. H. Ziska, C. R. Cervancia and P. A. Manalo 1996. "The influence of increasing carbon dioxide and temperature on competetive interactions between a C_3 crop, rice (*Oryza sativa*) and a C_4 weed (*Echinochloa glabrescens*)." *Australian Journal of Plant Physiology* 23: 795–802.

Awmack, C. S., R. Harrington and S. R. Leather 1997. "Host plant effects on the performance of the aphid *Aulacorthum solani* (Kalt.) (Homoptera: Aphididae) at ambient and elevated CO_2." *Global Change Biology* 3: 545–549.

Awmack, C. S., R. Harrington, S. R. Leather and J. H. Lawton 1996. "The impacts of elevated CO_2 on aphid-plant interactions." *Aspects of Applied Biology* 45: 317–322.

BassiriRad, H., R. B. Thomas, J. F. Reynolds and B. R. Strain 1996. "Differential responses of root uptake kinetics of NH_4^+ and NO_3^- to enriched atmospheric CO_2 concentration in field-grown loblolly pine." *Plant Cell and Environment* 19: 367–371.

Bazzaz, F. A. 1990. "The response of natural ecosystems to the rising global CO_2 levels." *Annual Review of Ecology and Systematics* 21: 167–196.

Bazzaz, F. A., K. Garbutt, E. G. Reekie and W. E. Williams 1989. "Using growth analysis to interpret competition between a C_3 and a C_4 annual under ambient and elevated carbon dioxide." *Oecologia* 79: 223–235.

Bazzaz, F. A. and K. D. M. McConnaughay 1992. "Plant-plant interactions in elevated CO_2 environments." *Australian Journal of Botany* 40: 547–563.

Bowman, W. D. and B. R. Strain 1987. "Interaction between CO_2 enrichment and salinity stress in the C_4 non-halophyte *Andropogon glomeratus* (Walter) BSP." *Plant Cell and Environment* 10: 267-270.

Bremer, D. J., J. M. Ham and C. E. Owensby 1996. "Effect of elevated atmospheric carbon dioxide and open top chambers on transpiration in a tallgrass prairie." *Journal of Environmental Quality* 25: 691–701.

Burgess, T. L., J. E. Bowers and R. M. Turner 1991. "Exotic plants at the desert laboratory, Tuscon, Arizona." *Madroño* 38: 96–114.

Campbell, B. D., W. A. Laing and P. C. D. Newton 1993. "Variation in the response of pasture plants to carbon dioxide." In *Proceedings of the XVII International Grassland Congress*, New Zealand Grassland Association, 1125–1126.

Cannon, R. J. C. 1998. "The implications of predicted climate change for insect pests in the UK, with emphasis on non-indigenous species." *Global Change Biology* 4: 785–796.

Carlson, R. W. and F. A. Bazzaz 1980. "The effects of elevated CO_2 concentrations on growth, photosynthesis, transpiration, and water use efficiency of plants." In *Environmental and Climatic Impact of Coal Utilization*, edited by Singh, J. J. et al., 609–622. New York: Academic Press.

Carlson, R. W. and F. A. Bazzaz 1982. "Photosynthetic and growth response to fumigation with SO_2 at elevated CO_2 for C_3 and C_4 plants." *Oecologia* 54: 50–54.

Chiariello, N. R. and C. B. Field 1996. "Annual grassland responses to elevated CO_2 in long-term community microcosms." In *Carbon Dioxide, Populations, and Communities*, edited by Körner, C. et al., 139–157. San Diego: Academic Press.

Conroy, J., E. W. R. Barlow and D. I. Bevege 1986. "Response of *Pinus radiata* seedlings to carbon dioxide enrichment at different levels of water and phosphorus: growth, morphology and anatomy." *Annals of Botany* 57: 165–177.

Conroy, J. P., M. Küppers, B. Küppers, J. Virgona and E. W. R. Barlow 1988. "The influence of CO_2 enrichment, phosphorus deficiency and water stress on the growth, conductance, and water use of *Pinus radiata* D. Don." *Plant Cell and Environment* 11: 91–98.

Conroy, J. P., P. J. Milham, M. Mazur and E. W. R. Barlow 1990. "Growth, dry weight partitioning and wood properties of *Pinus radiata* D. Don after 2 years of CO_2 enrichment." *Plant Cell and Environment* 13: 329–337.

Conroy, J. P., P. J. Milhat and E. W. R. Barlow 1992. "Effect of nitrogen and phosphorus availability on the growth response of *Eucalyptus grandis* to high CO_2." *Plant Cell and Environment* 15: 843–847.

Cotrufo, M. F., M. J. I. Briones and P. Ineson 1998. "Elevated CO_2 affects field decomposition rate and palatability of tree leaf litter: importance of changes in substrate quality." *Soil Biology and Biochemistry* 30: 1565–1571.

Cui, M., P. M. Miller and P. S. Nobel 1993. "CO_2 exchange and growth of the crassulacean acid metabolism plant *Opuntia ficus-indica* under elevated CO_2 in open-top chambers." *Plant Physiology* 103: 519–524.

Cui, M. and P. S. Nobel 1994. "Gas-exchange and growth responses to elevated CO_2 and light levels in the CAM species *Opuntia ficus-indica*." *Plant Cell and Environment* 17: 935–944.

Curtis, P. S., B. G. Drake and D. F. Whigham 1989. "Nitrogen and carbon dynamics in C_3 and C_4 estuarine marsh plants grown under elevated CO_2 in situ." *Oecologia* 78: 297–301.

D'Antonio, C. M. 2000. "Fire, plant invasions, and global change." In *Invasive Species in a Changing World*, edited by Mooney, H. A., and R. J. Hobbs. Washington, D.C.: Island Press.

D'Antonio, C. M., T. L. Dudley and M. Mack 1999. "Disturbance and biological invasions: direct effects and feedbacks." In *Ecosystems of Disturbed Ground,* edited by Walker, L. R., 413–452. Amsterdam: Elsevier.

D'Antonio, C. M. and P. M. Vitousek 1992. "Biological invasions by exotic grasses, the grass/fire cycle, and global change." *Annual Review of Ecology and Systematics* 23: 63–87.

Daehler, C. C. 1998. "The taxonomic distribution of invasive angiosperm plants: ecological insights and comparison to agricultural weeds." *Biological Conservation* 84: 167–180.

Den Hertog, J., I. Stulen and H. Lambers 1993. "Assimilation, respiration and allocation of carbon in *Plantago major* as affected by atmospheric CO_2 levels: a case study." *Vegetatio* 104/105: 369–378.

Díaz, S., J. P. Grime, J. Harris and E. McPherson 1993. "Evidence of a feedback mechanism limiting plant response to elevated carbon dioxide." *Nature* 364: 616–617.

Dippery, J. K., D. T. Tissue, R. B. Thomas and B. R. Strain 1995. "Effects of low and elevated CO_2 on C_3 and C_4 annuals. I. Growth and biomass allocation." *Oecologia* 101: 13–20.

Downton, W. J. S., O. Björkmann and C. S. Pike 1980. "Consequences of increased atmospheric concentrations of carbon dioxide." In *Carbon Dioxide and Climate: Australian Research,* edited by Pearman, G. I., 143-151. Canberra: The Australian Academy of Science.

Downton, W. J. S. and W. J. R. Grant 1994. "Photosynthetic and growth responses of variegated ornamental species to elevated CO_2." *Australian Journal of Plant Physiology* 21: 273–279.

Eamus, D. 1991. "The interaction of rising CO_2 and temperatures with water use efficiency." *Plant Cell and Environment* 14: 843–852.

Fajer, E. D., M. D. Bowers and F. A. Bazzaz 1991. "Performance and allocation patterns of the perennial herb, *Plantago lanceolata,* in response to simulated herbivory and elevated CO_2 environments." *Oecologia* 87: 37–42.

Field, C. B., F. S. Chapin, III, N. R. Chiariello, E. A. Holland and H. A. Mooney 1996. "The Jasper Ridge CO_2 experiment: Design and motivation." In *Ecosystem Responses to Elevated CO_2,* edited by Koch, G. W. et al., 121–145. London: Academic Press.

Field, C. B., C. P. Lund, N. R. Chiariello and B. E. Mortimer 1997. "CO_2 effects on the water budget of grassland microcosm communities." *Global Change Biology* 3: 197–206.

Fredeen, A. L., J. T. Randerson, N. M. Holbrook and C. B. Field 1997. "Elevated atmospheric CO_2 increases water availability in a water-limited grassland ecosystem." *Journal of the American Water Resources Association* 33: 1033–1039.

Guehl, J. M., C. Picon, G. Aussenac and P. Gross 1994. "Interactive effects of elevated CO_2 and soil drought on growth and transpiration efficiency and its determinates in two European forest tree species." *Tree Physiology* 14: 707–724.

Hebeisen, T., A. Lüscher, S. Zanetti, B. U. Fischer, U. A. Hartwig, M. Frehner, G. R. Hendrey, H. Blum and J. Nösberger 1997. "Growth response of *Trifolium repens* L.

and *Lolium perenne* L. as monocultures and bi-species mixture to free air CO_2 enrichment and management." *Global Change Biology* 3: 149–160.

Hobbs, R. J. and H. A. Mooney 1991. "Effects of rainfall variability and gopher disturbance on serpentine annual grassland dynamics." *Ecology* 72: 59–68.

Houghton, J. T., L. G. Meira Filho, B. A. Callander, N. Harris, A. Kattenberg and K. Maskell 1996. *Climate Change 1995: The Science of Climate Change: Contribution of Working Group I to the Second Assessment Report of the Intergovernmental Panel on Climate Change.* Cambridge, England: Cambridge University Press.

Huenneke, L. F., S. P. Hamburg, R. Koide, H. A. Mooney and P. M. Vitousek 1990. "Effects of soil resources on plant invasion and community structure in Californian [USA] serpentine grassland." *Ecology* 71: 478–491.

Hungate, B. A., J. Canadell and F. S. Chapin, III 1996. "Plant species mediate microbial N dynamics under elevated CO_2." *Ecology* 77: 2505–2515.

Hunt, R., D. W. Hand, M. A. Hannah and A. M. Neal 1991. "Response to CO_2 enrichment in 27 herbaceous species." *Functional Ecology* 5: 410–421.

Hunt, R., D. W. Hand, M. A. Hannah and A. M. Neal 1993. "Further response to CO_2 enrichment in British herbaceous species." *Functional Ecology* 7: 661–668.

Hunter, R. 1991. "*Bromus* invasions on the Nevada test site: Present status of *B. rubens* and *B. tectorum* with notes on their relationship to disturbance and altitude." *Great Basin Naturalist* 51: 176–182.

Huxman, T. E., E. P. Hamerlynck, D. N. Jordan, K. J. Salsman and S. D. Smith 1998. "The effects of parental CO_2 environment on seed quality and subsequent seedling performance in *Bromus rubens*." *Oecologia* 114: 202–208.

Jackson, R. B. and H. L. Reynolds 1996. "Nitrate and ammonium uptake for single- and mixed-species communities grown at elevated CO_2." *Oecologia* 105: 74–80.

Johnson, H. B., H. W. Polley and H. S. Mayeux 1993. "Increasing CO_2 and plant-plant interactions: effects on natural vegetation." *Vegetatio* 104/105: 157–170.

Lenssen, G. M. 1993. *Response of C_3 and C_4 species from Dutch Salt Marshes to Atmospheric CO_2 Enrichment.* Thesis, Free University, Amsterdam.

Lenssen, G. M., J. Lamers, M. Stroetenga and J. Rozema 1993. "Interactive effects of atmospheric CO_2 enrichment, salinity and flooding on growth of C_3 (*Elymus athericus*) and C_4 (*Spartina anglica*) salt marsh species." *Vegetatio* 104/105: 379–388.

Lindroth, R. L., K. K. Kinney and C. L. Platz 1993. "Responses of deciduous trees to elevated atmospheric CO_2: productivity, phytochemistry, and insect performance." *Ecology* 74: 763–777.

Mayeux, H. S., H. B. Johnson and H. W. Polley 1994. "Potential interactions between global change and intermountain annual grasslands." In *Proceedings—Ecology and Management of Annual Rangelands,* edited by Monsen, S. B. et al., 95–100. Ogden, Utah: United States Department of Agriculture, Forest Service, Intermountain Research Station.

Milchunas, D. G. and W. K. Lauenroth 1995. "Inertia in plant community structure: state changes after cessation of nutrient-enrichment stress." *Ecological Applications* 5: 452–458.

Morison, J. I. L. and R. M. Gifford 1984. "Plant growth and water use with limited

supply in high CO_2 concentrations. II. Plant dry weight, partitioning and water use efficiency." *Australian Journal of Plant Physiology* 11: 375–384.

Mortensen, L. M. 1994a. "Effects of carbon dioxide concentration on assimilate partitioning, photosynthesis and transpiration of *Betula pendula* Roth. and *Picea abies* (L.) Karst. seedlings at two temperatures." *Acta Agriculturae Scandinavica Section B—Soil and Plant Science* 44: 164–169.

Mortensen, L. M. 1994b. "The influence of carbon dioxide or ozone concentration on growth and assimilate partitioning in seedlings of nine conifers." *Acta Agriculturae Scandinavica Section B—Soil and Plant Science* 44: 157–163.

Newton, P. C. D., H. Clark, C. C. Bell, E. M. Glasgow and B. D. Campbell 1994. "Effects of elevated CO_2 and simulated seasonal changes in temperature on the species composition and growth rates of pasture turves." *Annals of Botany* 73: 53–59.

Nobel, P. S., M. Y. Cui, P. M. Miller and Y. Q. Luo 1994. "Influences of soil volume and an elevated CO_2 level on growth and CO_2 exchange for the crassulacean acid metabolism plant *Opuntia ficus-indica*." *Physiologia Plantarum* 90: 173–180.

Nobel, P. S. and V. Garcia de Cortazar 1991. "Growth and predicted productivity of *Opuntia ficus-indica* for current and elevated carbon dioxide." *Agronomy Journal* 83: 224–230.

Norby, R. J. 1987. "Nodulation and nitrogenase activity in nitrogen fixing woody plants stimulated by CO_2 enrichment of the atmosphere." *Physiologia Plantarum* 71: 77–82.

Norby, R. J. and M. F. Cotrufo 1998. "A question of litter quality." *Nature* 396: 17–18.

Owensby, C. E., R. C. Cochran and L. M. Auen 1996. "Effects of elevated carbon dioxide on forage quality of ruminants." In *Carbon Dioxide, Populations, and Communities*, edited by Körner, C. et al., 363–371. San Diego: Academic Press.

Owensby, C. E., P. I. Coyne, J. M. Ham, L. M. Auen and A. K. Knapp 1993. "Biomass production in a tallgrass prairie ecosystem exposed to ambient and elevated CO_2." *Ecological Applications* 3: 644–653.

Patterson, D. T. 1995. "Weeds in a changing climate." *Weed Science* 43: 685–701.

Patterson, D. T. and E. P. Flint 1980. "Potential effects of global atmospheric CO_2 enrichment on the growth and competitiveness of C_3 and C_4 weed and crop plants." *Weed Science* 28: 71–75.

Patterson, D. T., E. P. Flint and J. L. Beyers 1984. "Effects of CO_2 enrichment on competition between a C_4 weed and a C_3 crop." *Weed Science* 32: 101–105.

Patterson, D. T., M. T. Highsmith and E. P. Flint 1988. "Effects of temperature and CO_2 concentration on the growth of cotton (*Gossypium hirsutum*), spurred anoda (*Anoda cristata*), and velvetleaf (*Abutilon theophrasti*)." *Weed Science* 36: 751–757.

Petersson, R. and A. J. S. McDonald 1992. "Effects of elevated carbon dioxide concentration on photosynthesis and growth of small birch plants (*Betula pendula* Roth.) at optimal nutrition." *Plant Cell and Environment* 15: 911–919.

Petersson, R., A. J. S. McDonald and I. Stadenberg 1993. "Response of small birch plants (*Betula pendula* Roth.) to elevated CO_2 and nitrogen supply." *Plant Cell and Environment* 16: 1115–1121.

Polley, H. W. 1997. "Implications of rising atmospheric carbon dioxide concentration for rangelands." *Journal of Range Management* 50: 561–577.

Polley, H. W., H. B. Johnson and H. S. Mayeux 1997. "Leaf physiology, production, water use, and nitrogen dynamics of the grassland invader *Acacia smallii* at elevated CO_2 concentrations." *Tree Physiology* 17: 89–96.

Polley, H. W., H. B. Johnson, H. S. Mayeux and C. R. Tischler 1996a. "Are some of the recent changes in grassland communities a response to rising CO_2 concentrations?" In *Carbon Dioxide, Populations, and Communities*, edited by Körner, C. et al., 177–195. San Diego: Academic Press.

Polley, H. W., H. B. Johnson, H. S. Mayeux, C. R. Tischler and D. A. Brown 1996b. "Carbon dioxide enrichment improves growth, water relations and survival of droughted honey mesquite (*Prosopis glandulosa*) seedlings." *Tree Physiology* 16: 817–823.

Poorter, H. 1993. "Interspecific variation in the growth response of plants to an elevated ambient CO_2 concentration." *Vegetatio* 105: 77–97.

Poorter, H., C. S. Pot and H. Lambers 1988. "The effect of an elevated atmospheric CO_2 concentration on growth, photosynthesis and respiration of *Plantago major.*" *Physiologia Plantarum* 73: 553–559.

Poorter, H., C. Roumet and B. D. Campbell 1996. "Interspecific variation in the growth response of plants to elevated CO_2: a search for functional types." In *Carbon Dioxide, Populations, and Communities*, edited by Körner, C. et al., 375–412. San Diego: Academic Press.

Potvin, C. and L. Vasseur 1997. "Long-term CO_2 enrichment of a pasture community: species richness, dominance, and succession." *Ecology* 78: 666–677.

Reekie, E. G. 1996. "The effect of elevated CO_2 on developmental processes and its implications for plant-plant interactions." In *Carbon Dioxide, Populations, and Communities*, edited by Körner, C. et al., 333–346. San Diego: Academic Press.

Rejmánek, M. and D. M. Richardson 1996. "What attributes make some plant species more invasive?" *Ecology* 77: 1655–1661.

Reynolds, H. F. 1996. "Effects of elevated CO_2 on plants grown in competition." In *Carbon Dioxide, Populations, and Communities*, edited by Körner, C. et al., 273–286. San Diego: Academic Press.

Richardson, D. M., W. J. Bond, R. J. Dean, S. I. Higgens, G. F. Midgley, S. J. Milton, L. W. Powrie, M. C. Rutherford, M. J. Samways and R. E. Schulze. 2000. "Invasive alien species and global change: a South African perspective." In *Invasive Species in a Changing World*, edited by Mooney, H. A., and R. J. Hobbs. Washington, D.C.: Island Press.

Sage, R. F. 1996. "Modification of fire disturbance by elevated CO_2." In *Carbon Dioxide, Populations, and Communities*, edited by Körner, C. et al., 231–249. San Diego: Academic Press.

Sasek, T. W. and B. R. Strain 1988. "Effects of carbon dioxide enrichment on the growth and morphology of kudzu (*Pueraria lobata*)." *Weed Science* 36: 28–36.

Sasek, T. W. and B. R. Strain 1991. "Effects of CO_2 enrichment on the growth and morphology of a native and an introduced honeysuckle vine." *American Journal of Botany* 78: 69–75.

Scherer-Lorenzen, M., A. Elend, S. Nollert and E. D. Schulze. 2000. "Plant in Germany: general aspects and impacts of nitrogen deposition." In *Invasive Species in a Chang-*

ing World, edited by Mooney, H. A., and R. J. Hobbs. Washington, D.C.: Island Press.

Silvola, J. and U. Ahlholm 1995. "Combined effects of CO_2 concentration and nutrient status on the biomass production and nutrient uptake of birch seedlings (*Betula pendula*)." *Plant and Soil* 168/169: 547–553.

Smith, H. 1996. "The effects of elevated CO_2 on aphids." *Antenna* 20: 109–111.

Smith, S. D., B. R. Strain and T. D. Sharkey 1987. "Effects of carbon dioxide enrichment on four Great Basin [USA] grasses." *Functional Ecology* 1: 139–144.

Stewart, J. and C. Potvin 1996. "Effects of elevated CO_2 on an artificial grassland community: competition, invasion and neighbourhood growth." *Functional Ecology* 10: 157–166.

Taylor, K. and C. Potvin 1997. "Understanding the long-term effect of CO_2 enrichment on a pasture: the importance of disturbance." *Canadian Journal of Botany* 75: 1621–1627.

Tremmel, D. C. and D. T. Patterson 1993. "Responses of soybean and 5 weeds to CO_2 enrichment under 2 temperature regimes." *Canadian Journal of Plant Science* 73: 1249–1260.

Vasseur, L. and C. Potvin 1998. "Natural pasture community response to enriched carbon dioxide atmosphere." *Plant Ecology* 135: 31–41.

Wedin, D. A. and D. Tilman 1996. "Influence of nitrogen loading and species composition on the carbon balance of grasslands." *Science* 274: 1720–1723.

Whitson, T. D., L. C. Burrill, S. A. Dewey, D. W. Cudney, B. E. Nelson, R. D. Lee and R. Parker 1996. *Weeds of the West.* Jackson, Wyoming: Pioneer of Jackson Hole.

Wray, S. M. and B. R. Strain 1986. "Response of two old field perennials to interactions of CO_2 enrichment and drought stress." *American Journal of Botany* 73: 1486–1491.

Zak, D. R., K. S. Pregitzer, P. S. Curtis, J. A. Teeri, R. Fogel and D. L. Randlett 1993. "Elevated atmospheric CO_2 and feedback between carbon and nitrogen cycles." *Plant and Soil* 151: 105–117.

Zaller, J. G. and J. A. Arnone 1997. "Activity of surface-casting earthworms in a calcareous grassland under elevated atmospheric CO_2." *Oecologia* 111: 249–254.

Zanetti, S., U. A. Hartwig, C. van Kessel, A. Lüscher, T. Hebeisen, M. Frehner, B. U. Fischer, G. R. Hendrey, H. Blum and J. Nösberger 1997. "Does nitrogen nutrition restrict the CO_2 response of fertile grassland lacking legumes?" *Oecologia* 112: 17–25.

Ziska, L. H., K. P. Hogan, A. P. Smith and B. G. Drake 1991. "Growth and photosynthetic response of nine tropical species with long-term exposure to elevated carbon dioxide." *Oecologia* 86: 383–389.

Chapter 6

~

Microevolutionary Influences of Global Changes on Plant Invasions

Spencer C. H. Barrett

The succcess of invading species is largely determined by their ability to respond to novel environments in their adopted homes. Flexible responses allow individuals to adjust their growth and reproduction to local conditions, and it is well known that species differ in their capacity for such phenotypic plasticity (Schlichting and Pigliucci 1998). Over longer timescales, however, evolutionary responses are likely to occur through genetic changes in the adaptiveness of populations (Brown and Marshall 1981). An important issue for studies of the spread of invading species is the spatial and temporal scale over which local adaptation can develop. Microevolutionary investigations of plant populations indicate that adaptive responses can occur over short distances and with surprising rapidity (Linhart and Grant 1996). To predict evolutionary responses to environmental change, a knowledge of the amount of genetic variation for physiological and life-history traits of adaptive importance is critical (Geber and Dawson 1993; Mazer and LeBuhn 1999). How this variation is influenced by natural selection will depend on population structure, modes of reproduction, and the specific details of the local physical and biotic environment.

Human-driven global environmental changes in all their complexity provide a new set of ecological and evolutionary challenges for the world's biota. Most consideration of the impact of global change has focused on the problem of species extinctions and the need to preserve biodiversity (Wilson and Peters 1988; Leemans 1996). While there is no doubt that certain aspects of global change, such as habitat loss, are resulting in accelerated species extinctions, less attention has been paid to the ways in which global change might also influence other evolutionary processes such as adaptation and speciation (Lynch and Lande 1993). This neglect may be because of the assumption that the pace of global change is too rapid for organisms to adapt to changing conditions. While it is true that the most obvious influence of climate change involves ecological shifts in the distribution of organisms (Comes and Kadereit 1998), future migrations could be accompanied by the evolution of locally adapted races in species capable of rapid genetic change (Geber and Dawson 1993). This seems especially likely for many invading species because of their high dispersability, prolific regenerative capacities and flexible genetic systems (Baker 1974; Barrett 1992).

While biological invasions constitute part of global environmental change (Vitousek et al. 1996), it is also worth asking how other components of the process of global change are likely to influence the origin and spread of plant invasions. This chapter examines this issue by considering ecological and microevolutionary responses of plant populations to three components of global change: climate change, habitat fragmentation, and impacts resulting from advances in agriculture and biotechnology. These components of global change involve diverse aspects of the physical and biological environments of plant populations. Moreover, successful plant invaders constitute a heterogeneous assortment of species with contrasting taxonomic affinities and life-history traits. This biological complexity makes predictions concerning the evolutionary responses of plants to global change difficult (Geber and Dawson 1993). At the present time we are some way from being able to determine which plant species are likely to become successful invaders and what makes some ecosystems more susceptible to invasion than others (Mooney and Drake 1986; Rejmánek and Richardson 1996; Williamson 1996).

Faced with these uncertainties, broad generalizations concerning evolutionary scenarios become tenuous. For example, in a review of the potential microevolutionary consequences of climate change to plants and animals, Holt (1990) drew attention to the fact that "there is almost no species for which we know enough relevant ecology, physiology, and genetics to predict its evolutionary response to climate change" (p. 311). With this salutory warning firmly in mind, what follows is an attempt to predict some of the potential ecological and evolutionary responses of plant invaders to global changes using evolutionary theory and existing information, scant as it may

be, on their ecology and genetics. If nothing else, it is hoped that this review stimulates researchers to consider plant invaders as valuable model systems for investigating genetic and microevolutionary responses to global environmental changes.

Global Changes and Plant Evolution: General Responses

As a prelude to discussing the potential influences of specific components of global change to plant invasions, I begin by briefly reviewing the general evolutionary responses of plants to global environmental change. Two outcomes are most likely—extinction or local adaptation—with the particular response depending on the tempo and nature of change, combined with the biological attributes of individual species. In the first case, progressive extirpation of populations may lead inexorably to species extinction. Species loss can arise through diverse influences, and for some species extinction may be unrelated to the demographic or genetic characteristics of populations (e.g., through environmental catastrophes associated with habitat destruction). Of particular interest to evolutionary biologists are situations where extinction occurs because of the absence of appropriate heritable variation for adaptive traits (Travis and Futuyma 1993). Lack of genetic variation prevents adaptation to new environmental challenges, and the fitness of populations declines to the point where extinction is inevitable. How often populations can evolve rapidly enough to avoid local extirpation in the face of unfavorable environmental change is not well understood, and the importance of adaptive evolution in preventing species extinction is still a controversial topic (Gould 1985). Theoretical models of the evolution of fitness traits attempt to determine the critical rate of environmental change beyond which extinction is inevitable (Lynch and Lande 1993). The models highlight the importance of several key parameters, including the input of mutational variance into a population and its effective size and reproductive system.

Changing environmental conditions commonly result in migration and hence shifts in the geographical distribution and abundance of plant species. Migration in response to past climate change is well documented and depends, in part, on dispersal biology and the availability of migration routes (Comes and Kadereit 1998; Taberlet et al. 1998). Species on islands and isolated habitat fragments, or those with poor dispersal powers, are most vulnerable to extinction if environmental conditions deteriorate. Migration can set the stage for local adaptation in response to divergent selection pressures as long as appropriate genetic variation is present within colonizing populations. Evidence that this has occurred during the Pleistocene, in response to

past climate change, comes from numerous studies that have documented evolutionary differentiation in adaptive traits among populations that now occupy glaciated regions (e.g., Mooney and Billings 1961; Cwynar and MacDonald 1987). Recent phylogeographic studies using molecular markers provide opportunities to determine the migrational histories and genealogical relationships of plant invasions associated with past and future climate change (Soltis et al. 1997; Comes and Kadereit 1998; Schaal et al. 1998; Taberlet et al. 1998). A major challenge will be to try to use this phylogeographic information to devise methods that enable determination of the tempo of adaptive change in traits during the invasion process.

What plant traits are likely to be favored by natural selection during global change? This is a difficult question to address because of the diverse environmental influences that characterize each of its components. Nevertheless, if we accept that future ecosystems are likely to experience increased disturbance and greater habitat fragmentation, then it seems likely that opportunistic species with short life cycles, well-developed dispersal powers, and high reproductive output will be favored over longer-lived, more slowly growing species (Bazzaz 1996; Grime 1997). The former suite of traits are characteristic of life-history syndromes variously described as weedy (Baker 1965), r-selected (MacArthur and Wilson 1967), ruderal (Grime 1979), or invasive (Barrett 1992). The rapid life cycles of species with these syndromes and their well-developed phenotypic plasticity may provide greater responsiveness to rapidly changing environments. Thus disruptive land-use practices seem likely to favor opportunistic species of early successional habitats with traits that predispose them to become invaders. Under global change, invasiveness may become more prevalent as a plant strategy even in communities that have up to now been relatively immune from biological invasions (e.g., tropical forests, Groom and Schumaker 1993; arctic vegetation, Callaghan et al. 1997). Interestingly, it has been suggested that species with these traits were also favored following past climate change based on palaeobotanical evidence (DiMichele et al. 1987). Invasions are not only a part of global environmental change, but an increase in the abundance of plant invaders in regional floras seems likely to be promoted further by global change.

What information do we need to predict plant responses to global environmental changes? Ecologists are currently spending considerable effort in trying to predict how vegetation will respond to climate change (Walker and Steffen 1996). Part of this research has involved the screening of plant traits and the classification of species into a smaller number of functional groups (Grime 1997; Lavorel et al. 1997; Westoby 1998). This information is being used in models that attempt to predict how changes in temperature and CO_2 will influence the productivity and composition of vegetation. No comparable research program has been developed by plant evolutionary biologists to

predict how global change might influence population genetics and plant fit-ness. While considerable information is available for hundreds of plant species concerning the amounts and organization of variation at allozyme loci, and their association with life history and ecology (IIamrick and Godt 1997), it is still unclear to what extent this class of genetic variation is a reli-able predictor of heritable variation in adaptive traits. The best way of find-ing out whether populations are capable of responding to a specific environ-mental change is to first identify which traits are of adaptive importance in the new selection regime and then determine how much quantitative genetic variation is available for selection (Mitchell-Olds and Rutledge 1986; Mitchell-Olds and Bergelson 1990; Mazer and LeBuhn 1999). This is a rela-tively straightforward exercise, but it is time consuming and has only been attempted for a relatively small number of wild plant populations. Invading species are abundant and possess many attributes that make them ideal can-didates for this type of study. Unfortunately, little work has been conducted on their genetics and almost none within a global change framework (but see Curtis et al. 1994; Bazzaz et al. 1995).

Climate Change

There is incontrovertible evidence that climate acts as a powerful selective agent on plant traits. The convergent evolution of morphological and physi-ological traits in phylogenetically diverse families occupying similar climatic regimes provides one source of evidence (Box 1981; Nobel 1991). In addition, the formation within species of climatic ecotypes or races associated with lat-itude and altitude also demonstrates that adaptive responses can occur at a microevolutionary level (Clausen et al. 1947; Briggs and Walters 1997). Future global climate change is likely to involve three main aspects of the physical environment that are biologically relevant to plant populations: (1) increasing temperatures and accompanying changes in precipitation and evapotransporation, (2) changes in seasonality, and (3) increases in CO_2. There is insufficient information to predict at a local level how these changes will influence vegetation, but it seems reasonable to assume that plant popu-lations will respond through plastic responses over short timescales (e.g., acclimation of physiology to temperature) and over longer time spans through adaptive changes driven by natural selection.

Reproductive and Genetic Consequences

What impacts are these changes in climate likely to have on the reproduction and genetics of plant invaders? Although a truly global perspective is hard to assess, some educated guesses can be made for particular geographical

regions. The distribution of many species is currently limited by climatic conditions, and it is likely that increased temperatures and a longer growing season will favor their spread to more northern latitudes, especially in North America and Europe (Woodward 1987). An increase in the length of the growing season could have important influences on the reproductive capacity of populations. In many annual species, seed production is highly plastic and is strongly correlated with plant size (Harper 1977). A longer growing season would result in increased biomass and higher seed output. Such an effect might also arise from other elements of global change, such as elevated CO_2 levels, especially in C_3 plants, and through increased inputs of atmospheric nitrogen (Bazzaz 1996). Moreover, in higher latitudes, seed maturation in plant populations is often curtailed by low temperatures or frost so that any amelioration of climate could act to boost fertility. Any of these influences would have the effect of increasing the reproductive output of populations with potentially important genetic consequences because of the well-established theoretical relationship between population size and genetic diversity (Barrett and Kohn 1991; Ellstrand and Elam 1993). While population growth rates are obviously influenced by a variety of biotic and abiotic factors, it seems likely that elevated fertility, associated with a longer growing season, would result in increased population sizes, particularly for species at the margins of their range.

Firbank et al. (1995) examined the effects of a range of temperature and CO_2 levels on biomass and seed production in the annual grass *Vulpia ciliata*. They found that while CO_2 had little effect on these traits, at higher temperatures plants grew more quickly and achieved their highest biomass and seed production. They suggested that under global change this species has the potential for more rapid population growth and a northward range shift in the United Kingdom, as long as the open habitats that it normally occupies do not become dominated by species that are more competitive, or have higher rates of population increase. The influence of increased temperatures due to global warming on the northward spread of invading plant species in the Northern Hemisphere has been considered by Beerling (1993), who also points out that ecological interactions need to be carefully considered when predicting rates of spread based on dispersal and climatic variables (and see Huntley 1991).

A longer growing season and larger population sizes could be important for the reproductive biology of invading species that are animal-pollinated. Increased pollinator activity encouraged by warmer temperatures and a longer summer would have the effect of increasing fruit and seed set (Grime 1997). Plants occurring in small, isolated populations, typical of the early stages of colonization, are more likely to suffer pollen limitation than are those occurring in large populations. Indeed, the problem of reduced fertil-

ity, under low-density conditions, is thought to be a major factor responsible for the selection of mechanisms promoting self-fertilization in flowering plants (Lloyd 1980). Evidence that population size influences the probability of seed set comes from a study by Ågren (1996) of the insect-pollinated invader purple loosestrife (*Lythrum salicaria*, Lythraceae). In this species, plants were more likely to experience pollen limitation, owing to low pollinator service, if they occurred in small versus large populations. Increased fertility of *L. salicaria* populations is of particular significance for the spread of the species in North America since seed viability is exceptionally high and sexual reproduction is the principal means of population growth (Thompson et al. 1987).

Many plant species, including those with high invasive powers, have mixed mating systems with the frequency of cross-and self-fertilization depending on levels of pollinator activity. Increases in population size and plant density could have the effect of altering mating patterns toward increased outcrossing because pollinators prefer larger, more rewarding populations. Several studies have demonstrated that the demographic characteristics of populations, including their size and density, influence selfing rates in this manner (Barrett and Eckert 1990; Karron et al. 1995). Such effects are important because the mating system is a primary determinant of the amounts and organization of genetic variability within and among plant populations (Brown 1979). Outcrossing species maintain higher levels of polymorphism and allelic variability and are more heterozygous than species with higher selfing rates (Hamrick and Godt 1989). Alterations in mating pattern owing to climate-induced demographic changes to populations could therefore have important genetic and evolutionary consequences for plant invaders. However, predicting these consequences for particular species and locations will be difficult since, as discussed in the following sections, other components of global change, such as habitat fragmentation may have more dramatic influences on the demography and genetics of populations, nullifying effects that may arise from climatic warming alone.

Sexuality in Clonal Populations

Another potential influence of climate change on plant invasions concerns the increased seasonality and more pronounced wet and dry cycles that are predicted to occur in certain regions. One particular class of invaders—aquatic weeds—may be especially influenced by these changes. Many aquatic weeds reproduce primarily by clonal propagation in their introduced ranges, and hence populations are often genetically depauperate and composed of one or at most a few genotypes (Barrett et al. 1993). Restricted sexual reproduction can arise because of a variety of ecological and/or genetic factors. In

some species, such as the free-floating aquatic water hyacinth (*Eichhornia crassipes*, Pontederiaceae), sexual recruitment is largely prevented because of an absence of suitable ecological conditions for seedling establishment in introduced habitats (Barrett 1980). Populations frequently inhabit canals, drainage ditches, and reservoirs with steep sides and little exposed shoreline. Wet, exposed mud is a prerequisite for germination and seedling establishment so that populations are largely asexual despite the widespread formation of seed. In its native range in lowland South America, *E. crassipes* reproduces sexually, owing to the striking seasonal fluctuations in water level that characterize the aquatic habitats it occupies in Amazonia and the Pantanal. Climate-change-induced fluctuations in water level in the introduced range would have the effect of mimicking the changes that are a predictable feature of the species' natural environments. This would encourage bursts of sexual activity and lead to an increased amount of genetic diversity in populations. More frequent sexuality in aquatic invaders could have important implications for attempts at biological control since there is evidence that species that reproduce primarily by clonal means are considerably easier to control than are those in which sexual reproduction predominates (Burdon and Marshall 1981; Barrett 1989). Genetic diversity reduces the impact of predators, parasites, and diseases on host populations, especially in combination with frequency-dependent selection (Hamilton 1980).

Many plant species reproduce exclusively by clonal propagation at the limits of their range. For example, the common reed (*Phragmites australis*) in northern Europe often flowers so late that its ability to produce viable seeds before winter dieback is limited (McKee and Richards 1996). Low temperatures can inhibit any one of several stages in the sexual cycle, including flowering, gamete development, pollen-tube growth, ovule fertilization, and seed maturation. In addition, unfavorable environmental conditions at range limits can result in a lack of pollinators in animal-pollinated species, or prevent seed germination and seedling establishment. With an ameliorating climate in northern latitudes, it seems likely that some species that were formerly exclusively clonal may experience more suitable environmental conditions for sexual reproduction. An intriguing issue is whether these populations can take advantage of changed climatic conditions by reproducing sexually after many generations of clonal propagation. This may not be straightforward because there is some evidence that clonal populations may lose the facility for sexual reproduction because of the accumulation of sterility mutations causing sexual dysfunction (Klekowski 1988, 1997). For example, fruit and seed set are very low in populations of the self-compatible, clonal aquatic swamp loosestrife (*Decodon verticillatus*, Lythraceae) at the northern periphery of its range in North America. Populations are often composed of one or a few clones and hence are nearly genetically uniform (Dorken and Eckert

1999). Interestingly, the low fertility of clones is maintained under favorable environmental conditions in the glasshouse and with supplemental hand pollination. This suggests that genetic factors must play a major role in sexual dysfunction, and this has been confirmed in a population of *D. verticillatus* from Ontario by controlled crosses. Recessive mutations impairing pollentube growth were found to be the major cause of low fertility (Eckert et al. 1999). It would be of interest to determine the prevalence of sterility mutations in other clonal plants, particularly those at the margins of their ranges where sexual reproduction is rarely observed. Lack of sex severely limits adaptive responses to environmental change and also constrains dispersal potential and opportunities for climate-induced migration.

Land-Use Change and Habitat Fragmentation

While climate change will undoubtedly have ecological and evolutionary consequences for plant biodiversity, the effects of habitat destruction through agriculture, forestry, industrial development, and human settlement are more potent and immediate forces of global environmental change. These activities, which are a direct consequence of expanding human populations, lead to alterations of natural landscapes and the replacement of mature, species-rich ecosystems by early successional states. As discussed earlier, vegetation of this type is largely composed of opportunistic, short-lived species with well-developed dispersal powers. Disruptive land-use practices and the spread of open, disturbed environments will therefore change the average life span of vegetation in many locations, favoring species that exhibit rapid population turnover.

Ecology and Genetics of Metapopulations

What are the likely demographic and genetic consequences of these changing land-use patterns for plant populations with different life histories? Invasive species are likely to be favored by the spread of open, disturbed environments. In contrast, for species adapted to later successional vegetation, the loss and fragmentation of habitats will result in reductions in effective population size and a progressive loss of fitness (Barrett and Kohn 1991; Ellstrand and Elam 1993). This is because small populations are more vulnerable to genetic erosion owing to increased opportunities for the stochastic loss of diversity (Bijlsma et al. 1994). In addition, mating among relatives, a characteristic of small populations, reduces the viability and fertility of offspring due to inbreeding depression (Charlesworth and Charlesworth 1987). Since habitat fragmentation increases the isolation of populations, a critical issue for the long-term persistence of populations is the extent to which gene flow

acts to restore the diversity that is continually eroded through genetic drift. Efforts to investigate this problem require studies at the metapopulation level since it is at the landscape scale that the degree of connectedness among populations can best be appreciated (Sork et al. 1999).

Recent studies of two plant invaders illustrate the importance of considering landscape-level processes when evaluating the genetic consequences of habitat fragmentation. *Eichhornia paniculata* (Pontederiaceae) is a neotropical, tristylous, annual aquatic of ephemeral ponds, drainage ditches, and rice fields. Barrett and Husband (1997) investigated the influence of spatial isolation on the genetic diversity of populations among regions in northeastern Brazil. The regions chosen varied in the density of populations distributed across the landscape because of differences in the availability of suitable aquatic habitats. Populations occurring in areas with few other populations were significantly less variable at both allozyme and mating-system loci than those from regions with high population densities. This pattern reflects the relative importance of gene flow and genetic drift in determining the amount of genetic variation within populations. Genetic drift has been shown to reduce diversity in many *E. paniculata* populations because of their small effective size (Husband and Barrett 1992).

Lythrum salicaria is one of the most aggressive invaders of wetland environments in North America. Comparisons between native (southwestern France) and introduced (Ontario, Canada) populations of this species have also provided evidence for the relative importance of gene flow and genetic drift in the maintenance of the species' tristylous mating system (Eckert and Barrett 1992; Eckert et al. 1996). French populations surveyed were predominantly tristylous, whereas those in Ontario were often missing mating types. This pattern was associated with differences in ecology and metapopulation structure between the two regions. French populations of *L. salicaria* occur primarily in roadside ditches associated with the agricultural landscapes of the region. The distribution of populations results in a high level of connectivity, providing opportunities for gene flow among populations. Metapopulation models indicate that levels of gene flow on the order of $m \geq 0.05$ can account for the maintenance of tristyly even in small populations (Eckert et al. 1996). In contrast, introduced Ontario populations are more isolated from one another, and opportunities for missing morphs to establish in nontristylous populations through gene flow are restricted. Assessing the degree of connectivity of invading plant populations will be important for determining how susceptible populations are to genetic erosion and fitness loss.

What lessons can be drawn from these two studies in predicting the likely genetic impacts of land-use change on invading species? It is important to appreciate that the spatial distribution and dynamics of populations across

the landscape are relevant not only for understanding the nature of the invasion process and modeling its likely outcome (e.g., Higgins et al. 1996; Shigesada and Kawasaki 1997), but also for revealing that these aspects of population structure have important genetic and evolutionary consequences. Rates of gene flow and extinction and recolonization cycles have been shown to play a critical role in governing the partitioning of genetic variation within and among populations as well as the maintenance of variation by the entire metapopulation (McCauley 1993; Harrison and Hastings 1996). Over the past decade, metapopulation theory has advanced much more rapidly than our attempts to collect relevant empirical data. This is especially the case for plants where relatively few species have been investigated from a metapopulation perspective (Husband and Barrett 1996). Invading species could provide useful model systems for investigating these problems because of their rapid population turnover and prolific colonizing powers.

Mating Systems and Reproductive Assurance

Colonizing populations of *Eichhornia paniculata* and *Lythrum salicaria* are prone to loss of mating types through genetic drift, and this can interfere with normal reproductive function. This raises the question of what mating systems are favored in invading species, and how often plants in disturbed environments are unable to reproduce sexually because of an absence of pollinators or mates. If, as discussed earlier, we assume that future land-use change will result in an expansion of open, disturbed habitats, then species capable of founding new populations from single propagules, and then persisting during initial periods of low population density, seem likely to be favored. These requirements favor species that are self-compatible and capable of autonomous self-pollination. Indeed, selfing has been consistently identified as a common mating strategy in colonizing species (Brown and Burdon 1987). Of course, long-term persistence through clonal regeneration is also possible in colonists, but alone this will not provide for the generation of genetic diversity and would thus impede future opportunities for local adaptation.

Not all successful invading species that rely on sexual reproduction are selfers, indicating that some outcrossers can overcome the constraints imposed by colony foundation and low-density conditions during the invasion of patchy habitats. Pannel and Barrett (1998) recently addressed this issue theoretically by examining the benefits of reproductive assurance in selfers versus outcrossers in the context of a metapopulation. In their model they determined the seed productivity that would be required by an obligate outcrosser, in comparison with a selfer, for its maintenance in a metapopulation with varying immigration and colony extinction rates, and contrasting

life-history attributes. They found that the strength of selection favoring reproductive assurance was strongest when colony extinction rates in a metapopulation increased and the number of immigrants to a site and the proportion of sites occupied decreased. Selection for reproductive assurance was diminished in perennial plants and for those with a seed bank since populations with these attributes have more than one opportunity to reproduce. The models indicate that selfing will be most advantageous when a species is uncommon across the landscape, and will decrease in importance as local population densities increase.

This work suggests that an optimal mating system for a sexual invader in a fragmented landscape should include the ability to modify selfing rates according to local ecological and demographic conditions. When populations are small, or at low density, plants should self to maximize fertility, thus increasing population growth rates. However, when populations are large and pollinators and/or mates are not limiting, outcrossing and its attendant genetic benefits will be more beneficial. Clearly, sexual systems such as rigid self-incompatibility or dioecy will not generally provide this type of mating flexibility (although see Becerra and Lloyd 1992). This is more likely to be achieved in self-compatible plants, especially those that display prepotency of outcross over self-pollen. In these species the mating system is responsive to the size and composition of pollen loads received by stigmas, with outcross pollen favored in competitive situations, but self-pollen capable of fertilizing ovules when populations are small or pollen vectors are limiting (Cruzan and Barrett 1996).

How often is plant reproductive success pollen limited, especially in invading species? Comparisons of fruit and seed set in naturally pollinated flowers versus those that have received supplemental hand pollination can be used to assess the incidence of pollen limitation in plant populations. A survey of 258 species of flowering plants by Burd (1994) indicated that 62 percent were pollen limited at some times or locations. Few of the species included in this survey could be legitimately classified as successful invaders, presumably because most investigators interested in pollen limitation assumed that this group would be unlikely to suffer from low fertility due to insufficient pollination. This may not be a safe assumption, especially in animal-pollinated invaders encountering novel environments. As discussed earlier, pollen limitation occurs in small populations of *Lythrum salicaria* (Ågren 1996), even in its native range, and has also been documented in *Eichhornia crassipes* at the margin of its adventive range in California (Barrett 1980). At present our ability to predict which species are likely to suffer from pollen limitation is hampered by a lack of information on the ecological mechanisms responsible. A recent attempt to investigate the correlates of pollen limitation using the techniques of comparative biology identified several life-history traits that

decreased the likelihood of pollen limitation, the most obvious of which were self-compatibility and the facility for autonomous self-pollination (Larson and Barrett 2000). Experimental studies that compare the fertility of open- versus hand-pollinated flowers of outcrossing invaders under diverse environmental and demographic conditions, including those expected to occur under various global change scenarios, would be valuable in assessing the role that pollen limitation may have on the invasion process.

Agriculture and Biotechnology

One of the major causes of global land-use change is the clearance of self-sustaining wild vegetation and its replacement by cultivated lands used for agriculture, horticulture, and forestry. Cultivated lands are those regularly used to grow domesticated plants, ranging from agroforestry to permanent multi-cropping systems, to fodder species grown for animal grazing. The world total of cultivated lands is estimated to have increased since 1700 by 466 percent with a total of 12×10^6 km² of land brought into cultivation during this period (Richards 1990). While in some areas the pace of conversion has slowed or even stopped (e.g., Europe), at a global level cultivated lands are increasing to keep pace with the needs of an expanding human population.

The fundamental biological characteristic that unites cultivated lands and distinguishes them from almost all natural ecosystems is their dramatic reduction in ecological and genetic diversity. Cultivated lands appear as vast areas of environmental homogeneity with a high level of spatial and temporal predictability associated with land-use and management practices. One of the major goals of modern crop husbandry is to minimize the heterogeneity of the physical and biotic components of the environment in an effort to produce a uniform set of growing conditions. Through modern plant breeding and biotechnology, monocultures of genetically uniform crops contribute to the biological impoverishment of arable land. The application of pesticides, fungicides, and herbicides further reduces biological complexity in order to maximize the yields of cultivated plants.

Evolution of Agricultural Weeds

Invading plants have been associated with agriculture since its very beginnings. Agricultural weeds originated from pioneers of the early stages of secondary succession and possessed life-history traits that enabled them to rapidly colonize arable fields (Bunting 1960). Unlike natural migrations resulting from past climate change, or invasions of waste and derelict land, plants that colonize agricultural ecosystems confront a distinct set of challenges, the most serious of which is the grower's determination to eradicate

them through increasingly sophisticated weed control technologies. Is there evidence that invaders have responded to these challenges by evolving strategies that promote their own fitness? In common with several other anthropogenically driven environmental changes (e.g., pollution and heavy metal contamination, see Bradshaw and McNeilly 1991), the selection intensities imposed by agricultural practices are often considerably stronger than those evident in natural ecosystems. Indeed, some of the best examples of natural selection involve environmental pressures imposed by such human-related activities (Endler 1986; Gould 1991). Not surprisingly then, there is good evidence that some weed species have evolved races specifically adapted to agriculture (Barrett 1988). In some cases the degree of specialization is so fine-tuned that the invaders are incapable of surviving outside of the crop environment despite their abundance within fields. The existence of these satellite weeds of crops should warn us against any generalizations concerning the "ideal attributes" of invading species (Baker 1965). Instead of exhibiting broad ecological tolerance to a wide range of environments, a typical feature of many invaders, agricultural weed races usually possess several croplike traits, which gives them poor survival in most other environments.

Perhaps the most remarkable example of this phenomenon involves the evolution of crop mimicry among annual barnyard grasses (*Echinochloa* spp.). A handful of *Echinochloa* species are commonly found in and around cultivated rice fields in most regions of the world. However, in several Asian countries (e.g., China and Japan), hand-weeding has been practiced over a long period, and this has led to the evolution of rice mimicry (Barrett 1983, 1987). Barnyard grasses that are most different in appearance to the crop are preferentially removed from fields. Over time this favors a syndrome of traits that makes plants difficult to distinguish from cultivated rice because of convergent morphology and phenology. For example, *Echinochloa phyllopogon* (= *E. oryzicola*) is so similar in appearance to rice that it usually goes unnoticed during most of the growing season and seeds are harvested along with the rice because both plants reach maturity at the same time.

Today, because of the distribution of rice seed contaminated with barnyard grasses, the mimics occur in many regions of the world where cultivated rice is grown. In most of these areas, hand-weeding is no longer practiced, and the fate of the mimics depends on their ability to tolerate improved agronomic practices, including weed control by herbicides. Recent evidence suggests that at least in some regions, these invaders have the necessary genetic variation to enable evolutionary responses to these new challenges. In California, where *E. phyllopogon* was introduced from Japan at the beginning of rice cultivation in 1915 (Barrett and Seaman 1980), the species has recently developed resistance to Londax, the major herbicide controlling barnyard grasses in rice (D. Bayer, personal communication). This example is not an isolated case, and there are

now growing concerns that increased worldwide herbicide use is resulting in the spread of a new class of agricultural invaders: herbicide-resistant weeds.

Spread of Herbicide-Resistant Weeds

Beginning with the introduction of 2,4-D in 1946, agrochemical companies have developed a wide spectrum of selective herbicides aimed at reducing weed populations in cultivated lands. The use of herbicides simplifies weed management in most cropping systems so that growers no longer need to use tillage, burning, cover crops, fallow and crop rotation as strategies for reducing weed infestations. However, the reliance on a single means of control has drawbacks, especially if the efficacy of the method is threatened by the evolution of herbicide resistance in weed populations (Le Baron and Gressel 1982; Caseley et al. 1991). Resistance refers to the ability of some individuals to survive a herbicide treatment that under normal conditions would effectively control the weed population. The ability to survive is heritable, and selection of resistant genotypes can eventually result in control failure. Typically, resistant individuals occur at very low frequencies in weed populations usually ranging from 1 in 100,000 to 1 in 100 million. However, because of the high survival value of resistance genes in the face of repeated herbicide sprays, and the prodigious reproductive capacities of many weeds, the spread of individuals able to tolerate herbicides can be remarkably rapid.

Despite early predictions that herbicide resistance was unlikely to become widespread in weed populations (Harper 1956; Gressel and Segel 1978), a 1997 international survey recorded 188 cases of herbicide-resistant weeds in forty-two countries (Heap 1997). A total of 126 weed species are now known to have evolved resistance to one or more herbicides with, the vast majority of cases occurring in developed countries where herbicides are the primary method of weed control. Following the first report of triazine-resistant common groundsel (Senecio vulgaris) in 1968 (Ryan 1970), most early cases of herbicide resistance involved this class of herbicides. By 1983 triazine-resistant weeds accounted for 67 percent of the documented reports of herbicide resistance. Today, however, this figure has dropped to 15 percent because of the introduction of many new herbicides with differing modes of action. Of these, resistance to acetolactase synthase inhibitors, bipyridyliums, phenylureas, and ACCase (acetylcoenzyme A carboxylase) inhibitors is most commonly reported. In contrast, few weeds have evolved resistance to chloracteamides, diphenylethers, and glyphosphate, despite their widespread use. It is clear that the likelihood of weeds evolving resistance to herbicides varies with species and the mode of action of the herbicide.

Particularly alarming has been the development of cross-resistance and multiple resistance in weed populations. In the former, a weed genotype is

resistant to two or more herbicides due to a single resistance mechanism whereas the latter refers to situations where plants possess two or more distinct resistance mechanisms. These forms of resistance have developed when growers switch herbicides because the initial herbicide becomes ineffective. Weeds that have multiple resistance to a broad spectrum of herbicides are the most difficult to control and are therefore of greatest concern to growers. Several grass species (e.g., *Lolium rigidum* in Australia, *Alopecurus myosuroides* in Europe, and *Avena fatua* in North America, reviewed by Heap, 1997) fall into this category; and of these, *L. rigidum* (annual ryegrass) is fast developing a reputation in Australia as a "superweed" because of its resistance to a wide variety of different herbicides.

Biotechnology and Weed Invasions

Will future developments in genetic engineering and biotechnology thwart the spread of herbicide-resistant weeds? Unfortunately, this does not seem likely. One of the major commercial applications of biotechnology to crop production has been the development of herbicide-resistant crops (Gasser and Fraley 1989; Caseley et al. 1991; Lal and Lal 1993). Those already on the market include soybeans resistant to glyphosphate and sulfonylurea herbicides and corn resistant to imazethapyr. It seems likely that in the future biotechnology companies will place heavy emphasis on the development and marketing of many additional herbicide-resistant varieties. Rather than reducing herbicide use, these developments are likely to lead to a stronger dependency and prolonged use of herbicides, thus increasing the probability of developing more resistance in weed populations. Future management strategies that include ways to reduce herbicide use through a combination of lower application rates, diverse cropping systems, and rotation offer the best long-term solutions for developing farming systems that are not reliant on crops that have been genetically transformed to tolerate herbicide applications.

The final issue concerning the relationships between agriculture, biotechnological change, and plant invasions involves the potential threats to the environment posed by genetically engineered (transgenic) organisms. A considerable literature has developed in recent years on this topic (e.g., Colwell et al. 1985; Tiedje et al. 1989; Mooney and Bernardi 1990; Raybould and Gray 1993; Russo and Cove 1995; Snow and Palma 1997), but from the perspective of plant invasions the problem largely boils down to two main questions: Will transgenic crops themselves become invasive? Could the transfer of genes from transgenic crops to their wild relatives through natural hybridization result in the origin of more aggressive weedy types? There is a diversity of opinions concerning these two scenarios. Most scientists agree that transgenic

crops are rather unlikely to become successful invaders since the majority of genetic changes brought about by human domestication have resulted in traits with low survival value outside the crop environment (e.g., loss of seed dispersal, lack of dormancy, high palatability, and poorly developed chemical defences against pest and diseases). However, the occurrence of weedy hybrids containing genetic constructs from transgenic crops that confer increased invasibility is certainly possible, since many crops co-occur in fields with interfertile relatives and hybridization between crops and weeds is commonplace (Ellstrand and Hoffman 1990). Recently, genes for herbicide resistance engineered into outcrossing oilseed rape (*Brassica rapus*) were found to persist for several generations in hybrids between the transgenic rape and wild radish (*Raphanus raphanistrum*) under field conditions (Chèvre et al. 1997). Even in predominantly selfing plants, rare outcrossing events can result in genetic exchange between plants. For example, Bergelson et al. (1998) found that transgenic plants of the weed *Arabidopsis thaliana* resistant to the herbicide chlorsulphuron were twenty times more likely to donate pollen to wild-type plants than were other lines of the species containing the same mutant alleles. Introduction of transgenes for herbicide, disease, or pest resistance into weedy relatives of crops could increase their fitness in the crop environment and further exacerbate existing weed problems. Assessing the fitness effects and potential for invasiveness of such transgenes in weed species has rarely been attempted (but see Bergelson 1994; Purrington and Bergelson 1995).

The most obvious strategy to prevent the ecological risks associated with biotechnology involves a ban on the future development of transgenic crops. While this is unlikely to occur, especially in North America, recent developments in Europe involving protests and social action against biotechnology companies and widespread consumer distrust of products arising from genetic engineering, should give the more optimistic advocates of biotechnology cause for thought. In the meantime simple measures such as the growing of transgenic crops in areas where wild relatives are rare or absent should mitigate problems of genetic exchange between crops and weeds and reduce the likelihood of the accidental origin of novel plant invaders through genetic engineering.

Final Remarks

Global changes involve diverse environmental influences, many of which are likely to act as important selective pressures on plant populations. Predicting the particular microevolutionary responses to these changes is a difficult task without knowledge of the amounts and patterns of genetic variation for adaptive traits and the nature of selection acting on these traits. Whether var-

ious global change scenarios might lead to genetic alterations that promote increased plant invasiveness is at present unclear. Based on a review of several invaders (animals and micro-organisms), Williamson (1996) claimed that "the critical difference between success and failure [of an invader] will often come from differences at around 10 genes or fewer" (p. 154). Unfortunately, no work has been conducted on the genetic basis of invasiveness in plants, so it would be premature to speculate how many genes may be responsible in most cases. There is still considerable debate on the genetics of adaptation, and especially on whether genetic changes at a small number of loci are sufficient to promote significant changes in ecology (Orr and Coyne 1992).

Quantitative trait loci (QTL) mapping studies of adaptive characters that determine fitness offer the best hope for understanding the genetic architecture of plant invasiveness (see Mitchell-Olds 1995). However, in the future, even if we do determine the number of loci governing traits associated with colonizing ability, this information will be of little value without knowledge of the ecological context in which a particular invasion occurs. Genotypes may behave in a benign manner in some environments, whereas in other ecological settings they can be transformed into aggressive invaders. If we are interested in understanding the biological basis of invasions, the ecological and genetic dimensions of the problem should not be separated.

One of the most remarkable aspects of biological invasions is how unpredictable they are. Because of this, we should not be surprised if totally unexpected plant invaders appear, aided by new environmental conditions arising from global change. One potential mechanism by which this seems likely to occur is through hybridization, the mixing of genetically distinct gene pools. This may be especially important under global change scenarios of increased landscape disruption and the spread of disturbed habitats. These conditions have long been recognized as fertile ground for fostering genetic exchange between species (Anderson 1948). Several well-known cases of plant invasions promoted by interspecific hybridization resulting in new taxa are already known (Raybould et al. 1991; Soltis et al. 1995; Abbott 1992), and we should expect additional examples in the future, given the weak reproductive isolating mechanisms that are typical in many plant taxa.

A more insidious and less appreciated mechanism promoting invasiveness is the potential mixing of genetically differentiated population systems within outcrossing species in their alien ranges. The spectacular spread of the hypervariable Patterson's curse, *Echium plantagineum* (Boraginaceae) in Australia (Brown and Burdon 1983) and *Lythrum salicaria* in North America (Thompson et al. 1987), seems likely to have been promoted by crosses between genotypes introduced from different parts of Europe. Out of such a diverse "hybrid soup" inevitably comes genetic combinations with novel phenotypes. While the majority are usually maladapted, some will eventually dis-

play high fitness and superior colonizing ability. Further selection aided by abundant genetic variation will refine these phenotypes to local conditions. The expansion and mixing of plant distributions, aided by the globalization of world trade and the burgeoning horticultural industry, seem likely to provide more opportunities for the future genesis of new plant invasions.

Acknowledgments

I thank Chris Eckert, Marcel Dorken, and Brendon Larson for permission to cite unpublished work, Suzanne Barrett for comments on the manuscript, Bill Cole for providing technical support, and research grants from the Natural Sciences and Engineering Research Council of Canada that have supported my work on invading species.

References

Abbott, R.J. 1992. "Plant invasions, interspecific hybridization, and the evolution of new plant taxa." *Trends in Ecology and Evolution* 7: 401–405.

Ågren, J. 1996. "Population size, pollinator limitation, and seed set in the self-incompatible herb *Lythrum salicaria*." *Ecology* 77: 1779–1790.

Anderson, E. 1948. "Hybridization of the habitat." *Evolution* 2: 1–9.

Baker, H.G. 1965. "Characteristics and modes of origins of weeds." In *The Genetics of Colonizing Species,* edited by H.G. Baker and G.L. Stebbins, 141–172. London: Academic Press.

———. 1974. "The evolution of weeds." *Annual Review of Ecology and Systematics* 5: 1–24.

Barrett, S.C.H. 1980. "Sexual reproduction in *Eichhornia crassipes* (water hyacinth). II. Seed production in natural populations." *Journal of Applied Ecology* 17: 113–124.

———. 1983. "Crop mimicry in weeds." *Economic Botany* 37: 255–282.

———. 1987. "Mimicry in plants." *Scientific American* 257: 76–83.

———. 1988. "Genetics and evolution of agricultural weeds." In *Weed Management in Agroecosystems: Ecological Approaches,* edited by M.A. Altieri and M. Liebman, 57–76. Boca Raton, Florida: CRC Press Inc.

———. 1989. "Waterweed invasions." *Scientific American* 260: 90–97.

———. 1992. "Genetics of weed invasions." In *Applied Population Biology,* edited by S.K. Jain and L. Botsford, 91–119. Dordrecht: Kluwer Academic Publishers.

Barrett, S.C.H., and C.G. Eckert. 1990. "Variation and evolution of mating systems in seed plants." In *Biological Approaches and Evolutionary Trends in Plants,* edited by S. Kawano, 229–254. London: Academic Press.

Barrett, S.C.H., and B.C. Husband. 1997. "Ecology and genetics of ephemeral plant populations: *Eichhornia paniculata* (Pontederiaceae) in northeast Brazil." *Journal of Heredity* 88: 257–263.

Barrett, S.C.H., and J.R. Kohn. 1991. "Genetic and evolutionary consequences of small population size in plants: implications for conservation." In *Genetics and Conser-*

vation of Rare Plants, edited by D.A. Falk and K.E. Holsinger, 3–30. New York: Oxford University Press.

Barrett, S.C.H., and D.E. Seaman. 1980. "The weed flora of Californian rice fields." *Aquatic Botany* 9: 351–376.

Barrett, S.C.H. et al., 1993. "Evolutionary processes in aquatic plant populations." *Aquatic Botany* 44: 105–145.

Bazzaz, F.A. 1996. *Plants in Changing Environments.* Cambridge: Cambridge University Press.

———, et al. 1995. "Microevolutionary responses in experimental populations of plants to CO_2-enriched environments: parallel results from two model systems." *Proceedings of the National Academy of Sciences* 92: 8161–8165.

Becerra J.X., and D.G. Lloyd. 1992. "Competition-dependent abscission of self-pollinated flowers of *Phormium tenax* (Agavaceae): a second action of self-incompatibility at the whole flower level?" *Evolution* 46: 458–469.

Beerling, D.J. 1993. "The impact of temperature on the northern distribution limits of the introduced species *Fallopia japonica* and *Impatiens glandulifera* in northwest Europe." *Journal of Biography* 20: 45–53.

Bergelson, J. 1994. "Failing to predict invasiveness from changes in fecundity: a model study of transgenic plants using resistant *Arabidopsis thaliana.*" *Ecology* 75: 249–252.

———, et al. 1998. "Promiscuity in transgenic plants." *Nature* 395: 25.

Bijlsma, R., et al. 1994. "On genetic erosion and population extinction in plants: a case study in *Scabiosa columbaria* and *Salvia pratensis.*" In *Conservation Genetics,* edited by V. Loeschcke, J. Tomiuk, and S.K. Jain, 255–271. Basel: Birkhäuser.

Box, E.O. 1981. *Macroclimate and Plant Form.* The Hague: Junk.

Bradshaw, A.D., and T. McNeilly. 1991. "Evolution in relation to environmental stress." In *Ecological Genetics and Air Pollution,* edited by G.E. Taylor Jr., L.F. Pitelka and M.T. Clegg, 11–32. Berlin: Springer-Verlag.

Briggs, D., and S.M. Walters. 1997. *Plant Variation and Evolution.* Cambridge: Cambridge University Press.

Brown, A.H.D. 1979. "Enzyme polymorphisms in plant populations." *Theoretical Population Biology* 15: 1–42.

Brown, A.H.D., and J.J. Burdon. 1983. "Multilocus diversity in an outbreeding weed, *Echium plantagineum* L." *Australian Journal of Biological Sciences* 36: 503–509.

———. 1987. "Mating systems and colonizing success in plants." In *Colonization, Succession and Stability,* edited by A.J. Gray, M.J. Crawley, and P.J. Edwards, 115–131. Oxford: Blackwell Science Publishers.

Brown, A.H.D., and D.R. Marshall. 1981. "Evolutionary changes accompanying colonization in plants." In *Evolution Today,* edited by G.G.E. Scudder and J.L. Reveal, Proceedings of the Second International Congress of Systematic and Evolutionary Biology, 351–363. Pittsburgh: Carnegie-Mellon University.

Bunting, A.H. 1960. "Some refections on the ecology of weeds." In *The Biology of Weeds,* edited by J.L. Harper, 11–26. Oxford: Blackwell Science Publishers.

Burd, M. 1994. "Bateman's principle and plant reproduction: the role of pollen limitation in fruit and seed set." *Botanical Review* 60: 83–139.

Burdon, J.J., and D.R. Marshall, 1981. "Biological control and the reproductive mode of weeds." *Journal of Applied Ecology* 18: 649–658.

Callaghan, T.V., et al. 1997. "Arctic clonal plants and global change." In *The Ecology and Evolution of Clonal Plants,* edited by H. de Kroon and J. van Groenendael, 381–404. Leiden: Backhuys Publishers.

Caseley, J.C., et al. 1991. *Herbicide Resistance in Weeds and Crops.* Oxford: Butter-worth-Heinemann.

Charlesworth, D., and B. Charlesworth. 1987. "Inbreeding depression and its evolutionary consequences." *Annual Review of Ecology and Systematics* 18: 237–268.

Chèvre, A.-M., et al. 1997. "Gene flow from transgenic crops." *Nature* 389: 924.

Clausen, J., et al. 1947. "Experimental studies on the nature of species. I. The effect of varied environments on western North American plants." Publication 520, Washington, D.C.: Carnegie Institution of Washington.

Colwell, R.K., et al. 1985. "Genetic engineering in agriculture." *Science* 229: 111–112.

Comes, H.P., and J.W. Kadereit. 1998. "The effect of quaternary climatic changes on plant distribution and evolution." *Trends in Plant Sciences* 3: 432–438.

Cruzan, M.B., and S.C.H. Barrett. 1996. "Postpollination mechanisms influencing mating patterns and fecundity: an example from *Eichhornia paniculata.*" *American Naturalist* 147: 576–598.

Curtis, P.S., et al. 1994. "Genotypic-specific effects of elevated CO_2 on fecundity of wild radish (*Raphanus raphanistrum*)." *Oecologia* 97: 100–105.

Cwynar, L.C., and G.M. MacDonald, 1987. "Geographical variation of lodgepole pine in relation to population history." *American Naturalist* 129: 463–469.

DiMichele, W.A., et al. 1987. "Opportunistic evolution: abiotic environmental stress and the fossil record of plants." *Review of Palaeobotany and Palynology* 50: 151–178.

Dorken, M.E., and C.G. Eckert. 1999. "Severely reduced sexual reproduction in peripheral populations of a clonal plant, *Decodon verticillatus* (Lythraceae)." (Under review.)

Eckert, C.G., and S.C.H. Barrett. 1992. "Stochastic loss of style morphs from populations of tristylous *Lythrum salicaria* and *Decodon verticillatus* (Lythraceae)." *Evolution* 46: 1014–1029.

Eckert, C.G., et al. 1996. "Genetic drift and founder effect in native versus introduced populations of an invading plant, *Lythrum salicaria* (Lythraceae)." *Evolution* 50: 1512–1519.

———. 1999. "Loss of sex in clonal populations of a flowering plant, *Decodon verticillatus* (Lythraceae)." *Evolution* 53: 1079–1092.

Ellstrand, N.C., and D. R. Elam, 1993. "Population genetic consequences of small population size: implications for plant conservation." *Annual Review of Ecology and Systematics* 24: 217–242.

Ellstrand, N.C., and C.A. Hoffman. 1990. "Hybridization as an avenue of escape for engineered genes." *BioScience* 40: 438–442.

Endler, J.A. 1986. *Natural Selection in the Wild.* Princeton: Princeton University Press.

Firbank, L.G., et al. 1995. "Plant populations and global environmental change: the effect of different temperature, carbon dioxide and nutrient regimes on density dependence in populations of *Vulpia ciliata.*" *Journal of Applied Ecology* 9: 432–441.

Gasser, C.S., and R.T. Fraley. 1989. "Genetically engineering plants for crop improvement." *Science* 244: 1293–1299.

Geber, M.A., and T.E. Dawson, 1993. "Evolutionary responses of plants to global change." In *Biotic Interactions and Global Change,* edited by P.M. Kareiva, J.G. Kingsolver, and R.B. Huey, 179–197. Sunderland, Massachusetts: Sinauer Associates Inc.

Gould, F. 1991. "The evolutionary potential of crop pests". *American Scientist* 79: 496–507.

Gould, S.J. 1985. "The paradox of the first frontier: an agenda for paleobiology." *Paleobiology* 11: 2–12.

Gressel, J., and L.A. Segel. 1978. "The paucity of plants evolving genetic resistance to herbicides." *Journal of Theoretical Biology* 75: 349–371.

Grime, J.P. 1979. *Plant Strategies and Vegetation Processes.* Chichester: John Wiley and Sons.

———. 1997. "Climate change and vegetation." In *Plant Ecology,* edited by M.J. Crawley, 582-594. Oxford: Blackwell Science Ltd.

Groom, M.J., and N. Schumaker. 1993. "Evaluating landscape change: patterns of worldwide deforestation and local fragmentation." In *Biotic Interactions and Global Change,* edited by P.M. Kareiva, J.G. Kingsolver, and R.B. Huey, 24–44. Sunderland, Massachusetts: Sinauer Associates Inc.

Hamilton, W.D. 1980. "Sex versus non-sex versus parasite." *Oikos* 35: 282–290.

Hamrick, J.L., and M.J.W. Godt. 1989. "Allozyme diversity in plant species." In *Plant Population Genetics, Breeding, and Genetic Resources,* edited by A.H.D. Brown, M.T. Clegg, A.L. Kahler, and B.S. Weir, 43–63. Sunderland, Massachusetts: Sinauer Associates Inc.

———. 1997. "Effects of life history traits on genetic diversity in plant species." In *Plant Life Histories: Ecology, Phylogeny and Evolution,* edited by J. Silvertown, M. Franco, and J.L. Harper, 102–118. Cambridge: Cambridge University Press.

Harper, J.L. 1956. "The evolution of weeds in relation to resistance by herbicides." *Proceedings of the Third British Weed Control Conference* 1: 179.

———. 1977. *Population Biology of Plants.* London: Academic Press.

Harrison S., and A. Hastings. 1996. "Genetic and evolutionary consequences of metapopulation structure." *Trends in Ecology and Evolution* 11: 180–183.

Heap, I.M. 1997. The occurrence of herbicide-resistant weeds worldwide. *Pesticide Science* 51: 235–243.

Higgins, S.I., et al. 1996. "Modeling invasive plant spread: the role of plant environment interactions and model structure." *Ecology* 77: 2043–2054.

Holt, R.D. 1990. "The microevolutionary consequences of climate change." *Trends in Ecology and Evolution* 5: 311–315.

Huntley, B. 1991. "How plants respond to climate change: migration rates, individualism and the consequences for plant communitites." *Annals of Botany, Supplement* 67: 15–22.

Husband, B.C., and S.C.H. Barrett. 1992. "Effective population size and genetic drift in tristylous *Eichhornia paniculata* (Pontederiaceae)." *Evolution* 46: 1875–1890.

Husband, B.C., and S.C.H. Barrett. 1996. "A metapopulation perspective in plant population biology." *Journal of Ecology* 84: 461–469.

Karron, J.D., et al. 1995. "The influence of population density on outcrossing rates in *Mimulus ringens*." *Heredity* 75: 175–180.

Klekowski, E.J. Jr. 1988. *Mutation, Developmental Selection and Plant Evolution*. New York: Columbia University Press.

———. 1997. "Somatic mutation theory of clonality." In *The Ecology and Evolution of Clonal Plants*, edited by H. de Kroon and J. van Groenendael, 227–241. Leiden: Backhuys Publishers.

Lal, R., and S. Lal. 1993. *Genetic Engineering of Plants for Crop Improvement*. Boca Raton, Florida: CRC Press Inc.

Larson, B., and S.C.H. Barrett. 2000. "A comparative analysis of pollen limitation in angiosperms." *Biological Journal of the Linnean Society* 69: 503–520.

Lavorel, S., et al. 1997. "Plant functional classifications: from general groups to specific groups based on response to disturbance." *Trends in Ecology and Evolution* 12: 474–478.

Le Baron, H.M., and J. Gressel. 1982. *Herbicide Resistance in Plants*. New York: John Wiley and Sons.

Leemans, R. 1996. "Biodiversity and global change." In *Biodiversity: A Biology of Numbers and Difference*, edited by K.J. Gaston, 367–387. Oxford: Blackwell Science Ltd.

Linhart, Y.B., and M.C. Grant, 1996. "Evolutionary significance of local genetic differentiation in plants." In *Annual Review of Ecology and Systematics* 27: 237–278.

Lloyd, D.G. 1980. "Demographic factors and mating patterns in angiosperms." In *Demography and Evolution in Plant Populations*, edited by O.T. Solbrig, 67–88, Oxford: Blackwell Scientific Publications.

Lynch, M., and R. Lande. 1993. "Evolution and extinction in response to environmental change." In *Biotic Interactions and Global Change*, edited by P.M. Kareiva, J.G. Kingsolver, and R.B. Huey, 234–250. Sunderland, Massachusetts: Sinauer Associates Inc.

MacArthur, R.H., and E.O. Wilson. 1967. *The Theory of Island Biogeography*. Princeton, New Jersey: Princeton University Press.

Mazer, S., and G. LeBuhn. 1999. "Genetic variation in life history traits: heritability estimates within and genetic diffentiation among populations." In *Life History Evolution in Plants*, edited by T. Vuorisalo and P. Mutikanen. Dordrecht, Netherlands: Kluwer Academic (in press).

McCauley, D. 1993. "Genetic consequences of extinction and recolonization in fragmented habitats." In *Biotic Interactions and Global Change*, edited by P.M. Kareiva, J.G. Kingsolver, and R.B. Huey, 217–233. Sunderland, Massachusetts: Sinauer Associates Inc.

McKee, J., and A.J. Richards. 1996. "Variation in seed production and germinability in common reed (*Phragmites australis*) in Britain and France with respect to climate." *New Phytologist* 133: 233–243.

Mitchell-Olds, T. 1995. "The molecular basis of quantitative genetic variation in natural populations." *Trends in Ecology and Evolution* 10: 324–328.

Mitchell-Olds, T. and J. Bergelson. 1990. "Statistical genetics of an annual plant, *Impatiens capensis*. I. Genetic basis of quantitative variation." *Genetics* 124: 407–415.

Mitchell-Olds, T., and J.J. Rutledge. 1986. "Quantitative genetics in natural plant populations: a review of the theory." *American Naturalist* 127: 379–402.

Mooney, H.A., and G. Bernardi (eds.). 1990. *Introduction of Genetically Modified Organisms into the Environment.* SCOPE. New York: John Wiley and Sons.

Mooney, H.A., and W.D. Billings. 1961. "Comparative physiological ecology of arctic and alpine populations of *Oxyria digyna.*" *Ecological Monographs* 31: 1–29.

Mooney, H.A., and J.R. Drake. 1986. *Ecology of Biological Invasions of North America and Hawaii.* Berlin: Springer-Verlag.

Nobel, P.S. 1991. *Physiochemical and Environmental Plant Physiology.* New York: Academic Press.

Orr, H.A., and J.A. Coyne. 1992. "The genetics of adaptation: a reassessment." *American Naturalist* 140: 725–742.

Pannel, J.R., and S.C.H. Barrett. 1998. "Baker's Law revisited: reproductive assurance in a metapopulation." *Evolution* 52: 657–668.

Purrington, C.B., and Bergelson, J. 1995. "Assessing weediness of transgenic crops: industry plays plant ecologist." *Trends in Ecology and Evolution* 10: 340–342.

Raybould, A.F., and A. J. Gray. 1993. "Genetically modified crops and hybridization with wild relatives." *Journal of Applied Ecology* 30: 199–219.

Raybould, A.F., et al. 1991. "The evolution of *Spartina anglica* C.E. Hubbard (Gramineae): origin and genetic variability." *Biological Journal of the Linnean Society* 43: 111–126.

Rejmánek, M., and D.M. Richardson. 1996. "What attributes make some plant species more invasive?" *Ecology* 77: 1655–1661.

Richards, J.F. 1990. "Land transformation." In *The Earth as Tranformed by Human Action,* edited by B.L. Turner II, W.C. Clark, R.W. Kates, J.F. Richards, J.T. Mathews, and W.B. Meyer, 163–178. Cambridge: Cambridge University Press.

Russo, E., and D. Cove. 1995. *Genetic Engineering. Dreams and Nightmares.* London: Freeman.

Ryan, G.F. 1970. "Resistance of common groundsel to simazine and atrazine." *Weed Science* 18: 614–616.

Schlichting, C.D., and M. Pigliucci. 1998. *Phenotypic Evolution: A Reaction Norm Perspective.* Sunderland, Massachusetts: Sinauer Associates Inc.

Schaal, B.A., et al. 1998. "Phylogeographic studies in plants: problems and prospects." *Molecular Ecology* 7: 465–474.

Shigesada, N., and K. Kawasaki. 1997. *Biological Invasions: Theory and Practice.* Oxford: Oxford University Press.

Snow, A.A., and P.M. Palma. 1997. "Commercialization of transgenic plants: potential ecological risks." *BioScience* 47: 86–96.

Soltis, D.E., et al. 1997. "Chloroplast DNA intraspecific phylogeography of plants from the Pacific Northwest of North America." *Plant Systematics and Evolution* 206: 353–373.

Soltis, P.S., et al. 1995. "Genetic variation in *Tragopogon* species: additional origins of the allotetrapolyploids *T. mirus* and *T. miscellus* (Compositae)." *American Journal of Botany* 82: 1329–1341.

Sork, V.L., et al. 1999. Landscape approaches to historical and contemporary gene flow in plants. *Trends in Ecology and Evolution* 14: 219–224.

Taberlet, P., et al. 1998. "Comparative phylogeography and post-glacial colonization routes in Europe." *Molecular Ecology* 7: 453–464.

Thompson D.Q., et al. 1987. "Spread, impact and control of purple loosestrife (*Lythrum salicaria*) in North American wetlands." U.S. Fish and Wildlife Service. Fish and Wildlife Service Research 2.

Tiedje, J.M., et al. 1989. "The planned introduction of genetically engineered organisms: ecological considerations and recommendations." *Ecology* 70: 298–315.

Travis, J., and D.J. Futuyma. 1993. "Global change: lessons from evolutionary biology." In *Biotic Interactions and Global Change*, edited by P.M. Kareiva, J.G. Kingsolver, and R.B. Huey, 251–263. Sunderland, Massachusetts: Sinauer Associates Inc.

Vitousek, P.M., et al. 1996. "Biological invasions as global environmental change." *American Scientist* 84: 468–478.

Walker, B., and W. Steffen. 1996. *Global Change and Terrestrial Ecosystems*. Cambridge: Cambridge University Press.

Westoby, M. 1998. "A leaf-height-seed (LHS) plant ecology strategy scheme." *Plant and Soil* 199: 213–227.

Williamson, M. 1996. *Biological Invasions*. London: Chapman and Hall.

Wilson, E.O., and F.M. Peters (eds.). 1988. *Biodiversity*. Washington, D.C.: National Academy Press.

Woodward, F.I. 1987. *Climate and Plant Distribution*. Cambridge: Cambridge University Press.

Chapter 7

≈

Assessing the Extent, Status, and Dynamism of Plant Invasions: Current and Emerging Approaches

Richard N. Mack

Plant invasions—the spread, proliferation and persistence of naturalized plants (*sensu* Mack 1997)—present enormous consequences worldwide for both biodiversity and an increasingly interconnected global economy (Naylor 1996; Sandlund et al. 1996; Vitousek et al. 1997; Zavaleta, this volume). These phenomena collectively constitute a major component of global change (Vitousek et al. 1997 and references therein). The widely held perception among ecologists, agronomists, and conservationists is that these invasions are growing not only in their frequency but also in their areal extent, functions of humans' ability to facilitate both plant dispersal and naturalization in ever more habitats and locales (Drake et al. 1989; U.S. Congress 1993). But it is indeed largely a *perception*, not a view supported at all adequately by quantitative records of the areal extent of these invasions, much less by solidly based predictions of the future extent of these far-flung populations.

As a result, we usually lack the ability to provide explicit answers to the obvious questions asked by policy makers: "Across and within what specific

political boundaries are these invasions occurring?" "How abundant are the invaders?" "Which areas or habitats are next at risk of invasion?" "Are these invading populations expanding, remaining static, or even contracting?" Without ready answers, there is no sustained public interest, and more important, no sustained public support to control these pests (U.S. Congress 1993). Our current inability to answer these initial questions of appraisement for biotic invasions is fairly (if indelicately) analogous to a patient known by his/her physicians to be debilitated by parasites but without benefit of knowing which organs have already been attacked, the extent of the infection in those organs, the status of the parasite's populations (i.e., whether expanding, declining), the fate of as yet uninfected organs, and with only a murky understanding of the causative agents!

Documenting the scope, magnitude, and causes of human-induced changes to the earth's atmosphere has simultaneously provided the justification for societal action to curb industrial emissions (National Academy of Sciences 1988). Likewise, an early (if not the first) order of business in building global awareness of biotic invasions as agents of global change must involve building comprehensive and quantitative records of their extent, status, and dynamism. I outline below what has been and could be done to address these basic issues for biotic invasions, as well as illustrate both the breadth of our current limitations and their potential solutions. I draw mostly on examples of terrestrial plant invasions, but I hope these examples will elicit parallels for other taxonomic groups.

Early Descriptive Assessments

Given the exclusive use of description in the early history of ecology, it is not surprising that the earliest assessments of plant invasions were qualitative (or at best coarsely semiquantitative). Charles Darwin (1898) provided one of the first and certainly one of the most vivid descriptions of a plant invasion at its zenith, the dominance of *Silybum marianum* (variegated thistle) in the Argentinean pampas by 1833. In recounting his overland journey from Bahia Blanca to Buenos Aires, he noted that "very many (probably several hundred) square miles are covered by one mass of these prickly plants, and are impenetrable to man or beast. Over the undulating plains, where these great beds occur, nothing else can now live." Although Darwin was making by necessity the crudest type of estimate of the variegated thistle's extent, we have no reason to question his assessment. (They were later corroborated by Hudson [1923], a longtime resident.) His descriptions of almost impenetrable thickets of *S. marianum* are totally unquantified, yet his accounts of thistle stands so dense that travel was confined to meandering cow paths provide graphic testimony to the incredible alteration of the native pampean grasslands by alien plants.

Limitations of this approach need no elaboration: they are nonquantitative and largely unverifiable except in the most general terms, lack a temporal (and even a reliable spatial) scale, and are subject to unlimited bias by the observer. Even with Darwin's famed account, there is uncertainty on whether he witnessed invasions by two composites (*S. marianum* and *Cynara cardunculus* [cardoon]) or by variegated thistle alone (cf. Parsons and Cuthbertson 1992; Soyrinki 1991).

Chronologies of Invasions Compiled from Herbarium Records

Scientific plant collecting was well underway in Darwin's lifetime, and herbarium specimens have proven to be indisputably valuable records of plant invasions. First and foremost, the specimen itself is an irreplaceable record of the alien (or nonindigenous) species in a new range. The identity of a flowering specimen can almost always be verified. Furthermore, the specimen label with its information on collection locale and date, habitat, associated plants, and physical environment provides raw data for reconstructing the course of invasion. Herbarium specimens are often the first (albeit belated) evidence that an alien species has appeared in a new range.

Chronologies of herbarium records have been used as strictly qualitative records of the progressive spread of an alien species. The earliest date of collection in each locale is assumed to be an approximation for the date of the alien's first local appearance. Thus, Beger (as reported by Hegi 1929) mapped the apparent westward spread of the alien *Senecio vernalis* across Europe, based on its earliest collections records from the eighteenth to the early twentieth centuries. This general approach has been subsequently employed alone or in combination with other lines of evidence elsewhere in Europe, drawing on extensive European plant collections (Kornas [1990] and references therein). Perhaps best known is Kent's (1956, 1960, 1964a,b) detailed account of the spread in Britain of *Senecio squalidus* (Oxford ragwort), a southern European native, from the Oxford Botanic Garden along railways to many other locales. Kent did not build a map chronology of Oxford ragwort's spread (but see Salisbury 1961). A map based only on the locations of herbarium records would however show a distinct disjunct range in ragwort's early spread, with the alien species largely confined to railways or urban areas (Kent 1960).

This investigative approach has more recent counterparts, notably the historical reconstructions of plant invasions for the aliens *Lythrum salicaria* (purple loosestrife), *Lycopus asper*, and *Lycopus europaeus* in the Great Lakes region of the United States and southern Canada (Stuckey 1969, 1980; Stuckey and Phillips 1970). Reconstruction of the spread of *Epilobium hirsa-*

tum (great hairy willow herb) across the northeast quarter of the United States and Ontario shows a remarkably orderly westward movement (Stuckey 1970) (Fig. 7.1). The species entered North America by at least 1829 at Newport, Rhode Island. In the next half-century its range expansion was confined largely to New England, but by the late nineteenth and early twentieth-centuries one arm of the spread had entered New York State and then migrated northward to Ontario. Another arm apparently moved contemporaneously across central New York State. Whether descendants from these two advances met in the St. Lawrence River Valley (as Stuckey indicates, Figure 7.1) is problematical; willow herb is now however in many habitats around Lake Ontario, Lake Erie, and westward. Mid-twentieth-century spread has been around Lake Erie to the southern and eastern shores of Lake Michigan (Stuckey 1970).

Chronologies of plant invasions often rely on additional independent lines of evidence to supplement herbarium records. In North America and Australia, local floras were often published decades before more comprehensive regional treatments and provide general descriptions of the local abundance of introduced plants (Kloot 1985; Piggin 1977; Stuckey 1970). Other potentially valuable nineteenth-century contemporaneous accounts include survey records along the proposed routes for railways, U.S. Census reports (which include comprehensive sections on regional agriculture), government-commissioned rangeland and weed surveys, field station extension reports, and even sale lists produced by members of that quintessential Victorian profession, the professional plant collector. Any reliable source has been employed, often ones that were not motivated at all by tracing the spread of alien plants. All illustrate the extent to which early biologists and agronomists recorded their field observations with a thoroughness not usually practiced today (Mack 1981, 1988; Piggin 1977). The often detailed records of seed contaminants in domestic grain elevators represent little-used proxies for documenting the spread of alien plants. In contrast to the better-known use of the grain import records to trace the entry of alien species into a new range (Suominen 1979 and references therein; Piggin 1977 and references therein), long-term records from domestic grain elevators potentially provide evidence for the first (and continuing) appearance of an alien species across a new range. These records are additional raw data for chronologies of alien species at known locales across its path(s) of invasion (McNamara 1966; Mack 1981).

An alternative approach maps the time course of first occurrences for the alien species in small political entities, such as counties. Salisbury (1932, 1961) prepared many such maps in tracing the spread of alien species across comital and vice-comital (i.e., progressively smaller divisions of large counties) areas in the British Isles. His maps indicate the putative chronology of an alien's spread county by county at approximately ten- to fifteen-year intervals

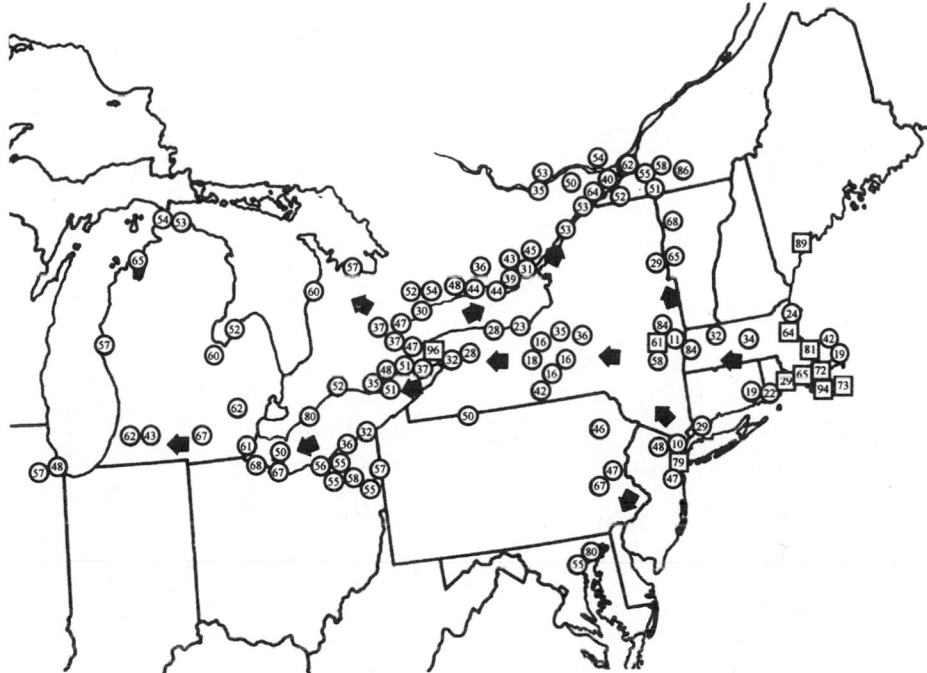

Figure 7.1. Spread of *Epilobium hirsutum* in eastern North America as inferred from the chronology of herbarium records. Each numbered symbol indicates a collection location. Numbers are the last two digits of the year for the oldest known collection at each location. Squares represent pre-1900 collections; circles represent post-1900 collections. Arrows indicate possible routes of spread (after Stuckey 1970).

(Salisbury 1961). No more detail on spatial extent is provided; in effect, one collection record for a county is deemed as meaningful as all subsequent records. Although these compilations have a coarse scale, they do suggest both possible direction(s) but more often the disjunct character of spread. Salisbury's mapping approach has been adopted by necessity in sparsely collected regions, such as western North America. Forcella (1985), Forcella and Harvey (1982, 1988), and Toney et al. (1998) have used this "first-collection-by-county" approach (*sensu* Forcella 1985) repeatedly in plotting the advance of alien species through the western United States. The putative course of the invasion by *Kochia scoparia* is illustrative of results inferred from this approach (Fig. 7.2). First collected in southeastern Wyoming before 1900, *K. scoparia* appears to have spread only in Wyoming before 1931–1940. After 1940, however, spread clearly accelerated, such that by 1980 *K. scoparia* occurred across extensive areas of Wyoming, Montana, and Idaho. More recent occurrences have been reported in Washington and Oregon (Forcella 1985).

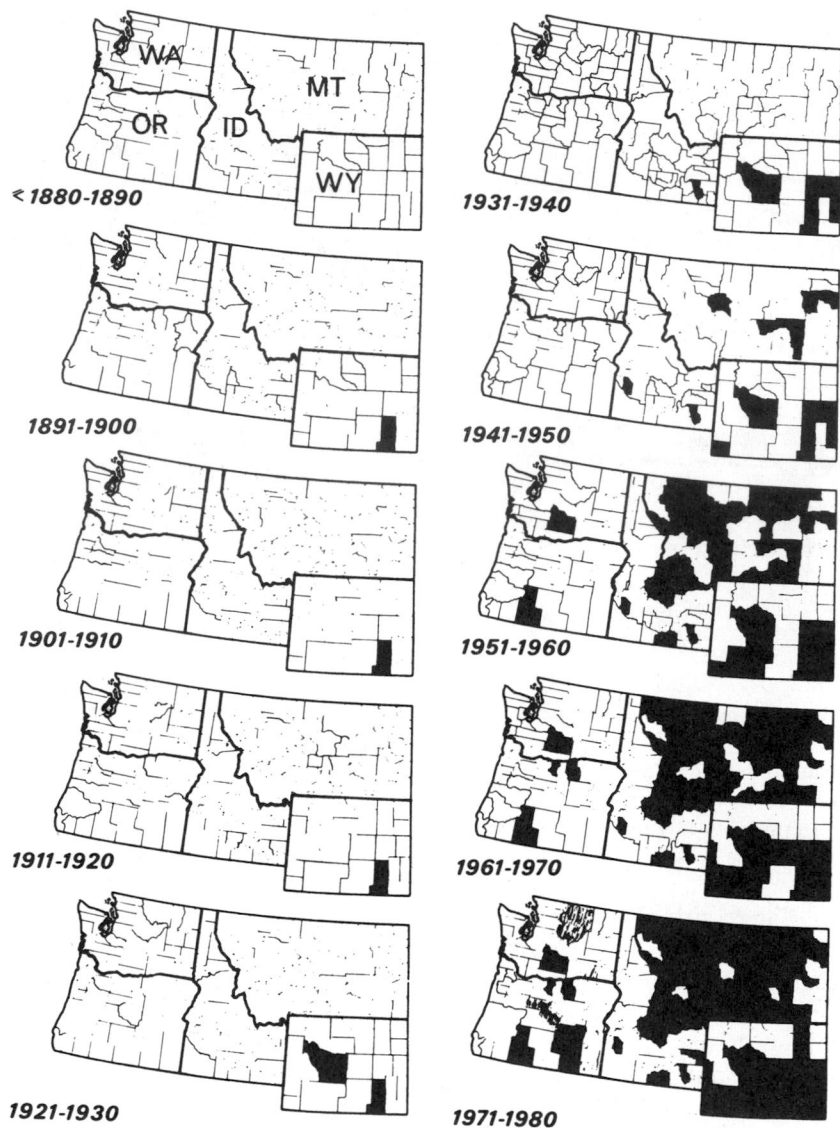

Figure 7.2. Spread chronology of *Kochia scoparia* in the northwestern United States based on the earliest collection record in each county. *Kochia scoparia* was collected pre-1891 in Wyoming; it was first detected in Idaho post-1930. Putative pattern of spread accelerated rapidly after 1950 (after Forcella 1985).

Attempts to compile all the herbarium records for large geographic regions, including nationwide compilations, have simultaneously enhanced the value of these records for assessing plant invasions. For example, the Mexican CONABIO (National Commission for the Knowledge and Use of Biodiversity) project is currently building the computer database for all specimen records of vascular plants collected in Mexico, regardless of whether specimens are housed in Mexico. One dividend of this comprehensive approach will be the ability to instantly generate dot (symbol) maps of the collection locales for any species, including aliens (Soberon et al. 1996). Obviously, these compilations can be readily updated with subsequent collections, making them of increasing value in detecting and characterizing the response of species' range to any future global change. Other similar national floristic efforts are in various stages of assembly, including projects in Australia (ERIN) and North America (north of Mexico) (Frost et al. 1995).

Plant spread, including invasions, is usually not impeded by political boundaries; thus spread will probably accelerate with the recent relaxation of trade (and trade inspection) barriers in Europe and North America as well as a consequence of any global climatic change (Pitelka et al. 1997). Consequently, the need for continental-scale maps of alien plant distributions will become increasingly necessary, as many invasions are continental phenomena. The Committee for Mapping the Flora of Europe (e.g., Jalas and Suominen 1972) has undertaken the daunting task of combining and standardizing national floristic efforts in Europe into a continental atlas for all vascular plants, including alien species. Maps are compiled from "Any reliable record . . . not only those based on herbarium specimens but also reliable published or unpublished sight records" (Jalas and Suominen 1972), and incorporate records into grid-based systematic surveys.

Limitations and Sources of Error

Assessments of the distribution of alien plants—whether first-county-records, assessments that combine herbarium specimens with independent lines of evidence, or the more recent national floristic compilations—have varying merit and suffer common underlying limitations (aside from usually lacking any estimate of local abundance).

First, this general approach rests on the tacit assumption that the species was first collected at a locale (i e , county, state, or province, even a nation), at *approximately* the same time as it first appeared in that locale. Where collecting has long been intense and frequent—best illustrated by twentieth-century western Europe—this may be a reasonable assumption. For example, the Botanical Society of the British Isles has long reported newly arrived species in the British flora. Society members routinely canvas potential entry sites (e.g., seaports, waste dumps, and other disposal sites of imported material)

searching for new immigrants (Clement 1981). But elsewhere, a nonindigenous species may reside, even spread locally, and not be detected for decades; thus, a herbarium-specimen-based invasion chronology could be spurious. For instance, *Crupina vulgaris*, a noxious annual from Europe, was first discovered in the United States in a remote area in Idaho in 1969; at that time, it already covered about 16 hectares (Stickney 1972). Obviously, it had arrived at the site well before 1969 and probably did not enter the United States in Idaho, an inland state. The number of such cases, particularly for inconspicuous species or those with similarly appearing native congeners, is probably large.

Ironically, even if a new introduction is collected, it may be misidentified. *Anthemis austriaca* was collected in Pullman, Washington (U.S.A.) in 1910, but the specimen was misidentified (and accessioned) as the well-known *Anthemis cotula*. The specimen was not annotated until 1991; by then *A. austriaca* was common (but still unrecognized) on the Washington State University campus in Pullman (R. Old and R. Hartman, personal communication). Such misidentifications are probably common and recurring, for example, *Galinsoga ciliata* was confused with *G. parviflora* before 1950 in the Netherlands (van der Meijden et al. 1989). Simple error, however, does not account for all misidentification. New immigrants are unlikely to appear in published regional floras. Consequently, only a diligent investigator would first identify a new entry as previously unreported and then pursue its correct identification. There are doubtless many new regional and national records for alien plants lying undetected among holdings in herbaria worldwide, either misaccessioned or in the "unknowns" folders.

Sequences or chronologies of first records (e.g., Forcella 1985; Salisbury 1961) also rest on the assumption that once an alien species is recorded from an area, it then persists; that is, these maps indicate an ever-expanding range. But new ranges, even of invaders, can decline. Dynamism in the range of the alien *Elodea canadensis* in Britain has included both its entry into new areas and also its apparent disappearance in others (Simpson 1984).

Most fundamental, the lack of collection records from a location cannot be validly interpreted to mean that the species has never resided there. The intensity of plant collection from place to place varies enormously. For example, collection activity (so-called Collector's Syndrome) at or near centers of floristic research (universities, botanical gardens, agricultural experiment stations) is far greater than in remote or inaccessible locales (Soberon et al. 1996). Although scenarios of spread based on chronologies of collection records may be quite plausible (e.g., Stuckey 1970), their validity is directly proportional to the duration, frequency, and intensity of collecting. These sources of error substantially limit the amount that can be reliably deduced from these compilations.

Grid-Based Systematic Floristic Surveys

As outlined above, records of plant spread formed from compilations of herbarium specimens vary enormously in temporal and spatial detail. Most, however, lack the detail that reliably permits accurate reconstruction of spread. Happenstance too often governs the frequency and location in which an alien species will be detected.

Far preferable would be a deliberate program of plant collection that provides truly comprehensive coverage for alien species in a new range with repeated collection efforts at regular intervals. Ideal would be a collecting/recording system based within topographic grids, that is, squares or other regular units of the landscape, rather than nonsystematic point locations. This overall goal has reached fruition (although not with alien species as the main object of investigation) through systematic collection efforts in western Europe, for example, Great Britain and Ireland (Perring and Walters 1976; Rich and Woodruff 1996), Germany (Haeupler and Schoenfelder 1989), and the Netherlands (van der Meijden et al. 1989). These national projects have common elements in their effort to document the spatial and temporal distribution of their floras: in each case the *entire* nation has been sectioned into topographic grids (e.g., 11–12 kilometer squares or smaller in Germany, Schoenfelder 1999). Plant collectors canvass assigned topographic units and collect or compile lists of all the vascular plants encountered. In the more recent executions, systematists compile and verify the information from the field, and dot maps are prepared of each species' distribution in the national grid. Distribution maps of the naturalized (including invasive) species are but one product of these herculean efforts.

Systematic plant surveys in the Netherlands illustrate the power of such endeavors to answer (or at least strongly suggest answers to) basic questions that arise about the breadth, spatial pattern, and coarse-scale dynamism of alien plant spread. Systematic surveys of the Dutch flora began in 1902 within 30 × 20.83 kilometer rectangles in which some plant groups were often collected at a much finer scale (e.g., 1.25 × 1.04 km). These collections were greatly expanded as well as supplemented by provincial surveys after 1950. As a result of this long-term national commitment, systematic plant collections have been compiled into distribution maps for two major periods: collections made from 1902 to 1950 (on a 5 × 5 km basis) and another based on collections from 1950 to 1987 (on a 5 × 4.17 km basis). Many of the 433,286 pre-1950 collections were made around 1935; the largest fraction of the post-1950 collections (495,119 records) were made in the mid-1970s (Witte 1998).

These species-by-species grid maps reveal numerous changes in the distribution of the Dutch nonindigenous flora that merit further study, changes

that would likely remain undetected without this intense level of collection. *Elodea nuttallii*, a North American aquatic plant, was found in only 6 grids before 1950. By 1987 it had been detected in 1,057 grids, or cells—a 176-fold increase in spatial occurrence. In contrast, its congener, *E. canadensis*, which occupied 865 cells by 1950, had a somewhat contracted range (751 cells) by 1987 (Fig. 7.3). This decrease in the range (and abundance) of *E. canadensis* roughly coincides with an increased distribution of *E. nuttallii* (though not as pronounced) that has been occurring for the last 100 years in Britain (Simpson 1984 and references therein). Explanation for the cyclical character of range occupation by *E. canadensis* remains enigmatic. But comprehensive national maps, which are now augmented with much environmental and habitat information, provide the basis for forming alternative, testable hypotheses. For example, the expanding range of *E. nuttallii* may be due to its potentially greater tolerance of pollution than *E. canadensis*. Other alien species for which range expansion was pronounced after 1950 include *Veronica filiformis, Solidago gigantea* (late goldenrod), and *Polygonum cuspidatum* (Japanese knotweed) (van der Meijden et al. 1989). Some alien species had either reached the environmental limits of their new range in the Netherlands by 1950 or appeared prone to a ruderal, transient existence that produced little or no net increase in their new range (e.g., *Lepidium virginicum* [peppergrass], Mennema et al. 1985) (Fig. 7.4).

Maps of species distribution prepared at the fine scale of the long-term Dutch and German floristic efforts (now codified into the FLORBASE [Witte 1998] and Florein systems [Schoenfelder 1999], respectively) provide an excellent means to detect contemporaneous changes in the fate of nonindigenous species. To this end, the German floristic mapping project is preparing a new atlas with maps for three time intervals: pre-1945/1950, 1945/1950–1980, 1981–1996 (Schoenfelder 1999). Their value as indices of global change, either plant invasions or changes in the ranges of native species, can only increase with time.

Limitations and Sources of Error

Problems cited with retrospective assessments based on herbarium records are substantially diminished in recurring grid-based surveys, but they are not eliminated. Such databases usually lack indices of abundance within the cells or grids. The possibility remains that an alien species will not be detected until long after its arrival (however unlikely in the Dutch and German projects, given their intense collection activity). Even detailed grid-based collections provide only a cell-by-cell qualitative assessment of whether each species was "present" or "not detected"; they cannot unequivocally indicate "absent."

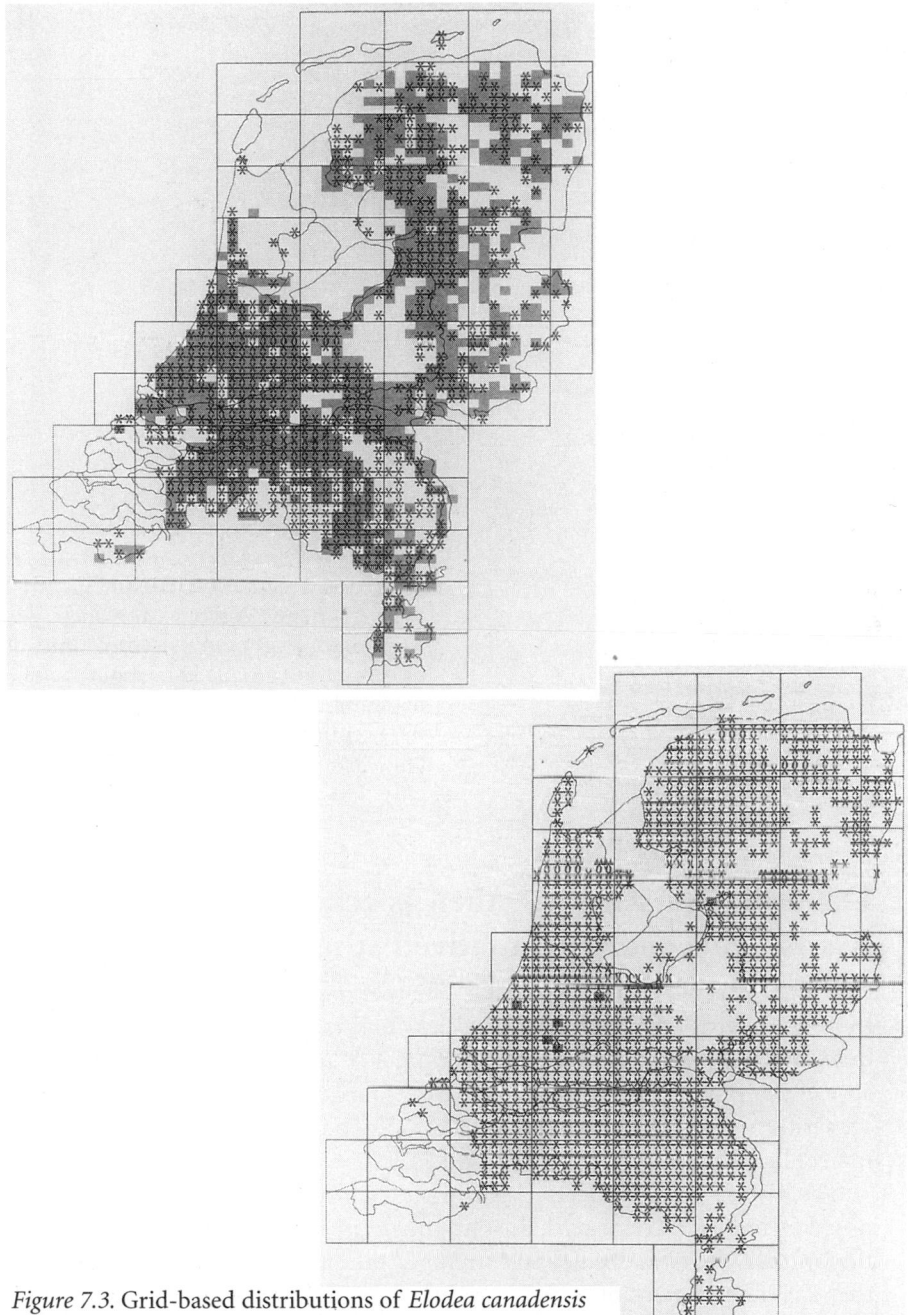

Figure 7.3. Grid-based distributions of *Elodea canadensis* (top) and *Elodea nuttallii* (bottom), pre-1950 (shaded grids) and post-1950 (asterisked grids), in the Netherlands. While the extent of *E. canadensis* has not changed substantially in the twentieth century, *E. nuttallii* has clearly expanded enormously in range since 1950. Each grid is 5 × 4.17 km (van der Meijden et al. 1989).

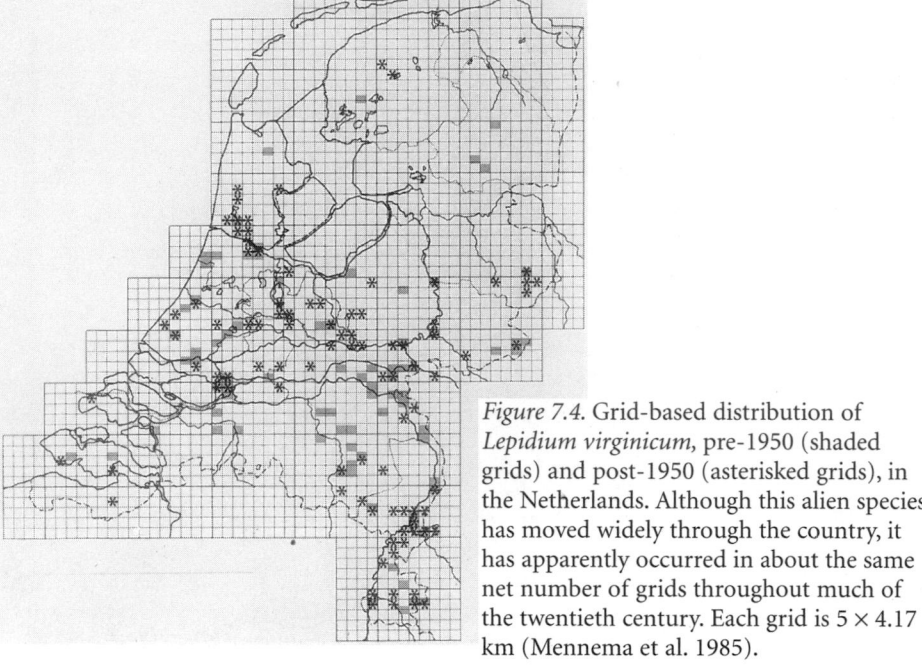

Figure 7.4. Grid-based distribution of *Lepidium virginicum,* pre-1950 (shaded grids) and post-1950 (asterisked grids), in the Netherlands. Although this alien species has moved widely through the country, it has apparently occurred in about the same net number of grids throughout much of the twentieth century. Each grid is 5 × 4.17 km (Mennema et al. 1985).

Deliberate Searches for Alien Species: Qualitative Assessments and Quantitative Estimates

The often urgent need to assess the extent and status of plant invaders has long prompted deliberate single-species surveys, often with an attempt to quantify the degree of infestation. Such urgency springs from the accelerating spread of almost all future invaders in a new range. Furthermore, under many scenarios for global climatic change, a rapidly changing climate would hasten many plant invasions (Pitelka et al. 1997).

The history of such surveys is surprisingly long. The threat to agriculture posed by *Salsola iberica* (*kali*), Russian thistle, in the northern Great Plains of the United States was deemed so extreme at the end of the nineteenth century that U.S. Department of Agriculture investigators canvassed the wheat- and flax-growing counties in both North and South Dakota, Minnesota, Nebraska, and Iowa for infestations. Their survey produced a map denoting two categories of Russian thistle infestation: "abundant and causing serious damage" and "present but not yet so abundant as to cause serious damage" (Dewey 1894).

Assessments of invasive species prepared by the California Department of Food and Agriculture illustrate the modern counterparts of the late-nineteenth-century survey for *S. iberica*. *Centaurea solstitialis* (yellow star thistle), a serious pest in crops and rangelands, was first detected in California in 1869. The most recent statewide assessment of its distribution and abundance was conducted in 1996 by soliciting estimates of its status from local investigators and pest-control workers from each township (9,324 hectares each) throughout the state. Survey participants ranked abundance as none, low, high, or unknown. Any survey that estimates abundance across almost 1 km^2 will inevitably contain much variance. The statewide pattern that emerged shows the pest's abundance as "none" (i.e., undetected, in strict terms) in the Mojave Desert and other desert areas, as well as "none" or "low" throughout the Sierra Nevada. Greatest abundance of yellow star thistle occurs in the arable northern Central Valley (Woods 1997). This basic protocol has been used repeatedly at different scales to produce semiquantitative maps for potentially invasive species in North America (Dunn 1979; Maffei 1994), Europe (Palmer 1994), and southern Africa (Anon. 1996/97).

SAPIA (Southern Africa Plant Invaders Atlas) is representative of much more ambitious national efforts to compile the distribution, abundance, and habitat information for nonindigenous species. From 1979 to 1993, Henderson (1998 and references therein) conducted extensive roadside surveys of several hundred alien species in South Africa. She has coupled her data with other more recent records to create the SAPIA database (33,000 records of alien species) for more than 300 naturalized species in South Africa, Lesotho, and Swaziland. Distribution maps based on 15-minute-resolution quadrangles have been prepared from this database.

Ideally, a single-species survey would include an exhaustive search for plants throughout the entire potential new range. Seldom (and perhaps only once) has the incentive been sufficiently high to approach this standard. The simultaneous search and destruction of *Berberis vulgaris* (common barberry), the intermediate host for stem rust (*Puccinia graminis*), in thirteen U.S. states came closest to this goal. This federal survey began in 1924 and involved the close inspection (quaintly termed "foot scouting") of more than 1,888,000 farms and thousands of municipalities. As reported by Hutton (1927, p. 116), "In many instances the intensive survey has involved the foot scouting of entire townships and often of large portions of entire counties" (p. 13). Distribution maps were apparently not prepared since the surveyors destroyed plants as they detected them. Even in such an unprecedented effort, the investigators were well aware that some isolated plants would inevitably be overlooked. Their ingenious solution took advantage of the likelihood that finding a field with a high percentage of infected cereals must signal that barberry was nearby. Thus, the infected cereals served as proxies

that greatly narrowed the search area for isolated barberry plants (Freeman and Melander 1924). Regrettably, this sensitive, yet elegantly simple, technique is unlikely to find wide application for detecting isolated or cryptic alien plants.

Limitations and Sources of Error

The accuracy and detail of single-species surveys are direct functions of the effort expended in plant search. In the usual absence of sufficient resources to search directly, indirect techniques have been employed, most often a questionnaire or survey of local residents (e.g., Palmer 1994; Dunn 1979; Roche and Roche 1988). The potential for error in this approach is so large (e.g., local unfamiliarity with the target species, highly subjective *ad hoc* estimates of abundance and areal extent, error in estimating abundance based on conspicuousness alone) as to make any survey that contains such information unreliable (Zamora et al. 1989). (Ironically, quantitative vegetation sampling arose 100 years ago in response to these same intrinsic sources of error, Tobey 1981). Unfortunately, many quantitative assessments and even some qualitative surveys for single species stem in part from such dubious information. This practice should be discouraged.

Although subject to considerable error (e.g., overlooking small foci of infestation), direct field surveys (not questionnaires) for single species can be informative. The general procedure well illustrated in compiling the SAPIA (Henderson 1998) has been employed widely, especially where the potential new range is crisscrossed with a high density of roads (e.g., Paterson 1976; Wilson et al. 1992). Furthermore, as the accuracy of portable GPS (Global Positioning System) instruments improves, single-species surveys may also improve substantially. Using current differential GPS techniques, coordinate accuracy is to the nearest 3 meters (99 percent confidence interval [CI]); employing survey grade GPS improves accuracy to within the nearest 1 meter (95 percent CI) (Hofmann-Wellenhof et al. 1997). As a result, coordinates can be provided for single trees, or strings of coordinates can be readily collected to document the boundaries of a population. In the common absence of alternatives, the approach provides a preliminary answer to the basic question, "Where does the species occur currently?"

Remote Sensing

Not only do some plant invasions now encompass huge areas (e.g., *Bromus tectorum* [cheatgrass] in the U.S. intermountain West [Mack 1981], *Cryptostegia grandiflora* in Australia [Humphries et al. 1991]), but invasions also form collectively a truly global phenomenon; few terrestrial habitats are invulnerable to invasions (e.g. areas covered by perennial ice or snow). Not

surprisingly, ecologists have long considered remote sensing techniques (*sensu* Roughgarden et al. 1991) as practical solutions to the formidable task of documenting the global distribution of plant invasions.

Remote sensing encompasses a wide array of techniques that vary in the altitude (and scale) of the sensors as well as in the segments of the radiation spectrum that are measured. I make no attempt here to review this rapidly developing field: many reviews provide comprehensive assessment of these tools, particularly as they relate to plant detection (e.g., Hobbs 1990; Rock et al. 1993). The results of implementing remote sensing techniques to assess invasions are so far decidedly mixed but nevertheless contain much promise.

As might be predicted, the most success in measuring the extent of plant invasions has occurred across (or beneath) open water (Bogucki et al. 1980) and in habitats invaded by alien species that represent distinctive or previously unrepresented life-forms (Frenkel and Boss 1988; Maekawa and Nakagoshi 1997). An extensive program of detection has begun in Uganda for mapping the extent of *Eichhornia crassipes* (water hyacinth) across Lake Victoria. Water hyacinth is deservedly considered one of the world's most noxious invaders, responsible for causing both economic and environmental havoc in the Congo River drainage and throughout much of the Old World tropics (Schulthorpe 1967). It was first detected in Lake Victoria in 1989 and has become increasingly prominent along the lakeshore. Detection employed SPOT satellite imagery from March 1994 of the lake surface in conjunction with ground surveys to correlate plant spectra of water hyacinth compared with native species. By early 1994, *E. crassipes* had already covered >1,545 hectares (approx. 1.5 percent) of the lake surface. This amount is ominous because water hyacinth is largely confined to the lake's margin, the zone of highest potential biodiversity, and where it forms an impenetrable barrier to local fishing vessels (Anon. 1995).

Particularly valuable would be successive estimates of areal extent during the spread of an alien species. Although successive aerial photographs have been taken in some locales for more than fifty years, these examples include few sites where invaders can be readily detected from aerial photographs (Frenkel and Boss 1988; Maekawa and Nakagoshi 1997). Part of the time frame (1979–1985) for the rapid spread of *Mimosa pigra* in Northern Territory, Australia, was documented through aerial photography (Lonsdale 1993) (Fig. 7.5). In this case, the invading woody plant invaded treeless floodplain communities as well as the *Melaleuca* swamp forests fringing the floodplains (Lonsdale et al. 1989). Lonsdale (1993) quantified the development of this alien shrub's infestation around a shallow lake in the Adelaide River floodplain. In most years the invasion advanced at >76 m yr^{-1}, largely the result of water transport. By 1984, the Adelaide River floodplain alone supported >30,000 hectares of *M. pigra* dominated communities.

Invasive woody plants occupy a wide range of habitats (Richardson 1998),

Figure 7.5. The spread of *Mimosa pigra* in the Adelaide River floodplain in the Northern Territory, Australia, as derived from successive aerial photographs (Lonsdale 1993).

yet their spread has seldom been documented even in treeless areas (Frenkel and Boss 1988; Maekawa and Nakagoshi 1997). It would be informative to follow more woody plant invasions with remote sensing, not only as guides for their control but also as potentially excellent case histories documenting the rates of invasion, for example, the invasions of *Tamarix* spp. in the south-western United States, *Acacia nilotica* in northern Queensland, Australia, and *Prosopis* spp. in Brazil.

Detecting the extent of invaders into communities with morphologically similar natives is difficult, especially using satellite imagery compared to aerial photography. The invasion of *Melaleuca quinquenervia* (melaleuca Australian paperback) in the Florida Everglades posed the need for accurate measures of its extent. Capehart et al. (1977) employed Landsat imagery in attempting to discriminate *M. quinquenervia* from native species. In general, they were unable to identify a unique spectral signature for melaleuca, although they could distinguish it in structurally simple communities (e.g., pastures, barren sites, and some mangrove forests). Signatures narrow enough to distinguish melaleuca from cypress and mangrove stands failed to identify all the large monospecific stands of the alien tree.

Southern Florida was however the site for a more recent project that illustrates the convergence (and emergence) of remote-sensing technologies as

potentially important tools in detecting plant invasions. In this case, a regional geographic information system (GIS) database of vegetation maps was prepared by integrating satellite imagery (SPOT panchromatic images with 10-m pixel resolution), 1:40,000-scale color infrared (CIR) aerial photographs, and field verification (Welch et al. 1995). Accurate registration of plant communities and other features on the maps was enhanced by establishing a network of common locations between the SPOT imagery, GPS measurements, National Geodetic base points, and topographic maps of areas adjacent to the region's national parks (including the Everglades). Core data on the distribution and extent of the vegetation was derived from CIR aerial photographs with pixel resolution < 1-m. Emphasis was placed on classifying vegetation so that species could be identified, a mandatory requirement for documenting the spread of a plant invader. One class in the system recognizes the principal plant invaders in southern Florida: *M. quinquenervia, Schinus terebinthifolius* (Brazilian pepper), *Casuarina equisetifolia,* along with *Colubrina asiatica* (latherleaf). An obvious advantage of this project is the ability to routinely update the status of noxious plant invaders in response to changes in regional hydrology, land use, and control strategies. It is revealing that the core information for this promising approach was derived principally from CIR photographs and field verification—techniques that were available long before the development of satellite imagery.

Limitations and Sources of Error

Despite impressive advances made in the past two decades in detecting plant and environmental parameters (e.g., pathogen infection, nutrient deficiency, LAI, photosynthetic rate, soil moisture) (Roughgarden et al. 1991; Gamon et al. 1993; Rock et al. 1993), a basic goal in assessing plant invasions—accurately identifying the invader itself against a background of native species—remains elusive. Needed is a unique spectral signature for any target species with which to discriminate it from neighbors, but the "signal:noise" ratio is usually too low. Although spectral signature can indeed vary substantially among plants, the differences tend to be among major plant groups, for example, dicots compared to monocots compared to gymnosperms. Differences within these groups are unacceptably low. For example, the ability to distinguish reliably among dicots, even members of different plant families, is difficult (Avery and Berlin 1992). In those grasslands in which both invaders and the prominent native species are all grasses (Mack 1981), this difficulty becomes acute.

Detection of illicit *Cannabis sativa,* which is incidentally an alien species in North America, simultaneously illustrates the potential and the intrinsic problems in identifying a species-specific spectral signature. Daughtry and Walthall (1998) simulated the canopy reflectance spectra of marijuana based

on spectral data collected from the leaves of plants in field experiments. These spectra were compared with spectra from nineteen other herbaceous and woody species growing near the marijuana gardens. They report the ability to discriminate marijuana from other species by concentrating on spectral band widths of less than 30 nanometers that were near 550, 670, and 800 nanometers. Discrimination improved with dense canopies. They did not however evaluate whether discrimination could be achieved under realistic field conditions, that is, from aloft in mixed-species canopies.

Nevertheless, the strong incentive to develop new tools in remote sensing suggests that current shortcomings in spectral discrimination will likely be reduced. New tools and reanalysis/redevelopment of older tools (e.g. MEIS [Multi-detector Electro-optical Imaging] [Franklin 1994], multispectral videography [Thomasson et al. 1994] and SAR [Synthetic Aperture Radar] [Kasischke and Bourgeau-Chavez 1997]) have each been proposed as particularly suitable for conducting vegetation inventories, including the ability to discriminate among species in mixed-species canopies (Thomasson et al. 1994). Additional information is anticipated from the broad spectral and spatial resolution in the AVIRIS (Airborne Visible/Infrared Imaging Spectrometer) system, once it is fully deployed (Vane et al. 1993). The ability to employ many of these tools from low-flying aircraft offers much advantage over satellite-based detectors. For example, Thomasson et al. (1994) were able to distinguish among *Salix nigra, Taxodium distichum,* and *Fraxinus pennsylvanica* by multispectral videography data collected by aircraft over forests in the Atchafalaya Basin in Louisiana. Although uncritical faith in inevitable advances in technology is never prudent, there is cause for legitimate optimism for employing remote sensing in detecting plant invasions. The accelerating global impact of plant invasions dictates that remote sensing will play an expanding role in assessment; no other approach can provide truly global assessment at the sampling frequency that will be needed.

Permanent Plots: A Venerable Tool in an Era of Rapid Global Change

Ecologists routinely grapple with the consequences of basing predictions upon samples collected with less accuracy and precision, or both, than we desire (Grubb 1989); assessing the status, extent, and dynamism of plant invasions is no exception. Each of the approaches discussed earlier has limitations: they are small samples (herbarium compilations), they are retrospective (herbarium compilations, grid-based surveys), the discriminating power is limited (remote sensing), the time span of assessment is insufficiently long or infrequent (grid-based surveys, single-species surveys), the data are prox-

ies for plant presence and spread (seed contaminants). Furthermore, they are all strictly qualitative or at best semiquantitative; they may be unable to detect important changes in the extent of the invader, particularly its earliest appearance. Finally, none of these approaches allows us a telescoping view of change from the landscape to the local population—all of which we may require simultaneously.

Ironically, a tool that overcomes many of these shortcomings is also among the oldest in the toolbox of field ecologists—the permanent plot. It was conceived as a tool to detect change in vegetation over time with potentially great accuracy (White 1985); it is well suited for investigating the spread and dynamism of alien plant species. A network of routinely censused plots can serve as "trip wires" in a landscape by recording the early appearance of an alien species at a precise location—a great advantage in assessing plant invasions. Furthermore, the dynamism within the plots (for populations of both nonindigenous and native species) can be quantified in great detail. As White points out, permanent plots are most valuable as the precise sites in which plant censuses may be conducted; any aspect of the population biology of each species can be recorded and readily compared with its performance over time.

The value of permanent plots increases directly with their age, density, and numbers across a landscape. Unfortunately, we lack the comprehensive networks of permanent plots in the path (or well inside the boundaries) of almost all plant invasions. White (1985) describes the extensive use of these tools in the first half of the twentiethcentury in western U.S. rangelands, where thousands of permanent plots were established in badly overgrazed regions. Information on plant attributes in widely varying detail, including even plant demographic data, was recorded in these plots. Few of these data have ever been published (White 1985). Equally unfortunate is that little attention has been given to relocating these plots and resuming plant censuses. In contrast, the network of permanent plots in New Zealand has fared much better: more than 3,000 permanent plots were established in grasslands alone. Furthermore, many of these plots have been sampled repeatedly since the mid-1950s (Wiser and Rose 1997). As a result, New Zealand has probably the closest approximation of a truly national network of permanent plots.

The potential of this tool for assessing plant invasions is apparent, even if examples are as yet scattered. *Eragrostis lehmanniana* (Lehmann love grass) has rapidly invaded arid communities in southern Arizona since its deliberate introduction in 1932. Records from permanent plots established in 1959 document the local spread of love grass at the Santa Rita Experimental Range. By 1989, this alien grass was present in more than 85% of 75 widely separated permanent plots across the 20,200 hectare range, even though the grass had been originally introduced within only 200 hectares. A prime advantage of permanent plots was exploited here as several within-plot indices (a measure

of frequency of occurrence within plots [closest-plant technique] and net annual above-ground biomass) were determined along with spread across the experimental range. Clearly, permanent plots allowed levels of recurring analysis at several spatial scales (Anable et al. 1992).

Repeated monitoring (1970, 1985, 1993) of 250 permanent plots within and adjacent to forests of *Nothofagus solandri* var. *cliffortioides* in New Zealand has documented the spread of invasive *Hieracium lepidulum* from 11 percent to 57 percent of these plots. Although the initial spread was from fire-induced tussock grasslands into the *Nothofagus*-dominated forests, the pattern of subsequent spread across the 200 km^2 study area has become multidirectional as invaded forests have also become likely sources for the wind-dispersed seeds. More important, the data address the conventional wisdom on the relative vulnerability to alien plant entry of species-poor compared with species-rich habitats. These *Nothofagus* forests have extraordinarily few vascular plant species; yet the paucity of potential competitors in the forest understory did not substantially influence the rate of *Hieracium* entry (Wiser et al. 1998) (Fig. 7.6).

In the course of assessing the efficacy of biological control of *Hypericum perforatum* by *Chrysolina quadrigemina*, Huffaker and Kennett (1959) measured plant dominance in permanent plots from 1951 to 1957. At the Shasta County, California, location, *H. perforatum* clearly responded to the growing effectiveness of the biocontrol agent, steadily declining in a dominance rating in the permanent plots from 51.3 in 1951 to 4.6 by 1957. But the same plots simultaneously recorded the progressive rise in prominence of a future regional pest, *Centaurea solstitialis*, along with an even larger increase in *Bromus mollis*. It is tempting to speculate that the demise of *H. perforatum* contributed to the rise of *C. solstitialis* and *B. mollis*; only subsequent experimentation would resolve this matter. Important here is that the close coincidence of these events would likely go undetected by any other tool. Plot data recorded the demise of one invaders while simultaneously serving as harbingers of others. We have no way of knowing how many other valuable clues to the timing and character of plant invasions are lying within the long-neglected data from permanent plots—it could well be sizable. Restoration of permanent plots (and the plot data already collected) deserves attention in any future comprehensive assessment of terrestrial plant invasions.

The value derived from networks of frequently censused permanent plots is apparent for documenting change in vegetation, regardless of the source. The theme of this volume deals with broad-sense global change: potential changes in the biosphere at many levels through pervasive human activity. Plant invasions represent only one, albeit an early, form of this global change (Mack 1997). Other changes, such as those wrought by future alteration of the atmosphere, will require careful detection and demonstra-

Figure 7.6. Chronology of the invasion of *Hieracium lepidulum* in the eastern ranges of the Southern Alps, New Zealand, based on permanent plot records in 1970, 1985, and 1993. Plots occupied (black circles) and unoccupied (open circles) by *H. lepidulum* are indicated (Wiser et al. 1998).

tion over time. Widely placed networks of permanent plots would serve all these needs admirably by providing an unequivocal spatial context of known history for measurement, comparison, experimentation, and prediction. It may be only a small exaggeration that much of the global examination of terrestrial invasions, regardless of taxon, could be greatly facilitated by widespread application of this one tool (and the detailed measurements that it allows).

Limitations and Sources of Error

Full value from permanent plots arises from detailed in-plot censuses. But repeated plant censuses of the type that would reveal the dynamism within and among populations are exceptionally laborious (White 1985). Furthermore, their use will be limited until networks of plots are established within the ranges of potential invaders. Unfortunately, this latter limitation will likely prevail.

Conclusions

Distilling evaluations of the approaches for assessing plant spread as organized here produces the following initial conclusions.

1. Purely descriptive accounts, while often fascinating, are obviously of little value beyond providing an historical narrative for early invasions.
2. Herbarium specimen-based chronologies rise in reliability in direct proportion to collection intensity and the reliability of contemporaneous independent records (e.g., government survey records). Consequently, some such chronologies are quite informative; most however are speculative and problematical.
3. Grid-based systematic surveys form potentially the best retrospective assessments. As with herbarium records, reliability of the chronology and assessment of areal extent are directly proportional to collection duration and intensity.
4. Single-species surveys probably represent the weakest approach in the current assessment tool-kit, although widespread incorporation of GPS-determined locations in field surveys could substantially improve the products of this approach.
5. Remote sensing, despite its current limitations, must be pursued aggressively as an assessment tool; the areal extent of many plant invasions is simply too large (and too dynamic) to be effectively measured with any other tool.
6. Assessments derived from permanent plots could be the standard by which other approaches are evaluated. Unfortunately, regional networks of permanent plots will likely remain only a goal.

None of the tools outlined above is a panacea for assessing plant invasions—often for quite different reasons. Consequently, their most effective use will likely arise in combination, that is, drawing wherever possible on the perspective that each may offer. For example, compilations of herbarium records can provide a historical perspective that can be extended into the future with recurring national grid-based records. Similarly, grid-based

records can provide a coarse-grain picture of an invasion that can then be focused with intensive single-species field surveys. Remote sensing can provide the regional (or even global) context for an invasion that can be explored locally with field verification (single-species surveys, permanent plots).

Summary

Plant invasions well illustrate our dilemma in assessing the profound global changes that biotic invasions in general hold for environments and economies: we usually lack comprehensive and accurate records that even characterize these species' areal extent, much less document the population dynamism throughout their history within a new range. Maps of collection chronologies have long been prepared for alien species; this approach is being rejuvenated by the instantaneous retrieval and mapping of national herbarium records. In systematic plant surveys (e.g., the national efforts in the British Isles, Germany, and the Netherlands), all alien species' distributions are repeatedly recorded within a national grid system, thereby minimizing inadvertent collection bias.

Attempts to quantify the invader's population(s) usually remain semiquantitative and often cursory. Nevertheless, single-species field surveys can potentially document the course of invasions and provide estimates of abundance. Rapid development of increasingly accurate, portable GPS tools could improve the reliability and speed of these surveys. Remote sensing potentially offers practical solutions to the daunting task of assessing widespread plant invasions. So far, aerial photography (e.g., CIR) has provided the most information (e.g., detecting a tree invasion into a heretofore treeless landscape). Success with satellite imagery remains elusive, but recently developed tools prompt legitimate hope for improved assessment. A venerable tool, the permanent plot, if established in extensive national networks could provide extraordinary assessments of invasions at several scales: comprehensive chronological detection, a repetitive gauge of local status, and the opportunity for repeated population census. No nationwide, much less global, network of such plots exists. Codifying and expanding the use of permanent plots emerges as a worthy goal.

Accurate assessment, involving complementary techniques, will prove essential in documenting the areal extent of biotic invasions. To determine an invader's total quantitative role in global change, *all* indices of its performance in a new range must eventually be extrapolated from its areal extent. This simple fact simultaneously underlies and justifies any initiative to implement and refine the assessment tools outlined here. Given the pace of global change arising from biotic invasions, there will be no dearth of subject material for these assessments.

Acknowledgments

I thank W. Kardong and H. Schwabl for invaluable translations of Dutch and German texts, respectively; A. S. Hope and R. Old for very informative discussions; and L. Arriaga, P. Baas, R. Hartman, H. Hauepler, B. J. Huntley, R. Randall, J. Sarukhan, M. Scherer-Lorenzen, P. Schoenfelder, J. Soberon, D. Thill, and R. van der Meijden for valuable assistance. H. A. Mooney once again organized a stimulating SCOPE meeting, for which he deserves lasting praise.

References

Anable, M. E., M. P. McClaran, and G. B. Ruyle. 1992. "Spread of introduced Lehmann lovegrass *Eragrostis lehmanniana* Nees. in southern Arizona, USA." *Biological Conservation* 61: 181–188.

Anon. 1995. "Mapping of the distribution of water hyacinth using satellite imagery. Pilot study in Uganda." Nairobi, Kenya: RCSSMRS/French Technical Assistance.

Anon. 1996/97. "The working for water programme." 1996/97 Annual Report. South African Department of Water Affairs and Forestry. Stellenbosch, South Africa.

Avery, T. E., and G. L. Berlin. 1992. *Fundamentals of Remote Sensing and Airphoto Interpretation*, 5th ed. New York: Macmillan.

Bogucki, D. J., G. K. Gruendling, and M. Madden. 1980. "Remote sensing to monitor water chestnut growth in Lake Champlain." *Journal of Soil and Water Conservation* 35: 79–81.

Capehart, B. L., J. J. Ewel, B. R. Sedlik, and R. L. Myers. 1977. "Remote sensing survey of *Melaleuca*." *Photogrammetric Engineering and Remote Sensing* 43: 197–206.

Clement, E. J. 1981. "Sweet bromegrass in Britain." *Adventive News* 20. *Aliens and Adventives*. 12–19. Botanical Society of the British Isles News No. 28, September.

Darwin, C. 1898. *Journal of Researches into the Natural History and Geology of the Countries Visited during the Voyage of H.M.S. Beagle Round the World, under the Command of Capt. Fitz Roy, R.N.* New York: D. Appleton.

Daughtry, C. S. T., and C. L. Walthall. 1998. "Spectral discrimination of *Cannabis sativa* L. leaves and canopies." *Remote Sensing of the Environment* 64: 192–201.

Dewey, L. H. 1894. "The Russian thistle." *United States Department of Agriculture. Division of Botany Bulletin* No. 15.

Drake, J. A., H. A. Mooney, F. di Castri, R. H. Groves, F. J. Kruger, M. Rejmánek, and M. Williamson. 1989. *Biological Invasions: A Global Perspective*. New York: Wiley.

Dunn, P. H. 1979. "The distribution of leafy spurge (*Euphorbia esula*) and other weedy *Euphorbia* species in the United States." *Weed Science* 27: 509–516.

Forcella, F. 1985. "Spread of *Kochia* in the northwestern United States." *Weeds Today* 16: 4–6.

Forcella, F., and S. J. Harvey. 1982. "Spread of *Filago arvensis* L. in the United States." *Madrono* 29: 119–121.

———. 1988. "Patterns of weed migration in northwestern USA." *Weed Science* 36: 194–201.

Franklin, S. E. 1994. "Discrimination of subalpine forest species and canopy density

using digital CASI, SPOT PLA, and Landsat TM data." *Photogrammetric Engineering and Remote Sensing* 60: 1233–1241.

Freeman, E. M., and L. W. Melander. 1924. "Simultaneous surveys for stem rust: a method of locating sources of inoculum." *Phytopathology* 14: 359–362.

Frenkel, R. E., and T. R. Boss. 1988. "Introduction, establishment and spread of *Spartina patens* on Cox Island, Siuslaw Estuary, Oregon." *Wetlands* 8: 33–49.

Frost, H. M., P. J. Terry, and P. Bacon. 1995. "A feasibility study into the creation of a database on weeds and invasive plant species." In *Weeds in a Changing World,* edited by Stirton, C. H., 35–49. British Crop Protection Council Symposium Proceedings No. 64.

Gamon, J. A., C. B. Field, D. A. Roberts, S. L. Ustin, and R. Valentini. 1993. "Functional patterns in an annual grassland during an AVIRIS overflight." *Remote Sensing of the Environment* 44: 239–253.

Grubb, P. J. 1989. "Toward a more exact ecology: a personal view of the issues." In *Toward a More Exact Ecology,* edited by Grubb, P. J., and Whittaker, J. B., 3–29, Oxford: Blackwell.

Haeupler, H., and P. Schoenfelder (eds.). 1989. *Atlas der Farn- und Blutenpflanzen der Bundesrepublik Deutschland.* Stuttgart: E. Ulmer.

Hegi, G. 1929. *Illustrierte Flora von Mittel-Europa.* Band VI. Vol. 2. Vienna: A. Pichler's Witwe and John.

Henderson, L. 1998. "Southern African plant invaders atlas (SAPIA)." *Applied Plant Sciences* 12: 31–32.

Hobbs, R. J. 1990. "Remote sensing and temporal dynamics of vegetation." In *Remote Sensing of Biosphere Functioning,* edited by Hobbs, R. J., and Mooney, H. A., 203–219. New York: Springer.

Hofmann-Wellenhof, B., H. Lichtenegger, and J. Collins. 1997. *Global Positioning System, Theory and Practice,* 4th ed. Vienna: Springer-Verlag.

Hudson, W. H. 1923. *Far Away and Long Ago.* London: J. M. Dent, New York: AMS Press reprint (1968).

Huffaker, C. B., and C. E. Kennett. 1959. "A ten-year study of vegetational changes associated with the biological control of Klamath weed." *Journal of Range Management* 12: 69–82.

Humphries, S. E., R. H. Groves, and D. S. Mitchell. 1991. "Plant invasions of Australian ecosystems." Part 1. In *Plant Invasions. The Incidence of Environmental Weeds in Australia.* Kowari 2. Canberra: Australian National Parks and Wildlife.

Hutton, L. D. 1927. "Barberry eradication reducing stem rust losses in wide area." *Yearbook of the U.S. Department of Agriculture,* pp. 114–118.

Jalas, J., and J. Suominen (eds.). 1972. *Atlas Florae Europaeae. vol. 1 Pteridophyta (Psilotacoao to Agollacoao).* Helsinki: Committee for Mapping the Flora of Europe.

Kasischke, E. S. and L. L. Bourgeau-Chavez. 1997. "Monitoring south Florida wetlands using ERS-1 SAR imagery." *Photogrammetric Engineering and Remote Sensing* 63: 281–291.

Kent, D. H. 1956. "*Senecio squalidus* L. in the British Isles -1, early records (to 1877)." *Proceedings of the Botanical Society of the British Isles* 2: 115–118.

———. 1960. "*Senecio squalidus* L. in the British Isles -2, the spread from Oxford (1879–1939)." *Proceedings of the Botanical Society of the British Isles* 3: 375–379.

————. 1964a. "*Senecio squalidus* L. in the British Isles -4, Southern England (1940 ->)." *Proceedings of the Botanical Society of the British Isles* 5: 210–213.

————. 1964b. "*Senecio squalidus* L. in the British Isles -5, The Midlands (1940 ->)." *Proceedings of the Botanical Society of the British Isles* 5: 214–216.

Kloot, P. M. 1985. "Plant introductions to South Australia prior to 1840." *Journal of the Adelaide Botanical Garden* 7: 217–231.

Kornas, J. 1990. "Plant invasions in Central Europe: historical and ecological aspects." In *Biological Invasions in Europe and the Mediterranean Basin,* edited by di Castri, F., Hansen, A. J., and Debussche, M., 19–36. Dordrecht: Kluwer.

Lonsdale, W. M. 1993. "Rates of spread of an invading species—*Mimosa pigra* in northern Australia." *Journal of Ecology* 81: 513–521.

Lonsdale, W. M., I. L. Miller, and I. W. Forno. 1989. "The biology of Australian Weeds 20. *Mimosa pigra* L." *Plant Protection Quarterly* 4: 119–131.

McNamara, D. W. 1966. "The distribution of wild oat species in New South Wales." *Agricultural Gazette New South Wales* 77: 761–763.

Mack, R. N. 1981. "Invasion of *Bromus tectorum* L. into western North America: An ecological chronicle." *Agro-Ecosystems* 7: 145-165.

————. 1988. "First comprehensive botanical survey of the Columbia Plateau, Washington: the Sandberg and Leiberg expedition of 1893." *Northwest Science* 62: 118–128.

————. 1997. "Plant invasions: early and continuing expressions of global change." In *Past and Future Rapid Environmental Changes: The Spatial and Evolutionary Responses of Terrestrial Biota,* edited by Huntley, B., Cramer, W., Morgan, A.V., Prentice, H. C., and Allen, J. R. M., 205–216. Berlin: Springer-Verlag.

Maekawa, M-A., and N. Nakagoshi 1997. "Riparian landscape changes over a period of 46 years, on the Azusa River in Central Japan." *Landscape and Urban Planning* 37: 37–43.

Maffei, M. D. 1994. "Invasive non-indigenous species on national wildlife refuges in Florida." In *An Assessment of Invasive Non-indigenous Species in Florida's Public Lands.* Florida Department of Environmental Protection, Bureau of Aquatic Plant Management. Technical Report No. TSS-94-100, pp. 179–185.

Mennema, J., A. J. Quene-Boterenbrood, and C. L. Plate 1985. *Atlas van der Nederlandse Flora,* vol. 2. Utrecht: Bohn, Scheltema and Holkema.

National Academy of Sciences. 1988. *Toward Understanding Global Change. Initial Priorities for U.S. Contributions to the International Geosphere-Biosphere Program.* Washington, D.C.: National Academy Press.

Naylor, R. L. 1996. "Invasions in agriculture: assessing the cost of the golden apple snail in Asia." *Ambio* 25: 443–448.

Palmer, J. P. 1994. "*Fallopia japonica* (Japanese Knotweed) in Wales." In *Ecology and Management of Invasive Riverside Plants,* edited by de Waal, L. C., Child, L. E., Wade, P. M., and Brock, J. H., 159–171. New York: Wiley.

Parsons, W. T. and E. G. Cuthbertson. 1992. *Noxious Weeds of Australia.* Melbourne: Inkata.

Paterson, J. G. 1976. "The distribution of *Avena* species naturalized in western Australia." *Journal of Applied Ecology* 13: 257–264.

Perring, F. H., and S. M. Walters. 1976. *Atlas of the British Flora,* 2nd ed. Cambridge: T. Nelson and Sons.

Piggin, C. M. 1977. "The herbaceous species of *Echium* (Boraginaceae) naturalized in Australia." *Muelleria* 3: 215–244.

Pitelka, L. F., and the Plant Migration Workshop Group. 1997. "Plant migration and climate change. *American Scientist* 85: 464–473.

Rich, T. C. G., and E. R. Woodruff. 1996. "Changes in the vascular plant floras of England and Scotland between 1930–1960 and 1987–1988: the BSBI monitoring scheme." *Biological Conservation* 75: 217–229.

Richardson, D. M. 1998. "Forestry trees as invasive aliens." *Conservation Biology* 12: 18–26.

Roche, C. T. and B. F. Roche, Jr. 1988. "Distribution and amount of four knapweed (*Centaurea* L.) species in eastern Washington." *Northwest Science* 62: 242–253.

Rock, B. N., D. L. Skole, and B. J. Choudhury. 1993. "Monitoring vegetation change using satellite data." In *Vegetation Dynamics and Global Change,* edited by Solomon, A. M., and Shugart, H. H., 153–167. New York: Chapman and Hall.

Roughgarden, J., S. W. Running, and P. A. Matson. 1991. "What does remote sensing do for ecology?" *Ecology* 72: 1918–1922.

Salisbury, E. J. 1932. "The East Anglian flora: a study in comparative plant geography." *Transactions of the Norfolk and Norwich Naturalist's Society* 13: 191–263.

Salisbury, E. 1961. *Weeds and Aliens.* London: Collins.

Sandlund, O. T., P. J. Schei, and A. Viken (eds.). 1996. *Proceedings of the Norway/UN Conference on Alien Species.* Trondheim: Directorate for Nature Management and Norwegian Institute for Nature Research.

Schoenfelder, P. 1999. "Mapping the flora of Germany." *Acta Botanica Fennica* 162: 43–53.

Schulthorpe, C. D. 1967. *The Biology of Aquatic Vascular Plants.* London: Edward Arnold.

Simpson, D. A. 1984. "A short history of the introduction and spread of *Elodea* Michx in the British Isles." *Watsonia* 15: 1–9.

Soberon, J., J. Llorente, and H. Benitez. 1996. "An international view of national biological surveys." *Annals of the Missouri Botanical Garden* 83: 562–573.

Soyrinki, N. 1991. "On the alien flora of the province of Buenos Aires, Argentina." *Annals of Botanica Fennici* 28: 59–79.

Stickney, P. F. 1972. "*Crupina vulgaris* (Compositae: Cynareae), new to Idaho and North America." *Madrono* 21: 402.

Stuckey, R. L. 1969. "The introduction and spread of *Lycopus asper* (western water horehound) in the western Lake Erie and Lake St. Clair region." *Michigan Botanist* 8: 111–120.

———. 1970. "Distributional history of *Epilobium hirsutum* (Great hairy willowherb) in North America." *Rhodora* 72: 164–181.

———. 1980. "Distributional history of *Lythrum salicaria* (Purple Loosestrife) in North America." *Bartonia* 47: 3–20.

Stuckey, R. L., and W. L. Phillips. 1970. "Distributional history of *Lycopus europaeus* (European water-horehound) in North America." *Rhodora* 72: 351–369.

Suominen, J. 1979. "The grain immigrant flora of Finland." *Acta Botanica Fennica* 111: 1–108.

Thomasson, J. A., C. W. Bennett, B. D. Jackson, and M. P. Mailander. 1994. "Differentiating bottomland tree species with multispectral videography." *Photogrammetric Engineering and Remote Sensing* 60: 55–59.

Tobey, R. C. 1981. *Saving the Prairies.* Berkeley: University of California Press.

Toney, J. C., P. M. Rice, and F. Forcella. 1998. "Exotic plant records in the northwest United States 1950–1996: an ecological assessment." *Northwest Science* 72: 198–209.

U.S. Congress, Office of Technology Assessment. 1993. *Harmful Non-indigenous Species in the United States,* OTA-F-565. Washington, D.C.: U.S. Government Printing Office, September 1993.

van der Meijden, R., C. L. Plate, and E. J. Weeda. 1989. *Atlas van de Nederlandse Flora,* vol. 3. Leiden: Rijksherbarium/Hortus Botanicus.

Vane, G., R. O. Green, T. G. Chrien, H. T. Enmark, E. G. Hansen, and W. M. Porter. 1993. "The airborne visible/infrared spectrometer (AVIRIS)." *Remote Sensing of the Environment* 44: 127–143.

Vitousek, P. M., C. M. D'Antonio, L. L. Loope, M. Rejmánek, and R. Westbrooks. 1997. "Introduced species: a significant component of human-caused global change." *New Zealand Journal of Ecology* 21: 1–16.

White, J. 1985. "The census of plants in vegetation." In *The Population Structure of Vegetation,* edited by White, J., 33–88. Dordrecht: Junk.

Welch, R., M. Remillard, and R. F. Doren 1995. "GIS database development for South Florida's national parks and preserves." *Photogrammetric Engineering and Remote Sensing* 61: 1371–1381.

Wilson, J. B., G. L. Rapson, M. T. Sykes, A. J. Watkins, and P. A. Williams. 1992. "Distributions and climatic correlations of some exotic species along roadsides in South Island, New Zealand." *Journal of Biogeography* 19: 183–194.

Wiser, S. K., R. B. Allen, P. W. Clinton, and K. H. Platt. 1998. "Community structure and forest invasion by an exotic herb over 23 years." *Ecology* 79: 2071–2081.

Wiser, S. K., and A. B. Rose. 1997. *Two Permanent Plot Methods for Monitoring Changes in Grasslands: A Field Manual.* Investigation No. 617. Manaaki Whenua—Landcare Research. Christchurch, New Zealand.

Witte, J-P. M. 1998. *National water management and the value of nature.* Ph.D. dissertation, Wageningen Agricultural University, the Netherlands. 223 pp.

Woods, D. M. (ed.). 1997. "Biological Control Annual Summary, 1996." California Department of Food and Agriculture, Division of Plant Industry, Sacramento.

Zamora, D. L., D. C. Thill, and R. E. Eplee. 1989. "An eradication plan for plant invasions." *Weed Technology* 3: 2–12.

Part II

Societal Impacts

Chapter 8

~

The Future of Alien Invasive Species: Changing Social Views

Jeffrey A. McNeely

Many people warmly welcome globalization of trade, and growing incomes in many parts of the world are leading to increased demand for imported products. A generally unrecognized side effect of this globalization is the introduction of exotic species, at least some of which may be harmful (invasive). These species are of interest to the Conference of the Parties of the Convention on Biological Diversity (CBD), which calls on the parties to "prevent the introduction of, control or eradicate those alien species which threaten ecosystems, habitats, or species" (Article [8h]).

This chapter examines the history and ecology of the global trade in species of plants and animals, explores the concept of "naturalness" and what it means at a time when human influence on ecosystems is pervasive, compares purposeful and accidental introductions, suggests how climate change relates to the global economy and alien species, introduces some economic concepts relevant to the issue of global trade and alien species, and recommends steps that could be taken by the global community to deal more effectively with the issue of harmful alien species.

People introduce species into new habitats for a number of reasons. Levin

(1989) identified three major categories: accidental introductions, species imported for a limited purpose that then escape, and deliberate introductions. Many of the introductions relate to the human interest in providing species that are helpful to people. This is particularly true of agricultural species; indeed, in most parts of the world, the great bulk of human dietary needs are met by species that have been introduced from elsewhere (Hoyt 1992). Species introductions in this sense, therefore, are an essential part of human welfare in virtually all parts of the world. Further, maintaining the health of these introduced species of undoubted benefit to humans may require the introduction of additional species for use in biological control programs that import natural enemies of, for example, agricultural pests (Waage 1991).

Many harmful exotics are not the result of intentional releases or contraband brought in by international travelers, but rather are due to unintentional "hitchhiking" through international trade, with exotics stowing away in ships, planes, trucks, shipping containers, and packing materials, or arriving on nursery stock, unprocessed logs, fruits, seeds, and vegetables (Office of Technology Assessment [OTA] 1993). Jenkins (1996) concludes, "Increased international trade has the potential to cause more harmful exotic species introductions. More proactive, more comprehensive, and better funded international efforts are needed to ensure that widely adapted invasive exotics do not further homogenize biological systems on a global scale" (p. 302).

Indeed, the biggest hidden danger from introduced species may well be their contribution to global homogenization, a seemingly inevitable process that involves multiple factors ranging from communications technology to consumer mentality. People have always been on the move, which helps explain how our species spread over the planet. Australian aborigines brought in the dingo; Polynesians sailed with pigs, taro, yams, and at least thirty other species of plants (and rats as stowaways); and the Asians who first peopled the Americas also brought dogs with them. The impact of these earliest colonists was devastating on the local species, leading to numerous extinctions (see, e.g., Martin and Klein 1984) and numerous introductions, at least by the later colonists who already had developed agriculture (Cuddihy and Stone 1990). The period of European colonialism that began with the voyage of Columbus in 1492 (Crosby 1972) (leaving aside the earlier unsuccessful attempts by Vikings) ushered in a new era of species introductions, as the Europeans sought to recreate the familiar conditions of home (Crosby 1986). They took with them species such as wheat, barley, rye, cattle, pigs, horses, sheep, and goats, but in the early years were limited by the available means of transport. Once steam-powered ships came into common use, the floodgates opened and over 50 million Europeans emigrated between 1820 and 1930, taking

numerous plants and animals with them and often overwhelming the native flora and fauna.

More recently, global trade has greatly increased: the growth in global economic output during the 1980s was greater than that during the several thousand years from the beginning of civilization until 1950. The value of total imports increased from US$192 billion in 1965 to $3 trillion in 1990, a 17-fold increase in twenty-five years (World Resources Institute [WRI] 1994). Imports of agricultural products and industrial raw materials—those which have the greatest potential to contribute to the problem of invasive species—amounted to $482 billion in 1990, up from $55 billion in 1965. This tremendous economic performance has been built on an increasingly homogenized foundation of information, finance, culture, and ecosystems.

This homogenization—which has been termed "biological pollution" (Luken and Thieret 1996)—reduces the diversity of crops and livestock and can increase their vulnerability to both native and exotic pests, often leading to the increased use of pesticides that may have broad negative impacts on ecosystems. Thus introductions may lead to "cascades" of effects that were not part of the decisions that led to the introduction. Species introductions may thus be considered part of the class of phenomena that economists call "externalities," impacts of an activity that affect others outside the activity; the interests of those others are usually ignored by those undertaking the activity.

As a biodiversity issue, it is not always possible to identify invasions as inherently "bad"; di Castri (1989) asserts that overall, the central European flora has undergone an enrichment of diversity over historical time as a result of human-induced plant invasions. Britain's mammalian fauna totaling about 49 species includes some 21 introduced species, including 8 large mammals: wild goat (*Capra hircus*), fallow deer (*Dama dama*), Sika deer (*Cervus nippon*), Indian muntjak (*Muntiacus muntjak*), Chinese muntjak (*Muntiacus reevesi*), Chinese water deer (*Hydropetes inermis*), Bennett's wallaby (*Macropus rufogriseus bennetti*), and reindeer (*Rangifer tarandus*). It is thus highly likely that due to human influence, the mammalian fauna of Britain is more species-rich now than at any time since the Neolithic (though with few large carnivores). The genetic diversity of this fauna is also very high, including species originating from Asia, North America, Europe, and Australia (Jarvis 1979). Jacobs (1975) describes the transformation of the saline Lake Nakuru from an ecosystem of very low diversity (a large population of flamingoes, 2 species of algae, and a few invertebrate species) to one of much higher diversity (including 30 species of fish-eating birds) after the introduction of a fish, *Tilapia grahami*, to control mosquitoes in 1961. More generally, cities—where the majority of the world's people live—are greatly enriched by invasive species of plants. Many invasive species seem to do best in urban and urban-

fringe environments where long histories of human disturbance have created vacant niches and abundant bare ground. Cities tend to be the focal points of the global economy and the entry points for many invasives. They also tend to be largely anthropogenic habitats, often of very great species richness. For example, London has some 2,100 species of flowering plants and ferns growing wild while the rest of Britain has no more than 1,500 species, and Berlin has 839 native species of plants and 593 invasives (Kowarik 1990; McNeely 1995).

Despite some arguably positive effects on biodiversity at the local level, however, overwhelming evidence indicates the profoundly negative effects of introductions on species and genetic diversity at both local and global levels. Such introductions can lead to severe disruption of ecological communities (Drake 1989; Smith 1972; Zaret and Paine 1973; Mooney and Drake 1987; Carlton and Geller 1993), and heavily influence the genetic diversity of indigenous species. Some protected areas established to conserve native species have been profoundly affected by introduced species (Bratton 1982), and on some islands introduced species closely match or even outnumber native ones (Table 8.1). If one judges biodiversity only by species richness, then those islands are now twice as valuable as they were when they were "natural." However, most known extinctions—at least of birds—have taken place on islands, so while the individual islands may have more species, the world as a whole has lost diversity. The unique has been replaced by the commonplace.

In the cases where the direct cause of extinction is identifiable, introduced species head the list. For example, introduced mammals are responsible for all but one of the nine known extinctions of endemic vertebrate species or subspecies from the islands of northwestern Mexico. Globally, almost 20 percent of the vertebrates thought to be in danger of extinction are threatened in some way by invasive species (Table 8.2). The single biggest tragedy is the

Table 8.1. Known numbers of invasive and native species in various countries/areas.

Country/area (species type)	Number of native species	Number of invasive species	Source
New Zealand (plants)	1,790	1,570	Heywood 1989
Hawaii (plants)	956	861	Wagner et al. 1990
Hawaii (all species)	17,591	4,465	Miller and Eldridge 1996
Tristan de Cunha Island (plants)	70	97	Moore 1983
Campbell Island (plants)	128	81	Moore 1983
South Georgia Island (plants)	26	54	Moore 1983
California (freshwater fish)	83	50	Moyle 1976

Table 8.2. The percentage of threatened terrestrial vertebrate species affected by introductions in the continental landmasses of the different biogeographic realms and on the world's islands. (The total number of threatened species in the realm is given in parentheses).

	Mainland areas		Insular areas	
Taxonomic group	%	(n)	%	(n)
Mammals	19.4	(283)	11.5	(61)
Birds	5.2	(250)	38.2	(144)
Reptiles	15.5	(84)	32.9	(76)
Amphibians	3.3	(30)	30.8	(13)
Total for all groups considered	12.7	(647)	31.0	(294)

Data from Macdonald et al. 1989.

probable loss of at least 200 of the 300 endemic cichlid species in Lake Victoria as a result of the introduction of the Nile perch (*Lates niloticus*) to the lake (Lowe-McConnell 1993); this was exacerbated by eutrophication of the lake and the introduction of new fishing gear. The global effects of certain invasive species such as the European pig (*Sus scrofa*) (Oliver 1993), rats (*Rattus* spp.) (Atkinson 1985; Brockie et al. 1989; Stuart and Collar 1988) and the aquatic plants (*Salvinia molesta*) and water hyacinth (*Eichhornia crassipes*) (Ashton and Mitchell 1989) also attest to the destructive power of invasives.

The general global picture is, then, one of tremendous mixing of species with unpredictable long-term results. While many introduced species have special cultivation requirements that restrict their spread, many other species are finding appropriate conditions in their new homes, while many more may invade their new habitats and constantly extend their distribution, thereby representing a potential threat to local species. All of this calls into question the concept of "naturalness." The fauna and flora of any area at a specific point in time have some special characteristics that make them different from other times in history. Because chance factors, human influence (including species introductions), and small climatic variation can cause very substantial changes in vegetation and the associated fauna, the biodiversity for any given landscape will vary substantially over any significant time period—and no one variant is necessarily more "natural" than the others (Sprugel 1991).

The future is certain to bring considerable additional ecological shuffling as people influence ecosystems in various ways, not least through both purposeful and accidental introduction of species. This shuffling will have both winners and losers, although the overall effect will likely be a global loss of biodiversity at species and genetic levels.

Global Trade and Species Introductions:
Intentions and Accidents

The trade-based global economy stimulates the spread of economically important species, often with funding from development agencies to establish plantations of rubber, oil palm, pineapples, and coffee, and fields of soybeans, cassava, maize, sugarcane, wheat, and other species in countries far from their place of origin. But it also stimulates the accidental spread of species through a variety of pathways (Jenkins 1996; OTA 1993). While it is difficult with present information to determine precisely how much of the invasives problem globally is due to conscious intent and how much to inadvertence, some hints are available:

- The Office of Technology Assessment (OTA) (1993), in a comprehensive review, concludes that about 4,500 exotic species occur in a free-ranging condition in the United States, and that about 20 percent of them have caused serious economic or ecological harm. The OTA concluded that 81 percent of the harmful new exotics detected from 1980 through 1993 where the pathway could be identified were from unintentional imports. Examples include the zebra mussel (*Dreissena polymorpha*) introduced into the Great Lakes via ship ballast water and the Asian tiger mosquito (*Aedes albopictus*) introduced via used tire imports.
- The World Wildlife Fund (WWF) reports that more than sixty introduced species have been found in the Baltic Sea, with many species apparently having arrived via ballast water. For example, the bristleworm *Marenzellaria viridis* has become a dominant species in the Vistula Lagoon, constituting 97 percent of the biomass of bottom-living macrofauna.
- The rapid decline in frog populations in Queensland is attributed to a virus that is exotic to Australia and that may have been introduced through the thriving international trade in ornamental fish.
- The OTA (1993) found that the importation of raw logs from Siberia to the West Coast of the United States carried with them pests with significant potential negative economic impacts. These included the Siberian gypsy moth, which is considered more damaging to coniferous forests than the European gypsy moth, which has already caused significant damage. (As a result, imports of raw logs from Siberia have now been banned).
- With an estimated 3,000 species, on any one day, of freshwater, brackish water (estuarine), and marine protists, animals, and plants in motion around the world in the ballast of oceangoing ships, numerous opportunities are available for the invasion of aquatic environments by exotic organisms. In the last decade for example, the Japanese sea star (*Astrias amurensis*) has appeared in Australia, where it has broad potential impacts on the

shellfish industry; the Japanese shore crab (*Hemigrapsus sanguineus*) has colonized Atlantic North America (where it is now becoming relatively common from Cape Cod to Chesapeake Bay); the American comb jelly fish (*Mnemiopsis leidyi*) has invaded the Black and Azov Seas and has been linked to the near demise of regional anchovy fisheries; the Chinese estuarine clam *Potamocorbula amurensis* has become one of the most abundant benthic organisms in San Francisco Bay, where the disappearance of spring phytoplankton blooms in parts of the bay and extensive decreases in zooplankton have been attributed to high densities of this clam; and the Indo-Pacific mussel *Perna perna* has colonized Caribbean mangrove ecosystems and Gulf of Mexico jetties, where it forms extensive monoculture beds. In the Great Lakes of Canada and the United States, three European fish, two species of zebra mussels, and a carnivorous water flea, all unknown in North America in 1980, are now six of the most common species regionally or in large parts of those waters.

It appears, then, that "the problem of invasive species" has two very distinct elements: species that are introduced consciously, and for which management procedures such as environmental impact assessments are available; and inadvertent invasives, which may be far more pervasive and far less amenable to management intervention.

Globalization, Climate Change, and Exotic Species

The Intergovernmental Panel on Climate Change (IPCC) (1996) has concluded, on the basis of long and detailed studies, that human activities are having a discernable impact on the climate—primarily through the burning of fossil fuels, which is increasing the amount of carbon dioxide in the air and thereby contributing to the so-called greenhouse effect. Much of the global economy is based on these fossil fuels: global trade in fossil fuels was $335 billion in 1990 (WRI 1994). Without the cheap petroleum-based transport that subsidizes global trade, commodities would be far more expensive and trade would be greatly reduced, with a commensurate reduction in the threats from introduced species.

The expected climate change could well promote the interests of invasive species, especially since invasives are especially likely to become established in habitats disturbed by human or other factors (Mooney and Hobbs, this volume). When CO_2 increases, seedlings in forest gaps may grow more quickly, so turnover rates in tropical forests may increase. It may well be that increased fire or other disturbances that break up the forest canopy would increase the likelihood of invasion by alien species.

Thus climate change could open up new opportunities for introduced

species that could devastate native flora and fauna. For example, if the species that are dominant in the native vegetation are no longer adapted to the environmental conditions of their habitat, what species will replace them? It may well be that exotic species will find these "new" habitats especially attractive, and the increasing presence of new species and the decline of old ones will drastically change successional patterns, ecosystem function, and the distribution of resources. Thus concepts of global change need to include consideration of the behavior and distribution of invasive species. It seems highly likely that invasive species are going to have far more opportunities in the future than they have at present.

Many variables may limit the distribution of a species in different parts of its range, and detailed studies are required to define the distribution limit of various invasive species as climates change. Sutherst et al. (1996), for example, used a computer program for comparing the relative climatic potential for population and persistence of the invasive Cane toad (*Bufo marinus*) in relation to season and locality. This type of study is likely to be increasingly relevant and important.

Global Solutions to the Global Problem of Alien Species

While this chapter has supported the argument that global trade promotes invasive species, it is possible that agreements under the World Trade Organization (WTO) could offer some help in dealing with exotic species, though bans and restrictions should be founded on science-based risks so that they will be less likely to be challenged before the WTO. But such risk assessment is often extremely expensive; for example, the risk assessment for the proposed importation of raw Siberian larch cost the U.S. government about $500,000 (Jenkins 1996).

As Yu (1996) points out, the General Agreement on Tariffs and Trade (GATT) contains three important provisions to protect the environment and human health, which might be expanded to deal with exotic species. These provisions include the Agreement on Sanitary and Phyto-sanitary Measures, the Agreement on Technical Barriers to Trade, and Article 20: General Exceptions, which protects the right of members to take any measures "necessary to protect human, animal, or plant life or health."

Even so, the impact of trade on biodiversity remains poorly addressed. Free traders maintain that liberalized markets will solve environmental problems by promoting more efficient use of natural resources, while others maintain that global markets actually undermine efforts to protect the environment. The former argue that increased revenues will lead to decreased environmen-

tal damage, while the latter contend that increasing revenues are precisely the problem leading to overconsumption of biological resources. The United Nations Conference on Environment and Development (UNCED) was relatively ineffective in addressing trade issues, much less trade's promotion of invasives. It endorsed the establishment of strong environmental rules on trade without exploring the basic principles of trade reform that would enable a balance to be struck between trade and environment. The language adopted by Agenda 21 in Rio generally adopted the line being promoted by the GATT Uruguay round of negotiations but ignored the possibility that GATT could itself undermine the environmental measures initiated by the Earth Summit (Prudencio 1993).

Several global mechanisms already exist to address the problem of invasives carried in ballast water. For example, the United Nations Convention on the Law of the Sea requires states to take all measures necessary to prevent, reduce, and control intentional or accidental introduction of alien or new species into the marine environment, and Agenda 21 directs states to consider adopting appropriate rules on ballast water discharge to prevent the spread of invasives.

Jenkins (1996) calls for an international advisory panel under the Convention on Biological Diversity (CBD) to advise the various convention secretariats, trade regulation bodies, and national governments regarding risky trade routes, potentially threatening species, the nations and ecosystems most vulnerable to exotic threats to biodiversity, and improvements in prevention and control efforts. As a means of implementing Article 8(h) of the CBD, he calls for independent assessments to be conducted for the most vulnerable areas identified, based on at least the following elements:

- Natural histories of exotic species impacts on native biodiversity.
- Current and projected future pathways of exotic species introductions.
- Laws, policies, and programs for preventing and managing exotics affecting biodiversity.
- Institutional and technological capabilities for preventing and managing exotics.
- Public education and awareness strategies, as called for under Article 13 of the CBD.

As suggested earlier, other international conventions might also be brought to bear on the invasive species problem. Particularly interesting in this regard is the Climate Change Convention, which has very broad government support, especially in the industrialized countries. It also has an associated scientific body, the Inter-governmental Panel on Climate Change; the latter has not yet had the issue of invasive species brought to its attention, but is increasingly recognizing the importance of climate change on biodiversity

more generally. It too could be mobilized in support of a global effort to address the invasive species problem.

Another global solution might be through the World Health Organization, especially for invasives that are relevant to human health—primarily viruses and bacteria. While most chapters in this volume look at insects, vertebrates, and plants, the bacteria and viruses may be much more interesting to governments and the general public, as indicated by the popularity of books and films dealing with the Ebola virus. Mechanisms designed to address these disease-causing invasives may also be relevant to other parts of the invasive species problem.

Costs and Benefits of Alien Species

It is probably fair to say that most people who seek to introduce an exotic or alien species into a new habitat are doing so for an economic reason. They may wish to increase their profits from agriculture, they may believe that the public will like a new flower from a distant part of the globe, or they may think that exotic species will be able to carry out functions that native species cannot carry out as effectively.

But it may also be fair to say that most of those introducing exotic species have not carried out a thorough cost-benefit analysis before initiating the introduction, at least partly because they may not have been aware of the advantages of such analyses. On the other hand, it is also possible that at least some people would prefer to ignore the negative impacts that may follow from species introductions, because they might be expected to compensate those who are negatively affected.

Similarly, those who have been responsible for inadvertently introducing species into new habitats may not have been willing to make the investment to prevent such accidents from occurring. They may not have realized the dangers, and in any case the dangers would be unlikely to have much economic impact on their own welfare. Rather, the costs of such accidents are borne by people other than those who are permitting the accidents to happen. Thus the costs of introducing alien species into new habitats are "externalized" in considerations of the costs of global trade. The line of responsibility is insufficiently clear to bring about the necessary changes in behavior, so the general public—or future generations—ends up paying most of the costs.

This chapter introduces, in a preliminary way, some of the economic factors affecting the issue of alien species. It will quickly become clear that this field is still relatively immature, but that considerable benefits for biodiversity will come from a more inclusive consideration of economic factors, and the application of economic tools to deal with them.

Good Intentions: Somebody Is Going to Make Money

Many exotic species were introduced for economic purposes. Introduced fish can produce excellent sport fishing; introduced plants can provide food, fodder, and energy; and introduced insects can provide biological controls. A few examples (from among hundreds that could be quoted):

- Brush-tailed possums from Australia were introduced to New Zealand between 1858 and 1900 to establish a fur trade, but in New Zealand they have fewer competitors, fewer predators, and fewer parasites than in their native Australia, so they have successfully spread and have sometimes reached densities ten times greater than in their native Australia. They have been a bonanza for the fur industry, though some problems have arisen due to social pressures to stop wearing fur.
- A number of woody plants from various parts of the world, such as acacias from Australia, were introduced into South Africa in the middle of the nineteenth century for purposes of dune stabilization, tannin extraction, and firewood. This appears to have been an economically successful invasion, with the greater Cape Town region alone supporting a 30 million Rand charcoal and firewood industry.
- In the Thar Desert of India, the African tree *Prosopsis juliflora* was introduced 70 years ago and has become the dominant flora around human habitats. With its dense green vegetation, this tree is very useful in checking soil erosion, reducing the dryness of the desert air, giving shelter to several species of wild animals, and providing legumes that are relished by wild as well as domesticated animals. It meets 85 percent of firewood demands of rural people.
- The triclad flatworm *Platydemus manokwari*, first described from New Guinea in 1963, is a successful predator of the giant African snail *Achatina fulica*, so it was transported as a biological control agent to areas where the African snail had become established in the Pacific.
- Water hyacinth (*Eichhornia crassipes*) was introduced into China from South America in the 1930s and was spread through mass campaigns in the 1950s to the 1970s as an ornamental plant, to provide livestock food, and to control pollution through absorbing heavy metals.

But Something Went Wrong: Somebody Had to Pay the Costs

We all know that there is no free lunch. Introduced species can carry a heavy price tag, in terms of reduced crop and livestock production, loss of native biodiversity, increased production costs, and so forth. As just one example, the OTA (1993) estimates that the total direct costs to the United States of invasive species of weeds is $3.6–$5.4 billion per year. This figure does not

include environmental, human health, regulatory, and other indirect costs of using herbicides on these weeds, though these costs are estimated to be at least $1 billion per year; if herbicides were not available, the crop losses would jump to nearly $20 billion per year.

All of the introductions listed in the previous section carried with them some hidden—or, in retrospect, obvious—costs:

- The Australian brush-tailed possums introduced into New Zealand have caused considerable damage to native forests, changing forest composition and structure through the defoliation and progressive elimination of favored food plants. Note that none of these costs are particularly relevant to those interested primarily in the benefits from furs. In an effort to control these possums, New Zealand is working on biocontrol agents, including the possibility of a genetically engineered immunocontraceptive virus, as is Australia for rabbits and foxes. This innovative approach could have profound implications elsewhere in the world, showing that some problems may lead to solutions that have considerable global value.
- As a result of the introduced woody plant species into South Africa, the highly endemic Cape flora is under serious threat and the watersheds are becoming less productive, potentially causing a considerable increase in the price of water (van Wilgen et al. 1996). (See page 184 for more details).
- While *Prosopis juliflora* has been a boon to people in the Thar Desert who need firewood and fodder, it overwhelms other flora in the area, thereby reducing the range of products available to local people and reducing biodiversity.
- The triclad flatworm now poses a serious threat to the native gastropod fauna of the Pacific region. This is especially troubling because the Pacific has seen a remarkable radiation of the snail family Partulidae, and some twenty-four of these are on the 1994 International Union for Conservation of Nature and National Resources (IUCN) Red List of Threatened Animals. The triclad flatworm has become established on Guam, Saipan, Tinian, Rotar, and Palau.
- Water hyacinth, the infamous aquatic weed originating from South America, was introduced to China in 1930 as forage for domestic animals and to purify water. It has now spread throughout much of the country, with south China the most severely affected. By 1994, over 10 square kilometers of Dianchi Lake in Yunan Province, one of China's most famous and scenic lakes, was infested, causing economic losses in fisheries and tourism, as well as the loss of several native species of aquatic plants.

Few of these examples have explicit costs attached to them, but qualitative costs are often available. For example, in the early 1900s, the most economically important hardwood species in eastern U.S. forests was the chestnut

Table 8.3. Estimated cumulative losses to the United States from selected harmful nonindigenous species, 1906–1991.

Category	Species analyzed (number)	Cumulative loss estimates (millions of U.S. dollars, 1991)	Species not analyzed (number)
Plants (except agricultural weeds)	15	603	—
Terrestrial vertebrates	6	225	>39
Insects	43	92,658	>330
Fish	3	467	>30
Aquatic invertebrates	3	1207	>35
Plant pathogens	5	867	>44
Other	4	917	—
Total	79	96,944	>478

Data from Office of Technology Assessment 1993.

(*Castanea dentata*), but the chestnut blight brought in on diseased horticultural stock from China killed nearly a billion trees and all but eliminated this species, leading to ecosystem changes in the eastern hardwood forests (U.S. Department of Agriculture 1991).

More quantitative cost estimates have also been made. For example, the OTA (1993) estimated the cumulative losses to the United States from 79 alien species from 1905 to 1991 at more that US$96 billion, a conservative estimate since data were available for only a few years (Table 8.3).

The OTA (1993) also projected potential future losses under a "worst-case scenario," estimating that just fifteen species of plants, insects, plant pathogens, and aquatic invertebrates could eventually cause economic losses of over U.S.$134 billion over a fifty-year period. Since the United States has over 4,500 alien species, the potential for considerable damages is very great.

Despite such figures, the issue of costs and benefits is not always clear, at least partly because different people have different perceptions of what these are. Luken and Thieret (1996), for example, report that within less than a century after the deliberate introduction of Amur honeysuckle into North America to improve habitat for birds, serve ornamental functions in landscape plantings, and stabilize and reclaim soil, it had become established in at least twenty-four states in the eastern United States. While many resource managers perceive the plant as an undesirable element, gardeners and horticulturalists consider it an extremely useful plant. Thus the "noxious invasive" of one group is the "desirable addition" of other groups. How can costs and benefits be determined in such a case?

Diamond et al. (1991) have estimated the costs and benefits of controlling the invasive tree *Melaleuca quinquenervia* in Florida. Total annual benefits,

based largely on tourism, of preventing infestation from the tree would be $168.6 million, while the costs to honey producers to whom the tree provides nectar would amount to just $15 million. Again, the costs and benefits in this case are differentially distributed: those who suffer losses are unlikely to be compensated, while those who benefit pay few of the costs.

Considerable work has now been done in the United States on the cost-benefit ratios for various forms of managing invasive species (though the distribution of these continues to be ignored). The OTA (1993) presents a summary of these, with Table 8.3 highlighting a number of cases. Note the very wide range of cost-benefit ratios, though in nearly all cases, the benefits of control far outweigh the costs involved. This strongly suggests that significantly increased investment in managing invasive species is justified in economic terms, though again those paying the costs—usually the taxpaying public—may not always be the primary beneficiaries; and those who earned the benefits from the invasives in the first place are paying virtually none of the costs.

As an indication of one interesting approach to measuring costs and benefits, van Wilgen et al. (1996) presented a case study showing how invasion by alien plants has affected water resources in the mountain catchment areas of the Western Cape Province, South Africa. They found that the sustained supply of high-quality water depends on maintaining the cover of fynbos (shrubland) vegetation. The fynbos binds the soil, preventing erosion, while its relatively low biomass ensures conservative water use and low-intensity fires, which in turn ensure high water yields and low impacts on the soil from periodic fires. Fynbos-clad mountain catchments fulfill approximately two-thirds of the Western Cape's water requirements, an ecosystem service that plays a crucial role in the region's economy and contributed to a gross domestic product of U.S.$15.3 billion in 1992. The fynbos flora is widely harvested for cut flowers, dried flowers, and thatching grass, producing a combined value in 1993 of $18–19.5 million and providing a livelihood for 20–30,000 people.

However, catchment management is complicated by the invasion of the fynbos vegetation by nonindigenous woody trees and shrubs, which increase biomass and reduce runoff. Fynbos ecosystems are remarkably prone to invasion by alien woody species, which displace the native fynbos and increase biomass by between 50 and 1,000 percent. These invasive plants were introduced to South Africa to provide a source of fast-growing timber in the relatively treeless landscape, as hedge plants, as agents for binding the shifting dunes along the coast, and as ornamental plants. The most important invasive species originated in Australia and the Mediterranean-climate areas of Europe and North America. On the slopes of Table Mountain, above Cape Town, invasion by alien species has increased fire intensities, leading to severe soil erosion.

Van Wilgen et al. (1996) developed a computerized model that indicated that alien plants would invade approximately 40 percent of the area within 50 years and 80 percent after 100 years, with a corresponding increase in biomass of 150 percent or more. This invasion would result in an average decrease of 347 cubic meters per hectares per year of water at the end of 100 years, resulting in average losses of more than 30 percent of the water supply to the city of Cape Town. In some years, when large areas would be covered by mature trees, losses would be much greater, exceeding 50 percent of the runoff from similar uninvaded areas. They concluded that investments in managing alien plants at a level that would ensure that they are no longer part of the ecosystem would lead to a net unit cost of water of $.12 per cubic meter, as compared to $.14 without the management of alien plants.

While it is important to identify the costs and benefits, such identification does not automatically determine a decision because value judgments and distributional questions are nearly always involved. Further, the magnitude of the costs may sometimes be so high as to render an action politically unacceptable, even when the benefits are likely to be even greater; part of the problem is that the benefits may be widely spread throughout the public over a period of many years, while the costs of control may need to be paid rather quickly by taxpayers.

Conclusions and Recommendations

One of the main side effects of liberalizing trade as advocated by the World Trade Organization is to stimulate an even greater volume in materials traded, thereby offering—in addition to more goods for consumers—greater opportunities for introduction of exotics and ultimately greater homogenization of ecosystems. Despite the evidence of significant impacts of invasives, the response of governments is inadequate to prevent the increased trade that is resulting in more introductions of harmful species (Jenkins 1996). And if even governments with relatively well developed control structures are unable to deal with the problem, what of the many tropical countries that have even less capacity for dealing with such problems? Here are some suggestions for the global community:

- Use the Convention on Biological Diversity (CBD) more effectively. The issue of invasive species is clearly also an issue of biosafety. Yet the convention's biosafety focus is on living modified organisms (Article 19.3), which more properly is just a subset of the invasive species problem covered by Article 8(h). While the discussion on biosafety has already gone on for several years, it is perhaps not too late to bring the relevance of the broader invasive species issue to the attention of the Conference of the Parties of the

CBD for inclusion in the biosafety protocol being negotiated. This carries the recommendations of Jenkins (1996) one step further, and while it is unlikely that the biosafety protocol discussion will be broadened, at least the process of addressing Article 8(h) will begin.

- Bring the issue of invasive species to the attention of the World Trade Organization, perhaps through a statement adopted by the Conference of the Parties of the CBD. Such a statement will need to be relatively concise and explicit, and contain within it specific responses that would be expected from the WTO.
- Build on the experience of countries faced with significant invasive species problems (e.g., the United States, Australia, New Zealand) to develop further a body of principles and practice that could be transferred to developing countries.

It is apparent from the material presented in this chapter, which is only a small sample of a much larger literature, that economics has much to contribute to programs to address the problems of alien species. Decision makers often find arguments couched in economic terms to be more convincing than those cast in emotive or ethical terms, and this chapter has suggested some ways that economics-based arguments can be used to support stronger programs to deal with invasive species. Without trying to be comprehensive, I suggest at least the following actions to be considered by those developing national responses to the problem of invasives:

- Build an economics component into any international program to deal with invasive species. This should include IUCN's Species Survival Commission recruiting economists onto its Invasive Species Specialist Group, and ICSU-SCOPE ensuring that economists are involved in their invasive species research programs. A partnership between ecologists working on invasive species and economists could be extremely productive. Economic analysis can provide a useful and rigorous structure to guide policy makers who might otherwise "externalize" some of the most relevant factors. Applying numbers to the problem can highlight the areas of debate and uncertainty, particularly when they look at the distribution of costs and benefits.
- In each country, or as part of each program to deal with one or more invasive species, seek to quantify the costs and benefits involved. Ensure that such quantification is as complete as possible, so that some costs (or benefits) are not "externalized." The ability of economists to provide useful analyses will depend to a large extent on how well biologists are able to estimate the probabilities of future impacts of alien species in a consistent, convincing, and comparable way. Because economic models provide little

assistance where they rest on vague or equivocal predictions of biological events, an effective partnership between ecologists and economists is essential.

- Mobilize economic instruments, including grants, taxes, and fines to ensure better compliance with programs dealing with invasive species. Economic analysis can help design appropriate economic instruments, such as incentives and disincentives, helping to determine appropriate levels of fines and penalties for those introducing alien species.

The problem of human-induced invasive species is as old as our own species. But the severity of the problem has grown tremendously as the global economy has reached into virtually all corners of our planet. As a significant global problem with negative impacts on all countries, it is deserving of a significant global response.

References

Ashton, P.S., and D.S. Mitchell. 1989. "Aquatic plants: patterns and modes of invasion, attributes of invading species and assessment of control programmes." Pp. 111–147 in J.A. Drake, H.A. Mooney, F. di Castri, R.H. Groves, F.J. Kruger, M. Rejmánek, and M. Williamson (eds.), *Biological Invasions: A Global Perspective.* Scope 37. John Wiley and Sons, New York, NY.

Atkinson, S.F. 1985. "Habitat-based methods for biological assessment." *The Environmental Professional* 7(3):265–282.

Bratton, S.P. 1982. "The effects of exotic plant and animal species on nature preserves." *Natural Areas Journal* 2(3):3–12.

Brockie, R.E., L.L. Loope, M.B. Usher, and O. Hamann. 1989. "Biological invasions of island nature reserves." *Biological Conservation* 44:9–36.

Carlton, J.T., and J.B. Geller. 1993. "Ecological roulette: the global transport of nonindigenous marine organisms." *Science* 261:78–82.

Crosby, A.W. 1972. *The Colombian Exchange: Biological and Cultural Consequences of 1492.* Greenwood Press, Westport, CT.

———. 1986. *Ecological Imperialism: The Biological Expansion of Europe, 900–1900.* Cambridge University Press, Cambridge, UK.

Cuddihy, L.W., and C.P. Stone. 1990. *Alteration of Native Hawaiian Vegetation: Effects of Humans, Their Activities and Introductions.* University of Hawaii Press, Honolulu.

Diamond, C., D. Davis, and D.C. Schmitz. 1991. "Economic impact statement: The addition of *Melaleuca quinquenervia* to the Florida Prohibited Aquatic Plant List." *Proceedings of the Symposium on Exotic Pest Plants.* U.S. Department of the Interior, Washington, D.C.

di Castri, F. 1989. "History of biological invasions with special emphasis on the Old World." Pp.1–26 in J.A. Drake, H.A. Mooney, F. di Castri, R.H. Groves, F.J. Kruger, M. Rejmánek, and M. Williamson (eds.), *Biological Invasions: A Global Perspective.* Scope 37. John Wiley and Sons, New York, NY.

Ding, J. R. Wang, and Z. Fan. 1995. "Distribution and infestation of water hyacinth and control strategy in China." *Journal of Weed Science* 9:49–51.

Drake, J.A. (ed.). 1989. *Biological Invasions: A Global Perspective.* Wiley, Chichester.

Heywood, V. 1989. "Patterns, extents and modes of invasions by terrestrial plants." Pp. 31–51 in J.A. Drake, H.A. Mooney, F. di Castri, R.H. Groves, F.J. Kruger, M. Rejmánek, and M. Williamson (eds.), *Biological Invasions: A Global Perspective.* Scope 37. John Wiley and Sons, New York, NY.

Hoyt, E. 1992. *Conserving the Wild Relatives of Crops.* IBPGR, IUCN, and WWF. Second Edition.

Intergovernmental Panel on Climate Change (IPCC). 1996. *Climate Change 1995: The Science of Climate Change.* Cambridge University Press, Cambridge, UK.

Jacobs, J. 1975. "Diversity, stability and maturity in ecosystems influenced by human activities." Pp. 187–207 in van Dobben, W.H., and R.H. Lowe-McConnell (eds.), *Unifying Concepts in Ecology.* Junk, The Hague.

Jarvis, P.H. 1979. "The ecology of plant and animal introductions." *Progress in Physical Geography* 3:187–214.

Jenkins, P.T. 1996. "Free trade and exotic species introductions." *Conservation Biology* 10(1):300–302.

Kowarik, I. 1990. "Some responses of flora and vegetation to urbanization in Central Europe." Pp. 45–74 in Sukopp, H., S. Mejny, and I. Kowarik (eds.), *Urban Ecology: Plants and Plant Communities in Urban Environments.* SPB Academic Publishing, The Hague.

Levin, S.A. 1989. "Analysis of risk for invasions and control programmes." Pp. 425–432 in J.A. Drake, H.A. Mooney, F. di Castri, R.H. Groves, F.J. Kruger, M. Rejmánek, and M. Williamson (eds.), *Biological Invasions: A Global Perspective.* Scope 37. John Wiley and Sons, New York, NY.

Lowe-McConnell, R.H. 1993. "Fish faunas of the African Great Lakes: origins, diversity, and vulnerability." *Conservation Biology* 7:634–643.

Luken, J.O., and J.W. Thieret. 1996. "Amur honeysuckle, its fall from grace." *BioScience* 46(1):18–24.

Macdonald, I.A.W., L.L. Loope, M.B. Usher, and O. Hamann. 1989. "Wildlife conservation and the invasion of nature reserves by introduced species: a global perspective." Pp. 215–280 in J.A. Drake, H.A. Mooney, F. di Castri, R.H. Groves, F.J. Kruger, M. Rejmánek, and M. Williamson (eds.), Biological Invasions: A Global Perspective. Scope 37. John Wiley and Sons, New York, NY.

Martin, P.S., and R.G. Klein (eds.). 1984. *Quaternary Extinctions: A Prehistoric Revolution.* University of Arizona Press, Tucson, AZ.

McNeely, J.A. 1995. "Cities, nature, and protected areas: a general introduction." Paper presented to *Symposium on Natural Areas in Conurbations and on City Outskirts,* Barcelona, Spain, 25–27 October.

Miller, S.E., and L.G. Eldridge. 1996. "Numbers of Hawaiian species: Supplement one." *Bishop Museum Occasional Papers* 45:8–17.

Mooney, H., and J.A. Drake. 1987. "The ecology of biological invasions." *Environmentalist* 19(5):10–37.

Moore, R.M. 1983. "Human impact on island vegetation." Pp. 237–246 in Holzner, W.,

M.J.A. Werger, and M. Ikusima (eds.), *Man's Impact on Vegetation.* Junk, The Hague.

Moyle, Peter B. 1976. "Fish introductions in California: history and impact on native fishes." *Biological Conservation* 9(2):101–118.

Office of Technology Assessment (OTA). 1993. *Harmful Non-Indigenous Species in the United States.* U.S. Government Printing Office, Washington, D.C.

Oliver, W.L.R. (ed.). 1993. *Pigs, Peccaries and Hippos: Status Survey and Conservation Action Plan.* IUCN, Gland, Switzerland.

Prudencio, R.J. 1993. "Why UNCED failed on trade and environment." *Journal of Environment and Development* 2(2):103–109.

Smith, S.H. 1972. "Factors of ecologic succession in oligotrophic fish communities of the Laurentian Great Lakes." *Journal of the Fisheries Research Board of Canada* 29:717–730.

Sprugel, D.G. 1991. "Disturbance, equilibrium and environmental variability: what is "natural" vegetation in a changing environment?" *Biological Conservation* 58:1–18.

Stuart, S.N. and N.J. Collar. 1988. "Birds at Risk in Africa and Related Islands: The Causes of Their Rarity and Decline," *Proceedings of the Sixth Pan-African Ornithological Congress,* Francistown, Botswana.

Sutherst, R.W., R.B. Floyd, and G.F. Maywald. 1996. "The potential geographical distribution of the Kaintode, *Bufo marinus* in Australia." *Conservation Biology* 10(1):294–299.

U.S. Department of Agriculture (USDA). 1991. "Pest risk assessment of the importation of larch from Siberia and the Soviet Far East." *Forest Service Miscellaneous Publication* 1495.

van Wilgen, B.W., R.M. Cowling and C.J. Burgers. 1996. "Valuation of ecosystems services." *BioScience* 46(3):184–189.

Waage, J.K. 1991. "Biodiversity as a resource for biological control." Pp. 149–163 in Hawksworth, D.L. (ed.), *The Biodiversity of Micro-organisms and Invertebrates: Its Role in Sustainable Agriculture.* CAB International, Oxford, UK.

Wagner, W.L., D.R. Herbst, and S.H. Sohmer. 1990. *Manual of the Flowering Plants of Hawaii.* Bishop Museum Press; University of Hawaii Press, Honolulu.

World Resources Institute (WRI). 1994. *World Resources: 1994–95.* Oxford University Press, New York, NY.

Yu, D.W. 1996. "New factor in free trade: reply to Jenkins. *Conservation Biology* 10(1):303–304.

Zaret, T.M., and R.T. Paine. 1973. "Species introduction in a tropical lake." *Science* 182:449–455.

Chapter 9

≋

Global Changes, Invasive Species, and Human Health

Anthony J. McMichael and Menno J. Bouma

Recent human experience has drawn attention to the ecological, often evolutionary, character of the origins and spread of infectious diseases. The unexpected appearance of HIV/AIDS, the *Ebola* virus, and the "mad cow"-associated neurodegenerative Creutzfeld-Jacob disease are three better-known examples of a wider catalogue of change. Various seemingly new infectious diseases have appeared in the past few decades in response to land clearance, extensions of agriculture and irrigation, intensive food production, biomedical technology, and human mobility. Meanwhile, the geographic range of many established infectious diseases, such as cholera, dengue, malaria, and various types of encephalitis, has been extended by land use, regional climate change, long-distance trade and travel, demographic shifts and social (especially urban) behaviors. Further, genetic shifts are occurring in infectious agents, particularly in response to the widespread use—often misuse—of antibiotics in clinical medicine, animal husbandry, and horticulture. An understanding of the context in which these changes in infectious disease risks have occurred connects the topic with the general topic of "invasive

species." Vitousek and colleagues (1997) argue that infectious disease agents are true invaders across most of their range of occurrence.

Human infectious disease is just one example—albeit the major one—of how invasive species can affect human health. Other invaders that impair food yields, food storage, or the production of foodborne biotoxins also pose risks to human health. Each of these categories of hazard is addressed in this chapter. First, however, it is instructive to review the historical aspects of this fascinating topic.

The Challenge

Invasive species, large and small, have accounted for many of history's great public health disasters. The three main types of invaders over the past ten millennia have been (1) other humans as conquerors, enslavers, and colonizers; (2) unfamiliar types of infectious agents, either acquired by humans from domesticated and other cohabiting animals, or imported inadvertently by human invaders; and (3) pests and pathogens that have devastated local food and livestock production, thereby causing hunger and famine.

The issue facing us today, in a world undergoing increasingly massive environmental disruption and global change, is not whether invasive species pose a new type of environmental health hazard. That is not doubted; in situations of environmental change and ecological disturbance, pests and pathogens have routinely posed risks to human health. Rather, it is the *type, scale,* and *tempo* of change in health risk under the contemporary conditions of global change that warrants exploration. The second and third types of above-mentioned historical invasives are briefly discussed here. The first category (human conquest, cruelty, and colonial oppression) needs no elaboration as a cause of misery, maiming, morbidity, and death.

Historical Entry of New Infections into Human Populations

From around 10,000 years ago as hunting-gathering and nomadism evolved into neolithic settled farming and herding, various bacteria, viruses, and protozoa began to invade human populations from their established enzootic mammalian and avian hosts. Over countless earlier millennia, pre-agrarian hominids must have experienced chronic helminth (worm) infections, wound infections from ubiquitous streptococcal and staphylococcal bacteria, and occasional cross-infection (sleeping sickness, monkey malaria, yellow fever, etc.) from wild animal sources. But most of the infections that dominate medical texts today—measles, chicken pox, tuberculosis, leprosy, diphtheria, influenza, the common cold, and so on—derive from the neolithic

agrarian "revolution." This radical change in human ecology created vast new opportunities for opportunistic strains of microbes to jump species and become human infections (McNeill 1976).

As the scale of farming, herding, and the associated land clearance and irrigation increased, so critical thresholds of population size and density must have been passed that allowed various of these new infectious diseases to become endemic. Measles, for example, requires a sedentary population of around a half million to achieve sustainable circulation. A sufficient continuing supply of previously uninfected (i.e., unimmunized) young children is needed for the circulating virus.

Malaria is another interesting example. This infection has long occurred in birds, monkeys, apes, and several other animal groups, and the coevolutionary process has rendered it a mild condition in the infected animal. Human strains of malaria probably became endemic in western and northern Africa from around 5,000 years ago, and in the eastern Mediterranean from around 3,000 years ago, as human population densities increased and as farming and settlement practices increased opportunities for mosquito breeding.

The period from Hellenistic to early imperial Roman times was one of demographic and economic expansion. The vast extensions of agriculture, to feed enlarging urban populations and armies, entailed increasing deforestation. Coastal alluviation, caused by deforestation, cultivation, and soil erosion, peaked in Asia Minor between 300 and 100 B.C. and in southern Greece around a century later (Butzer 1974). This deforestation probably created auspicious habitat conditions for several *Anopheles* (mosquito) species. This would accord with historical and medical texts indicating that malaria became a serious public health problem in the first and second centuries A.D. At around that time, the more severe type of malaria, caused by *Plasmodium falciparum*, was probably introduced from southwest Asia and northern Africa via trade and military campaigns. This invasive organism would then have adapted to the existing mosquito species long involved in the transmission of *P. malariae* and *P. vivax* (Bruce-Chwatt 1988). The prolonged impact of malaria on the populations of classical Greece and Rome appears to have become severe only in the late Roman Empire and its Byzantine period—perhaps assisted by the onset of the medieval warm period.

Contacts between Civilizations

The introduction of new infections accounted for much of the destructive shock experienced by vulnerable, immunologically naive civilizations when first contacted by traders, armies, and colonizers from distant lands (McNeill 1976). Around 3,000 years ago, the Hittites (of the Syrian region), whose

army had just returned triumphant from pharaonic Egypt, were decimated by alien infections acquired from their more cosmopolitan and immunologically toughened Egyptian prisoners. Similarly, between 2,500 and 1,500 years ago the classical cities of Athens, Rome, and Constantinople were struck staggering blows by spectacular new epidemic infections brought in from Middle Eastern and Indian sources by traders and armies. Measles and smallpox, entering China for the first time in the third and fourth centuries A.D., caused massive die-offs.

In the fifth to eighth centuries A.D., the bubonic plague entered human populations—perhaps for the first time. From its probable ancient origins in infected ground-dwelling rodents somewhere in the central Asian or Himalayan regions, the plague bacterium infected (via the transfer of fleas) black-rat stowaways in the early trade caravans. Thereafter, plague cut swathes through the hapless urban and village populations of the Roman Empire, the emerging Muslim civilization from Alexandria to Damascus, and China.

Almost a thousand years later, European smallpox and measles, with a little help from Spanish conquistadorial gunpowder and steel, brought the mighty Aztec and Inca empires to their knees in the sixteenth century. Russian pioneers, pushing east of the Urals in the following centuries, unwittingly introduced devastating epidemics into the native populations of Siberia. European explorers and colonizers in the Pacific and Australia inadvertently wiped out high proportions of the indigenous populations with smallpox, measles, influenza, tuberculosis, and other infections—infections to which European populations had, by then, become biologically accommodated.

Parasitic Invasions of Human Food Species

Pests and pathogens afflict all multicellular species, not just humans. Human food species have often been prey to invasions of such parasites. Doubtless some of the great Mosaic Plagues of Egypt, around 3,500 years ago, were of this kind: eutrophic blood-red algal blooms on the Nile, plagues of locusts that darkened the skies, and others. We can assume that the early exchanges in exotic species between neighboring civilizations as agricultural practices spread, especially within the greater Eurasian continent, resulted in many introductions of exotic parasites that devastated local crops. We know that there were famines associated with outbreaks of ergot poisoning in wheat crops in late Middle Ages Europe. The best-documented recent catastrophe is that of the Irish Potato Famine in the 1840s, when a fungal "blight," *Phytophthera infestans,* thought by some to have been introduced by sea trade from North America, resulted in widespread infection and destruction of

potato crops in northwestern Europe. (Irish vulnerability was greatly amplified by the heavy reliance of the rural poor on potatoes, the amplification of that poverty by repressive British rule, and protectionist Corn Laws that forbade the import of overseas cereal grains into Ireland.)

There have been other close calls in recent decades—for example, viral disease in maize crops in the Americas in the 1970s and renewed anxieties about variants of potato blight tending to spread intercontinentally in the 1990s. Less hazardous to human nutrition and health, but very damaging to economies and the joys of the bon vivant, was the disastrous infiltration of phylloxera (plant lice) from U.S. sources that wiped out most of the French vineyards in the 1860s.

The notion of health-related "invasion" can also accommodate the modern invasion by introduced commercial crop monocultures that may increase the vulnerability of economically and politically marginal communities to food shortages. The robustness and versatility of traditional mixes of crops and other food plants has long been part of human cultural practice as a recognized means of maximizing long-term food security (albeit often at subsistence levels)—whereas large-scale, monocultural cash-cropping is directed at short-term harvest abundance and profitability, often at the expense of soil vitality. As agroecosystems undergo simplification, in the cause of economic aggrandization and efficiency, so we compound the risks of unexpected crop disasters from invading pests and pathogens. Perhaps the genetic modification of plants (assisted by "smart" pesticides) will fend off such invasion. But the microbial and insect world, with hundreds of millions of years of evolutionary experience, may well adapt to this threatened loss of nutrition and energy supplies—as they are now generally responding to the intense selection pressures posed by humankind's use of antibiotics.

Invasive Species as Contemporary Health Hazards

This historical review makes clear that invasions by other humans and by other species have long been major causes of human disease, particularly infectious disease. These invasions have been associated, variously, with increases in human population density, vulnerability, and interpopulation mobility; with intensification of trade; and with land-use activities that simplify and disturb ecological systems.

These are the three main pathways by which invasive species can affect human health:

1. Changes in exposure to infectious disease agents, either by the emergence or spread of infectious agents or, in the case of vectorborne infections, by the spread of vector species or alternate host species.

2. Damage by invasive species to natural or managed food-producing ecosystems.
3. Exposure to exobiotoxins produced by invasive species.

Several aspects of this list can be dealt with briefly. First, in relation to items 1 and 2, the emergence of antibiotic-resistant bacteria (Tomasz 1994; Jones et al. 1997) and pesticide-resistant insects in response to widespread use of these chemical agents over the past half century represents a particular type of "invasion"—the within-species emergence and spread of resistant strains. Second, in relation to biotoxins (item 3), as marine ecosystems come under stress, toxin-producing phytoplankton (especially the dinoflagellates and cyanobacteria) often proliferate at the expense of other benign species. Approximately 1 percent of the world's thousands of species of marine phytoplankton can product potent biotoxins, and these toxins can enter the food chain via shellfish to cause various types of food poisoning in humans. The resultant toxic disorders include amnesic, diarrheic, and paralytic shellfish poisoning.

Those aspects are not considered further here. The following sections of the chapter focus on how disturbance of ecological systems can enable the entry and proliferation of invasive species that, directly or indirectly, then influence the risks of infectious diseases in human populations. Brief note is also made of how the increase in physical dissemination of exotic species by trade and human mobility can also affect infectious disease patterns.

Trade, Technology, and Development: Recent Examples

Long-distance shipping apparently introduced the cholera bacterium into Peruvian coastal waters in 1991, causing the first outbreak of cholera in that continent for nearly a hundred years. Similarly, in the 1980s, intercontinental trade in used automobile tires introduced the East Asian mosquito vector for dengue fever, *Aedes albopictus*, into South America, the southern United States, and Africa. Modern patterns of human labor, touristic mobility, and sexual networks potentiated the spread of HIV from a quiet backwater in central Africa. Other aspects of modern human ecology—the rapid worldwide urbanization, intensification of food production and distribution systems, and various clinical and recreational exchanges of blood and other tissues between human individuals—are all opening new doorways for microbial traffic.

In the 1950s, René Dubos pointed out that technological innovation, whether industrial, agricultural, or medical, disrupts natural ecological balances and unleashs infectious diseases (Dubos 1959). In the wake of the third quarter of the twentieth century—the decades of the Rostowian model of

Western-style economic development in the Third World—it became clear that large-scale human interventions in the natural environment often, and usually adversely, affected infectious disease patterns (Hughes and Hunter 1970; Heyneman 1984). During this century, large development projects such as dams, irrigation schemes, land reclamation, road construction, and population resettlement programs (as is currently occurring in Indonesia) have often potentiated the spread of diseases such as malaria, dengue, schistosomiasis, and trypanosomiasis (Inhorn and Brown 1990; Kloos and Thompson 1979). Such large-scale developments in the eastern Mediterranean, Africa, South America, and Asia have been consistently associated with increases in communicable diseases, especially schistosomiasis and filariasis (which includes "elephantiasis"). However, because changes in land-use patterns are typically accompanied by variations in interannual rainfall, temperature, population density, population mobility, and pesticide usage, it is difficult to apportion blame for any changes in rates of disease.

Land-use Patterns and Infectious Disease

Rinderpest and the Ebb and Flow of African Sleeping Sickness

The story of the ebb and flow of African sleeping sickness over the past century illustrates the ecological complexity of the interplay among natural ecosystems, human economic activity, and human beliefs. African sleeping sickness, or trypanosomiasis, is caused by a fluke (the trypanosome) spread by the tsetse fly. The natural host species for the trypanosome comprise cattle and other ungulates; humans are a secondary host.

The viral disease rinderpest was introduced into Africa in the 1890s, via infected cattle imported into Ethiopia. This disease subsequently decimated both domesticated and wild herds of bovids in eastern and central Africa. The immediate impact on human health was the starvation of many of the nomadic pastoralists. Approximately one-quarter of the cattle-dependent Masai pastoralists starved to death in the early years of this century.

A more protracted impact arose from disturbance of the pattern of transmission of trypanosomiasis. Scrub and brush (the habitat of the tsetse fly) subsequently proliferated in the vacated grazing lands. Nevertheless, the absence of bovid hosts led initially to a net downturn in human trypanosomiasis. With the subsequent recovery of herds, and the reclearing of land for grazing, human exposure greatly increased. A typical "forest edge" effect occurred, and sleeping sickness thus increased. The European colonial authorities devised programs for controlling the tsetse breeding grounds, particularly the elimination of brush growth in moist valleys. This practice, however, was often resisted or discontinued in postcolonial times—sometimes because it did not square with local beliefs about the source of the dis-

ease (Miner 1960). In the benighted Democratic Republic of the Congo (previously Zaire), the number of annual cases of sleeping sickness has escalated by 20- to 40-fold over the past four decades as social infrastructure and health care have also progressively disintegrated (Pépin 1997).

Contemporary Land Use and Infectious Diseases

Under the contemporary pressures of population growth, economic development, deregulated foreign investment, and the need to discharge international debt, environmental changes are being amplified and intensified in many locations.

Forest clearance in South America during recent decades, to extend agricultural land, has mobilized various viral hemorrhagic fevers that previously circulated quietly (and generally benignly) in wild animal hosts. For example, the Junin virus, which causes Argentine hemorrhagic fever, naturally infects wild rodents (the mouse, *Callomys callosus*). However, extensive conversion of grassland to maize cultivation in recent decades stimulated a proliferation of this species of virus-bearing mouse, thus exposing human farmworkers to this "new" virus. In the past thirty-five years, the land area carrying this new human disease has expanded sevenfold and the average annual number of infected persons is of the order of several hundred, up to one-third of whom die (WHO 1997). More recently, the virulent "Guanarito" virus entered humans in Venezuela. Chronically infected cotton rats are thought to have been the source of the virus. Land-use changes provided an extended habitat and improved food supplies for the rats, and the virus readily passed to the increasingly large and dense populations of seasonal rural workers (Tesh 1994).

Likewise, other new viral infectious diseases in rural South American populations have been caused by the Machupo virus, Basia virus, Oropouche fever, and so on. In South America, leishmaniasis (spread by sand flies) is now widely considered an occupational disease of forest workers engaged in land clearance for agriculture, road building, timber extraction, or mining (Service 1989).

Ongoing land clearance in other populous regions of the developing world, and the extension of irrigation, continue to influence the patterns of infectious diseases. In the Sudan, for example, schistosomiasis appeared within several years of the start of the Gezira Scheme to irrigate cotton production; simultaneously, the prevalence of malaria also increased markedly in this region (Fenwick et al. 1981; Gruenbaum 1983). In Senegal, the irrigation of rice and sugarcane agriculture that followed the construction of the Diama Dam on the Senegal River caused a massive outbreak of schistosomiasis

(WHO 1997, 58). Similarly, the building of the Aswan Dam on the Nile River resulted in a sevenfold increase in schistosomiasis in the local population. Lymphatic filariasis in the southern Nile Delta has increased 20-fold in prevalence since the 1960s, primarily due to the increase in breeding sites for the mosquito *Culex pipiens* following the rise in the water table caused by extensions of irrigation. The situation has been exacerbated by increased pesticide resistance in mosquitoes due to heavy agricultural pesticide use and by rural-to-urban commuting among farmworkers.

In Sri Lanka, the clearing of land for irrigation schemes in recent decades has depleted the complex local biodiversity, with expansion of the malaria-transmitting mosquito *Anopheles culicifacies.* The density of mosquito populations, and their biting habits, are also much influenced by the types and numbers of livestock in the locale (WHO 1997, 59). Human interventions in nature do not necessarily increase the risks of infectious disease; there can be both gains and losses. For example, deforestation in parts of Southeast Asia destroyed the habitat of the mosquito species *Anopheles dirus,* the main vector for malaria. However, the replanting of forest and the development of plantation agriculture (e.g., for oil palms, rubber trees, or fruit trees) can not only reintroduce malaria transmission, but may do so at far higher levels than prevailed in the natural primary forest.

Other aspects of land use also contribute to the generation of new or amplified infectious disease agents. An example of the production of new variants of infectious agent is that of the influenza virus. This virus has its origins in birds. As the number and density of cohabiting farmers, ducks, and pigs in southern China increases, so the probabilities multiply of creating and launching new genetic recombinants of the influenza virus. Pigs, infected by multiple strains of avian influenza virus, act as genetic "mixing vessels," yielding new recombinant-DNA viral strains that may then infect the pig-tending humans.

An example of the environmental amplification and habitat extension of a common human infectious disease is that of cholera transmission—once viewed simplistically as occurring directly between infected humans via contaminated drinking water. Recent evidence indicates that aquatic ecosystems provide a natural reservoir for this bacterium where, as a microbial inhabitant, it subsists on the nutrients in local waterways, and where under unfavorable conditions it can reside in a dormant sporelike state in zooplankton (Colwell, 1996). Environmental conditions that cause algal blooms with subsequent proliferation of zooplankton—such as climate-induced warming of waterways, and their eutrophication by excessive agricultural and domestic runoff of nitrate and phosphate wastes—can therefore act to increase dissemination of cholera, via seafood, into human populations (Colwell 1996).

Lyme Disease: A Problem of Land Use in Developed Countries

Lyme disease was first identified in the northeastern United States in 1976, where it is now a very prominent public health problem. The disease is caused by the spirochete *Borrelia burgdorferi,* transmitted by infected *Ixodes ricinus* ticks. Lyme disease arose mostly because of the altered patterns of land use in that region, leading both to increased numbers of tick-bearing deer and to increased human contact with them (Wilson 1995). Deer numbers increased 20-fold during the twentieth century as abandoned farmland has reverted to woodland and because the deer's natural predators, wolves, have been eliminated. Human contact has increased as middle-class suburbia and its golf courses have extended into those woodlands.

The ixodic tick has a complex three-stage life cycle, and parasitizes various mammalian species, especially rodents and deer. During its nymph stage, the tick in the northeastern United States is infected by feeding on spirochete-infected, white-footed mice. The tick also feeds on other small mammals—if they are present. However, most of those other mammals do *not* carry the spirochete. Hence, in impoverished local ecosystems in which the tick nymphs are obliged to feed on the infected species of mouse, the proportion of infected ticks is much greater than when the ecosystem has a diversity of vertebrate food sources for ticks. Transmission is influenced by both land-use patterns and climate because terrain, temperature, and rainfall affect the geographic range of the intermediate host mammals and the speed of maturation of the immature (larval-nymphal) tick. Lyme disease also occurs within Europe and across temperate Asia, where it is transmitted via other subspecies of *Ixodes ricinus* ticks.

Lyme disease is not new. Neuroborreliosis was known long before the terms "Lyme disease" and *Borrelia burgdorferi* were coined. However, the critical role of impoverished, mouse-dominated ecosystems and of an invasive species, deer, account for the rapid emergence of this disease as a major modern public health problem.

A similar account applies to the disease syndromes caused by hantaan viruses. These viral diseases have been known in Asia for centuries, but they are now spreading elsewhere because of economic and ecological transformations that have increased contact between rodents and humans. The El Niño event of the early 1990s was associated, initially, with exacerbation of drought conditions in the southwestern United States. This led to a decline in vegetation and in animal populations, including the natural predators (owls, snakes, and coyotes) of the deer mouse (Epstein 1998). When heavy rains occurred in 1993, with resultant proliferation of grasshoppers and piñon nuts, there was an unchecked tenfold expansion in the deer mouse population. These rodents harbor a virus that can be transmitted to humans via dried excreta and which causes hantavirus pulmonary disease—first

described at that time (Duchin et al. 1994). This disease has subsequently spread to many contiguous U.S. states, and has reached western Canada.

Global Climate Change

Global climate change is one of a set of large-scale global-change processes appearing in today's world as the scale of human environmental impact escalates. Climate change will affect the range and activity of various invasive species, many of which might then affect human health. The consequences of climate change for human food production, via climatic influences on invasive species, is not considered further here since that topic is addressed more expertly elsewhere in this volume. Suffice it to say that this relationship has not been included in the assessments made by the Intergovernmental Panel on Climate Change (IPCC) of how climate change would affect terrestrial food production (IPCC 1990; IPCC 1996). Under conditions of climate change, new infestations of pests and pathogens are likely to arise in agroecological systems—but, of course, these cannot be directly forecast via simple extrapolation from past experience.

A change in the background conditions and the variability of world climate would affect infectious disease patterns in various ways (McMichael et al. 1996; Patz et al. 1996). Warmer and longer summers would increase the probabilities of transmission of food poisoning—already rising in many western countries for various reasons (WHO 1997). Warmer conditions would tend to extend the geographic range (elevation and latitude) and the seasonality of many vectorborne infectious diseases (VBDs) such as malaria and dengue fever, while curtailing the range of others (e.g., schistosomiasis, for which more regions would become uncomfortably warm for the intermediate-host water snail). The mosquito species that transmit malaria and dengue have known temperature thresholds for their survival; and, further, their size, biting behavior, and longevity and the duration of the within-mosquito incubation of the infectious agent are all temperature dependent. Changes in precipitation would also affect some of these diseases. If, therefore, the upper limit of the great southwest Asian monsoon system migrates several hundred kilometers farther north, as seems likely in view of paleoclimatic documentation of its shifts over the past twenty millennia with changes in average world temperatures over a 6°C range, then the geography of various, especially mosquitoborne, infections would be expected to change.

Increased frequency or intensity of flooding would increase outbreaks of water-related diseases such as Rift Valley fever (a mosquitoborne viral infection that ravaged northern Kenya and Somalia in the wake of the 1997 ENSO [El Niño Southern Oscillation]-related floods), or diarrheal diseases such as

typhoid (which broke out in Tajikstan in 1994 when unusually heavy rainfall overwhelmed the urban sewer systems). Climatic perturbations of the kind associated with ENSO cycles would cause events similar to the outbreak of bubonic plague in Surat, northeastern India, in 1994 and of the above-mentioned hantavirus pulmonary syndrome in the southwestern United States in 1993—in each of which a period of unusual drought followed by heavy rains resulted in proliferations of disease-spreading rodent populations (rats and deer mice, respectively).

Climate Change and VBDs: What Is the Empirical Evidence?

Considerable recent effort has gone into modeling future changes, for example, in malaria, dengue fever, and schistosomiasis in response to scenarios of climate change (McMichael et al. 1996). Is there yet any empirical evidence of recent changes in infectious disease in response to what may be the beginnings of global climate change?

Much empirical evidence of a general association between climatic conditions and infectious disease has accrued over the past century. However, inferring a causal relation between environmental conditions and the transmission of pathogens is usually difficult. The relationship may be indirect—for example, epidemics of measles occur in winter not because the pathogen prefers cold weather but because the indoor crowding response of people facilitates transmission.

The textbook description of the ailments that typify hotter climates as "tropical diseases" implies an association between warm temperature, related ecological conditions, and those diseases. Laboratory studies have indeed shown that tropical infectious disease pathogens, their vectors, and the conditions in which transmission occurs are sensitive to temperature and humidity. The geographic correlations of these infectious diseases with temperature, rainfall, and humidity have been described in several recent publications (McMichael et al. 1996; Patz et al. 1996). However, few serious attempts have yet been made to confirm the inferred temperature dependence of malaria transmission in the presence of other variables that also affect transmission.

Of the diseases likely to be affected by global environmental change, vectorborne diseases are widely regarded as being particularly sensitive to the forecast change in world climate over the coming century. Most of the vector species are susceptible to ecological and climatic changes—for example, mosquitoes, water snails, and ticks are cold-blooded and have limited ability to regulate their temperature by means of mobility. Not surprisingly, the process of coevolution has typically conferred a temperature sensitivity on the pathogen that matches that of its vector. Some vectors have a wide ecological niche—for example, *Aedes aegypti* (carrier of dengue, urban yellow fever, and

Japanese encephalitis), which is adapted to human settlements; or the many different *Anopheles* species that transmit malaria, each adapted to different local conditions. Such vectors will be better able to take advantage of a global increase in temperature than will those disease vectors with a narrow ecological niche and a limited capacity to migrate/invade—such as the tsetse fly that carries sleeping sickness in Africa, or the *Mansonia* and *Haemagogus* mosquito species that transmit forest yellow fever.

Prior to the recent forecasts of greenhouse-induced global climate change (IPCC 1996), there were few incentives to study the associations among geography, climate, and disease. Alongside the earlier controlled laboratory studies, quantitative epidemiological studies remain scarce. Medical geography and medical climatology after World War II were regarded as descriptive disciplines with little practical value—and, further, were relegated to the realm of "medical history" in view of the spectacular early successes of malaria eradication efforts, achieved with mass treatment and vector control with residual insecticides. Despite the subsequent emergence of resistance to drugs and pesticides, human intervention with those agents has certainly reduced the local influence of weather and climate on the transmission of several VBDs; thus, the affordability of drugs and insecticides is a particularly important influence on VBD distribution. This complicates studies of how climate change and other large-scale environmental changes affect VBDs, and this in turn impairs our capacity to forecast infectious disease invaders resulting from climate change and other global change.

The increase in average global temperature over the past century has been of the order of 1°C. This is a signal of the same magnitude as the typical interannual climate variability. Therefore, in view of the alternative explanations for the recent resurgence of infections, including reduced efficacy of control efforts, human-made ecological disturbances, human mobility, trade, social disruption, and increased population density, a study of changes in VBD occurrence over recent decades is unlikely to yield unequivocal conclusions. The climate drivers of most VBDs are still poorly understood (e.g., bacterial meningitis in Africa) or controversial (e.g., cholera, for which a change in sea-surface temperature, as determinant of planktonic proliferation and the consequent amplification of the cholera vibrio, may be important). Even for well-studied diseases such as malaria, which in some areas such as Venezuela show striking associations with El Niño events (i.e., interannual climate variability), the specific climate drivers remain elusive (Bouma and Dye 1997).

There is more consensus among climatologists about future global rises in temperature than about changes in the intensity and distribution of precipitation. Therefore, although most VBDs also show intimate associations with rainfall and humidity, they are not reviewed here. The main evidence for an

effect of temperature is based on associations of VBD incidence with inter-annual temperature variation in locations where temperature is a limiting factor for the development of vector or pathogen. Several studies have shown the role of temperature in the tropical highlands. For example, minimum nighttime temperature has been shown to be positively associated with the level of malaria in Rwanda (Loevinsohn 1994). Nighttime temperature is more important than daytime temperature, since the former would pose limiting conditions in marginal locations (Epstein et al. 1998). If so, this would be relevant to the observation that, globally, nighttime temperatures have increased approximately twice as much as daytime temperatures since 1950 (Easterling et al. 1997). Sensitivity to temperature has been epidemiologically demonstrated for dengue fever (Koopman et al. 1991) and for its mosquito vector *Aedes aegypti,* for sleeping sickness and its vector (tsetse fly) (Rogers and Packer 1993), and for the mosquito vector of St. Louis encephalitis and Western equine encephalitis, *Culex tarsalis* (Reisen et al. 1993). In Europe, ticks responsible for transmission of viral encephalitis that have rodents and deer as their intermediate hosts, are sensitive to temperature and humidity. An earlier onset of spring and a later arrival of the winter season appears related to increases in the incidence of tickborne encephalitis in Sweden (Lindgren and Gustafson 1998).

The other category of historical evidence, pertaining to gradual, inter-decadal, climate change and trends in VBD occurrence, is inconclusive. Dengue may have increased its altitudinal range in Central and South America, as has malaria in East Africa and Papua New Guinea (Epstein et al. 1998). A study in the highlands of Ethiopia showed an increase in malaria incidence and in the upper limit of altitude at which falciparum malaria was reported in association with decadal increases in minimum nighttime temperature (Tulu 1996). An example of malaria in northern Pakistan, where temperatures during part of the transmission season appear to have risen in excess of the global average over many decades, is given below.

Malaria

The global distribution of malaria shows some regions where rainfall limits malaria transmission (desert fringes), and some tropical regions where temperature restricts the disease (highland fringe malaria). Of the four human species of the *Plasmodium* parasite, *P. falciparum* requires the highest temperature to develop (16–19°C, Molineaux 1988), and is therefore restricted to tropical and subtropical areas. However, the mosquito vector also varies by region, and the mosquitoes multiply faster and feed more frequently at higher temperature. The duration of development of *P. falciparum* within the mosquito (the "extrinsic incubation period" [EIP]) halves from twenty-six to thirteen days for a temperature rise from 20° to 25°C (Macdonald 1957). The

relationship between EIP and temperature, between the mosquito's critical minimum and maximum temperatures, is curvilinear.

Prior to its control in developed countries around midcentury, the latitude fringe of malaria reached as far north as Sweden, Canada, and Siberia. However, the fringe has subsequently been compressed back toward the tropics with socioeconomic development and deliberate, expensive, control measures. The current latitude borders of malaria are mostly not climate sensitive (excluding regions in social turmoil such as in central Asia) and are therefore unlikely to be directly affected by global climate change. The temperature gradient of malaria relating to elevation is more dramatic than that for latitude. In terms of temperature change, 100 meters of altitude corresponds with over 100 kilometers in latitude. In general, temperature influences are more likely to explain small vertical shifts of malaria pathogen or vector in highland regions than to cause larger-scale latitude changes that would span many ecological zones.

In Asia, there was an apparent emergence of malaria in the highland areas of Pakistan, evident on malaria maps, between 1924 and 1990 (Bouma 1995), particularly in regions at 1,500–2,000 meters altitude. Christophers showed that regions over 1,500 meters in this part of erstwhile British India were free of malaria (Hehir 1927). In the warmer, more southern highlands (Quetta region), the cutoff point may have been around 1,800 meters (Mansell 1931). The detailed epidemiological studies of that time mean that malaria would not have gone unnoticed in these highlands. In contrast, in the 1990 map from the Directorate of Malaria Control (1991), all highlands except in the very northernmost part of the country in the Himalayas and Hindukush (over 2,000 meters) are shown as low-to-medium malarious (see Figure 9.1). Over that seven-decade time-span, temperature has increased by 1.5–2°C in critical months in northern Pakistan—more than the average in the Northern Hemisphere. This may have contributed to the apparent recent emergence of malaria in the highlands of northern Pakistan.

Serious seasonal epidemics in northern Pakistan, even of falciparum malaria, are now common in regions over 1,500 meters (Bouma 1995). The temperature in critical months has indeed been identified as one of the critical parameters driving malaria in northern Pakistan; *P. falciparum* has been shown to vary with altitude and with interannual variation of ambient temperature (Bouma et al. 1996). Temperature is likely to have played an important role in the dramatic increase in *P. falciparum* in northern Pakistan in recent years.

Viewed collectively, the results of these studies in Pakistan, along with other historical empirical evidence from studies elsewhere, indicate that a global temperature rise would increase the probability of malaria transmission in various high altitude and latitude areas with poor malaria control.

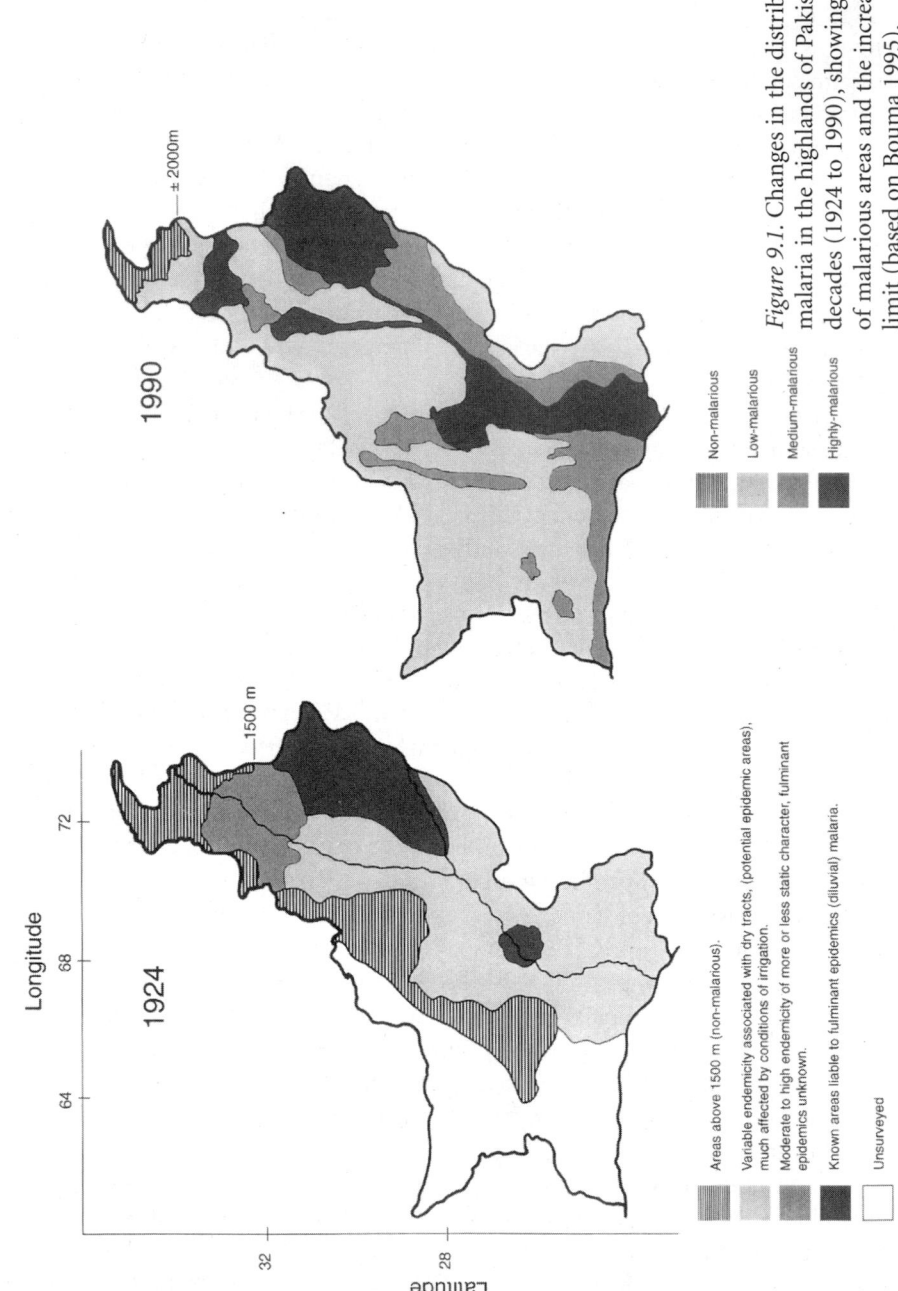

Figure 9.1. Changes in the distribution of malaria in the highlands of Pakistan, over seven decades (1924 to 1990), showing the extension of malarious areas and the increasing altitudinal limit (based on Bouma 1995).

1990

- Non-malarious
- Low-malarious
- Medium-malarious
- Highly-malarious

1924

- Areas above 1500 m (non-malarious).
- Variable endemicity associated with dry tracts, (potential epidemic areas), much affected by conditions of irrigation.
- Moderate to high endemicity of more or less static character, fulminant epidemics unknown.
- Known areas liable to fulminant epidemics (diluvial) malaria.
- Unsurveyed

Longitude

Latitude

However, for any single study, the central difficulty faced by epidemiologists is how to apportion causal blame between coexistent causal factors. In the previously mentioned study of malaria time-trends in the Ethiopian highlands, for example, one must take account of changes in land-use patterns, population density, lowland-highland population mobility, pesticide usage, and the spread of drug-resistant malaria before one can reasonably attribute part of the observed spatial or seasonal shift in malaria to changes in climatic conditions. Since conclusive answers cannot come from single locations, we must search on a larger geographic canvas for consistency of patterns across a variety of settings in which local climate changes have occurred.

The scope of historical studies, requiring reliable longitudinal and/or spatial disease data is often restricted to areas with good recording practices, and further empirical evidence of the consequences of climate change is likely to emerge from careful monitoring of disease intensity and distribution. The modeling of future impact of global climate change on vectorborne diseases has not sought to be comprehensive; the models have been limited to several linked main subsystems. Most of the work has been done in relation to malaria (Martens et al. 1995; Martin and Lefebre 1995). This modeling, albeit of limited ability to describe the past or present malaria distribution, indicates the shifts in the geographic distribution of malaria that would result from global change. A 1.1°C rise in global temperature would increase the proportion of the world population living in potential malaria transmission zones from approximately 45 to 60 percent. These models can assist in identifying regions where monitoring of disease and climate is warranted, and can also reveal much about the nonclimatic variables that drive vectorborne diseases and therefore guide research in attributing risk to environmental and societal factors.

Conclusion

Invasive species affect human health via several pathways. Changes in the range and incidence of human infectious disease is the major example. Other invasive species that impair food yields (pests, pathogens, weed competitors, or the longer-term consequences of monocultural cropping) and food storage (pests, molds), or that produce foodborne biotoxins (certain species of aquatic algae and molds), also pose significant risks to human health

The new fluidity in patterns of human infectious disease that has been evident over the past several decades provides a clear signal that ecological opportunities and physical dissemination pathways are increasing in the contemporary world. The geographic range of many human infectious diseases has increased with recent changes in patterns of land use and regional climate. Intercontinental trade has introduced various pathogens into distant

populations: some of the more dramatic examples include the introduction of the Asian tiger mosquito (*Aedes albopictus*, which spreads dengue fever and yellow fever) to the Americas, Africa, and southeastern Europe; the reintroduction (after a century of absence) of the cholera bacterium to South America; and the spread of the life-threatening *E. coli 0157* bacterium in meat exports. Meanwhile, antibiotic-resistant bacteria (e.g., tuberculosis, staphylococci, enterococci)—a special type of "invasive" variant—are now becoming a widespread problem for human health.

A clear signal has appeared over the past decade or two that continued human encroachment on and disruption of the natural environment, and extended physical mobility and dissemination of people, goods, insects, and microbes around the world, are creating a spectrum of new and resurgent infectious disease hazards for human populations.

References

Bouma, M.J., Dye, C., and van der Kaay, H.J. 1996. Falciparum malaria and climate change in the North-West Frontier Province of Pakistan. *Amercian Journal of Tropical Medicine and Hygiene* 55: 131–137.

Bouma, M.J., and Dye, C. 1997. Cycles of malaria associated with El Niño in Venezuela. *Journal of the American Medical Association* 278: 1772–1774.

Bouma, M.J. 1995. *Epidemiology and control of malaria in Northern Pakistan. With reference to the Afghan refugees, climate change and the El Niño Southern Oscillation.* Thesis, Dordrecht, The Netherlands: ICG Printing.

Bruce-Chwatt, L.J. 1988. History of malaria from prehistory to eradication. In *Malaria: Principles and Practice of Malariology* (Vol. 2), edited by Wernsdorfer, W.H., and McGregor, I., 1–59. Edinburgh: Churchill Livingstone.

Butzer K.W. 1974. Climate Change. In *Encyclopaedia Brittanica,* 15th Edition. Chicago: Encyclopaedia Britannica.

Colwell, R. 1996. Global climate and infectious disease: the cholera paradigm. *Science* 274: 2025–2031.

Directorate of Malaria Control, Pakistan. 1991. *Diary for Malaria Workers.* Jaffar Brothers, Karachi, Pakistan.

Dobson, A., and Carper, R. 1993. Health and Climate Change. Biodiversity. *Lancet* 342: 1096–1099.

Dubos, R. 1959. *Mirage of Health: Utopias, Progress, and Biological Change.* New York: Harper & Row.

Duchin, J.S., Koster, F.T., Peters, C.J., et al. 1994. Hantavirus pulmonary syndrome: a clinical description of 17 patients with a newly recognized disease. *New England Journal of Medicine* 330: 949–955.

Easterling, D.R., Horton, B., Jones, P.D., Peterson, T.C., Karl, T.R., Parker, D.E., Salinger, M.J., Razuvayev, V., Plummer, N., Jamason, P., and Folland, C.K. 1997. Maximum and minimum temperature trends for the globe. *Science* 277: 363–367.

Epstein, P.R. 1998. Emerging diseases and global change: past, present and possible

futures. In *New and Resurgent Infections*, edited by De Cock, K., and Greenwood, B., 33–46. Chichester: Wiley.

Epstein, P.R., Diaz, H.F., Elias, S., Grabherr, G., Graham, N.E., Martens, W.J.M., Mosley-Thomson, E., and Susskind, J. 1998. Biological and physical signs of climate change: focus on mosquito-borne diseases. *Bulletin of the American Meteorological Society* 78: 409–417.

Fenwick, A., Cheesmond, A.K., and Amin, M.A. 1981. The role of field irrigation canals in the transmission of *Schistosoma mansoni* in the Gezira Scheme, Sudan. *Bulletin of the World Health Organization* 59: 777–786.

Gruenbaum, E. 1983. Struggling with the mosquito: malaria policy and agricultural development in Sudan. *Medical Anthropology* 7: 51–62.

Hehir, P. 1927. *Malaria in India*. Oxford: Oxford University Press.

Heymann, D.L., and Rodier, G. 1997. Reemerging pathogens and diseases out of control. *Lancet* 349 (suppl III): 8–9.

Heyneman, D. 1984. Development and disease: a dual dilemma. *Journal of Parasitology* 70: 3–17.

Hughes, C.C., and Hunter, J.M. 1970. Disease and "development" in Africa. *Social Science and Medicine* 3: 443–493.

Inhorn, M.C., and Brown, P.J. 1990. The anthropology of infectious disease. *Annual Review of Anthropology* 19: 89–117.

IPCC. 1990. *First Assessment Report. Climate Change 1990* (Vols. I, II, III). New York: Cambridge University Press.

———. 1996. *Second Assessment Report. Climate Change 1995* (Vols. I, II, III). New York: Cambridge University Press.

Jones, M.E., Peters, E., Weersink, A-M., Fluit, A., and Verhoef, J. 1997. Widespread occurrence of integrons causing multiple antibiotic resistance in bacteria. *Lancet* 349: 1742–1743.

Kloos, H., and Thompson, K. 1979. Schistosomiasis in Africa: an ecological perspective. *Journal of Tropical Geography* 48: 31–46.

Koopman, J.S., Prevots, D.R., Vaca Marin, M.A., Gomez Dantes, H., Zarate Aquino, M.L., Longini, I.M. Jr., and Sepulveda Amor, J. 1991. Determinants and predictors of dengue infection in Mexico. *American Journal of Epidemiology* 133: 1168–1178.

Lindgren, E., and Gustafson, R., 1998. Climate and tick-borne encephalitis in Sweden. *Conservation Ecologist* 5: 1–14. [http://www.consecol.org/journal/vol2/iss1/art5].

Loevinsohn, M. 1994. Climatic warming and increased malaria incidence in Rwanda. *Lancet* 343: 714–718.

Macdonald, G. 1957. *The Epidemiology and Control of Malaria*. Oxford: Oxford University Press.

Mansell, R.A. 1931. A discussion on malaria in the Quetta-Pishin district. *Journal of the Royal Army Medical Corps* 56: 26–40.

Martens, W.J., Niessen, L., Rotmans, J., Jetten, T., and McMichael, A.J. 1995. Potential impact of global climate change on malaria risk. *Environmental Health Perspectives* 103: 458–464.

Martens, W.J.M. 1997. *Health Impacts of Climate Change and Ozone Depletion. An Eco-epidemiological Modelling Approach*. Maastricht: University of Maastricht.

Martin, P., and Lefebre, M. 1995. Malaria and climate: sensitivity of malaria potential transmission to climate. *Ambio* 24: 200–207.

McMichael, A.J., Haines, A., Slooff, R., and Kovats, S. (eds). 1996. *Climate Change and Human Health.* (WHO/PEP90.10). Geneva: WHO.

McNeill, W. 1976. *Plagues and Peoples.* New York: Doubleday.

Miner, H. 1960. Culture change under pressure: a Hausa case. *Human Organization* 19: 164–167.

Molineaux, L. 1988. The epidemiology of human malaria as an explanation of its distribution, including some implications for its control. In *Malaria: Principles and Practice of Malariology* Vol. 2, edited by Wernsdorfer W.H., and McGregor, I., 913–998. Edinburgh: Churchill Livingstone.

Patz, J.A., Epstein, P.R., Burke, T., and Balbus, J.M. 1996. Global climate change and emerging infectious diseases. *Journal of American Medical Association* 275: 217–223.

Pépin, J. 1997. Zaire (Congo): resurgence of trypanosomiasis ("patients within borders"). *Lancet* 349: (suppl III) 10–11.

Reisen, W.K., Meyer, R.P., Presser, S.B., and Hardy, J.L. 1993. Effect of temperature on transmission of western equine encephalitis and St. Louis encephalitis viruses by Culex tarsalis. *Journal of Medical Entomology* 330: 151–160.

Rogers, D.J., and Packer, M.J. 1993. Vector-borne diseases, models, and global change. *Lancet* 342: 1282–1284

Service, M.W. (ed). 1989. *Demography and vector-borne diseases.* Boca Raton, Florida: CRC Press Inc.

Tesh, R.B. 1994. The emerging epidemiology of Venezuelan haemorrhagic fever and Oropouche fever in tropical South Africa. In *Disease Evolution: Global Changes and Emergence of Infectious Diseases,* edited by Wilson, M.E., Levins, R., and Spielman, A., pp. 129–137. New York: New York Academy of Sciences (Annals of the New York Academy of Sciences No. 740).

Tomasz, A. 1994. Multiple antibiotic resistant bacteria: a report on the Rockefeller University Workshop. *New England Journal of Medicine* 330: 1247–1251.

Tulu, A.N. 1996. *Determinants of Malaria Transmission in the Highlands of Ethiopia: The Impact of Global Warming on Morbidity and Mortality Ascribed to Malaria.* Ph.D. thesis, London School of Hygiene and Tropical Medicine (library).

Vitousek, P.M., Mooney, H.A., Lubchenco, J., and Melillo, J.M. 1997. Human domination of Earth's ecosystems. *Science* 277: 494–499.

WHO. 1996. *World Health Report 1996. Fighting Disease, Fostering Development.* Geneva: WHO.

———. 1997. *Health and Environment in Sustainable Development.* WHO/EHG/97.8. Geneva: WHO.

Wilson, M.E. 1995. Infectious diseases: an ecological perspective. *British Medical Journal* 311: 1681–1684.

Chapter 10

⋙

Climate Change and Invasive Species: A Conceptual Framework

Robert W. Sutherst

Invasive species can dominate natural systems by displacing native fauna and flora, including rare species, and so alter ecosystem structure and function (Usher 1986; Sutherst 1995; Clout 1998). The numbers of invasive species are increasing at an exponential rate in some regions (Carr 1993; Baskin 1996), and this global domination by a few invasive species threatens to create a homogeneous world (Macdonald 1994). In the face of this powerful force of change, the question posed in this chapter is, "How vulnerable are terrestrial systems to invasive species under climate change?" A number of authors, including Macdonald (1994), Beerling and Woodward (1994), Sutherst (1995), and Dukes and Mooney (1999), summarized likely impacts of global or climate change on invasive species. Therefore, I have concentrated instead on presenting a conceptual framework for the assessment of risks from invasive species under climate change.

Other chapters in this volume discuss the many attempts to define the attributes that make species successful invaders. Outcomes of invasions depend not only on the attributes of the invasive species but also on the vulnerability of the invaded ecosystems. Thus we need to give at least as much

attention to understanding the recipient ecosystem as to the alien species if there is to be any chance of predicting outcomes of an invasion. Williamson (1996) argues that outcomes of such introductions are mostly unpredictable due to the extreme complexity of natural systems. This chapter discusses the role of climate change in mediating the interactions between invasive species and natural systems.

Climatic and landscape features set the ultimate limits to the geographical distribution of species and determine the seasonal conditions for growth and survival. Within those limits, biotic factors determine the species' realized distribution and abundance. Climate change is one of several global change drivers, and there are strong interactions between the effects of each driver. These drivers include land-use change, climate change, and altered geochemistry and atmospheric composition—particularly CO_2 (carbon dioxide). Some authors add trade liberalization, which leads to accelerated rates of international trade with translocation of invasive species (Jenkins 1996).

The Intergovernmental Panel on Climate Change (IPCC) approach to the assessment of vulnerability under climate change (Parry and Carter 1998) emphasizes consideration of both impacts and adaptive management measures in the risk-assessment process. The concept of vulnerability is applicable to either regions or systems. Top-down approaches rely on climate change scenarios from general climate models (GCM) to evaluate likely impacts, while bottom-up approaches use sensitivity analysis to explore the responsiveness of the model to variation in a range of input parameters. In the present analysis, preference is given to sensitivity analysis due to the immature state of the GCMs. The vulnerability of ecosystems and regions is assessed, as the product of the impacts in the absence of response measures and the potential for adaptive management to reduce the effects of the impacts, that is,

Vulnerability = Impacts × (1 − *Adaptive Management*) of a specific region and system.

Likely effects of invasive species are evaluated by assessing the vulnerability of regions and ecosystems to invasive species under climate change, taking into account any management actions (referred to in the global change community as adaptation options) that may be available.

The *impact* of climate change on each of the three elements of invasions— the source location, the pathway, and the destination—needs to be assessed as part of the process of estimating vulnerability to a given invasive species. The impact on the region or ecosystem depends on the attributes of the alien species and its interaction with its environment. The plant pathologists' "Host-Pathogen-Environment" triangle (Fig. 10.1) is a good model with which to consider the impact of global change on systems, as it emphasizes a

Figure 10.1. "Host-Pathogen Environment"

holistic approach. The model is applicable to invasive invertebrates, but needs "Competitor" to be substituted for "Host" in the case of invasive plants.

In the process of assessing vulnerability, it is essential to specify the location as well as the system of interest, because the geographical location has a profound effect on the nature of impacts through local climate. As shown in Figure 10.2, the responsiveness of species to perturbations of climate will vary greatly depending on whether it is near the core of the distribution or at the edge. Populations near the edge necessarily experience a greater range and variability of climatic conditions than populations near the core, where the duration of optimal conditions is greatest and climatic stresses are minimized. Near the edges there is likely to be significant disruption of the ecosystems under climate change, making native species particularly vulnerable to invasion. As species' ranges are each uniquely different, such disruptions will be widely distributed, thus presenting numerous opportunities for fresh invasions.

Estimates of vulnerability also need to include an evaluation of the costs and benefits of different options for adaptive management (Tol et al. 1998). These can be either autonomous adjustments by individuals, who change their behavior gradually in reaction to a dynamic environment, or anticipatory, policy-driven responses that have wider implications and are dedicated to the particular issue.

Natural systems have limited ability to adjust to alien species and available options are made more difficult by the fragmentation of habitats (Pitelka et al. 1997). In natural systems, prevention of invasions will almost invariably require human intervention. Responses to invasions are limited to early eradication, spatial containment, or integrated management, preferably based on biological control. The economic and often environmental costs of containing widespread infestations of alien species, in landscapes that do not generate high economic returns, is prohibitive because there is little opportunity to recover costs except through tourism or provision of water (see Zavaleta, this volume).

Figure 10.2. The relative responsiveness of populations on the edge (B) or in the center (A) of a geographical distribution to climate. Populations at the edge spend more time in marginally suitable temperatures and moisture, while populations in the core of the distribution spend most time in favorable conditions. Population responses are estimated from CLIMEX growth index (GI) (——), and cold (CS), hot (HS), dry (DS), and wet (WS) (- - -) stresses, respectively.

Pests, diseases, and weeds have many characteristics in common, but they also differ in important respects. Plants are much more sessile than most pests and diseases. Human intervention will be necessary to assist ecosystems to respond to climate change without excessive disruption and loss of biodiversity. Costs, sustainability of adaptive management options under current conditions, and their robustness under global change need to be considered in choosing options for adaptive management (Sutherst et al. 1998). Computer models provide a method for diagnosing causes of changes in the behavior of populations arising from environmental changes and for tuning responses (Sutherst et al. 1996b).

The need to assess adaptive management options under the IPCC approach means that the Host/Competitor-Pathogen-Environment triangle is no longer an adequate framework. It needs to include "Management" (Fig. 10.3). Before we can consider the role of management in responding to climate change, we need to assess the impacts of climate change on invasion processes. This requires suitable analytical tools, which are considered briefly below.

Figure 10.3. A holistic approach to the assessment of risks posed by invasive species under global climate change. *Host-Pathogen-Environment triangle with Management as the core.*

Tools for Analysis of Risk from Invasive Species under Climate Change

Climate change has physical effects on ecological systems, but policy makers need socioeconomic measures in order to compare the impacts on different systems when setting priorities. This demands a mixture of biological and economic tools. The choice of tool depends on the quality of available data and the need to optimize adaptive management strategies. Tools vary from expert systems, through inferential climate matching to process based modeling and economic spreadsheet models. Given the large number of species and different natural and modified ecosystems, it is essential that generic approaches are adopted (Sutherst et al. 1996b). This chapter deals only with biological impacts.

Some of the main impacts will arise from changes in species' distributions and others from changes in abundance in already endemic areas. Extreme climatic events will exacerbate these impacts. Species' distributions are a product of the population dynamics of that species. Any life-cycle process can affect the way in which the population density declines toward the edge of the species' distribution. The boundary will be set by limits to survival or by constraints to reproduction. This demands tools that can give estimates of relative changes in both time and space, on temporal scales of years or decades and large spatial scales. Ideally, any tools must be able to take account of all the processes affecting the target invasive species. However, holistic analyses are rarely possible due to the lack of sufficient data or resources to conduct such a large study, so compromises are needed to meet policy needs for information. Therefore, pragmatism is needed in impact assessments, and we need to address only those environmental variables that will have the most effect.

Usually, that will be the direct effects of climate change on the species concerned. However, in some cases second-order effects, such as interactions with other species in the same (competitors), higher (predators), or lower (host plants or animals) trophic levels, may have to be considered in the knowledge that climatic and other global change drivers are affecting those species as well. Interactions become more evident when extreme climatic events are involved, causing severe stress to host plants or animals.

The approaches available for analyzing changes in species' distributions were compared by Sutherst et al. (1995). The options for analyzing species' population dynamics and their integration with crop models were presented by Teng et al. (1996) and Sutherst et al. (1996b). In this chapter, use is made of one of those analytical tools, the CLIMEX model (Sutherst et al. 1995).

Climate determines the suitability of temperature and moisture for population growth in favorable seasons and also sets constraints to species' survival in unfavorable seasons. Both types of effects have been described in CLIMEX, a climatic matching model. The model combines an estimate of climatic potential for population growth in relation to temperature and soil moisture (Growth Index [GI]) with indices of stress from extreme temperatures or moisture (Stress Indices) to produce an overall index of suitability of a location for a given species, the Ecoclimatic Index (EI). Conditions with inadequate heat accumulation to maintain essential metabolism are a more common limiting factor than extreme low temperatures. Other climatic constraints include the length of the growing season and chilling requirements for diapause or vernalization.

The implications for a species of geographical variation in climate are rarely given adequate consideration. Emphasis in traditional ecological studies is placed on point studies to the detriment of a broader interpretation of climatic impacts. One strength of CLIMEX is in its ability to extract maximum information on a species' climatic responses from limited geographical data. Inconsistencies found in the climate space occupied by a species in different continents point to the existence of nonclimatic limiting factors such as hybrid zones or other competitive displacement mechanisms. CLIMEX also leads to the development of a synoptic view of the species' climatic responses, so that any local interpretation can be put into the context of the species' climatic requirements (Fig. 10.2). Finally, CLIMEX automatically integrates spatial and temporal variation in species' responses to climate, so information is provided on both geographical and seasonal responses to climate.

CLIMEX, with its weekly time step, has a much higher temporal resolution than statistical approaches, and it is the only climate-matching tool that automatically takes account of novel climates. The subtlety of climates needs detailed analysis to interpret and anticipate small changes in conditions that

may have major effects on the phenology of species. In particular, coincidence of suitable temperature and rainfall conditions is vital for flowering of many species. In the event that such conditions segregate under climate change, some species will either alter their seasonal phenology or fail to reproduce, as in the case of some flowering annual trees such as *Eucalyptus* spp. (Specht and Specht 1999).

More in-depth interpretation of climate change impacts requires process-based models to describe life-cycle processes, phenology, and responses to interventions (Sutherst et al. 1996b), based on detailed life-cycle data. Multispecies and multidriver analyses are logistically so demanding that they are usually not feasible. Unfortunately, most population studies have the greatest effort invested in populations in favorable habitats, and so the model parameters are poorly defined in marginal areas that are most relevant in climate change risk assessments. This makes the models unreliable near the edges of a species' distribution. A corollary to this phenomenon is that mapping of the results of model simulations is a powerful way of evaluating model performance over a wide range of parameter values. The use of geographic information systems (GIS) to model spatial variation and movement and to integrate climate, physical, and biotic variables has been particularly useful (Teng et al. 1996). The inclusion of economic spreadsheet models to estimate the regional economic impact of climate change adds the socioeconomic dimension so necessary for policy makers (Sutherst et al., 2000).

Impacts of Climate Change on Invasive Processes

Climate change influences all invasive species by affecting their spread and colonization of new habitats. In this section, those processes are reviewed in the context of climate change. While the IPCC assessment approach provides a suitable broad framework for the assessment of vulnerability to climate change (Parry and Carter 1998), more specific analytical procedures are needed to analyze the processes involved in invasions by alien species. The approach adopted by the IPPC (International Plant Protection Convention) quarantine pest risk analysis (PRA) community is a useful template with which to evaluate risks from exotic species. It divides the invasion process into three elements: sources, pathways, and destinations. A combination of the IPCC and PRA approaches provides a useful framework for analysis of the mediating effects of climate change on risks posed by exotic, invasive species to natural and modified systems. The uniqueness of exotic species is that global change can affect them on a global scale, by affecting their sources, pathways, and destinations. We analyze the likely impacts of climate change on each of these elements.

Sources

Source locations of invasive species are concurrently destinations for other species, so many of the issues related to sources are common to destinations and are thus considered in that context here. The issues relate largely to the existence of a species in an exporting area and to the efficacy of postharvest treatments. Under the World Trade Organization (WTO), the source location of a potential infection is treated seriously enough to have led to the concept of "area freedom." Under this protocol, a commodity may only be exported if it can be demonstrated that the pest, or invasive species in the present context, is absent from the growing area. One such example is the catholic-feeding Queensland fruit fly, *Bactrocera tryoni*, which is invasive wherever suitable fruits are found in favorable climates (Yonow and Sutherst 1998). A major citrus-growing area in Australia has area freedom status for the fruit fly, and it is being maintained by mass releases of sterile male flies, which are only cost-effective at low population pressures, preceded by insecticidal baits and sprays.

The concept of area freedom is at serious risk from climate change. The declared area depends on a species being unable to complete development in winter, so the integrity of area freedom may be very sensitive to global warming. For this reason, the main export citrus-growing area in Australia has been found, using CLIMEX, to be extremely vulnerable to Queensland fruit fly with increases in temperatures as small as 2°C (Sutherst et al. 2000). As the area is subject to repeated introductions of fruit flies, there is an ongoing need to prevent the flies from establishing. The increased fruit fly pressure will inevitably lead to greatly increased costs. Costs of suppression were estimated to increase by up to 80 percent with a 2°C increase in temperature. Nevertheless, it may be feasible to maintain area freedom if the industry is sufficiently profitable to cover the extra costs. Hence we can conclude that the citrus industry in southern Australia is very sensitive to the impact of Queensland fruit fly under climate change, but adaptive management options have the potential to reduce that impact. The vulnerability of the industry will be dependent largely on its capacity to absorb both the greater costs and the perceived threats to public health and the environment from intensive pesticide applications. Similarly, the spread of many species with climate change will challenge the WTO surveillance systems as invasive species continue to encroach on areas that were previously designated as outside its endemic range.

Management responses to climate change will result in changes in the patterns of production and trade in commodities, with tropically adapted crops being grown more competitively in higher latitudes and altitudes. The sources of tropical invasive species that contaminate crop produce will also spread to higher latitudes. The resulting uncertainties about the spatial extent

of sources will add to the risks posed by invasive species that are moved through trade, tourism, or other accidental means. As new source locations are created, they pose additional risks, as shown by the major threat to the Americas now posed by the African livestock tick *Amblyomma variegatum*, which colonized the Caribbean in recent historical times.

Pathways

In the pest risk analysis process, pathways refer to the routes by which species move from one continent or country to another. Here, pathways refer to ways of crossing political boundaries because the latter are the units used in decision making for adaptive management purposes. Invasive species may move naturally or with human involvement. The pressures on pathways are increasing with increased trade and tourism and the development of a global economy. This is reflected in the increased demand from the WTO for national quarantine agencies to tolerate "acceptable" rather than minimum risks of introduction of invasive species if there are commensurate benefits from the trade in question. As a result, there is an accelerating spread of exotic species (Jenkins 1996) with the additional dimension of a change in the species composition of invaders, resulting from a increased east-west trade within hemispheres replacing the older north-south trade (Waage, this volume). New patterns of international trade in response to changes in average climatic conditions also have the potential to alter the composition of invasive species that are spread around the world.

Climate change per se is likely to have limited direct effects on movement of invasive species along trade routes. While the main source of transfer of pests appears to be trade, another accelerating source is the massive displacement of peoples from countries affected by political unrest. Any increase in the frequency and intensity of extreme climatic events associated with the intensification of the hydrological cycle under climate change has great potential to disrupt the fragile balance of food supplies and refugee problems in regions already made vulnerable by overpopulation and land degradation. The impacts of droughts, made more severe by political unrest and overexploitation of natural resources, are leading to increasing movements of refugees. These refugees often bring their livestock with them, and the herds can form an important mechanism by which exotic parasites are moved around. The associated food and other materials such as seed that are provided as drought relief could also act as vectors for invasive species. These risks are greatest in Africa, Asia, and South America, where political boundaries are poorly supervised.

Climate and wind systems affect the long-distance migration routes of some severe pests. The seasonal direction and strength of prevailing winds

influences the spread of species such as the brown plant-hopper that attacks rice (Pender 1994). Farrow (1991) suggested that wind shifts caused by changes in climate have the potential to affect the patterns of migration of species of insects, such as locusts and heliothis moths that feed on many types of vegetation. The main impact on pathways is likely to come from changed synoptic conditions that affect the spread of migratory pests and waterborne weeds and pathogens.

Global change drivers related to human activities will dominate future patterns of movement of invasive species along pathways. Where the climate influences natural pathways, adaptive management options are limited and countries are vulnerable to invasions along the modified pathways. In cases where pathways involve human vectors, some adaptive management measures, such as intensified decontamination of transport vessels, may be feasible and indeed desirable even under present conditions. Thus it is likely that pathways will continue to be a source of vulnerability of countries to invasions under climate change.

Destinations

The process of establishment of invasive species in the new environments at their destinations has received most attention from researchers and managers in the quarantine community. The success of alien species is dependent on their interaction with their new environment, particularly climate. The impact of these species at their destinations depends on (1) their initial success in establishment, (2) their direction and rate of spread, and (3) their population dynamics and geographical distributions.

Initial Establishment

The success of an invasive species in colonizing a new habitat or ecosystem depends on a number of conditions related to the place and timing of its arrival. On arrival, an invasive species has to establish at a point in the chain of movement of the associated commodity or other vector. Systemic changes have occurred at the traditional arrival points in many developed countries with extensive urbanization and mechanized handling of commodities. These have affected the potential success of initial establishment of many exotic species by altering the supply and vulnerability of hosts and habitats, and the patterns of movement of commodities. Stochastic events are also likely to be important, when small numbers of organisms are involved. This context needs to be kept in mind when addressing likely changes in risks of initial establishment of new species under climate change.

The probabilities of survival and reproduction of the arriving population depend on the ability of the propagule to survive for prolonged periods. Plant

seeds are naturally more likely than insects to survive transport to distant locations, perhaps mixed with the commodity or in vehicles.

The success of plants in establishing depends strongly on the amount of competition that exists, because they are sedentary and need to occupy a fixed air and soil space. Hence the importance of disturbance in providing temporary windows of opportunity for invasive plant species. Given the extent of human disturbance, the likelihood of establishment of weeds under climate change will be increased.

The relative risk of small populations of an invasive alien species becoming established and dominating local ecosystems depends greatly on the suitability of the climate at that location. If it is near the core of the species' climatic envelope, the alien species will be able to multiply and compete much more effectively than it could near the edge of its potential range (Fig. 10.2). On the other hand, short-term weather conditions may also play a part even in areas where the average climate is favorable for the species. These two constraints may have contributed to the failure of the Old World screwworm fly, *Chryomya bezziana*, to establish in different ports in Australia (Sutherst et al. 1989). Specimens of *C. bezziana*, have been reported on more than one occasion in ships arriving in Portland and Sydney, Australia, from overseas. This indicates a risk of invasion by the fly, but it is evident from the seasonal growth indices at each port that the flies have had limited opportunity to establish and survive there because the average climate is not suitable. In addition, both ports are surrounded by extensive urbanization that reduces the availability of suitable hosts. Natural variation in climate can be important when short-lived, reproductive stages of invasive species in particular are involved. For example, a number of live adults of the *C. bezziana* were trapped in Darwin in northern Australia in the autumn of 1988. They had arrived on a ship returning from delivering livestock to Southeast Asia. It was fortunate that the flies arrived in April in a year when the April rainfall was 15 percent of the average. This may have contributed to the reported successful eradication of the fly, because the fly does not tolerate dry conditions (Sutherst et al. 1989).

On a continental scale, the extent of this spatial and temporal variation is evident from seasonal CLIMEX Growth Indices for Queensland fruit fly in San Francisco and Houston in the United States (Fig. 10.4). Flies arriving in San Francisco would have limited prospects of success, given their limited prospects for population growth and the adverse winter conditions. Conversely, arrivals in Houston would not be constrained by the climate, except in years with extreme cold, and would have very suitable conditions for population growth in summer.

Extreme events such as prolonged droughts can have major impacts on small numbers of newly arrived species. Such an impact is illustrated by the

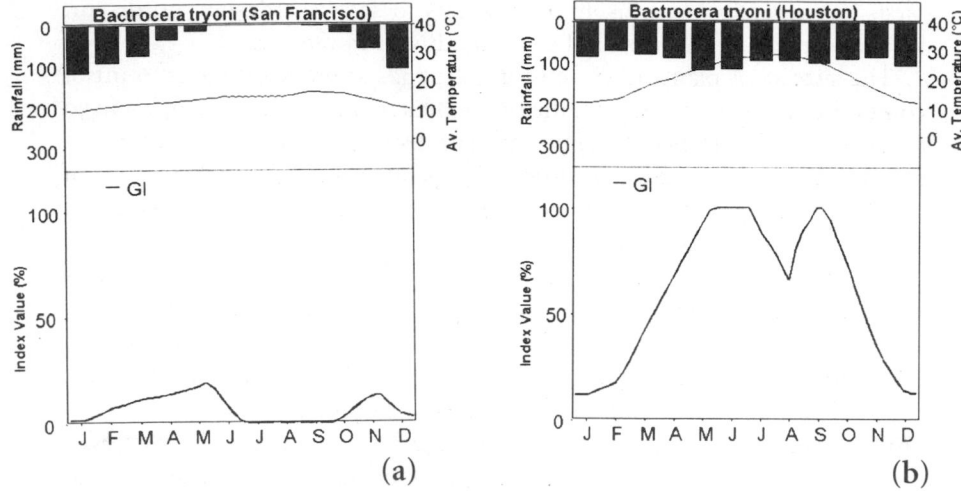

Figure 10.4. Seasonal CLIMEX Growth Indices for Queensland fruit fly at (a) San Francisco and (b) Houston in the United States.

failure of a release of some species of dung beetles in Australia. The beetles were introduced as biological control agents for dung-breeding flies (Waterhouse 1974). A number of tropical species of dung beetles from southern Africa failed to establish when released into the field in the early 1980s. Their failure was attributed to a severe and prolonged drought in 1982–83 (Sutherst 1998). Such extreme events may cause some of the most important impacts of climate change on biological systems because they also stress indigenous species, reducing their resistance to invasions. The spread of *Lantana camara* following the death of forest trees in drought is such an example (Sutherst 1995).

Spread

The direction and rate of spread of invasive species are important factors in determining adaptive management options. Patterns of spread are determined by the species involved, the suitability of the environment for propagation, and the incidence of extreme climatic events. Weeds have rapid dispersal rates compared with many native plants or trees. Tree migration in North America occurred at about 5 kilometers per year (Pitelka et al. 1997), which imply assistance from animals and birds. Nevertheless, weed dispersal rates in modern times can be much higher (Lonsdale and Lane 1994). Episodic recruitment events often involve transport of seed over long distances by water, vehicles, or livestock. The native fauna in Australia is heavily impacted by the cane toad *Bufo marinus*, following its introduction in an ill-

conceived attempt at biological control. The cane toad *Bufo marinus* (Seabrook and Dettmann 1996) and parthenium weed (*Parthenium hysterophorus*) (Auld et al. 1982/1983) in Australia are examples of severely invasive species that have dispersed naturally or been assisted by transport, respectively, along roads.

As for plants, invertebrate pests and diseases often colonize new areas with outliers generating new foci of infection at long distances from the main advancing front. The cane toad has yet to reach its climatic limits and is spreading toward important national parks in the cool south and the tropical northwest in Australia. A recent unpublished report has recorded the toad in several locations in Sydney at a latitude of 34°S, about 400 kilometers from the nearest resident population. Transport of bananas from northern Australia is suspected as being the vector. Under climate change the toad is likely to spread south along the coast toward the Victorian border. However, its geographical limits cannot be defined precisely at present (Sutherst et al. 1996a) because the southern limit of its home range has not been defined accurately in South America. This example highlights the interactions between climate change and other global change drivers such as accelerating transport.

The spread of Old World screwworm flies, *C. bezziana*, provides an extreme example of natural dispersal. Individual flies disperse in the familiar pattern, with the majority of the population making short-distance movements while outliers establish new populations. Flies were recovered after flying 100 kilometers from a release site in Papua New Guinea, but the vast majority of the flies remained within 10 kilometers (Spradbery et al. 1995).

Climatic gradients are likely to play a role in determining the rate and direction of spread of an invasive species. For example, the spread of the cane toad, *Bufo marinus*, in Australia was much more rapid as it passed through the humid wet tropics than it has been in recent years at the southern, cooler part of its range or across drier parts of the north of the country. The temperate Asian tiger mosquito, *Aedes albopictus*, that transmits dengue fever, spread rapidly north in the United States, along a gradient of increasingly suitable territory after its introduction into the southeastern states (Francy et al. 1990). It spread more slowly south and has yet to succeed in colonizing the Florida Keys. Difficulties in adapting to diapause-triggering conditions at different latitudes may have been involved (Focks et al. 1994). Conversely, the horn fly *Haematobia irritans irritans* invaded South America from the north and colonized that continent as far south as Argentina in a very short period (Romano et al. 1991) as it crossed highly suitable climatic zones (Fig. 10.5).

Climate change may also alter the frequency and intensity of extreme events (Wigley 1985), which are important in many dispersal processes. Wind and water transport is affected by climate, with storms, prolonged rainy sea-

Figure 10.5. The relative suitability of representative locations in South America for invasion by the horn fly, *Haematobia irritans irritans,* as estimated using the CLIMEX model. The sizes of the circles are proportional to the suitability of the climate for the fly.

sons, and flooding aiding the dispersal of many invaders. Extreme weather triggers episodic recruitment or major expansions of the ranges of some invasive species that currently have limited distributions. Isolated events such as major floods can allow invasive species to escape from areas that were secure for decades, as shown by the example of *Mimosa pigra* in Australia. This woody weed escaped from the Darwin Botanical Gardens after eighty years of residence, during a major flood that took seed into the catchment of the north Adelaide River, which traverses through the sensitive Kakadu National Park (Lonsdale 1993).

Mobile insect pests, such as the buffalo fly *Haematobia irritans exigua* (Williams et al. 1985), midge vectors of virus diseases, such as *Culicoides brevitarsis* in Australia (Murray and Nix 1987) and the African tick, *Rhipicephalus appendiculatus,* (Norval and Perry 1990), have expanded their ranges greatly during successive years with high rainfall. Such events can have permanent effects on the distribution and abundance of invasive species because the species may not retreat to preinundation distributions, as in the case of the buffalo fly.

We can conclude that climate change will affect the incidence of episodic recruitment events of invasive species, by altering the frequency, intensity, and duration of flooding in particular. This process alone may cause immense changes in natural ecosystems because a single event can have an irreversible impact by allowing aggressive species to escape from local, constrained refugia.

Population Dynamics and Geographical Distributions

The abundance and geographical distribution of a species are the observable consequences of the balance between births, deaths, and movements in different environments. The distribution limits lie where the death rate exceeds the birth rate. Climate is just one of the environmental influences that determine the abundance of a species. Nonclimatic variables, such as the availability and suitability of hosts and the presence of competitors and predators, can have overriding effects on the attainable size of a species' population. Nevertheless, the suitability of the climate for reproduction and survival forms a fundamental part of the template on which all other variables must operate (Southwood 1977). Assuming that all else is equal, the role of climate in determining the potential size of the population can be described using the CLIMEX Growth Index and Stress Indices, as outlined earlier. Where nonclimatic influences play a large role, a process-based population model will be required to describe the interactions involved.

The potential for population growth each year depends on the duration and suitability of the season. Long growth seasons allow species with few generations to undergo an extra generation or part of one, causing proportionally larger population increases than are observed with species with one or multiple generations (Sutherst et al. 1995). They also allow perennial species such as woody weeds to increase their biomass rapidly and to pass through the vulnerable seedling stage more successfully than usual (Brown and Carter 1998). Episodic recruitment of woody weeds, in successive years with extremely high rainfall, leads to thicket formation when seedlings survive in large numbers. Prickly acacia, *Acacia nilotica*, is one such species (Brown and Carter 1998). Climate change is likely to alter the frequency and intensity of such conditions.

As climate change and enhanced CO_2 will affect soil moisture availability, they will also affect plant population dynamics. Differential water-use efficiency by C_3 and C_4 plants is likely to affect the outcomes of plant competition. Similarly, the projected increase in the amount of foliage produced by plants under elevated CO_2 is likely to alter the microclimate by retaining more moisture in the canopy. This is likely to favor the propagation of invasive fungal diseases (Chakraborty et al. 1998).

Populations of migratory species fail to survive the unfavorable season regardless of their success in multiplying in the favorable period. Limiting climatic conditions occur when the temperature or moisture levels either reach extreme values or remain unfavorable for development for prolonged periods. Description and explanation of geographical limits requires the limiting factors in each direction to be identified. In pragmatic terms that usually means defining the climate envelope associated with the realized, as opposed to the funda-

mental, niche of the species. Occupation of the whole of the fundamental niche may be blocked by interspecific competition for various resources. When an invasive species enters a new continent, unaccompanied by its natural enemies, it experiences what has been termed an "ecological release" that allows it to reach much higher population densities than occurs in its native range. It will be able to occupy a much greater proportion of its fundamental niche as a result. This observation forms the basis for successful planting of exotic species of ornamentals in gardens and commercial forests (Booth 1996) and for the practice of biological control with introduced natural enemies (Huffaker 1974). Under climate change, this realized niche may remain relatively constant in terms of climate space while shifting significantly in geographical space. A change in the realized niche could occur if fast-moving species encounter new interspecific interactions, but that is beyond the scope of this chapter.

In CLIMEX terms, the climatic limits are determined first by *stress* factors associated with either extreme or chronically unfavorable temperature or moisture conditions. For example, a species may be limited by minimum temperatures below 2°C if they are experienced for a period of more than two weeks. Second, *constraints* to continuous occupation of an area arise when the growing season is too short or there is a lack of the appropriate conditions for diapause or hibernation in certain species. Both of these limiting mechanisms will be affected by global warming in ways particular to the species and the habitat involved.

While distributions can be correlated with long-term average climatic conditions, occasional severe winters in some regions with high climatic variation can reduce or even eliminate populations of less mobile species in local areas, or in extreme cases over wide areas. This was shown by Krakauer (1968) in Florida for the cane toad *Bufo marinus*. The finding was supported by an analysis comparing climates in New Orleans, where toads failed to establish, with Mt. Tamborine in Queensland, Australia, where the average winter temperatures are almost identical but where the toad has successfully established breeding populations (Sutherst et al. 1996a). An examination of the lowest recorded minimum temperature at each place between 1957 and 1978 showed that it was much lower (−13.9°C) at New Orleans than at Mt. Tamborine (0.3°C), despite the mean temperatures being the same. The effect that climate change may have on the frequency and intensity of such extreme low temperatures is particularly significant in areas like the southern United States, where very extreme conditions already occur intermittently.

Climatic Effects on Species Interactions

Climate has mediating effects on interactions between invasive species and their host plants, predators, and competitors (Kingsolver 1989) in addition to

direct effects on species. These interactions have pervasive effects on ecosystems (van Emden 1999) and need to be taken into account when making a risk assessment for global change impacts. They mean that it is not possible to develop a holistic impact assessment of a species without also assessing the impact of the environmental changes on the other species in the same and different trophic levels in the system. This is a task that has been too demanding for most community ecologists, and routine risk assessments with this level of detail are beyond the scientific and policy communities' resources, even for a limited number of studies. We have to find ways of making assessments that include an approximate measure of likely second-order impacts without having to fully understand the whole web of interactions. One promising approach is to infer likely disruptive changes based on a comparison of the geographical distributions of the various species concerned in any particular interaction (Sutherst 1998).

Invasive species interact with the resident vegetation and wildlife in a range of different ways. They may displace natives from their niches, either stochastically or by superior competitive ability, as suggested by Horvitz et al. (1998) and Newsome and Noble (1986). This view does not rely on major disturbance altering the ecosystem to create new conditions to which the native species are not adapted, as required by other models proposed by Mooney and Drake (1989) and Rejmanek (1989). Nevertheless, the evidence that disturbance greatly facilitates many invasions by alien species is strong and adds another dimension to the risks from invasive species.

The most rigorous analysis therefore requires a full understanding of the species' interaction with biotic factors, including hosts, competitors, and predators. For example, host organisms that support high rates of reproduction of an insect will allow it to persist further into marginal climatic zones than is possible on less suitable hosts. This phenomenon is illustrated for the pantropical livestock tick *Boophilus microplus* that attacks bovines of various types. This Asian tick is extremely invasive in Africa, the Americas, and Australia, because of its very high fecundity rate, ability to overcome host defences, and efficient dispersal on livestock. In Australia, zebu cattle, which are highly immune to tick feeding, almost eliminated the ticks from ranches in southern Queensland where the winter is unsuitable for four months each year. Meanwhile, the ticks were still seasonally abundant on European breeds of cattle with low immunity (Bourne et al. 1988). In a more climatically suitable environment in central Queensland, significant tick numbers were maintained on all breeds (Bourne et al. 1988). Under climate change, tick numbers are expected to increase in southern Queensland and to extend their potential range southward.

Sutherst and Utech (1991) gave examples of how changes in host resistance of livestock to parasites can have an overwhelming effect on the pop-

ulation dynamics of the parasite. These changes may result from climatically induced nutritional stress in the host during prolonged dry seasons in the tropics or severe winters at higher latitudes. While dry conditions in tropical environments lead to low survival rates of free-living stages of the cattle tick *Boophilus microplus,* the same conditions result in weight loss by the tick's bovine hosts (McCown 1981), leading to a loss of resistance to tick feeding (Sutherst et al. 1983). The outcome is that livestock and wildlife suffer heavy infestations at the end of prolonged stressful seasons, as reported by DelGiudice et al. (1997). In the field it is difficult to determine whether heavy infestations cause nutritional stress as claimed by DelGiudice et al. or vice versa. Experimental studies show that nutritional stress of the host leads to heavy infestations with ticks. Under climate change, there is a risk that the duration and intensity of droughts will increase, with the attendant effects on the nutrition and hence host resistance of herbivores to parasites.

Climatically induced stress on plants can reduce their ability to resist invaders. Vegetation, made vulnerable by the stress of a changing climatic environment often falls prey to insects or pathogens, or succumbs to competition. For example, drought kills native plants, leaving gaps in vegetation that are quickly occupied by invasive species such as *Lantana camara* in rain forests. Drought and freezing reduce the resistance of trees to insect attack (Mattson and Haack 1987; Auclair et al. 1996) and each phenomenon is likely to change in both frequency and intensity under climate change (Wigley 1985).

Different species at the destination may limit the population growth rates of an invasive species through a variety of mechanisms. An example of a climatically mediated interaction that limits the success of an invasive species is given by the hybrid zones between tick species in Africa. The tick *B. microplus* is prevented from colonizing very large areas by competition from an indigenous species, *B. decoloratus,* which has an advantage in cooler and drier habitats or in those with game animals (Sutherst 1987a).

Conversely, an invasive species may outcompete an established species and displace it from a large region, as happened with the introduction of the Asian tiger mosquito, *Aedes albopictus,* in the United States (Francy et al. 1990). It was better adapted to breeding at high densities in water with low nutrient supplies in car tires, and so rapidly displaced *Aedes aegypti* (Juliano 1998). Given the greater tolerance of high temperatures by *A. albopictus,* mediation of the interaction by temperature will result in an even greater advantage being bestowed on *A. albopictus* by global warming.

Fortunately, such extreme cases are relatively infrequent and usually involve closely related species. The results are usually dramatic and are unlikely to be overlooked when using software such as CLIMEX, which detects

inconsistencies in climate envelopes in different regions (Sutherst and Maywald 1985). The multiplicity of niches in the spatially and temporally heterogeneous dimensions in nature enable the coexistence of many species (Hutchinson 1957/8), even though simple laboratory experiments in confined, homogenous environments suggest that competitive exclusion will occur and be mediated by climatic factors (Davis et al. 1998).

The above examples contrast with the usual situation where exotic species arrive in new habitats and are free from predators and competitors and so can colonize wider climate envelopes than is possible in their area of origin. This observation forms the basis for the practice of biological control of invasive species. As the interactions are mediated by climate, it is not unexpected that the effectiveness of biocontrol varies regionally. Similarly, the balance between predators and their prey may vary with the seasons. Bouma and Dye (1997) suggested that an ENSO (El Niño Southern Oscillation)-induced drought can result in mortality of predators of mosquitoes leading to later epidemics of malaria in Venezuela. Climate change will therefore alter the effectiveness of biological control of some species in some regions. However, the greatest impact of climate change is likely to be through the impact of extreme climatic events on establishment rates of small populations of introduced biocontrol agents (Sutherst 1998), rather than through the effect of changed average conditions on the size of equilibrium populations of the agents. This fortunately is amenable to adaptive management measures, concentrated first on accurately matching climate envelopes that will shift over time. The success rates of releases of biocontrol agents could also be improved by using ENSO/SOI (Southern Oscillation Index) and sea surface temperatures (SSTs) or related medium-range forecasts that are becoming more reliable (Sutherst 1998).

Interaction between Climate Change and Other Global Change Drivers

As climate change is only one of several global change drivers, it is necessary to consider the interactive effects of each driver as it affects invasive species. Further details of these additional drivers are given in other chapters in this volume. Land use, including fire, cultivation, or deforestation, disturbs natural vegetation. The resulting fragmentation of the landscape reduces the ability of resident species to resist invasion by opportunistic invasive species. Corridors for movement of beneficial species can also provide access for noxious organisms, as shown by the giant toads moving along roads to invade new habitats in Australia. In addition, the development of pesticide-resistant strains of pests, diseases, and weeds threatens agriculture and natural ecosys-

tems. Under climate change, higher temperatures will accelerate selection rates of resistance genes by shortening generation times.

Changes in atmospheric concentrations of CO_2 are already occurring and are projected to triple from preindustrial levels by the end of the next century. As plant species with different photosynthetic pathways respond differently to CO_2, there is likely to be a shift in the balance of beneficial plants and weeds of different types (Patterson and Flint 1990; Dukes, this volume). Some of these responses will benefit crops and native species while others will benefit weeds, and the balance will depend on the plant type and its interaction with CO_2, temperature, and available moisture (Campbell et al. 1997).

Shifting land use can exacerbate effects of climate change. Episodic recruitment of woody weeds, in years with extremely high rainfall, leads to thicket formation when seedlings survive in large numbers. Livestock, which act as local vectors as well as provide opportunities for long-distance transfer, affect weed recruitment. When cattle replaced sheep in northern Australia, *Acacia nilotica* spread in dung, whereas previously sheep had digested the seed (Brown and Carter 1998). This led to extensive spread of the tree into prime grazing country, and thickets formed on dry-land areas in years with successful heavy rainfall (Hobbs, this volume). In this example, the change from sheep to cattle resulted from an economic response to market forces, and the spread was mediated by climate.

The available soil moisture depends greatly on the landscape, with topography determining effective rainfall by affecting runoff. It results in a higher incidence of waterlogging on flats that often also have heavier soils. Soil types determine water-holding capacity and drainage characteristics and hence the predisposition of a population of an invasive species to respond to extreme rainfall events. While light soils limit the amount of available water, heavy clays retain moisture and facilitate the propagation of invasive plant pathogens, such as *Phytophthora cinnamomi*. Brasier and Scott (1994) showed that under climate change, such pathogens pose a significant threat to oak forests of Europe. Inclusion of soil types in an assessment of areas in the United Kingdom at risk from *Fallopia japonica* under climate change resulted in a more targeted list of sites considered vulnerable to invasion (Beerling et al. 1995).

We have already seen how international trade is accelerating under the drive for globalization and the WTO. Climate change has the potential to affect the rate of spread of exotic, invasive species by affecting the sources, pathways, and destinations of those organisms. These interactive effects mean that it is necessary to treat climate change as one of several components of any system under study rather than as a driver of change in isolation.

An example of closely related taxa, whose distributions are affected by biotic factors that are mediated by climate and changing patterns of trade, is

provided by the extremely invasive and polyphagous silverleaf whitefly, *Bemisia tabaci* biotype B. It is notorious for its ability to develop resistance to pesticides and has spread around the world from its origins in Europe. It has recently been introduced to Australia, probably on imported ornamental plants from the United States. Despite being known to pose a high risk to Australia, the pest still evaded quarantine precautions and has spread widely around the country. It is prevented from colonizing many of the open field crops by interactions with the native *Bemisia* biotype and its parasitoids (De Barro and Hart, in prep.). These interactions vary geographically in response to variation in climate. The example demonstrates three important aspects of the risks posed by global change and invasive species. First, the increasingly severe trade pressures on countries to accept imports of living material threatens natural ecosystems, agriculture, and human health in other countries. Second, the example demonstrates the value of native biodiversity in preserving the health of agriculture. Third, it also illustrates the mediating effect of climate on the interbiotype interaction, which varies in its outcomes in different climatic environments.

Disturbance from multipurpose use of protected areas carries high risks of providing opportunities for invasion by pests such as *P. cinnamomi* or amphibian pathogens such as *Chytridiomycosis* that are being spread by human activity (Berger et al. 1998). Every effort should be made to keep those areas, which are set aside to protect natural ecosystems, free from human contact with its attendant risks of spreading invasive plants and animals. This is in direct conflict with current trends toward multiple use of protected areas to generate income to support their conservation, but it is probably one of the largest contributions that can be made to adapt to climate change.

Impacts of Invasive Species on Some Ecosystems under Climate Change

Having explored the processes by which invasive species dominate natural systems, we can now briefly consider three examples of the vulnerability of ecosystems to invasive species under climate change.

Many native plants and forests are susceptible to the root pathogen *P. cinnamomi*, which also threatens horticulture in many parts of the world. Any increase in incidence of high rainfall events and high temperatures will favor outbreaks of this pathogen, as growth is maximized at high soil moisture levels with temperatures between 25°C and 30°C, following prolonged dry spells. Given a 3°C rise in temperature and an intensification of the hydrological cycle under climate change, the incidence of extremely dry or wet weather events is likely to increase disproportionately and lead to more out-

breaks of the disease. Because the fungus is moved mainly by human activity, and because it attacks many species of trees in disturbed situations (Podger et al. 1990), the threat of increased risks from this pathogen is a serious concern to managers of native forests in Australia and Europe (Brasier and Scott 1994). It is increased by multiple-use activities that have the potential to spread the fungus in protected areas.

Invasive species are now recognized as being responsible for significant losses of biodiversity, and global change is likely to accelerate those losses by increasing disturbance and stressing native species at the margins of the distributions of native species (Vitousek et al. 1997). The common wasp *Vespula vulgaris* preys on a variety of local insects and competes with them for beech honeydew in parks such as the Tongariro National Park in New Zealand (Fordham 1991). Together with the European wasp *Vespula germanica,* they threaten native species of insects and therefore possibly insectivorous birds and plants that rely on insects for pollination (Moller and Tilley 1989). The European wasp is less able to control the temperature in its nests in the ground, and as a result, in Europe only the queens overwinter to establish a nest in the spring (Spradbery, personal communication). A warming of temperate areas will enable entire colonies of European wasps to overwinter as they have done in Australia. Global warming is likely to increase wasp numbers, provided that the beech trees remain healthy. On the other hand, the wasps do not appear to thrive in hot and humid environments (Spradbery and Maywald 1992), and their range could retract somewhat in the subtropics.

The biodiversity of vast areas of Australia is threatened by rabbits, which are less directly affected by climate than are the cold-blooded animals. The distributions of such vertebrates are more likely to be determined by changes in their habitats than by direct effects of climate. Nevertheless, for its reproduction, the rabbit is reliant on climate for winter growth of vegetation. Population growth is inhibited in hot areas with no winter rainfall (Cooke 1992). Thus the rabbit is likely to retract its range further south in Australia with global warming, but the relative impact of this indirect effect of climate change on biodiversity is unclear because the direct effect of climate change on the native fauna and flora has not been defined.

Relative Risks from New Invasions and Changes in Status of Invasive Species under Climate Change

It is instructive to compare the magnitude of some current risks from invasive species with the incremental impact that is likely with an increase in average temperatures and changed patterns of rainfall under climate change. There are numerous invasive species around the world with the potential to

create major impacts in other continents (Macdonald 1994). They have the potential to reach populations high enough to cause significant impacts in areas with climates similar to those in their existing climatic envelopes. This provides a benchmark against which to measure the relative importance of climate change (Sutherst 1998). The following two examples illustrate the relative severity of the risks from new invasions compared with expansion of the ranges of existing invasive species.

Most of coastal Australia is at risk from the Asian tiger mosquito, *Aedes albopictus,* which is an efficient vector of dengue fever, but the incremental increase in risk under higher average temperatures with global warming is negligible because the species has such a wide tolerance of climatic conditions (Sutherst 1998). Similarly, the African tick, *Amblyomma variegatum,* threatens livestock and wildlife in the Americas if it spreads from the Caribbean onto the mainland (Sutherst 1987b). This catholic-feeding tick causes large wounds on wildlife, including mammals and birds, and transmits to ruminants a lethal disease called heartwater, caused by a rickettsia, *Cowdria ruminantium.* It threatens all terrestrial mammals over a massive area in the Americas (Fig. 10.6) and the impact would be greatly increased by interaction with the resident screwworm fly *Cochliomyia hominivorax,* which is attracted to wounds on animals. Note that the precise limit of the potential distribution in North America is not defined. The species' tolerance of the extreme

Figure 10.6. The potential area in the Americas at risk from invasion by the African tick, *Amblyomma variegatum:* (a) current conditions and (b) climate change scenario with +2°C, as estimated using the CLIMEX Ecoclimatic Index (EI). The extent of the risk is proportional to the size of the circles for representative locations.

low temperatures, which occur intermittently in the southern United States, could not be inferred from long-term average temperatures, and the necessary modeling scenarios or experimental studies have not been done.

Given the major current risk to the Americas from this tick, what are the additional risks posed by global warming? CLIMEX was run with an increase in the average minimum and maximum temperatures of 2°C. The result was that climate change per se was likely to have a marginal additional impact to that caused by the initial introduction of the tick to the new habitats. Introductions of African ticks and other livestock parasites continue apace in the United States (Allan et al. 1998), but fortunately with few successful establishments in the wild under current climatic conditions.

These results illustrate that prevention of invasions is of paramount importance. The effect of climate change on the risks from invasive species will depend on the responsiveness of the species to climate and on the specific ecosystem and region involved, so it is not possible to generalize from these examples.

Adaptive Management

There is limited potential in natural systems to adjust to impacts of climate change (U.S. National Academies of Science and Engineering/Institute of Medicine 1992), and this applies equally to invasion by nonindigenous species.

In agriculture, changes in regional climates will affect current, ecologically based management practices to contain outbreaks of pests, as illustrated by the following example with the livestock tick *Boophilus microplus* in Australia. In climatically favorable areas of New South Wales, uninterrupted chemical control for at least six months is essential for eradication and costs about A$0.5 million to contain each significant outbreak. By contrast, outbreaks in areas with a severe winter are contained by placing a quarantine on affected farms and allowing the winter to kill the ticks. This has major cost savings but depends on having reliable ecological knowledge from models such as CLIMEX. In such situations, adaptive management options under climate change will rely even more on sound ecological knowledge that can be applied at the local level. Monitoring of climatic trends and their biological consequences will need to be coupled with modeling to tune adaptive management measures progressively.

Conclusions

Species will be more sensitive to climate change toward the edges of their distributions than in the middle of the range. Natural systems will be more vul-

nerable to climate change than will managed systems where there is an extra level of control provided by human intervention. However, there is a need to develop criteria to measure and classify impacts on natural systems because such systems are dynamic assemblages. The global community needs to develop early warning systems to identify the first impacts of invasive species on terrestrial systems under global change. From the biogeographical perspective, based on experience with CLIMEX, here are some suggestions. As evidence of global warming will first be apparent on the margins of species' distributions, it will be more rewarding to place surveillance systems along transects across these boundaries than to put them near the core of the species' distribution. It will be important to identify the mechanisms by which current climates limit the distribution of species in each direction from the core. For example, where the edge of the range is on a trend with decreasing temperatures, we need to distinguish between the different effects of lethal minimum temperatures, insufficient degree-days to support metabolism during the winter and the duration of those conditions, and growth seasons that are too short for the species to reproduce or complete a generation. This needs interpretive modeling rather than pattern matching of meteorological data. A priori modeling studies to identify the vulnerable regions that may be most affected by each species will help to identify the most rewarding sites to place surveillance transects and barriers to movements. If this fails to be implemented, we can look forward to an accelerating homogenization of the world's flora and fauna.

Summary

Invasive species are causing profound and usually irreparable changes to natural, terrestrial ecosystems and to agroecological systems around the world. Many exotic ornamental and agricultural plants as well as invertebrate pests and diseases of plants and animals are moved between countries either for trade or by accident. The spread of these noxious species is accelerating under the influence of a number of global change drivers. These include increased trade and tourism, disruptive land-use practices, climate change with its likely attendant increase in the frequency of extreme events, geochemical and atmospheric change, and the development of pesticide- and drug-resistant species. International trade is accelerating under the drive for globalization and the World Trade Organization, creating pressures to liberalize quarantine restrictions. Climate change has the potential to modify the impacts of exotic, invasive species by affecting their sources, pathways, and destinations.

In this chapter the analytical approaches adopted by three unrelated scientific communities are combined to produce a framework for the assessment of vulnerability of systems or geographical regions to invasive species under

climate change. The three approaches are (1) pest risk analysis, borrowed from the plant and animal protection community; (2) a protocol for assessment of vulnerability from the IPCC climate change community; and (3) a modified version of the plant pathologists' Host-Pathogen-Environment framework. Some tools for assessing impacts are described, and the effects of climate change on the processes that determine the success of invasive species are outlined. Using this analytical framework, knowledge of the vulnerability of terrestrial systems to the impacts of invasive species is reviewed and illustrated with examples.

The evidence indicates that some of the greatest impacts of climate change on invasive species will arise from changes in the frequency and intensity of extreme climatic events. These disturb ecosystems, making them vulnerable to invasion, and they provide exceptional opportunities for dispersal and growth of invasive species.

Acknowledgments

Professor Hal Mooney invited the author to participate in the San Mateo Workshop, and IUCN/SCOPE contributed funding toward his participation.

References

Allan, S.A., Simmons, L., and Burridge, M.J. (1998). Establishment of the tortoise tick *Amblyomma marmoreum* (Acari: Ixodidae) on a reptile-breeding facility in Florida. *Journal of Medical Entomology* 35: 621–624.

Auclair, N.D., Lill, J.T., and Revenga, C. (1996). The roles of climate variability and global warming in the dieback of northern hardwoods. *Water, Air, and Soil Pollution* 91: 163–186.

Auld, B.A., Hosking, J., and McFadyen, R.E. (1982/1983). Analysis of the spread of tiger pear and parthenium weed in Australia. *Australian Weeds* 2: 56–60.

Baskin, Y. (1996). Curbing undesirable invaders. *BioScience* 46: 732–736.

Beerling, D.J., Huntley, B., and Bailey, J.P. (1995). Climate and the distribution of *Fallopia japonica:* use of an introduced species to test the predictive capacity of response surfaces. *Journal of Vegetation Science* 6: 269–282.

Beerling, D.J., and Woodward, F.I. (1994). Climate change and the British scene. *Journal of Ecology* 82: 391–397.

Berger, L., Speare, R., Daszak, P., Green, D.E., Cunningham, A.A., Goggin, C.L., Slocombe, R., Ragan, M.A., Hyatt, A.D., McDonald, K.R., Hines, H.B., Lips, K.R., Marantelli, G., and Parkes, H. (1998). *Chytridiomycosis* causes amphibian mortality associated with population declines in the rain forests of Australia and Central America. *Proceedings of the National Academy of Sciences of the United States of America* 95: 9031–9036

Booth, T.H. (1996). *Matching trees and sites.* ACIAR proceedings No. 63, 126 pp.

Bouma, M.J., and Dye, C. (1997). Cycles of malaria associated with El Niño in Venezuela. *The Journal of the American Medical Association* 278: 177–180.

Bourne, A.S., Sutherst, R.W., Sutherland, I.D., Maywald, G.F., and Stegeman, D.A. (1988). Ecology of the cattle tick (*Boophilus microplus*) in subtropical Australia. III. Modelling populations on different breeds of cattle. *Australian Journal of Agricultural Research* 39: 309–318.

Brasier, C.M., and Scott, J.K. (1994). European oak declines and global warming: a theoretical assessment with special reference to the activity of *Phytophthora cinnamomi. Bulletin-OEPP* 24: 221–232.

Brown, J.R., and Carter, J. (1998). Spatial and temporal patterns of exotic shrub invasion in an Australian tropical grassland. *Landscape Ecology* 13: 93–102.

Campbell, B.D., Stafford Smith, D.M., and McKeon, G.M. (1997). Elevated CO_2 and water supply interactions in grasslands: a pastures and rangeland management perspective. *Global Change Biology* 3: 117–187.

Carr, G.W. (1993). Exotic flora of Victoria and its impact on indigenous biota. In *Flora of Victoria*, Vol. 1, Introduction, ed. D.B. Foreman and N.G. Walsh, pp 256–297. Inkata Press, Melbourne.

Chakraborty, S., Murray, G.M., Magarey, P.A., Yonow, T., O'Brien, R., Croft, B.J., Barbetti, M.J., Sivasithamparam, K., Old, K.M., Dudzinski, M.J., Sutherst, R.W., Penrose, L.J., Archer C., and Emmett, R.W. (1998). Potential impact of climate change on plant diseases of economic significance to Australia. *Australasian Plant Pathology* 27: 15–35.

Clout, M. (1998). And now, the Homogocene. In *Invaders from Planet Earth*. World Conservation 4/97–1/98, p. 4.

Cooke, B.D. (1992). Computer modelling for the biological control of wild rabbits. *The Australian Rural Science Annual*, 20–23.

Davis, A.J., Lawton, J.H., Shorrocks, B., and Jenkinson, L.S. (1998). Individualistic species responses invalidate simple physiological models of community dynamics under global environmental change. *Journal of Animal Ecology* 67: 600–612.

DelGiudice, G.D., Peterson, R.O., and Samuel, W.M. (1997). Trends of winter nutritional restriction, ticks, and numbers of moose on Isle Royale. *Journal of Wildlife Management* 61: 895–903.

Dukes, J.S., and Mooney, H.A. (1999). Does global change increase the success of biological invaders? *TREE* 14: 135–139.

Farrow, R.A. (1991). Implications of potential global warming on agricultural pests in Australia. *OEPP/EPPO Bulletin* 21: 683–696.

Focks, D.A., Linda, S.B., Craig, G.B. Jr., Hawley, W.A., and Pumpuni, C.B. (1994). *Aedes albopictus* (Diptera: Culicidae): a statistical model of the role of temperature, photoperiod, and geography in the induction of egg diapause. *Journal of Medical Entomology* 31: 278–286.

Fordham, R.A. (1991). Vespulid wasps at the upper forest margin in Tongariro National Park. *New Zealand Journal of Zoology* 18: 151–153.

Francy, D.B., Moore, C.G., and Eliason, D.A. (1990). Past, present and future of *Aedes albopictus* in the United States. *Journal of the American Mosquito Control Association* 6: 127–132.

Horvitz, C.C., Pascarella, J.B., McMann, S., Freedman, A., and Hofstetter, R.H. (1998). Functional roles of invasive non-indigenous plants in hurricane-affected subtropical hardwood forests. *Ecological Concepts in Conservation Biology* 8: 947–974.

Huffaker, C.B. (Ed) (1974). *Biological control*. 511 pp. Plenum/Rosetta, NY.

Hutchinson, G.E. (1957/8). Concluding remarks. *Cold Spring Harbor Symposia on Quantitative Biology* 22: 415–427.

Jenkins, P.T. (1996). Free trade and exotic species introductions. *Conservation Biology* 10: 300–302.

Juliano, S.A. (1998). Species introduction and replacement among mosquitoes: interspecific resource competition or apparent competition? *Ecology* 79: 255–268.

Kingsolver, J.G. (1989). Weather and the population dynamics of insects: integrating physiological and population ecology. *Physiol. Zool.* 62: 314–334.

Krakauer, T. (1968). The ecology of the neotropical toad *Bufo marinus* in South Florida. *Herpetologica* 24: 214–221.

Lonsdale, W.M. (1993). Rates of spread of an invading species—*Mimosa pigra* in northern Australia. *Journal of Ecology* 81: 513–521.

Lonsdale, W.M., and Lane, A.M. (1994). Tourist vehicles as vectors of weed seeds in Kakadu National Park, northern Australia. *Biological Conservation* 69: 277–283.

Macdonald, I.A.W. (1994). Global change and alien invasions: implications for biodiversity and protected area management. In *Biodiversity and Global Change,* ed. Solbrig, O.T., van Emden, H.M., and van Oordt, P.G.W.J., pp. 197–207. International Union of Biological Sciences (IUBS), Paris, France.

McCown, R.L., Gillard, P., Winks, L., and Williams, W.T. (1981). The climatic potential for beef cattle production in tropical Australia: Part II—liveweight change in relation to agro-climatic variables. *Agricultural Systems* 7: 1–10.

Mattson, W.J., and Haack, R.A. (1987). The role of drought in outbreaks of plant-eating insects. Drought's physiological effects on plants can predict its influence on insect populations. *Bioscience* 37: 110–118.

Moller, H., and Tilley, J.A.V. (1989). Beech honeydew: seasonal variation and use by wasps, honey bees and other insects. *New Zealand Journal of Zoology* 16: 289–302.

Mooney, H.A., and Drake, J.A. (1989). Biological invasions: a SCOPE program overview. In *Biological Invasions: A Global Perspective,* ed. Drake, J.A., Mooney, H.A., di Castri, F., Groves, R.H., Kruger, F.J., Rejmanek, M., and Williamson, M., pp. 491–506. SCOPE. John Wiley & Sons, New York.

Murray, M.D., and Nix, H.A. (1987). Southern limits of distribution and abundance of the biting-midge *Culicoides brevitarsis* Kieffer (Diptera: Ceratopogonidae) in south-eastern Australia: an application of the GROWEST model. *Australian Journal of Zoology* 35: 575–585.

Newsome, A.E., and Noble, I.R. (1986). Ecological and physiological characters of invading species. In *Ecology of Biological Invasions,* ed. Groves, R.H., and Burdon, J.J., pp. 1–20. Cambridge University Press, Sydney, Australia.

Norval, R.A.I., and Perry, B.D. (1990). Introduction, spread and subsequent disappearance of the brown ear-tick, *Rhipicephalus appendiculatus,* from the southern lowveld of Zimbabwe. *Experimental and Applied Acarology* 9: 103–111.

Parry, M., and Carter, T. (1998). *Climate Impact and Adaptation Assessment.* Earthscan Publications, United Kingdom.

Patterson, D.T., and Flint, E.P. (1990). Implications of increasing carbon dioxide and climate change for plant communities and competition in natural and managed ecosystems. In *Impact of Carbon Dioxide, Trace Gases, and Climate Change on Global Agriculture,* American Society of Agronomy Special Publ. No. 53.

Pender, J. (1994). Migration of the brown plant hopper, *Nilaparvata lugens* (Stal.), with special reference to synoptic meteorology. *Grana* 33: 112–115.

Pitelka, L.F., Gardner, R.H., Ash, J., Berry, S., Gitay, H., Noble, I.R., Saunders, A., Bradshaw, R.H.W., Brubaker, L., Clark, J.S., and Davis, M.B. (1997). Plant migration and climate change. *American Scientist* 85: 464–473.

Podger, F.D., Mummery, D.C., Palzer, C.R., and Brown, M.J. (1990). Bioclimatic analysis of the distribution of damage to native plants in Tasmania by *Phytophthora cinnamomi*. *Australian Journal of Ecology* 15: 281–289.

Rejmánek, M. (1989). Invasibility of plant communities. In *Biological Invasions: A Global Perspective*, ed. Drake, J.A., Mooney, H.A., di Castri, F., Groves, R.H., Kruger, F.J., Rejmánek, M., and Williamson, M., pp. 369–388. SCOPE 37. John Wiley & Sons, Chichester, United Kingdom.

Romano, A., Greco, J., Doti, F., Vogel, A., and Alberdi, J. (1991). The horn fly *Haematobia irritans* (Linnaeus 1758). A serious threat to livestock in Argentina. *Veterinaria Argentina* 8: 683–688.

Seabrook, W.A., and Dettmann, E.B. (1996). Roads as activity corridors for cane toads in Australia. *Journal of Wildlife Management* 60: 363–368.

Southwood, T.R.E. (1977). Habitat, the templet for ecological strategies? *Journal of Anima Ecology*, 46: 337–365.

Specht, R.L., and Specht, A. (1999). *Australian Plant Communities*. 492 pp. Oxford University Press, Melbourne.

Spradbery, J.P., and Maywald, G.F. (1992). The distribution of the European or German wasp, *Vespula germanica* (F.) (Hymenoptera: Vespidae), in Australia: past, present and future. *Australian Journal of Zoology* 40: 495–510.

Spradbery, J.P., Mahon, R.J., Morton, R., and Tozer, R.S. (1995). Dispersal of the Old World screw-worm fly *Chrysomya bezziana*. *Medical and Veterinary Entomology* 9: 161–168.

Sutherst, R.W. (1987a). The dynamics of hybrid zones between tick (Acari) species. *International Journal for Parasitology* 17: 921–926.

———. (1987b). Tick ecology, importance of population dynamics in developing national tick control and eradication programs. *Proceedings of the Expert Consultation on the Eradication of Ticks with Special Reference to Latin America*, Mexico City, June 1987. FAO, Rome, pp. 196–210.

———. (1995). The potential advance of pests in natural ecosystems under climate change: implications for planning and management. In *Impacts of Climate Change on Ecosystems and Species: Implications for Protected Areas*, ed. Pernetta, J.C., Elder, D., Humphrey, S., and Leemans, R., pp. 83–98. IUCN, Gland, Switzerland.

———. (1998). Implications of global change and climate variability for vector-borne diseases: generic approaches to impact assessments. *International Journal for Parasitology* 28: 935–945.

Sutherst, R.W., Collyer, B.S., and Yonow, T. (2000). The vulnerability of Australian horticulture to the Queensland fruit fly, *Bactrocera (Dacus) tryoni*, under climate change. *Australian Journal of Agricultural Research* 51: 467–480.

Sutherst, R.W., Floyd, R.B., and Maywald, G.F. (1996a). The potential geographical distribution of the cane toad, *Bufo marinus* L. in Australia. *Conservation Biology* 10: 294–299.

Sutherst, R.W., Ingram, J., and Scherm, H. (1998). Global Change and Vector-Borne Diseases. *Parasitology Today* 14: 297–299.

Sutherst, R.W., Kerr, J.D., Maywald, G.F., and Stegeman, D.A. (1983). The effect of season and nutrition on the resistance of cattle to the tick *Boophilus microplus. Australian Journal of Agricultural Research* 34: 329–339.

Sutherst, R.W., and Maywald, G.F. (1985). A computerised system for matching climates in ecology. *Agriculture Ecosystems & Environment* 13: 281–299.

Sutherst, R.W., Maywald, G.F., and Skarratt, D.B. (1995). Predicting insect distributions in a changed climate. In *Insects in a Changing Environment,* ed. Harrington, R., and Stork, N.E., pp. 59–91. Academic Press, London.

Sutherst, R.W., Spradbery, P., and Maywald, G.F. (1989). The potential geographical distribution of the Old World screw-worm fly, *Chrysomya bezziana. Medical and Veterinary Entomology* 3: 273–280.

Sutherst, R.W., and Utech, K.B.W. (1991). Controlling livestock parasites with host resistance. In *CRC Handbook of Pest Management in Agriculture,* 2nd Edition, Vol. II, ed. Pimentel, D., pp. 379–401. CRC Press, Boca Raton, Florida.

Sutherst, R.W., Yonow, T., Chakraborty, S., O'Donnell, C., and White, N. (1996). A generic approach to defining impacts of climate change on pests, weeds and diseases in Australasia. In *Greenhouse: Coping with Climate Change,* ed. Bouma, W.J., Pearman, G.I., and Manning, M.R., pp. 281–307. CSIRO, Melbourne.

Teng, P.S., Heong, K.L., Kropff, M.J., Nutter, F.W., and Sutherst, R.W. (1996). Linked pest-crop models under global change. In *Global Change in Terrestrial Ecosystems,* ed. Walker, B., and Steffen, W., pp. 291–316. Cambridge University Press.

Tol, R.S.J., Fankhauser, S., and Smith, J. (1998). The scope for adaptation to climate change: what can we learn from the impact literature? *Global Environmental Change* 2: 109–123.

U.S. National Academies of Science and Engineering/Institute of Medicine. (1992). *Policy Implications of Greenhouse Warming: Mitigation, Adaptation and the Science Base,* National Academy Press, Washington, D.C.

Usher, M.B. (1986). Invasibility and wildlife conservation: invasive species on nature reserves. *Philosophical Transactions of the Royal Society London* B 314: 695–710.

van Emden, H.F. (1999). Are two methods better than one? *International Journal of Pest Management* 45: 1–2.

Vitousek, P.M., D'Antonio, C.M., Loope, L.L., Rejmanek, M.N., and Westbrooks, R. (1997). Introduced species: a significant component of human-caused global change. *New Zealand Journal of Ecology* 21: 1–16.

Waterhouse, D.F. (1974). The biological control of dung. *Scientific American* 230: 101–109.

Wigley, T.M.L. (1985). Impact of extreme events. *Nature* 316: 106–107.

Williams, J.D., Sutherst, R.W., Maywald, G.F., and Petherbridge, C.T. (1985). The southward spread of buffalo fly (*Haematobia irritans exigua*) in Eastern Australia and its survival through a severe winter. *Australian Veterinary Journal* 62: 367–369.

Williamson, M. (1996). *Biological Invasions.* Chapman & Hall, London.

Yonow, T., and Sutherst, R.W. (1998). The geographical distribution of the Queensland fruit fly, *Bactrocera (Dacus) tryoni,* in relation to climate. *Australian Journal of Agricultural Research* 49: 935–953.

Chapter 11

〜

The Economics of
Alien Species Invasions

Rosamond L. Naylor

Alien species invasions are now recognized as an important component of global environmental change. Once considered a phenomenon largely restricted to oceanic islands, invasions of nonnative species are occurring at increasing rates throughout the world—on continental landmasses, in oceans, and in freshwater ecosystems. The breakdown of biogeographic barriers is changing ecosystem structure and function, and it is accelerating the decline in biodiversity on a global scale. Moreover, invasions are proving to be economically damaging to an extent that is only beginning to be appreciated by economists and policy makers.

Invasions often affect objectives that economists dwell on, such as economic growth, poverty alleviation, and food security. For instance, the spread of *Imperata cylindrica* grass throughout an estimated 60 million hectares of Asia has left large tracks of land infertile and has exacerbated the problems of poverty in many locations (Garrity et al. 1997; Tomich et al. 1997). Similarly, the invasion of the golden apple snail (*Pomacea canaliculata*) in Asian rice systems has increased the costs of producing rice and has led to the undesirable applications of harmful pesticides in densely settled areas (Naylor 1996).

Invasions also affect ecosystem functions, such as the hydrologic capacity of watersheds. Analyses of woody tree and shrub invasions in the South African fynbos (van Wilgen et al. 1996) and tamarisk invasions in the southwest United States (Zavaleta, this volume) both point to reduced availability of water for human use at a time when water demand for economic growth and urban expansion is increasing.

In addition, the spread of alien invasions poses increasing difficulties for protecting biodiversity—an objective that continues to gain the attention of economists. Despite the proliferation of economic and policy analyses on the value of biodiversity and the associated costs of species loss,[1] relatively little work has focused on the topic of invasions per se. Nonetheless, virtually all economists informed about invasions understand the cost associated with invasion-driven losses in biodiversity, such as the near extirpation of native forest bird, bat, and reptile populations on Guam that resulted from the invasion of the brown tree snake (Fritts and Rodda 1998).

Indeed, economists have much to offer on the subject of alien species invasions by means of analysis and insight. Economic theory can be helpful in diagnosing the sources of invasions problems, particularly when invasions occur inadvertently from an intentional introduction (thus representing an externality to production or consumption), when information on the risks associated with invasions is absent, or when invasions damage public goods like biodiversity or common-property watersheds. Economic analysis can also be useful in tackling certain decision problems: for example, in deciding when, where, and how to control invasives; in estimating the expected benefits of various control programs; and in minimizing the costs of controlling invasions that have already taken place. Assessing alien species invasions along these lines can be seen as a direct application of existing economic theory. The gap between conceptual and empirical progress remains great, however, and there are still high hurdles to overcome in integrating biological and economic data in a meaningful way.

This chapter outlines some of the basic economic principles and logic that can be applied to the issue of invasions, and points to several areas for further research. It begins with a description of methods for valuing costs and foregone benefits associated with invasions. The application of these methods in evaluating alternative control strategies for actual and potential invasions is then illustrated, and the rationale for preventive measures is discussed. The analytical framework highlights the concepts of intertemporal decision processes, irreversibilities, and uncertainty, all of which become more pronounced in the broader context of global change. Just as climate change and land-use change influence the probability of an alien species invading an ecosystem, invasions add to the overall costs of global environmental change.

Valuation

Most economic analyses of invasions in the literature rely on benefit-cost methods to estimate damages from invasions and net benefits of alternative control strategies for specific cases.[2] The largest class of studies to date includes least-cost methods of controlling invasions that have already taken place. Such *ex post* analyses, commonly referred to as cost-effectiveness analyses, are helpful in identifying control strategies that are economically viable and in estimating the overall cost of existing invasions. Benefits are not measured specifically in this type of analysis; the focus is instead on minimizing the cost of controlling a given level of damage.

Another class of studies compares the costs and benefits of strategies that prevent invasions from occurring with those that allow invasions to occur. The goal of such *ex ante* analyses is to compare the gain or loss to different groups of people from a set of "with and without" invasion strategies, and to choose a course of action that yields the highest net level of satisfaction. Pursuing *ex ante* benefit cost analyses for invasions requires two steps. The first step is to understand how an invasion will affect different species, ecosystem services (such as water supply, pollination, or pest control), and economic activities (such as agriculture or ranching). This step primarily involves descriptive, as opposed to normative, analyses by biologists and natural resource managers. The second step is to assess what those species, services, and economic activities are worth in monetary terms. The results of such descriptive biological and economic analyses often lead to normative conclusions; that is, to recommendations on what should be done.

Benefit-cost analysis is typically anthropocentric in nature and bases all values on human satisfaction (Goulder and Kennedy 1997). Equal weight is usually assumed for every person's assessment of satisfaction, which implies a strong utilitarian approach to valuation. Those interested in the principle of preserving natural ecosystems may feel uneasy with utilitarian analyses. However, benefit-cost analysis—if done correctly—does not necessarily lead to overexploitation of an ecosystem, nor does it ignore nonmonetary satisfaction. Since many problems resulting from invasions are external to the market (such as species extinction), nonmarket valuation is critical.

Several types of values can and should be estimated in a benefit-cost framework in order to capture both the economic and biological dimensions of the invasion problem. These components include direct-use (consumptive and nonconsumptive) values, indirect-use values, and non-use values. If all of these categories are included in the analysis, benefit-cost calculations provide a sound method for determining a broadly acceptable strategy for controlling invasions. Unfortunately, indirect-use and non-use values, which are inherently difficult to measure, are ignored in most benefit-cost analyses.

Direct (Consumptive and Nonconsumptive)-Use Values

Consumptive-use values reflect the monetary worth of specific, market-based goods and services that may be affected by an invasion, such as urban water supplies, livestock, and crops. This category is the easiest set of values to analyze; direct valuation methods based on prices generally can be applied to such cases. In applying these methods, economists typically distinguish between social (economic) and private (financial) prices (Eatwell et al. 1987). Private prices are those seen directly in the market. These prices do not always represent true values to society, however, because they may include distortions by government policies (e.g., taxes, subsidies, overvalued exchange rates), and may not reflect costs of associated environmental damages and failures in labor, land, and capital markets. The market price that a farmer or rancher pays for water, for example, may underestimate the true social value of water if it is highly subsidized. As a result, social prices—calculated by adjusting private prices for policy distortions, environmental externalities, and market failures—are often used in cost-benefit analysis.

Nonconsumptive-use values, such as the value of bird watching, are more difficult to analyze. For example, if an alien species invasion diminishes a bird habitat or directly reduces bird populations through predation, there may be a direct cost to those people who enjoy the hobby of bird watching. Such nonconsumptive values usually cannot be inferred directly from market prices. They must be estimated instead by indirect approaches, such as travel cost or survey methods that indicate people's revealed preference or willingness to pay for a certain amenity (Smith 1996). The travel cost method estimates the value of the benefits or satisfaction derived from amenities, such as rare birds, in a certain area by the aggregate amount of money that people spend to travel to that area in a defined time period (e.g., per year).

Indirect-Use Values

Indirect-use values, which include the value of ecosystem services that are lost as a result of an invasion, are even more difficult to measure.[3] For example, a woody tree species invasion may affect the ecosystem function and service of a watershed, and it may lead to more frequent fire cycles that alter a forest's capacity to mitigate global greenhouse gas concentrations. In such cases, the value of the ecosystem services may be estimated by replacement costs; that is, the cost of replacing naturally available water by alternative water supply schemes, and the cost of replacing a natural greenhouse gas sink by reduced emissions in industry. However, while these costs offer a rough gauge of ecosystem service values, there is not necessarily a direct relationship between replacement costs and the value of foregone services. Another method of valuation is to estimate the value of the water supply and greenhouse gas sink in

an ecosystem without invasive woody species; these values reflect an opportunity cost of a given piece of land that is already dominated by alien species.[4] If the opportunity cost is high enough, eliminating an existing invasion through control and restoration programs may be financially and socially desirable. Opportunity costs are distinct from replacement costs in that they pertain specifically to foregone benefits, not to the cost side of the ledger.

Non-use Values

Finally, non-use values are often key to the analysis of invasive species. One type of non-use value is existence value—the value that people assign to a species or an ecosystem that they may never directly or indirectly use or even see. The concept of existence value essentially reflects people's appreciation of just knowing a species or ecosystem exists. For example, the unique evolution of species and the high degree of endemism on the Galapagos Islands are widely appreciated by people within (and even outside of) the international environmental community, yet many of these people may never have the opportunity to visit the archipelago. Still, many of these people would be willing to pay some amount of money to prevent the invasion of a nonnative predator of finches, boobies, flightless cormorants, and albatrosses. Such an invasion would destroy the archipelago's unique mix of species.

Another set of non-use values comprises option and quasi-option values, which are the premiums that people assign to environmental amenities above and beyond their expected use values.[5] Such a premium may account for people's risk-averse attitudes in the face of uncertainty regarding the future availability and quality of the environmental goods or services in question (the original option value concept). The premium may also reflect the value of knowledge that can be gained about ecosystem processes over time, or the value of flexibility in being able to decide on a course of action in the future, as long as irreversible damage does not occur as a result of an invasion now (the quasi-option value concept).[6] In all cases, non-use values typically are estimated by means of survey methods, such as contingent valuation that elicits people's willingness to pay for a given amenity (Mitchell and Carson 1989).

Total vs. Marginal Values

In estimating direct- and indirect-use values, nonconsumptive values, and non-use values, it is important to distinguish between total and marginal valuation. In many cases, economic analyses of invasions focus on the total costs and benefits of alternative control strategies over time. However, the relevant policy question might center instead on the change in value that

results from an incremental degree of invasion when effective controls are not pursued. Such marginal costs can be measured either by the incremental land area affected by an invasion or by the change in impact caused by a higher density of an alien species in a given area. The question in this case is whether a small change in the extent of an invasion leads to a small loss in ecosystem value, or whether a small change leads to large economic and ecosystem losses.

The answer requires sound integration of knowledge and data from economists and ecologists. Even when the total cost of an invasion is estimated, many analyses use a given market price to assess economic and ecological damages, which is inherently a marginal concept. The market price is derived from the intersection of demand and supply at the margin, and incremental changes in demand or supply alter the price. Two main challenges inherent in benefit-cost analysis of invasions are thus: sorting out the nature of total and marginal loss functions from data supplied by biologists on the potential and known patterns of alien species invasions for specific cases; and applying relevant prices to those losses.

Control Strategies

Assessing and predicting patterns of invasion is more easily said than done, especially in the broader context of global change. Hobbs and Humphries (1995) argue convincingly that successful invasions depend not only on the attributes of the invading species, but also on the nature, history, and dynamics of the ecosystem being invaded. They present a stylized representation of the spread of invasives for well-known cases of plant invasions (Fig. 11.1), in which alien populations may remain small and noninvasive for long periods of time before undergoing an explosive range expansion.

Often the explosion occurs as a result of disturbance, either natural (e.g., floods, storms, and fires) or anthropogenic (e.g., land clearing, the development of infrastructure projects like roads and irrigation canals, and managed fires). Such disturbances are likely to become more predominant in the future in association with the wide range of global changes discussed in this book. Indeed, a major uncertainty in assessing patterns of invasion will be in predicting the "time bombs" or sudden nonlinearities of invasions that occur in the context of global environmental change.

The time dimension of invasions is critical to the way in which economists look at the problem of valuing and controlling alien species. For time-dependent problems, a typical economic approach is to estimate the net present value (NPV), using a discount rate to reflect a rate of time preference for real income. The discount rate is equal to the marginal rate of intertemporal substitution, and it amounts to the preference that individuals have for holding

Figure 11.1. Stylized representation of the spread of an invasive plant species over time (Hobbs and Humphries 1995).

money now versus the future. Even accounting for inflation, $100 in the pocket today may be worth much more than $100 (inflation adjusted) ten or twenty years from now. Assuming rational behavior, this rate is often set at the relevant after-tax real rate of interest; it typically falls in the range of 1–4 percent in industrialized economies and varies among individuals (Freeman 1993). For some developing countries experiencing rapid economic growth and high returns to investment, the discount rate may be on the order of 10 percent. A rate of 2–3 percent is commonly used for the United States and other industrialized regions, at least where streams of benefits and costs accrue to people in the same generation; discounting over much longer periods of time, such as two or more generations, is much more controversial (Freeman 1993). Nonetheless, the choice of discount rate influences how much consideration is given to future generations compared with the current generation in investment decisions.

In the context of invasions, the NPV equals the stream of future benefits from preventing or controlling invasions, minus the stream of control and damage costs if an invasion occurs. The stream of benefits and costs is then discounted over the time period of economic or policy analysis, as shown in Equation 1.

$$\text{NPV} = {}_0\!\int^t (B - C)\, e^{-rt} \tag{1}$$

where:

t = time (0 equals present, t equals some point of time in the future)
B = benefits stream
C = costs stream
e = natural exponent
r = discount rate

In this equation, benefits are estimated by direct-use values, indirect-use values, and non-use values that apply to that portion of the ecosystem where invasions have been prevented or controlled. The costs include the efforts of control, as well as the damage to ecosystem services, species, and economic activities for that portion of the ecosystem where invasions have not been controlled effectively. One step in estimating costs is to calculate those of prevention and control, which are depicted in a stylized graph in Figure 11.2.

In this part of the decision problem, specificity of control is weighed against the cost of control over the entire time period of analysis. Three strategies are illustrated in Figure 11.2: the prevention of a wide range of invasions through an effective quarantine program (e.g., 100 alien species controlled); the control of alien species that demonstrate early invasive properties, but which have not yet fully invaded an ecosystem (e.g., 10 alien species controlled); and the control of an individual species once it has become a major problem (e.g., 1 alien species controlled). In the preventive case, the

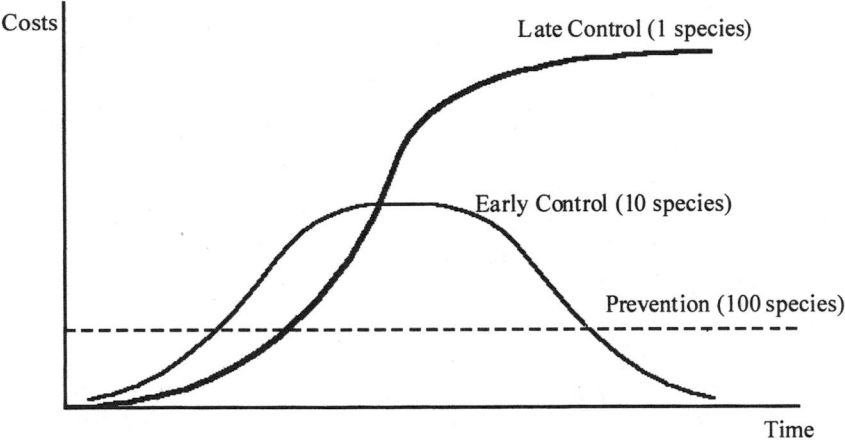

Figure 11.2. Illustrated trade-off between target specificity and cost of control for three control strategies. Late control of a single species that actually becomes invasive will be less costly in the short run, but far more costly in the long run, than prevention measures for a much larger number of species, many of which may never invade.

costs over the entire management period are relatively low, but the specificity of targeting species that will truly become a major problem is also low. As a result, the share of funds spent on controlling nonproblematic species will likely be high. In the early-control strategy, the initial costs of control rise above the preventive program costs, but costs fall substantially once the more targeted group of invasive species is brought under control. In the late-control case, the initial costs are lower than both the preventive and early-control programs, but then rise significantly in the long run. In the latter case, all of the costs are devoted to controlling a specific invasion problem and its related impacts, and the costs may never plateau.

The preventive and early-control strategies may appear superior to the late-control strategy in terms of financial costs. If the discount rate is assumed to be at or close to zero, then calculating the integrals under the curves in Figure 11.2 would determine the accuracy of this conclusion. If the discount rate is high, however, then decision makers may actually prefer a late-control strategy. Spending financial resources in the short run on other investments that yield a higher return may be the best option in terms of private (market-based) profitability over the long run. Nonetheless, if the time period in question extends over two or more generations, the use of a discount rate high enough to validate the late-control program would be questionable. A fundamental tenet of welfare economics is that the winners of any given action or policy are able (potentially) to compensate losers. If a chosen strategy benefits the current generation but imposes large costs on future generations, it is unlikely that there will be a mechanism for compensation, and the losers would have no voice in the decision.[7]

The decision problem becomes more interesting and more complicated when damage from invasives is brought into the cost estimates. Opting for a late-control strategy can result in irreversible damages to an ecosystem, including the extinction of genetically distinct populations and the alteration of such ecosystem processes as primary production, decomposition, hydrology, geomorphology, nutrient cycling, and natural disturbance regimes (Vitousek et al. 1987, 1996; Beerling 1995). Species extinction is perhaps the most irreversible damage resulting from biological invasions, and the number of cases is growing. For example, invasive pathogens from Europe that were not effectively controlled in eastern U.S. forests essentially eliminated the once dominant American chestnut and American elm trees (Langdon and Johnson 1992). About two-thirds of the known cases of fish extinction since the turn of the century in stream and lake habitats of the United States have been caused in part by the invasion of exotic fish species (Wilcove and Bean 1994). In addition, when the brown tree snake was not controlled in Guam, virtually all of the indigenous forest bird species on the island were lost forever (Fritts and Rodda 1998). A similar situation is plausible on the Hawaiian

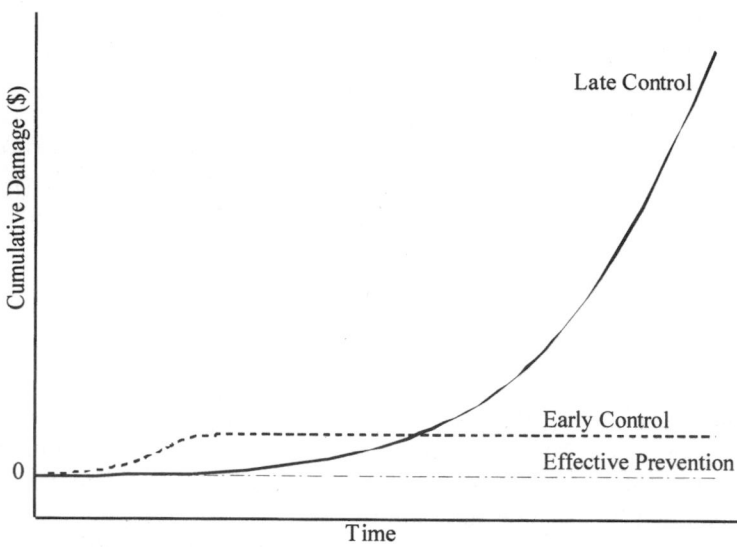

Figure 11.3. Illustrated value of cumulative damage over an extended time period with three control strategies. With late control, the value of damages created by an invasion might rise indefinitely if irreversible losses in biodiversity occur.

Islands if preventative and early-control measures are not pursued. Some brown tree snakes have already been collected at Hawaiian airports, having traveled in wheel hubs of aircraft.

A set of hypothetical damage costs from invasions is depicted in Figure 11.3. When irreversible damage to an ecosystem occurs, the cumulative damage costs from a late-control strategy can be far above the costs of preventive or early-control strategies, and they may rise indefinitely. Because the evolution of species results from geomorphological and biological processes that occur over eons, there are no substitutes for loss in biodiversity, and there is no turning back once the extinction damage has been done. The damage function for a late-control strategy would look very different—and less ominous—if irreversible damages did not occur. One of the challenging aspects of choosing a cost-effective and ecologically sound control strategy, therefore, is to understand the nature of uncertainty.

Rationale for Preventative Measures

Infinite cost increases associated with "system blowups" present a real challenge to economists in terms of resource allocation criteria. Irreversible damages to ecosystems that support human activity and enhance human welfare

directly or indirectly are obviously worth avoiding. The question is, with what degree of certainty will these damages occur? In the case of invasions, the degree of confidence is fairly low; efforts to predict the course of invasions either by the characteristics of invaders or by the components of an invasive-prone ecosystem remain highly uncertain and controversial (Lodge 1993; Daehler and Strong 1993). Many alien species persist in low densities in an ecosystem for long periods before invading, and the explosion of invasives is often unforeseen (Hobbs and Humphries 1995). The uncertainty of invasion patterns and effects becomes even more pronounced in combination with other global changes, such as climate change.

The interesting dimensions of the economic problem are thus the inter-temporal characteristics of invasions and control strategies, the possibility of irreversibilities, and uncertainty. Conceptually, economists have a well-developed framework to lean on for thinking about resource allocation under these three conditions—that of quasi-option value.[8] Quasi-option value, as defined earlier in the chapter, is the premium over and above the expected use value that individuals assign to protecting an ecosystem against uncertain, irreversible damages in order to maintain flexibility and gain more information that will influence future actions. In the context of alien species, this premium reflects the gain from being able to learn more about future benefits of an undisturbed ecosystem, which might be precluded by invasions if preventive measures are not undertaken. If the consequences of invasions are irreversible, the quasi-option value represents a flexibility premium associated with postponing the introduction and potential establishment of an invasive species. Because the likelihood of an invasion and its long-run impacts on an ecosystem are uncertain, there is value in holding future options open.[9]

The analysis of quasi-option values can be illustrated by a two-period model (present and future) with two alternatives strategies (with and without early, preventive measures to protect an ecosystem from invasions).[10] The decision problem thus becomes: (1) prevent all alien species invasions in the first period, at a cost that includes control efforts with low specificity of targeted organisms and no damage costs from invasions in the second period; or (2) do not prevent invasions or pay for control in the first period, and possibly pay high control costs and damage costs in the second period. There may be large benefits in the future from the preventive strategy in terms of the preservation of species, ecosystem services, and economic activities; however, these benefits are not known with certainty at the outset. Knowledge about these benefits can be accrued by the second period so long as the system is not invaded in the first period. The quasi-option value is therefore a conditional value, especially under an assumption of irreversibility. The overall goal is to maximize expected benefits over the two periods, accounting specifically for the quasi-option value. This type of estimation is a straightforward applica-

tion of benefit-cost analysis, in which the analysis is conducted *ex ante,* or prior to, the occurrence of an invasion.

A few examples will help to ground this concept. In many parts of Southeast Asia, the development of shrimp aquaculture ponds in mangrove ecosystems along coastlines have failed (Chamberlain 1997; Primavera 1998; Boyd and Clay 1998). The intensification of these systems has led to disease outbreaks within the shrimp populations and, hence, yield declines that have forced farmers to move to new areas or to simply stop production. As a result, many tracts of cleared mangrove forests now remain unproductive economically and ecologically. Two options for these degraded lands seem apparent: implement restoration projects to regenerate mangrove forests that support a productive coastal ecosystem (Gammage 1997); or convert the abandoned ponds to new economic activities. One such activity being discussed among the development community is breeding a saltwater-tolerant tilapia that could survive in the ponds and produce a viable income to coastal communities (though much lower than the income from shrimp farming). Very little thought thus far has been directed toward the possibility of a saltwater-tolerant tilapia invading coastal marine ecosystems and causing a decline in real incomes that is derived from near-shore fisheries. This possibility entails both uncertainties and potential irreversibilities. The quasi-option value in this case would reflect the value of knowledge that could be gained about the ecology and economics of coastal fisheries, and about the likelihood of invasion by the saltwater-tolerant tilapia.

Another example that has been analyzed more concretely is the introduction of exotic woody tree and shrub species in semiarid areas like the fynbos shrubland of South Africa (van Wilgen et al. 1996). The fynbos ecosystem plays an important hydrological function in the Western Cape Province. Native species of vegetation have evolved to be efficient users of water—particularly during summer drought periods—and they have adapted to nutrient-poor soils and to the fires that periodically occur in the Cape mountains. The native shrubs of the fynbos prevent erosion in these mountainous areas by binding the soil, and their relatively low biomass enhances water efficiency and ensures low-intensity fires. The ecosystem thus provides a relatively large amount of good-quality water to densely settled areas, such as Cape Town and Port Elizabeth. In addition to the role that the fynbos play in the region's water supply, the ecosystem is extremely rich in biodiversity, and it supports a number of plant species that have significant economic value in terms of horticultural, agricultural, and medicinal products (van Wilgen et al. 1996).

Unfortunately, the fynbos is highly prone to exotic woody tree invasions, which have increased the overall biomass and water demands of the Cape mountain region, raised fire frequency and intensity, and reduced the amount

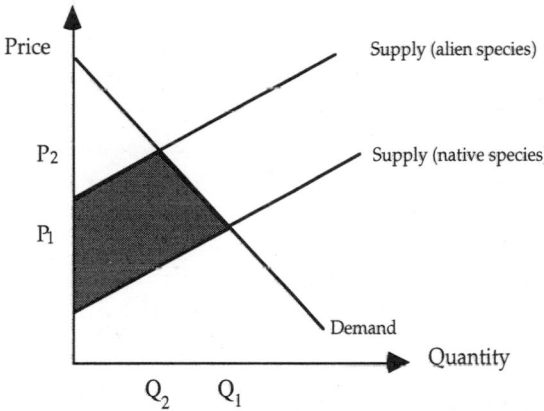

Figure 11.4a. Demand and supply for consumptive water use.

of water available for human use. The invasive plants were introduced to the region intentionally, mainly as a source of fast-growing timber and also as hedge plants, ornamental plants, and plants for binding shifting dunes along the coast. The net cost of these invasives has been large. Van Wilgen et al. (1996) estimate that the watershed would yield 30 percent more water naturally if alien species were managed, and even including the costs of such management, unit costs of water to the consumer would decline by 15 percent. In the context of quasi-option values, there would have been a high value at the time of the initial introduction to learning about the effects of woody tree species on the hydrology of the region. At this point, it is very difficult and extremely costly to return completely to the original, undisturbed fynbos ecosystem.

A stylized version of this example is shown in Figure 11.4a. Water demand for consumptive use is equilibrated with water supply at Q_1 when the native fynbos comprises the entire ecosystem. At this point, the consumer pays P_1 for a unit of water. When exotic woody tree species invade the system, the marginal cost (or supply) curve for consumptive water use shifts upward. Consumers now pay P_2 for a unit of water and demand Q_2. The shaded area represents the loss in both consumer and producer welfare from the change in the ecosystem service with invasives. Less water is available to consumers from natural processes, and water supply projects to ensure water availability become more expensive. This loss in welfare is especially great in arid regions.

The shaded area in Figure 11.4a represents the additional, expected cost of water with the alien invasion over and above the expected cost without the invasion, and it reflects the quasi-option value. Two types of uncertainties complicate the calculation of this value, however: the first pertains to the like-

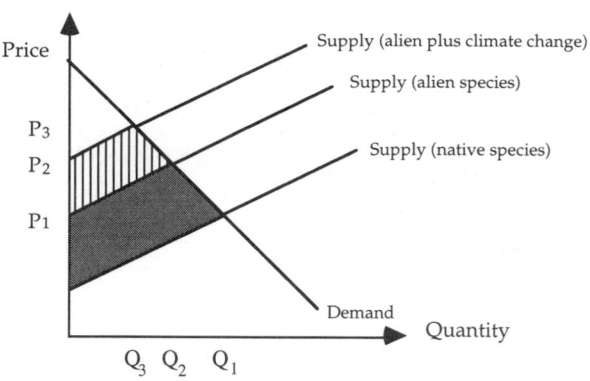

Figure 11.4b. Demand and supply for consumptive water use with climate change.

lihood, timing, and extent of an invasion actually occurring; and the second pertains to the invasion's impact on hydrological processes in the watershed. Assigning probability weights to an invasion and assessing its potential effects require input from biologists and hydrologists. Insights from biologists, hydrologists, and climatologists are also needed to inform economists and policy makers about future changes in the probability distributions. For example, decreased rainfall in the Western Cape Province as a result of long-term climate change or shorter-run El Niño Southern Oscillation effects could cause the marginal cost of water for human consumption to shift up even further than is the case with alien species alone. The added loss in consumer and producer welfare is shown by the hatched area in Figure 11.4b. If invasives are capturing water that has become more scarce with climate change, then each unit taken away from human consumptive use will have a higher value. Of course, the opposite is also possible if precipitation increases with climate change. The uncertainty of these climate-induced effects at the regional scale makes quasi-option concepts especially relevant for this example.

Figures 11.4a and 11.4b are presented as a conceptual framework for discussing the economic effects of invasions with and without global change. They help to demonstrate that there is real value to assessing the implications of invasions on ecosystems before decisions are made to introduce an exotic species intentionally. Moreover, they illustrate the potential benefits, or avoided costs, of pursuing a preventive control strategy for unintentional introductions and invasions. They also indicate, perhaps inadvertently, that the data requirements for such calculations are significant and somewhat foreboding.

Conclusion

Some ecologists reject the use of benefit-cost analysis in the context of invasions, on the basis that it often leads to ineffective control strategies or the intentional introduction of harmful invasives. This chapter argues that if the analysis is done correctly, by incorporating both economic and ecological damages from invasions, then benefit-cost analysis can be very useful in decision making and may well lead to more stringent preventative programs for invasives. Economists have now developed a wide range of tools to estimate nonconsumptive values, indirect-use values, and non-use values for environmental goods and services. In addition, the conceptual approach toward choosing discount rates has become more conservative, particularly for cases involving irreversibilities, thresholds, or time periods spanning two or more generations. In these cases, sound theoretical and applied arguments can be made for selecting a discount rate close to zero.

In addition, the theory of quasi-option value firmly establishes the need to "look (and learn) before you leap" on decisions that involve uncertainty and irreversibilities. There are clearly gains to be made from additional knowledge about the functioning of an ecosystem and its long-run economic potential as measured by both use and non-use values. However, conceptual progress in this area of economics is still far ahead of empirical applications. Quasi-option values are particularly difficult to measure *ex ante*. Survey methods to estimate non-use values, such as contingent valuation, have become more sophisticated, although many challenges in survey design and interpretation remain (Portney 1991; Hausman 1993). There is need, especially in the context of invasions, for the development of additional empirical tools that can be used in this type of economic analysis.

Perhaps an even greater need is for increased collaboration among disciplines in calculating damages and identifying solutions for ongoing and potential invasions. As a start, more thorough empirical studies of important ecosystems would be useful. A natural question might be whether to focus on cases in which there is a high probability of low-damage events, or a low probability of high-damage events (e.g., the civil war–nuclear war analogy). In the case of invasions, there are certain cases of high-probability, high-damage events that would provide a good starting place for the development of empirical economic methods. For example, isolated island ecosystems with high degrees of endemism are exceptionally prone to damaging invasions, whereas interior mainland regions with higher habitat diversity and lower degrees of endemism are less prone to such damages (D'Antonio and Dudley 1995).

Unfortunately, there is little time to wait for further studies. The problems associated with invasions are accelerating as the world becomes more open

and global, in terms of both biological and economic systems (Jenkins 1996). The policy instruments for prevention and control, as well as the institutions required to make the instruments effective, need further development in both industrialized and developing countries. In particular, there is an immediate need for assessments of different kinds of prevention instruments and their effectiveness. Taking a forward look at avoiding invasions will likely yield much higher net benefits in the long run than looking backward—especially in the uncertain and potentially explosive context of global climate change.

Acknowledgments

The author wishes to thank Walter Falcon, Larry Goulder, Peter Vitousek, Donald Kennedy, Charles Perrings, Mark Drew, and Nikolas Wada for their helpful comments and assistance.

Notes

1. For reference, see Weitzman 1992, 1993; Solow et al. 1993; Montgomery et al. 1994; Polasky and Solow 1995; Metrick and Weitzman 1998; and Brown and Shogren 1998.
2. See, for example, Macdonald et al. 1986; McNeely 1988; van Wilgen et al. 1996; Naylor 1996; and Hiebert 1997.
3. The most comprehensive and thorough set of analyses that focus on valuing ecosystem services can be found in Daily 1997.
4. The opportunity cost is defined as the value of a given factor in its next-best use. For further explanation, see Eatwell et al. 1987.
5. This classification follows from Goulder and Kennedy 1997; however, others sometimes classify option and quasi-option values as use values.
6. For further reference on the original option value concept, see Zeckhauser 1969; Cicchetti and Freeman 1971; Schmalensee 1972; and Bohm 1975. The concept of quasi-option values will be discussed in greater detail later in the chapter.
7. Welfare calculations rely essentially on required compensation, either for a change (compensating measure) or to avoid a change (equivalent measure) (often referred to as Kaldor and Hicks compensation measures, respectively). The ethical justification for making these welfare calculations is that compensating measures can be used to determine how much the losers of an action should be compensated such that no one is made worse off. When the winners and losers are in the same generation, compensation is possible. For further reference on compensating measures, see Freeman 1993.
8. For further reference on the concept of quasi-option value, see Arrow and Fisher 1974; Henry 1974; Conrad 1980; Freeman 1984; Fisher and Hanemann 1986; and Hanemann 1989.
9. A formal derivation of this conclusion, as applied to tropical forest habitat, is given in Chapter 11 of Dasgupta 1982.
10. This decision problem is described very clearly in Fisher and Hanemann 1986.

References

Arrow, K. J. and A. C. Fisher. 1974. "Environmental preservation, uncertainty, and irreversibility." *Quarterly Journal of Economics* 88: 312–319.

Beerling, D. J. 1995. "General aspects of plant invasions: an overview." In *Plant Invasions: General Aspects and Special Problems,* edited by Pysek, P. et al., 237–247. Amsterdam: SPB Academic Publishing.

Bohm, P. 1975. "Option demand and consumer surplus: comment." *American Economic Review* 65: 733–736.

Boyd, C. E. and J. W. Clay. 1998. "Shrimp aquaculture and the environment." *Scientific American* 278, 6: 58–65.

Brown, G. M. and J. F. Shogren. 1998. "Economics of the Endangered Species Act." *Journal of Economic Perspectives* 12, 3: 3–20.

Chamberlain, G. W. 1997. "Sustainability of world shrimp farming." In *American Fisheries Society Symposium 20,* edited by Pikitch, E. K. et al., 1–15. Bethesda, Maryland.

Cicchetti, C. J. and A. M. Freeman. 1971. "Option demand and consumer surplus: further comment." *Quarterly Journal of Economics* 85: 528–539.

Conrad, J. M. 1980. "Quasi-option value and the expected value of information." *Quarterly Journal of Economics* 95 (June): 812–820.

Daehler, C. and D. Strong. 1993. "Reply." *Trends in Ecology and Evolution* 8, 10: 381–382.

Daily, G. C. (ed.) 1997. *Nature's Services: Societal Dependence on Natural Ecosystems.* Washington, D.C.: Island Press.

D'Antonio, C. M. and T. L. Dudley. 1995. "Biological invasions as agents of change on islands versus mainlands." *Ecological Studies,* 115: 103–121.

Dasgupta, P. 1982. *The Control of Resources.* Oxford: Basil Blackwell.

Eatwell, J., M. Milgate, and P. Newman. 1987. *The New Palgrave Dictionary of Economics,* 3, 4: 393–395, 718–721. London: McMillan Press Ltd.

Fisher, A. C. and W. M. Hanemann. 1986. "Option value and the extinction of species." *Advances in Applied Micro-Economics* 4: 169–190.

Freeman, A. M. 1984. "The quasi-option value of irreversible development." *Journal of Environmental Economics and Management* 11 (September): 292–295.

———. 1993. *The Measurement of Environmental Resource Values.* Washington, D.C., Resources for the Future.

Fritts, T. H. and G. H. Rodda. 1998. "The role of introduced species in the degradation of island ecosystems: a case history of Guam." *Annual Review of Ecological Systems* 29: 113 140.

Gammage, S. 1997. "Estimating the returns to mangrove conversion: sustainable management or short-term gain?" Discussion paper 97-02. International Institute for Environment and Development, London (June).

Garrity, D. P., M. Soekardi, M. van Noordwijk, R. De La Cruz, P. S. Pathak, H. P. M. Gunasena, N. Van So, G. Huijun, and N. M. Majid. 1997. "The *Imperata* grasslands of tropical Asia: area, distribution, and typology." *Agroforestry Systems* 36: 3–29.

Goulder, L. H. and D. Kennedy. 1997. "Valuing ecosystem services; philosophical bases and empirical methods." In *Nature's Services: Societal Dependence on Natural Ecosystems,* edited by Daily, G. C., 23–47. Washington, D.C.: Island Press.

Hanemann, W. M. 1989. "Information and the concept of option value." *Journal of Environmental Economics and Management* 16: 23–37.

Hausman, J. A. 1993. *Contingent Valuation: A Critical Assessment.* Amsterdam, New York: North-Holland.

Henry, C. 1974. "Investment decisions under uncertainty: the irreversibility effect." *American Economic Review* 64: 1006–1012.

Hiebert, R. 1997. "Prioritizing invasive plants and planning for management." In *Assessment and Management of Plant Invasions,* edited by Luken, J. O. and J. W. Thieret, 195–212. New York: Springer-Verlag Press.

Hobbs, R. J. and S. E. Humphries. 1995. "An integrated approach to the ecology and management of plant invasions." *Conservation Biology* 9, 4 (August): 761–770.

Jenkins, P. T. 1996. "Trade and exotic species introductions: comment." *Conservation Biology* 10, 2 (February): 300–302.

Langdon, K. R. and K. D. Johnson. 1992. "Alien forest insects and diseases in eastern USNPS units: impacts and interventions." *The George Wright Forum* 9, 1: 2–14.

Lodge, D. 1993. "Biological invasions: lessons for ecology." *Trends in Ecology and Evolution* 8, 4: 133–137.

Macdonald, I. A. W., F. J. Kruger, and A. A. Ferrar. 1986. *The Ecology and Management of Biological Invasions in Southern Africa.* Cape Town and New York: Oxford University Press.

McNeely, J. A. 1988. *Economics and Biological Diversity: Developing and Using Economic Incentives to Conserve Biological Resources.* Gland, Switzerland: International Union for the Conservation of Nature.

Metrick, A. and M. L. Weitzman. 1998. "Conflicts and choices in biodiversity preservation." *Journal of Economic Perspectives* 12, 3: 21–34.

Mitchell, R. C. and R. T. Carson. 1989. *Using Surveys to Value Public Goods: The Contingent Valuation Method.* Washington, D.C.: Resources for the Future.

Montgomery, C. A., G. M. Brown, and D. M. Adams. 1994. "The marginal cost of species preservation: the northern spotted owl." *Journal of Economics and Management* 26, 2: 111–128.

Naylor, R. L. 1996. "Invasions in agriculture: assessing the cost of the Golden Apple Snail in Asia." *AMBIO* 25, 7 (November): 443–448.

Polasky, S. and A. Solow. 1995. "On the value of a collection of species." *Journal of Environmental Economics and Management* 29, 3: 298–303.

Portney, P. R. 1991. "The contingent valuation debate: why economists should care." *Journal of Economic Perspectives* 8, 4: 3–17.

Primavera, J. H. 1998. "Tropical shrimp farming and its sustainability." In *Tropical Mariculture,* edited by De Silva, S., 257–289. London: Academic Press.

Schmalensee, R. 1972. "Option demand and consumer surplus: valuing price changes under uncertainty." *American Economic Review* 62: 813–824.

Smith, V. K. 1996. *Estimating Economic Values for Nature.* Cheltenham: Edward Elgar Publishing, Ltd.

Solow, A., S. Polasky, and J. Broadus. 1993. "On the measurement of biological diversity." *Journal of Environmental Economics and Management* 24, 1: 60–68.

Tomich, T. P., J. Kuusipalo, K. Menz, and N. Byron. 1997. "*Imperata* economics and policy." *Agroforestry Systems* 36: 233–261.

van Wilgen, B. W., R. M. Cowling, and C. J. Burgers. 1996. "Valuation of ecosystem

services: a case study from South African fynbos ecosystems." *BioScience* 46, 3 (March): 184–189.

Vitousek, P. M., L. R. Walker, L. D. Whiteaker, D. Mueller-Dombois, and P. M. Matson. 1987. "Biological invasion by *Myrica faya* alters ecosystem development in Hawaii." *Science* 238: 802–804.

Vitousek, P. M., C. M. D'Antonio, L. Loope, and R. Westbrooks. 1996. "Biological invasions as global environmental change." *American Scientist* 84: 468–478.

Weitzman, M. L. 1992. "On diversity." *Quarterly Journal of Economics* 107, 2: 363–405.

———. 1993. "What to preserve? An application of diversity theory to crane conservation." *Quarterly Journal of Economics* 108, 1: 157–183.

Wilcove, D. S. and M. J. Bean. 1994. *The Big Kill: Declining Biodiversity in America's Lakes and Rivers.* Washington, D. C.: Environmental Defense Fund.

Zeckhauser, R. 1969. "Resource allocation with probabilistic individual preferences." *American Economic Review* 59: 546–552.

Chapter 12

〜

Valuing Ecosystem Services Lost to *Tamarix* Invasion in the United States

Erika Zavaleta

Evidence abounds of the adverse ecological impacts that exotic species have worldwide. Nevertheless, large-scale efforts to control and prevent harmful invasions remain scarce. Small-scale control efforts have taken place in some parks and preserves to address impacts on wildlife, aesthetic, and other ecological values (Neill 1983; Taylor and McDaniel 1998). However, decisions to bear the high costs of eradication on a larger geographic scale generally require economic justification. Cost-benefit analyses of control strategies have driven a few efforts to manage harmful invasives on a regional scale in the United States (see e.g., Simberloff et al. 1997; Bureau of Reclamation 1995) and overseas (e.g., van Wilgen et al. 1996). Studies of the economic impacts of invasives are badly needed to inform further management decisions, as well as to illustrate the nature and magnitude of impacts that invasives have on society (see Naylor, this volume). In particular, studies that incorporate the effects of global changes can provide insight into what the future holds for areas affected by harmful invasives.

This study of the economic costs and benefits of *Tamarix* control in the western United States has several goals. Most directly, it seeks to provide a

basis for future decisions about the management of the *Tamarix* species complex, a widespread and damaging invader of the arid regions of North America. *Tamarix* has been the subject of numerous small-scale control campaigns in national parks and wildlife refuges because of its negative impacts on wildlife (Neill 1983; Loope et al. 1988). The economic feasibility of controlling it on larger scales has been considered by the agency principally responsible for western U.S. waterways, the Bureau of Reclamation (Bureau of Reclamation 1992; Great Western Research 1989), whose interests in the invader include its impacts on water supplies and flood damage as well as wildlife. Yet *Tamarix* has somehow failed to generate the widespread attention of policy makers that it deserves. Despite consensus among ecologists and resource managers that *Tamarix* is among the worst weeds in the Southwest and possibly the United States, *Tamarix* does not appear on the exotic species lists of any Colorado Plateau state (Zimmerman 1997). This study reaffirms that, despite its high costs, a campaign to eradicate *Tamarix* from the United States will yield net economic gains as well as considerable ecological and societal benefits. More generally, this study illustrates that the costs of controlling a widespread invader, though very high, may still yield net economic benefits.

The enormous costs of *Tamarix*'s impacts and eradication may also provide an impetus for stronger policies to prevent the introduction of potentially damaging species. The characteristics of species that make them successful invaders—short generation times, early and consistent reproduction, enormous numbers of seeds, rapid growth rates and the capacity to recover from disturbances such as fire (Rejmanek and Richardson 1996)—also often make them expensive and difficult to remove and control. When faced with a decision either to spend billions of dollars in control or to tolerate tens of billions of dollars in continued damages by the invader, one is reminded that both costly choices could have been prevented—and could be prevented in the future—by decisions to aggressively prevent and stop introductions at an earlier stage.

This study also illustrates how economic assessments of invasives can begin to take global climate and atmospheric changes into account and how these global changes may specifically interact with *Tamarix*'s effects. Thanks to growing interest in the responses of invasive species to rising atmospheric carbon dioxide, increased nitrogen deposition, and changing climates, enough biological information is available to begin to pinpoint the directions in which these global changes will push the socioeconomic and ecological impacts of invasive species (Dukes and Mooney 1999). Global climate and atmospheric changes have the potential to strongly influence the effects of *Tamarix* invasion on riparian and riverine ecosystems in the United States.

The presence of the invader conversely may influence the severity of other global change impacts on the region.

Finally, and most generally, rising interest in "nature's services" (Daily 1997) has prompted a number of efforts to estimate the value of the benefits conferred to humanity by components of the biosphere (Costanza et al. 1997; van Wilgen et al. 1996; Pimentel et al. 1997). The most prominent of these studies have generated total values for services such as waste recycling and biosphere components like fresh water. Few, however, have explicitly addressed the marginal values of damages to these services by particular anthropogenic impacts. Estimates of marginal losses associated with particular anthropogenic impacts are more useful guides than total value studies for policy and management decisions and better illustrations of our potential impact on global ecosystem services. This study provides an opportunity to quantify the marginal losses that society suffers when particular impacts to the integrity of ecosystem services occur. The *Tamarix* case illustrates that the economic importance of a single species affecting ecosystem services in its naturalized range can be substantial—so much so that even costly eradication may be a better alternative than continued tolerance.

The Ecological Impacts of *Tamarix* in the Western United States

Thicket-forming members of the genus *Tamarix* were originally introduced to North America from their native range in Eurasia over 100 years ago as ornamentals, windbreaks, and agents of erosion control (Baum 1978; Walker and Smith 1997; Brock 1994). Approximately seven species of the genus *Tamarix* are thought to have become established in the United States (Baum 1967). *T. ramosissima* and *T. chinensis* are best-studied and most widespread species. Others are limited in distribution and not always distinguished among in the literature. In the last fifty years, *Tamarix* (commonly referred to as saltcedar) has spread rapidly into nearly every perennial drainage in the arid and semiarid regions of the western United States, benefiting from anthropogenic disturbances to the natural flow regimes of rivers and streams (Everitt 1980). To date, it has replaced native riparian forest and scrub communities in approximately 500,000 hectares (1.2 million acres) of principally riparian floodplain habitat in twenty-three states, from sea level to 7,000 feet (Everitt 1980; Robinson 1965; Christensen 1962). It is especially pervasive in the southwestern states of Arizona, New Mexico, west Texas, Nevada, and Utah but is also widespread in southern California, the Rocky Mountain states, the western Plains states, and parts of Oregon and Idaho. While less is

known about its naturalized range outside of the United States, it does occur throughout broad regions of northwestern Mexico (Great Western Research 1989; J. Harrison, Stanford University Dept. of Geological and Enviromental Sciences, personal communication).

Though alterations of natural flow regimes in rivers appear important to *Tamarix*'s tremendous success, the species complex also possesses many classic weedy characteristics that have enabled its rapid spread and effective displacement of native vegetation. *Tamarix* can produce as many as 17 seeds per square centimeter (80 seeds per square inch) of ground in a single season (Warren and Turner 1975) that germinate easily and quickly in a wide range of conditions (Everett 1980). Once germinated, it grows rapidly—up to 4 centimeters (2 inches) a day (Loope et al. 1988). In the process, it consumes tremendous quantities of water and draws salts up to the surface from deep in the soil. These salts are secreted on the invader's leaves, which fall every year (Baum 1978) and give rise to increasingly saline surface and shallow soils (Berry 1970). *Tamarix* will tolerate this accretion of salt up to levels of 36,000 parts per million (ppm), while native riparian species it displaces, such as *Salix gooddingii* (Goodding willow) and *Populus fremontii* (Fremont cottonwood), can only tolerate salinities up to 1,500 ppm (Jackson et al. 1990; Shafroth et al. 1995). Mature *Tamarix* can tolerate both drought and flooding to degrees that native species cannot (Cleverly et al. 1997; Busch and Smith 1995). It can withstand submersion for up to three months (Warren and Turner 1975), but it can also withstand prolonged desiccation and is more able than native species to establish in areas with deep zones of permanent moisture availability (Brock 1994). Fire may also assist the spread of *Tamarix* both because *Tamarix* resprouts readily from belowground parts and because the accumulation of its litter increases the probability of fires and salinizes the soil when fires occur (Wiesenborn 1996; Busch and Smith 1993).

When *Tamarix* invades, it changes the functioning of the riparian zone in three key ways. First, *Tamarix* consumes water 35 percent more rapidly, on average, than native vegetation, drawing down water tables, drying up desert springs, and lowering the flow rates of waterways and the levels of lakes (Johns 1990; MacDonald et al. 1989; Loope et al. 1988; Vitousek 1986). Second, the invader fosters sedimentation and reduces the width and depth of river channels, reducing the water-holding capacity of waterways and increasing the frequency and severity of overbank flooding (Graf 1978, 1980; Blackburn et al. 1982). Finally, *Tamarix* provides poor habitat for many species of native wildlife and drastically reduces the abundance and diversity of riparian taxa (DeLoach 1997). Each of these impacts represents damage to the services normally provided by riparian ecosystems in the western region, and each of them is associated with a quantifiable economic cost to the region.

Estimating the Economic Impact of *Tamarix*

This study builds upon the work of two other efforts to evaluate the economic feasibility of *Tamarix* control. In 1989, Great Western Research, a consulting group under contract to the Bureau of Reclamation, completed a substantial, unpublished study of the economic costs and benefits of *Tamarix* control in the western United States. The Great Western Research study rested on the assumption that riparian areas would *not* be revegetated after *Tamarix* removal. It also differed from this study in its methods for evaluating some market impacts, and it did not include estimates of nonconsumptive use values. Nevertheless, it provided a strong foundation for this analysis. The Bureau of Reclamation more recently undertook a detailed cost-benefit analysis of *Tamarix* removal and revegetation along the lower Colorado River below Davis Dam (Bureau of Reclamation 1992, 1995; Salas et al. 1996) and a detailed cost analysis of *Tamarix* control on specific sites in the upper Colorado River (Sisneros 1994). These two analyses also provided useful background information for this study.

To estimate the economic effects of *Tamarix* invasion, I reviewed ecological and resource management literature to quantify the impacts of supplanting native vegetation with *Tamarix* on water supplies, flood control, and wildlife. I reviewed economics and policy literature to develop annual, monetary estimates of the benefits to each value of replacing *Tamarix* with native vegetation. These monetary estimates were constrained by the types of data available on water, flood control, and wildlife values. As a result, I had to use a variety of valuation techniques, from direct cost measures to willingness-to-pay data, to develop strong regional estimates for each ecosystem service (Table 12.1).

Table 12.1. Summary of valuation methodologies applied to each ecosystem service impacted by *Tamarix*. For simplicity, a discount rate of 0 percent is assumed throughout the study. Net economic benefits to be derived from *Tamarix* eradication are computed for a fifty-five-year period. See text for further discussion.

Ecosystem service	Valuation method
WATER PROVISION	
Municipal value	Replacement cost
Agricultural value	Farm budget residual method
Hydropower value	Replacement cost
River recreation value	Contingent valuation/willingness to pay*
FLOOD CONTROL	Avoided damages
WILDLIFE	Contingent valuation/willingness to pay*

* Total estimates of benefits are computed both with and without willingness-to-pay values. For a discussion of the contingent valuation method and its limitations, see Diamond and Hausman 1993.

These valuation techniques are discussed elsewhere (Naylor, this volume; Goulder and Kennedy 1997).

At each step in the ecological and economic analyses, I either made conservative assumptions about the values associated with *Tamarix* removal, or split estimates into conservative and bolder alternatives. The boldest of these estimates remains somewhat conservative because the relatively nascent state of empirical research into nonconsumptive use, existence, and option values of ecosystem components such as wildlife made it impossible to attach any value to certain known ecological benefits that would result from *Tamarix* eradication (Goulder and Kennedy 1997).

For simplicity only, I assumed a zero discount rate throughout the analysis. Discount rates of 1–6 percent diminish the net benefits of controlling and replacing *Tamarix* but do not affect the overall result that eradication makes economic sense (Box 12.1). I estimated the costs of controlling *Tamarix* through a twenty-year, comprehensive program of site evaluation, eradica-

Box 12.1. The influence of discount rate

If the program of control and restoration outlined in this study were undertaken, outlays of money for eradication and revegetation would occur early, during the first twenty years of the analysis period. Most of the fifty-five-year benefits stemming from *Tamarix* removal would begin in year two, however, and accrue well beyond the completion of the restoration effort.[1] Because outlays would precede most of the accumulation of revenues, the net economic benefit of eradicating *Tamarix* is sensitive to discount rate.

The discount rate reflects the extent to which money in hand now is worth more than money that will be obtained in the future. It reflects, but is not necessarily equal to, the amount by which interest rates exceed the pace of inflation (see Naylor, this volume). Throughout this chapter, for simplicity, a discount rate of 0 percent has been assumed. However, low positive discount rates are typical for the United States. To test the sensitivity of the benefit-cost ratio to discount rate, rates of 1–6 percent were applied to the set of values and costs associated with *Tamarix* removal. The ranges of projected net benefits and benefit-cost ratios decline with increasing discount rate but remain, respectively, positive and greater than one throughout the 1–6 percent range. At a discount rate of 6 percent, the minimum estimate of net benefits remains nearly $100 per restored acre (Fig. 12.1).

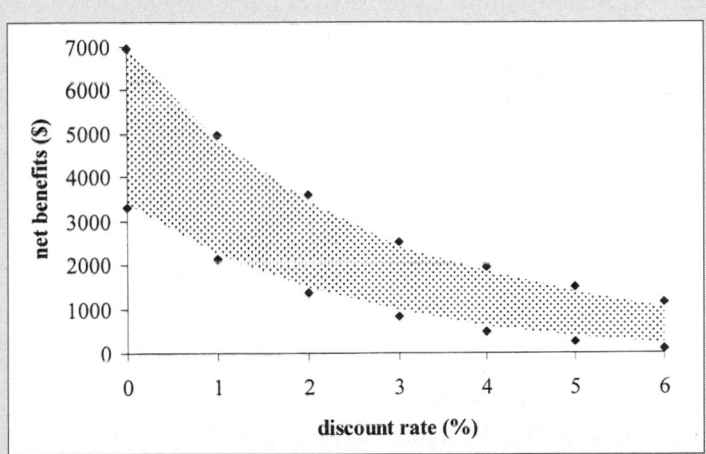

Figure 12.1. The influence of discount rate on net per-acre benefits of *Tamarix* eradication over a fifty-five-year period. Rising discount rates reduce net benefits because eradication costs must be paid before the resulting benefits are recovered. Nevertheless, net benefits remain strongly positive at discount rates up to 6 percent.

Discount rate	Range of per-acre net benefits	Range of benefit/cost ratios
0%	$3,312–6,975	2.10–3.32
1%	$2,146–4,966	1.78–2.80
2%	$1,363–3,584	1.54–2.41
3%	$837–2,525	1.36–2.12
4%	$484–1,954	1.23–1.91
5%	$249–1,483	1.13–1.75
6%	$95–1,147	1.05–1.63

tion, revegetation, and monitoring. I then compared the total costs (in 1998$) of this control program to the cumulative value (in 1998$) over fifty-five years of the benefits of removing *Tamarix* and restoring native vegetation. With a zero discount rate, net benefits could in principle accrue well beyond fifty-five years. However, resource supplies and demand are changing quickly enough that today's estimates of costs and benefits will not apply several decades in the future. Atmospheric carbon dioxide (CO_2) concentrations are also expected to double from preindustrial levels within fifty to sixty years, bringing changes in climate and resource availability that will sharply influ-

ence *Tamarix*'s economic impact. I chose to evaluate benefits over a fifty-five-year period to limit analysis to the period of pre-doubled-CO_2 atmosphere, and for convenience—costs have already been computed over this time period for three key water-capturing projects (see page 271).

The Areal Extent of Tamarix *Invasion*

Quantifying the impacts of *Tamarix* on ecosystem services requires a reasonable estimate of the area that it occupies in the western United States. By 1961, *Tamarix* had invaded approximately 930,000 acres of riparian habitat in fifteen states (Robinson 1965). That number was revised, albeit crudely, to 1,017,000 acres in 1989 (Great Western Research 1989). For a conservative estimate of *Tamarix*'s range in 1998, I used an annual rate of spread, calculated for each state from the difference between the 1961 and 1989 studies, to update the 1989 figures. The resulting estimate of 1,160,000[2] acres reflects the observation that *Tamarix* continues to spread rapidly in some parts of its range but appears to have reached its maximum extent in others (Robinson 1965; Great Western Research 1989; Salas et al. 1996).

A difficulty with estimating *Tamarix*'s range through such broad-scale studies is that they cannot account for changes at the scale of individual sites in the dominance of *Tamarix* compared to other vegetation. To better incorporate these dynamics into an estimate of *Tamarix*'s current extent, I combined the two existing, geographically comprehensive studies with a detailed study in which the occurrence of *Tamarix* along a 280-mile stretch of the lower Colorado River was monitored from 1981 to 1994 using aerial photography (Bureau of Reclamation 1992; Salas et al. 1996). During thirteen years on the lower Colorado, *Tamarix* increased its extent by nearly 20 percent, or roughly 1.3 percent per year. I applied this rate of expansion to those drainages and states estimated to have had lower expansion rates in the 1988 study to generate a bolder estimate of 1,610,000 acres currently occupied by *Tamarix* species in the western states. For each economic impact estimated in this study, values are given for both the conservative and bold estimates of acreage.

Water Losses to Tamarix

In the arid southwestern states, water is scarce for both natural systems and human populations. Municipalities, farmers, the hydropower industry, fishermen, and other recreationists all clamor for access to surface and groundwater that in some regions of the Southwest—notably, the lower Colorado River (Morrison 1996)—is in imminent danger of falling short of the needs of growing human populations (Waggoner and Schefter 1990).

Tamarix stands, with their dense and leafy canopies and rapid growth rates, have been found consistently to transpire larger quantities of water than the native species they displace (Johns 1990; Brock 1994; numerous studied cited below, but see Busch and Smith 1995). *Tamarix* also increases the area covered by riparian vegetation in a given stream corridor in two ways: it reaches deeper for groundwater farther from waterways, and it builds up banks and islands through sediment capture which it can then colonize (Graf 1978, 1980; Blackburn et al. 1982; P. Vitousek, Stanford University Dept. of Biological Sciences, personal communication; Brock 1994). *Tamarix* invasion therefore not only represents an acre-per-acre replacement of less thirsty vegetation by a species that consumes more water; it also increases the spatial extent of heavily vegetated (and therefore heavily transpiring) areas near waterways.

Nearly twenty studies of *Tamarix* and native riparian species transpiration have been conducted, ranging from several early, direct tank studies of whole plants or stands (e.g., Muckel and Blaney 1945; Robinson and Bowser 1959; van Hylckama 1974) to stem flow and leaf-level studies (Sala et al. 1996), to indirect energy budget studies of whole stands (Ball et al. 1994). Most of these studies are reviewed and evaluated by Johns (1990).[3] Transpiration rates of both *Tamarix* and native species vary with weather, stand density, and water availability (Davenport et al. 1982; Great Western Research 1989; Johns 1990), but under no condition has *Tamarix* been found to transpire less than native vegetation, and in all comparative studies *Tamarix* has been found to transpire more than native vegetation.

The mean water uses measured over all of the studies reviewed by Johns (1990), Great Western Research (1989), and myself are 4.61 feet/year[4] for native woody vegetation such as willow, cottonwood, and mesquite (*Salix, Populus, Prosopis*) and 6.15 feet/year for *Tamarix*. On average, *Tamarix* therefore transpires roughly 1.54 feet of water per year more than the vegetation it displaces. For this study, two levels of excess transpiration by *Tamarix* were applied—a mean value of 1.5 feet/year corresponding to the mean difference between *Tamarix* and native vegetation observed across all studies, and a conservative value of 1.0 feet/year to account for any possible overestimation across the studies.

The fate of the excess water transpired by *Tamarix* is not well understood because the movement of atmospheric water vapor in and out of the western United States is not perfectly understood. It is likely that some of the excess water transpired by *Tamarix* falls back into the arid West and rejoins surface runoff, mitigating the effects of its having been transpired to begin with. In a study of atmosphere-land water exchanges in the Amazon Basin, a region of classic wet, convergent dynamics leading to high returns of surface water, approximately half of the water transpired from the region returns to it as

Table 12.2. Estimated annual water losses due to *Tamarix* invasion in the western United States.

	Conservative estimate	Bold estimate
Tamarix-infested acreage	1,160,330	1,609,320
Annual excess transpiration by *Tamarix*	1.0 feet/year	1.5 feet/year
Annual water loss to region	1,160,330 acre-feet (1.4 billion cubic meters)	2,413,980 acre-feet (3.0 billion cubic meters)

precipitation (Salati and Nobre 1991). In a region of low humidity and rapidly moving air masses such as the American Southwest, the potential exists for greater water transport out of the region (R. Dunbar, Stanford University Dept. of Geological and Environmental Sciences, personal communication). Nevertheless, some of the water lost to *Tamarix* will likely return to the region, particularly to areas with greater orographic (mountain) rainfall such as the western Rocky Mountains (Grimm et al. 1997). I will return to this point when tabulating the overall relative costs and benefits of tolerating or eradicating *Tamarix*. For the present, *Tamarix* will be treated as consuming 1.0 or 1.5 acre-feet/acre/year more than the native vegetation it displaced. Given these estimates and the estimates of its current areal extent, *Tamarix* currently costs the western United States 1,160,000 to 2,410,000 acre-feet, or roughly 1.4–3.0 billion cubic meters, of water every year (Table 12.2).[5]

The economic losses associated with this transpiration loss include withdrawals by households and irrigators as well as instream uses like hydroelectric power generation, boating, and fishing. In a region of plentiful water, the marginal value of water lost to *Tamarix* might be negligible—but in an environment of shortage, where there are real, positive costs associated with replacing the water lost to *Tamarix,* its marginal value is considerable (Pimm 1997; Goulder and Kennedy 1997). Economic losses due to *Tamarix*'s water consumption occur in four sectors in the region: municipal users, agricultural users, hydroelectric power generation, and river recreationists.

Municipal and Agricultural Losses

Two urban areas within the region affected by *Tamarix* need more water urgently enough that they are actively pursuing, at significant cost, schemes to augment their supplies: the Metropolitan Water District of southern California (serving cities including Los Angeles), and the four major cities of central Arizona—Phoenix, Tucson, Scottsdale, and Mesa (Great Western Research 1989). In both cases, additional water that would remain in source

rivers if *Tamarix* were eradicated would help to meet these municipal demands.

The Metropolitan Water District (MWD), serving municipal users in southern California, is entitled to 1.212 million acre-feet (af) of water every year from the Colorado River if the needs of agricultural users—who have priority rights in the area—are met[6] (Matusak 1998; Arizona Department of Water Resources 1997). When MWD's needs exceed 1.212 million af, or when deliveries are insufficient to meet both farmers' needs and MWD's full entitlement, MWD must turn to purchasing extra water from agricultural users (Matusak 1998). The other six states along the Colorado River—Arizona, Nevada, Colorado, New Mexico, Utah, and Wyoming—have yet to tap their maximum entitlements to Colorado River water[7] and currently extract as much water as they need from the system (Matusak 1998; C. S. Harris, Arizona Department of Water Resources, Office of Colorado River Management, personal communication). For that reason, one would not expect any water added to the Colorado River system—by removal of *Tamarix*, for instance—to be taken by any other state before it reached southern California.

An estimated 210,000–460,000 acre-feet of water that otherwise would be available to southern California are lost every year through transpiration by *Tamarix* on the Colorado River.[8] Right now, the MWD has plans to fund three costly water projects that would conserve and desalinate agricultural water in order to make it available for municipal use (Table 12.3). The first two projects, which involve lining agricultural canals to reduce water loss, would provide a total of 93,000 acre-feet of water per year over the next fifty-five years at a total cost of $190 million, or approximately $40 an acre-foot. The third project, a desalinization plant that could be built to provide either 150,000 or 300,000 af/year, would cost $1.3–2.5 billion over fifty-five years, over $150 per acre-foot. If the water currently lost to *Tamarix* were available to the MWD, all or nearly all of the costs associated with these three projects could be avoided. The fifty-five-year value of the lost 210,000 af/year, based on the avoided costs of building these three water-supply enhancement projects, is $1.2 billion. The fifty-five-year value of 460,000 af/year by the same measure is $3.2 billion.

Near Arizona's big cities, as in southern California, municipal users compete with farmers for water supplies. In Arizona, an open water market exists in which utilities purchase and fallow agricultural land in order to increase water supplies to sell to municipal users (C. S. Harris, personal communication; Great Western Research 1989). The mean price paid for this land is high—just over $150 per acre-foot of water recovered by fallowing these farmlands (Great Western Research 1989). Approximately 32,000–42,000 acres along the Salt and Gila rivers and their tributaries near Arizona's big

Table 12.3. Three planned Metropolitan Water District projects that could be avoided through *Tamarix* eradication.

Project	Annual water yield (af = acre-feet)	Cost	Total cost over 55-year lifespan (capital + annual)*
55-year All American Canal Lining Agreement	67,700 af	$31.72/af	$118.13 million
55-year Coachella Canal Lining	25,680 af	$50.64/af	$71.53 million
Agricultural Drainage Water Desalting	150,000–300,000+ af	$148–158/af	$1.3–3.01 billion
TOTAL COMBINED COSTS			$1.178–3.201 billion

*1998 dollars, 0 percent discount rate
(Data from J. Matusak [MWD], unpublished.)

cities are infested with *Tamarix* that consumes an estimated 32,000–64,000 acre-feet more of water than the native vegetation it replaced.[9] The value of this water, based on the market value of land purchased to provide extra water to Arizona's cities, is approximately $4,900,000–$9,600,000/year—for a fifty-five-year value of $270–530 million.

The total value of southern California and Arizona municipal water supplies lost to *Tamarix* over fifty-five years is therefore estimated at $1.4–3.7 billion.

Throughout *Tamarix*'s naturalized range, water is sufficiently scarce and precipitation sufficiently low that agriculture relies on irrigation—either to allow the growing of less-drought-tolerant crops or to increase yields to profitable levels (Great Western Research 1989). Several reviews of work on the marginal value of water used for agricultural irrigation provide area- and crop-specific estimates for much of the region affected by *Tamarix* (Colby 1989a–b; Gibbons 1986; Young 1984). Agricultural demands are diffuse, and responses to small decreases in water availability, such as that generated by *Tamarix* invasion, are more likely to involve subtle changes in water use or cropping than attempts to increase supply. For these reasons, most studies encountered use a farm budget residual approach rather than an avoided costs approach to estimate irrigation water values. The farm budget method subtracts all inputs into crop production from the total revenue generated by a crop. The residual—treated as the value of the water that went into crop production—is the maximum amount that the farmer could pay for water and still generate positive revenue (Gibbons 1986; Colby 1989a).

For each state affected by *Tamarix,* I calculated two estimates of the value of irrigation water lost to *Tamarix:* one that employed a weighted average of the crop-specific water values for that state,[10] and one based only on the min-

Table 12.4. Annual dollar values of irrigation water lost to *Tamarix*. (All values are adjusted to 1998 dollars using the general U.S. Consumer Price Index [CPI]. Crop CPI values were not selected because farm input prices reflect price changes in a number of categories. A discount rate of 0 percent is assumed. The value of a unit of water is not expected to change in response to *Tamarix* control because the proportional change in water supply due to eradication would be small.)

Subregion	Low acre-foot water value[a] (dollars)	High acre-foot water value[b] (dollars)	Total annual losses (dollars)	
			Low estimate[c]	Mean estimate[d]
Arizona	14.56	860.55	818,699	20,177,700
Texas High Plains	53.05	196.48	28,476,000	72,548,000
Oklahoma[e]	53.05	196.48	3,290,000	11,325,000
Rocky Mountains	15.68	29.93	16,210	42,790
Ogallala region (Kansas, South Dakota, eastern Colorado)	64.76	72.86	2,835,000	7,971,000
Idaho and Wyoming	16.19	24.29	42,000	96,520
New Mexico, S.W. Texas, Utah, Nevada, and S.E. Oregon[e]	14.56	14.56	3,170,000	9,133,000
55-YEAR TOTAL			2.124 billion	6.671 billion

[a,b] Lowest and highest reported values, respectively, for an acre-foot of water in the specified region. Per-unit values of water reflect both crop type and weather.

[c] Low estimates of annual lost irrigation water value for the specified region are calculated using only the lowest unit water value reported for each region, and the low estimates of *Tamarix*'s areal extent and water use (1.0 af/acre/year).

[d] Mean estimates for each region are calculated using a weighted average of 80 percent low unit water value and 20 percent high unit water value, reflecting the distribution of crops typically grown in the western United States (Young 1984). The values reported here were calculated using the higher estimate of *Tamarix*'s areal extent and the mean value of its water use (1.5 af/acre/year).

[e] No values were available in the literature for Oklahoma, which is assumed to share agricultural characteristics of the Texas High Plains; or for the arid Great Basin and Chihuahuan Desert regions, which are conservatively assumed to share Arizona's lowest water value for all crops.

imum reported crop-specific value for that state (Table 12.4). Crop-specific values for an acre-foot of water ranged from under $20 for some grain crops to over $800 for specialty crops like melons. While the weighted average estimates provide a more realistic picture of the crop revenues that could be generated with the addition of water lost to *Tamarix*, the minimum-value estimates provide a conservative lower bound. The total, estimated fifty-five-year

value of water lost to irrigators because of *Tamarix*'s presence ranges from $2.1 billion for the lowest water values in each state and the low estimates of *Tamarix* water use and areal extent, to $6.7 billion for crop-weighted water values and mean estimates of *Tamarix* water use and extent.

Losses to Instream Use Values

In most of the region under consideration, it has been assumed that water lost to *Tamarix* would otherwise be removed for agricultural end uses. Since this water would be withdrawn immediately from surface flows for irrigation, it would not have the opportunity to provide instream use values. In the Colorado River system, however, the highest-valued end use is by municipal users in southern California, and in order for that use to be realized, water conserved upstream through *Tamarix* removal would have to be left in the river until it reached the aqueducts and canals supplying the Metropolitan Water District. In the Colorado River, therefore, water now lost to *Tamarix* would have the opportunity to generate instream flow values.

Four dams on the lower Colorado River supply hydroelectric power to growing energy markets in the southwestern United States: Glen Canyon, Hoover, Parker, and Davis. Each is able to generate, based on its height, a given amount of electricity per acre-foot of water that drops through its turbines. The costs of providing this electricity through alternative means—such as coal-fired steam or gas turbine generation—have been estimated to range from $74 to $180 per acre-foot of water (Colby 1989b). These are the extra costs of replacing hydroelectrical production lost due to a decrease in flow with more expensive sources of electricity. Gibbons (1986) actually estimates the value of an acre-foot of water for electricity generation at each of the four dams on the lower Colorado as the avoided cost of providing the same electricity at the nearest coal-fired steam generation plant. Using these findings, the calculated acreages of *Tamarix* infestation above each of the dams on the Colorado, and the estimated per-acre water lost to *Tamarix*, the lost value of hydropower generation is approximately $16–44 million per year (Table 12.5). The fifty-five-year value of hydroelectric generation lost to *Tamarix* is an estimated $880 million to $2.4 billion.

For many recreational instream uses such as fishing, the marginal value of additional units of water is very low or zero at all but the lowest river flow levels. River rafters and kayakers, however, are more sensitive to changes in river flow and positively value additional units of water over a range of low-flow levels (Colby 1989a). A number of contingent valuation studies have investigated the willingness of river boaters to pay for access to rivers at various flow levels, and evaluated the mean value of an additional acre-foot of water at low flows (reviewed in Colby 1989a–b, Postel and Carpenter 1997). The Colorado River and one of its major tributaries, Utah's Green River, are both tremen-

Table 12.5. The annual value of hydroelectric power generation lost to *Tamarix* on the Colorado River. (All values are reported in 1998 dollars. Annual values are rounded to the nearest 1,000.)

Dam	Value/acre-foot of water (dollars)	Estimated upstream Tamarix *acreage*	Annual value lost to Tamarix *(dollars)*
Glen Canyon	23.72	99,367–196,312	2,357,000–6,985,000
Hoover	45.19	124,666–229,253	5,634,000–15,540,000
Parker	25.97	142,499–252,738	3,701,000–9,845,000
Davis	29.79	142,499–252,738	4,245,000–11,294,000
TOTAL			15,937,000–43,664,000
55-YEAR TOTAL			876,501,000–2,402,500,000

dously popular whitewater boating rivers that experience extremely low relative flows for several months of every year (Penny 1991). While willingness-to-pay values of up to $80/acre-foot have been estimated for the low-flow season in northern Utah (Colby 1989a), I used the lowest available findings of $5.90–11.80/acre-foot (Daubert et al. 1979; Gibbons 1986) to provide conservative estimates of the lost river boating value of water consumed by *Tamarix*.

Only the Green River and the portion of the Colorado River above Lake Mead was considered for this valuation, because the seat of value for river recreation on the Colorado is between Lake Powell and Lake Mead in the Grand Canyon (Penny 1991). The Green River, which is assumed conservatively to have a low-flow season of three months, loses roughly 10,000–29,000 af of water per year to *Tamarix*. A disproportionate amount of water loss to *Tamarix* might be expected to occur in the summer low-flow season because hot, dry conditions increase plant transpiration rates. Nevertheless, I treat water losses here as though they occur evenly throughout the year—during the three-month dry season, three-twelfths of the total annual water loss to *Tamarix* is assumed to occur. The value to boaters of this lost water is an estimated $14,000–$80,000 each year. The Colorado River experiences a rather long period each summer and fall—over six months—of suboptimal boating flows (Penny 1991). Assuming a six-month low-flow period, *Tamarix* removes an estimated 175,000–390,000 af of water from the Colorado above Lake Mead during the low-flow season each year. The value of this lost water to boaters in the Grand Canyon is estimated to be $520,000–$2,300,000 each year. In sum, the fifty-five-year value to boaters of water lost to *Tamarix* on the Colorado and the Green is some $29–132 million. This figure does not include lost values to lake boaters due to lowered water levels on the popular reservoirs of the Colorado (Colby 1989a).

Flood Control

When *Tamarix* invades a riparian corridor, it establishes in thickets more dense and extensively rooted than the vegetation that it typically replaces. These qualities of *Tamarix* stands—the same ones that make *Tamarix* a valuable tool for erosion control—also cause *Tamarix* to stabilize and trap sediment on sandbars, riverbanks, and midstream islands (Graf 1980). Steady accretion enlarges these banks and islands, narrowing river channels and reducing their water-holding capacity. These effects are not subtle. The Brazos River in Texas has narrowed nearly 90 meters (100 yards) since its invasion by *Tamarix* began in approximately 1940 (Blackburn et al. 1982). Comparisons of current aerial photographs with photographs taken by John Wesley Powell's 1871 expedition show that the Green River in Utah's Canyonlands National Park has narrowed by almost a third since *Tamarix* reached it near the end of the nineteenth century (Graf 1978).

When storms and rapid snowmelt cause western rivers to rise, the reduced capacity of *Tamarix*-infested channels leads to flooding at lower river stages than before invasion. When these floodwaters overflow the banks of infested rivers, the density of the exotic vegetation traps debris and impedes downstream flow, backing up water and exacerbating flooding (Hadley 1961; Graf 1980, 1978). In 1977–79, major flooding in Arizona caused damages in just one county that in today's dollars would exceed $150 million. These floods first drew attention to *Tamarix*'s role in worsening the frequency and severity of flood damage.

In 1989, Great Western Research used an Army Corps of Engineers hydrological flow model to simulate the effects of *Tamarix* on flood events in the Rio Grande and lower Colorado Rivers. Damage frequency curves were developed for levels of *Tamarix* removal up to 90 percent for particular reaches of these two rivers, and the results were extrapolated to other invaded areas and converted to economic damage estimates. The figures they obtained are at best a rough first approximation of the flood control costs of *Tamarix,* particularly since they were comparing *Tamarix* to bare soil rather than to native vegetation. Nevertheless, GWR's rough estimates are relatively conservative for at least three reasons. First, the study considered up to 90 percent, not 100 percent, removal of *Tamarix* and considered damages based on the 1989, not the larger 1998, areal extent of the invader along western rivers. Second, the study did not consider the effect of long-term channel narrowing by *Tamarix*—only the increased resistance of dense *Tamarix* thickets to overbank flow was varied in their model simulations. Channel narrowing arguably has the greatest impact on flood damages because by substantially reducing channel capacity, it greatly increases the likelihood that overbank flow will occur in the first place. Finally, economic flood damage estimates reflect the amount of urban, agricultural, and other development that exists

in river floodplains. With the human populations of the western states expanding rapidly, development within the boundaries of potential flood areas is likely to have increased significantly since 1989.

Converting Great Western Research's results to 1998 dollars yields an estimate of the average annual impact of *Tamarix* on flood damages throughout its naturalized range of $52 million. Over fifty-five years, with a zero discount rate, the total costs incurred will be approximately $2.9 billion.

Wildlife

The negative impacts on wildlife of the displacement of native plant communities by dense, monospecific stands of *Tamarix* are well documented. In short, *Tamarix* lacks palatable fruits and seeds, fails to harbor plant-eating insects that insectivores can eat, occurs in high-density stands with little structural or microclimatic diversity, and is too small in stature and limb size to meet the habitat requirements of raptors and woodpeckers (DeLoach 1997). In the deserts of southern California and the southern portions of Arizona, Texas, and New Mexico, *Tamarix* also dries up springs and oases— necessary habitat and water sources for desert wildlife ranging from bighorn sheep and quail to endangered pupfish (DeLoach 1997; Loope et al. 1988; Neill 1983).

While clear effects of *Tamarix* on reptiles and mammals have been documented—in one study, reptile densities were found to be more than ten times lower in *Tamarix* than in native stands (Engel-Wilson and Ohmart 1978)— its effects on avian communities have been better studied than those on any other class of animals. Bird densities, diversity, and individual health are greatly reduced in *Tamarix* stands compared to native vegetation. Total avian abundances in *Tamarix* on the lower Colorado River ranged seasonally from 39 percent to 59 percent of those found in native willow, cottonwood, and mesquite habitats (Anderson and Ohmart 1977; Anderson et al. 1983). Willow flycatchers (*Empidonax trailii*), of which the southwestern subspecies is federally endangered, were found to be both more scarce and lower in individual body mass and fat stores in *Tamarix* stands than in cottonwood habitats on the Rio Grande (Yong and Finch 1997). Several bird species are found only in native cottonwood habitat and never in *Tamarix* stands, including cavity nesters and timber drillers such as the gilded northern flicker (*Colaptes auratus*) and downy woodpecker (*Picoides pubescens*), and passerines like the summer tanager (Piranga rubra), a listed species in California (Ellis 1995; Hunter et al. 1988; Anderson et al. 1983). *Tamarix* avian communities become increasingly depauperate as one moves west from the eastern limit of *Tamarix*'s range in Texas, perhaps because as summer temperatures rise along that gradient, low, shrubby *Tamarix* thickets fail to provide the increasingly

necessary cooling that would occur beneath a multilayered canopy of mature trees (Hunter et al. 1988).

No economic studies have yet established values for biological diversity or abundance per se, so the overall effects that *Tamarix* has on native wildlife cannot yet be feasibly incorporated into an economic impacts estimate. However, several studies have developed quantitative estimates of household and park visitor willingness-to-pay values for the partial or total recovery of federally threatened and endangered species. Although only a fraction of the species affected by *Tamarix* invasion both are federally listed and have sufficiently defined habitat needs to allow quantification of *Tamarix*'s impact on them, they provide a starting point for considering the economic values of wildlife lost to exotic species invasions.

Three federally listed species and one candidate for federal listing suffer clear, quantifiable negative impacts from *Tamarix* invasion: respectively, the southwestern willow flycatcher (*Empidonax trailii extimus*), the bald eagle (*Haliaeetus leucocephalus*), the whooping crane (*Grus americana*), and the peninsula bighorn sheep (*Ovis canadensis cremnobates*). For each, I used a model of willingness to pay (WTP) for endangered species (Loomis and White 1996) to calculate the approximate price that visitors to parks and refuges would pay to improve the species' status by the amount that *Tamarix* currently affects it (Box 12.2). For each species, information was also collected about the occurrence of these species at National Wildlife Refuges

Box 12.2. Modeling the value of threatened and endangered species

From a legal and societal perspective, threatened and endangered species cannot be bought and sold as commodities. They have no price, but the fact that laws protect them from market exploitation indicates that they clearly have value. Contingent valuation involves seeking out the willingness of individuals to pay for nonmarket goods and services, such as the protection of endangered species (Hausman 1993). Loomis and White (1996) reviewed contingent valuation studies of eighteen species in the United States and developed from them a meta-analytical regression model that can be used to estimate the willingness to pay (WTP) for various levels of recovery of other threatened and endangered species. This model allowed the development of an economic estimate of the losses in threatened and endangered species values suffered to *Tamarix* invasion.

Components of the model not necessary for this analysis are excluded below for clarity:

WTP (1993) = −49.43
+ 0.61 × (percent change in endangered population to be paid for)
+ 42.01 × (1 if a single lifetime payment, 0 if an annual payment)
+ 23.55 × (1 if the paying group is only park and refuge visitors, 0 if
it is the general human population of the area where the
species occurs)
+ 21.72 × (1 if the species is a bird, 0 if not)

The WTP (in $1993) for species recovery is calculated from a constant, plus a term indicating whether the recovery in question is for a 10 percent, 20 percent, 100 percent, and so forth, increase in the population of the species. If the payment requested only has to be made once in the lifetime of the payer, the size of the payment he or she is willing to make goes up. Visitors to parks and refuges where the endangered species occurs are willing to pay more than the general public for species recovery, so if the paying group is limited to visitors, the per-person payment increases by another factor. Finally, fish, marine mammals, and birds command higher WTP values than other taxa. Because *Tamarix*'s impacts have only been well studied for endangered birds and terrestrial mammals, only the additional "bird" variable is included in this model version. The version above has the best predictive value of four models developed in the meta-analysis ($R^2_{adj} = 0.677$, $N = 38$, $F = 16.57$, $p << .001$).

In the analysis of *Tamarix*, all values are converted to 1998 dollars using the U.S. Consumer Price Index. A conservative, simplifying assumption was also made for each species calculated to have a positive annual WTP value. Refuge visitors each agree to make annual payments for the rest of their lives at the calculated amount, so a new crop of visitors each year provides a new pool of annual payers for the species' recovery. Instead of adding new payers for each year in the fifty-five-year analysis period, I assumed that exactly the same people visited refuges every year and therefore added no additional payers beyond the first year's crop of visitors. I also assumed that over fifty-five years, despite rapidly growing U.S. and western states' populations, annual visitation to parks and refuges—the pool of payers—would not increase. In addition, I assumed that *Tamarix* has no impact on visitation itself or the revenues generated by visitor fees and purchases. Finally, I included only federal, and not state, county, or local, parks and refuges (with the exception of the large and heavily visited Anza-Borrego Desert State Park in southern California). For all of these reasons, the costs of *Tamarix* invasion's impacts on endangered species presented in this study are underestimates of its true costs.

invaded by *Tamarix* and the numbers of annual human visitors to each refuge. These findings were used to compute the annual loss of endangered species value to *Tamarix* (Table 12.6). Calculations of annual and fifty-five-year costs are highly conservative because I assumed no turnover in refuge visitors—that is, I assumed that the same people visit refuges every year and make annual payments for species recovery—no new annual payers ever join the pool.

The southwestern willow flycatcher has received considerable attention recently because of the 1997 designation of critical habitat for its recovery in such highly populated areas as San Diego and Orange County, California. The bird relies on riparian woodland vegetation for both foraging and nesting (Brown and Trosset 1989), so damage to riparian habitat directly reduces its survival and reproductive success. Still, much of the literature on habitat use and natural history of the flycatcher, including the U.S. Fish and Wildlife Service's listing of critical habitat, treats all riparian vegetation as equivalent in terms of habitat quality (e.g., Sogge et al. 1997a–b, U.S. Fish and Wildlife Service 1997). The flycatcher does use *Tamarix* successfully in areas where it is the only riparian vegetation available (Brown and Trosset 1989). However, there is agreement among a number of wildlife biologists working in the Southwest that the flycatcher fares worse in *Tamarix* than in native stands (DeLoach 1997; various personal communications). Some clear evidence exists to support their observations. In a large, two-year, mist-netting study in western Texas, significantly more flycatchers than expected were found in native willow habitat, while significantly fewer were found in stands containing *Tamarix* and exotic Russian olive (*Eleagnus angustifolia*) (Yong and Finch 1997). Flycatchers caught in willow also had higher body mass and observable fat stores than those in the mixed habitats, suggesting that willow provides superior foraging habitat (op. cit.). In addition, a study comparing bird use of *Tamarix* and native cottonwood communities found *E. trailii* only in native cottonwood stands (Ellis 1995). More study is certainly warranted to quantify the impact of *Tamarix* on this endangered songbird, especially since reproductive success rather than mere presence is the best indicator of habitat quality. Nevertheless, it is reasonably clear that native riparian woodlands provide better habitat than *Tamarix*. Concern about *Tamarix* removal negatively affecting *E. trailii* should be tempered by the potential for well-planned removal and revegetation to benefit the subspecies.

To estimate the economic consequences of *Tamarix* invasion on willow flycatcher populations, I assumed that at *Tamarix*-infested refuges and national parks within *E. trailii extimus*'s range, *Tamarix* reduces the flycatcher's population by 10% from pre-invasion levels. Nearly 6 million annual visitors to parks and refuges are affected by this estimated reduction if one includes Grand Canyon National Park (GCNP). A possible objection to including

Table 12.6. Summary of threatened and endangered species values lost to *Tamarix*.

Species	Major impact of Tamarix	Estimated population impact at parks and refuges where species and Tamarix co-occur	Number of visitors to parks and refuges where impacts occur	Annual visitor WTP (1998 $) for recovery from Tamarix's impact	Total annual value lost to Tamarix
Southwestern willow flycatcher	Displacement of riparian forest habitat	−10%	5,953,933 (1,378,333 without GCNP*)	$0.97	$6.49 million (1.50 million without GCNP)
Whooping crane	Encroachment into marsh habitat	−20%	130,000	$9.01	$1.17 million
Bald eagle	Loss of roosting and nesting sites	−10%	459,917	$2.17	$998,000
Peninsula bighorn sheep	Drying of desert springs	−10%	66,000	$22.23 (lifetime payment)	$54,820
TOTAL ANNUAL COST					$3,722,820– $8,712,820
TOTAL 55-YEAR-COST					$85,646,165– $369,953,385

* Grand Canyon National Park.

GCNP, however, is that the flycatcher on balance has not suffered in the Grand Canyon from *Tamarix* invasion because it is unclear that *Tamarix*-invaded areas were previously colonized fully by native woodland species (Brown and Trossett 1989; Powell 1895). If *Tamarix* were not successfully replaced by native species, its removal would not benefit the flycatcher. Given this uncertainty, I have estimated economic impacts to *E. trailli extimus* both with and without GCNP. The estimated visitor WTP in 1998 dollars for 10 percent recovery of a bird species is $1.94. I divided this figure in half ($0.97) to account for the possibility that the public places less value on a small song-bird (the flycatcher) than on large, "charismatic" bird species such as the Northern spotted owl (*Strix occidentalis*) and the whooping crane (*Grus americana*). Only the latter type of bird was used to develop the original WTP model (Loomis and White 1996). Based on an annual visitor WTP of $0.97, the total fifty-five-year cost of *Tamarix's* impact on the southwestern willow flycatcher is estimated at $86–360 million.

The endangered whooping crane occurs mainly east of *Tamarix's* range, but one population—at Bosque del Apache National Wildlife Refuge, New Mexico—is seriously affected by the encroachment of *Tamarix* thickets into its critical marsh habitat (Great Western Research 1989). The 130,000 annual visitors to Bosque del Apache are estimated to be willing to pay about $9 a year to reverse the impact that *Tamarix* has on the crane. The value lost to *Tamarix's* impacts on whooping cranes at the Bosque del Apache refuge is therefore an estimated $1.2 million each year, or $59 million over the next fifty-five years. In the vicinity of the Bosque del Apache refuge, the costs of removing *Tamarix* are currently an order of magnitude lower than the esti-mated WTP of visitors for its removal to benefit whooping cranes. Control costs could therefore easily be offset through an appeal to visitors concerned about the crane.

The bald eagle requires large-limbed trees for nesting and prefers them to smaller-statured vegetation for roosting (Great Western Research 1989). It is affected in areas where heavy *Tamarix* infestation has displaced all or most of the native trees of the riparian zone, such as the Cibola, Imperial, and Havasu National Wildlife Refuges of the lower Colorado River (personal communi-cations, U.S. Fish and Wildlife Service Refuges). Impacts to the eagle in less heavily infested areas are less certain. Visitors to those refuges where heavy infestation does affect bald eagle populations number nearly half a million because of the proximity of the lower Colorado refuges to urban areas in southern California. With an estimated WTP of $2.17 for 10 percent bald eagle recoveries at these refuges, the value lost to these visitors and the refuge system because of *Tamarix* totals nearly $1 million each year.

Finally, the peninsula bighorn sheep of southern California and northern Baja California, Mexico, is a candidate for listing under the Endangered

Species Act. In the hot deserts of its range, *Tamarix* completely dries remote springs that the bighorn depends on for water (National Park Service 1981; Neill 1983; DeLoach 1997). Because the bighorn occurs in remote areas and, as a terrestrial mammal, is valued less highly than endangered bird species by park and refuge visitors, it commands a positive lifetime, but not annual, WTP of $22.23. Assuming that visitors making these lifetime payments are replaced only every fifteen years by a crop of new visitors making new lifetime payments, the annual value of bighorn sheep lost from desert parks like Anza-Borrego as a result of *Tamarix* infestation is estimated at $55,000, or $3 million over fifteen years. This estimate excludes potentially large losses of value to big game hunters, who may pay tens of thousands of dollars for the opportunity to hunt a peninsula bighorn while the species is unprotected by the Endangered Species Act but may miss that opportunity because of declines in the bighorn's populations (P. Cohen, Jasper Ridge Biological Preserve, Stanford University, personal communication).

The total endangered species value lost over fifty-five years to *Tamarix* invasion is an estimated $85–360 million. Left out here are the many nonendangered species of birds, mammals, reptiles, and insects negatively affected by the invader—species valuable to park and refuge visitors who enjoy wildlife as well as to the functioning of desert, riparian, and riverine ecosystems, but impossible to attach specific prices to given the current state of eco nomic knowledge. Also left out are both nonendangered and endangered fish species. Though the impacts of *Tamarix* on them have not been quantified, fishes clearly suffer when *Tamarix* dries up desert ponds and streams, turns once perennial bodies of water into ephemeral ones, and lowers the flows of rivers such as the Colorado, home to the federally endangered razorback sucker (*Xyrauchen texanus*), bonytail chub (*Gila elegans*), humpack chub (*Gila cypha*), and Colorado squawfish (*Ptychocheilus lucius*) (Maddux et al. 1993). If the presence or spread of *Tamarix* actually pushes any of these species irreversibly to extinction, losses of value will jump—if not become impossible to measure. Finally, other values to visitors associated with parks and refuges—the scenic qualities of riparian areas, for example—are not considered here.

Other Values and Losses Associated with Tamarix

Positive values associated with the presence of *Tamarix* must also be considered to give a complete picture of its role in influencing ecosystem services. By stabilizing sediment along waterways, *Tamarix* slows the rate of sedimentation and loss of storage capacity in reservoirs (Great Western Research 1989). This effect turns out to be rather small because the additional sediment trapped by *Tamarix* is only a small proportion of the total sediment

load of rivers and streams in the region—over fifty-five years, the total benefit of this service was estimated to be $72 million (Great Western Research 1989). *Tamarix* also benefits the dove hunting industry in Texas and Arizona because even though most native birds fare relatively poorly in *Tamarix* stands, white-winged and mourning doves (*Zenaida asiatica* and *Z. macroura*) appear to thrive in them (Cottam and Trefethen 1968; Shaw and Jett 1959; Great Western Research 1989). The fifty-five-year estimated value of *Tamarix* for supporting dove populations, based again on an estimate made by Great Western Research in their 1989 study, is $21 million. Finally, described benefits of *Tamarix* as an ornamental and a food plant for exotic honeybees (*Apis mellifera*) are considered valueless in this study because these services are just as easily provided by noninvasive species. As an ornamental, *Tamarix* is easily substituted for by native and noninvasive exotic ornamental plants. As a food source for commercial honeybees, even if the problems associated with enhancing another exotic invasive species' population are ignored (Lovich 1996), *Tamarix* is considered no better by beekeepers than native riparian species such as mesquite and catclaw (Great Western Research 1989). A total of $93 million in positively valued ecosystem services can therefore be attributed to the presence of *Tamarix* over a fifty-five-year period.

The presence of *Tamarix* in the western United States also has a number of impacts with negative economic consequences that are beyond the scope of this study to quantify. The losses of insect diversity and abundance associated with *Tamarix* invasion compromise pollinator services, crucial and economically valuable inputs to the production of one-third of the crops grown in the United States (Abramowitz 1998; Nabhan and Buchmann 1997). *Tamarix*'s lowering of water tables associated with the drying of desert springs likely increases groundwater pumping costs, which directly reflect the distance water must be raised (P. Cohen, personal communication). Increases in both soil and water salinity result from the transport and deposition of deep salts by *Tamarix* on the soil surface, accelerating the rate of salinization of irrigated lands and reducing the effectiveness of field flushing for desalinization. As already discussed, the impacts *Tamarix* has on difficult-to-quantify values such as nonendangered wildlife, big game hunting, and recreational lake use have been omitted out of necessity. Many conservative simplifying assumptions have also been made, such as disregarding the positive effect of *Tamarix*-induced riverbank sedimentation on the areal extent of riparian vegetation and the implications of that increase for transpirational water losses. Finally, the benefits of *Tamarix* eradication are treated in this analysis as though they would exist for only fifty-five years even though they would in reality accrue indefinitely. The lost ecosystem service values estimated in this study represent only a portion of the total economic losses associated with *Tamarix* infestation.

Table 12.7. Summary of fifty-five-year values lost to *Tamarix* (0 percent discount rate).

Ecosystem service	Lowest estimate (dollars)	Highest estimate (dollars)
Irrigation water	2.124 billion	6.671 billion
Municipal water	1.448 billion	3.730 billion
Flood control	2.860 billion	2.860 billion
Hydropower (Colorado River)	876.5 million	2.402 billion
Wildlife habitat	85.65 million	360.0 million
River recreation	29.17 million	132.1 million
Sedimentation	–71.81 million	–71.81 million
Dove hunting	–21 million	–21 million
TOTAL	7,331 billion	16,062 billion
TOTAL 55-YEAR VALUE LOST PER ACRE	6,318	9,981
EXCLUDING WTP VALUES	6,219	9,675
ESTIMATED PER-ACRE COST OF ERADICATION AND REVEGETATION	3,006	3,006
NET BENEFIT PER ACRE OF ERADICATION	3,312	6,975
NET TOTAL BENEFITS OF ERADICATION	3,843 billion	11,225 billion

Comparing the Costs and Benefits of Eradication

In total, after subtracting the values of benefits associated with it, the presence of *Tamarix* in the western United States will cost an estimated $7–16 billion in lost ecosystem functions over the next fifty-five years (Table 12.7). This loss amounts to $6,300–$10,000, on average, per acre of land infested with *Tamarix* ($15,600–$24,600/hectare). The exclusion of river recreation and wildlife, the values estimated in terms of willingness to pay, decreases total losses only slightly to $6,200–$9,700 per acre ($15,400–$23,900/hectare).[11] Losses of value to *Tamarix*, therefore, are dominated by losses of market-valued goods and services with real replacement costs that could be recovered through eradication.

While there would be large economic benefits associated with the removal of *Tamarix* from the western states, the costs of eradicating it and restoring native vegetation in its place would also be high. *Tamarix* is a tenacious species, capable of resprouting from rootstock and surviving prolonged desiccation and flooding (Brock 1994), so permanent removal usually requires labor-intensive, repeated mechanical and chemical measures (Taylor and McDaniel 1998; Great Western Research 1989; Bureau of Reclamation 1992). Revegetation with native species is even more costly because to ensure success in the most arid parts of the West, seedlings must be greenhouse-reared, transplanted, and watered until their roots reach the zone of permanent water (Bureau of Reclamation 1992). Highly successful eradication and revegetation

projects at the Bosque del Apache National Wildlife Refuge in New Mexico cost roughly $2,000 per acre. Other large eradication and revegetation projects have ranged in expense from about $200 in central Texas, where postplanting care is unnecessary, to nearly $5,000 in the most arid regions, where several years of watering are required (Bureau of Reclamation 1992, Great Western Research 1989). *Tamarix* is a candidate for biocontrol with imported insects (DeLoach 1997), but until this approach has been more thoroughly tested, it cannot be considered a substitute for the prevailing methods.

For this analysis, the costs of regionwide eradication of *Tamarix* were evaluated for a hypothetical twenty-year program of planning, eradication, revegetation, and monitoring (Table 12.8). The most comprehensive methods for removal of *Tamarix,* normally required in areas with the most stubborn infestations, were assumed necessary for all sites in the region. Initial site evaluation in the first year of the program would guide the selection of native species to plant, minimizing the costs associated with revegetation failure (Bureau of Reclamation 1992). Such site evaluation typically costs $30–$50 per acre (Bureau of Reclamation 1992), so a cost of $50/acre is assumed for this analysis. The actual removal of *Tamarix* through cutting and root plowing the following year would cost about $60 per acre. The hand application of relatively expensive but safe, water-based herbicides (Garlon) to root stumps in years three through six would minimize the chances of resprouting and seed germination at an estimated per-acre cost of slightly over $600 (Bureau of Reclamation 1992).

While revegetation costs vary substantially, the mean cost per acre is likely to be low because (1) economies of scale drastically reduce costs (Great Western Research 1989), (2) initial site evaluation will allow the most suitable species to be chosen for each location (Bureau of Reclamation 1992), (3) some areas such as the near-bank portions of *Tamarix*-narrowed rivers will not be revegetated at all, and (4) recent, successful programs in arid areas have been able to revegetate for well under $2,000 (Taylor and McDaniel 1998). For this analysis, a mean cost of $2,000 per acre over years seven through fourteen was assumed for greenhouse rearing, transplanting, and watering of native trees and shrubs. Finally, monitoring the course of revege-

Table 12.8. Estimated cost per acre of a comprehensive eradication and revegetation program.

Activity	Cost per acre (dollars)
Site evaluation (year 1)	50
Root plowing (year 2)	59
Hand application of herbicide (years 3–6)	624
Revegetation (years 7–14)	2,000 [reported range: 165–8,000]
Monitoring (years 15–20)	273
TOTAL	3,006

tation and checking for recolonization by *Tamarix* typically add 10 percent to a project's costs (Bureau of Reclamation 1992) over time. About $275 per acre was added to the cost of control to account for the need for annual checks (Table 12.8). For convenience, this monitoring is assumed to all take place in the five years following completion of the revegetation phase.

The twenty-year total cost of this hypothetical program is $3,000 per acre, approximately $1,000 more per acre than the most successful eradication campaign currently underway in the region. At $3,000 per acre, the costs of eradication and revegetation are outweighed by the entire range of estimates of the fifty-five-year benefits that eradication would confer (Table 12.8). Long-term benefits outweigh costs by $3,300 to nearly $7,000 per acre, and by $3.8 billion to over $11 billion across the entire region. The resulting benefit-cost ratio lies in the range of 2.1–3.3. The finding that benefits significantly outweigh costs of eradication is robust to both elimination of willingness-to-pay values and considerable reduction in the estimated transpirational water loss associated with *Tamarix* (Box 12.3). It is also robust to variation in discount rate from 0 to 6 percent (Box 12.1).

The Impacts of Global Change

The establishment of *Tamarix* in the United States is itself a symptom of a global change: the proliferation of biological invasions instigated by human action. Other key global changes affecting the western states—population growth, increasing atmospheric concentrations of CO_2, and climate change—are likely to interact with *Tamarix* invasion and to influence its economic consequences for the region. The extent of change that we can expect in the next century and the effects that given degrees of change will have on ecosystems are not sufficiently quantified to yield specific estimates of the changes in economic damage that will result. However, enough knowledge exists to allow reasonable projection of the directions in which specific global changes will drive economic impacts to ecosystem services.

Human populations in the region affected by *Tamarix* are growing rapidly because of both immigration from other parts of the country and Mexico and intrinsic growth (Morrison 1996). In particular, the areas of highest water scarcity that rely heavily on the Colorado River—southern California, Arizona, northern Mexico, and southern Nevada—are growing explosively and are expected to expand from 1990 population levels by over 50–100 percent in the next two decades (Table 12.9). As regional populations grow, demands for water itself and all of the services it provides, including hydropower and recreation, will necessarily increase. Water supplies in the region cannot, however, increase to match this demand. Instead, the value, or price, of water to those who need it will increase—and the marginal value of additional units of water that would become available in the absence of *Tamarix*

Box 12.3. Accounting for returns of transpired water to the region

	Most conservative	*Least conservative*
Minimum expected net transpirational loss to *Tamarix*, assuming a 50% return of transpired water to regional surface flows	0.50	0.75
Minimum contribution of *Tamarix* to water loss that maintains positive net value of eradication	0.43	0.24

The fate of additional water transpired by *Tamarix* is not entirely clear—up to half of it may plausibly return to the region's surface flows as precipitation (Salati and Nobre 1991; Grimm et al. 1997). If half of all water transpired by vegetation returned to the region, then water losses associated with *Tamarix* would be reduced to only half of the difference in transpiration rate between it and native vegetation: 0.50–0.75 acre-feet/acre/yr instead of 1.0–1.5 af/ac/yr. To test the sensitivity of the cost-benefit results to variation in the water loss associated with *Tamarix*, I repeated the analysis with a range of lower water loss rates. Under the most conservative set of assumptions, any water loss to *Tamarix* greater than 0.43 af/ac/yr renders the benefits of eradicating the species greater than the costs of eradication and revegetation. Under the least conservative set of assumptions, any water loss to *Tamarix* greater than 0.24 af/ac/yr continues to favor eradication. In both cases, the minimum plausible transpirational loss (assuming 50 percent return to the region's surface flows) exceeds the minimum economically significant transpirational loss by a comfortable margin. This suggests that while returns of transpired water to the region do reduce the economic costs of *Tamarix* (and the net benefits of eliminating it), they do not change the result that the economic benefits of removing *Tamarix* from the western United States outweigh its costs.

Table 12.9. Population projections: 1990–2020 (from Morrison 1996).

Region	% increase
Arizona	90
Southern California	57
Southern Nevada	104
Mexico (area relying on Colorado River)	91

will also increase. Similarly, increases in human populations imply both that more development is likely to occur in the floodplains of waterways and that demand for the aesthetic resources of the western states, such as wildlife, will continue to increase. As a result, the economic impact of *Tamarix*'s detrimental effects on flood control and wildlife will also increase as populations rise.

As demand for water rises in the future, it is likely that supplies of water will fall. Precipitation and temperature changes predicted for the southwestern United States are expected to have strong negative impacts on surface runoff (Schaake 1990; Gleick 1990; Nash and Gleick 1991). Even if transpirational water losses to *Tamarix* stay the same, they will represent a larger fraction of a diminishing pool of available water and will have greater negative economic impact as each unit of water becomes more valuable in the face of scarcity. A regional climate model recently developed for the Great Plains and the western United States predicts overall annual decreases in rainfall of roughly 65 millimeters (2.6 inches)/year and increases in temperature of 4–5°C with a doubling of atmospheric CO_2 (Giorgi et al. 1998) (Table 12.10). These rainfall decreases correspond to a 15–35 percent decrease in annual precipitation to the chief southwestern river basins affected by *Tamarix* (Table 12.11). Surface runoff in the region is highly sensitive to such large changes in precipitation. A model of Colorado River flows under climate change predicts a 40 percent decline in annual flow volumes if temperatures increase by 4°C and precipitation declines by 20 percent (Nash and Gleick 1991). Even if precipitation does not change (models of precipitation under doubled atmospheric CO_2 produce more variable results than models of temperature, which consistently predict increases), a 4°C increase in temperature alone produced a 20 percent decrease in modeled Colorado River flows (Nash and Gleick 1991). In a river currently producing about 15 million acre-feet (maf) per year, all of which are already fully allocated for use by the Colorado

Table 12.10. Estimated summary data for southwest region from Giorgi et al. (1998) regional climate model runs, $2 \times CO_2$ control.

	Winter	Spring	Summer	Fall
Temperature change (°C)	+4	+5	+4.5	+4.5
Precipitation change (millimeters/day)	−0.5	+0.25	−0.25	−0.25
Seasonal total precipitation change (millimeters)	-44.5	+22.25	−22.25	−22.25

TOTAL ANNUAL PRECIPITATION CHANGE: −66.75 millimeters (−2.63 inches)

MEAN ANNUAL TEMPERATURE CHANGE: +4.5°C

Table 12.11. Estimated precipitation
changes under $2 \times CO_2$ by river basin.

River	Percent change
Colorado	−20–35
Rio Grande	−20
Pecos	−20
Red/Arkansas	−15
Gila	−15–20

Basin states and Mexico, flows would drop to 9.5–12.8 maf/year (Matusak 1998; Morrison 1996, C. Harris, personal communication). These predicted flows are millions of acre-feet short of current needs, which are themselves rising rapidly (Matusak 1998; Arizona Department of Water Resources 1997).

In addition to the direct effects of climate on water supply in the region, increased temperatures may increase transpirational losses of water through plants. However, elevated atmospheric CO_2 has the opposite effect on transpiration rates—increased availability of the CO_2 resource allows plants to keep their stomates closed more often, improving their ability to conserve water (Huenneke 1997). Consequently, elevated CO_2 may reduce transpirational losses of water in the future (Wigley and Jones 1985). The effects of higher temperatures and higher atmospheric CO_2 concentrations may cancel each other out or sum to either net increases or decreases in transpiration. The relative responses of *Tamarix* and native vegetation to temperature and CO_2 availability changes also are not known; the marginal water loss associated with *Tamarix* may change in either direction depending on how both it and its native substitutes respond. It is therefore not possible to predict what the net transpirational response to heating and increased CO_2 will be for whole, diverse landscapes in the western United States, or to predict whether runoff will be substantially affected by transpiration changes. The predicted direct responses of water supply to the expected magnitude and direction of climate change, however, remain troubling.

Beyond the effects that global change will exert on the supplies of and demands for ecosystems goods and services affected by *Tamarix*, climate change also has the potential to exacerbate the impact of this invader in two other ways. First, increases in temperature may worsen the effects of *Tamarix* on some native birds. The negative effects of *Tamarix* on bird diversity increase as one moves along a gradient of increasing summer temperatures from the Pecos River in Texas to the hot lower Colorado River (Hunter et al. 1988; Engel-Wilson and Ohmart 1978; Anderson et al. 1983). One suggested explanation for this pattern is that the failure of *Tamarix* to provide cool, sub-canopy microclimates has increasing consequences for heat-sensitive birds as

temperatures rise (Hunter et al. 1988). If hotter temperatures do worsen the invader's effects on native birds, then predicted 4–5°C increases in temperature throughout the region would likely deal a blow to some bird species currently able to tolerate the conditions of *Tamarix* stands.

A second additional impact of climate change may be increases in the size of *Tamarix*'s naturalized range. The species' current distribution in the United States is limited at high latitudes and altitudes, and in wetter areas such as the coastal Pacific Northwest and east Texas (Robinson 1965). *Tamarix* is thought to be physiologically limited in distribution by temperature (Baum 1978, S. Smith, University of Nevada at Las Vegas Dept. of Biology, personal communication), which suggests that increases in temperatures throughout the western United States might allow it to expand its range north and uphill. If the eastern limit of its distribution is, as it appears, related to high rainfall and outcompetition by species that occur in mesic areas (Robinson 1965; N. E. West, Utah State University Dept. of Rangeland Management, personal communication) then it may also be the case that declining precipitation would allow *Tamarix* to expand its range eastward into the Midwest and westward into wetter regions of the Pacific Northwest. Drought-related declines in overbank flooding throughout its range may also facilitate *Tamarix* establishment (Everitt 1980). Range expansions driven by either temperature or precipitation would increase the area adversely affected by *Tamarix* as well as increase total water losses from the region.

Predicted climate changes are likely to reduce the impact of *Tamarix* in only one way: an overall decrease in flood risk. Long-term regional climate models' predictions of both temperature increases and precipitation decreases (Giorgi et al. 1998) are likely to reduce the frequency and intensity of flood events (Nash and Gleick 1991; Wigley and Jones 1985) and hence to reduce, over time, the annual marginal impact of *Tamarix* on flooding. Nevertheless, even an extremely conservative projection of declining flood risks has a relatively small impact on the cost-benefit analysis of *Tamarix* control. If it is assumed that by year fifty-five there will be *zero* net marginal flood control benefits of controlling *Tamarix*, and if these benefits are assumed to decrease linearly from a 1998 value of $52 million over the next fifty-five years, then the total flood control value lost to *Tamarix* over the next fifty-five years is approximately $1.4 billion rather than $2.9 billion. This has the effect of reducing total net benefits slightly, but does not affect the overall result that benefits exceed costs substantially at a range of discount rates.

In summary, *Tamarix*'s impacts on water and the services it provides are likely to worsen under global change because of increasing demands combined with shrinking supplies. *Tamarix*'s impacts on flood damages might be expected to decline as precipitation drops, but to increase to the extent that *Tamarix* expands its range and development in river floodplains increases. Impacts on wildlife may worsen, because of both growing demand for the ser-

vices that wildlife provide and the possible increasing sensitivity of wildlife to *Tamarix*'s effects at higher temperatures. Overall, these changes will increase the economic impacts of *Tamarix* and the potential benefits of eradicating it. Taken together, there is strong reason to expect the economic effects of *Tamarix* to grow worse in the coming decades and the net benefits of eradicating it to grow larger.

Conclusions

As global changes—regional population growth, a changing atmosphere, and secular climate trends—advance, the arguments for controlling *Tamarix* grow more compelling. The precedent set by South Africa in its succeeding campaign to control woody invasives in fynbos ecosystems (van Wilgen et al. 1996; D. Richardson and P. Vitousek, personal communication) demonstrates that large-scale, labor-intensive control programs not only are possible but also can generate collateral benefits such as job creation. While further study and planning would have to precede the adoption of a program of *Tamarix* eradication in the United States, this study illustrates the likelihood that such a course of action would have clear benefits, economically as well as socially and ecologically. Additional studies of this kind may help to establish that the overall picture of global change exacerbating biological invasions is likely to be accompanied by serious—and quantifiable—economic damage to the services that natural ecosystems provide.

Economics cannot be the sole measure of the worth of a species, nor the single tool used to guide decisions about ecosystem management. From a purely economic standpoint, the optimal riparian "vegetation" in the western United States might be bark mulch, not native forests or woodlands. Bare soil, which has also been suggested as economically preferable to native vegetation, would invite recolonization, by *Tamarix* itself or possibly by other exotic grasses and shrubs, and would promote swift erosion. On the other hand, a layer of mulch could prevent natural revegetation and might slow erosion. Mulch would reduce evapotranspirational losses of water and improve flood control by decreasing resistance to floodwaters. While mulch would eliminate most wildlife, wildlife do not have recognized economic value comparable to that of water in an arid region. While the aesthetic and recreational values associated with rivers throughout the West would diminish substantially, these values lack the clear economic force of water scarcity and flood damages. The presence of native vegetation might confer other, poorly understood ecosystem services, but until these are understood, they will not significantly influence the outcome of an economic valuation. Nevertheless, economists and land managers have never considered the possibility of replacing riparian vegetation—exotic or native—with acres of mulch! The

fact that cost-benefit analysis favors a particular decision is not sufficient to justify that decision as the best one.

On the other hand, when social and ecological arguments already militate in favor of a particular action, the finding that economics also favor it makes a compelling case to pursue it. The findings presented in this chapter can only be considered rough and preliminary estimates of the costs and benefits that controlling *Tamarix* would incur. Many of the benefits of control would accrue to groups whose responsibility to contribute to control costs may be unclear, such as farmers, refuge visitors, and residents of floodplains. The execution of an eradication campaign would require a detailed partitioning of benefits and costs. Moreover, the practical challenges of eliminating *Tamarix* in a coordinated way from throughout its naturalized range (which includes northern Mexico) while preventing recolonization are not trivial. Nevertheless, the results presented here strongly suggest that an economic motivation can be added to social and ecological arguments for aggressively eliminating *Tamarix* from the western United States and restoring the native riparian forests and shrublands that it has displaced over the last century.

Acknowledgments

I want to extend warm thanks to Hal Mooney for the opportunity to explore this subject in depth. For advice, assistance, support, and valuable criticisms, I also thank David Ackerly, Kevin Bonine, Phillippe Cohen, Jeff Dukes, Chris Field, Jonathan Friedman, Michael Goldbach, Chris Harris, Richard Mack, Jan Matusak, Roz Naylor, John O. Niles, Lydia Olander, Anna Sala, Stan Smith, Julie Stromberg, Peter Vitousek, Bill Wiesenborn, the California Urban Water Coalition, and many others in the federal and state agencies that manage western landscapes.

Notes

1. The only values that will not accrue fully until after revegetation is complete are wildlife values. Whooping crane and bighorn sheep habitat will be restored as soon as *Tamarix* is removed from the springs and marshes in question, but willow flycatchers and bald eagles need mature native trees before their recovery can commence. All other values (water-related and flood control values) will begin to accrue as soon as *Tamarix* is absent from the riparian zone and may actually be enhanced by the absence of transpiring and bank stabilizing native replacement vegetation.
2. Estimates are rounded in the text for readability but are not rounded in tables or for calculations.
3. Water-use studies on *Tamarix* and native riparian vegetation include Ball et al. 1994, Blaney et al. 1933, Bowie and Kam 1968, Bowser 1952, Culler et al. 1982,

Gatewood et al. 1950, Gay and Hartman 1982, McDonald and Hughes 1968, Qashu and Evans 1967, Robinson 1970, Robinson and Bowser 1959, Sala et al. 1996, Schumann 1967, Thomsen and Schumann 1968, van Hylckama 1974, van Hylckama 1980, Weeks et al. 1987, Young and Blaney 1942.

4. Convention in the western United States is to report water use in feet of water consumed, or in acre-feet per acre per year. One acre-foot of water equals 1,233 cubic meters. One foot per year is equivalent to 1,233 cubic meters per acre per year or 3,050 cubic meters per hectare per year.

5. While the increase in water availability that would result from *Tamarix* control is large in absolute terms, it is small relative to the West's total water supply. For this reason, the per-unit value of water is not expected to respond to the estimated supply changes that would accompany *Tamarix* eradication.

6. Agricultural users in southern California are entitled to 3.85 million af each year before MWD can increase its withdrawals to 1.212 million af. If MWD receives this 1.212 million af, agricultural users are entitled to another 300,000 af before MWD can further increase its share.

7. Because the Upper Colorado River Basin states—Colorado, Utah, New Mexico, and Wyoming—demand significantly less than their full entitlements at present, a lot of water beyond maximum entitlements is available to Arizona and California. Eventually, if populations in the Upper Basin states continue to grow, California and Arizona will actually have to decrease their withdrawals of Colorado River water to allow Upper Basin states to take their full allotments.

8. Evaporative losses of water originating far upstream of southern California are expected to be less that 10 percent and are not accounted for here. Total evaporative losses of Colorado River water are typically below 10 percent, and only half of the water consumed by *Tamarix* originates from above the two storage reservoirs—Lake Mead and Lake Powell—where most of the evaporative losses occur (Morrison 1996).

9. While this quantity is large in absolute terms, it is small relative to the total water supply and therefore is not expected to alter the price of water significantly.

10. Young (1984) estimates that 80% of crops grown in the western United States have relatively low value per unit of additional water, whereas the remaining 20% are specialty crops with significantly higher value per unit of water. For the weighted estimate, I computed a total value using 80 percent × the minimum crop-specific water value reported for each state and 20 percent × the highest reported value.

11. These WTP values, because they are not actually paid for, would not generate revenues to help offset the costs of eradication and revegetation. This shouldn't be taken to mean that the values do not exist—if *Tamarix* were eradicated, these real values would be enjoyed by river recreationists and refuge visitors for free, subsidized by whomever bore the costs of control. Alternatively, the value added to these services through eradication could be collected to help fund the control program—for instance, admission fees to benefiting refuges and permit fees for the Grand Canyon and the Green could be increased. Given the present, non-market nature of these services, however, it is helpful to consider the case where increases in their value are not available to offset the costs of control.

References

Abramowitz, J. N. 1998. "Putting a value on nature's 'free' services." *Worldwatch* 11: 10–18.

Anderson, B. W. and R. D. Ohmart. 1977. "Wildlife use and densities report of birds and mammals in the lower Colorado River valley." Report No. 7-07-30-V0009. Tempe: Arizona State University and Bureau of Reclamation.

Anderson, B. W., R. D. Ohmart, and J. Rice. 1983. "Avian and vegetation community structure and their seasonal relationships in the lower Colorado River Valley." Condor 85: 392–405.

Arizona Department of Water Resources. 1997. "Arizona Water Banking Authority Study Commission: Interim Report." Phoenix: Arizona Department of Water Resources.

Ball, J. T., J. B. Picone, and P. D. Ross. 1994. "Evapotranspiration by riparian vegetation along the Lower Colorado River." Report No. 1-CP-30-08910. Reno, NV: Desert Research Institute.

Baum, B. R. 1967. "Introduced and naturalized tamarisks in the United States and Canada (Tamaricaceae)." *Baileya* 13: 19–25.

———. 1978. *The Genus* Tamarix. Jerusalem: Israel Academy of Sciences and Humanities.

Berry, W. L. 1970. "Characteristics of salts secreted by *Tamarix aphylla*." *American Journal of Botany* 57: 1226–1230.

Blackburn, W. H., R. W. Knight, and J. L. Schuster. 1982. "Saltcedar influence on sedimentation in the Brazos River." *Journal of Soil and Water Conservation* 37: 298–301.

Blaney, H. F., C. A. Taylor, A. A. Young, and H. G. Nickle. 1933. "Water losses under natural conditions from wet areas in southern California." Bulletin 44. Part 1. California Department of Public Works, Division of Water Resources.

Bowie, J. E. and W. Kam. 1968. "Use of water by riparian vegetation in Cottonwood Wash, Arizona." Report No. 1858. Washington: U.S. Geological Survey.

Bowser, C. W. 1952. "Water conservation through elimination of undesirable phreatophyte growth." *Transactions of the American Geophysical Union* 33: 72–74.

Brock, J. H. 1994. "*Tamarix* spp. (salt cedar), an invasive exotic woody plant in arid and semi-arid riparian habitats of western USA." In *Ecology and Management of Invasive Riverside Plants,* edited by L. C. deWaal et al., 27–43. Chichester: John Wiley and Sons.

Brown, B. T. and M. W. Trosset. 1989. "Nesting-habitat relationships of riparian birds along the Colorado River in Grand Canyon, Arizona." *Southwestern Naturalist* 34: 260–270.

Bureau of Reclamation. 1992. "Vegetation management study—Lower Colorado River, Phase I." Boulder City, NV: Bureau of Reclamation, Lower Colorado Region.

———. 1995. "Vegetation management study, Lower Colorado River: Phase II final report." Boulder City, NV: Bureau of Reclamation, Lower Colorado Region.

Busch, D. E. and S. D. Smith. 1993. "Effects of fire on water and salinity relations of riparian woody taxa." *Oecologia* 94: 186–194.

————. 1995. "Mechanisms associated with decline of woody species in riparian ecosystems of the southwestern U.S." *Ecological Monographs* 65: 347–370.

Christensen, E. M. 1962. "The rate of naturalization of *Tamarix* in Utah." *American Midland Naturalist* 68: 51–57.

Cleverly, J. R., S. D. Smith, A. Sala, and D. A. Devitt. 1997. "Invasive capacity of *Tamarix ramosissima* in a Mojave Desert floodplain: the role of drought." *Oecologia* 111: 12–18.

Colby, B. G. 1989a. "The economic value of instream flows—can instream values compete in the market for water rights?" In *Instream Flow Protection in the West*, edited by L. J. MacDonnell et al., 87–102. Boulder, CO: Natural Resources Law Center.

————. 1989b. "Estimating the value of water in alternative uses." *Natural Resources Journal* 29: 511–527.

Costanza, R., R. d'Arge, R. deGroot, S. Farber, M. Grasso, B. Hannon, K. Limburg, S. Naeem, R. V. O'Neill, J. Paruelo, R. G. Raskin, P. Sutton, and M. van den Belt. 1997. "The value of the world's ecosystem services and natural capital." *Nature* 387: 253–260.

Cottam, C. and J. B. Trefethen. 1968. *Whitewings: The Life History, Status, and Management of the Whitewinged Dove*. Princeton, NJ: Van Nostrand.

Culler, R. C., R. L. Hanson, R. M. Myrick, R. M. Turner, and F. P. Kipple. 1982. "Evapotranspiration before and after clearing phreatophytes, Gila River flood plain, Graham County, Arizona." Report No. 655-P. Washington: U.S. Geological Survey.

Daily, G. C., ed. 1997. *Nature's Services: Societal Dependence on Natural Ecosystems*. Washington: Island Press.

Daubert, J. T., R. A. Young, and S. L. Gray. 1979. "Economic benefits from instream flow in a Colorado mountain stream." Report No. 91. Fort Collins: Colorado State University.

Davenport, D. C., P. E. Martin, and R. M. Hagan. 1982. "Evapotranspiration from riparian vegetation: water relations and irrecoverable losses for saltcedar." *Journal of Soil and Water Conservation* 37: 233–236.

DeLoach, C. J. 1997. "Biological Control of Weeds in the United States and Canada." In *Assessment and Management of Plant Invasions*, edited by J. O. Luken and J. W. Thieret, 172–194. New York: Springer.

Diamond, P. A. and J. A. Hausman. 1993. "On contingent valuation measurement of nonuse values." In *Contingent Valuation: A Critical Assessment*, edited by J. A. Hausman, 3–38. New York: Elsevier.

Dukes, J. S. and H. A. Mooney. 1999. "Does global change increase the success of biological invaders?" *Trends in Ecology and Evolution* 14: 135–139.

Ellis, L. M. 1995. "Bird use of saltcedar and cottonwood vegetation in the Middle Rio Grande Valley of New Mexico, U.S.A." *Journal of Arid Environments* 30: 339–349.

Engel-Wilson, R. W. and R. D. Ohmart. 1978. "Floral and attendant faunal changes on the lower Rio Grande between Fort Quitman and Presidio, Texas." Report No. WO-12, 139–147. Washington: U.S. Forest Service.

Everitt, B. L. 1980. "Ecology of saltcedar: a plea for research." *Environmental Geology* 3: 77–84.

Gatewood, J. S., T. W. Robinson, B. R. Colby, J. D. Hem, and L. C. Halfpenny. 1950.

"Use of water by bottom-land vegetation in Lower Safford Valley, Arizona." Report No. 1103. Washington: U.S. Geological Survey.

Gay, L. W. and R. K. Hartman. 1982. "ET measurements over riparian saltcedar on the Colorado River." *Hydrology and Water Resources of Arizona and the Southwest* 12: 9–15.

Gibbons, D. C. 1986. *The Economic Value of Water.* Washington: Resources for the Future.

Giorgi, F., L. O. Mearns, C. Shields, and L. McDaniel. 1998. "Regional nested model simulations of present day and 2xCO$_2$ climate over the Central Plains of the U.S." *Climatic Change* 40: 457–493.

Gleick, P. H. 1990. "Vulnerability of Water Systems." In *Climate Change and U.S. Water Resources,* edited by P. E. Waggoner 223–242. New York: John Wiley and Sons.

Goulder, L. H. and D. Kennedy. 1997. "Valuing ecosystem services: philosophical bases and empirical methods." In *Nature's Services,* edited by G. C. Daily, 23–48. Washington: Island Press.

Graf, W. L. 1978. "Fluvial adjustments to the spread of tamarisk in the Colorado Plateau region." *Geological Society of America Bulletin* 89: 1491–1501.

———. 1980. "Riparian management: a flood control perspective." *Journal of Soil and Water Conservation* 35: 158–161.

Great Western Research. 1989. "Economic analysis of harmful and beneficial aspects of saltcedar." Report No. 8-CP-30-05800. Mesa, AZ: Bureau of Reclamation.

Grimm, N. B., A. Chacon, C. N. Dahm, S. W. Hostetler, O. T. Lind, P. L. Starkweather, and W. W. Wurtsbaugh. 1997. "Sensitivity of aquatic ecosystems to climatic and anthropogenic changes: the Basin and Range, American Southwest, and Mexico." In *Freshwater Ecosystems and Climate Change in North America,* edited by C. E. Cushing, 205–222. Chichester: John Wiley and Sons.

Hadley, R. F. 1961. "Influence of riparian vegetation on channel shape, northeastern Arizona." Report No. 424-C. Washington: U.S. Geological Survey.

Hausman, J. A. 1993. *Contingent Valuation: A Critical Assessment.* New York: Elsevier.

Huenneke, L. F. 1997. "Outlook for plant invasions: interactions with other agents of global change." In *Assessment and Management of Plant Invasions,* edited by J. O. Luken and J. W. Thieret, 95–103. New York: Springer.

Hunter, W. C., R. D. Ohmart, and B. W. Anderson. 1988. "Use of exotic saltcedar (*Tamarix chinensis*) by birds in arid riparian systems." *Condor* 90: 113–123.

Jackson, J., J. T. Ball, and M. R. Rose. 1990. *Assessment of the Salinity Tolerance of Eight Sonoran Desert Riparian Trees and Shrubs.* Yuma, AZ: Bureau of Reclamation.

Johns, E. L. 1990. *Vegetation Management Study, Lower Colorado River: Appendix 1, Water Use of Naturally Occurring Vegetation.* Denver, CO: Bureau of Reclamation

Loomis, J. B. and D. S. White. 1996. "Economic benefits of rare and endangered species: summary and meta-analysis." *Ecological Economics* 18: 197–206.

Loope, L. L., P. G. Sanchez, P. W. Tarr, L. L. Loope, and R. L. Anderson. 1988. "Biological invasions of arid land reserves." *Biological Conservation* 44: 95–118.

Lovich, J. E. 1996. "A brief overview of the impact of *Tamarisk* infestation on native plants and animals." In *Saltcedar Management Workshop,* edited by J. DiTomaso and C. E. Bell. Rancho Mirage, CA: U.C. Cooperative Extension and CalEPPC.

Macdonald, I. A. W., L. L. Loope, M. B. Usher, and O. Hamann. 1989. "Wildlife conservation and the invasion of nature reserves by introduced species: a global perspective." In *Biological Invasions: A Global Perspective,* edited by J. A. Drake et al., 215–255. New York: John Wiley and Sons.

Maddux, H. R., W. R. Noonan, and L. A. Fitzpatrick. 1993. *Overview of the Proposed Critical Habitat Designation for the Four Colorado River Endangered Fishes.* Salt Lake City: U.S. Fish and Wildlife Service.

Matusak, J. P. 1998. *Colorado River Matters.* Los Angeles: Metropolitan Water District of Southern California.

McDonald, C. C. and G. H. Hughes. 1968. "Studies of consumptive use of water by phreatophytes and hydrophytes near Yuma, Arizona." Report No. 655-E. Washington: U.S. Geological Survey.

Morrison, J. I. 1996. *The Sustainable Use of Water in the Lower Colorado River Basin.* Oakland, CA: The Pacific Institute and the Global Water Policy Project.

Muckel, D. C. and H. F. Blaney. 1945. *Utilization of the Waters of Lower San Luis Rey Valley, San Diego County, California.* Los Angeles, CA: Division of Irrigation, Soil Conservation Service.

Nabhan, G. P. and S. L. Buchmann. 1997. "Services provided by pollinators." In *Nature's Services: Societal Dependence on Natural Ecosystems,* edited G. C. Daily, 133–150. Washington: Island Press.

Nash, L. L. and P. H. Gleick. 1991. "Sensitivity of streamflow in the Colorado Basin to climatic changes." *J. Hydrology* 125: 221–241.

National Park Service. 1981. *Proposed Natural and Cultural Resources Management Plan and Draft EIS, Death Valley NM.* Washington: U.S. Dept. of the Interior.

Neill, W. M. 1983. "The tamarisk invasion of desert riparian areas." Report No. 83-4. Desert Protective Council, Inc., Spring Valley, CA.

Penny, R. 1991. *The Whitewater Sourcebook: A Directory of Information on American Whitewater Rivers.* Birmingham, AL: Menasha Ridge Press.

Pimentel, D., C. Wilson, C. McCullum, R. Huang, P. Dwen, J. Flack, Q. Tran, T. Saltman, and B. Cliff. 1997. "Economic and environmental benefits of biodiversity." *Bioscience* 47: 747–757.

Pimm, S. L. 1997. "The value of everything." *Nature* 387: 231–232.

Postel, S. and S. Carpenter. 1997. "Freshwater Ecosystem Services." In *Nature's Services: Societal Dependence on Natural Ecosystems,* edited by G. C. Daily, 195–214. Washington: Island Press.

Powell, J. W. (1895). *Canyons of the Colorado.* Flood and Vincent. Reprinted as (1961). *The Exploration of the Colorado River and its Canyons.* New York: Dover Publications.

Qashu, H. K. and D. D. Evans. 1967. "Water disposition in a stream channel with riparian vegetation." *Soil Science Society of America Proceedings* 31: 263–269.

Rejmanek, M. and D. M. Richardson. 1996. "What attributes make some plant species more invasive?" *Ecology* 77: 1655–1661.

Robinson, T. W. 1965. "Introduction, spread, and areal extent of saltcedar (*Tamarix*) in the western states." Report No. 491-A. Washington: U.S. Geological Survey.

———. 1970. "Evapotranspiration by woody phreatophytes in the Humboldt River Valley, near Winnemucca, Nevada." Report No. 491-D. Washington: U.S. Geological Survey.

Robinson, T. W. and C. W. Bowser. 1959. "Buckeye Project—water use by saltcedar." Report No. 59-3. Menlo Park, CA: U.S. Geological Survey and Bureau of Reclamation.

Sala, A., S. D. Smith, and D. A. Devitt. 1996. "Water use by *Tamarix ramosissima* and associated phreatophytes in a Mojave Desert floodplain." *Ecological Applications* 6: 888–898.

Salas, D. E., J. R. Carlson, B. E. Ralston, D. A. Martin, and K. R. Blaney. 1996. "Riparian vegetation mapping of the lower Colorado River from the Davis Dam to the international border." Report No. 8260-96-03. Denver: Bureau of Reclamation.

Salati, E. and C. A. Nobre. 1991. "Possible climatic impacts of tropical deforestation." *Climatic Change* 19: 177–196.

Schaake, J. C. 1990. "From climate to flow." In *Climate Change and U.S. Water Resources,* edited by P. E. Waggoner, 177–206. New York: John Wiley and Sons.

Schumann, H. H. 1967. "Water resources of lower Sycamore Creek, Maricopa County, Arizona." Tucson: M.S. thesis, University of Arizona.

Shafroth, P. B., J. M. Friedman, and L. S. Ischinger. 1995. "Effects of salinity on establishment of *Populus fremontii* (cottonwood) and *Tamarix ramosissima* (saltcedar) in southwestern United States." *Great Basin Naturalist* 55: 58–65.

Shaw, H. and J. Jett. 1959. "Mourning dove and white-winged dove nesting in the Gila River bottom between Gillespie Dam and the junction of the Salt and Gila Rivers, Maricopa County, Arizona." Report No. W-53-R-10, WPS, J2. Phoenix: Arizona Fish and Game Department.

Simberloff, D., D. C. Schmitz, and T. C. Brown. 1997. *Strangers in Paradise: Impact and Management of Nonindigenous Species in Florida.* Washington, D.C.: Island Press.

Sisneros, D. 1994. *Upper Colorado Region Saltcedar Cost Analysis/Evaluation.* Denver: Bureau of Reclamation.

Sogge, M. K., R. M. Marshall, S. J. Sferra, and T. J. Tibbitts. 1997a. "A southwestern willow flycatcher natural history summary and survey protocol." Report No. NPS/NAUCPRS/NRTR-97/12. Flagstaff: National Park Service.

Sogge, M. K., T. J. Tibbitts, and J. R. Petterson. 1997b. "Status and breeding ecology of the southwestern willow flycatcher in the Grand Canyon." *Western Birds* 28: 142–157.

Stegner, W. 1954. *Beyond the Hundredth Meridian.* Boston: Houghton Mifflin.

Taylor, J. P. and K. C. McDaniel. 1998. "Restoration of saltcedar (*Tamarix* ipp.)-infested floodplains on the Bosque del Apache National Wildlife Refuge." *Weed Technology* 12: 345–352.

Thomsen, B. W. and H. H. Schumann. 1968. "Water resources of the Sycamore Creek Watershed, Maricopa County, Arizona." Report No. 1861. Washington: U.S. Geological Survey.

U.S. Fish and Wildlife Service. 1997. "Endangered and threatened wildlife and plants; final determination of critical habitat for the southwestern willow flycatcher." *Federal Register* 62: 39, 129–39, 147.

van Hylckama, T. E. A. 1974. "Water use by saltcedar as measured by the water budget method." Report No. 491-E. Washington: U.S. Geological Survey.

———. 1980. "Weather and evapotranspiration studies in a saltcedar thicket, Arizona." Report No. 491-F. Washington: U.S. Geological Survey.

van Wilgen, B. W., R. M. Cowling, and C. J. Burgers. 1996. "Valuation of ecosystem services." *BioScience* 46: 184–189.

Vitousek, P. 1986. "Biological invasions and ecosystem properties: can species make a difference?" In *Ecology of Biological Invasions of North America and Hawaii*, edited by H. A. Mooney and J. A. Drake, 163–176. New York: Springer-Verlag.

Waggoner, P. E. and J. Schefter. 1990. "Future water use in the present climate." In *Climate Change and U.S. Water Resources*, edited by P. E. Waggoner, 19–40. New York: John Wiley and Sons.

Walker, L. R. and S. D. Smith. 1997. "Impacts of invasive plants on community and ecosystem properties." In *Assessment and Management of Plant Invasions*, edited by J. O. Luken and J. W. Thieret, 69–86. New York: Springer.

Warren, D. K. and R. M. Turner. 1975. "Saltcedar seed production, seedling establishment, and response to inundation." *Arizona Academy of Science* 10: 131–144.

Weeks, E. P., H. L. Weaver, G. S. Campbell, and B. T. Tanner. 1987. "Water use by saltcedar and by replacement vegetation in the Pecos River floodplain between Acme and Artesia, New Mexico." Report No. 491-G. Washington: U.S. Geological Survey.

Wiesenborn, W. D. 1996. "Saltcedar impacts on salinity, water, fire frequency, and flooding." In *Proceedings of the Saltcedar Management Workshop*, 9–12. Rancho Mirage, CA.

Wigley, T. M. L. and P. D. Jones. 1985. "Influences of precipitation changes and direct CO_2 effects on streamflow." *Nature* 314: 149–152.

Yong, W. and D. M. Finch. 1997. "Migration of the willow flycatcher along the Middle Rio Grande." *Wilson Bulletin* 109: 253–268.

Young, A. A. and H. F. Blaney. 1942. "Use of water by native vegetation." Bulletin 50. Division of Water Resources, State of California.

Young, R. A. 1984. "Local and regional economic impacts." In *Water Scarcity: Impacts on Western Agriculture*, edited by E. A. Englebert and A. F. Schuering, 244–272. Berkeley: University of California Press.

Zimmerman, J. A. C. 1997. *Biology and distribution of* Tamarix chinensis *Lour. and* T. parviflora *DC., Tamaricaceae*. Flagstaff, AZ: U.S. Geological Survey, Biological Resources Division.

Part III

Regional Examples

Chapter 13

≫

Invasive Alien Species and Global Change: A South African Perspective

David M. Richardson, William J. Bond,
W. Richard J. Dean, Steven I. Higgins,
Guy F. Midgley, Suzanne J. Milton,
Leslie W. Powrie, Michael C. Rutherford,
Michael J. Samways, and Roland E. Schulze

South African ecosystems have been affected by invasive alien organisms from most major taxonomic groups (Macdonald et al. 1986). Invasions in South Africa are, however, unique in several respects when compared with those in other parts of the world. Noteworthy features for plants invading South Africa are the huge extent and impacts of alien trees and shrubs, and the fact that very few alien grasses have caused real damage (Richardson et al. 1997). Although several alien birds have spread over large areas, all are commensals, and none have had major impacts on natural systems (Brooke et al. 1986). Alien mammals have fared exceptionally poorly as invaders of intact systems

in South Africa (Brooke et al. 1986; cf. Ebenhard 1988 for other parts of the world). As in other parts of the world, alien insects have caused little (if any) disruption to ecosystems in South Africa without significant human disturbance.

Invasive aliens are having ecological and economical impacts, and managing aliens is a major task in land set aside for conservation and water production (van Wilgen et al. 1990). In many cases, significant investments have been made in designing and implementing long-term strategies of integrated management. For plants, these usually involve mechanical, chemical, and biological control measures. Programs such as the "Working for Water" initiative represent a major investment in the future of the region's famously diverse natural heritage and in the sustained yield of various goods and services from natural and seminatural systems (van Wilgen et al. 1997). Increasingly, management of aliens is being initiated as a result of financial considerations (e.g., van Wilgen et al. 1996). It is therefore essential to explore scenarios for the future to ensure that flexibility can be built into management strategies.

The emergence of such enhanced awareness of the need to deal with invasive alien organisms coincides with a period of profound social transformation in South Africa following centuries of colonialism and minority rule. Social transformation in the region involves land reallocation, entailing, among other things, a shift from intensive agriculture using advanced technology to less intensive practices over a much greater area. Also important is the rapid trend toward urbanization and rural depopulation. This is giving rise to metropolitan conurbations and hubs of human activity, with a rapid growth in the extent of "informal settlements" (shack towns) and escalating impacts on the environment through pollution and unsustainable demands for resources such as water and fuelwood. These factors are already altering the dimensions of the problems with invasive alien organisms. Further changes at local and regional scales, together with changes at a global scale in atmospheric composition and climate are very likely to cause a reorganization of invasive alien organisms. The likely nature and dimensions of the impacts of these rapidly changing patterns of land use on the aliens problem have yet to be thoroughly assessed. There is, however, no doubt that changes such as those outlined here will result in the inexorable replacement of many mature (often species-rich) ecosystems by early-successional states in which the vegetation is dominated by recently established and short-lived species. Higher rates of population turnover in systems subjected to increased human-induced disturbance create conditions where the plant cover is likely to respond more quickly to climate change, both by permitting invasions and extinctions and by allowing rapid genetic changes within existing populations.

For several reasons, South Africa provides a fascinating arena for reflection on the likely impacts of global change on alien species:

- There are many opportunities for invasion in the rich array of natural ecosystems: aquatic systems, grasslands, deserts, forests, mediterranean-type shrublands, savannas, and semiarid shrublands. All these systems have analogues in other parts of the world; these provide useful natural experiments that provide many clues on likely trajectories of change. Useful insights have already emerged from comparisons with regions where the same alien organisms are present but where different conditions (climate, soil nutrients, disturbance) exist (e.g., Richardson et al. 1994 for *Pinus*).
- The ecology of invasive alien species has been reasonably well studied in South Africa (Macdonald et al. 1986). We thus have good benchmarks and the ecological understanding required for making informed predictions.
- South Africa is in a phase of rapid social change that is exerting many new pressures on the environment, many of which are likely to affect the distribution and abundance of alien species.

Rather than discuss scenarios for a wide range of alien organisms in South Africa in general terms, we focus on plants, birds, and insects. The determinants of invasive success (or lack thereof) and distribution limits are best understood for these groups. For plants and birds, South African invasions are unique in many facets. Although the situation with alien insects is similar in broad terms to many other parts of the world (important impacts of aliens in human-modified systems, but very little impact in natural systems), some interesting trends are evident. We feel that the suite of approaches selected here for exploring likely changes in these taxa has potential for application in other parts of the world.

Alien Plant Invasions

Biogeoclimatic Modeling

Biogeoclimatic modeling provides a useful method for exploring the potential response of particular species to changing environmental conditions. Here we demonstrate potential applications of this approach by deriving profiles for several important invasive alien plant species in South Africa and exploring how predicted changes in climate could change distribution limits. This was achieved by matching comprehensive distribution records in South Africa with environmental (climatic and soil) records at a spatial resolution detailed enough to avoid ambiguity caused through local heterogeneity.

We selected for study five plant taxa, each representing an important life-form in South Africa's invasive alien flora. Taxa were also selected to illustrate

particular aspects likely to be important when attempting to predict the effects of climate change based on information derived from the current distribution of a plant species. The selected species were assumed to have had sufficient time (100–300 years) to occupy a large part of their potential range in South Africa:

1. *Briza maxima* (big quaking grass; Poaceae): a tufted annual grass from the Mediterranean Basin.
2. *Cirsium vulgare* (spear thistle; Asteraceae): a biennial subshrub, native to Europe and a weed in many parts of the world.
3. *Hakea sericea* (silky hakea; Proteaceae); an Australian shrub introduced to South Africa in 1858 that spread to cover thousands of hectares of natural vegetation in the fynbos (shrubland) biome.
4. *Opuntia ficus-indica* (prickly pear; Cactaceae): a succulent shrub native to Central America and Mexico, introduced in the early 1700s, that spread to cover about 900,000 ha before biocontrol reduced its levels of invasion.
5. *Prosopis* species (mesquite; Fabaceae): *Prosopis glandulosa, P. juliflora,* and *P. velutina* were introduced from North America during the 1800s (see Zimmermann [1991] for best estimates of arrival dates for each species). Hybrids of these species now cover large areas of the karoo (dry tableland).

Distribution data for these species were available from different sources, and we selected the best data for each species. For *Briza, Cirsium, Opuntia,* and *Prosopis* we utilized data from the ACKDAT (Acock's Database) database, which contains comprehensive plant abundance records for about 12,000 species over 3,500 sites well distributed throughout South Africa (Rutherford et al. 1996). Data for *Hakea sericea* came from the Protea Atlas project (Rebelo 1991). Data for all these species were available as exact coordinates. The data for *Prosopis* were much cruder than for the other species, as ACKDAT has only 10 records for this species (as opposed to 75 for *Briza*, 215 for *Cirsium*, and 288 for *Opuntia*). There were 2,838 records for *Hakea*.

A climatic database at a spatial resolution of 1 minute × 1 minute of a degree of latitude/longitude provided temperature and water availability information for almost half a million grid cells that cover the large climatic ranges found in South Africa. We used two primary and independent climatic determinants of plant establishment. The first was a low-temperature factor expressed as minimum temperature of the coldest month (monthly mean of daily values). The second was number of optimum growth days expressed as the number of days when the actual evapotranspiration is more than half the potential evaporation for the topsoil horizon and when monthly mean temperature exceeded 24°C. Growth days were calculated from daily soil-water budgeting routines using actual soil properties and assuming hydrological

vegetation characteristics. Optimum growth days fell to zero in a few high altitude areas that contained very few plant record sites and occurred outside the current area of model applications.

Environmental envelopes were derived for each species using the mean of the three minimum and three maximum extremes for each climatic parameter. The approach is described in more detail in Rutherford et al. (1996). Soil requirements were computed by matching localities to a national coverage of eighty-four broad, natural, homogenous soil types identified by the Institute of Soil, Climate, and Water (Schulze 1997).

We computed envelopes both for present conditions and for a likely scenario of climate change involving a 2°C increase at 30° South, with temperature change increasing at higher latitudes, and no change in precipitation (South African Committee for Climate Change). The likely temperature increases result in reduced frost incidence and a decrease in number of optimum growth days in more arid parts due to increased evapotranspiration and to an increase in number of optimum growth days in the more mesic areas owing to longer growing seasons. These changes impact a species metapopulation with characteristic sensitivity limits to the environment. Population configuration is reconciled with spatial environmental reconfiguration resulting in niche options.

Results of the analyses (Figs. 13.1–13.5) predict that the five species will be affected very differently by climate change. Warming is predicted to reduce the total area of suitable habitat to 63 percent (*Opuntia*), 78 percent (*Briza*), 87 percent (*Cirsium*), 90 percent (*Prosopis*) and 92 percent (*Hakea*) of the currently suitable area. In all cases, limited tolerance of particular soil conditions is likely to reduce the magnitude of potential change in distribution. This is most clearly evident for *Hakea sericea*, which is currently confined to the nutrient poor, sandstone-derived soils of the fynbos biome, with some plants in coastal KwaZulu-Natal (of the 2,838 locality records used, 96 percent were on five of the eighty-four soil types mapped for the country). Changing climatic conditions have little impact on its potential range other than making the current east coast enclave unsuitable (Fig. 13.3). For *Opuntia ficus-indica*, there is little difference between present and future areas of potential suitability. Nonetheless, it is important to note that biological control agents have greatly reduced the levels of invasion within range shown here. Invasion levels may increase or reinvasion may occur as a result of climate change (e.g., if biocontrol fails; see page 314 for further discussion). Our (crude) envelope based on *Prosopis* data from ACKDAT, and the known current distribution (Richardson et al. 1997) that was not used in deriving the envelopes, shows mesquite to be suited to the entire western half of the country (see page 322) "Processes and Costs of *Prosopis* Invasion," for qualifications and further discussion). According to our simulation,

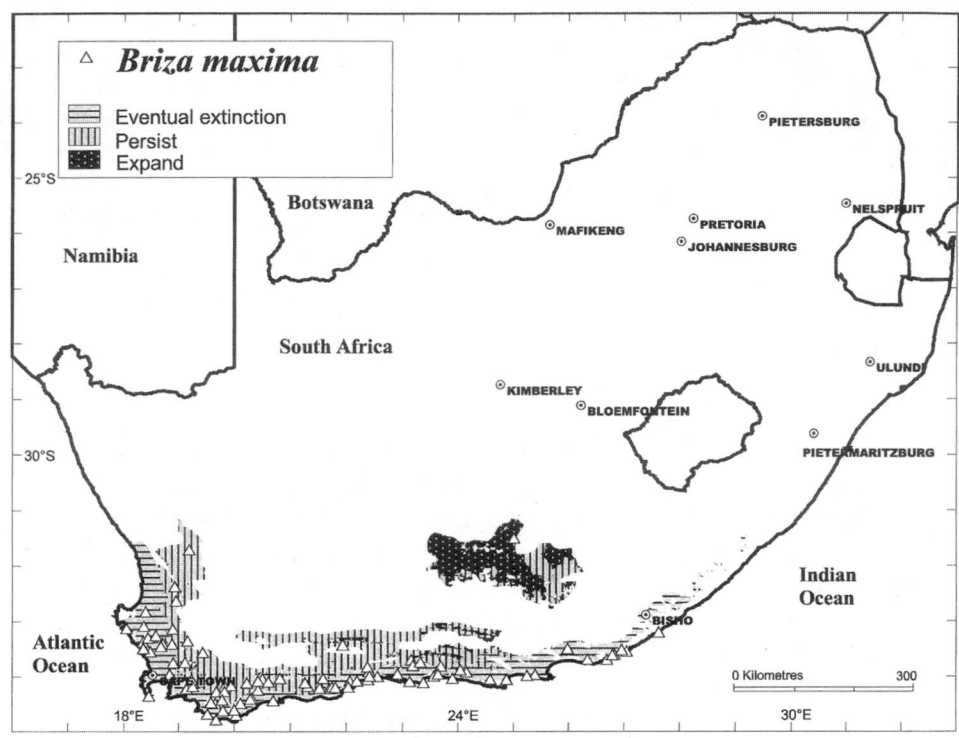

Figure 13.1 Projected shift in the distribution of *Briza maxima* in South Africa with climate change using biogeoclimatic modeling. Indicated are areas into which the species is expected to expand due to newly suitable environmental conditions ("Expand"); areas in which the species should persist owing to the environment remaining within the species' tolerance range ("Persist"); and areas in which the environmental conditions may become unsuitable for the species and lead to its eventual local extinction ("Eventual extinction"). Triangles represent recorded localities for the species.

increased temperatures will shrink the potential area for mesquite (Fig. 13.5).

Cirsium vulgare currently occupies a large range of sites in the eastern half of South Africa (Fig. 13.2), where it is apparently far more limited by soil requirements than by climate (it favors moist, nutrient-rich soils). Climate change is predicted to reduce the area of the country climatically suitable for this species (notably in the western half). However, since no suitable soils exist in this part of the country, changed conditions are not predicted to have any major influence on its distribution. Records from the ACKDAT database showed the C_3 grass (see Chapter 5) *Briza maxima* to be virtually confined to the southern and southwestern parts of the country. Predicted changes in cli-

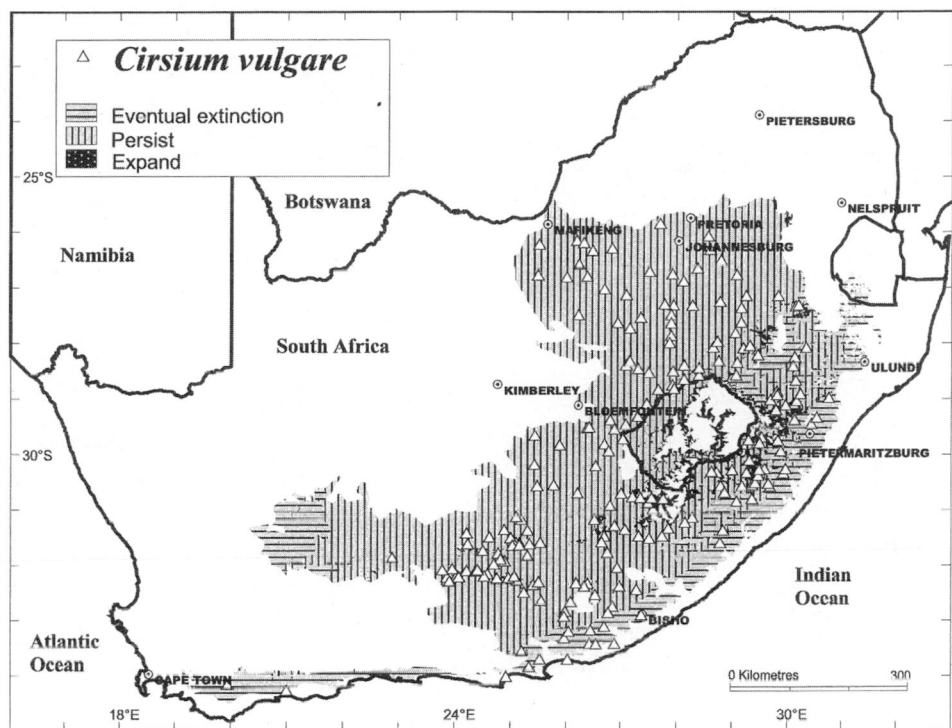

Figure 13.2. Projected shift in the distribution of *Cirsium vulgare* in South Africa with climate change using biogeoclimatic modeling (see Figure 13.1 caption for explanation of distribution categories).

mate result in an inland shift of the area of suitability for this species, and an increase in the potential range on the poorly drained soils in an area between Murraysberg, Tarkastad, and Cookhouse in the Great Karoo. If the five species we have selected for study are representative of the alien flora of the country, then our results suggest that temperature change of the magnitude considered here (*in the absence of other factors*) is unlikely to cause a fundamental reshuffling of alien plants.

But how accurate are the envelopes on which we have based our analyses? Since we based our assessments for four species on data in ACKDAT (collected between 1936 and 1975), this affords us the opportunity to consider any subsequent range changes (e.g., with reference to van Oudtshoorn 1992; Henderson 1995; Richardson et al. 1997) and to consider whether the envelopes derived using ACKDAT data match the current ranges (which reflect up to five decades of further spread). The range of *Opuntia ficus-indica* has possibly shrunk since these data were collected

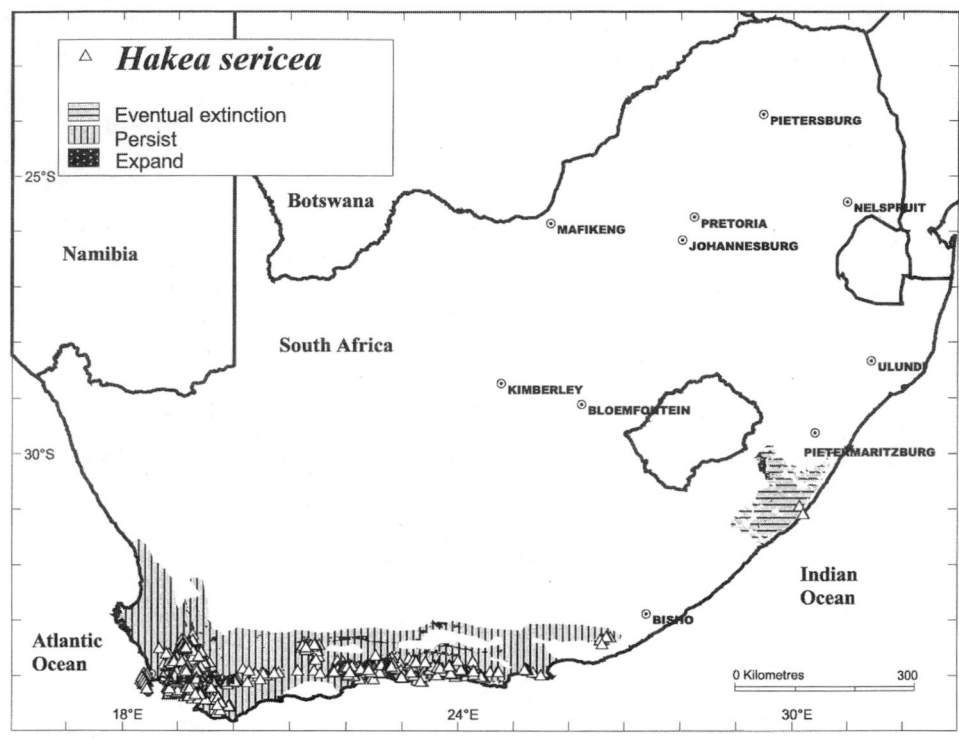

Figure 13.3. Projected shift in the distribution of *Hakea sericea* in South Africa with climate change using biogeoclimatic modeling.

(see page 314 on "How *Opuntia ficus-indica* Broke the Barriers and Was Pushed Back"). The current range of *Cirsium vulgare* (Henderson 1995) coincides very closely with the area of suitable habitat as computed, suggesting that the data used in building the environmental envelope for this species covered a reasonable selection of sites potentially suitable for this species. On the other hand, our analysis, based on early records of *Briza maxima,* did not predict the recent spread of this species into inland parts of eastern South Africa (van Oudtshoorn 1992, p. 256). Similarly, the meagre data in ACKDAT for *Prosopis* was clearly inadequate for defining a sound envelope, since this species has spread well beyond the area deemed to be appropriate in our model. These discrepancies raise an important issue: Clearly, the value of biogeoclimatic models depends fundamentally on the quality of the envelope. Many alien species, especially recent introductions, have yet to reach equilibrium distributions in South Africa, and care must be taken when applying such models.

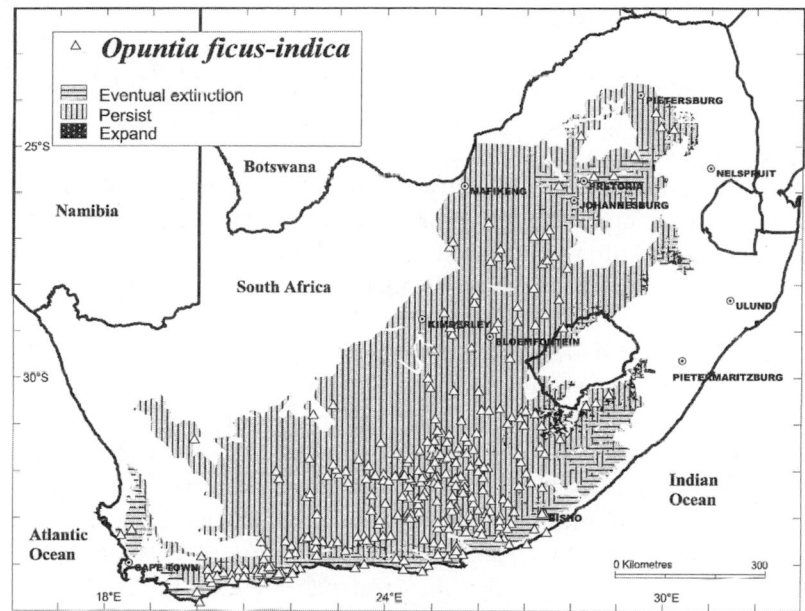

Figure 13.4. Projected shift in the distribution of *Opuntia ficus-indica* in South Africa with climate change using biogeoclimatic modeling.

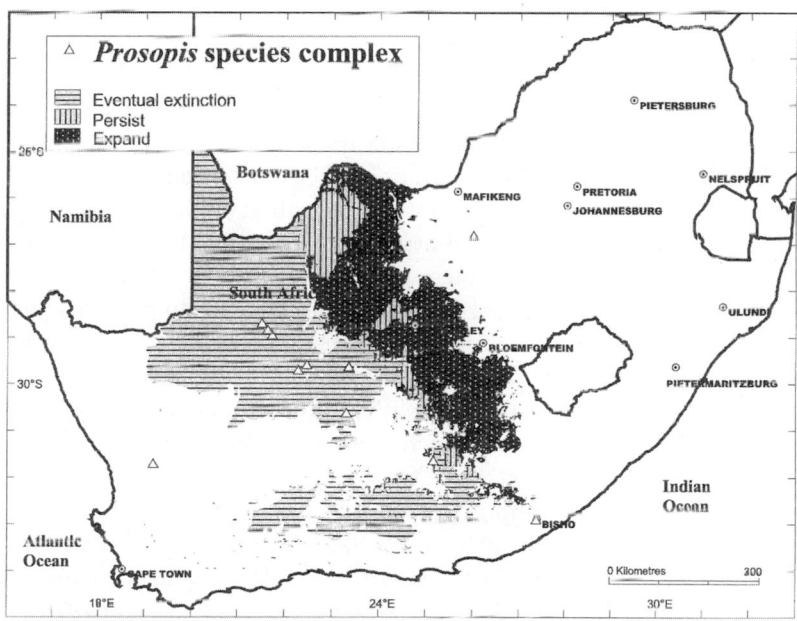

Figure 13.5. Projected shift in the distribution of *Prosopis* species in South Africa with climate change using biogeoclimatic modeling.

Plant Invasions and Global Change: Breaking the Barriers

Biogeoclimatic modeling is useful for exploring possible changes in climatic optima for species under scenarios of global change. In many cases, however, changes to conditions that influence establishment and population growth are likely to be much more important than climate change in affecting changes over the time frames under consideration (Bond and Richardson 1990). It is useful to conceptualize the many contributing factors as a series of barriers.

Kruger et al. (1986) suggested that in order for an alien organism to increase its range, it must overcome geographic, habitat, and biotic barriers. Dispersal is the key to the geographic barrier, whereas the habitat barrier is the result of preadaptation, genetic adjustment, climate change, or habitat modification. The biotic barrier falls away when predation is limited and suitable mutualists and facilitators are present in the new land. The invasion of South African habitats by *Opuntia ficus-indica, Pinus* spp., *Prosopis* spp., and C_3 grasses illustrates the role that dispersal, natural selection, predation, and habitat modification play in alien invasions, and suggests the role that global change might have in determining the future of "veteran" and "novice" alien organisms in this country. Our first example addresses the importance of fecundity of alien plants in overcoming the geographic barrier, and readily illustrates that aliens fare better than natives in fragmented landscapes.

A Simulation Study with *Acacia cyclops* in the Fynbos Lowlands

Biogeoclimatic modeling can predict the distribution of suitable sites for a plant species. The ability of species to occupy new sites of suitable environmental quality depends on their migration and colonization. The anticipated rates of climate change and the migration rates observed in the paleoecological record suggest that plant distributions will lag behind their potential distribution (Peters 1990). This problem is further compounded by the negative effect that another form of global change, habitat loss, has on potential migration rates (Pitelka et al. 1997). If we assume that preemptive competition and colonization rates strongly influence the structure of plant communities (Tilman 1997), it follows that species with rapid migration rates will be overrepresented in the communities that are reassembled during global change.

Migration rates are a function of several interacting factors: dispersal, fecundity, longevity, generation time, disturbance regime, landscape structure, and the distribution of habitat (Pitelka et al. 1997). Recent work on plant migration has shown that rare long-distance dispersal events most strongly determine the migration rate (Shigesada et al. 1995; Clark 1998; Cain et al. 1998; Higgins and Richardson 1999). Importantly, this work has shown that rare long-distance dispersal interacts positively and strongly with fecundity, because plants that produce more seeds are more likely to have a few

seeds travel long distances (Higgins and Richardson 1999). A consistent feature of alien plants is their high fecundity relative to native species in the same environment. The high fecundity of alien plants has been largely attributed to predator release (e.g., Hönig et al. 1992). The strong interaction between fecundity and long-distance dispersal suggests that alien plants should migrate faster than native species and that they should be less influenced by habitat loss. The implication of rapidly migrating alien plants is that we can expect alien plants to be overrepresented in the communities that are reassembled as global climate change proceeds.

A model developed by Higgins and Richardson (1999) provides a useful framework for exploring the potential migration rates of alien and native species migrating through increasingly fragmented landscapes. The model simulates the spatial demography of plant populations and uses this to predict invasion rates. We parameterized the model to simulate the spread of the Australian shrub *Acacia cyclops* across fynbos landscapes subject to different levels of habitat loss (10 percent to 90 percent). To explore how release from predators (and hence enhanced fecundity) influences a plant species' ability to respond to habitat loss, we used two parameterizations for *A. cyclops*. The first, the "home parameterization," represents the fecundity of *A. cyclops* in Australia. The second, the "foreign parameterization," simulates the fecundity of *A. cyclops* in fynbos where it is dramatically more fecund (Gill and Neser 1984; Gill 1985). The results of the simulation show that the migration abili-

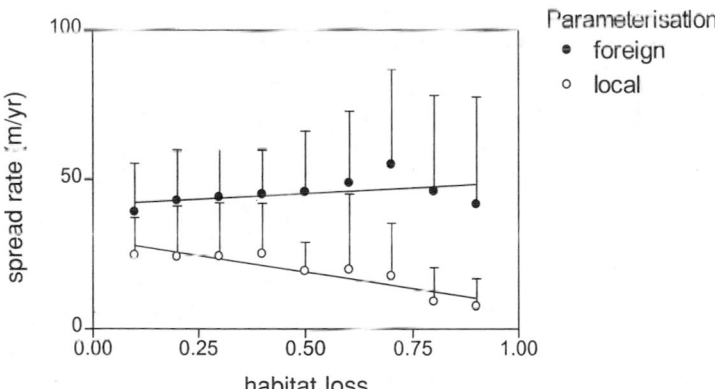

Figure 13.6. The effect of different levels of habitat loss on the mean spread rate (error bars are standard deviations of twenty-five model runs) predicted for *Acaia cyclops*. The foreign parameterization represents the situation in which individuals are released from herbivore pressure and allocate resources to reproduction rather than to herbivore defense. In the local parameterization individuals are subject to herbivore pressure and therefore have less resources to allocate to reproduction. These predictions are derived from a model developed by Higgins and Richardson (1999).

ty of the "foreign" version of *A. cyclops* is hardly influenced by the level of habitat loss, whereas the "home version" is significantly influenced by habitat loss (Fig. 13.6). The "foreign" *A. cyclops* produces so many seeds that even a small population will produce enough long-distance dispersers to jump across the barriers posed by fragmented landscapes. By contrast, the "home" *A. cyclops* has far fewer seeds and consequently rarely produces these jump dispersers. The superior migration and competitive ability of alien plants suggests a double bind for native species under global change. The results of the simulation model leads us to predict that alien species will be dramatically overrepresented in the new plant communities that are formed during global change.

How *Opuntia ficus-indica* Broke the Barriers and Was Pushed Back

A spineless form of *Opuntia ficus-indica* was introduced to South Africa in the early 1700s (Annecke and Moran 1978). It appears that the thornless variety gradually reverted to the thorny "wild-type," which, being less favored by herbivores, survived and spread effectively to become a problem plant in semiarid karoo and savanna (Annecke and Moran 1978). Although frequently planted in the karoo in 1770s, it only became a troublesome weed in the late 1800s (Zimmermann and Moran 1991). By 1942, the invaded area covered about 900,000 ha (Du Toit 1942). The cochineal insect *Dactylopius opuntiae* was introduced in 1938 as a biocontrol agent, and by 1946 had substantially reduced the density of cactus. As Zimmermann et al. (1986) have pointed out, the present distribution of *O. ficus-indica* in South Africa reflects the success of this biocontrol agent, as well as the response of the cactus to the environment.

Overlays of climatic and topographic features on a recent distribution map (Richardson et al. 1997) shows that *O. ficus-indica* is most abundant at altitudes below 1,400 meters in summer-rainfall regions with mean annual rainfall of 400–600 millimeters (or 60–80 rain days annually), and on rocky substrata. It therefore appears to be limited by summer aridity in the winter-rainfall region and in the central karoo, by freezing temperatures at high altitudes, and by sandy substrates in the Kalahari. Plantations of spineless prickly pear are established from cladodes (flattened photosynthetic branches resembling ordinary foliage leaves) at altitudes from 1,400 meters to 1,600 meters, and are used as fodder banks for sheep and cattle in dry and cold periods. Self-seeded prickly pear plants are not found at these altitudes.

Dispersal may be an additional factor affecting the spatial distribution and density of *O. ficus-indica*. Seeds are dispersed to perch sites by birds (particularly crows) and to riverbeds and woodlands by primates (humans, vervet monkeys and baboons) that eat the sweet, watery fruits. In the drier parts of the low-altitude karoo, this cactus is found mostly along riverbeds. This may be because of directed dispersal of seeds, particularly by crows and humans,

rather than the inability of the plant to establish on open karoo plains. Crows use human-made structures such as pylons and telephone poles for perching, roosting, and nesting (Macdonald and Macdonald 1983); and crow pellets, containing regurgitated bones and seeds, are most common around such perch sites, as are seedlings of prickly pear (Milton and Dean 1987).

It took *Opuntia ficus-indica* nearly two centuries to overcome geographical, habitat and biotic barriers in South Africa, but only 10 years for an imported natural enemy to curtail its population growth again (Annecke and Moran 1978; Zimmermann and Moran 1991). Factors that improve dispersal and seedling survival or reduce the fecundity of biocontrol agents, are likely to lead to rapid population expansion of *O. ficus-indica*. Climatic changes that may favor the spread of this species are a southwesterly extension of the summer rainfall zone, an increase in summer rainfall in the arid karoo, or a rise in minimum winter temperatures at altitudes above 1,400 meters in the karoo, grassland, and savanna biomes. The cochineal insect that has maintained prickly pear at low to moderate densities since the mid-1940s is particularly effective in hot arid areas. Wetter conditions limit the fecundity of this wind-dispersed insect (Zimmermann et al. 1986), and would therefore enable *O. ficus-indica* to expand its range and increase its density in the karoo. Increases in roads, overland electricity cables, human population, and crows are all likely to facilitate the spread of this and other Cactaceae. Regardless of global change and land-use scenarios, deep sands will probably remain free of *O. ficus-indica*.

The prickly pear invasion of the early 1900s was one of the worst agricultural catastrophes in South Africa's history. The nuisance value and economic cost of impenetrable thickets of spiny cactus is reflected in the numerous popular and scientific articles that refer to the labor, herbicide, and research invested in control during those years (Annecke and Moran 1978). At the peak of the invasion, *O. ficus-indica* reduced farming productivity and rural incomes so that landowners abandoned their properties. Severe overgrazing by domestic livestock, as well as by feral pigs and donkeys, occurred on the remaining usable veld (grassland with scattered trees and shrubs). Should *O. ficus-indica* escape its biocontrol agent now that the human population has grown from 10 million to 40 million people, the economic and social consequences would be far more severe.

Complex Interactions between Life-History Traits and Disturbance Determine Invasive Success: Approaches for Predicting How Global Change Will Affect Pine Invasions

Nine *Pinus* species are invasive in South Africa (Richardson and Higgins 1998). Five species (*P. elliottii, P. patula, P. pinaster, P. pinea* and *P. radiata*) feature in a list of the eighty-four most important environmental weeds in southern Africa compiled using criteria used in recent surveys (Richardson

et al. 1997). Another species (*P. halepensis*) also belongs in this category (Richardson and Higgins 1998). Pine invasions are most widespread and damaging in the fynbos biome, where *P. halepensis, P. pinaster,* and *P. radiata* are most widespread. Invasive pines also affect the grassland (*P. elliottii, P. patula,* and *P. taeda*) and the forest (mainly *P. patula, P. pinaster,* and *P. elliottii*) biomes (Richardson and Higgins 1998).

Information from several sources provides helpful insights on how the dimensions of pine invasions could alter in South Africa with global change. Evidence of determinants of range changes of pines in other parts of the world, both within and outside the natural range of *Pinus,* is useful. In a global review of pine invasions and range expansions, Richardson and Bond (1991) showed that interactions between pine seedlings and various biotic factors in the regeneration niche are fundamentally important in defining range limits. Pine seedlings are light-demanding and are easily suppressed by more vigorous plants. Even in cases where range changes were attributed to climate change, the proximate factor responsible for shifts in pine distribution and/or density was usually the ability of seedlings to survive interactions with other biota. Pines are well adapted to exploit competitive release as a result of disturbance, and are superb colonizers; they are excellent subjects for the study of potential range changes as a result of global change (Richardson and Rundel 1998).

Support for the view that alien pine distribution is fundamentally mediated by biotic barriers comes from a more detailed assessment of conditions that allowed pines to invade (or prevented them from invading) a wide range of habitats in the Southern Hemisphere. Conveniently, all the invasive pines in South Africa are also planted and are invasive to some extent in other parts of the Southern Hemisphere: *P. canariensis* (Australia), *P. elliottii* (Argentina, Australia), *P. halepensis* (Australia, New Zealand), *P. patula* (Madagascar, Malawi, New Zealand), *P. pinaster* (Australia, Chile, New Zealand, Uruguay), *P. pinea* (Australia), *P. radiata* (Australia, Chile, New Zealand), *P. roxburghii* and *P. taeda* (Argentina, Brazil, New Zealand) (Richardson et al. 1994; Richardson and Higgins 1998). In each area the degree of invasion has been influenced by different combinations of a suite of factors. By comparing the performance of the same species in different areas (where different combinations of factors interact) one can get a good idea of how changing conditions in a particular area are likely to affect invasive pines. We believe that geographically isolated "samples" can thus be used (with care) as surrogates for samples from a time series at one site.

Such a "correlative" approach reveals a list of features associated with pine-invaded sites (Richardson and Higgins 1998). Vegetation types may be crudely ranked according to their openness to invasion by pines: bare ground > dunes > grassland > shrubland > forest. Also, invasions are more likely in areas with

nutrient-poor soils and which lack an abundant cover of vigorous herbs. Susceptibility to invasion by pines increases with: proximity to large parent stands with a long residence time; reduced vegetation cover; moderate increases in the frequency of natural or human-induced disturbance; presence and abundance of organisms required for mutualistic interactions (e.g., seed-dispersing vertebrates and mycorrhizal symbionts). This scheme provides a qualitative procedure for assessing likely changes in the susceptibility of South African systems to pine invasions as a result of global change. There is good evidence to support the validity of this approach. For example, Southern Hemisphere forests are inherently fairly resistant to pine invasions. However, forests are invaded at many localities where one or more of the factors listed above have modified forest composition or structure (Richardson and Higgins 1998).

Such insights are useful for predicting changes in the susceptibility of systems to pine invasion. A predictive understanding, however, demands the ability to model interactions between invading pines and salient environmental factors in a mechanistic fashion. Disturbance is a fundamental mediator of pine invasions, but different plants respond in different ways to disturbance, and qualitatively different types of disturbance characterize different environments. Operational definitions of disturbance and plant response to disturbance are needed for a balanced perception of how pine invasions will be influenced by changing disturbance regimes. Higgins and Richardson (1998) developed a model that explicitly simulated the interactions between plants and disturbance regimes. This model enables us to explore the effects of changing disturbance regimes on invasion dynamics in South African grasslands, forests, and fynbos. The main aspect of global change in southern African grasslands is increased stocking rates, which causes more patchy and less intense fires. In shrublands such as fynbos, the increase in ignition sources is important; this leads to more frequent and less intense fires. Forests are subject to increasing levels of timber extraction, which alters opportunities for recruitment of invaders (see Higgins and Richardson 1998, Richardson and Higgins 1998 for details).

We modeled invasions of two idealized life-history syndromes, conforming with two major categories of pine life histories described by Keeley and Zedler (1998): (1) an "early-seral" pine typical of landscapes characterized by predictable stand-replacing fires; and (2) a "late-seral" pine that occurs in habitats with unpredictable stand-replacing fires (see Higgins and Richardson 1998 for details of the life history syndromes). These categories include most of the pine species that invade in the Southern Hemisphere. In agreement with invasion theory: (1) rates of invasion generally increased as disturbance levels increased, (2) grasslands and shrublands are more open than forests to invasion, and; (3) the early-seral pine is more invasive than the

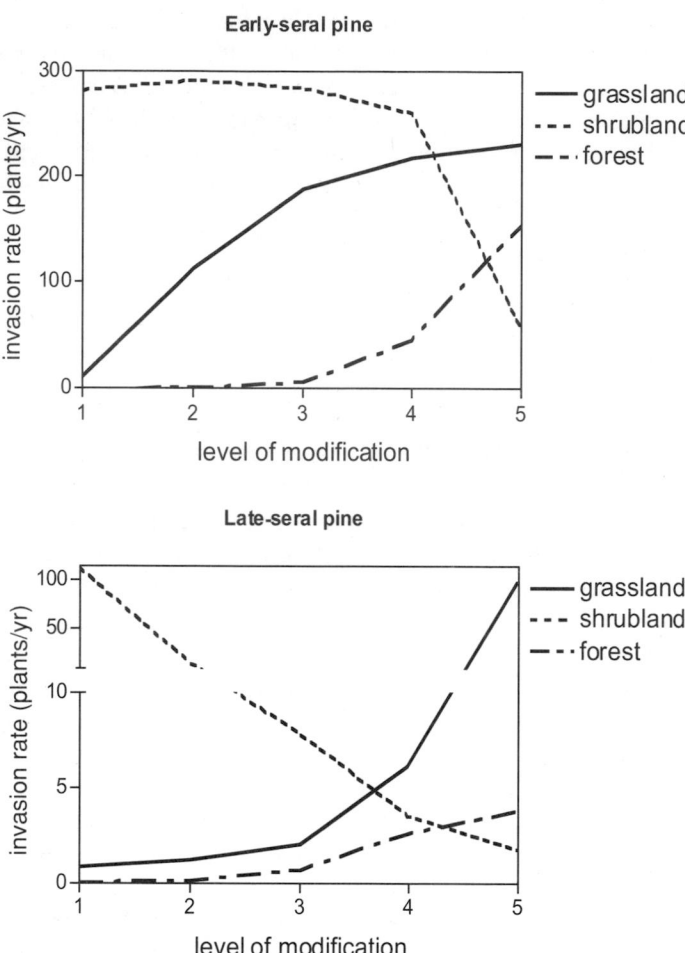

Figure 13.7. The predicted invasion of two-life-history syndromes of *Pinus* defined by Keeley and Zedler (1998) invading three environment types subject to increasing levels of human disturbance. These predictions are based on a spatially explicit, individual-based simulation model developed by Higgins and Richardson (1998).

late-seral pine (Fig. 13.7; see also Higgins and Richardson 1998, Richardson and Higgins 1998). More important, the simulations showed that interactions between environmental factors, disturbance regime, and life-history features are as important as the main effects. Plant responses to the anticipated effects of global change on disturbance regimes tended to be nonlinear and idiosyncratic. Such individualistic species responses are in agreement with observations on the response of North American forest species to the last postglacial.

For instance, although increasing levels of disturbance generally facilitate pine invasions, increased disturbance levels in shrublands may reduce the ability of late-seral pines to invade. The complexity of the causal pathways in invasions means that detailed understanding of how plants interact with anticipated changes in disturbance regimes is essential for predicting invasive success. The dynamics of such interactions are difficult to conceptualize without such simulation tools. We suggest that this approach is a useful way of exploring how global change could influence invasions. Much work, however, will be needed to resolve which key interactions are involved.

Processes and Costs of *Prosopis* Invasion

Prosopis glandulosa, P. juliflora, and *P. velutina* were introduced to karoo and arid savanna areas in the late 1800s (Zimmermann 1991). Within 100 years these species and their hybrids have formed dense stands over 180,000 ha, mainly in the northern Cape (Harding and Bate 1991). The densest invasions in this arid region are in almost frost-free, summer-rainfall areas on alkaline sandy soils where groundwater is near the surface. Our predictions of the effects of global change on the extent of future invasions are based on known responses of the various life-history stages of *Prosopis* spp. to interactions, conditions, resources, and disturbances (Table 13.1).

Figure 13.8 summarizes factors that may influence the range and abundance of *Prosopis* in South Africa. Changes that increase minimum winter temperatures and reduce the frequency of frost should enable *Prosopis* spp. to invade at higher altitudes where they are currently excluded by frost. Elevated nighttime temperatures, likely to be caused by atmospheric pollution or increased cloud cover, would enhance growth and productivity of *Prosopis,* increasing its invasiveness. Access to more water or increased water-use efficiency during the growing season would increase seed production, germination, seedling survival, competitive ability, and growth through improved *Rhizobium* infection and maintenance of larger leaf areas. Increased availability of moisture in summer may be brought about by a shift in rainfall seasonality. Increased summer rainfall in the southwestern Cape may lead to an increase in *Prosopis* in the winter-rainfall succulent karoo, but the shrub is unlikely to invade fynbos on acid sand and sandstone. Elevated CO_2, larger rainfall events in summer, a rise in the water table, or expansion of cultivated areas under irrigation might lead to increased frequency and density of *Prosopis* in dryland sites away from riverbeds in the karoo.

Growth in human and domestic animal populations on rangelands will increase seed dispersal to suitable microsites along watercourses. An increase in the volume of vehicular transport will disperse *Prosopis* seeds widely. Intensification of land use in arid and semiarid areas is likely to exacerbate

Table 13.1. Factors leading to range expansion or population density increases in *Prosopis* spp.

Factor	Effect	Evidence
Hybridization, local selection	Makes future generation better fitted for local conditions	Assumption based on theory of natural selection
Increased rainfall or large rainfall events with temperatures of 30–35°C	Increased germination, seedling survival, growth, maturation rate, and seed production	Poynton (1987), Perez and De Moraes (1990), Hull (1958)
Higher nighttime temperatures (>13°C) in summer	Increased growth rate	Peacock and McMillan (1965), Hull (1958)
Reduced winter frost days and higher winter temperatures	Increased seedling survival	Henderson and Harding (1992), Peacock and McMillan (1965), Felker et al. (1982), Poynton (1987)
Elevated atmospheric CO_2	Increases water-use efficiency of C_3 plants enabling them to compete more effectively with C_4 grasses	Polley et al. (1994, 1996)
Elevated water table or more rain	Increases leaf area, improves growth and survival of established trees	Stromberg et al. (1993), Ansley et al. (1992)
Irrigation	Enables seedlings to establish in dry years and in sites normally too dry for germination; increased *Rhizobium* symbionts	Gurbachan et al. (1990), Miettinen et al. (1988)
Suitable dispersers, including cattle, sheep, horses, donkeys, large antelope, and porcupines	Directed dispersal to bare soil patches, nutrient-enriched, better-watered sites. One sheep can spread 1,000 intact seeds daily.	Hoon et al. (1995), Marmillon (1986), Archer (1990, 1995), Prajapati et al. (1994)
Vehicular translocations of domestic livestock between camps, farms, and districts	Seed passage through sheep takes 2–10 days. Many *Prosopis* seeds may be moved hundreds of kilometers in animals.	Hoon et al. (1995)
Flash flooding of rivers	Long-distance dispersal to suitable sites on deep, fertile, disturbed alluvial soils	Henderson and Harding (1992)
Reduction of herbaceous cover by grazing	Facilitates seedling establishment by reducing competition for water and light	Brown and Archer (1989), Bush and Van Auken (1995), Van Auken and Bush (1988, 1997), Henderson and Harding (1992)

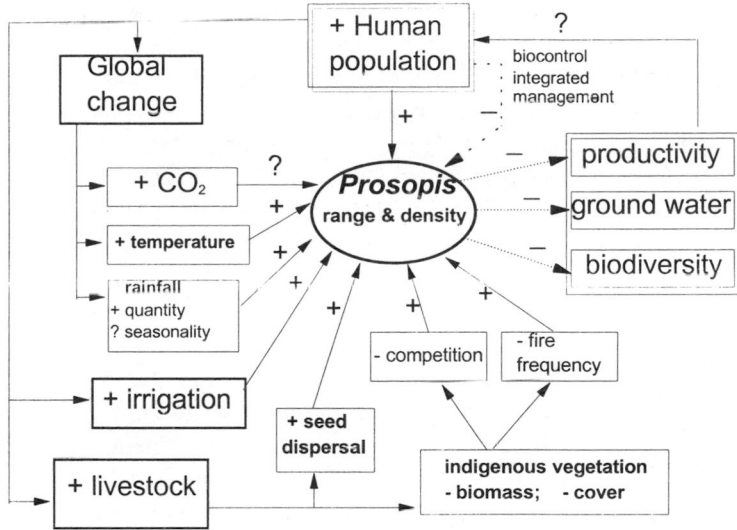

Figure 13.8. Factors leading to increases or decreases in the range and abundance of *Prosopis* spp. in South Africa.

flash flooding, seed transport, and disturbance in seasonal river courses. Increased densities of livestock, particularly cattle, reduce competition from indigenous plants, increasing the probability that *Prosopis* seedlings that germinate in wet years will survive. In the arid and semiarid Kalahari savanna, reduction of standing biomass by herbivores will reduce the probability of fires after high-rainfall years (Jeltsch et al. 1996). Reduced fire frequency, together with reduced competition from herbaceous plants and increased dispersal of *Prosopis* seeds by livestock, may increase the northern and eastern extent of *Prosopis* invasion.

What are the environmental and economic consequences of an increase in the incidence of *Prosopis* thickets, and is expenditure on clearing justifiable? By excluding herbaceous vegetation, *Prosopis* thickets increase runoff of rainwater and accelerate soil erosion. In small catchment experiments in the southern United States, herb cover increased after clearing of thickets, resulting in reduced rates of runoff and soil erosion (Martin and Morton 1993). Clearing is therefore justified where the objective is to restore herbaceous cover and reduce soil erosion. On the other hand, clearing on purely hydrological grounds can only be justified where the objective is to increase the water supply downstream of a thicket. Fully grown *Prosopis* trees transpire 30–75 liters/day (Ansley et al. 1992) or 120–220 mm/ha at moderate densities of 50 trees/ha (Lahiri and Kumar 1967), and their removal reduced evaporation by 40 percent in the short term, but this was neutralized after one year by increases in herbaceous cover

(Carlson et al. 1990; Dugas and Mayeux 1991). Water use by *Prosopis* is proportional to canopy area and to water availability, being most extravagant along watercourses and in bottomlands (Easter and Sosebee 1975). Dense stands of *Prosopis* are therefore likely to reduce availability of water in ephemeral watercourses and in pans, which in turn will influence the potential for small-scale arable agriculture and water supply to farms and rural villages.

The negative impact of increased *Prosopis* thickets on forage availability to domestic livestock will probably be greater than their effect on hydrology in the karoo and Kalahari. In scattered stands of *Prosopis*, losses of herbaceous biomass to trees are compensated by the production of carbohydrate- and protein-rich pods. In thickets, however, stunted *Prosopis* shrubs produce very few pods and may be so dense that they exclude livestock and game animals as well as reduce herbaceous ground cover (Harding and Bate 1991; Zimmermann 1991). Besides its impacts on agricultural productivity, the replacement of open dwarf shrubland and grassland by *Prosopis* thickets reduces species richness of dung beetles (Steenkamp and Chown 1996) and is likely to have similar effects on insects and birds in densely invaded bottomlands.

Negative effects feed back to influence human attitudes and behavior (Fig. 13.8), and such social change may also be viewed as a type of global change. There is a growing awareness in rural communities of the alien origin and undesirable effects of *Prosopis* spp. Changing attitudes are likely to lead landowners to apply preventative measures such as introducing biocontrol agents onto farms (Zimmermann 1991), storing pods until seed viability has been reduced by introduced seed-attacking beetles, and penning of sheep for a week after a dietary supplement of *Prosopis* pods (Hoon et al. 1995).

In summary, we suggest that *Prosopis* is likely to spread (1) *westward* of its current distribution (Richardson et al. 1997), to form denser stands in Namaqualand if summer rainfall increases in this winter-rainfall zone; (2) *northward* if grazing is intensified in the Kalahari; (3) *to dryland sites in the karoo* with increased annual rainfall and irrigation; (4) *eastward* (as shown in Figure 13.5) if fire frequency decreases; and (5) *to higher altitudes* if warming leads to higher temperature minima. Excluded from these considerations are the effects of elevated CO_2 and warmer, wetter conditions on population processes in indigenous shrubs, C_4 grasses, granivorous rodents, recently introduced biocontrol agents, and management attitudes toward the planting of *Prosopis* and the use of pods as forage. Alone or in combination, these factors might negate the postulated advantages of global change to *Prosopis* and halt or reverse its potential for population growth and range expansion.

Alien Grass Invasion of C_4-Dominated Grasslands

It is surprising that alien grass species have not been more successful as invaders of natural and seminatural systems in the grassland biome of South

Africa (*sensu* Rutherford and Westfall 1986). Only two species, *Nasella trichotoma* and *N. tenuissima* (both C_3 grasses), appear to invade successfully (Wells et al. 1986; Richardson et al. 1997). Even these species have localized distributions, and are clearly dependent on disturbance for establishment and spread (Henderson and Anderson 1966). This biome has been utilized relatively intensively by livestock (Hoffman 1997), thus theoretically providing ample sites of anthropogenic disturbance for alien establishment, according to the ideas expressed by Mack (1981). Grasslands in many other parts of the world have been heavily invaded by alien species such as *Bromus tectorum* (cheatgrass) and *Eragrostis lehmanniana* (Lehmann love grass) (Mack 1981; McClaran and Anable 1992). Disturbance by grazing has been identified as an important factor promoting invasion by, for example, Lehmann love grass (McClaran and Anable 1992). It is instructive to speculate whether southern African grasslands are inherently resistant to invasion by alien grasses, and, if so, how the situation could be altered by climate change.

The grasses that have caused problems as invaders of grasslands worldwide seem to possess mainly the C_3 photosynthetic pathway. It is feasible that the key to understanding the (apparent) resistance of southern African grasslands (dominated by C_4 grasses) to invasion by alien grasses centers around the competitive balance between C_3 and C_4 functional types. In this respect it is notable that southern Africa's grassland biome differs distinctly from other grassland ecosystems in the world. According to Ehleringer et al. (1997), the break-even point between C_3 and C_4 types is determined by an index of daytime temperature during the growing season, with C_4s dominating at higher temperatures due to their superior quantum yield of photosynthesis under those conditions. We have analyzed the C_3:C_4 balance (in terms of species numbers) in thirty 1/4° squares (27°–33°S, 26°–33°E). As predicted by Ehleringer et al. (1997), we found a linear, declining relationship between C_3:C_4 ratio and growing season maximum temperature. Unexpectedly, however, the analysis revealed a considerable overrepresentation of C_4 grass taxa in cooler climes; this contradicts the theoretical predictions of Ehleringer et al. (1997) and those of several empirical studies in many grassland ecosystems of the world (Fig. 13.9).

This, we suggest, implies that a factor other than temperature-determined quantum yield differences between C_3 and C_4 types controls the competitive balance of C_3 and C_4 taxa in southern Africa. It is well established that, apart from photosynthetic quantum yield differences, C_4 grasses have considerably superior nitrogen-use efficiencies (NUE) than do C_3 grasses (Brown 1978; Snaydon 1991). Our tentative suggestion is that C_4 grasses maintain their dominance in southern African grasslands through high NUE, and that this may also tend to exclude less nitrogen-use-efficient C_3 aliens. We develop this argument in the following section, and deliberate on the potential impact of rising atmospheric CO_2 for alien grass invasives.

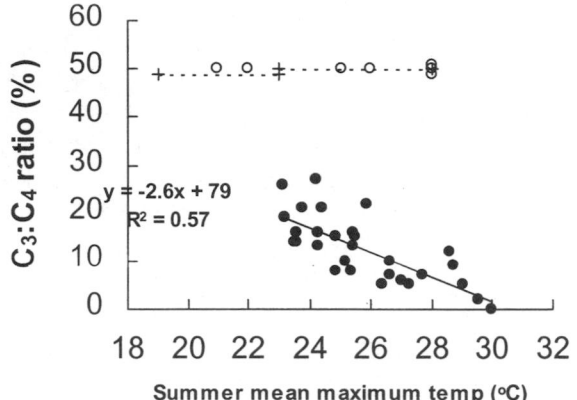

Figure 13.9. The relationship between $C_3:C_4$ grass ratios (in terms of species numbers) and growing-season maximum temperature in the grassland biome of South Africa (regression and solid circles), compared with the empirically determined $C_3:C_4$ break-even points according to studies cited in Ehleringer et al. (1997), given as points (open circles) or ranges (dashed lines bounded by crosses).

MECHANISM OF C_3/C_4 GRASS INTERACTION, AND IMPLICATIONS OF RISING ATMOSPHERIC CO_2

Tilman (1990) has suggested that grass species exclude one another through depleting soil nitrogen resources below critical tolerance levels. The winning grass species in an assemblage is that which is able to deplete the soil-nitrogen content to the lowest level. Species-specific tolerance levels are termed R^*. It is likely that R^* for nitrogen is related to the physiological efficiency with which plants use nitrogen to gain carbon and grow, as plants with low R^* also tend to have low tissue nitrogen contents (Tilman 1990). At the whole plant level, this efficiency is termed plant nitrogen productivity (Lambers et al. 1990). At the leaf level the critical measure of efficiency is photosynthetic nitrogen-use efficiency (PNUE), and Garnier et al. (1995) have shown that PNUE is a central determinant of plant nitrogen productivity in grass species. Apart from nitrogen productivity, plant allocation to root biomass is the other major determinant of R^*, and species competitive ability (Tilman 1990). Thus nitrogen productivity, and its chief determinant, PNUE, and carbon allocation to root mass, appear to be the key to the ranking of grass species on a competitive hierarchy. The logical sequence linking the position of a grass species on a competitive hierarchy through its soil-nitrogen tolerance level to its PNUE and root system allocation patterns is as follows:

$$\begin{array}{ccccc} \text{PNUE} & & & & \text{competitive} \\ \text{root system} & \rightarrow & R^*_{\text{nitrogen}} & \rightarrow & \text{hierarchy} \end{array}$$

There are, however, costs associated with low R^* that exclude low R^* species from highly productive or disturbed sites. Thus a trade-off between allocation to reproductive and dispersal functions and root development is responsible for successional trends that result in nutrient-competitive C_4 grass species with well-developed root systems replacing less nutrient-competitive, ruderal C_3 grass species with higher relative allocation to dispersal (Tilman 1990). Combining the theory of Tilman (1990) and the confirmed patterns of superior NUE in C_4 grasses (Brown 1978; Snaydon 1991), we can make the following predictions:

1. Where soil-nitrogen levels are low, and are not amended, C_4 grass species should exclude C_3s. This has indeed been confirmed (Tilman and Wedin 1991; Wedin and Tilman 1991). By implication, invasive C_3 grass species should be capable of gaining ground only where soil nitrogen is amended, or on naturally eutrophic soils.
2. Where disturbance levels are high (often associated with short-term increases in nitrogen availability), species with high allocation to seed dispersal, but not to root systems, should colonize rapidly.

Taken together, these suggest that invasive C_3s should be highly dependent on disturbance (i.e., removal of indigenous competitors) and nutrient addition to invade successfully. This seems to be the case.

We predict further that the NUE mediated interaction between C_3 and C_4 species will be altered by rising atmospheric CO_2. It is well documented that significant increases in PNUE accrue to C_3 species in elevated CO_2 (Drake et al. 1997), and C_3 tissue-nitrogen content decreases to levels similar to those found in C_4s (Wong 1979; Read et al. 1997). Interestingly, the aggressive invasive cheatgrass (*Bromus tectorum*; C_3) has proven highly responsive to elevated CO_2, even in relation to other C_3 grasses (Smith et al. 1987), and may thus be expected to increase its competitive dominance. Because of the efficient CO_2 concentrating mechanism that operates in C_4 plants even under current and lower atmospheric CO_2 levels, this functional type shows no such increases in PNUE in elevated CO_2 (Wong 1979). The likely result is that the R^* ranking, and thus competitive hierarchies will change, making ecosystems that are currently dominated by C_4 grasses more open to invasion by C_3 grasses. In fact, the general increase in PNUE in C_3 invasive grasses is likely to make them tolerant of less fertile sites. In combination with possible future increases in nitrogen deposition (Vitousek 1994), this will alter the constraints on their distributions globally.

Disturbance Scales in C_3 Grass Invasions in Fynbos and Karoo

South Africa has a rich grass flora tolerant of drought and grazing, but the Poaceae are insignificant in terms of both cover and diversity in the speciose

winter-rainfall fynbos and succulent karoo biomes. It is in these areas that European (e.g., *Briza maxima;* Fig. 13.1) and North African grasses are becoming increasingly prominent. A scenario with increased summer rainfall would favor alien and dubiously indigenous C_4 grasses such as *Paspalum vaginatum* occurring worldwide in flooded saline sites, *Pennisetum clandestinum* from east African highlands and spreading in well-watered sites (Gibbs Russell et al. 1990), and *P. setaceum* from North Africa and now invasive in South Africa, Australia, Fiji, Hawaii, and North America (Williams et al. 1995). On the other hand, warmer conditions would disadvantage the alien C_3 grasses that have invaded temperate and winter-rainfall ecosystems worldwide (Table 13.2).

By supplementing the scant South African literature on the niches of invasive C_3 grass genera with American and Australian literature, we can conceptualize the process of grass invasions in the winter-rainfall regions. We can also predict how natural disturbances, land-use changes, and atmospheric pollution might influence their distribution and abundance at patch, landscape, and biome scales (Fig. 13.10).

Seeds of most C_3 grasses have high potential for short and medium distance dispersal. Some species in the genera *Bromus, Hordeum, Stipa,* and *Vulpia* have barbed awns that cling to sheep and goats by the thousand (Shmida and Ellner 1983), and although 60 percent are shed within twenty-four hours, 10 percent remain in the wool for at least one month (Fischer et al. 1996). *Bromus diandrus* clings so effectively to clothing that it is known in the karoo as *predikanstluis* (Afrikaans for "priest's louse"), alluding to the unintentional transport of its seeds by priests travelling on foot or on horseback to visit their far-flung rural parishioners. Vehicles transport the seeds of many plants, including the whole range of alien grasses, between urban, cultivated, and natural areas (Wace 1977).

At the patch scale, small natural disturbances enable alien grasses to become established in natural vegetation as a diffuse metapopulation. For example, in dwarf succulent shrublands of southern Namaqualand, *Stipa capensis* was largely confined to termitaria (Acocks 1953, Steinschen et al. 1996) and *Bromus pectinatus* was mainly in sheltered sites beneath shrubs and in depressions made by aardvark *Orycteropus afer* foraging for termites and ants (Steinschen et al. 1996). At higher altitudes around Nieuwoudtville, *Bromus* spp. is abundant on the nutrient-enriched nest mounds of harvester ants *Messor capensis* (S.J. Milton, personal observation). The role of nutrient enrichment and protection from hot, dry conditions is also evident at the Goegap Nature Reserve near Springbok where *Bromus pectinatus* is confined to shade among boulders where soils have been enriched by the dung of rock hyrax *Procavia capensis* (S. J. Milton, personal observation). In the United States, the combination of small-scale disturbances, with or without nutrient

Table 13.2. Distributions, common species, and characteristics of C_3 grass genera represented in South Africa mainly by naturalized aliens. Distribution data from Gibbs Russell et al. (1990). Information on factors facilitating invasion from (1) Amor and Piggin (1977); (2) Hobbs and Atkins (1988); (3) Kotanen (1995); (4) Huenneke et al. (1990); (5) D'Antonio and Vitousek (1992); (6) Hobbs and Mooney (1995); (7) Whisenant (1990); (8) Bate (1983); and (9) Steinschen et al. (1996).

Genus	European or South American spp. A	African spp. B	Endemics	Distribution of alien spp. A and B in South Africa	Invasive outside South Africa	Factors that facilitate grass invasion
Avena	5 fatua, sativa	0	0	fynbos, succulent karoo	California, S Australia	disturbance, fertilizers (1,2)
Briza	2 maxima, minor	0	0	fynbos, succulent karoo	California, S Australia	disturbance (3)
Bromus	10 catharticus, diandrus	2 pectinatus	4 grassland	fynbos, succulent karoo, grassland	SW USA, S Australia, New Zealand	fertilizers, fire, soil disturbance, grazing, above-average rainfall (1,3,4,5,6,7)
Hordeum	5 murinum	0	1 fynbos, grassland	fynbos, succulent karoo	California, S Australia	grazing (1), fertilizers (1)
Lolium	5 perenne, rigidum, new hybrid	0	0	fynbos, succulent karoo	California, S Australia, New Zealand	N and P fertilizers (4)
Nassella	1 trichotoma	0	0	grassland	New Zealand, S Australia, Tasmania	ploughing, soil N-enrichment, grazing (8)
Stipa	5	1 capensis	1	succulent karoo, grassland, forest	?	grazing, soil disturbance (9)
Vulpia	4 muralis, myuros	0	0	succulent karoo	California, S Australia	fertilizers (1,4)

Note: Numbers in parentheses refer to references cited in table title.

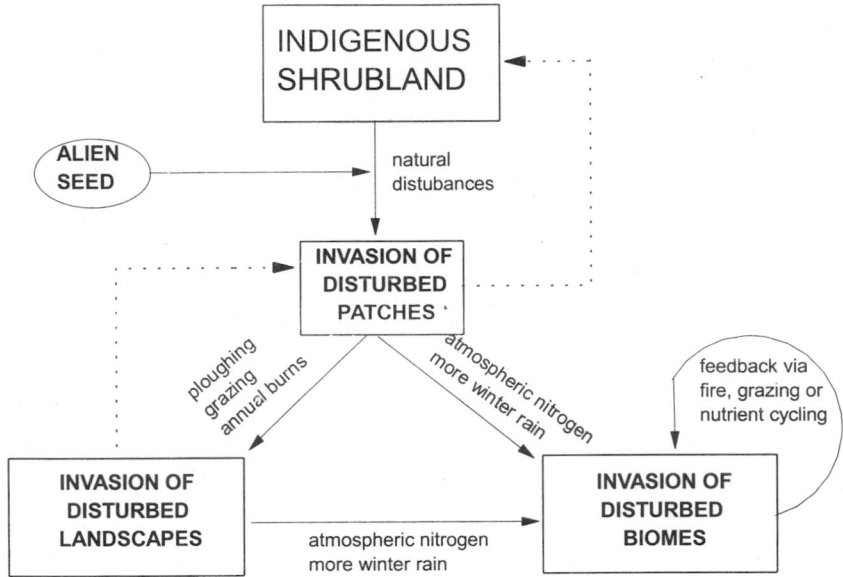

Figure 13.10. Conceptual model of scales and processes in C$_3$ grass invasions of the fynbos and karoo biomes of South Africa.

enrichment, enable small populations of alien *Aira, Briza, Bromus, Hordeum, Poa, Schizmus* or *Vulpia* to establish on rodent colonies and in rootlings of feral pigs (Schiffman 1994; Kotanen 1995), particularly in years of above-average rainfall (Hobbs and Mooney 1995).

Landscape-level dominance by C$_3$ alien grasses in the Western Cape is caused by brush-cutting or frequent burning of shrubland coupled with the application of phosphate fertilizers to improve the grazing value of land on nutrient-poor, sandy soils (Vlok 1988), the abandonment and grazing of uneconomic wheat lands (Macdonald 1989; Steinschen et al. 1996), and runoff of fertilizers from cultivated land into natural vegetation (Vlok 1988). It is ironic that intensive grazing and brush-cutting to promote the colorful displays of indigenous spring flowers for tourists in Namaqualand can reduce diversity (Van Rooyen et al. 1996) and increase susceptibility of natural communities to invasion by alien grasses (Vlok 1988). The occurrence of alien grasses on Australian offshore islands is correlated with anthropogenic disturbances (Abbot 1992), and their presence on islands off the western Cape coast (Brooke and Crowe 1982) is probably also related to human activities.

The addition of nutrients and the reduction of shrub cover give C$_3$ grasses a competitive advantage over indigenous plant species. Experimental addition of complete fertilizers as well as nitrogen and phosphate supplements in Californian grasslands increased the competitive ability of *Bromus mollis* and

Vulpia myuros by one order of magnitude, and *Lolium multiflorum* by two orders of magnitude (Huenneke et al. 1990). Disturbance improved growth of *Avena fatua* and fertilizers increase growth (Hobbs and Atkins 1988). In South African montane grasslands, soils where an indigenous C_4 bunchgrass *Themeda triandra* was most vigorous contained >5 ppm nitrate-N; soils dominated by alien C_3 perennial *Nassella trichotoma* had 12 ppm nitrate-N; and soils where the alien C_3 annual *Bromus catharticus* was abundant had 82 ppm nitrate-N (Bate 1983). It has yet to be demonstrated that the Australian *Acacia* species that increase topsoil fertility on alkaline sands in the Western Cape (Stock and Allsopp 1992), facilitate landscape-scale alien grass invasions that persist after the *Acacia* control, but this is likely. Seed banks of alien grasses that accumulate in ant nests and on natural disturbances are likely to facilitate landscape-level invasions.

Biome-level invasions of C_3 grasses in South Africa could develop from either patch- or landscape-level invasions, as they have done in parts of the United States, if there were biomewide changes in soil-nutrient status or climate. In the Americas and Australia there is evidence that frequent fires favor annual C_3 grasses, which in turn increase fire probabilities, reinforcing annual grass dominance (Whisenant 1990; D'Antonio and Vitousek 1992). Increased fire frequency would promote alien grasses in mesic fynbos and renosterveld (low fire-prone scrubland) vegetation types, but the more arid winter-rainfall regions of the succulent and Nama karoo seldom support enough biomass to burn. An increase in cool-season rainfall in these regions, however, would favor C_3 grasses not only directly but also indirectly by increasing fire probabilities. Anthropogenic nitrogen inputs from fertilizers, fossil fuels, and nitrogen-fixing crops account for 40–80 percent of global emissions, and models for global change indicate that atmospheric- and soil-nitrogen levels will continue to grow with human populations (Vitousek et al. 1997). Elevated atmospheric nitrogen is global rather than regional in its effects because long-distance transport distributes polluted air far from point sources. The varied consequences of nitrogen enrichment for nutrient-poor natural ecosystems include increased palatability of plants to herbivores, leading to changes in their competitive ability and demography, and the replacement of endemic plants with nitrophilous species, particularly grasses with wide distribution ranges (Jefferies and Maron 1997).

Alien Bird Invasions

The species and the dates of introduction and distribution of alien species of birds in southern Africa were reviewed by Brooke et al. (1986). Some forty-six alien avian species have been introduced or have invaded southern Africa, of which seven species have established viable populations, but only four of

these are widespread: feral pigeon (*Columba livia*), European starling (*Sturnus vulgaris*), Indian myna (*Acridotheres tristris*), and house sparrow (*Passer domesticus*). These four species, all commensals, have been present in southern Africa for almost a century (feral pigeon for more than three centuries) and are expanding in abundance and distribution (Brooke et al. 1986). A fifth species, the Indian house crow (*Corvus splendens*), the only alien species to be "self-introduced" in southern Africa, has markedly increased in numbers since the first (published) records of its occurrence in the early 1970s (Oatley 1973; Sinclair 1974; Berruti 1997). The Indian house crow is known to use steam and motor vessels to hitch lifts around the Indian Ocean (Long 1981). It probably made use of the increased marine traffic down the east African coast during the closure of the Suez Canal from 1967 to 1980 to reach Durban (Brooke et al. 1986), and subsequently East London and Cape Town (Berruti 1997). The roseringed parakeet (*Psittacula krameri*) also appears to have successfully invaded parts of southern Africa; though existing populations are small, they are apparently well established and are probably increasing (Maclean 1993). The seventh species is the mallard (*Anas platyrhynchos*), apparently increasing locally in abundance in South Africa (Cohen 1997).

Factors Influencing Successful Colonization by Alien Birds

Climate

European starlings are not preadapted to the warmer parts of southern Africa (Brooke et al. 1986) and are unlikely to expand their range much more than their current distribution in southern Africa. The species is virtually confined to the western and eastern Cape provinces and may have reached equilibrium distribution (Craig 1997a). However, European starlings are well adapted to cooler temperatures, and thus may be able to colonize new areas at higher altitudes.

Brooke et al. (1986) suggest that Indian mynas may not be well adapted to the cooler parts of southern Africa. If so, Indian mynas may have reached their southern distributional limits in the interior of South Africa. Warmer temperatures and mild winters have allowed the species to move along the coast from Durban, and birds have been seen at Port Elizabeth and Cape Town (Craig 1997b) but may not yet have established breeding populations. The species' failure to colonize parts of KwaZulu-Natal and the moist savannas of northern South Africa (see map in Craig 1997b) is not easily explained, but may be due to unsuitable land-use patterns in these areas.

Temperature seems unimportant in shaping the distributions of feral pigeons and house sparrows, and both species occur in the warmest and

coolest parts of southern Africa. The Indian house crow may be limited by temperature, and it has been suggested that the cooler winters in the Cape Town area have restricted population growth in this species (D. G. Allan, in Berruti 1997).

The distribution of feral pigeons and house sparrows, both species that are wholly dependent on humans for nest and foraging sites, appear to be independent of the rainfall regime, and are not, apparently, affected by drought. House sparrows are present in the driest parts of South Africa, and their distribution is not correlated with rainfall (Brooke 1997b). European starlings have colonized many areas in the western and eastern Cape, including some of the most arid parts of the karoo, but abandon such areas during prolonged droughts (Winterbottom 1966, 1978). Indian mynas are distributed mainly in areas of southern Africa where rainfall is greater than 600 millimeters per year so they may be restricted to higher rainfall areas. Indian house crows are similarly restricted to high rainfall areas, but the native distribution of roseringed parakeet includes semiarid to arid savanna, and thus has the potential to extend its present range into the drier parts of southern Africa.

Landscape-Level Changes

No alien birds have invaded undisturbed natural habitats in South Africa (Brooke et al. 1986). Although roseringed parakeets breed in "well-wooded natural vegetation" at Sodwana Bay (Brooke 1997a), they are apparently dependent on cultivation for foraging areas (Liversidge 1985; Fry et al. 1988). The most successful alien species appear to be those that are commensal with humans and largely restricted to urban areas. Feral pigeons and house sparrows are entirely restricted to the vicinity of buildings, whether these be in large urban centers, small towns, villages, farmhouses, or remote railway stations. They forage in parks and gardens, on pavements, and on city streets. Indian house crows seem to be present only in informal settlements and townships.

Transformed habitats, in combination with buildings, are important for some species. For example, European starlings forage on short grass or legume pastures and also feed on fruit, and provided that there are buildings for nest sites, are able to colonize most agricultural areas. Similarly, Indian mynas forage in short grass patches, lawns, and cultivated pastures, and nest in holes in buildings. This species, is, however, particularly adaptable in nest site selection and also uses holes in trees, bases of palm fronds, and in leaf whirls of alien screw pines (*Pandanus* spp.) in coastal KwaZulu-Natal.

Population Bottlenecks

While populations of alien birds remain small and isolated, there is the possibility of stochastic extinction. Fragmentation of the population (i.e., by sep-

arate introductions in different areas) may increase the probability of survival. Once a certain level has been reached, populations apparently expand rapidly and colonize new areas. This level, however, varies with species.

With the exception of the feral pigeon and Indian house crow, alien bird species in southern Africa appear to have had a slow population growth and restricted range initially, with relatively rapid expansion of both population and range after (usually) some decades. The lag period before the expansion of the population and range varies with the species. In the case of the house sparrow, the introduced birds came from a sedentary population in India (*P. domesticus indicus*) and it took around fifty years for the population in KwaZulu-Natal to become mobile and invasive (Brooke 1997b). The implication here is that the birds were "genetically resident." House sparrows are restricted to human habitation, and are now widespread through the southern African subcontinent, with their distribution controlled by settlements. Indian mynas show a similar pattern, with a slow initial population growth and slow range expansion, but by about fifty years after introduction at Durban, they had colonized most of western and northern KwaZulu-Natal (Craig 1997a). The range expansion of the European starling has been well documented (Craig 1997b) and has been steady, apparently without any initial lag (Fig. 13.11). For feral pigeons the picture is not clear since there have

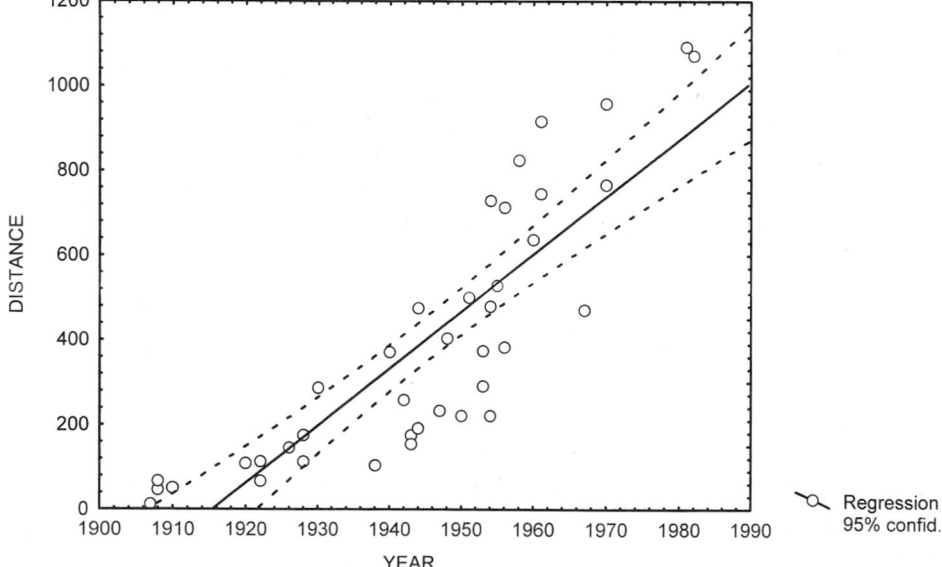

Figure 13.11. Rate of colonization of European starling (*Stumus vulgaris*) in southern and western South Africa. Data are taken from Winterbottom and Liversidge (1954) and Liversidge (1962). $y = 0.2592 + 13.5x$ ($r = 0.85$).

been many further advertent and inadvertent introductions since the initial release of birds brought from Holland in 1652. Few of the introductions have been documented in detail, and the birds can be confused with homing, racing, and other polymorphic domestic pigeons (Brooke 1997c). No data are available on the growth of the population.

Food

It may be significant that alien bird species that are widespread in southern Africa are omnivorous or granivorous, but even putative granivorous species such as the feral pigeon feed on a wide range of items (Maclean 1993). Catholic diets may be important in buffering populations against losses caused by shortages of particular food items. The successful alien bird species also seem to be opportunistic in obtaining food, with communal roosts that may be "information centers" (see Ward and Zahavi 1973).

Patterns of Changes Likely to Influence the Distribution of Alien Bird Species

Climate

Global warming is likely to affect only three of the alien bird species presently widespread in southern Africa. Increases in temperature may shift the northern limits of European starlings southward. Similarly, if (as we suspect) the Indian myna is currently limited by cool temperatures, any increase in temperature will shift the southern limits of its distribution southward and into the interior of arid and semiarid South Africa. Increased temperature will favor the Indian house crow, if, as currently thought, populations are limited by cool winters in part of its distribution range. It is unlikely that changes in rainfall seasonality and amount will influence the distribution of any of the alien bird species. However, Richardson (1992) notes that European starlings are absent from the Jonkershoek Valley near Stellenbosch during the dry summer but are superabundant during the wet winter. This implies that a shift in rainfall seasonality and amount could alter local movement and habitat-use patterns in this species.

Landscape-Level Changes

Five of the seven alien bird species that have thriving populations are strongly tied to humans, their structures, and cultivation. Any increase in urban areas will favor feral pigeons and house sparrows, and probably Indian house crows. Increases in the area under short grass (lawns and mown pastures) and cultivated lands will favor European starlings and Indian mynas, provided that there are also suitable nest sites. It may be significant that the Indian house

crow has been more frequently recorded in informal settlements, industrial sites, and harbors than in natural areas. Any increase in the area occupied by informal settlements and urbanization will favor population increases in this species in the southern part of its South African range, provided that there is a concomitant increase in temperature. In the northern parts of the range of the Indian house crow, where winter temperatures are generally higher, urbanization and expanding informal settlements alone should allow population and range expansion.

Patterns of Changes Likely to Influence the Impacts of Alien Bird Species

There are very few data on the impacts of alien bird species on either indigenous avifauna, other animals, or vegetation. Impacts are likely to be through interference competition and resource exploitation competition. Native species are likely to be competitively dominant in natural situations, but alien species may be competitively dominant in human-made habitats.

Changes in land-use type are likely to increase the available habitat and foraging areas for commensal alien birds. A shift from large-scale commercial farming to small-scale and subsistence farming should provide more habitat and food for commensal alien birds through a greater diversity of crops and animals on a landscape scale. Any increase in farmland per se (highly likely to occur with an increasing population) will result in the destruction of natural habitats and alter niches available for native bird species. Alien commensal birds should then be favored by the reduction of competition and their apparent ability to use human-modified habitats more efficiently.

Increases in the human population should also result in an increase in the numbers of domestic pets. Domestic dogs may not provide much of a threat to birds, but domestic cats are likely to impact both alien and native bird species in urban and suburban environments. This may feed back positively to alien commensal birds by reducing the numbers of potential competitors (Fig. 13.12).

Most alien bird species in South Africa occur in mesic habitats in their native environments. On a countrywide scale, habitats are generally more arid in South Africa, so an increase in rainfall or shifts in rainfall seasonality may favor some of the alien bird species. Increases in mean ambient temperature following global warming may increase the range of habitat suitable for alien species that are native to tropical and subtropical ecosystems. However, global changes in climate are unlikely to effect gross changes in the present suite of alien birds in South Africa. The lack of success of most of the introduced alien bird species may be due to one or more of the following factors: (1) their inability to use a wide range of nest sites; (2) small clutch sizes, and

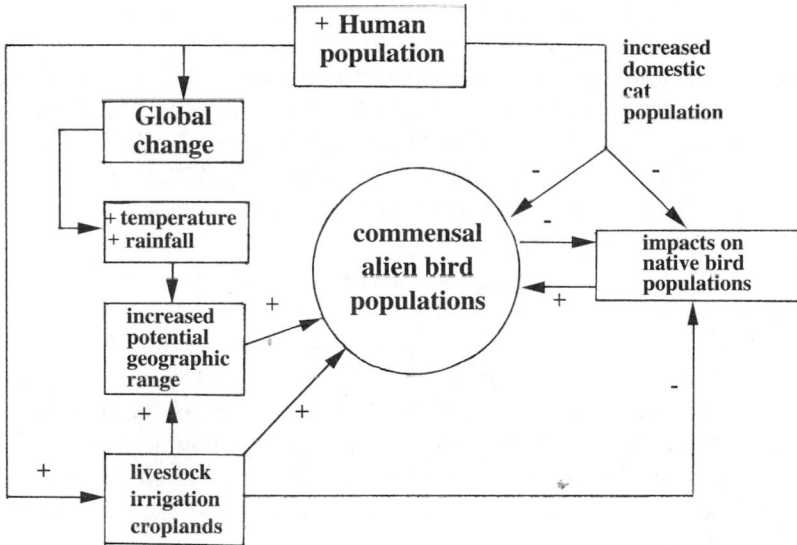

Figure 13.12. Conceptual diagram showing the effects of increased human population and global change on commensal alien bird species populations.

thus slow intrinsic population growth; (3) particular food or habitat requirements; and (4) competition from native species. Global change is unlikely to affect innate characteristics of alien bird species. There are likely to be unseen (or unpredictable) side effects on biota as a result of global change so that it may be impossible to predict what changes may take place other than a potential increase in distribution range of alien bird species. Among the many unknowns are what the effects of global change might be on native species, and what interactions between native and alien species might result from such changes.

Alien Insect Invasions

Invasive Insects and Natural Systems

Alien insects have caused little, if any, disruption to ecosystems in South Africa without significant human disturbance. One species that has invaded systems that are at least seminatural is the Argentine ant, *Linepithema humile* (Mayr). Where it has invaded fynbos, it negatively affects seed dispersal and regeneration of fynbos plants (Bond and Slingsby 1984; Bond and Breytenbach 1985). It also reduces the diversity and abundance of insects that visit the flowers of *Protea nitida* (Visser et al. 1996). De Kock and Giliomee (1989) found that the distribution of this ant correlates well with human disturbance, because humans inadvertently transport it. An alternative explana-

tion is that it may prefer anthropogenically disturbed areas. Certainly, large areas of unmodified fynbos within its reach have not been invaded. In the United States, a small reserve (480 ha) surrounded by residential and agricultural land has been invaded by *L. humile*, which has displaced native ants (Human and Gordon 1996) and changed the population levels (not all negatively) of other invertebrates (Human and Gordon 1997). In South Africa, *L. humile* also occurs in undisturbed fynbos adjacent to developed areas (C. Christian, personal communication). It appears that humans facilitate *L. humile* establishment by providing appropriate conditions (food and moist sites), and transporting it with nursery plants and by cars. It is unknown what determines its establishment success or what is the degree of biotic resistance of unmodified fynbos. Nevertheless, disturbance, especially if it involves irrigation, undoubtedly favors spread of the ant. As is the case in other parts of the adventive range of *L. humile*, increasing landscape fragmentation and climatic change involving wetter conditions are likely to facilitate further spread of this species, with potentially devastating results for the fynbos flora.

Invasive Alien Insects in Urban Areas

Well-established invasive insects in urban South Africa include well-known tramp species, such as the cockroaches *Periplaneta americana* (L.) and *Blatella germanica* (L.), and the fly *Musca domestica* (L.). Of particular concern is the recent appearance of the mosquito *Aedes albopictus* (Skuse) in Cape Town. It breeds in small pools of water held in discarded cans, plastic wrappings, tires, and in tree cavities. It spreads with commercial shipping and has been found in tires in Cape Town harbor (Craig 1993).

There are many ectoparasites of domestic animals and humans in South Africa. The bedbug *Cimex lectularius* L. has a worldwide distribution and, besides feeding on humans, also feeds on wild and domestic birds. Another species, *C. hemipterus* (Fab.), is mainly a parasite of humans but is also found on domestic birds and bats. Newberry and Mchunu (1989) recorded the invasion into South Africa from Mozambique (via informal human migration) of *C. hemipterus*, which then displaced *C. lectularius*, but with occasional interspecific cross-mating of *C. lectularius* females with *C. hemipterus* males under natural conditions (Walpole and Newberry 1988). These matings gave rise to a first-stage nymph (Newberry 1988). Nevertheless, part of the reason for replacement was that most of the *C. lectularius* females mated interspecifically with resultant deleterious effects. This limited *C. lectularius* in favor of *C. hemipterus* in areas of sympatry (Walpole and Newberry 1988).

An invader of the urban landscape is the wasp *Vespula germanica* (Fab.), which, although after some years of residence, is still confined to the 470 km^2

of the Cape Peninsula (Tribe and Richardson 1994), has the capacity to do great damage (New 1994). Its current range in South Africa is one of the most faunistically unusual areas of the world, with at least 111 endemic invertebrates (Picker and Samways 1996). Although the wasp is not necessarily a direct predator of these species, it has the potential to rob indigenous species (including Cape Peninsula endemics) of nectar and protein resources. It is possible, however, that it only thrives in highly disturbed areas and is spatially separated at the fine scale from the taxonomically unusual native fauna.

Urbanization impoverishes insect species richness in proportion to human population density (Davis 1979). Urbanization also encourages alien species that often have to be controlled for human health and hygiene reasons. These control measures, which are becoming increasingly important, are not in conflict with biodiversity conservation (Samways 1996a). Global warming is likely to be synergistic with the negative effects of urbanization, with more extensive outbreaks of some species (Martin and Lefebvre 1995).

Alien Insects on Crops

Although most commercial crops in South Africa are introduced, only 22 pest insects (and mites) are alien, whereas 765 are indigenous and 16 are of unknown origin (Moran 1983). The alien pest complex on many of these crops is similar to that in many other parts of the world. This has stimulated an ongoing and vigorous biological control program. The alien hard scale *Aonidiella aurantii* (Mask.), for example, is controlled throughout much of its range in South Africa by the indigenous parasitoid *Aphytis africanus* Quednau. The ladybird *Chilocorus nigritus* (Fab.) has also played a major role in controlling pests in the hotter parts of the country after it arrived here of its own accord (Samways 1984). There is circumstantial evidence that it may have displaced the indigenous *C. wahlbergi* Mulsant from some citrus orchards (e.g., at Letaba Estates *C. nigritus* is currently abundant where *C. wahlbergi* was dominant but is now rare). It appears that *C. nigritus* will remain dominant and in view of its distinct preference for a warm and moist climate (Samways 1989), it is likely to expand its geographical range with global climate changes.

Weeds such as prickly pear and other *Opuntia* spp. are kept under excellent control in most parts of South Africa apart from areas with relatively frequent, intense rain events (thundershowers), which seem to work against the effectiveness of their respective cochineal (*Dactylopius* spp.) controlling agents. So an increase in local temperature, combined with increased heavy downpours, is likely to retard this weed biocontrol program (S. Neser, personal communication).

Alien Insects on Crops: The Role of Climate

It is well known that certain natural enemies are limited in their distribution by climate (Franz 1964; Greathead 1971). In South Africa, this is illustrated by the parasitoid *Anaphes nitens* (Girault) that attacks the eggs of the *Eucalyptus* snout beetle *Gonipterus scutellatus* Gyllenhal, but only up to an elevation of 1,200 meters, where it is inhibited by cold (Tooke 1955). The role of climate in general was illustrated by large-scale translocations of populations of *Chilocorus nigritus* for potential biological control of *Aonidiella aurantii* (Samways 1989), a practice that is becoming increasingly environmentally unacceptable (Samways 1997). It was clear that this alien species would not establish no matter how many thousands of individuals were introduced, as the climate was not suitable (Samways 1989).

Regional climatic effects are often synergistic, with small-scale climatic effects causing changes in insect population levels (Samways 1996b). This has been shown with *Aphytis* spp. parasitoids that are so sensitive to microclimatic conditions that they occupy hosts in different parts of the tree canopy according to thermal patterns. This, in turn, is moderated by elevation (Samways 1985).

What Might Happen with Further Global Climate Change?

Climate change is likely to influence natural enemies more than hosts, as the latter normally have greater geographical ranges than the natural enemy, and hence more climatic tolerance (Franz 1964). The extent to which this will affect populations of natural enemies is pure speculation. Nonetheless, when we look at species such as *Anaphes nitens* and *Aphytis* spp., it is clear that global warming will have an effect. *Anaphes nitens* is likely to be more effective at higher elevations. The more-heat-tolerant *Aphytis melinus* DeBach is likely to expand its microrange over the tree canopy and also its geographical range at the expense of the less-heat-tolerant *A. africanus*. As both *A. africanus* and *A. melinus* are such effective agents, the biocontrol effectiveness is likely to change very little.

Classical biological control is a huge unplanned experiment that can throw light on how insects react to new climates. This is very different from computer prediction of how a range might change. Predictions of how the geographical ranges of species change implicitly assume that range can be determined without invoking climate change. But how accurate are predictions before entertaining global climate change? Recent studies show these predictions to be anything from 0 percent to 100 percent accurate. The reason for the less than 100 percent predictions are that a whole range of local landscape and/or biological factors (e.g., type of prey available, levels of parasitism, rainfall patterns, topographic landscape patterns) often confound simple cli-

matic predictions (Samways et al. 1999). Interestingly, Geertsema (2000) has shown that it is not climate, as has often been thought, but availability of food plants that limits the spread of some alien (and native) lepidopterans. It is likely that alien food plants will do more to encourage the spread of alien insects in South Africa than will climate changes of the magnitude predicted in the medium term.

The Future

The South African landscape is undergoing fragmentation and attrition with dramatic loss of populations (Samways 1995). This landscape change also benefits certain species, including invasive alien insects. It is not clear whether they benefit because natural biotic resistance is reduced or whether altered and increased disturbance opens up new biotopes and niches that suit them. Whatever the reason, certain anthropogenic disturbances benefit alien insects (Geertsema 2000). The greater the intensity and extent of those disturbances (e.g., agriculture and urbanization), the greater the proportion of alien invasive individuals and species to native ones. It also leads to homogenization of the regional biota, as native extirpations and extinctions and establishment of alien invasives are generally permanent.

Conclusions

This chapter is the first attempt to assemble what we know about invasive alien plants, birds, and insects in South Africa specifically for the purpose of exploring likely changes in distribution and abundance as a result of global change. Many of our projections are based on imperfect data and/or an inadequate understanding of the key processes that govern the distribution and abundance of the invaders. Nonetheless we feel that the approaches followed here, notably for plants, set a rational framework for more thorough assessments in the future. For improved biogeoclimatic modeling, we need to explore ways of defining the fundamental niches of alien plants more accurately. This is especially crucial where the aliens have a short history in the alien habitat, and have not had time to sample the full range of potential sites. We have shown, using *Pinus* and *Prosopis* as examples, the potential value of "borrowing" insights on regeneration dynamics of species from other parts of the world. As there will never be enough time or funding to do proper experiments for all the alien species, we will have to rely on natural experiments for many insights. There is, however, great scope for manipulative experiments. Our far-reaching predictions on likely changes in the invasibility of South African grasslands could be tested experimentally.

Our results suggest that the predicted increases in temperature alone are unlikely to cause a major reshuffling of invasive alien plants in South Africa.

However, such changes, together with changed precipitation patterns, elevated CO_2 and increasing levels of nitrogen deposition, will probably have a huge impact, e.g., by making fynbos and grasslands more open to invasion by alien C_3 grasses. Building all these eventualities and their interactions into spatially explicit models is a major challenge. We believe that our conceptual model for *Prosopis* (Fig. 13.8 and Table 13.1) is a step in the right direction.

Human-mediated disruption of prevailing disturbance regimes and the fragmentation of landscapes are certain to cause major changes. Modeling approaches have great potential for long-term planning to prevent the replacement of the region's diverse biota by simplified communities, dominated by generalist, weedy species.

References

Abbot, I. 1992. Biogeography of grasses (Poaceae) on islands of southwestern Australia. *Australian Journal of Ecology* 17: 289–296.

Acocks, J.P.H. 1953. Veld types of South Africa (revised ed. 1988). *Memoirs of the Botanical Survey of South Africa* 28: 1–192.

Amor, R.L. and Piggin, C.M. 1977. Factors influencing the establishment and success of exotic plants in Australia. *Proceedings of the Ecological Society of Australia* 10: 15–26.

Annecke, D.P. and Moran, V.C. 1978. Critical reviews of biological pest control in South Africa 2. The prickly pear, *Opuntia ficus indica* (L) Miller. *Journal of the Entomological Society of South Africa* 41: 161–188.

Ansley, R.J., Price, D.L., Dowhower, S.L. and Carlson, D.H. 1992. Seasonal trends in leaf area of honey mesquite trees: determination using image analysis. *Journal of Range Management* 45: 339–344.

Archer, S. 1990. Development and stability of grass/woody mosaics in a subtropical savanna parkland, Texas, U.S.A. *Journal of Biogeography* 17: 453–462.

———. 1995. Herbivore mediation of grass-woody plant interactions. *Tropical Grasslands* 29: 218–235.

Bate, G.C. 1983. "Aspects of the physiology of Nassella grass *Stipa trichotoma*." In *Proceedings of the Fifth National Weeds Conference of South Africa*, edited by S. Neser and A.L.P. Cairns, 89–95. Pretoria, South Africa: Plant Protection Research Institute.

Berruti, A. 1997. "House Crow." In *The Atlas of Southern African Birds*, edited by J.A. Harrison, D.G. Allan, L.G. Underhill, M. Herremans, A.J. Tree, V. Parker and C.J. Brown, 108. Johannesburg, South Africa: BirdLife South Africa.

Blydenstein, J. 1957. The survival of Velvet Mesquite (*Prosopis juliflora* var. *velutina*) after fire. *Journal of Range Management* 10: 221–223.

Bond, W.J. and Breytenbach, G.J. 1985. Ants, rodents and seed predation in Proteaceae. *South African Journal of Zoology* 20: 150–154.

Bond, W.J. and Richardson, D.M. 1990. What can we learn from extinctions and invasions about the effects of climate change? *South African Journal of Science* 86: 429–433.

Bond, W.J. and Slingsby, P. 1984. Collapse of an ant-plant mutualism: The Argentine ant (*Iridomyrmex humilis*) and myrmecochorous Proteaceae. *Ecology* 65: 1031–1037.

Brooke, R.K. 1997a. "Roseringed Parakeet." In *The Atlas of Southern African Birds*, edited by J.A. Harrison, D.G. Allan, L.G. Underhill, M. Herremans, A.J. Tree, V. Parker and C.J. Brown, 536. Johannesburg, South Africa: BirdLife South Africa.

———. 1997b. "House Sparrow." In *The Atlas of Southern African Birds*, edited by J.A. Harrison, D.G. Allan, L.G. Underhill, M. Herremans, A.J. Tree, V. Parker and C.J. Brown, 536–537. Johannesburg, South Africa: BirdLife South Africa.

———. 1997c. "Feral Pigeon." In *The Atlas of Southern African Birds*, edited by J.A. Harrison, D.G. Allan, L.G. Underhill, M. Herremans, A.J. Tree, V. Parker and C.J. Brown, 500. Johannesburg, South Africa: BirdLife South Africa.

Brooke, R.K. and Crowe, T.M. 1982. Variation in species richness among the offshore islands of the southwestern Cape. *South African Journal of Zoology* 17: 49–58.

Brooke, R.K., Lloyd, P.H. and de Villiers, A.L. 1986. "Alien and translocated terrestrial vertebrates in South Africa." In *The Ecology and Management of Biological Invasions in Southern Africa*, edited by I.A.W. Macdonald, F.J. Kruger and A.A. Ferrar, 63–74. Cape Town, South Africa: Oxford University Press.

Brown, J.R. and Archer, S. 1989. Woody plant invasion of grasslands: Establishment of honey mesquite (*Prosopis glandulosa* var. *glandulosa*) on sites differing in herbaceous biomass and grazing history. *Oecologia* 80: 19–26.

Brown, R.H. 1978. A difference in N use efficiency in C_3 and C_4 plants and its implications in adaptation and evolution. *Crop Science* 18: 93–98.

Brown, W.R. 1923. The mesquite *Prosopis juliflora*: A famine fodder for the Karoo. *Journal of the Department of Agriculture, Union of South Africa* 6: 62–67.

Bush, J.K. and Van Auken, O.W. 1995. Woody plant growth related to planting time and clipping of a C_4 grass. *Ecology* 76: 1603–1609.

Cain, M.L., Damman, H. and Muir, A. 1998. Seed dispersal and the Holocene migration of woodland herbs. *Ecological Monographs* 68: 325–347.

Carlson, D.H., Thurow, T.L, Knight, R.W. and Heitschmidt, R.K. 1990. Effect of honey mesquite on the water balance of Texas Rolling Plains rangcland. *Journal of Range Management* 43: 491–496.

Clark, J.S. 1998. Why trees migrate so fast: Confronting theory with dispersal biology and the paleorecord. *American Naturalist* 152: 204–224.

Cohen, C. 1997. "Mallard." In *The Atlas of Southern African Birds*, edited by J.A. Harrison, D.G. Allan, L.G. Underhill, M. Herremans, A.J. Tree, V. Parker and C.J. Brown, 765. Johannesburg, South Africa: BirdLife South Africa.

Craig, A.J.F.K. 1997a. "Indian Myna." In *The Atlas of Southern African Birds*, edited by J.A. Harrison, D.G. Allan, L.G. Underhill, M. Herremans, A.J. Tree, V. Parker and C.J. Brown, 454–455. Johannesburg, South Africa: BirdLife South Africa.

———. 1997b. "European Starling." In *The Atlas of Southern African Birds*, edited by J.A. Harrison, D.G. Allan, L.G. Underhill, M. Herremans, A.J. Tree, V. Parker and C.J. Brown, 452–453. Johannesburg, South Africa: BirdLife South Africa.

Craig, G.B. 1993. "The diaspora of the Asian tiger mosquito." In *Biological Pollution: The Control and Impact of Invasive Exotic Species*, edited by B.N. McKnight, 101–120. Indiana Academy of Science, Indianapolis, U.S.A.

D'Antonio, C.M. and Vitousek, P.M. 1992. Biological invasions by exotic grasses, the grass/fire cycle, and global change. *Annual Review of Ecology and Systematics* 23: 63–87.

Davis, B.N.K. 1979. The ground arthropods of London gardens. *London Naturalist* 58: 15–24.

De Kock, A.E. and Giliomee, J.H. 1989. A survey of the Argentine ant, *Iridomyrmex humilis*, (Hymenoptera: Formicidae), in South African fynbos. *Journal of the Entomological Society of Southern Africa* 52: 157–164.

Drake, B.G., Gonzalez-Meler, M.A. and Long, S.P. 1997. More efficient plants: A consequence of rising atmospheric CO_2? *Annual Review of Plant Physiology and Plant Molecular Biology* 48: 609–639.

Du Toit, R. 1942. The spread of prickly pear in the Union. *Farming in South Africa* 17: 300–304.

Dugas, W.A. and Mayeux, H.S. Jr. 1991. Evaporation from rangeland with and without honey mesquite. *Journal of Range Management* 44: 161–170.

Easter, S.J. and Sosebee, R.E. 1975. Influence of soil-water potential on the water relationships of Honey Mesquite. *Journal of Range Management* 28: 230–232.

Ebenhard, T. 1988. Introduced birds and mammals and their ecological effects. *Swedish Wildlife Survey* 13: 5–107.

Ehleringer, J.R., Cerling, T.E. and Helliker, B.R. 1997. C_4 photosynthesis, atmospheric CO_2, and climate. *Oecologia* 112: 285–299.

Felker, P., Clark, P.R., Nash, P., Osborn, J.F. and Cannell, G.H. 1982. Screening *Prosopis* (mesquite) for cold tolerance. *Forest Science* 28: 556–562.

Fischer, S.F., Poschlod, P. and Beinlich, B. 1996. Experimental studies on the dispersal of plants and animals on sheep in calcareous grasslands. *Journal of Applied Ecology* 33: 1206–1222.

Franz, J.M. 1964. Dispersion and natural-enemy action. *Annals of Applied Biology* 53: 510–515.

Fry, C.H., Urban, E.K. and Keith, G.S. 1988 (Eds). *The Birds of Africa*. Vol. 3. London: Academic Press.

Garnier, E., Gobin, O. and Poorter, H. 1995. Nitrogen productivity depends on photosynthetic nitrogen use efficiency and on nitrogen allocation within the plant. *Annals of Botany* 76: 667–672.

Geertsema, H. 2000. Range expansion, distribution records and abundance of some Western Cape insects. *South African Journal of Science* (in press).

Gibbs Russell, G.E., Watson, L., Koekemoer, M., Smook, L., Barker, N.P., Anderson, H.M. and Dallwitz, M.J. 1990. Grasses of southern Africa. *Memoirs of the Botanical Survey of South Africa* 58: 1–437.

Gill, A.M. 1985. *Acacia cyclops* G. Don (Leguminosae-Mimosaceae) in Australia: Distribution and dispersal. *Journal of the Royal Society of Western Australia* 67: 59–65.

Gill, A.M. and Neser, S. 1984. *Acacia cyclops* and *Hakea sericea* at home and abroad. In *Proceedings, 4th International Conference on Mediterranean Ecosystems*, edited by B. Dell, 57–58, Nedlands, Australia: University of Western Australia.

Glendening, G.E. and Paulsen, H.A. 1955. Reproduction and establishment of Velvet Mesquite [*Prosopis juliflora* var. *velutina*] as related to invasion of semidesert grasslands. Technical Bulletin USDA 1127: 1–50.

Greathead, D.J. 1971. *A Review of Biological Control in the Ethiopian Region.* Slough, England: Commonwealth Agricultural Bureau.

Gurbachan, S., Abrol, I.P., Cheema, S.S. and Singh, G. 1990. Effects of irrigation on *Prosopis juliflora* and soil properties of an alkali soil. *International Tree Crops Journal* 6: 81–99.

Harding, G.B. and Bate, G.C. 1991. The occurrence of invasive *Prosopis* species in the northwestern Cape, South Africa. *South African Journal of Science* 87: 188–192.

Henderson, L. 1995. *Plant Invaders of Southern Africa.* Plant Protection Research Institute Handbook 5: 1–177.

———. 1998. Southern African plant invaders atlas (SAPIA). *Applied Plant Sciences* 12: 31–32.

Henderson, M. and Anderson, J.G. 1966. Common weeds in South Africa. *Memoirs of the Botanical Survey of South Africa* 37: 1–440.

Henderson, L. and Harding, G.B. 1992. *Prosopis.* Weeds A.34. Directorate of Information, South African Department of Agriculture, Pretoria, 3 pp.

Higgins, S.I. and Richardson, D.M. 1998. Pine invasions in the Southern Hemisphere: Modelling interactions between organism, environment and disturbance. *Plant Ecology* 135: 79–93.

———. 1999. Predicting plant migration rates in a changing world: the role of long-distance dispersal. *American Naturalist* 153: 464–475.

Hobbs, R.J. and Atkins, L. 1988. Effects of disturbance and nutrient addition on native and introduced annuals in plant communities in the Western Australian wheatbelt. *Australian Journal of Ecology* 13: 171–179.

Hobbs, R.J. and Mooney, H.A. 1995. Spatial and temporal variability in California annual grassland: Results from a long-term study. *Journal of Vegetation Science* 6: 43–56.

Hoffman, M.T. 1997. "Human impacts on vegetation." In *Vegetation of Southern Africa,* edited by R.M. Cowling, D.M. Richardson and S.M. Pierce, 507–534. Cambridge, England: Cambridge University Press.

Hönig, M.A., Cowling, R.M. and Richardson, D.M. 1992. The invasive potential of Australian banksias in South African fynbos: A comparison of the reproductive potential of *Banksia ericifolia* and *Leucadendron laureolum. Australian Journal of Ecology* 17: 305–314.

Hoon, J.H., King, B.R. and Jordaan, G. 1995. Die ontrekkingsperiode van vee vanaf veld nadat prosopispeule ingeneem is. (The withdrawal period of livestock from rangeland after intake of *Prosopis* pods). *Grootfontein Agric* 1: 7–12.

Huenneke, L.F., Hamburg, S.P., Koide, R., Mooney, H.A. and Vitousek, P.M. 1990. Effects of soil resources on plant invasion and community structure in Californian serpentine grassland. *Ecology* 71: 478–491.

Hull, H.M. 1958. The effect of day and night temperature on growth, foliar wax content and cuticle development of Velvet Mesquite. *Weeds* 6: 133–142.

Human, K.G. and Gordon, D.M. 1996. Exploitation and interference competition between the invasive Argentine ant, *Linepithema humile,* and native ant species. *Oecologia* 105: 405–412.

———. 1997. Effects of Argentine ants on invertebrate biodiversity in northern California. *Conservation Biology* 11: 1242–1245.

Jeltsch, F., Milton, S.J., Dean, W.R.J. and van Rooyen. N. 1996. Tree spacing and coexistence in semi-arid savannas. *Journal of Ecology* 84: 583–595.

Jefferies, R.L. and Maron, J.L. 1997. The embarrassment of riches: Atmospheric deposition of nitrogen and community and ecosystem processes. *Trends in Ecology and Evolution* 12: 74–78.

Keeley, J.E. and Zedler, P.H. 1998. "Evolution of life histories in *Pinus*" In *Ecology and Biogeography of Pinus*, edited by D.M. Richardson, 219–251. Cambridge, England: Cambridge University Press.

Kotanen, P.M. 1995. Responses of vegetation to a changing regime of disturbance: Effects of feral pigs in a Californian coastal prairie. *Ecography* 18: 190–199.

Kruger, F.J., Richardson, D.M. and van Wilgen, B.W. 1986. "Processes of invasion by alien plants." In *The Ecology and Management of Biological Invasions in Southern Africa*, edited by I.A.W. Macdonald, F.J. Kruger and A.A. Ferrar, 145–156. Cape Town, South Africa: Oxford University Press.

Lahiri, A.N. and Kumar, V. 1967. The annual water turn-over from a xeric tree, *Prosopis cineraria*. *Science and Culture* 33: 77–78.

Lambers, H., Freisjen, N., Poorter, H., Hirose, T. and van der Werf, A. 1990. "Analyses of growth based on net assimilation rate and nitrogen productivity. Their physiological background." In *The Causes and Consequences of Variation in Growth Rate and Productivity in Higher Plants*, edited by H. Lambers, M.L. Cambridge, H. Konings and T.L. Pons, 1–17, The Hague, Netherlands: SPB Academic Publishers.

Liversidge, R. 1962. The spread of the European starling in the Eastern Cape. *Ostrich* 3(3): 13–16.

Liversidge, R. 1985. "Alien bird species introduced into southern Africa." In *Proceedings of the Birds and Man Symposium*, edited by L.J. Bunning, 31–44, Johannesburg, South Africa: Witwatersrand Bird Club.

Long, J.L. 1981. *Introduced Birds of the World*. London: David and Charles.

Macdonald, I.A.W. 1989. "Man's role in changing the face of southern Africa" In *Biotic Diversity in Southern Africa*, edited by B. Huntley, 51–77. Cape Town, South Africa: Oxford University Press.

Macdonald, I.A.W., Kruger, F.J. and Ferrar, A.A. (eds) 1986. *The Ecology and Management of Biological Invasions in Southern Africa*, Cape Town, South Africa: Oxford University Press.

Macdonald, I.A.W. and Macdonald, S.A. 1983. "The demise of the solitary scavengers in southern Africa—the early rising crow hypothesis." In *Proceedings of the Birds and Man Symposium*, edited by L.J. Bunning, 321–335. Johannesburg, South Africa: South African Ornithological Society.

Mack, R.N. 1981. Invasion of *Bromus tectorum* L. into western North America: An ecological chronicle. *Agro-Ecosystems* 7: 145–165.

Maclean, G.L. 1993. *Roberts' Birds of Southern Africa*. Cape Town, South Africa: John Voelcker Bird Book Fund.

Martin, P.H. and Lefebvre, M.G. 1995. Malaria and climate: Sensitivity of malaria potential transmission to climate. *Ambio* 24: 200–209.

Marmillon, E. 1986. Management of algarrobo (*Prosopis alba, P. chilensis, P. flexuosa* and *P. nigra*) in the semiarid regions of Argentina. *Forest Ecology and Management* 16: 33–40.

Martin, S.C. and Morton, H.L. 1993. Mesquite control increases grass density and reduces soil loss in southern Arizona. *Journal of Range Management* 46: 170–175.

McClaran, M.P. and Anable, M.E. 1992. Spread of introduced Lehmann love grass along a grazing intensity gradient. *Journal of Applied Ecology* 29: 92–98.

McLaughlin, S.P. and Bowers, J.E. 1982. Effects of wildlife on a Sonoran Desert plant community. *Ecology* 63: 246–248.

Miettinen, P., Luukkanen, O., Johansson, S., Eklund, E. and Mulatya, J. 1988. *Rhizobium* nodulation in *Prosopis juliflora* seedlings at different irrigation levels in eastern Kenya. *Plant and Soil* 112: 233–238.

Milton, S.J. and Dean, W.R.J. 1987. Cactus in the Karoo: A thorny problem. *Veld & Flora* 73: 128–131.

Moran, V.C. 1983. The phytophagous insects and mites of cultivated plants in South Africa: Patterns and pest status. *Journal of Applied Ecology* 20: 439–450.

New, T.R. 1994. *Exotic Insects in Australia.* Adelaide, Australia: Gleneagles.

Newberry, K. 1988. Production of a hybrid between the bedbugs *Cimex hemipterus* and *Cimex lectularius. Medical and Veterinary Entomology* 2: 297–300.

Newberry, K. and Mchunu, Z.M. 1989. Changes in the relative frequency of occurrence of infestations of two sympatric species of bedbug in northern Natal and KwaZulu, South Africa. *Transactions of the Royal Society of Tropical Medicine and Hygiene* 83: 262–264.

Oatley, T.B. 1973. Indian house crow—first SA sightings. *Bokmakierie* 25: 41–42.

Peacock, J.T. and McMillan, C. 1965. Ecotypic variation in *Prosopis* (Mesquite). *Ecology* 46: 35–51.

Perez, S.C.J.G.A. and De Moraes, J.A.P.V. 1990. Influencias da temperatura, da interacao temperatura giberelina e do estresse termico na germinacao de *Prosopis juliflora* (Sw) D.C. (Effects of temperature, temperature-gibberellin interaction and thermal stress on germination of *Prosopis juliflora* [Sw] D.C.). *Revista Brasileira de Fisiologia Vegetal* 2: 41–53.

Peters, R.L. 1990. Effects of global warming on forests. *Forest Ecology and Management* 35: 13–33.

Picker, M.D. and Samways, M.J. 1996. Faunal diversity and endemicity of the Cape Peninsula, South Africa—a first assessment. *Biodiversity and Conservation* 5: 591–606.

Pitelka, L.F. et al. 1997. Plant migration and climate change. *American Scientist* 85: 464–473.

Polley, H.W. Johnson, H.B. and Mayeux, H.S. 1994. Increasing CO_2: Comparative responses of the C_4 grass *Schizachyrium* and grassland invader *Prosopis. Ecology* 75: 976–988.

Polley, H.W. Johnson, H.B., Mayeux, H.S. and Tischler, C.R. 1996. "Are some of the recent changes in grassland communities a response to rising CO_2 concentrations?" In *Carbon Dioxide, Populations, and Communities,* edited by C. Korner and F.A. Bazzaz, 177–195. San Diego: Academic Press.

Poynton, R.J. 1987. Tree planting in South Africa, No. 3. Other genera: *Prosopis L.* Pretoria, South Africa: South African Forestry Research Institute. 51 pp.

Prajapati, M.C., Surender, S. and Singh, S. 1994. A beneficial aspect of nilgai (*Boselaphus tragocamelus*) in scientifically utilised ravines—an observation. *Indian Forester* 120: 890–897.

Read, J.J., Morgan, J.A., Chatterton, N.J. and Harrison, P.A. 1997. Gas exchange and carbohydrate and nitrogen concentrations in leaves of *Pascopyrum smithii* (C_3) and *Bouteloua gracilis* (C_4) at different carbon dioxide concentrations and temperatures. *Annals of Botany* 79: 197–206.

Rebelo, A. 1991. *Protea Atlas Manual.* Protea Atlas Project, Cape Town.

Richardson, D.M. 1992. Starlings: why have they been so successful? *African Wildlife* 46: 207–210.

Richardson, D.M. and Bond, W.J. 1991. Determinants of plant distribution: Evidence from pine invasions. *American Naturalist* 137: 639–368.

Richardson, D.M. and Higgins, S.I. 1998. "Pines as invaders in the southern hemisphere." In *Ecology and Biogeography of Pinus,* edited by D.M. Richardson, 450–473. Cambridge, England: Cambridge University Press.

Richardson, D.M., Macdonald, I.A.W., Hoffman, J.H. and Henderson, L. 1997. "Alien plant invasions." In *Vegetation of Southern Africa,* edited by R.M. Cowling, D.M. Richardson and S.M. Pierce, 535–570, Cambridge, England: Cambridge University Press.

Richardson, D.M. and Rundel, P.W. 1998. Ecology and biogeography of *Pinus*—an introduction. In *Ecology and Biogeography of Pinus,* edited by D.M. Richardson, 3–46. Cambridge, England: Cambridge University Press.

Richardson, D.M., Williams, P.A. and Hobbs, R.J. 1994. Pine invasions in the Southern Hemisphere: Determinants of spread and invadability. *Journal of Biogeography* 21: 511–527.

Rutherford, M.C., O'Callaghan, M., Powrie, L.W., Hurford, J.L. and Schulze, R.E. 1996. Predicting survival in new environments through analytical GIS application. *Environmental Software* 11: 113–121.

Rutherford, M.C. and Westfall, R.H. 1986. Biomes of southern Africa: An objective categorization. *Memoirs of the Botanical Survey of South Africa* 54: 1–98.

Samways, M.J. 1984. Biology and economic value of the scale predator *Chilocorus nigritus* (F.) (Coccinellidae). *Biocontrol News and Information* 5: 91–105.

———. 1985. Relationship between red scale, *Aonidiella aurantii* (Maskell) (Hemiptera: Diaspididae), and its natural enemies in the upper and lower parts of citrus trees in South Africa. *Bulletin of Entomological Research* 75: 379–393.

———. 1989. Climate diagrams and biological control: an example from the areography of the ladybird *Chilocorus nigritus* (Fabricius, 1798) (Insecta, Coleoptera, Coccinellidae). *Journal of Biogeography* 16: 345–351.

———. 1995. "Southern Hemisphere Insects: Their variety and the environmental pressures upon them." In *Insects in a Changing Environment,* edited by R. Harrington and N.E. Stork, 297–320. London: Academic Press.

———. 1996a. "Insects in the urban environment: Pest pressures versus environmental concern." In *Proceedings of the 2nd International Conference on Insect Pests in the Urban Environment,* 129–133. Edinburgh, Scotland.

———. 1996b. Insects on the brink of a major discontinuity. *Biodiversity and Conservation* 5: 1047–1058.

———. 1997. Classical biological control and biodiversity conservation: What risks are we prepared to accept? *Biodiversity and Conservation* 6: 1309–1316.

Samways, M.J., Osborn, R., Hastings, H. and Hattingh, V. 1999. Global climate change

and accuracy of prediction of species' geographical ranges: Establishment success of introduced ladybirds (Coccinellidae, *Chilocorus* spp.) worldwide. *Journal of Biogeography* 26: 795–812.

Schiffman, P.M. 1994. Promotion of exotic weed establishment by endangered giant kangaroo rats (*Diplodomys ingens*) in a California grassland. *Biodiversity and Conservation* 3: 524–537.

Schulze, R.E. 1997. *South African Atlas of Agrohydrology and -climatology.* Department of Agricultural Engineering, University of Natal, Pietermaritzburg, South Africa.

Shigesada, N., Kawasaki, K. and Takeda, Y. 1995. Modelling stratified diffusion in biological invasions. *American Naturalist* 146: 229–251.

Shmida, A. and Ellner, S. 1983. Seed dispersal on pastoral grazers in open mediterranean chaparral, Israel. *Israel Journal of Botany* 32: 147–159.

Sinclair, J.C. 1974. Arrival of the House Crow in Natal. *Ostrich* 45: 189.

Smith, S.D., Strain, B.R. and Sharkey, T.D. 1987. Effects of CO_2 enrichment on four Great Basin grasses. *Functional Ecology* 1: 139–143.

Snaydon, R.W. 1991. The productivity of C_3 and C_4 plants: A reassessment. *Functional Ecology* 5: 321–330.

Steenkamp, H.E. and Chown, S.L. 1996. Influence of dense stands of an exotic tree *Prosopis glandulosa* Benson, on a savanna dung beetle (Coleoptera: Scarabaeinae) assemblage in southern Africa. *Biological Conservation* 78: 305–311.

Steinschen, A.K., Görne, A. and Milton, S.J. 1996. Threats to the Namaqualand flowers: Out-competed by grass or exterminated by grazing? *South African Journal of Science* 92: 237–242.

Stock, W.D. and Allsopp, N. 1992. "Functional perspective of ecosystems." In *Fynbos— Nutrients, Fire and Diversity,* edited by R.M. Cowling, 241–259. Cape Town, South Africa: Oxford University Press.

Stromberg, J.C., Wilkins, S.D. and Tress, J.A. 1993. Vegetation hydrology models: Implications for management of *Prosopis velutina* (velvet mesquite) riparian ecosystems. *Ecological Applications* 3: 307–314.

Tilman, D. 1990. Constraints and trade-offs: Toward a predictive theory of competition and succession. *Oikos* 58: 3–15.

———. 1997. Community invasibility, recruitment limitation, and grassland biodiversity. *Ecology* 78: 81–92.

Tilman, D., May, R.M., Lehman, C.L. and Nowak, M.A. 1994. Habitat destruction and the extinction debt. *Nature* 371: 65–66.

Tilman, D. and Wedin, D. 1991. Plant traits and resource reduction of five grasses growing on a nitrogen gradient. *Ecology* 72: 685–700.

Tooke, F.G.C. 1955. The eucalyptus snout-beetle, *Gonipterus scutellatus* Gyll.: A study of its ecology and control by biological means. *Entomology Memoirs, Department of Agricultural Technical Services, South Africa* 3: 1282.

Tribe, G.D. and Richardson, D.M. 1994. The European wasp, *Vespula germanica* (Hymenoptera: Vespidae) in southern Africa, and its potential distribution as predicted by ecoclimatic matching. *African Entomology* 2: 1–6.

Van Auken, O.W. and Bush, J.K. 1988. Competition between *Schizachyrium scoparium* and *Prosopis glandulosa. American Journal of Botany* 75: 782–789.

————. 1997. Growth of *Prosopis glandulosa* in response to changes in aboveground and below-ground interference. *Ecology* 78: 1222–1229.

Van Oudtshoorn, F. 1992. *Guide to Grasses of South Africa.* Briza Publications, Pretoria, South Africa.

Van Rooyen, M.W., Theron, G.K. and Van Rooyen, N. 1996. Skilpad Wildflower Reserve—a flower-lover's paradise. *Veld & Flora* 82: 40–42.

van Wilgen, B.W., Everson, C.S. and Trollope, W.S.W. 1990. "Fire management in southern Africa: Some examples of current objectives, practices and problems." In *Fire in the Tropical Biota,* edited by J.G. Goldammer, 179–215. Berlin, Germany: Springer-Verlag.

van Wilgen, B.W., Cowling, R.M. and Burgers, C.J. 1996. Valuation of ecosystem services. A case study from South African fynbos ecosystems. *BioScience* 46: 184–189.

van Wilgen, B.W., Little, P.R., Chapman, R.A., Gorgens, A.H.M., Willems, T. and Marais, C. 1997. The sustainable development of water resources: History, financial costs, and benefits of alien plant control programmes. *South African Journal of Science* 93: 404–411.

Visser, D., Wright, M.G. and Giliomee, J.H. 1996. The effect of the Argentine ant, *Linepithema humile* (Mayr) (Hymenoptera: Formididae), on flower-visiting insects of *Protea nitida* Mill. (Proteaceae). *African Entomology* 4: 285–287.

Vitousek, P.M. 1994. Beyond global warming: Ecology and global change. *Ecology* 75: 1861–1876.

Vitousek, P.M., Aber, J.D., Howarth, R.W., Likens, G.E., Matson, P.A., Schindler, D.W., Schlesinger, W.H. and Tilman, D.G. 1997. Human alteration of the global nitrogen cycle: Sources and consequences. *Ecological Applications* 7: 737–750.

Vlok, J.H.J. 1988. Alpha diversity of lowland fynbos herbs at various levels of infestation by alien annuals. *South African Journal of Botany* 54: 623–627.

Wace, N. 1977. Assessment of dispersal of plant species—the car-borne flora in Canberra. *Proceedings of the Ecological Society of Australia* 10: 167–186.

Walpole, D.E. and Newberry, K. 1988. A field study of mating between two species of bedbug in northern KwaZulu, South Africa. *Medical and Veterinary Entomology* 2: 293–296.

Ward, P. and Zahavi, A. 1973. The importance of certain assemblages of birds as "information-centres" for food-finding. *Ibis* 115: 517–534.

Wedin, D. and Tilman, D. 1991. Dynamics of nitrogen competition between successional grasses. *Ecology* 72: 1038–1049.

Wells, M.J., Balsinhas, A.A., Joffe, H., Engelbrecht, V.M., Harding, G. and Stirton, C.H. 1986. A catalogue of problem plants in southern Africa. *Memoirs of the Botanical Survey of South Africa* 53: 1–658.

Whisenant, S.G. 1990. "Changing fire frequencies on Idaho's Snake River plains: Ecological and management implications." In *Proceedings: Symposium on Cheatgrass Invasion,* edited by E.D. McArthur, E.M. Romney, S.D. Smith and P.T. Tueller, 4–10, Intermountain Research Station General Technical Report INT-276.

Williams, D.G., Mack, R.N. and Black, R.A. 1995. Ecophysiology of introduced *Pennisetum setaceum* on Hawaii: The role of phenotype plasticity. *Ecology* 76: 1569–1580.

Winterbottom, J.M. 1966. Some alien birds in South Africa. Bokmakierie 18: 61–62.

———. 1978. "Birds." In *Biogeography and Ecology of Southern Africa*, edited by M.J.A. Werger, 951–979. The Hague, Netherlands: W. Junk.

Winterbottom, J.M. and Liversidge, R. 1954. The European starling in the southwest Cape. *Ostrich* 25: 89–96.

Wong, S.C. 1979. Elevated atmospheric partial pressure of CO_2 and plant growth. I. Interactions of nitrogen nutrition and photosynthetic capacity in C_3 and C_4 plants. *Oecologia* 44: 68–74.

Wright, H.A. and Bunting, S.C. 1975. Mortality of honey mesquite seedlings after burning. *Noxious Brush and Weed Control Research Highlights* 6: 39.

Zimmermann, H.G. 1991. Biological control of mesquite, *Prosopis* spp. (Fabaceae), in South Africa. *Agriculture, Ecosystems and Environment* 37: 175–186.

Zimmermann, H.G. and Moran, V.C. 1991. Biological control of prickly pear, *Opuntia ficus-indica* (Cactaceae), in South Africa. *Agriculture, Ecosystems and Environment* 37: 29–35.

Zimmermann, H.G., Moran, V.C. and Hoffmann, J.H. 1986. "Insect herbivores as determinants of the present distribution and abundance of invasive cacti in South Africa." In *The Ecology and Management of Biological Invasions in Southern Africa*, edited by I.A.W. Macdonald, F.J. Kruger and A.A. Ferrar, 269–274. Cape Town, South Africa: Oxford University Press.

Chapter 14

≈

Plant Invasions in Germany: General Aspects and Impact of Nitrogen Deposition

Michael Scherer-Lorenzen, Andreas Elend, Stephanie Nöllert, and Ernst-Detlef Schulze

It is now widely accepted that the invasion of alien species is one of the main components of human-caused global change that leads to modifications of community composition and species loss (Mooney and Hobbs, this volume; Soulé 1990). Other driving factors, such as land-use change and climate change, also have strong feedback on the invasibility of ecosystems (Bazzaz 1996; Davis 1986; Dukes, this volume; Hobbs, this volume). Alterations in the biogeochemistry of the global nitrogen cycle are a fourth element of global change: More nitrogen is fixed annually by human-driven processes than by natural ones; for example, for synthetic fertilizer production or as a by-product of fossil fuel combustion (Flaig and Mohr 1996; Mohr and Lehn 1994; Vitousek 1994). The current deposition of nitrogen compounds (NH_x and NO_x) is increasing worldwide and contributes to an unprecedented eutrophication of the biosphere at the landscape level. However, the possible interac-

tion of nitrogen deposition with the success of exotic plant invaders is not well understood.

In Germany, the presence and influence of invasive plant species on ecosystems has been well studied by Kowarik (1995), Jäger (1988), and Lohmeyer and Sukopp (1992), among many others. To summarize the existing data, we are asking: How has the number of species changed over time? Which sites have been successfully invaded by alien species? We also identify those invasive species causing the greatest problems in nature conservation and habitat management in Germany. Finally, we ask whether increasing nitrogen deposition might shift the competitive hierarchies in plant communities, and to what extent alien species may outcompete native species in the central European flora.

History of Plant Invasions in Germany

The German flora (with a total of approximately 3,300 vascular plant species) can be classified into three groups (Fig. 14.1): indigenous species (2,850 species, 86 percent), "old alien species" (165 species, 5 percent) and "new alien species" (315 species, 9 percent) (Jäger 1977; Korneck et al. 1996). The classification into these groups derives from the date of their first occurrence in central Europe (Fukarek 1980; Lohmeyer and Sukopp 1992; Schroeder 1969).

Since the beginning of human settlement some 8,000 years ago (neolithic), the cultivation of land increasingly influenced the vegetation. Wide areas of forests were cleared and the portion of grasslands and agricultural fields became significantly larger, especially during the twelfth and thirteenth centuries (Lang 1994). Before the "neolithic revolution" the vegetation was nearly undisturbed. Species that occurred in that period (until 6000 B.C.) are defined as indigenous (Lang 1994). Since the beginning of human land use, plants have invaded or have been introduced by humans from other floristic regions, in particular from southern and southeastern parts of Europe (di Castri 1989). These 165 species established in small clearings, agricultural fields, or disturbed sites around villages. We regard them as "old alien species" (based on German nomenclature: archaeophytes). Today, a majority of all agricultural weeds of central Europe are considered as old aliens and some of them are even subjects of conservation programs (e.g., *Adonis aestivalis*, *Adonis flammea*, *Agrostemma githago*).

The "new alien species" (neophytes) are plants that arrived in central Europe during the last 500 years, exactly since 1492 (discovery of the New World by Columbus). Most of these are native to North America or East Asia. Their number has increased exponentially as international trade intensified during and after the Industrial Revolution. Approximately 12,000 nonnative species have been introduced to central Europe (Sukopp 1976), but only a

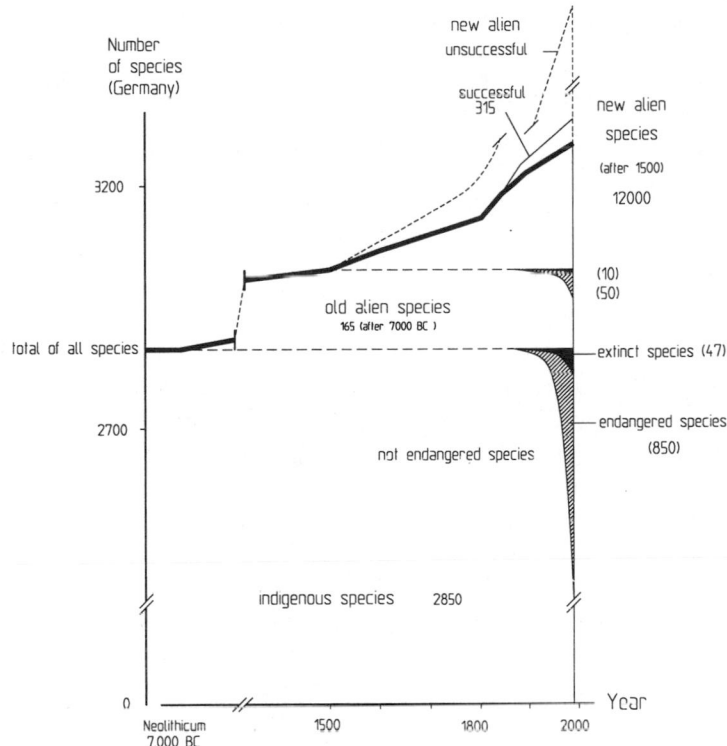

Figure 14.1. Changes of species number over time. The German flora (total of approximately 3,300 vascular plant species) is composed of three different groups of species: indigenous species (2,850 species, 86 percent), "old alien species" (165 species, 5 percent), and "new alien species" (315 species, 9 percent). The scattered areas indicate the proportion of endangered species, whereas the black sectors represent the extinct ones. The total of all nonnative species ever recorded in Germany is marked with a dashed line, but most of them did not establish successfully. The total species richness is shown by the bold solid line. (Data from Fukarek 1980; Jäger 1977; Korneck et al. 1996; Lang 1994; Lohmeyer and Sukopp 1992; and Sukopp 1976.)

small proportion became established in the German flora (315 species, 9 percent). Two hundred of them invaded seminatural or natural vegetation, such as forests, river basins, bogs, and grasslands (Lohmeyer and Sukopp 1992). Kowarik (1996) assumes that on average 100 out of 1,000 introduced species are able to spread spontaneously in central Europe, 20 become naturalized, and 10 are successful in invading natural or seminatural vegetation. Only 2 out of 1,000 species are likely to cause "undesirable" effects (Table 14.1). Such negative consequences include (1) the displacement of native species and/or

Table 14.1. Relation between the numbers of introduced species and their level of success (from Kowarik 1996).

1,000 introduced	100 spread spontaneously	20 naturalized	10 establish in seminatural and natural vegetation	2 cause undesirable effects

the hybridization with native species causing a reduction of biodiversity and changes in ecosystem structure and/or function, (2) reduction in crop yield and increased herbicide application due to the spread of invasive agricultural weed species, (3) impaired natural regeneration of forest trees and restrainment of silvicultural practices, (4) changes in flow dynamics of streams and destabilization of river banks, and (5) the spread of plants that are prejudicial to human health (Kowarik 1996).

The combination of land-use change and heavy fertilization has caused 850 indigenous species to become endangered during the last 150 years, and has driven forty-seven species to extinction. Similarly, forty-seven old alien species have become endangered and ten species have gone extinct (Korneck et al. 1996). In terms of absolute species numbers, there now seems to be an overcompensation for species loss by the establishment of invasive species in Germany.

The "Dirty 12"

We tried to identify the most important invasive plant species in Germany, based on several criteria, combining measures of population dynamics (changes in abundance and distribution) with measures of community effects (changes in species composition and diversity). Applied aspects (economic impact) were also included. Other criteria that might be used for impact assessments of invasive species include measures of the effects on individuals of native species, of effects on the genetics of native populations, and of effects on ecosystem processes (Parker et al. 1999). These last three criteria are omitted here due to a lack of available data for the whole area. Therefore, our list remains preliminary, but could serve as a starting point for more intensive studies about the ecological impact of invasive plant species in Germany.

Based on a literature survey, we identified a pool of thirty nonnative species with either known influence on species composition of ecosystems or high abundance in Germany. For each of the six criteria described below, we classified these thirty species into three broad categories (potentially causing high, medium, or low impact). The final selection of the "dirty dozen" was obtained from the absolute frequencies within each of those categories (Table 14.2).

Table 14.2. The twelve most important alien plant species in Germany (in alphabetical order). Selection is based on abundance, dominance, geographic expansion rates, ability to establish in natural communities, existence of eradication programs, and economic damage.

Species	Family
Elodea canadensis	Hydrocharitaceae
Helianthus tuberosus	Asteraceae
Heracleum mantegazzianum	Apiaceae
Impatiens glandulifera	Balsaminaceae
Impatiens parviflora	Balsaminaceae
Lupinus polyphyllus	Fabaceae
Prunus serotina	Rosaceae
Reynoutria japonica	Polygonaceae
Robinia pseudoacacia	Fabaceae
Solidago canadensis	Asteraceae
Solidago gigantea	Asteraceae
Spartina anglica	Poaceae

1. The ordnance survey map frequency provided by Ellenberg et al. (1991) is the relative frequency of a taxon referred to the distribution in all 10 × 10 kilometer cells of the *Atlas of Ferns and Flowering Plants of Germany* (Haeupler and Schönfelder 1988). Although the geographic distribution is not always directly related to the ecological impact of a species (Parker et al. 1999), it provides baseline information about possible effects on ecosystems. The invasion of an exotic species may cause dramatic effects on a very local scale, but the overall probability of causing such effects should increase with increasing distribution of that species. Therefore, species with a high map frequency were included in the category "causing high effects." Three different patterns of distribution appeared: riparian, ruderal, and regional. Riparian invaders such as *Impatiens glandulifera, Reynoutria japonica,* and *Helianthus tuberosus* show a close relationship to running water used as a transport agent of seeds and fragments of rhizomes (Pyšek and Prach 1993). Their favored habitats, as a result of the pronounced dynamic of running water, are riverbanks with periodical bare ground where seedling establishment does not interfere with closed vegetation (Kohler 1995). Ruderal and disturbed sites are homogeneously distributed in Germany, as records of, for example, *Solidago canadensis* reflect (Fig. 14.2a). The main group of invasives is only of regional importance. The coastal flat of the North Sea has been planted with *Spartina anglica* in order to support aggradation since 1927. Nowadays this alien species overgrows and displaces indigenous coastal vegetation, such as *Salicornia stricta* and *Puccinellia maritima*

Solidago canadensis (a)

Figure 14.2. (a) Ordnance map frequency of *Solidago canadensis,* a North American species dominating ruderal and disturbed sites. (b) Abundance of *Impatiens parviflora,* invading forests and other seminatural habitats. Open circles: before 1945; filled circles: 1945–1980; filled squares: after 1980; filled stars: naturalized; filled triangles: synanthropic; crosses: extinct. By courtesy of Zentralstelle für die Floristische Kartierung der Bundesrepublik Deutschland.

Impatiens parviflora

(b)

(Sukopp 1962). Domestic varieties of North American blueberries (*Vaccinium* subgen. *Cyanococcus*) have been cultivated in plantations in northwestern Germany since 1933, and have spread into pine forests and bogs during the last thirty years. In particular, the invasion into bogs conflicts with conservation issues (Schepker et al. 1997).

2. The **dominance** criterion by Ellenberg et al. (1991) describes whether a species grows as solitary individuals (low dominance), in closed patches (medium dominance), or in dense monocultures (high dominance). It distinguishes between aggressive invasives that replace native plant communities and form single-species stands (e.g., *Elodea canadensis, Lupinus polyphyllus, Reynoutria japonica, Solidago* spp.), and those that integrate into the communities without reducing native plant species richness (e.g., *Ailanthus altissima, Oenothera biennis* agg.). We therefore put the level of the dominance characteristics on par with the level of ecological impact. However, a complete displacement of an indigenous species by an alien has not been observed on a national scale so far (Korneck and Sukopp 1988; Kowarik 1996; Lohmeyer and Sukopp 1992; Schönfelder 1993), although local populations of rare species (*Matteuccia struthiopteris, Senecio sarracenicus*) have been displaced by exotic invaders at riverbanks.

3. The **geographic expansion rate** by Ellenberg et al. (1991) illustrates the changes in occupied area and abundance of a certain taxon over time. The majority of introduced plants are still expanding their geographical distribution in Germany (e.g., *Heracleum mantegazzianum, Prunus serotina, Reynoutria japonica*). The expansion of several species (e.g., *Impatiens parviflora*) has stagnated during the past decades. Others, such as *Elodea canadensis,* had been pests in former times but decreased in numbers recently (Fukarek 1987). We assumed that any occupation of space by invasive species lowers the availability of resources to native species (Tokeshi 1999). Therefore, species that increase in numbers were classified as causing high negative effects on ecosystem integrity. For a complete picture, however, one should compare the population dynamics of the exotic species with that of the native species within the target communities, but data on such possible correlation are not available on a national scale.

4. We paid particular attention to the **ability of nonnatives to establish in indigenous vegetation** with a consequent negative influence on species composition and diversity. Invasive species growing only in ruderal, or heavily disturbed, sites were classified as causing low effects (e.g., *Conyza canadensis*), whereas species invading seminatural (e.g., calcareous grasslands) or natural communities (e.g., bogs, forests) were regarded as causing high ecological impact. *Lupinus polyphyllus, Prunus serotina,* and *Robinia pseudoacacia* penetrate into seminatural forests, nutrient-poor grasslands, and heaths where endangered species may be suppressed (Klemm and Ristow 1995). The two legume species (*Lupinus polyphyllus* and *Robinia pseudoacacia*) increase the

nutrient level in those systems because of their symbiotic relationship with N_2-fixing bacteria, strongly favoring other nitrophilic species (Kowarik 1997). Only one alien species successfully invaded natural beech forests: *Impatiens parviflora* occupies "empty" niches due to its shallow root system without outcompeting any indigenous species (Trepl 1984). *Impatiens* is also successful in other seminatural habitats (Fig. 14.2b), but it has not driven native species to extinction.

5. A small group of invasives causes serious problems for habitat management, agriculture, forestry, water engineering, or human health and has to be controlled by mechanical, chemical, or biological methods. Their control is difficult due to their clonal growth and/or enormous seed output. We therefore included the existence of **eradication programs** in our selection of the dirty dozen. At the moment, approximately twenty-five exotic plant species are subjects of controlling programs in central Europe, primarily due to nature conservation reasons. One of the most problematic invasive plant species seems to be *Heracleum mantegazzianum*. The area occupied by this species is increasing exponentially. It invades many different habitats, ranging from riparian forests to meadows and ruderal sites (Brondegaard 1990; Kolbek et al. 1994). Its furanocumarines cause severe photodermatitis. Many authors demand a long-term management strategy and call for concrete laws for its eradication (Hartmann et al. 1995; Kübler 1995; Pyšek et al. 1995a; Tiley and Philip 1994).

6. In combination with the point 5, we implied known **economic damages or costs** originating from invaders themselves or from eradication programs. Especially in agriculture, forestry, and water engineering, such impairments are significant. For example, the large biomass production of the aquatic weed *Elodea canadensis* interferes with shipping traffic on rivers, leading to increased costs for the clearance of these rivers (Kowarik 1996). Along riverbanks, the absence of perennial understory vegetation in alien monocultures of *Helianthus tuberosus, Impatiens glandulifera,* and *Reynoutria japonica* may increase soil erosion after the growing season, requiring expensive countermeasures. The North American woody species *Prunus serotina* is now subject of intensive mechanical, chemical, and biological control efforts because it forms a dense shrub layer that impedes with silvicultural thinning of forest plantations (Kowarik 1996; Starfinger 1990).

Effects of Nitrogen Deposition on Plant Invasions

In Germany, the anthropogenic emission of nitrogen due to the combustion of fossil fuels and agricultural losses (which derive from overfertilization and excessive use of manure) has reached levels of 1,000,000 t NO_x-N a^{-1} and 540,000 t NH_x-N a^{-1} but is now slightly decreasing (Umweltbundesamt 1997). This leads to airborne nitrogen deposition of 30–60 kg N ha^{-1}a^{-1}, which

exceeds the natural background rate by two orders of magnitude (Flaig and Mohr 1996). These levels could rise up to more than 100 kg N $ha^{-1}a^{-1}$ in areas with intensive agriculture, as in the Netherlands, for instance (Lehn et al. 1995; Stanners and Bourdeau 1995). Thus, today more nitrogen is deposited every year from the atmosphere to all ecosystems than farmers applied fertilizer on their arable fields 150 years ago.

The fertilizing effect of nitrogen deposition is critical in ecosystems that are characterized by natural nitrogen deficiency, like northern temperate and boreal forests, ombrothrophic bogs, heathlands, nutrient-poor grasslands, and seminatural communities. Critical loads for nitrogen are in a range of 5 to 20 kg N $ha^{-1}a^{-1}$ for these ecosystems, suggesting that soils tend to become saturated with nitrogen (Mohr and Lehn 1994). Nitrate leaching, imbalances in plant nutrition leading to increased sensitivity against stress, and acidification of soils are detrimental consequences closely related to enhanced nitrogen supply (Schulze 1989; Schulze and Gerstberger 1993).

Despite some methodological difficulties, there is strong evidence that species composition changes under continuous nitrogen deposition (Flaig and Mohr 1996; Haber 1994; McNeely et al. 1995; Tyler 1987). Especially in oligo- and mesotrophic sites, nitrogen-deposition causes irreversible loss of biodiversity due to competitive exclusion by organisms adapted to nutrient-rich sites, which result in widespread species-poor and homogenous communities.

For natural ecosystems in the temperate zone forest biome, nitrogen has always been in limited supply. Until the introduction of mineral fertilizers (in the second half of the nineteenth century) the human exploitation of natural ecosystems led to an unidirectional flow of nutrients from forests and grasslands to agricultural sites through grazing, and hay and forest-litter collecting. During that 600-year process, the nutrient supply of forest and grassland soils decreased strongly and caused ecological degradation (Haber 1994; Schulze and Gerstberger 1993). However, an increase in species and habitat diversity occurred at the same time. In Germany, about 60 percent of all higher plant species, even 75 percent of all the endangered species and almost all extinct ones, are—or were—adapted to nutrient-poor soil conditions and grow only in oligo- or mesotrophic sites (Fig. 14.3). These nutrient-poor ecosystems are very rich in plant and animal species and are of main interest for nature conservation today, but depend on continuous management, which has been difficult and expensive.

In contrast, the majority of the nonnative species that have become successfully established in Germany require nitrogen-rich soils; therefore, they invade and eventually dominate mostly nutrient-rich sites influenced by human disturbance or fertilization. With increasing levels of disturbance, nitrogen, light, and temperature also increase, but soil moisture often decreases. As shown by Pyšek et al. (1995b) for the Czech flora, aliens are

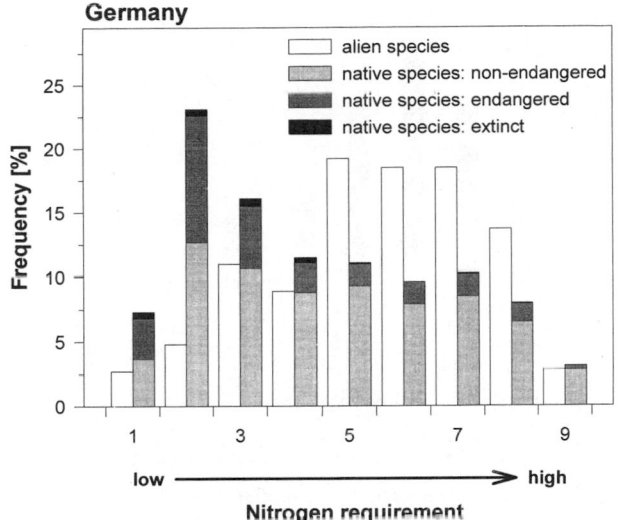

Figure 14.3. Nitrogen requirement (Ellenberg's indicator values, Ellenberg et al. 1991) of plant species. For native species (1,795 species classified), differing intensities of grey indicate the levels of risk of extinction. White bars represent nonindigenous species (total of 144 species classified). Modified after Ellenberg 1986, cited in Schulze and Gerstberger 1993.

especially well adapted to these conditions, corresponding to their warmer areas of origin. Kowarik (1995) analyzed the relationship between species richness and human disturbance in urban plant communities, showing that the number of native species is highest at low or intermediate levels of disturbance, whereas the nonnative ones predominate in number only at very high levels (Fig. 14.4). He points out that "these results may help to refine the intermediate disturbance hypothesis [*sensu* Connell 1978; Grime 1979] by differentiating according to species' origin. Furthermore, they support the theory of the positive relationship between disturbance and the promotion of alien species" (Kowarik 1995, p. 91).

Given the differences between native and alien species with respect to their nitrogen requirement, it is likely that the latter profit relatively more from nitrogen deposition and thus become even more "aggressive." Pyšek et al. (1995b) stated that the "capability of growing in nitrogen-rich sites seems to support successful performance in many habitats of nutrient-overdosed Czech landscape" (p. 54). However, it is difficult to predict which species—native or alien ones—will dominate the community, because there are a lot of native nitrophilous species too, and because more factors than nitrogen supply affect competitive interactions between species.

Unfortunately, there are no empirical studies focusing on the effect of

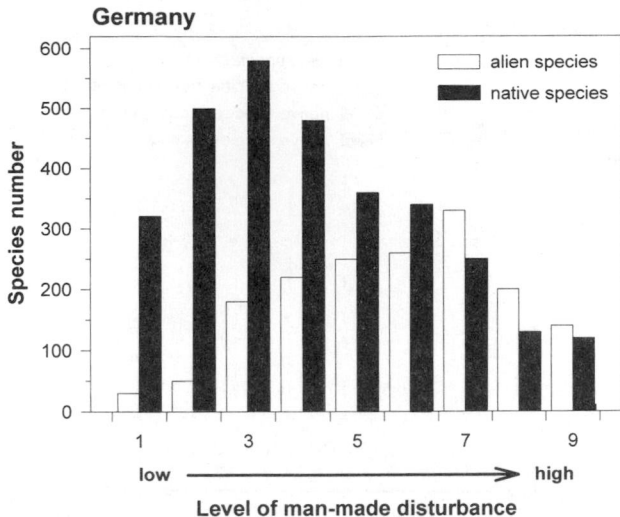

Figure 14.4. The relationship between plant species richness and the level of human disturbance of the vegetation in Berlin, Germany. A total of 5,136 vegetation samples (relevés) were classified according to a scale expressing the intensity and frequency of human disturbances. Black bars represent native species; white bars represent the alien ones. Modified after Kowarik 1995.

nitrogen deposition on the invasibility of plant communities in Germany. However, Wedin and Tilman (1996) showed for nitrogen-limited prairie ecosystems in North America that a simulation of nitrogen deposition through fertilizer application resulted in decreasing species diversity and dramatic changes in species composition due to invasion of weedy European grasses. Other fertilization studies (Burke and Grime 1996; Hobbs et al. 1988; Huenneke et al. 1990) also found significant positive effects of increased levels of soil nutrients on invasion success of both indigenous and exotic invaders. In all cases, the invading species were able to suppress the autochthonous species due to higher biomass production.

Plant traits of successful nonindigenous invaders in central Europe were analyzed among others by Pyšek et al. (1995b), Starfinger (1990), Sukopp (1995), and Trepl (1994). Lohmeyer (1971) analyzed the example of *Helianthus tuberosus* invading into *Urtica dioica* (stinging nettle) stands, which underlines the importance of the growth form for the competitive ability of plant species (Fig. 14.5). *Urtica dioica* is known to be one of the most successful native species able to dominate moist and nutrient-rich disturbed sites because of its clonal growth and its reallocation of carbohydrates and nitrogen compounds from suppressed ramets (connected members of a clone) (Teckelmann 1987, cited in Stitt and Schulze 1994). In contrast, *Helianthus tuberosus,* with its fast-growing

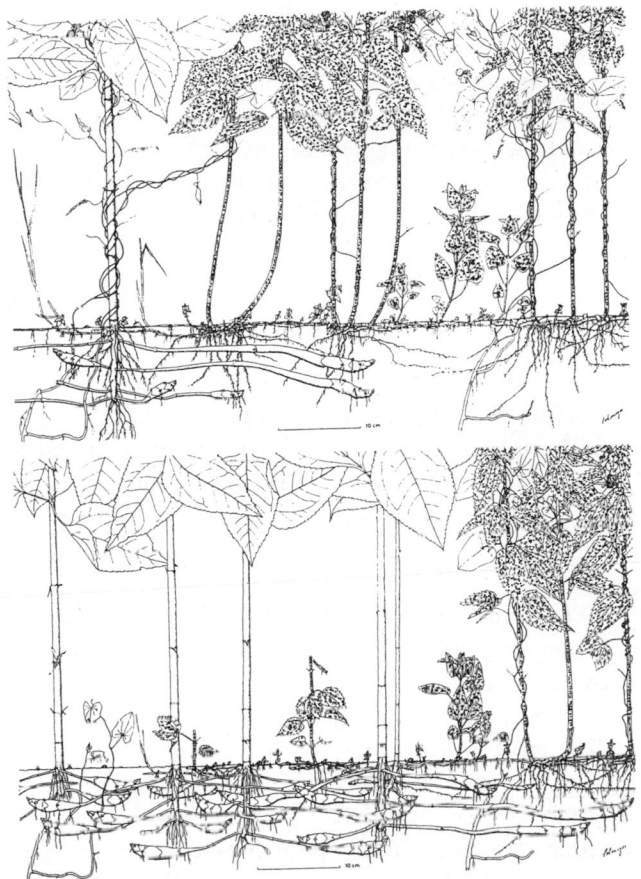

Figure 14.5. Competitive exclusion of the native plant species *Urtica dioica* (dotted leaves, on the right side) by the alien species *Helianthus tuberosus* (white leaves, on the left side). *Top:* With its fast growing rhizomes, a single individuum of *H. tuberosus* "undermines" a community dominated by *U. dioica*, the most successful native species of moist and nutrient-rich disturbed sites. *Bottom:* The same location one year later. Tall and densely foliated ramets of *H. tuberosus* developed from the stoloniferous tubers grown in the previous year and have overgrown ramets of *U. dioica*. New rhizomes advance further into the *Urtica* stand. Modified after Lohmeyer (1971).

rhizomes in deeper soil layers than *Urtica dioica* and its tall and dense canopy, may finally undermine and outshade the native species, which is in this case also an aggressive nitrogen-indicator species.

In central European mountainous spruce stands affected by forest decline, there is a continuous replacement of the understory grass species *Deschampsia flexuosa* by another, *Calamagrostis villosa*. In this case, a combi-

nation of increased nitrogen and light availability due to atmospheric nitrogen-deposition and the thinning of the spruce canopy is the cause of this shift in community composition (Betz 1998; Koppisch 1995). The change in physical factors induces different physiological responses of the two species. *Calamagrostis villosa* is better adapted to the new conditions and finally replaces *Deschampsia flexuosa*. Both grasses are native, but the mechanisms of competitive exclusion could be the same for an alien species invading those stands.

Conclusions

The distribution and spread of nonindigenous plant species is very well documented in Germany. Most studies deal with their biology, with phytosociological characterization of the communities they invade, or with eradication issues. Nevertheless, knowledge of possible influences on ecosystem processes is poor. Field observations of the influence of invasive species on succession trajectories and erosion are the primary sources of that information.

The invasion of exotic species increases plant diversity in Germany. They are not an important threat to biodiversity at a national or regional scale, but could be problematic on a local scale. The main reason for species extinction is land-use change and anthropogenic effects on the nutrient balance of competing species. The most invaded sites are open, nutrient-rich, and human-made disturbed habitats. But as some examples show, even natural ecosystems are not resistant against invasions.

Airborne eutrophication of nutrient-poor sites leads to the expansion of a few strong competitors—both native and alien species—into the species-rich communities. The combination of specific traits like growth form or nutrient-use efficiency may result in competitive exclusion of species. It appears that most of the successful invasive species in central Europe are favored by nitrogen deposition, but the success or failure of newly introduced species cannot be definitely predicted. There is a strong need for experimental approaches to test the effect of nitrogen deposition on the invasibility of plant communities.

Acknowledgments

The authors would like to thank the editors, Pedro Gerstberger, and an anonymous reviewer for helpful comments on the manuscript. Nina Buchmann and Erik Stein tried to improve our English, and Libuse Badewitz helped with drawing some figures.

References

Bazzaz, F. A. 1996. *Plants in Changing Environments: Linking Physiological, Population, and Community Ecology.* Cambridge: Cambridge University Press.

Betz, H. 1998. "Untersuchungen zur Ausbreitungsökologie des Wolligen Reitgrases (*Calamagrostis villosa* [CHAIX] J.F. GMEL)." *Bayreuther Forum Ökologie* 58: 1–208.

Brondegaard, V. J. 1990. "Massenausbreitung des Bärenklaus." *Naturwissenschaftliche Rundschau* 43(10): 438–439.

Burke, M. J. W. and J. P. Grime. 1996. "An experimental study of plant community invasibility." *Ecology* 77(3): 776–790.

Connell, J. H. 1978. "Diversity in tropical rain forests and coral reefs." *Science* 199: 1302–1310.

Davis, M. B. 1986. "Climatic instability, time lags and community disequilibrium." In *Community Ecology*, edited by Diamond, J. and T. J. Case, 269–284. New York: Harper and Row.

di Castri, F. 1989. "History of biological invasions with special emphasis on the Old World." In *Biological Invasions: A Global Perspective*, edited by Drake, J.A. et al., 1–30. New York: Wiley.

Ellenberg, H., H. E. Weber, R. Düll, V. Wirth, W. Werner and D. Paulissen. 1991. "Zeigerwerte von Pflanzen in Mitteleuropa." *Scripta Geobotanica* 18: 1–248.

Flaig, H. and H. Mohr. 1996. "Der überlastete Stickstoffkreislauf—Strategien einer Korrektur." *Nova Acta Leopoldina* 70(289): 5–168.

Fukarek, F. 1980. "Über die Gefährdung der Flora der Nordbezirke der DDR." *Phytocoenologia* 7 (Festband Tüxen): 174–182.

———. 1987. "Pflanzen in Ausbreitung: Gefährdete Arten—gefährliche Arten?" *Botanische Rundbriefe für den Bezirk Neubrandenburg* 19: 3–8.

Grime, J. P. 1979. *Plant Strategies and Vegetation Processes.* Chichester: Wiley.

Haber, W. 1994. "The impact of increased nitrogen levels on the temperate zone biosphere in Europe." *Nova Acta Leopoldina* 70(288): 424–428.

Haeupler, H. and P. Schönfelder (Eds.). 1988. *Atlas der Farn- und Blütenpflanzen der Bundesrepublik Deutschland.* Stuttgart: Ulmer.

Hartmann, E., H. Schuldes, R. Kübler and W. Konold. 1995. *Neophyten: Biologie, Verbreitung und Kontrolle ausgewählter Arten.* Landsberg: Ecomed.

Hobbs, R. J., S. L. Gulmon, V. J. Hobbs and H. A. Mooney. 1988. "Effects of fertiliser addition and subsequent gopher disturbance on a serpentine annual grassland community." *Oecologia* 75: 291–295.

Huenneke, L. F., S. P. Hamburg, R. Koide, H. A. Mooney and P. M. Vitousek. 1990. "Effects of soil resources on plant invasion and community structure in Californian serpentine grassland." *Ecology* 71(2): 478–491.

Jäger, E. J. 1977. "Veränderungen des Artbestandes von Floren unter dem Einfluß des Menschen." *Biologische Rundschau* 15: 287–300.

———. 1988. "Möglichkeiten und Prognosen synanthroper Pflanzenausbreitungen." *Flora* 180: 101–131.

Klemm, G. and M. Ristow. 1995. "Floristisch-vegetationskundliche Untersuchungen

im NSG Wilhelmshagen-Woltersdorfer Dünenzug (Berlin-Köpenick)." *Verhandlungen der Botanischen Vereinigung Berlin und Brandenburg* 128(2): 193–228.

Kohler, A. 1995. "Neophyten in Fließgewässern - Beispiele aus Süddeutschland und dem Elsaß." *Schriftenreihe für Vegetationskunde* 27 (Sukopp-Festschrift): 405–412.

Kolbek, J., S. Lecjaksova and H. Härtel. 1994. "The integration of *Heracleum mantegazzianum* into the vegetation: an example from Central Bohemia." *Biologia* 49(1): 41–51.

Koppisch, D. 1995. "Nährstoffhaushalt und Populationsdynamik von *Calamagrostis villosa* (CHAIX.) J.F. GMEL., einer Rhizompflanze des Unterwuchses von Fichtenwäldern." *Bayreuther Forum Ökologie* 12: 1–187.

Korneck, D., M. Schnittler and I. Vollmer. 1996. "Rote Liste der Farn- und Blütenpflanzen (Pteridophyta et Spermatophyta) Deutschlands." *Schriftenreihe für Vegetationskunde* 28: 21–187.

Korneck, D. and H. Sukopp 1988. "Rote Liste der in der Bundesrepublik ausgestorbenen, verschollenen und gefährdeten Farn- und Blütenpflanzen und ihre Auswertung für den Arten- und Biotopschutz." *Schriftenreihe Vegetationskunde* 19: 1–210.

Kowarik, I. 1995. "On the role of alien species in urban flora and vegetation." In *Plant Invasions: General Aspects and Special Problems,* edited by Pyšek, P. et al., 85–103. Amsterdam: Academic Publishing.

———. 1996. "Auswirkungen von Neophyten auf Ökosysteme und deren Bewertung." *Texte des Umweltbundesamtes* 58/59: 119–155.

———. 1997. "Unerwünschte Folgen der Ausbreitung neophytischer Baum- und Straucharten." *Beiträge zur Gehölzkunde* 1997: 18–28.

Kübler, R. 1995. "Versuche zur Regulierung des Riesenbärenklaus (*Heracleum mantegazzianum*)." In *Gebietsfremde Pflanzenarten: Auswirkungen auf einheimische Arten, Lebensgemeinschaften und Biotope, Kontrollmöglichkeiten und Management,* edited by Böcker, R. et al., 89–92. Landsberg: Ecomed.

Lang, G. 1994. *Quartäre Vegetationsgeschichte Europas.* Jena: Fischer.

Lehn, H., H. Flaig and H. Mohr 1995. "Vom Mangel zum Überfluß: Störungen im Stickstoffkreislauf." *Gaia* 4: 13–25.

Lohmeyer, W. 1971. "Über einige Neophyten als Bestandesglieder der bach- und flußbegleitenden nitrophilen Staudenfluren in Westdeutschland." *Natur und Landschaft* 46(6): 166–168.

Lohmeyer, W. and H. Sukopp. 1992. "Agriophyten in der Vegetation Mitteleuropas." *Schriftenreihe für Vegetationskunde* 25: 1–185.

McNeely, J. A., M. Gadgil, C. Leveque, C. Padoch and K. Redford. 1995. "Human influences on biodiversity." In *Global Biodiversity Assessment,* edited by Heywood, V. H., 711–821. Cambridge: Cambridge University Press.

Mohr, H. and H. Lehn. 1994. "Present views of the nitrogen cycle." *Nova Acta Leopoldina* 70(288): 11–26.

Parker, I. M., D. Simberloff, W. M. Lonsdale, K. Goodell, M. Wonham, P. M. Kareiva, M. H. Williamson, B. von Holle, P. B. Moyle, J. E. Byers, and L. Goldwasser. (1999). "Impact: Toward a framework for understanding the ecological effects of invaders." *Biological Invasions* 1: 3–19.

Pyšek, P., T. Kucera, J. Puntieri and B. Mandak. 1995a. "Regeneration in *Heracleum mantegazzianum:* response to removal of vegetative and generative parts." *Preslia* 67: 161–171.

Pyšek, P. and K. Prach. 1993. "Plant invasions and the role of riparian habitats: a comparison of four species alien to Central Europe." *Journal of Biogeography* 20: 413–420.

Pyšek, P., K. Prach and P. Smilauer. 1995b. "Relating invasion success to plant traits: an analysis of the Czech alien flora." In *Plant Invasions—General Aspects and Special Problems,* edited by Pyšek, P. et al., 39–60. Amsterdam: Academic Publishing.

Schepker, H., I. Kowarik and E. Garve. 1997. "Verwilderungen nordamerikanischer Kultur-Heidelbeeren (*Vaccinium* subgen. *Cyanococcus*) in Niedersachsen und deren Einschätzung aus Naturschutzsicht." *Natur und Landschaft* 72(7/8): 346–351.

Schönfelder, P. 1993. "Bayerns Flora: Zustand und Entwicklungsprognose." In *Dynamik von Flora und Fauna—Artenvielfalt und ihre Erhaltung,* edited by Bayerische Akademie der Wissenschaften, 39–48. München: Pfeil.

Schroeder, F.-G. 1969. "Zur Klassifizierug der Anthropochoren." *Vegetatio* 16: 225–238.

Schulze, E.-D. 1989. "Air pollution and forest decline in a spruce (*Picea abies*) forest." *Science* 244: 776–783.

Schulze, E.-D. and P. Gerstberger. 1993. "Functional aspects of landscape diversity: a Bavarian example." In *Biodiversity and Ecosystem Function,* edited by Schulze, E.-D. and H. A. Mooney, 453–466. Berlin: Springer.

Soulé, M. E. 1990. "The onslaught of alien species, and other challenges in the coming decades." *Conservation Biology* 4: 233–239.

Stanners, D. and P. Bourdeau, eds. 1995. *Europe's Environment—The Dobrís Assessment.* Copenhagen: Earthscan Publications.

Starfinger, U. 1990. "Die Einbürgerung der Spätblühenden Traubenkische (*Prunus serotina* Ehrh.) in Mitteleuropa." *Landschaftsentwicklung und Umweltforschung* 69: 1–119.

Stitt, M. and E.-D. Schulze. 1994. "Plant growth, storage, and resource allocation: from flux control in a metabolic chain to the whole-plant level." In *Flux Control in Biological Systems,* edited by Schulze, E.-D., 57–118. San Diego: Academic Press.

Sukopp, H. 1962. "Neophyten in natürlichen Pflanzengesellschaften Mitteleuropas." *Berichte der Deutschen Botanischen Gesellschaft* 75: 193–205.

———. 1976. "Dynamik und Konstanz in der Flora der Bundesrepublik Deutschland." *Schriftenreihe für Vegetationskunde* 10: 9–27.

———. 1995. "Neophytie und Neophytismus." In *Gebietsfremde Pflanzenarten: Auswirkungen auf einheimische Arten, Lebensgemeinschaften und Biotope—Kontrollmöglichkeiten und Management,* edited by Böcker, R. et al., 3–32. Landsberg: Ecomed.

Tiley, G. E. D. and B. Philip. 1994. "*Heracleum mantegazzianum* (giant hogweed) and its control in Scotland." In *Ecology and Management of Invasive Riverside Plants,* edited by de Waal, L. C. et al., 101–109. Chichester: Wiley.

Tokeshi, M. 1999. *Species Coexistence. Ecological and Evolutionary Perspectives.* Oxford: Blackwell Science.

Trepl, L. 1984. "Über *Impatiens parviflora* DC. als Agriophyt in Mitteleuropa." *Dissertationes Botanicae* 73: 1–400.

Tyler, G. 1987. "Probable effects of soil acidification and nitrogen deposition on the floristic composition of oak (*Quercus robur* L.) forest." *Flora* 179: 165–170.

Umweltbundesamt. 1997. *Daten zur Umwelt.* Berlin: Erich Schmidt.

Vitousek, P. M. 1994. "Beyond global warming: ecology and global change." *Ecology* 75(7): 1861–1876.

Wedin, D. A. and D. Tilman. 1996. "Influence of nitrogen loading and species composition on the carbon balance of grasslands." *Science* 274: 1720–1723.

<p style="text-align:center">Chapter 15</p>

<p style="text-align:center">≈</p>

Invasive Species and Environmental Changes in New Zealand

Mick N. Clout and Sarah J. Lowe

In this chapter we review the complex interactions between environmental change and invasive species in New Zealand, which is one of the most isolated yet most invaded places on Earth. First we summarize the changes wrought by biological invasions on the native fauna, flora, and ecosystems of New Zealand. We then examine the interactions between land-use change and biological invasion and consider the potential consequences of climate change on the spread and impacts of invasive species. We conclude by describing recent changes in approaches to management of invasive species in New Zealand, and some of the environmental consequences of this management. Throughout the chapter, we use invasive animals as our primary examples, because the evidence of recent extinctions shows that these organisms (and especially the predators among them) pose the most significant and immediate threats to native biodiversity.

Biotic Change and Invasive Species

The archipelago of New Zealand was the last major landmass to be settled by humans; perhaps as recently as only 700 years ago (Anderson 1991; Ogden et

<p style="text-align:center">369</p>

al. 1998). Prior to this colonization by Polynesian voyagers, New Zealand had been isolated from other landmasses for over 60 million years, resulting in the evolution of high levels of floral and faunal endemism. Its unique terrestrial ecosystems contained no indigenous land mammals apart from some small bats.

An ecological holocaust followed the initial arrival of people and the alien organisms that they brought with them, which included dogs (*Canis familiaris*), Polynesian rats (*Rattus exulans*), and a few crop plants. Large areas of forest were burned and cleared, and many species of native animals became extinct. Overall, at least 35 bird species were lost following Polynesian settlement, including several species of large flightless birds such as moa (*Dinornithidae*), which were probably hunted to extinction by people and dogs (Anderson 1989). The introduced Polynesian rat seems to have eliminated several species of small birds, flightless insects, and reptiles (Atkinson and Moller 1990).

In the 200 years since European settlement of New Zealand began, over 80 species of alien vertebrates have been introduced, including 34 mammals. These include 3 species of rodents, 3 mustelids, 6 marsupials, and 7 deer species. Predatory European mammals (e.g., ship rats [*R. rattus*], stoats [*Mustela erminea*], and cats [*Felis catus*]) have caused the extinction of 9 endemic bird species in the past 150 years and they continue to threaten several more. Herbivorous mammals (e.g., brushtail possums [*Trichosurus vulpecula*], red deer [*Cervus elaphus*], and goats [*Capra hircus*]) continue to alter the structure and composition of native plant communities through their selective browsing (King 1990).

Although introduced mammals may have caused most of the recent extinctions in New Zealand, they are not the most numerous invaders. Over 1,600 species of plants and several species of insects, birds, and fish, have also been introduced in the past 200 years (Atkinson and Cameron 1993). Among them are many invasive species that threaten native biodiversity (Table 15.1) including alien fish (salmonids and cyprinids), insects such as social wasps (*Vespula* and *Polistes*), and at least 240 species of alien plants that are classed as "ecological weeds" (Williams 1997). Large sectors of the terrestrial and freshwater biota are now dominated by introduced species (Table 15.1). Establishment of new plant species continues at an average rate of 4 per year (E. Cameron, personal communication) and animal invasions also continue, albeit at a lower rate. Most of the new animals are now insects, including those introduced for biological control purposes, but some invasive vertebrates (e.g., fish such as rudd *Scardinius erythrophthalmus* and carp *Cyprinus carpio*) have also established in the past 25 years (McDowall 1990).

Although only 23 percent of the original forest cover of New Zealand remains, the rate of habitat loss has reduced drastically in the past few

Table 15.1. Numbers of alien and native species in New Zealand by taxonomic group (based on tables in Atkinson and Cameron 1993 and Clout 1998).

Group	Native species	Established alien species
Dicots	1,591	1,199
Monocots	621	380
Conifers	24	24
Ferns and allies	113	20
Land mammals	2	34
Resident landbirds	77	33
Breeding seabirds	69	—
Reptiles	60	1
Amphibians	4	2
Freshwater fish	27	20
Insects	c. 18,500	c. 1,500

decades, and the permanent clearance of indigenous forest on public or private lands is now essentially illegal. Biological conservation in New Zealand now concentrates increasingly on mitigating the impacts of alien invasive species on native species and ecosystems.

For most threatened animals, and for many threatened plants, invasive species now pose the most significant remaining threats to their continued survival. Competition or predation by introduced mammals, in particular, threatens many endemic species. Brushtail possums and red deer are especially significant agents of floristic change in indigenous ecosystems, through their selective browsing and inhibition of regeneration of many native plants (Cowan 1990; Challies 1990). Brushtail possums are also significant nest predators of threatened birds (Brown et al. 1993), so this particular invasive mammal is having multiple impacts on indigenous ecosystems in New Zealand (Clout 1999). Rats, cats, and stoats are important agents of faunal change through their predation on behaviorally vulnerable and slow-breeding native animals such as large-bodied invertebrates and ground-feeding or hollow-nesting birds. Flightless birds have proved especially susceptible to mammal predation, with surviving species such as takahe (*Porphyrio mantelli*) and kakapo (*Strigops habroptilus*) now close to extinction as a result (Clout and Craig 1995).

The most damaging invasive species in New Zealand are arguably the mammalian predators that have caused several species extinctions and threaten more. However, there are also many invasive plants that, although they may not threaten immediate extinction of any particular species, have the potential to radically alter native ecosystems over a long time period by outcompeting or smothering native species and altering successional pathways.

Prominent among the long list of invasive plants that threaten indigenous ecosystems in this way (Williams 1997) are species such as *Clematis vitalba, Tradescantia fluminescens, Hedychium gardnerianum, Ligustrum lucidum, Elodea canadensis, Pinus contorta,* and *Hieracium* spp.

Known losses of plant species have been far less numerous than those of animals, but at least 5 endemic plants have become extinct since 1840 and a further 45 are highly threatened (Cameron et al. 1993; P. de Lange, personal communication). Nine of these species, which are likely to become extinct in the wild in the near future, are threatened by weeds (C. Buddenhagen, personal communication).

A recent analysis by the New Zealand Department of Conservation (Molloy and Davis 1994) lists 403 New Zealand taxa (species, subspecies, and forms) as threatened. The total includes 159 plants, 98 invertebrates, and 146 vertebrates. Birds are particularly threatened. In the IUCN Red List (IUCN 1996), 45 of the surviving 287 bird species (150 of them endemic) are listed as threatened. Forty-one of these threatened birds are endemic, and many of them now occur only on mammal-free islands, or in dwindling mainland populations. No country has a higher proportion of its avifauna classed as threatened.

Land-Use Change and Invasive Species

Prior to human settlement, about 78 percent of the land area of the main islands of New Zealand, from coast to treeline, was covered with forest (King 1990). Podocarp/hardwood forest covered most of the lowlands, and southern beech (*Nothofagus*) forest much of the hill country. Fires set by Polynesian settlers destroyed large areas of the original forest (Ogden et al. 1998), so that by 1840, when European colonization started, the forest cover had been reduced to about 53 percent of the land area. Large-scale clearance for farms has since reduced the original forest cover to about 23 percent of the land area. Most of this remaining forest is on hill country and a disproportionate amount is in the wetter and cooler parts of the South Island, in the west and southwest of the country (Fig. 15.1). Lowland forests have been heavily fragmented and the remnants are prone to further degradation due to browsing by introduced mammals and weed invasion. Approximately 52 percent of the land area of New Zealand is now "open country," most of which is pastoral land covered by introduced grasses and clover. A further 6 percent of the land area is covered by agricultural crops, exotic forestry plantations, or cities (King 1990).

This relatively rapid change from a primarily forested landscape to lowlands dominated by open habitats with fragments of native vegetation, has had major impacts on the native flora and fauna, especially those that are nat-

Figure 15.1. Map of New Zealand showing change in forest cover.

urally restricted to lowland habitats. The land-use change has also aided establishment and invasion by alien species, many of which are particularly successful in open or disturbed habitats. Most of the invaders have been introduced by people, either deliberately or accidentally (Atkinson and Cameron 1993), but some have colonized New Zealand naturally over the past century. Among these "self-introductions" have been several Australian bird species that are typical of open country or forest edges (Heather and Robertson 1996). They include (with dates of colonization) the silvereye (*Zosterops lateralis*) (1856), spur-winged plover (*Vanellus miles*) (1932), white-faced heron (*Ardea novaehollandiae*) (1941), royal spoonbill (*Platalea regia*) (1949), and welcome swallow (*Hirundo tahitica*) (1958). These species were presumably vagrant to New Zealand for millennia, but were only able to colonize once suitable conditions had been created by land-use change.

Fragmentation of natural habitats into small patches reduces the effective population size of native species that are reliant on these habitats, especially those with poor dispersal abilities and low natural densities. Reduced population viability and local extinctions are likely for such species. Habitat fragmentation is also associated with an increased ratio of edge to interior and increased vulnerability to invasive species around the margins. The invasion of weeds into natural habitats from edges is well known. However, this problem is not restricted to weed invasion; it may also involve increased risks of predation on vulnerable native forest fauna by open country or "edge" predators. One example is the recently arrived Asian paper wasp (*Polistes chinensis antennalis*), which inhabits forest edges and preys on native invertebrates

(Clapperton et al. 1996). Another is the Australasian harrier (*Circus approximans*), a native bird of open country that has become common as a result of land-use change and the presence of introduced mammalian prey (Heather and Robertson 1996). This predator penetrates forest remnants where it preys on birds, including the nestlings of rare native species such as the kokako (*Callaeas cinerea*) (J. Innes, personal communication). Forest edges also harbor introduced vertebrate predators, such as feral and domestic cats, ferrets, Indian mynas (*Acridotheres tristis*), and Australian magpies (*Gymnorhina tibicen*). Large mammalian predators such as feral cats and ferrets require access to prey such as rabbits, which occur mainly in open habitats, but the predators themselves range into adjacent forest remnants where they take native fauna (C. Gillies, personal communication).

Land-use change in New Zealand has clearly exacerbated the adverse effects of invasive species on native biodiversity by creating suitable habitats for such species, from which they can either permanently or temporarily invade remaining indigenous habitats.

Climate Change and Invasive Species

New Zealand is an isolated archipelago, located in the southern reaches of the Pacific Ocean. Its main landmasses extend from around 34° S to 47° S, with outlying island groups extending from around 29° S to 52° S. The climate is temperate to cool temperate and is dominated by westerly air flows, the surrounding oceanic environment, and the central mountain chain, which modifies airflows as they pass eastward. Northerly intrusions of warm, moist air move southward into New Zealand latitudes during summer. Temperature extremes are mainly confined to places east of the main ranges. There is no consensus on exactly how global warming caused by greenhouse gases will affect the New Zealand climate over the next century, but it may result in a rise, by 2070, of 1°C to 3°C in mean temperatures (Whetton et al. 1996), combined with wetter conditions in the west, drier conditions in the east, and a 2–35 cm rise in sea level by 2050 (Hannah 1990).

Because of New Zealand's southern position on the globe, organisms entering the country via human activity (cargo shipments, passenger arrivals, ballast water) almost all originate from the north. Australia and the South Pacific Island nations are the closest neighbors, but ships and aircraft also carry cargo and passengers to New Zealand from Asia, Europe, the Americas, and elsewhere in the world. In 1995–96, total visitor arrivals (virtually all by air) comprised 37 percent from Asia and Oceania, 28 percent from Australia, 18 percent from Europe, and 13 percent from North America (Statistics New Zealand 1996). From 1993 to 1996 the number of international arrivals increased by 5.5–14.9 percent per annum. The main point of entry for people (around 75 percent of total) is Auckland, in the warm northern part of the country (Fig. 15.1). In 1995

Auckland airport also unloaded 49 percent of all overseas trade cargo. Not surprisingly, the Auckland area has the highest rate of naturalization of new plants (Atkinson and Cameron 1993). Between 1870 and 1970 new vascular plants naturalized there at an average rate of 4 species per year, giving Auckland a total of 615 naturalized species by 1987 (Esler and Astridge 1987).

Climate change is likely to influence the distributions of both native and introduced species in New Zealand. A warming of climate is most likely to permit the southward expansion of existing species that are limited by cold temperatures, and to allow the colonization of warmer northern parts of the country by species from warm temperate or subtropical areas, which are currently unable to establish themselves at all.

Models have recently been developed to predict the likely perturbation of local climates in New Zealand caused by rising global temperatures (Kenny et al. 1995). A study of the likely effects of climate change on the distribution of 41 native tree species has suggested that their distributions, and the composition of native forests that contain them, will change markedly if the climate warms by an overall 2°C (Leathwick et al. 1996).

Little research has been conducted in New Zealand to suggest what the effects of such a projected climate change might be on existing introduced species or potential invaders. Among the exceptions are studies on alligator weed (*Alternanthera philoxeroides*) (Stewart et al. 1995) and on the potential for invasion by *Aedes* mosquitoes (Kay 1997). Stewart et al. used the CLIMEX climate matching program (Sutherst and Maywald 1985) to determine the potential range of alligator weed in New Zealand. This weed of waterways and pastures is currently well established in the northern North Island. CLIMEX indicated that under current climatic conditions, it has potential to spread south as far as the coastal regions of the northern South Island, but that other regions are currently unsuitable because of cold stress in winter. A rise in minimum winter temperatures would presumably permit this species to spread further south and inland into areas where it cannot currently establish.

Disease-bearing mosquitoes such as *Aedes aegypti*, *A. albopyctus*, *A. camptorhynchus*, *A. japonicus*, and *A. vigilax* are potential invaders of New Zealand under scenarios of climate warming (Kay 1997). In December 1998, a population of *Aedes camptorhynchus* was discovered in a salt marsh area near the port of Napier in the North Island. It is most likely to have arrived in the cargo of a ship. An eradication campaign started in 1999. The congeneric *A. notoscriptus* invaded New Zealand by 1920, but recent annual average temperature rises of up to 1.7°C in some North Island localities have apparently facilitated an extension of its range (Laird 1995). *Aedes vigilax*, a known major vector of Ross River and Barmah Forest viruses, has been introduced to Fiji and Tonga and could establish in northern New Zealand, especially if the climate warms (Kay 1997). In Australia it is currently limited to north of latitude 37° S. One New Zealand climate change scenario (Wratt et al. 1991)

predicts temperature rises of between 1.5°C and 3.0°C, combined with a 30–50 centimeter rise in sea level and wetter and drier conditions in the west and east respectively. This could convert areas that are currently climatically marginal into potential habitat for species such as *A. aegypti* and could create new estuarine breeding habitats for others such as *A. vigilax* (Kay 1997). Alternative hosts among introduced mammal species in New Zealand may facilitate the establishment of viruses carried by *Aedes* mosquitoes. For example the main vertebrate hosts of the Ross River virus are marsupials. The absence of these animals from the Pacific islands may explain the failure of the virus to establish in places such as Fiji and Samoa (Kay 1997). However, in New Zealand the introduced brushtail possum is common, and so might facilitate the establishment of the Ross River virus if its mosquito vector became established.

Other introduced species for which some data exist on recent spread or potential distribution in relation to climate change include the Indian myna and introduced social wasps (*Vespula* and *Polistes*). Indian mynas were introduced to both the North and South Islands from India in the 1870s. Over a period of several decades, they disappeared from the South Island and from the cooler southern parts of the North Island, but flourished in the warmer northern regions, which they colonized from the 1940s onward (Heather and Robertson 1996). Their current distribution is restricted to north of 40° S. It has been suggested (P.R. Wilson, personal communication) that the tropic-evolved myna has the habit of leaving its eggs unattended for periods during the day while foraging. In cooler New Zealand climates this leads to egg chilling, nest failure, and an inability to maintain populations unless food is highly abundant and foraging bouts are short. A similar explanation has been invoked to explain the failure of the crested myna (*Sturnus cristatellus*) to expand its range in British Columbia (Johnson and Cowan 1974). For the Indian myna, a rise in mean temperatures during the summer nesting season would probably permit it to extend its New Zealand range southward. This would have negative consequences for native birds that are subject to egg predation and harrassment by this invasive bird.

New Zealand has been invaded by four species of social wasps: *Polistes humilis,* which has been in New Zealand since the 1880s; *Vespula germanica,* which established in 1945; *V. vulgaris,* which established by 1978; and *P. chinensis antennalis,* which established by 1979 (Clapperton et al. 1989). All four species prey on native invertebrates. Both of the *Vespula* species have now spread throughout the main islands, but the two *Polistes* wasps are restricted to the north of the country, to around 39° S (Clapperton et al. 1996).

P. humilis is native to Tasmania (Yoshikawa 1962) and has had an apparently stable northerly distribution in New Zealand for several decades. However, the more recent polistine invader, *P. chinensis antennalis* (a native of

China and Japan), may still be expanding its range in New Zealand. This species depends on sunny areas for nesting, and does not normally penetrate continuous native forest. Temperature is likely to be an important factor limiting its eventual distribution, and a key constraint may be temperatures in spring when colonies are initiated. The temperature threshold for egg development is known to be 14.8°C (Miyano 1981), so a warming trend resulting in consistently higher spring temperatures may permit further southward and inland spread of *P. chinensis antennalis*.

Both of the introduced vespulid wasps (*V. germanica* and *V. vulgaris*) are now widespread throughout the two main islands of New Zealand; although *V. vulgaris* is still absent from some areas (Clapperton et al. 1994). Both species prey on native invertebrates. In honeydew beech (*Nothofagus*) forests of the South Island, *V. vulgaris* has replaced *V. germanica* and competes with native birds for honeydew (Moller et al. 1991; Beggs and Wilson 1991). Both vespulid species undergo major seasonal cycles in abundance, with populations peaking in late summer and autumn and falling away in winter, when most nests die with the onset of cold, wet weather. However, nests of both species can sometimes overwinter (Plunkett et al. 1989), especially in warmer areas, such as the north of the North Island. The critical climatic conditions that allow overwintering are not known, but it is possible that the frequency will increase with climate warming. The significance of this for impacts on native ecosystems would lie in the possibility of an earlier seasonal peak in wasp numbers, which would increase the predation risk to native invertebrates with vulnerable life-cycle stages in spring or early summer (J.R. Beggs, personal communication). Under this sort of scenario, the effects of global warming may have effects not only in permitting range extensions of invasive species, but also in increasing the severity of the impacts of such species through changes in their life cycles and seasonal patterns of abundance.

Changing Approaches to the Management of Invasive Species

Eradication

Although the eradication of any invasive species is unusual globally, in New Zealand there have been several successful eradication campaigns. Most of these have been on islands and have been directed against introduced mammals, using a variety of methods, including hunting, trapping, and (more commonly) the aerial application of toxic baits (Veitch and Bell 1990; Veitch 1994). Rodents, rabbits, and cats have now been eradicated from many small islands. Recent successes on large islands have included the eradication of cattle (*Bos taurus*) and sheep (*Ovis aries*) from Campbell Island (11,216 ha);

goats (*Capra hircus*) from Raoul Island (2,938 ha); cats from Little Barrier Island (2,900 ha); brushtail possums, Norway rats (*Rattus norvegicus*), and Polynesian rats from Kapiti Island (1,970 ha); and rabbits (*Oryctolagus cuniculus*) and mice (*Mus musculus*) from Enderby Island (710 ha) (Veitch 1994).

It should also be possible to eradicate new invasions on mainland areas if these are detected early enough. A recent test of this was the eradication of an established population of an insect invader from the inner suburbs of Auckland, a city of over 1 million people. The white-spotted tussock moth (*Orgyia thyellina*), which occurs naturally in Japan, Korea, and China, was identified in Auckland in April 1996 when a member of the public handed a highly distinctive caterpillar to government scientists. On investigation, a population of the moth was found to be established in gardens within an area of about 7 square kilometers. The population is thought to have been established for over a year when discovered. Although the white-spotted tussock moth is not known to have established anywhere else in the world outside its natural range, it is closely related to the invasive gypsy moth (*Lymantria dispar*), has a catholic diet, and is considered a risk to horticulture, forestry plantations, and the indigenous forests of New Zealand. A decision was made by the New Zealand government to attempt a complete eradication. This was attempted using a combination of aerial and ground spraying with Btk (*Bacillus thuringiensis* var. *kurstaki*), some local ground spraying with pyrethrum insecticide, and the placement of pheromone traps. In all, a total of 23 aerial sprayings and 21 rounds of ground sprays were used, and 20,000 pheromone traps were placed. Controls were also placed (under the Biosecurity Act 1993) on the removal of any plant material from the zone where the moths were found. During April 1997, after the initial year of the eradication attempt, six moths were trapped within a small area of the original infestation. No more moths were caught in the pheromone traps over the following year, and it is now (2000) considered that the species has been completely eradicated. Cooperation of the public was essential to the success of the eradication, which involved the repeated spraying of a large suburban area. Despite extensive media publicity and concern about possible health consequences from some members of the public, the vast majority of local residents were totally cooperative. For example, of the 2,000 properties that were selected for placement of pheromone traps, only 8 refused, and that was not because of any objection to the techniques being used, but because they did not support the government (G. Hosking and J. Clearwater, personal communication). In retrospect, the keys to this successful eradication of a potentially damaging alien species were public awareness, early detection, rapid response, and the retention of public support throughout, by providing full information on the reasons for the operation, the choice of methods, and the progress of the eradication.

Control

In New Zealand, as elsewhere in the world, the most common response to the presence of an invasive species that threatens native biodiversity is no action at all. However, for some particularly damaging biodiversity pests in manageable situations, attempts are often made at control.

The most widespread control attempts have been those directed at invasive plants or invertebrates using biological control. Benign examples include the introduction of spider mites and seed weevils to control gorse (*Ulex europaeus*), and the parasitic wasp *Sphecophaga vesparum* to control vespulid wasps. More rarely, biological control has also been directed at vertebrate invaders. The most notorious example is the string of attempts to control rabbits, first by the disastrous introduction of mustelids in the 1880s, then by the failed introduction of myxomatosis in the 1950s, and most recently by the illegal introduction of rabbit calicivirus disease in 1997.

The most extensive chemical control waged against an invasive species in New Zealand is the ongoing campaign against brushtail possums, to protect native ecosystems and prevent the transmission of bovine tuberculosis to livestock. Possum control typically involves the aerial distribution of baits containing 1080 poison (sodium monofluoroacetate) over large areas of native forest, or the placement of baits containing anticoagulant toxin in bait stations. Such control may have side effects, including the beneficial reduction of populations of other invasive mammals such as rats, pigs, and deer. Secondary poisoning of mustelids (such as stoats) feeding on poisoned rodents may also follow (Alterio et al. 1997), although less beneficial diet switching by surviving stoats to feed more on birds can occur after reductions in rat numbers (Murphy and Bradfield 1992).

Temporary mammal control of possums and other mammals to enhance the breeding success of native birds is now a routine procedure. Examples include stoat control to benefit yellowheads (*Mohoua ochrocephala*) in the Eglinton Valley, Fiordland (O'Donnell et al. 1992), rat control to benefit New Zealand pigeons (*Hemiphaga novaeseelandia*) at Wenderholm, Auckland (Clout et al. 1995), and the control of possums, rats, and mustelids to benefit kokako at Kaharoa and Mapara (Saunders 1990; Hay 1995).

Flowing from these successes, a new approach to control of invasive species in New Zealand is the concept of "mainland islands." These are defined areas of natural habitat on the New Zealand mainland, selected for permanent, intensive pest control and ecological restoration. Within these areas invasive species (especially mammals) are controlled to minimum densities to permit recovery of threatened native species and ecosystem processes. Early results of these large-scale management experiments have revealed that when key invasives are removed, there can be dramatic recovery in the species and the

ecosystems that they have been affecting (Clout and Saunders 1995; Clout 1999).

The widespread use of toxins to control invasive species in New Zealand itself has the potential to cause environmental change, and not necessarily in readily foreseeable ways. The use of broad-spectrum toxins such as 1080 and anticoagulant poisons clearly carries the risk of nontarget kills and (in the case of anticoagulants) the environmental accumulation of toxins. Because New Zealand has no native terrestrial mammals apart from bats, nontarget mammal deaths (e.g., deer, pigs, carnivores) are normally of little concern in conservation areas. Repeated trials have failed to show long-term negative impacts of poison bait distribution on populations of birds or other native wildlife. Nevertheless, there is growing public unease about the widespread and repeated use of poisons, and there is consequently an active search for alternative methods of biological pest control. The biological control of conservation pests is potentially more sustainable than the perpetual use of toxins, but it entails the risk of introducing yet more alien species that might be nonspecific in their action, or have other side effects. Thus, the presence of invasive species, followed by decisions to attempt to control them, inevitably precipitates a series of other environmental changes, not all of which are easily foreseen.

Conclusions

The biota and ecosystems of New Zealand have undergone a fundamental transformation over the past few hundred years, as an isolated flora and fauna has been devastated by human-induced environmental changes. These changes have included the large-scale replacement of native forests with tracts of open farmland, the fragmentation of remaining native habitats, and the introduction of a vast array of alien species. Several of these species have proved to be highly invasive and have caused many faunal extinctions. A consequence is that the conservation of native biodiversity in New Zealand is now increasingly equivalent to the management of invasive species. Although there have been a few noteworthy management successes—for example, in eradicating alien mammals from islands—the overall prognosis remains grim, with many native species and ecosystems threatened by invasive species. The challenge of the next century will be to maintain New Zealand's existing biodiversity in the face of these threats, together with the added ones of global climate change and the rising risks of new biological invasions caused by international trade and travel. There is a need for action on several fronts, to prevent further erosion of native biodiversity. The first necessity is to raise public awareness of the threats posed by invasive species and to garner public support for action to detect and prevent further avoidable invasions. The

second necessity is to improve current control practices to allow for sustainable management of existing invasive species. The final necessity is to establish databases and targeted research programs to permit better prediction of new invaders, or the invasive spread of existing alien species, under likely scenarios of climatic and environmental change.

References

Alterio, N., Brown, K., and Moller, H. 1997. Secondary poisoning of mustelids in New Zealand Nothofagus forest. *Journal of Zoology (London)* 243: 863–869.

Anderson, A. 1989. *Prodigious birds.* Cambridge University Press.

————. 1991. The chronology of colonisation of New Zealand. *Antiquity* 65: 767–795.

Atkinson, I.A.E., and Cameron, E.K. 1993. Human influence on the terrestrial biota and biotic communities of New Zealand. *Trends in Ecology and Evolution* 8: 447–451.

Atkinson, I.A.E., and Moller, H. 1990. Kiore. In C. M. King (ed.), *The Handbook of New Zealand Mammals,* pp. 175–192 . Oxford University Press, Oxford, UK.

Beggs, J. R., and Wilson P.R. 1991. The kaka *Nestor meridionalis,* a New Zealand parrot endangered by introduced wasps and mammals. *Biological Conservation* 56: 23–38.

Brown, K., Innes, J., and Shorten, R. 1993. Evidence that possums prey on and scavenge birds' eggs, birds and mammals. *Notornis,* Vol. 40, part 3, pp. 169–177.

Cameron, E.K., de lange, P.J., Given, D.R., Johnson, P.N., and Ogle C.C. 1993. New Zealand Botanical Society threatened and local plant lists. *New Zealand Botanical Society Newsletter* 32: 14–19.

Challies, C.N. 1990. Red deer. In C. M. King (ed.), *The Handbook of New Zealand Mammals* pp. 436–458. Oxford University Press, Oxford, UK.

Clapperton, B.K., Tilley, J.A.V., Beggs, J.R., and Moller, H. 1994. Changes in the distribution and proportions of *Vespula vulgaris* (L.) and *Vespula germanica* (Fab.) (Hymenoptera: Vespidae) between 1987 and 1990 in New Zealand. *New Zealand Journal of Zoology* 21: 295–303.

Clapperton, B.K., Moller, H., and Sandlant, G.R. 1989. The distribution of social wasps (Hymenoptera: Vespidae) in New Zealand in 1987. *New Zealand Journal of Zoology* 16: 315–323.

Clapperton, B.K., Tilley, J.A.V., and Pierce, R.J. 1996. Distribution and abundance of the Asian paper wasp *Polistes chinensis* and the Australian paper wasp *P. humilis* (Fab.) (Hymenoptera: Vespidae) in New Zealand. *New Zealand Journal of Zoology* 23: 19–25.

Clout, M.N. 1999. Biodiversity conservation and the management of invasive animals in New Zealand. In O.T. Sandlund, P.J. Schei, and A. Viken (eds.), *Invasive Species and Biodiversity Management,* pp. 349–361. Kluwer Academic Press, Dordrecht.

Clout, M.N., and Craig, J.L. 1995. The conservation of critically endangered flightless birds in New Zealand. *Ibis* 137: S181–190.

Clout, M.N., Denyer, K., James, R.E., and McFadden, I.G. 1995. Breeding success of

New Zealand pigeons (*Hemiphaga novaeseelandiae*) in relation to control of introduced mammals. *New Zealand Journal of Ecology* 19: 209–212.

Clout, M.N., and Saunders, A.J. 1995. Conservation and ecological restoration in New Zealand. *Pacific Conservation Biology* 2: 91–98.

Cowan, P.E. 1990. Brushtail possum. In C.M. King (ed.), *The Handbook of New Zealand Mammals*, pp. 68–98. Oxford University Press, Auckland.

Esler, A.E., and Astridge, S.J. 1987. The naturalisation of plants in urban Auckland, New Zealand. 2. Records of introduction and naturalisation. *New Zealand Journal of Botany* 25: 523–537.

Hannah J. 1990. Sea-levels—past, present and future. In *New Zealand Climate Report 1990*, pp. 53–56. Bulletin 28, Royal Society of New Zealand, Wellington.

Hay, J.R. 1995. Mapara revisited. *Conservation Science Newsletter* (April 1995): 4–5, Department of Conservation, Wellington.

Heather, B.D., and Robertson, H.A. 1996. *The Field Guide to the Birds of New Zealand*. Viking, Auckland. 432 pp.

IUCN 1996. *1996 IUCN Red List of Threatened Animals*. IUCN, Gland, Switzerland.

Johnson, S.R., and Cowan, I.M. 1974. Thermal adaptation as a factor affecting colonizing success of introduced Sturnidae (aves) in North America. *Canadian Journal of Zoology* 52: 1559–1576.

Kay, B.H. 1997. *Review of New Zealand Programme for Exclusion and Surveillance of Exotic Mosquitoes of Public Health Significance*. Ministry of Agriculture and Fisheries, Wellington.

Kenny, G.J., Warrick, R.A., Mitchell, N.D., Mullan, A.B., and Salinger, M.J. 1995. CLIMPACTS: an integrated model for assessment of the effects of climate change on the New Zealand environment. *Journal of Biogeography* 22: 883–895.

King, C.M. 1990. Introduction. In C. M. King (ed.), *The Handbook of New Zealand Mammals*, pp. 3–20. Oxford University Press, Oxford, UK.

Laird, M. 1995. Background and findings of the 1993–94 mosquito survey. *New Zealand Entomologist* 18: 77–90.

Leathwick, J.R., Whitehead, D., and McLeod, M. 1996. Predicting changes in the composition of New Zealand's indigenous forests in response to global warming: a modelling approach. *Environmental Software* 11: 81–90.

McDowall, R.M. 1990. *New Zealand Freshwater Fishes: A Natural History and Guide*. Heinemann Reed, Auckland. 553 pp.

Miyano, S. 1981. Brood development in *Polistes chinensis antennalis* Perez L. Seasonal variation of immature stages and an experiment on the thermal response of egg development. *Bulletin of the Gifu Prefectural Museum* 2: 75–85.

Moller, H., Tilley, J.A.V., Thomas, B.W., and Gaze, P.D. 1991. Effect of introduced social wasps on the standing crop of honeydew in New Zealand beech forests. *New Zealand Journal of Zoology* 18: 171–179.

Molloy, J., and Davis, A. 1994. *Setting Priorities for the Conservation of New Zealand's Threatened Plants and Animals*. Department of Conservation, Wellington, New Zealand.

Murphy, E.C., and Bradfield, P. 1992. Change in diet of stoats following poisoning of rats in a New Zealand forest. *New Zealand Journal of Ecology* 16: 137–140.

O'Donnell, C.F.J., Dilks, P.J., and Elliott, G.P. 1992. Control of a stoat population

irruption to enhance yellowhead breeding success. *Science and Research Internal Report No.124,* Department of Conservation, Wellington.

Ogden, J., Basher, L., and McGlone, M. 1998. Fire, forest regeneration and links with early human habitation: evidence from New Zealand. *Annals of Botany* 81: 687–696.

Plunkett, G.M., Moller, H., Hamilton, C., Clapperton, B.K., and Thomas, C.D. 1989. Overwintering colonies of German (*Vespula germanica*) and common wasps (*Vespula vulgaris*) (Hymenoptera: Vespidae) in New Zealand. *New Zealand Journal of Zoology* 16: 345–353.

Saunders, A. J. 1990. Mapara: island management "mainland" style. In D. R. Towns, C. H. Daugherty, and I.A.E. Atkinson (eds.), *Ecological Restoration of New Zealand Islands,* pp. 147–149. Conservation Sciences Publication No. 2, Department of Conservation, Wellington, New Zealand.

Statistics New Zealand. 1996. Demographic Trends. December 1996.

Stewart, C.A., Julien, M.H., and Worner, S.P. 1995. The potential geographical distribution of alligator weed (*Alternathera philoxeroides*) and a biological control agent, *Agasicles hygrophila,* in New Zealand. *Proceedings of 48th NZ Plant Protection Conference 1995* 270–275.

Sutherst, R.W., and Maywald, G.F. 1985. A computerised system for matching climates in ecology. *Agricultural Ecosystems and Environment* 13: 281–299.

Veitch, C.R., and Bell, B.D. 1990. Eradication of introduced mammals from the islands of New Zealand. In D.R. Towns, C.H. Daugherty, and I.A.E. Atkinson (eds.), *Ecological Restoration of New Zealand Islands,* pp. 137–146. Conservation Sciences Publication No. 2, Department of Conservation, Wellington, New Zealand.

Veitch, C.R. 1994. Habitat repair: a necessary prerequisite to translocation of threatened birds. In M. Serena (ed.), *Reintroduction Biology of Australian and New Zealand Fauna,* pp. 97–104. Surrey Beatty & Sons, Chipping Norton, New South Wales, Australia.

Whetton, P., Mullan, A.B., and Pittock, A.B. 1996. Climate change scenarios for Australia and New Zealand. In W.J. Bouma, G.I. Pearman, and M.R. Manning (eds.), *Greenhouse Coping with Climate Change,* pp. 145–168. CSIRO Publishing, Collingwood, Victoria, Australia. 682 pp.

Williams, P.A. 1997. Ecology and management of invasive weeds. *Conservation Sciences Publication No. 7.,* Department of Conservation, Wellington.

Wratt, D.S., Mullan, A.B., Clarkson, T.S., Salinger, M.J., von Dadelszen, J., and Plume, H. May 1991. Climate Change: The consensus and the debate. *New Zealand Climate Change Programme.* New Zealand Meteorological Service and Ministry for the Environment.

Yoshikawa, K. 1962. Introductory studies on the life economy of polistine wasps. VI. Geographical distribution and its ecological significance. *Journal of Biology,* Osaka City University 13: 19–44.

Plant Invasions in Chile: Present Patterns and Future Predictions

Mary T. Kalin Arroyo, Clodomiro Marticorena, Oscar Matthei, and Lohengrin Cavieres

Alien plant invasions constitute one of the most pervasive, fast-moving, and often visually striking manifestations of global change. Alien invasives by definition, are species establishing in the wild beyond their natural distribution ranges following intentional or accidental transportation of whole plants or propagules by humans or human-related activities. Intentional introductions include plants of horticultural, medicinal, silvicultural, or agricultural value that escape from cultivation and subsequently become naturalized. Accidental introductions are the result of "piggybacking," as with weed seed carried around with crops, adhesion of seeds on domestic animals transported from one continent to another, and propagules contained in ballast dumped at points of disembarkation.

The successful establishment of an invasive plant species leads initially to a pulse of new biodiversity in a flora with subsequent regional floristic enrichment. While there is little evidence to suggest that all invasives are harmful (Vermeij 1996), conventional wisdom would suggest that *any* alien

introduction should be considered as a potential risk until otherwise proven unharmful. Because many alien plant species have evolved under intense pressures for invasiveness, and native floras from different parts of the world show unequal propensities with regard to the evolution of colonizing ability (di Castri 1989; Rapoport 1991; Arroyo et al. 1995; Rejmánek 1996a), aliens, usually aided by some form of disturbance (Rejmánek 1989), may displace native species locally, and indeed have provoked some major transformations of ecosystems. Classic cases include the ousting of perennial grasses by introduced annuals in the Central Valley of California (Mooney et al. 1986), the transformation of intermountain West grasslands where annual introduced *Bromus tectorum* became dominant in less than fifty years of the date of introduction (Mack 1986), and the replacement of native species by aliens in a heavily impacted conservation area in Metropolitan Boston (Drayton and Primack 1996).

Less evident but by no means insignificant effects of invasive species include alteration of the course of succession affecting whole chains of plant species and associated plant-animal interactions, and preemption of the ever-increasing amount of disturbed habitat on earth, thereby diminishing the possibility for the evolution of colonizing races among the diverse evolutionary lineages represented in native regional floras.

A foreseen outcome of the increasing globalization of world markets, exploitation and fragmentation of natural ecosystems, and a burgeoning ecotourism trade bringing more and more people into natural ecosystems from faraway places, is a dramatic increase in the spread of alien plant species both globally and locally, leading to the homogenization of regional floras and landscapes. It is indeed ironic that in striving to protect local biodiversity through ecologically preferable non-extractive economic activities such as conventional tourism and ecotourism, man himself once again stands to become a major player in the dispersal of diaspores at the intercontinental and local levels (cf. Timmins and Williams 1991). Under the newly emerging scenario, knowledge of the relative susceptibility of different geographical areas to invasion, rates of spread of invasive species in the past, and the ecological roles of aliens in disturbed and undisturbed habitats are germane to our quest for understanding the invasive process per se as well as for managing invasive species on managed and wild lands. In particular, comparisons of invasion patterns in regions with similar climates should be useful for making predictions and establishing measures to avoid future harmful effects where anthropogenic impacts are still less pervasive.

Here we consider the case of Chile, located to the west of the Andean divide in southern South America. The main concerns addressed are how many alien species coexist with the highly endemic flora (Marticorena 1990) of Chile, and from whence have they come? Is there any evidence to suggest that Chile is overly susceptible to alien invasion? What role have land-use pat-

terns played in the spread and abundance of invasive species in Chile? What predictions can be made about the future spread of invasives within Chile based on comparisons with climatically similar lands in western North America and neighboring lands in the Southern Hemisphere.

Historical Background

There are few areas of the world that display the ecosystem diversity of Chile. Ranging from extreme deserts in the north to temperate rain forest and subantarctic wetlands in the south, Chile's ecosystems are underpinned by exceptional floristic diversity. Biogeographically, Chile stands at the cross-roads of the neotropical floristic realm pertaining to the South American continent, and the Gondwanan province that once connected South America to Australia and New Zealand via Antarctica (Arroyo et al. 1996a). These ties, added to long-distance dispersal of biota from convergent mediterranean-type climate and semiarid ecosystems that emerged in western North America over a similar period in time (Raven 1973), have led to a phylogenetically rich, present-day native vascular plant flora of 4,979 species and intraspecific varieties (CONCB 1998). Close to one-half of all native vascular plant species are endemic (Marticorena 1990), and in the smaller winter rainfall area (mediterranean-type climate area and winter rainfall deserts combined) that occupies less than 40 percent of Chilean territory (300,000 km^2) and is considered a global hotspot (Mittermeier et al. 1998), an outstanding 47 percent of vascular plant species are endemic (Arroyo and Cavieres 1997). In the southern temperate South American rain forests, around one-third of all genera and two plant families are endemic to the Chilean phytogeographic region (Arroyo et al. 1996a), with many genera typically represented by a single species.

As of the year 1536 (an early date in comparison with analogous developments in California, Australia, and New Zealand; Fox 1990), the phylogenetically rich and highly endemic flora of Chile, accommodated up until that time in a relatively pristine landscape, was subject to hitherto unknown levels of anthropogenic disturbance, coupled with invasion by alien plants and animals carried directly to Chile by Spanish colonizers from their primary distribution areas in the Old World. It now appears, following the breakthrough work at Monteverde in southern Chile, that indigenous peoples may have occupied southern South America for at least 13,000 years (Dillehay 1997), and evidence of human-mediated fire has been found in the paleoecological record since around 11,000 B.P. (Heusser 1983). In the mid–sixteenth century, fire was being used by indigenous peoples for clearing land for winter rain-fed crops in the mediterranean area of central Chile; llama herding in the high northern Andes began around 2000 B.P. (Fox 1995). However, pre-European levels of disturbance were minor in relation to the wave set off by

such activities as wholesale wood cutting for agriculture, burning of vegetation for charcoal production, and the introduction of European livestock (Aschmann and Bahre 1977) and rabbits (Jaksic and Fuentes 1991) during the colonial period. Today central Chile is about as heavily impacted by intensive agriculture and plantation forestry as the state of California, its mediterranean-climate analog in western North America (Table 16.1).

During the nineteenth century, additional sources of aliens became available to Chile as a result of interchange between Australia, Chile, and California (Fox 1990), such that by midcentury, some 134 alien plant species with recognized weedy properties today (based on Matthei 1995) had become established in Chile (Gay 1845–1854). At this early date many typical European weeds (e.g., *Erodium circutarium, Avena barbata, Conium maculatum, Foeniculum vulgare, Bellis perennis*) were already widely distributed throughout the central provinces of Chile (Barnéoud in Gay 1845–1854), giving a first inkling of what lay ahead. The rapid rate of spread of early invasives in Chile may be illustrated in the case of the showy California poppy, *Eschscholtzia californica* Cham. Johow (1948) wrote: "This plant is very interesting for its rapid naturalization in Chile. Originating from California, it was introduced into the gardens of Valparaíso and Viña del Mar in the 1890s where it escaped immediately from cultivation, becoming established first along railway lines. In 1892 the author saw it at Limache, five years later it had arrived at Llay-Llay. It ascended the Coastal cordillera, and by the first years

Table 16.1. Major anthropogenic impacts on the landscape and population size for Chile, central Chile (regions V–VIII) with a mediterranean-type climate, and California in western North America, also with a mediterranean-type climate.

Impact	Chile (754,061 km²)	Central Chile (115,133 km²)	California (411,470 km²)
Km of road/km²	0.1	0.2	0.7
Urban land (%)	0.2	1.0.	4.9
Crops, pastures, managed rangelands, plantation and managed native forestry (%)*	8.0	36.2	33.9
Total intensively used land (%)	8.2	36.4	38.7
Population (millions)	13.3	8.6	30.8

* Figures for California do not include activities on federal lands.

Sources of data: *Land use:* Chile: CONAF-CONAMA-BIRF-1997; California: California Land Cover/Use, 1992 and USDA Forest Service, PNW Research Station, Oregon, 1997; *Population:* Chile: 1992 census; California: 1995 census.

of this century it had appeared in Tiltil. Around 1905 it had arrived in Santiago [where according to Philippi (1881) it was also cultivated in the Santiago Botanical Garden—but between that time and at least until Reiche (1894) had only escaped in the Valparaíso area], and continued invading toward the south along railway lines. With the construction of the main north-south railway, it spread north, although it is not clear how far it has reached at this point" (pp. 114–115) (authors' translation from Spanish). Continuing, some 32 years later, Frías et al. (1975) indicate that E. californica had extended 240 kilometers north of Santiago to Los Vilos, and as far south as the Bio Bio River, 520 kilometers to the south of Santiago. Today, some 110 years after its putative date of introduction, herbarium records attest to the further spread of E. californica some 60 kilometers north and 90 kilometers south to Caleta Oscuro and Traiguen, respectively, to now cover some seven degrees of latitude or more than 750 kilometers, being found from sea level to above 2,000 meters in the Andean mountains close to Santiago.

Present-day Alien Flora of Chile

The most recent comprehensive published list of alien plants for Chile can be found in Marticorena and Quezada (1985). This list includes species occurring on the island territories of Easter Island, Juan Fernández Islands, and other minor islands under the jurisdiction of Chile. Since 1985, many new introductions have been recorded (cf. Matthei 1995), and there have been taxonomic changes and differing views on the alien status in some species. To determine the present-day alien flora of continental Chile and lay the background for the analyses presented in this chapter, a checklist of exotic species was compiled from monographic treatments, the Chilean flora database (CONCB-98) (which incorporates the original information in Marticorena and Quezada 1985, now separated according to presence of species on island territories and continental Chile), the Matthei (1995) treatise on Chilean weeds, and recently published regional floristic checklists (Henríquez et al. 1995; Marticorena et al. 1998).

These sources suggest that some 690 species (excluding intraspecific varieties where present) (Appendix 16.1) of alien plants have become naturalized in continental Chile (hereafter Chile) since the colonial period. For the portion of the mediterranean area of central Chile climatically comparable to that part of the California Floristic Province contained within California (approximately regions V–VIII of Chile's thirteen political regions; see Arroyo et al. 1995 for definitions), there are 507 aliens. The complete set of Chilean aliens are contained in 73 families and 337 genera, with strong concentrations of species in the Gramineae (151 species), Asteraceae (92 species), and Papilionaceae (62 species), families that are typically well represented in

alien floras worldwide (Pysek 1998). Some 31 species would appear to be rare, and could conceivably have gone extinct since first reporting. As in other areas of the world, aliens in Chile reflect accidental and intentional introductions. For example, 43 naturalized aliens today considered as invasives appear among over 2,000 plant species that were cultivated in the Santiago Botanical Garden in the latter half of the nineteenth century according to catalogues published in 1881 and 1884 (Matthei 1995). Twenty-three naturalized aliens today considered as invasives were purposely introduced as forage plants, with an additional 16 introduced as medicinal plants.

By far the majority of aliens, however, seem to have been transported to Chile accidentally. Among invasives in Chile are found over 25 percent of the 200 weeds responsible for 90 percent of damage to agricultural crops worldwide (Holm et al. 1997), although a few are not considered to be weedy in Chile (Appendix 16.1). Finally, for comparison, close to two-thirds of the aliens in Chile are found in the flora of California, as mostly alien there.

A striking aspect of the alien flora of Chile is the impressive contribution of species of Eurasian and North African (hereafter Eurasian) origin (71 percent) (Table 16.2). The latter percentage is almost as high as in California (73

Table 16.2. Origin and life-forms of alien species in the flora of continental Chile. Origins of alien weeds (as per Matthei 1995) are shown for appearances in Chile over different time intervals.

Origin	All Aliens N (%)	Alien Weeds <1900 N (%)	Alien Weeds ≥1900 N (%)	Alien Weeds ≥1950 N (%)	All Aliens Annual herbs	Biennial herbs	Perennial herbs	Shrubs & trees
Eurasia–North Africa	491 (71.2)	194 (80.8)	144 (75.8)	79 (75.9)	274	27	165	25
Tropical–Warm Regions	60 (8.7)	11 (4.6)	14 (7.4)	8 (7.7)	26	0	23	11
South America (mainly temp.)	42 (6.1)	11 (4.6)	11 (5.8)	5 (4.8)	18	0	16	8
North America (mainly temp.)	41 (5.9)	15 (6.3)	10 (5.3)	8 (7.7)	17	0	21	3
South Africa	16 (2.3)	2 (0.8)	6 (3.2)	1 (0.9)	4	0	11	1
North Temperate	13 (1.9)	1 (0.4)	0	0	2	0	11	0
Australasia	10 (1.4)	2 (0.8)	2 (1.0)	0	2	0	1	7
North and South America (mainly temp.)	7 (1.0)	2 (0.8)	3 (1.6)	3 (2.9)	4	0	3	0
OTHERS	10 (1.4)	2 (0.8)	0	0	2	0	8	2
Total	690	240	190	104	349	27	259	55
PERCENTAGE					50.6	3.9	37.5	14.1

percent, Raven and Axelrod 1978), another region known for concentrating Eurasian aliens but located much closer to the Old World than is Chile. Of note, the Eurasian element in Chile is considerably higher than the average of 59 percent for 26 floras widely distributed throughout the world (Pysek 1998).

If the particular area of central Chile matching California more closely for climate is singled out (V–VIII regions), the percentage of aliens of Eurasian origin (377 of 507 species = 74.4 percent) is almost identical to that in California. On the other hand, as in California, and despite the large South American continental hinterland, Chile has received surprisingly few alien species from South America, the New World in general, and other temperate areas of similar climate such as Australasia and South Africa (Table 16.2). Indeed, the numbers of aliens in Chile of North and South American origin are about the same, despite great differences in proximity of Chile to the two areas.

The preponderance of aliens of Eurasian origin in Chile reflects strong initial contact between Chile and the Old World. However, as Pysek's (1998) recent survey shows, predominance of Eurasian elements in temperate alien floras tends to be a worldwide phenomenon. The high invasive capacity of Eurasian species is considered to be a result of an evolutionary history on a large continental mass that suffered major upheavals during the glacial period and a longer association between humans and plants in the Old World (di Castri 1989); consequently, aliens of Eurasian origin because of their higher competitiveness, vagility, and plasticity are likely to invade areas even when interchange is fairly limited.

Fox (1995) suggested that invasions in mediterranean-type climate areas outside the Old World occurred in three phases: a primary wave of herbaceous Eurasian invasives, followed by a secondary exchange of woody species, and tertiary invasion within each region from initial migrants. Considering aliens classified as invasives (the introduced weeds of Matthei 1995), where information exists on dates of introduction, it can be seen that species of Eurasian origin have dominated the alien invasive flora in Chile from the colonial period right up to the present (Table 16.2). Such continued dominance of Eurasian elements at a time of little direct agricultural interchange between Chile and the Old World, suggests that Chile may be at a stage of acquiring invasive species of Eurasian origin secondarily from neighboring South American and even Pacific countries.

In dealing with aliens, we tend to forget that every point invasion further potentiates the spread of a species by providing additional foci from which it can spread. This simple rule issues a warning that the homogenization process is not only being speeded up on account of greater disturbance and increased opportunities of diaspore transport, but also as a result of the internal dynamics of the invasive process itself. The probability of an aggressive

invasive species of Eurasian origin appearing in Chile may be as high, or perhaps even higher today than during the colonial period, due to the existence of numerous secondary centers of distribution providing multiple opportunities for initial establishment.

Susceptibility to Alien Invasion

Accepting that there is an inherent risk of indigenous biodiversity being threatened by invasive species, a critical question in invasion theory, and for dealing with aliens in practice, is knowing whether a particular region shows higher than average susceptibility to invasion. Intrinsic susceptibility will be determined by a resident flora's ability of ward off incoming aliens; biotic resistance *sensu* Simberloff 1986. Degree of invasion per se, of course, will be a product of intrinsic susceptibility and extrinsic factors (e.g., level of disturbance providing habitat for invasive species), but if the purpose is to detect a large-scale biogeographical pattern in invasions, it is intrinsic susceptibility that is of most relevance. Capacity to outcompete aliens should be related to overall richness and diversity, and a flora's potential to generate native colonizing species capable of preempting disturbed habitats. Tropical vegetation with high species richness tends to be somewhat resistant to colonization by aliens (Rejmánek 1996b), whereas islands with low species richness and disharmonic floras can be prone to invasion (Moulton and Pimm 1986).

Chile may be considered a continental island habitat on account of its strong isolation from the rest of South America due to the high Andes on the eastern border, the Pacific Ocean to the west, and the Atacama Desert to the north (Arroyo et al. 1998a). The southern South American temperate forest zone, distributed principally in Chile, moreover, is strongly isolated from other forested areas on the South America continent (Arroyo et al. 1996a; Armesto et al. 1998), adding to the island syndrome.

Compared with the California Floristic Province, central Chile's mediterranean ecological analog in western North America, and another albeit more leaky biogeographical island, equal-sized areas in central Chile exhibit lower native species and generic richness (Arroyo et al. 1995), and indeed, intrinsic species richness in central Chile is lowest among all mediterranean-type climate areas (Cowling et al. 1996). In relative terms, thus, central Chile could be expected to show less biotic resistance (cf. Simberloff 1986) to alien invasion in relation to, say, the mediterranean area of California. Chile's rain forests, on the other hand, exhibit higher species richness than their western North American counterparts (Arroyo et al. 1996a), which might confer on them higher biotic resistance to invasion. Thus it is of interest to ask where Chile stands in terms of susceptibility to invasion.

Beyond the last considerations, a case can further be made for parts of

Chile being more prone to invasion than climatically similar areas in North America, irrespective of an insular nature. As in the case of Europe and Asia, high latitude areas in North America also experienced major upheavals in the Pleistocene, to the extent that greater native colonizing ability, vagility, and weed-making capacity could be expected in the temperate North American flora in comparison with relatively insular southern South America with a more benign climate (Arroyo et al. 1996a). More precisely, one might expect increasing divergence in the degree of susceptibility to alien invasion in moving poleward in the two western Americas, with the extreme south of Chile showing exaggerated susceptibility in relation to Alaska, and midlatitude areas such as the mediterranean-type climate areas and winter rainfall deserts being relatively more convergent with perhaps Chile leading over California in the two last cases.

These hypotheses could be appropriately tested by comparing the number of aliens in analagous biogeographical areas in the two Americas, while controlling for differences in land use, area, and native species richness. Unfortunately, while data on aliens exists for all areas, good information on land-use cover and native species richness is lacking for several, such that any conclusions made at this stage will necessarily have to remain in the realm of speculation.

At the subpolar extremes of the two west coasts, Alaska (and neighboring territories), a land area that shares a large number of native species with Eurasia and is over 400 times the size of Tierra del Fuego, has an estimated 222 alien species representing 14.2 percent of the flora (calculated from Hultén [1968] on the basis of the number of species cited as alien and descriptions of 88 percent of known species) in comparison with 128 (23.5 percent) in Tierra del Fuego (Moore 1983), representing a statistically higher proportion ($G = 55.01$, $p < 0.001$) (Fig. 16.1). The lower alien density in Alaska, on face value is consistent with the continental glacial hypothesis. Differing land-use patterns, nevertheless, could be affecting alien density in the two subpolar areas. Sheep grazing is practiced extensively in natural steppe vegetation in Tierra del Fuego and could be expected to favor alien establishment. Alaska's main disturbance is timber harvesting (Hultén 1968).

The winter rainfall deserts of Chile, occupying a smaller land area than Baja California, also appear to harbor more aliens than their closest North American analog (Fig. 16.1). An important difference between the winter rainfall deserts of Chile and those of Baja California resides in their relative degree of connectivity to the New World tropics. Baja California, connected directly to New World tropics, would appear to house many native neotropical weedy species distributed over the general area of Mexico and Baja California. The Chilean winter rainfall deserts are strongly isolated from the tropical latitudes on account of the hyperarid Atacama Desert (Arroyo et al.

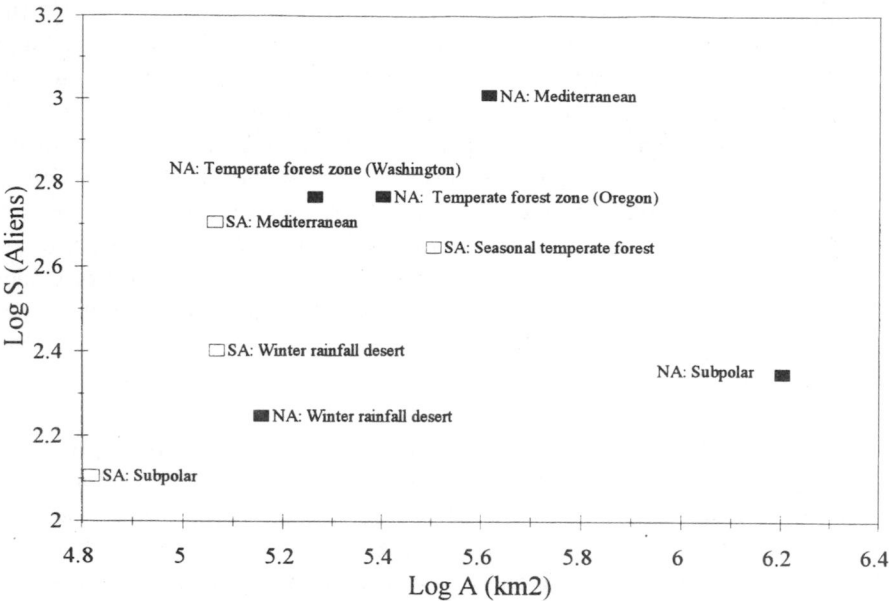

Figure 16.1. Comparison of number of alien species in ecologically similar areas along the west coasts of North America (NA) and South America (SA).

Sources of data: Winter rainfall deserts—South America: Regions III–IV of Chile; North America: Baja California (Wiggins 1980). Mediterreanean areas—South America: Regions V–VIII of Chile; North America: California (Hickman 1993). Transition Mediterranean-Seasonal Temperate rain forest—South America: Regions IX–XI of Chile; North America: state of Washington, state of Oregon (Invaders Data Base, version July 2, 1999; http://invaders.dbs.umt.edu/query3asp). Subpolar areas—South America: Tierra del Fuego (Moore 1983); North America: Alaska and neighboring territories (Hultén 1968).

1988); few weeds of American tropical origin are resident for competing with aggressive Eurasian species.

The humid-mediterranean-seasonal rain forest zone in Chile, an area only slightly larger than the state of Washington has considerably fewer aliens (381 versus 581) (Fig. 16.1), which is consistent with greater biotic resistance in Chile. Both mediterranean areas harbor very large numbers of alien species in relative terms (Fig. 16.1), but it is not immediately obvious from Figure 16.1 which area has been more invaded.

The mediterranean areas can be further investigated by comparing the overall percentage contribution of aliens, and numbers of aliens for different sized areas on each continent (Fig. 16.2). The alien flora of the much smaller mediterranean area of central Chile (regions V–VIII), comprises 507 species, which combined with Arroyo et al.'s (1995) figure of 2,395 native species for

roughly the same geographical area as the V–VIII regions gives an estimate of 17.5 percent of aliens for central Chile. The latter is identical to the percentage of aliens in the flora of California (1,023 aliens and 4,839 native species = 17.5 percent aliens; Hickman 1993). If the California Floristic Province had been used to represent California on the grounds of it being a better climatic match for central Chile (Arroyo et al. 1995), the percentage of aliens for California would be higher than 17.5 percent, given that practically all aliens in the flora of California are to be found in the California Floristic Province, whereas a large number of native species are not (Hickman 1993).

Turning to the numbers of aliens on a per area basis (Fig. 16.2), alien invasion appears to have been somewhat lower to date in central Chile. However, against the latter, considering all types of high impact land use, including road density and urban development, California is more heavily impacted than central Chile (Table 16.1) a situation that undoubtedly would also hold for the states of Oregon and Washington in comparison with regions IX–XI in Chile (cf. Table 16.3). Greater human impact could be expected to favor the establishment of larger numbers of aliens in the states of California, Oregon, and Washington, especially at smaller biogeographical scales, making it again difficult to arrive at reliable conclusions with regard to intrinsic susceptibility in the two Americas. What is more than apparent, however, is that Chile is

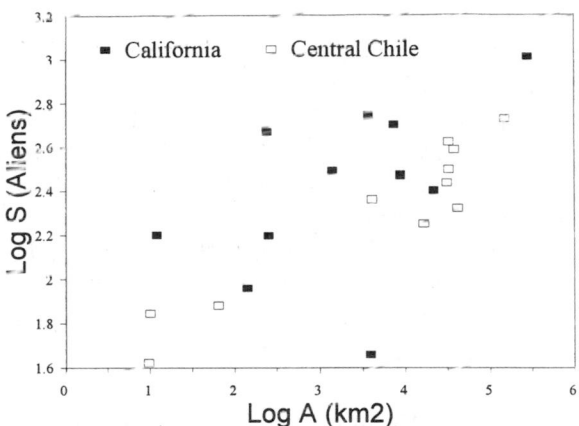

Figure 16.2. Comparison of number of alien species according to area in climatically equivalent areas of central Chile and mediterranean California on a log-log scale. Data points for California are from Mooney et al. 1986, Table 15.3, excluding Angel Island, St. Barbara Island, Tiburon Coounty (no data on aliens), Trinity County (no data on aliens), White Mountains, and Lassen Park (Table 15.3). Data for Chile are for the V+RM, VI, VII, VIII, V–VIII regions (see Table 16.3, column for Total alien species), Zapallar (Johow 1948), La Plata Valley (Schlegel 1966), Santiago Basin (Navas 1973–1979). Data for aliens for individual regions as shown in Table 16.3.

nowhere as heavily invaded as are a number of typical oceanic islands. Neither the alien flora of 690 species of Chile as a whole (comprising about 15 percent of total flora—CONCB-98) or that of central Chile (17.5 percent) comes anywhere close to the alien floras of New Zealand (45 percent; Smith 1997), Hawaii (47 percent; Wagner et al. 1990), Canary Islands (29 percent; Loope and Mueller-Dombois 1989), Galápagos Islands (35.6 percent; Loope and Mueller-Dombois 1989), and Channel Islands (26.8 percent; Loope and Mueller-Dombois 1989). And the much smaller land areas of Hawaii (16,500 km^2, 672 aliens; Wagner et al. 1990) and New Zealand (268,000 km^2, 1896 aliens; Smith 1997) in comparison with continental Chile house almost as many, to close to three times the number of aliens than the latter. Closer to home, while numbering only 195 species, aliens make up between 61.4 percent and 83.3 percent of the flora of the three islands comprising the Juan Fernández Archipelago (Matthei 1993).

Consideration of the ratio of naturalized to native invasive species in a flora (A/N ratio) (cf. Rapoport 1991, 1993) provides an alternate way of assessing susceptibility to alien establishment, and one that has the advantage of being less affected by differences in anthropogenic impact. Where strong propensity for invasiveness exists in a native flora, the establishment of exotics theoretically should be rendered more difficult. To the contrary, floras lacking a well-developed native invasive component (as for example, New Zealand and Hawaii) should be more susceptible to alien invasion. All others things being equal, elevated A/N ratios would tend to indicate exaggerated susceptibility to alien invasion. Resorting to the comparison between climatically similar central Chile and California, 379 of the 507 aliens occurring in central Chile are recognized in Matthei (1995) as conventional weeds. An additional 120 weeds recognized by Matthei (1995) that occur in central Chile are native species, leading to an A/N ratio of 3.2.

For California, restrictions of information force an estimate of A/N on the basis of the broader set of naturalized aliens and the total number of native species capable of colonizing disturbed habitats. Analysis of habitat information in Hickman (1993) leads to an estimate of some 395 native species in California capable of invading disturbed habitats (e.g., waste areas, roadsides, agricultural fields, fallow fields, ditches, logged forest, etc.), leading to a slightly lower (2.6), but not significantly different ($G = 2.762$; NS) A/N ratio.

Results pertaining to A/N thus do not provide any strong evidence of greater intrinsic susceptibility to alien invasion in the mediterranean-type climate flora of central Chile. Consideration of the biogeographical affinities of genera containing native weeds nevertheless suggests that the capacity to evolve invasive species is nonrandomly distributed in Chile. Of the 105 genera represented among the native weedy species occurring in all continental Chile, only around a quarter are of putative southern/Andean South America

Table 16.3. Number of alien species, different land-use types, and population in the political regions in continental Chile. Regions are located from north to south along Chile. Alien species considered as weeds and native weeds as in Matthei 1995 are also shown. MR = metropolitan region; URBA = urban areas; AGRI = agricultural areas; PLAF = plantation forestry; NATF = native forest; SBGR = shrublands and grasslands; WETL = wetlands; WATB = continental waters; RODE = road density; INTLU = intensive land use; INTLA calculated as the sum of URBA, AGR, PLAF divided by the sum of all land-use types shown. Areas covered by permanent ice and without vegetation and a minor percentage of unclassified vegetation were not included in the total for all land-use types. Land-use data from CONAF-CONAMA-BIRF 1997.

Political region	Area (1000s of km^2)	Total alien species	Alien weeds	Native weeds	Population (1000s)	URBA (1000s of km^2)	AGRI (1000s of km^2)	PLAF (1000s of km^2)	NATF (1000s of km^2)	SHGR (1000s of km^2)	WETL (1000s of km^2)	WATB (1000s of km^2)	% INTLU	RODE km for km^2 (×100)
I	59.1	100	67	44	339.6	0.09	0.31	0.27	0.08	18.42	0.47	0.03	3.4	7.81
II	126.0	111	91	42	410.7	0.03	0.04	0.03	0.00	18.30	0.52	0.06	0.5	4.41
III	75.7	127	104	55	230.9	0.01	0.46	0.00	0.00	31.15	0.07	0.08	1.5	8.41
IV	40.6	206	166	78	504.4	0.02	1.65	0.02	0.01	31.43	0.16	0.06	5.1	12.20
V+MR	31.4	411	324	102	6639.0	0.88	4.41	0.70	1.87	15.64	0.07	0.09	25.3	18.39
VI	16.3	178	158	66	696.4	0.12	4.32	1.02	1.18	5.92	0.03	0.09	43.1	25.07
VII	30.3	269	238	85	836.1	0.12	7.10	4.26	3.70	8.18	0.08	0.29	48.4	24.31
VIII	37.1	380	309	106	1734.3	0.25	10.10	9.78	7.86	6.06	0.11	0.48	58.1	31.09
IX	31.8	310	255	92	781.2	0.11	9.47	3.79	9.08	7.21	0.23	0.55	43.9	38.90
X	66.8	293	231	80	948.8	0.13	0.18	2.10	36.10	17.86	0.75	3.31	4.0	15.87
XI	107.1	64	51	27	80.5	0.02	0.03	0.08	48.31	13.01	11.46	3.92	0.2	2.30
XII	112.3*	183	115	27	143.1	0.03	0.00	0.00	26.25	31.88	31.00	3.15	<0.1	2.89

* Antarctic province not included.

or Gondwanaland origin. Typical genera endemic to, or centered on Chile such as *Chaetanthera, Homalocarpus, Leucheria, Menonvillea, Schizopetalon, Schizanthus,* even though they may contain annual species (Arroyo et al. 1990), are not invasive to any extent.

The great majority of native Chilean genera considered invasive species turn out to be either cosmopolitan, widely distributed in both hemispheres with predominantly Northern Hemisphere roots, or from tropical or warm areas. It is especially interesting that several amphitropical disjunct species figure prominently among Chilean native invasives (e.g., *Madia sativa, M. chilensis, Amsinckia calycina, Clarkia tenella, Lupinus microcarpus, Collomia biflora*). This group of species (mostly annuals) is thought to have dispersed to Chile naturally by long-distance dispersal, primarily from northwestern North America and not vice versa (Raven 1963).

Life-forms

Darwin (1859) suggested that alien invasions are more likely to be successful when the invading species do not confront cogeners in a recipient area. Some support for this exists in the case of California (Rejmánek 1996b). Darwin's general idea could be analogously argued in relation to life-form. Predictably, invasive species of a particular life-form are more likely to be successful when that life-form is poorly represented in a recipient flora.

The central Chilean flora is characterized by a relatively high degree of woodiness and proportionately few native annuals (Arroyo et al. 1990, 1995) in comparison with the California Floristic Province (Arroyo et al. 1995). Moreover, significantly fewer native genera in Chile make annuals than in California (Arroyo et al. 1995). The meager showing of native annuals in Chile is considered to be grounded in more oceanic conditions in temperate South America than in continental areas in the Northern Hemisphere (Arroyo et al. 1995), in turn favoring greater longevity in the resident floras that gave rise to the present-day mediterranean flora (Arroyo et al. 1995).

Given differences in the life-form spectra of the native central Chilean and Californian floras, a relatively higher proportion of annual species might be expected among central Chilean aliens. Lack of native weedy annuals in Chile is another reason why Chile might have been predictably more susceptible to alien invasion given the strong representation of annuals among invasive species in general (cf. Table 16.2). In this respect, in Chile, for grasses alone, there are 76 alien annual species, almost twice the number of native annual grasses (32 species; Arroyo et al. 1990) and more than 50 percent of the 49 most serious alien weeds are annuals. Nevertheless, when alien species occurring in central Chile are considered ($N = 507$), the percentage of annuals stands at 53.3 percent, which is not significantly different from California

(58.7 percent; Raven and Axelrod 1978; $G = 1.616$; NS) with a much larger native annual flora. Neither is there any suggestion that the more woody native flora of Chile has excluded woody aliens to a greater degree than in California. Using Raven and Axelrod's (1978) figures for California, 5.3 percent of aliens are woody, as opposed to a 7.3 percent in central Chile ($G = 1.887$; NS); if anything, there is tendency for slightly more woody aliens in Chile. Thus there is little support for the life-form exclusion hypothesis, at the level of species richness at least.

Spread of Aliens within Chile

Numbers of aliens and species considered as weeds found in the thirteen political regions of Chile may be found in Table 16.3. Figure 16.3 compares numbers of alien species in Chile's political regions on an area basis. The central mediterranean regions (V–IX) with highest concentrations of aliens correspond to an area with most of Chile's population and where grazing and modern agriculture commenced very early and are still concentrated today. Reflecting the latter, at a local scale, well-preserved *matorral* (evergreen scrub) in the La Plata Valley contains around 22 percent alien species (Schlegel 1966). In the heavily impacted mediterranean area, familiar aliens such as *Taraxacum officinale* and *Erodium circutarium* can still be found in altitudinally extreme environments above 3,000 meters, with 9 percent aliens recorded on one alpine site (Squeo et al. 1994). Annual exotic grasses and other annual forbs are particularly abundant in the herbaceous layer of open mediterranean scrubland throughout central Chile, which is without any doubt Chile's most invaded natural vegetation type (Montenegro et al. 1991).

The success of the introduced grasses, and indeed of many other annuals, has been guaranteed by heavy grazing by domestic animals and browsing by the introduced European rabbit, which together have reduced woody cover and eliminated the native perennial herbs locally, while maintaining a regime of small-scale disturbance favoring further invasion. Another important factor here are large extensions of seminatural, grazed shrublands in Chile generally not subject to fertilization and larger-scale disturbance as seen in intensely cultivated agricultural fields. Scherer and Deil (1997) recently showed that alien diversity remained twice as high in traditional *dehesas* (pastures) in central Chile in comparison with areas under highly technified agriculture. Nevertheless, fifty-eight annual alien grasses in Chile are accorded invasive status on agricultural criteria (Matthei 1995), although few are serious weeds. A second focus of aliens in Chile is found in southernmost region XII containing heavily grazed Patagonian steppe (Table 16.3, Fig. 16.3), and the island of Tierra del Fuego already alluded to in its southern extreme. In the drier eastern Patagonian mountains in region XII, where higher alpine

Figure 16.3. Number of aliens versus area for the political regions of Chile on a log-log scale. Regions I–XIII run from the extreme north to the extreme south of Chile. Filled squares: central Chile, mediterranean area in a broad sense. Open squares: northern Chile, summer rainfall and winter rainfall deserts. Filled triangles: southern Chile, southern temperate area. Data on aliens from Table 16.3 (column: Total alien species).

habitats abut directly onto Patagonian steppe, 10 percent of the flora is composed of aliens, mostly grasses (Arroyo et al. 1989). Overall, the still heavily forested and mountainous Region XI of Chile has been most spared of invasion (Table 16.3).

The spread of invasives in Chile must have occurred very rapidly in many species judging by their relatively ample distributions today (Table 16.4). Naturalized aliens not recognized as weeds occupy on average 2.2 regions (size of regions are given in Table 16.3), while invasive aliens occupy significantly larger ranges, averaging 5.4 regions. The casual observer would probably find it difficult to believe that there are 180 alien species in Chile distributed as widely or more so than showy *Eschscholtzia californica* that caught the eye of earlier workers! Indeed, twelve alien species have been recorded in twelve to thirteen of the thirteen political regions in Chile, signifying their individual establishment in all of Chile's four major ecoregions (summer rainfall area, winter rainfall deserts, mediterranean area, southern temperate area). Nevertheless, geographical ranges for alien weeds are significantly smaller than for native weeds (Table 16.4), suggesting, again, that many currently recognized alien weeds might not yet fully occupy available weedy niches.

Chile's protected areas, occupying 19 percent of the land area (Arroyo and Cavieres 1997), have by no means escaped alien invasion either. Surprisingly

Table 16.4. Distribution of aliens and native weeds in Chile in terms of number of political regions occupied. Alien weeds as in Matthei 1995 also given. Nonweedy aliens are naturalized aliens not given weedy status in Matthei 1995. Total possible regions = 13. Different letters indicate significant differences (Mann-Whitney U Test).

Category	Number of species	Mean (range) regions occupied	Median number of regions occupied
Aliens (weeds)	430	5.41[a] (1–13)	5
Aliens (nonweeds)	260*	2.21[b] (1–13)	1
Native weeds	132	6.64[c] (1–12)	7
Aliens (all)	690*	4.21 (1–13)	3

* 31 species without reliable distribution data are assumed to occur in one region.

large numbers of aliens (13 percent) occur in El Morado National Park (alpine) close to Santiago (Teillier et al. 1994), and in Puyehue National Park (12 percent) (temperate forest and alpine) in the lake district (Muñoz-Schick 1980). Llullaillaco National Park, located above 4,500 meters in the driest part of the northern Chilean Andes is the only national park on record entirely lacking alien species (Arroyo et al. 1998b), although Rundel et al. (1996) report only a single alien in Pan de Azucar National Park in the hyperarid coastal desert in northern Chile, and Arroyo et al. (1992) report two for the physically harsh subantarctic alpine alongside the Southern Patagonian Icefield in Torres del Paine National Park.

Basically, patterns of invasion in Chile's protected areas can be seen to mimic the local setting. In many cases (e.g., *Avena barbata, Erodium circutarium*), invasive species were established well prior to land being set aside for protection, and such species, no doubt, will continue forever to be part of the scene, along with new additions that can be expected to be brought in by increasing numbers of tourists and associated horse trekking.

Land Use and Aliens

A comprehensive plan for managing aliens requires knowledge of factors promoting the spread of aliens. Although it is clear that aliens are concentrated in Chile's most populous and developed sectors, it remains to be determined which of man's particular activities are driving invasions. Toward this end, we have investigated the contribution of different land-use types as explanatory factors for alien species richness using stepwise regression (Table 16.5). All alien species, aliens accorded the status of weeds by Matthei (1995), and native weeds were used as dependent variables; independent variables were urban land, agricultural land, pine and eucalyptus plantations, shrub and

Table 16.5. Results of stepwise regressions of number of aliens and native weeds on land-use types. See Table 16.3 for original data and land-use types.

Alien Weeds

	Including road density				Not including road density		
Effect	DF	F	p	Effect	DF	F	p
In				*In*			
URBA	1	12.541	0.006	URBA	1	9.480	0.013
RODE	1	20.790	0.001	AGRI	1	15.374	0.004
Out				*Out*			
AGRI	1	0.080	0.785	SHGR	1	0.922	0.365
SHGR	1	1.709	0.227	NATF	1	0.337	0.577
NATF	1	0.459	0.517	PLAF	1	1.391	0.272
PLAF	1	2.568	0.148	WETL	1	0.032	0.863
WETL	1	0.252	0.629				

Native Weeds

	Including road density				Not including road density		
Effect	DF	F	p	Effect	DF	F	p
In				*In*			
URBA	1	6.348	0.033	AGRI	1	15.372	0.003
RODE	1	23.308	0.001				
Out				*Out*			
AGRI	1	0.038	0.849	URBA	1	4.143	0.072
SHGR	1	2.203	0.176	SHGR	1	0.396	0.545
NATF	1	0.310	0.593	NATF	1	0.442	0.523
PLAF	1	0.743	0.414	PLAF	1	0.020	0.889
WETL	1	2.365	0.163	WETL	1	4.171	0.071

All Aliens

	Including road density				Not including road density		
Effect	DF	F	p	Effect	DF	F	p
In				*In*			
URBA	1	11.984	0.007	URBA	1	9.816	0.012
RODE	1	13.133	0.006	AGRI	1	10.412	0.010
Out				*Out*			
AGRI	1	0.050	0.828	SHGR	1	1.696	0.229
SHGR	1	2.624	0.144	NATF	1	0.540	0.483
NATF	1	0.664	0.439	PLAF	1	1.740	0.224
PLAF	1	2.412	0.159	WETL	1	0.125	0.733
WETL	1	1.032	0.339				

grasslands, native forest, wetlands, and road density (see Table 16.3 for original data).

The model shows that in all three cases only urban area and road density had significant effects (Table 16.5). Contrary to expectation, the amount of agricultural land did not have a significant effect. This turned out to be due to the fact that road density is not entirely independent of agricultural land and in fact is highly correlated ($r = 0.932$, $p = < 0.001$). When road density was removed from the model (Table 16.5), the amount of agricultural land moved into a position of significance, except in the case of native weeds, where only agricultural land had a significant effect. There were no significant effects of plantation forestry (Table 16.5), a result that perhaps is not unexpected, given that most exotic plantations in Chile are in the first rotation and have yet to be exploited. In an effort to combine the impact of road density, agricultural land, and urban land, a composite index was constructed by ranking the three variables and averaging their ranks. The resultant regressions of species richness for alien weeds and all aliens on the impact index are highly significant (Figure 16.4). That is, more aliens have appeared locally within Chile as more land has been dedicated to agriculture, roads, and urban development.

It might come as a surprise that urban area and road density play more important roles than agriculture in explaining the distribution of alien plant species. In heavily managed agricultural areas, many aliens are unable to survive the intense competition from a few aggressive agricultural weeds and the effects of agrochemicals (cf. Scherer and Deil 1997). Roads and city streets constitute less competitive habitats than do agricultural fields, allowing apparently for colonization by a greater diversity of alien species. At the same time, roads, city streets (a large proportion of which in Chilean cities lack paving and conventional plantings) and vacant lots constitute more stable habitats than do agricultural fields, where intense manipulation is practiced annually, selecting for a narrower and more specialized set of agricultural weeds. In addition, many ornamental aliens initially escape from gardens in urban areas and are likely to be still found within the radius of major cities.

The combined effect of all these factors make roads and cities centers of reception and conduits for the spread of invasive species. These results might explain the lower number of aliens on a per area basis in central Chile. With lower road density and less urban development in comparison with California (Table 16.1), aliens would have penetrated to a more limited extent throughout Chile than in California (Fig. 16.2). Indeed, the importance of roads for the spread of aliens can be deduced from habitats listed for Chilean weeds by Matthei (1995). Close to 40 percent of alien weeds in Chile are listed as occurring on roadsides, a far higher percentage than for any other habitat type. Other studies corroborate the importance of urban areas as foci for alien species. An increase in alien species occurs with increased density of

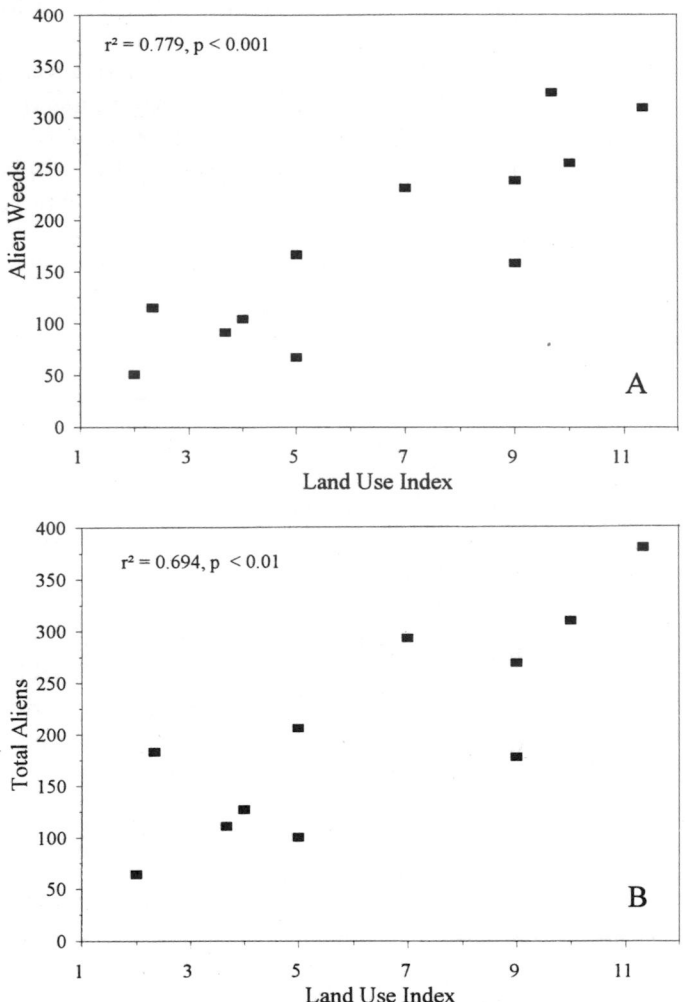

Figure 16.4. Alien plant species versus intensive land use. The land-use index was constructed by ranking the values for road density (RODE), amount of agricultural land (AGRIC), and amount of urban land (URBA) for each political region in Chile and calculating the average value of the three ranks. See Table 16.3 for land-use values and number of aliens per region. (A) Alien weeds; (B) Total aliens.

houses in the Bariloche area in Argentina (Rapoport 1993). The city of Auckland, New Zealand, houses some 615 aliens, more than all of central Chile, while Leipzig, with 583 aliens, has almost as many aliens as all of Germany (595 species) (Pysek 1998). Villagrán (1998) reported 75 weeds on the Faculty of Science campus at the University of Chile.

In an interesting paper, Celesti Grapow and Blasi (1998) recently showed

that aliens comprised only between 12 percent and 26 percent of the urban floras of five Italian cities, for a total of 684 species accumulated in the five urban areas. These authors point out that many of Old World mediterranean native species are naturally adapted to disturbance and as such are preadapted to urban habitats (Celesti Grapow and Blasi 1998). The contrast between Old World mediterranean cities as areas of concentration of native colonizing species, and urban areas in central Chile containing predominantly alien weeds, once again highlights the asymmetrical capacity of the native mediterranean floras in the Old and New Worlds to evolve native species with strong colonizing ability.

What Will the Future Bring for Chile?

The species accumulation curve for weedy species in Chile is far from asymptotic (Matthei 1995), suggesting that new alien species can be expected in the near future. Nevertheless, the Chilean species accumulation curve should be interpreted with a certain amount of care. Little focused work has occurred on weeds in Chile during the first half of this century. Thus many weeds reported over the past fifty years could well have been in existence before this date, in which case the species accumulation curve would be flatter than apparent.

Four additional types of evidence suggest that future range extensions of existing alien species within Chile itself can be expected:

1. Figure 16.5 compares the frequency distribution of alien weeds according to number of political regions occupied, comparing species reported for the first time in Chile before and after 1900, as well as during the past fifty years. Aliens appearing before 1900 tend to be more widely distributed than those reported for the first time after 1900; those registered for the first time since 1950 are the least widespread. The latter in particular can be expected to expand their distributions significantly in the near future.

2. Higher proportions of the set of alien weeds that became established prior to 1900 are recognized in the more serious weeds categories, in comparison with species that appeared after 1900 (Fig. 16.6). Over time, some of the latter could be expected to acquire similar status as their earlier establishing counterparts.

3. Some of the 260 alien species not accorded weedy status at the moment, with relatively reduced geographical ranges in relation to their weedy cousins (see Table 16.4), could also be expected to expand their distributions within Chile over time.

4. Chile is experiencing a period of economic expansion involving the con-

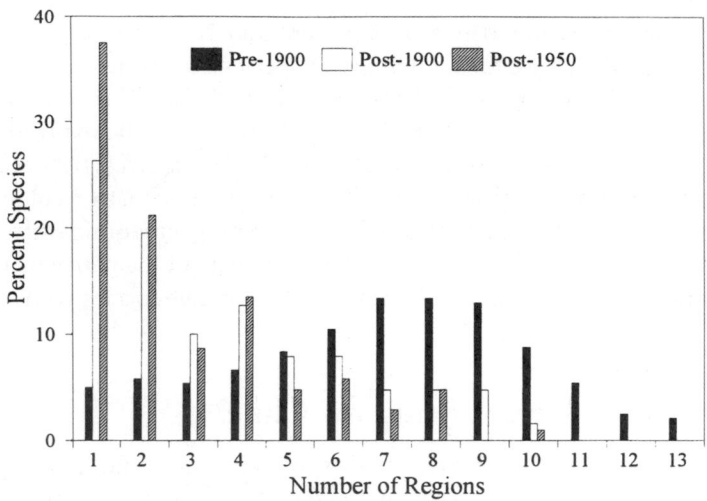

Figure 16.5. Comparison of number of regions occupied by alien weeds, according to their time of establishment in Chile. Pre-1900: $N = 240$; Post-1900: $N = 190$; Post-1950: $N = 104$.

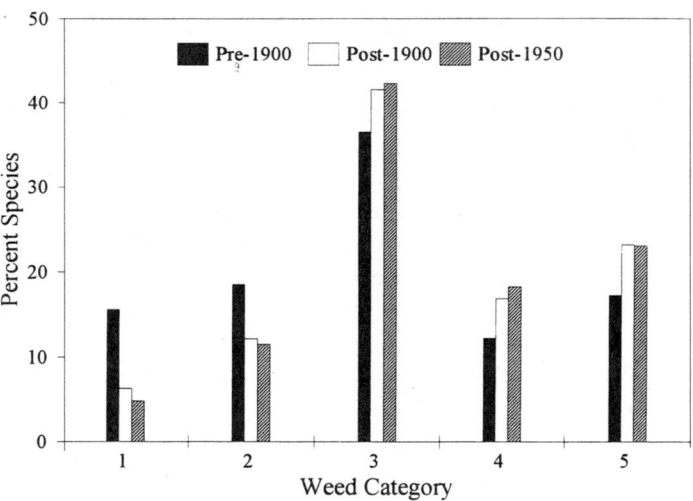

Figure 16.6. Comparison of percentage of alien weeds assigned to six categories of weediness, according to time of establishment in Chile. Pre-1900: $N = 238$; Post-1900: $N = 190$; Post-1950: $N = 104$. Weed categories as in Matthei 1995. Species scoring 1 are the most severe weeds.

struction of hydroelectric plants, gas pipelines, and the exploitation of native forest. The recently constructed Austral Highway has provided access to the largely wild region XI, and huge areas of forest on the Coast Range have been felled and planted in pines and eucalyptus (see Table 16.3).

Of course, some of the aliens reported more recently in Chile conceivably could have arrived at much earlier dates and persisted in low densities so as to escape attention; corroborating this will require much skillful detective work.

Insofar as new invasions are concerned, many alien weeds found in climatically similar California are potential candidates. It was shown that intrinsic susceptibility to alien invasion is very similar in central Chile and California, but that central Chile has not yet acquired the alien density seen in California. If the ultimate objective is to stall the establishment of the most harmful alien species, our best bet might be to pay special attention to species that have invaded climatically similar areas but have not yet arrived in the recipient area of interest, and to those serious aliens that have had a long history in one area, and have appeared fairly recently in a second. Some aliens reported as serious weeds or invaders of natural ecosystems in California with similar climates to central Chile that have appeared relatively recently in Chile include yellow star thistle (*Centaurea solstitialis*), presently a major weed in California. Yellow star thistle has been known in Chile as of 1960 (Matthei 1995). *Hieracium pilosella* (ssp. *euronotum*), also in California, was reported by Moore (1983) in Tierra del Fuego and has invaded sandy beaches of major drainages throughout the island. *Bromus tectorum* (cheatgrass), a major invader in western North America (Mack 1986), was first detected in Chile in 1948 (Matthei 1995). Thus far, it has been reported only on roadsides. It would be within Chile's economic and environmental interests to monitor species of this kind.

With increasing levels of commerce and exchange of tourists between Chile, Argentina, and Brazil in the framework of the recently established Mercosur trade agreement, and across the Pacific to New Zealand, Australia, and Asia as part of the Asia-Pacific agreement, it would be as well to give more attention to highly invasive species occurring in Chile's neighbors in the Southern Hemisphere. A surprisingly large number of the world's 200 most serious weeds found in temperate Australia, Argentina, and/or New Zealand have not turned up in Chile to date (Table 16.6).

Certain omissions in the alien flora of Chile call for special alert. It is quite remarkable that *Pteridium aquilinum,* one of the world's most invasive and difficult ferns to eradicate, has not appeared in Chile, given its presence on the eastern side of the Andes (Holm et al. 1997) and in climatically similar areas

Table 16.6. Species among 200 weeds considered by Holm et al. 1997 to be responsible for 90 percent of world agricultural losses, found in Argentina, New Zealand, or temperate Australia but not recorded by the authors to occur in Chile.

Species	Family	Argentina (N=20)	New Zealand (N=19)	Australia (N=43)
Acanthospermum hispidum	Asteraceae	•		•
Achyranthes aspera	Amaranthaceae	•	•	•
Aeschynomene apera	Papilionaceae			•
*Alopecurus myosuroides**	Poaceae		•	•
Alternanthera philoxeroides	Amaranthaceae	•	•	•
Alternanthera sessilis	Amaranthaceae			•
Artemisia vulgaris	Asteraceae	•	•	•
Azolla pinnata	Salviniaceae		•	•
Brassica kaber	Brassicaceae	•	•	•
Cassia occidentalis	Caesalpinaceae	•		•
Cassia tora	Caesalpinaceae	•		•
Chrondrilla juncea	Asteraceae	•	•	•
Corchorus olitorius	Tiliaceae			•
Cuscuta campestris+	Cuscutaceae		•	•
Cyperus brevifolius	Cyperaceae	•	•	•
Cyperus haspan	Cyperaceae	•		•
Digitaria longiflora	Poaceae			•
Eleocharis dulcis	Cyperaceae			•
Emilia sonchifolia	Asteraceae			•
Erigeron canadensis+	Asteraceae		•	•
Euphorbia heterophylla	Euphorbiaceae		•	•
Heliotropium europaeum	Boraginaceae			•
Hydrilla verticillata	Hydrocharitaceae		•	•
Ipomoea aquatica	Convolvulaceae		•	•
Ipomoea triloba	Convolvulaceae	•	•	•
Marsilea quadrifolia	Marsileaceae			•
Melastoma malabathricum	Melastomataceae			•
Momordica charantia	Cucurbitaceae	•	•	
Najas marina	Najadaceae	•		•
Najas graminea	Najadaceae	•	•	•
Oxalis latifolia	Oxalidaceae			•
Physalis angulata	Solanaceae			•
Potamogeton crispus	Potomogetonaceae			•
Potamogeton natans	Potomogetonaceae			•
Pteridium aquilinum	Dennstaediaceae	•		•
Sagittaria sagittifolia	Alismataceae	•	•	•
Setaria pallide-fusca	Poaceae		•	•
Spirodela polyrhiza	Lemnaceae	•		•
Stachytarpheta jamaicensis	Verbenaceae			•
Synedrella nodiflora	Poaceae			•
Trianthema portulacastrum	Aizoaceae	•		•
Tridax procumbens	Asteraceae			•
Vallisneria spiralis	Hydrocharitaceae	•		•
Veronica cinerea	Asteraceae	•		•

*Species recorded in Chile but not given in Holm et al. 1997 as occurring there.
+Species recorded for Chile in Holm et al. 1997 requiring confirmation for Chile.

in New Zealand. Invasive gymnosperms are wanting in Chile. Although plantation pines cover more than 2 million hectares (Table 16.3), there is no strong evidence at this point of pervasive seeding in the wild, as reported in South Africa (Richardson and Bond 1991; Rejmánek and Richardson 1996). It should be cautioned, however, that development of large-scale plantation forestry in Chile dates only to the early 1970s; thus it would be unwise to issue the last word on pines. For an area with abundant lakes and rivers (see Table 16.3), aquatic plants are also poorly represented among the aliens (see Appendix 16.1). Nevertheless, one aquatic species (*Eichhornia crassipes*) shows signs of becoming problematical in the Valdivia area in southern Chile, indicating a niche still to be filled. A dearth of aquatic invasives in Chile might be a reflection of lakes being concentrated at mid to high elevations and at high latitudes, where it is probably too cold for many of the world's most invasive aquatic plants.

Concluding Remarks

The highly dynamic nature of invasions deems that alien surveys, the equivalent of single frames in a time-lapse film, become obsolete in a very short period of time. The snapshots researchers are compelled to use to understand and test theory on invasions, moreover, are far from perfect. Lists of species tend to be generated over time, and taxonomists are not in the habit of checking to see whether species reported at earlier dates continue to persist in the wild.

As many authors have pointed out, while we have good knowledge of alien establishment, local extinctions are poorly understood. Moreover, floristic lists can be published at widely different dates, with decades separating revisions, introducing further complications into comparisons. Yet broad surveys, as this chapter shows, can provide the starting point for detecting the major patterns and for developing new hypotheses to be tested as better information comes to hand. The low number of native species capable of colonizing disturbed areas in Chile, a high component of aliens of Eurasian origin, and the particular generic composition of the native invasives in Chile further confirm a well-established difference between the New and Old Worlds in relation to native invasive capacity and susceptibility to alien invasion. At the same time, new and interesting north-south intercontinental differences in invasion levels have been pointed to.

Clearly, a fine-grained picture of alien invasions (cf. Mack 1996) will only become available in Chile as detailed monitoring programs are set in place and long-term regional databases are established. In a country like Chile, given the dearth of specialists with good taxonomic training (Simonetti 1997) and the strong focus on the more attractive, highly endemic native flora, it is

unlikely that detailed monitoring programs will come into force in the near future. However, monitoring the future spread of invasives at the broader level of Chile's political regions using data of the kind provided here as a baseline for the end of the present millennium should be possible: Chile possesses one of the best electronic floristic databases in all of Latin America.

At a more theoretical level, it became apparent to us in conducting this first comprehensive analysis of the alien flora of Chile, that aliens tend to defy the traditional ecological order and the kinds of comparative analyses used in studies of native floras. Our comparisons between Chile and the West Coast of North America provided evidence for and against greater susceptibility to alien invasion in Chile, but as we acknowledged, any conclusions at this point must be viewed as highly tentative and more as an invitation to undertake additional work than as the final word. To obtain more definitive answers, better control of time of first invasion and type and intensity of land use at intermediate scales (e.g., county or region) is essential.

Our comparison for areas *within* Chile showed that degree of intensive land use is the best predictor of alien species richness. Incorporating accurate land-use data into an intercontinental analysis of aliens in central Chile and California at intermediate spatial scales should allow teasing out to what extent, if any, patterns of alien invasion in the two regions are affected by biogeographic history, phylogenetic constraints, and large-scale hemispheric and continental effects. Of course, as already intimated, any analysis will only be as reliable as the information it is based on. Given the fast-moving nature of alien invasions, there can be no other area of biology that would benefit more from the establishment of long-term databases.

Finally, we were struck by the wide latitudinal and altitudinal ranges of many invasives in Chile. The fact that species introduced into Chile less than 500 years ago can adapt to the wide range of environmental conditions found along Chile's forty-four degrees of latitude following establishment from what was not necessarily a single introduction, but surely a limited sample of the genetic variation of the source area, suggests that some aliens are definitely adapting to local environmental conditions at extraordinarily rapid rates. This causes both concern and excitement. Concern stems from the fact that the native flora of Chile is poorly adapted to evolve species with strong colonizing ability.

As aliens occupy more space in Chile, the native flora stands to suffer even more than it has at present. It is exciting because it begs us to refocus our research questions. Modern molecular tools (e.g., Hillis et al. 1996) are now available to study the evolution of invasiveness in far greater detail than ever before. Use of hypervariable DNA regions permits tracking population differentiation at a fine level, and potentially discriminating between primary and secondary sources of alien invasion. Knowing, for example, to what

extent aliens of Eurasian origin in Chile have established from secondary sources is vital for advancing understanding of the rate at which the world's flora is being homogenized. Indeed, understanding a few invasive aliens in great detail might provide us with important clues as to what can be expected in general with global change. At a practical level, of course, much more attention needs to be given to preventive measures for dealing with aliens. If roads are a major driver of the spread of invasive species, as we concluded, much would probably be gained by rehabilitating roadsides with barriers of native species *immediately* after new roads are opened up (Arroyo et al. 1996b). Especially critical in this sense are roads in managed forests where new arriving invasives will not be restrained by the aggressive weeds of agricultural fields.

Acknowledgments

Research was carried out on a Chilean Presidential Science Appointment (MTKA). Floristic records and collections compiled under FONDECYT Project No. 1980705 (MTKA-OM) contributed to the distribution data on aliens. Some ideas were initially developed through financial support from IAI Grant "Biological invaders—their increasing role as disrupters of earth system processes" (MTK, OM, LC). We have benefited from discussions with M. Hershkovitz regarding opportunities to solve critical problems in invasive species biology using molecular markers.

Appendix 16.1

Naturalized alien vascular plants in continental Chile. Species recognized as strongly invasive (= weeds according to Matthei 1995) are shown in italics. Native invasive species are not given. Asterisks indicate alien species in Chile included among the world's 200 worst major agricultural weeds (according to Holm et al. 1997).

PTERIDOPHYTES: ADIANTACEAE: Adiantum capillus-veneris L. DRYOPTERIDACEAE: Dryopteris filix-mas (L.) Schott. SALVINIACEAE: Salvinia auriculata Aubl. SELAGINELLACEAE: Selaginella apoda (L.) Spring.

DICOTYLEDONS: AIZOACEAE: *Mesembryanthemum crystallinum* L., M. nodiflorum L., Sesuvium portulacastrum (L.) L., *Tetragonia tetragonoides* (Pall.) Kuntze. AMARANTHACEAE: *Amaranthus albus* L., *A. deflexus* L., *A. emarginatus* Moq. ex Uline et W.L.Bray, *A. hybridus* L., *A. retroflexus* L.*, A. viridis L.* APIACEAE: *Ammi majus* L., *A. visnaga* (L.) Lam., *Anthriscus cau-*

calis M. Bieb., A. silvestris (L). Hoffm., Apium graveolens L., *A. nodiflorum* (L.) Lag., *Conium maculatum* L.*, *Daucus carota* L.*, D. pusillus Michx., *Foeniculum vulgare* Mill., *Levisticum officinale* W.D.J.Koch, *P. sativa* L., *Scandix pecten-veneris* L., Seseli libanotis (L.) W.D.J.Koch, *Sium latifolium* L., *Torilis arvensis* (Huds.) Link, *T. nodosus* (L.) Gaertn. APOCYNACEAE: *Vinca major* L. ASCLEPIADACEAE: Asclepias curassavica L.* ASTERACEAE: *Achillea millefolium* L., *Acmella glaberrima* (Hassl.) R.K.Jansen, Ambrosia arborescens Mill., *A. artemisiifolia* L., *A. peruviana* Willd., *Anthemis arvensis* L., *A. cotula* L., *Arctium minus* (Hill) Bernh., *Arctotheca calendula* (L.) Levyns, Arnica angustifolia Vahl, *Artemisia absinthium* L., *Bellis perennis* L., *Bidens aurea* (Aiton) Sherff, *B. laevis* (L.) Britton, Sterns et Poggenb. *B. pilosa* L., *B. pseudocosmos* Sherff, *B. subalternans* DC, *Calendula arvensis* L., *C. officinalis* L., *C. tripterocarpa* Rupr., *Carduus nutans* L.*, *C. pycnocephalus* L.*, *Carthamus lanatus* L., C. tinctorius L., *Centaurea calcitrapa* L., *C. jacea* L., *C. melitensis* L., *C. nigra* L., *C. solstitialis* L., *Chamaemelum mixtum* (L.) All., *Chrysanthemoides monilifera* (L.) Norl., *Chrysanthemum coronarium* L., C. segetum L., *Cichorium intybus* L.*, *Cirsium arvense* (L.) Scop., *C. vulgare* (Savi) Ten.*, *Cnicus benedictus* L., *Coleostephus myconis* (L.) Rchb.f., *Conyza bonariensis* (L.) Cronquist, *Cotula australis* (Sieber ex Spreng.) Hook.f., *C. coronopifolia* L., *Crepis capillaris* (L.) Wallr., *C. pulchra* L., C. setosa Haller f., *C. vesicaria* L., *Cynara cardunculus* L., *Erigeron karwinskianus* DC., *Gnaphalium luteoalbum* L., *Hedypnois cretica* (L.) Dum. Cours., *Helianthus tuberosus* L., *Hieracium aurantiacum* L., H. flagellare Willd., H. murorum L., *H. pilosella* L., H. praealtum Vill. ex Gochnat, *Hypochaeris glabra* L., *H. radicata* L., Lactuca sativa L., *L. serriola* L., *Lapsana communis* L., *Leontodon autumnalis* L., *L. hirtus* L., *L. saxatilis* Lam., *Leucanthemum vulgare* Lam.*, *Logfia gallica* (L.) Coss. et Germ., *Matricaria matricarioides* (Less.) Porter, *M. recutita* L.*, *Onopordum acanthium* L., Parthenium hysterophorus L., *Picris echioides* L., *Scolymus hispanicus* L., Senecio angulatus L.f., *S. aquaticus* Hill, *S. mikanioides* Otto ex Walp., *S. sylvaticus* L., *S. vulgaris* L.*, *Silybum marianum* (L.) Gaertn.*, *Sonchus arvensis* L.*, *S. asper* (L.) Hill*, *S. oleraceus* L., *S. tenerrimus* L., Tagetes daucoides Schrad., *Tanacetum parthenium* (L.) Sch.Bip., *T. vulgare* L., *Taraxacum officinale* Weber ex F.H.Wigg.*, *Tolpis barbata* (L.) Gaertn., *Tragopogon porrifolius* L., *Tripleurospermum perforatum* (Mérat) Laínz, *Urospermum picroides* (L.) Scop. ex F.W.Schmidt, *Xanthium cartharticum* Kunth, *X. cavanillesii* Schouw ex Didr., *X. spinosum* L. BETULACEAE: *Alnus glutinosa* (L.) Gaertn. BORAGINACEAE: Anchusa arvensis (L.) M.Bieb., *Asperugo procumbens* L., *Borago officinalis* L., *Cynoglossum creticum* Mill., C. limense Willd., C. zeylanicum Thunb. ex Lehm., *Echium plantagineum* L., *E. vulgare* L., Heliotropium angiospermum Murray, *Myosotis arvensis* (L.) Hill, M. azorica H.G.Watson, *M. discolor* Pers., M. latifolia Poir., M. laxa Lehm., M. ramosissima Rochel, M. scorpioides L., M. stricta Link ex Roem. et Schult.,

Omphalodes linifolia (L.) Moench. BRASSICACEAE: Alyssum alyssoides (L.) L., *Barbarea verna* (Mill.) Asch., *Brassica napus* L., *B. nigra* (L.) W.D.J.Koch, B. oleracea L., *B. rapa* L.*, Camelina alyssum (Mill.) Thell., *Capsella bursa-pastoris* (L.) Medik., *Cardaria draba* (L.) Desv.*, Coronopus squamatus (Forssk.) Asch., Crambe filiformis Jacq., *Descurainia sophia* (L.) Webb ex Prantl, *Diplotaxis muralis* (L.) DC., *Draba verna* L., *Eruca vesicaria* (L.) Cav., *Hesperis matronalis* L., *Hirschfeldia incana* (L.) Lagr.-Foss., *Isatis tinctoria* L., *Lepidium bonariense* L., *L.* sativum L., *Lobularia maritima* (L.) Desv., *Raphanus raphanistrum* L.*, *R. sativus* L., *Rapistrum rugosum* (L.) All., *Rorippa sylvestris* (L.) Besser, Sisymbrium altissimum L., *S. austriacum* Jacq, *S. irio* L., *S. officinale* (L.) Scop., *S. orientale* L., *Teesdalia nudicaulis* (L.) R.Br., *Thlaspi arvense* L*. CACTACEAE: Opuntia ficus-indica (L.) Mill. CAESALPINIACEAE: Caesalpinia gilliesii (Hook.) D.Dietr., *Senna bicapsularis* (L.) Roxb., S. septemtrionalis (Viv.) H.S.Irwin et Barneby, Sambucus nigra L. CARYOPHYLLACEAE: *Agrostemma githago* L., Arenaria serpyllifolia L., *Cerastium arvense* L., *C. fontanum* Baumg, *C. glomeratum* Thuill., *Dianthus armeria* L., *Herniaria cinerea* DC., Lychnis coronaria (L.) Desr., *Petrorhagia dubia* (Raf.) G. López et Romo, *P. prolifera* (L.) P.W.Ball et Heywood, *Polycarpon tetraphyllum* (L.) L., *Sagina apetala* Naud., S. procumbens L., Saponaria officinalis L., *Scleranthus annuus* L., *Silene armeria* L., *S. gallica* L., *S. vulgaris* (Moench) Garcke, *Spergula arvensis* L., Spergularia bocconei (Scheele) Graebn., S. marina (L.) Griseb., *S. media* (L.) K.Presl ex Griseb., S. platensis (Cambess.) Fenzl, *S. rubra* (L.) J.Presl et K.Presl, Stellaria alsine Grimm, S. media (L.) Cirillo, S. pallida (Dumort.) Piré. CHENOPODIACEAE: *Atriplex hortensis* L., A. nummularia Lindl., *A. patula* L., *A. prostrata* Boucher ex DC., A. rosea L., *A. semibaccata* R.Br., *A. suberecta* I.Verd., *A. tatarica* L., *Bassia hyssopifolia* (Pall.) Kuntze, Beta vulgaris L., *Chenopodium album* L., *C. ficifolium* Sm., *C. hircinum* Schrad., *C. multifidum* L., *C. murale* L.*, C. urbicum L., C. vulvaria L., Maireana brevifolia (R.Br.) Paul G.Wilson, *Salsola kali* L.* CONVOLVULACEAE: *Calystegia sepium* (L.) R.Br., *Convolvulus arvensis* L., Ipomoea dumetorum (Kunth) Willd. ex Roem. et Schult., *I. purpurea* (L.) Roth. CRASSULACEAE: Sedum acre L. DIPSACACEAE: *Dipsacus sativus* (L.) Honck., *Knautia integrifolia* (L.) Bertol., *Scabiosa atropurpurea* L. EUPHORBIACEAE: *Eremocarpus setigerus* (Hook.) Benth., *Euphorbia cyathophora* Murray, E. engelmannii Boiss., *E. falcata* L., *E. helioscopia* L.*, *E. hirta* L., *E. lathyris* L., *E. maculata* L., *E. peplus* L., *E. platyphyllos* L., *Ricinus communis* L. FUMARIACEAE: *Fumaria agraria* Lag., *F. capreolata* L., F. officinalis L.*, *F. parviflora* Lam. GENTIANACEAE: Centaurium littorale (Turner) Gilmour, C. pulchellum (Sw.) Druce. GERANIACEAE: *Erodium botrys* (Cav.) Bertol., *E. cicutarium* (L.) L'Hér. ex Aiton, *E. malacoides* (L.) L'Hér. ex Aiton, *E. moschatum* (L.) L'Hér. ex Aiton, Geranium columbinum L., *G. dissectum* L., G. macrorrhizum L., *G. molle* L.,

G. pusillum L., G. pyrenaicum Burm.f., *G. robertianum* L. GUTTIFERAE: *Hypericum androsaemum* L., *H. perforatum* L., *Hypericum x inodorum* Mill. LAMIACEAE: *Galeopsis tetrahit* L., *Glechoma hederacea* L., *Lamium amplexicaule* L.*, L. purpureum L., *Lycopus europaeus* L., *Marrubium vulgare* L., *Melissa officinalis* L., *M. aquatica* L., *M. piperita* L., *M. pulegium* L., *M. suaveolens* Ehrh., *Prunella vulgaris* L., *Stachys arvensis* (L.) L. LINACEAE: Linum catharticum L., *Linum usitatissimum* L. LYTHRACEAE: *Ammannia coccinea* Rottb., *A. latifolia* L., Lythrum album Kunth, *L. hyssopifolia* L., L. maritimum Kunth, L. portula (L.) D.A.Webb, L. salicaria L. MALVACEAE: Abutilon grandifolium (Willd.) Sweet, *Anoda cristata* (L.) Schltdl, Gossypium barbadense L., Gynatrix pulchella (Willd.) Alef., *Hibiscus trionum* L.*, Lavatera arborea L., L. assurgentiflora Kellogg, Malva moschata L., *M. neglecta* Wallr., *M. nicaeensis* All., *M. parviflora* L., M. sylvestris L., *Modiola caroliniana* (L.) G.Don, *Sida spinosa* L. MIMOSACEAE: Acacia armata R.Br., A. aroma Gillies ex Hook. et Arn., *A. dealbata* Link, A. horrida (L.) Willd., A. macracantha Humb. et Bonpl. ex Willd., A. melanoxylon R.Br., A. visco Lorentz ex Griseb., Desmanthus virgatus (L.) Willd. MOLLUGINACEAE: Mollugo verticillata L. NYMPHAEACEAE: Nymphaea alba L. ONAGRACEAE: Epilobium obscurum Schreb., E. tetragonum L., Oenothera biennis L., O. glazioviana Micheli, *O. rosea* L'Hér. ex Aiton. OROBANCHACEAE: *Orobanche minor* Sm.*, *O. ramosa* L.* OXALIDACEAE: *Oxalis corniculata* L., O. pes-caprae L. PAPAVERACEAE: *Eschscholzia californica* Cham., Papaver dubium L., *P. rhoeas* L.*, *P. somniferum* L. PAPILIONACEAE: Crotalaria incana L., *C. scoparius* (L.) Link, *C. striatus* (Hill) Rothm., Desmodium subsericeum Malme, Dolichos lignosus L., *Galega officinalis* L., Indigofera suffruticosa Mill., Lathyrus cicera L., L. hirsutus L., L. japonicus Willd., L. sativus L., *Lotus corniculatus* L., *L. tenuis* Waldst. et Kit. ex Willd., *L. uliginosus* Schkuhr, *Lupinus albus* L., *L. angustifolius* L., *L. arboreus* Sims, L. polyphyllus Lindl., *Medicago arabica* (L.) Huds., M. arborea L., *M. lupulina* L., *M. minima* (L.) Bartal., M. orbicularis (L.) Bartal., *M. polymorpha* L., *M. sativa* L., M. turbinata (L.) All., *Melilotus albus* Desr., M. altissimus Thuill., *M. indicus* (L.) All., M. officinalis (L.) Lam., *Ornithopus compressus* L., O. pinnatus (Mill.) Druce, *O. sativus* Brot., Rhynchosia minima (L.) DC., *Robinia pseudoacacia* L., *Spartium junceum* L., *Teline monspessulana* (L.) K.Koch, *Trifolium angustifolium* L., *T. arvense* L., *T. aureum* Pollich, T. campestre Schreb., *T. dubium* Sibth., T. fragiferum L., *T. glomeratum* L., T. hybridum L., *T. incarnatum* L., *T. pratense* L., *T. repens* L., T. spadiceum L., *T. striatum* L., T. subterraneum L., T. suffocatum L., *T. tomentosum* L., Trigonella monspeliaca L., *Ulex europaea* L.*, Vicia articulata Hornem., *V. benghalensis* L., *V. hirsuta* (L.) Gray, *V. sativa* L., V. tenuissima (M.Bieb.) Schinz et Thell., *V. tetrasperma* (L.) Schreb., *V. villosa* Roth. PASSIFLORACEAE: Passiflora foetida L.* PLANTAGINACEAE: *Plantago coronopus* L., *P. lanceolata* L., *P. major* L. POLYGONACEAE: Emex spinosa (L.) Campd., *Fallopia convolvulus* (L.) A.Löve, Koenigia islandica L., *Polygonum acumina-*

tum Kunth, *P. aviculare* L.*, P. brasiliense K.Koch, *P. campanulatum* Hook.f., *P. hydropiper* L.*, *P. hydropiperoides* Michx., *P. lapathifolium* L.*, P. maritimum L., P. orientale L., *P. persicaria* L.*, Rumex acetosa L., *R. acetosella* L.*, *R. conglomeratus* Murray, *R. crispus* L., *R. cristatus* DC., *R. longifolius* DC., *R. obtusifolius* L., *R. pulcher* L., R. sanguineus L. PORTULACACEAE: *Portulaca oleracea* L. PRIMULACEAE: *Anagallis arvensis* L., Samolus valerandi L. RANUNCULACEAE: Aquilegia vulgaris L., Clematis denticulata Vell., *Ranunculus arvensis* L., *R. muricatus* L., *R. parviflorus* L., *R. repens* L.* RESEDACEAE: Reseda decursiva Forssk., *R. lutea* L., R. odorata L., *R. phyteuma* L. ROSACEAE: *Aphanes arvensis* L., Duchesnea indica (Andrews) Focke, Potentilla anserina L., P. reptans L., *Rosa canina* L., *R. moschata* Herrm., *R. rubiginosa* L., R. candidans Weihe ex Rchb., *Rubus constrictus* P.J.Müll. et Lefèvre, *R. ulmifolius* Schott, *Sanguisorba minor* Scop. RUBIACEAE: *Galium aparine* L., G. divaricatum Pourr. ex Lam., G. murale (L.) All., G. parisiense L., *G. tricornutum* Dandy, *Rubia tinctorum* L., *Sherardia arvensis* L. RUTACEAE: Ruta chalepensis L., R graveolens L. SALICACEAE: Salix babylonica L., S. caprea L., S. viminalis L. SAPINDACEAE: Dodonaea viscosa (L.) Jacq. SAXIFRAGACEAE: Saxifraga umbrosa L. SCROPHULARIACEAE: *Bartsia trixago* L., Calceolaria tripartita Ruiz et Pavón, *Cymbalaria muralis* P.Gaertn., B.Mey. et Scherb.M., *Digitalis purpurea* L., *Kickxia elatine* (L.) Dumort., *Linaria texana* Scheele, *L. vulgaris* Mill., *Mecardonia procumbens* (Mill.) Small, *Misopates orontium* (L.) Raf., *Parentucellia latifolia* (L.) Caruel, *P. viscosa* (L.) Caruel, *Scrophularia auriculata* L., Verbascum densiflorum Bertol., *V. thapsus* L., *V. virgatum* Stokes, *Veronica anagallis-aquatica* L., *V. arvensis* L.*, V. beccabunga L., V. chamaedrys L., V. officinalis L., V. peregrina L., *V. persica* Poir.*, V. scutellata L., *V. serpyllifolia* L. SIMAROUBACEAE: *Ailanthus altissima* (Mill.) Swingle. SOLANACEAE: *Datura ferox* L., D. inoxia Mill., *D. stramonium* L.*, *Nicotiana glauca* Graham, N. sylvestris Speg. ex Comes, Petunia parviflora A.Juss., *Physalis peruviana* L., *P. pubescens* L., *P. viscosa* L., *Solanum marginatum* L.f., S. pseudocapsicum L., S. radicans L.f., S. sisymbriifolium Lam. STERCULIACEAE: Waltheria indica L. TROPAEOLACEAE: Tropaeolum majus L. URTICACEAE: Parietaria judaica L., Soleirolia soleirolii (Req.) Dandy, Urtica urens L.*, VALERIANACEAE: Valerianella eriocarpa Desv., V. locusta (L.) Laterr., V. rimosa Bastard. VERBENACEAE: *Phyla canescens* (Kunth) Greene, Phyla nodiflora (L.) Greene, *P. reptans* (Kunth) Greene, *Verbena officinalis* L., V. rigida Spreng. VIOLACEAE: *Viola arvensis* Murray, V. odorata L., *V. tricolor* L. ZYGOPHYLLACEAE: *Tribulus terrestris* L.

MONOCOTYLEDONS: ALISMATACEAE: *Alisma lanceolatum* With., *A. plantago-aquatica* L. AMARYLLIDACEAE: *Amaryllis belladona* L., APONOGETONACEAE: Aponogeton distachyos L.f. ARACEAE: Pistia stratiotes L., Zantedeschia aethiopica (L.) Spreng. COMMELINACEAE:

Tradescantia fluminensis Vell. CYPERACEAE: Carex hispida Willd. ex Schkuhr, Cyperus alternifolius L., *C. articulatus* L., *C. difformis* L., C. esculentus L., C. laevigatus L., C. lanceolatus Poir., C. odoratus L., *C. rotundus* L., C. squarrosus L., C. strigosus L., Eleocharis acicularis (L.) Roem. et Schult.*, E. atropurpurea (Retz.) Kunth, *E. palustris* (L.) Roem. et Schult.*, Scirpus cernuus Vahl, S. maritimus L.*, *S. mucronatus* L.* HYDROCHARITACEAE: *Egeria densa* Planch., *Elodea canadensis* Michx.*, *Limnolobium spongia* (Bosc) Steud. IRIDACEAE: *Crocosmia x crocosmiiflora* (Lemoine ex Burb. et Dean) N.E.Br., Iris pseudacorus L. LILIACEAE: *Allium vineale* L., *Asphodelus fistulosus* L.* LIMNOCHARITACEAE: Hydrocleys nymphoides (Willd.) Buchenau. POACEAE: Agropogon littoralis (Sm.) C.E.Hubb., Agropyron cristatum (L.) Gaertn., *Agrostis capillaris* L., A. castellana Boiss. et Reuter, A. gigantea Roth, A. scabra Willd., *A. stolonifera* L., A. vineali Schreb., *Aira caryophyllea* L., A. elegantissima Schur, *A. praecox* L., Alopecurus aequalis Sobol.*, A. geniculatus L., *A. myosuroides* Huds.*, A. pratensis L., A. arenaria (L.) Link, *Anthoxanthum odoratum* L., *Apera interrupta* (L.) P.Beauv., Arrhenatherum elatius (L.) P.Beauv. ex J.Presl et K.Presl, Arundo donax L., *Avena barbata* Pott ex Link, *A. fatua* L., A. sativa L., A. sterilis L., *A. strigosa* Schreb., Bothriochloa ischaemum (L.) Keng, B. laguroides (DC.) Herter, B. saccharoides (Sw.) Rydb., *B. distachyon* (L.) P.Beauv., *Briza maxima* L., *B. minor* L., *Bromus diandrus* Roth, B. erectus Huds., *B. hordeaceus* L., *B. lanceolatus* Roth, *B. madritensis* L., *B. racemosus* L., *B. scoparius* L., *B. secalinus* L., *B. squarrosus* L., *B. sterilis* L., *B. tectorum* L., Calamagrostis stricta (Timm) Koeler, Catabrosa aquatica (L.) P.Beauv., *Catapodium rigidum* (L.) C.E.Hubb., *Cenchrus echinatus* L., *C. incertus* M.Curtis, *C. myosuroides* Kunth, *Chloris radiata* (L.) Sw., *C. virgata* Sw., Cymbopogon citratus (DC.) Stapf, *Cynodon dactylon* (L.) Pers., Cynosurus cristatus L., *C. echinatus* L., *Dactylis glomerata* L., Deschampsia setacea (Huds.) Hackel, *Digitaria aequiglumis* (Hackel et Arechav.) Parodi, D. ciliaris (Retz.) Koeler, D. horizontalis Willd.*, *D. ischaemum* (Schreb. ex Schweigg.) Schreb. ex Muhl., *D. sanguinalis* (L.) Scop., *Echinochloa colona* (L.) Link, *E. crusgalli* (L.) P.Beauv., *E. cruspavonis* (Kunth) Schult. f., E. polystachya (Kunth) Hitchc., Ehrharta calycina Sm., *Eleusine tristachya* (Lam.) Lam., *Elytrigia repens* (L.) Desv. ex Nevski, Eragrostis cilianensis (All.) Vignolo, E. ciliaris (L.) R.Br., E. curvula (Schrad.) Nees, E. minor Host, E. pilosa (L.) P.Beauv.*, *Eriochloa montevidensis* Griseb., E. punctata (L.) Desv. ex Ham., Eustachys distichophylla (Lag.) Nees, *Festuca arundinacea* Schreb., F. filiformis Pourr., F. juncifolia St.-Amans, F. rubra L., *Gastridium phleoides* (Nees et Meyen) C.E.Hubb., G. ventricosum (Gouan) Schinz et Thell., Glyceria fluitans (L.) R.Br., Gynerium sagittatum (Aubl.) P.Beauv., *Holcus lanatus* L., *Hordeum jubatum* L., *H. marinum* Huds., *H. murinum* L.*, *H. secalinum* Schreb., *Lagurus ovatus* L., *Lamarckia aurea* (L.) Moench, Leymus arenarius (L.) Hochst., *Lolium multiflorum* Lam., *L. perenne* L., L. rigidum Gaudin, *L. temulentum* L., Microchloa indica (L.f.) P.Beauv., Miscanthus sinensis

Andersson, *Monerma cylindrica* (Willd.) Coss. et Durieu, Oryza sativa L.*, *Panicum capillare* L., *P. dichotomiflorum* Michx., *P. miliaceum* L., *Parapholis incurva* (L.) C.E.Hubb., P. strigosa (Dumort.) C.E.Hubb., *P. distichum* (Michx.) Scribn.*, *P. urvillei* Steud., *P. vaginatum* Sw., *Pennisetum clandestinum* Hochst. ex Chiov., *P. villosum* R.Br. ex Fresen., *Phalaris aquatica* L., P. arundinacea L., P. canariensis L., P. caroliniana Walter, P. minor Retz., Phleum pratense L., *Piptatherum miliaceum* (L.) Coss., Poa ampla Merr., P. angustifolia L., *P. annua* L.*, P. compressa L., P. glauca Vahl, P. gracillima Vasey, P. nemoralis L., P. palustris L., *P. pratensis* L., P. stenantha Trin., P. trivialis L., Polypogon maritimus Willd., *P. monspeliensis* (L.) Desf., *P. viridis* (Gouan) Breistr., *Rostraria cristata* (L.) Tzvelev, *Schismus arabicus* Nees, *S. barbatus* (L.) Thell., Schizachyrium sanguineum (Retz.) Alston, S. scoparium (Michx.) Nash, *Setaria parviflora* (Poir.) Kerguélen*, S. pumila (Poir.) Roem. et Schult.*, *S. verticillata* (L.) P.Beauv., *S. viridis* (L.) P.Beauv., Sorghum bicolor (L.) Moench, *S. halepense* (L.) Pers., *Sporobolus indicus* (L.) R.Br., S. pyramidatus (Lam.) Hitchc., S. virginicus (L.) Kunth, Stenotaphrum secundatum (Walter) Kuntze, *Taeniatherum caput-medusae* (L.) Nevski, Trisetum flavescens (L.) P.Beauv., T. mollifolium Louis-Marie, *Vulpia bromoides* (L.) Gray, *V. myuros* (L.) C.C.Gmel. PONTEDERIACEAE: *Eichhornia crassipes* (Mart.) Solms.

References

Armesto, J. J., R. Rozzi, C. Smith-Ramírez and M. T. K. Arroyo. 1998. "Conservation targets in South American temperate forests." *Science* 282: 1271–1272.

Arroyo, M. T. K. and L. A. Cavieres. 1997. "The mediterranean-type climate flora of central Chile—What do we know and how can we assure its protection?" *Noticiero de Biología* 5: 48–56.

Arroyo, Mary T. K., F. A. Squeo, J. J. Armesto and C. Villagrán. 1988. "Effects of aridity on plant diversity in the northern Chilean Andes: Results of a natural experiment." *Annals of the Missouri Botanical Garden* 75: 55–78.

Arroyo, M. T. K., C. Marticorena, P. Miranda, O. Matthei, A. Landero and F. Squeo. 1989. "Contribution to the high elevation flora of the Chilean Patagonia: A checklist of species on mountains on an east-west transect in the Sierra de los Baguales, Latitude 50°S." *Gayana Botánica* 46: 119–149.

Arroyo, M. T. K., C. Marticorena and M. Muñoz. 1990. "A checklist of the native annual flora of continental Chile." *Gayana Botánica* 47: 119–135.

Arroyo, M. T. K., C. P. von Bohlen, L. A. Cavieres and C. Marticorena. 1992. "Survey of the alpine flora of Torres del Paine National Park, Chile." *Gayana Botánica* 49: 47–70.

Arroyo, M. T. K., L. Cavieres, C. Marticorena and M. Muñoz. 1995. "Convergence in the mediterranean floras of central Chile and California: Insights from comparative biogeography." In *Ecology and Biogeography of Mediterranean Ecosystems in Chile, California and Australia,* edited by Arroyo, M. T. K. et al., 43–88. New York: Springer-Verlag.

Arroyo, M. T. K., M. Riveros, A. Peñaloza, L. Cavieres and A. M. Faggi. 1996a. "Phyto-geographic relationships and regional richness patterns of the cool temperate rain-forest flora of southern South America." In *High Latitude Rainforests and Associated Ecosystems of the West Coast of the Americas: Climate, Hydrology, Ecology, and Conservation,* edited by Lawford, R. G. et al., 134–172. New York: Springer-Verlag.

Arroyo, M. T. K., C. Donoso, R. Murúa, E. Pisano, R. Schlatter and I. Serey. 1996b. *Toward an Ecologically Sustainable Forestry Project. Concepts, Analysis and Recommendations. Protecting Biodiversity and Ecosystem Processes in the Río Cóndor Project, Tierra del Fuego.* Santiago: Departamento de Investigación y Desarrollo, Universidad de Chile.

Arroyo, M. T. K., R. Rozzi, J. Simonetti, P. Marquet and M. Salaberry. 1999. "Central Chile." In *Hotspots: Earth's Biologically Wealthiest and Most Threatened Ecoregions,* edited by R. A. Mittermeier et al., Mexico D.F.: CEMEX.

Arroyo, M. T. K., C. Castor, M. Marticorena, M. Muñoz, L. Cavieres, O. Matthei, F. Squeo, M. Grosjean, and R. Rodríguez. 1998b. "The flora of Llullaillaco National Park located in the transitional winter-summer rainfall area of the northern Chilean Andes." *Gayana Bótanica* 55: 93–110.

Aschmann, H. and C. Bahre. 1977. "Man's impact on the wild landscape." In *Convergent Evolution in Chile and California Mediterranean Climate Ecosystems,* edited by Mooney, H. A., 73–84. Stroudsburg, Pennsylvania: Dowden, Hutchinson and Ross, Inc.

CONAF-CONAMA-BIRF. 1997. *Catástro y evaluación de los recursos vegetacionales nativos de Chile.* Santiago.

CONCB. 1998. *Chilean Flora Data Base, version 1998.* Electronic, private. Universidad de Concepción, Chile.

Cowling, R. M., P. W. Rundel, B. B. Lamont, M. K. Arroyo and M. Arianoutsou. 1996. "Plant diversity in mediterranean-climate regions." *Trends in Ecology and Evolution* 11: 362–366.

Celesti Grapow, L. and C. Blasi. 1998. "A comparison of the urban flora of different phytoclimatic regions in Italy." *Global Ecology and Biogeography Letters* 7: 367–378.

Darwin C. 1859. On the Origin of Species. London: Murray.

di Castri, F. 1989. "History of biological invasions with special emphasis on the Old World." In *Biological Invasions: A Global Perspective,* edited by Drake, J. R. et al., 1–30. New York: John Wiley and Sons.

Dillehay, T. D. 1997. *Monte Verde, a Late Pleistocene Settlement in Chile, Vol. 2: The Achaeological Context and Interpretation.* Washington, D.C.: Smithsonian Institution Press.

Drayton, B. and R. Primack. 1996. "Plant species lost in an isolated conservation area in metropolitan Boston from 1894 to 1993." *Conservation Biology* 10: 30–39.

Fox, M. 1990. "Mediterranean weeds: Exchanges of invasive plants between the five mediterranean regions of the world." In *Biological Invasions in Europe and the Mediterranean Basin,* edited by di Castri, F. et al., 179–200. Dordrecht: Kluwer Academic Publisher.

———. 1995. "Australian mediterranean vegetation: Intra- and intercontinental comparisons." In *Ecology and Biogeography of Mediterranean Ecosystems in Chile, California, and Australia,* edited by Arroyo, M. T. K. et al., 137–159. New York: Springer-Verlag.

Frías, D., R. Godoy, P. Ittura, S. Koref-Santibáñez, J. Navarro, N. Pacheco and G. L. Stebbins. 1975. "Polymorphism and geographic variation of flower color in Chilean populations of *Eschscholzia californica.*" *Plant Systematics and Evolution* 123: 185–198.

Gay, C. 1845–1854. *Historia Física y Política de Chile según Documentos Adquiridos en esta Republica durante Doce Años de Residencia en ella y Publicada bajo los Auspicios del Supremo Gobierno.* Santiago.

Henríquez, J. M., E. Pisano and C. Marticorena 1995. "Catálogo de la flora vascular de Magallanes (XIIa Region), Chile." *Anales del Instituto de la Patagonia* 23: 5–30.

Heusser, C. 1983. "Quaternary pollen record from de Tagua-Tagua, Chile." *Science* 219: 1429–1432.

Hickman, J.C. (Editor). 1993. *The Jepson Manual.* Berkeley: University of California Press.

Hillis, D. M., C. Moritz and B. K. Mable. (Editors). 1996. *Molecular Systematics.* Sunderland: Sinauer Associates, Inc.

Holm, L., J. Doll, E. Holm, J. Pancho and J. Herberger. 1997. *World Weeds. Natural Histories and Distribution.* New York: John Wiley and Sons.

Hultén, E. 1968. *Flora of Alaska and Neighboring Territories. A Manual of the Vascular Plants.* Stanford: Stanford University Press.

Jaksic, F. and E. Fuentes. 1991. "Ecology of a successful invader: The European rabbit in central Chile." In *Biogeography of Mediterranean Invasions,* edited by Groves, R. H. and F. di Castri. 273–283. Cambridge: Cambridge University Press.

Johow, F. 1948. "Flora de las plantas vasculares de Zapallar." *Revista Chilena de Historia Natural* 49: 8–566.

Loope, L. L. and D. Mueller-Dombois. 1989. "Characteristics of invaded island, with special reference to Hawaii." In *Biological Invasions: A Global Perspective,* edited by Drake, J. A. et al., 257–280. New York: John Wiley and Sons.

Mack, R. N. 1986. "Alien plant invasion into the intermountain west: A case history." In *Ecology of Biological Invasions of North America and Hawaii,* edited by Mooney, H. A. and J. A. Drake, 192–213. New York: Springer-Verlag.

———. 1996. "Predicting the identity and fate of plant invaders: Emergent and emerging approaches." *Conservation Biology* 78: 107–121.

Marticorena, C. 1990. "Contribución a la estadística de la flora vascular de Chile." *Gayana Botánica* 47: 85–114.

Marticorena, C. and M. Quezada. 1985. "Catálogo de la flora vascular de Chile." *Gayana Botánica* 42: 1–155.

Marticorena, C., O. Matthei, M. T. K. Arroyo, M. Muñoz, R. A. Rodriguez, F. A. Squeo and G. Arancio. 1998. "Nuevas citas para la flora de Chile, basadas en colecciones de la Segunda Región." *Gayana Botánica* 55: 17–27.

Marticorena, C., O. Matthei, R. Rodríguez, M. T. K. Arroyo, M. Muñoz, R. A. Rodríguez, F.A. Squeo and G. Arancio. 1998. "Catálogo de la flora vascular de la Segunda Región (Región de Antofagasta), Chile." *Gayana Botánica* 55: 23–83.

Matthei, O. 1993. "La flora adventicia del Archipelago de Juan Fernández." *Gayana Botánica* 50: 69–102.

———. 1995. *Manual de las Malezas que crecen en Chile.* Santiago: Alfabeta Impresores.

Mittermeier, R. A., N. Myers, J. B. Thomsen, G. A. Da Fonseca and S. Olivieri. 1998.

"Biodiversity hotspots and major tropical wildness areas: Approaches to setting conservation priorities." *Conservation Biology* 12: 516–520.

Montenegro, G., S. Teillier, P. Arce and B. Poblete. 1991. "Introduction of plants into the mediterranean-type climate area of Chile." In *Biogeography of Mediterranean Invasions,* edited by Groves, R. H. and F. di Castri, 103–114. Cambridge: Cambridge University Press.

Mooney, H. A., S. P. Hamburg and J. A. Drake. 1986. "The invasions of plants and animals into California." In *Ecology of Biological Invasions of North America and Hawaii,* edited by Mooney, H. A. and J. A. Drake, 250–272. New York: Springer-Verlag.

Moore, D. 1983. *Flora of Tierra del Fuego.* St. Louis: Missouri Botanical Garden.

Moulton, M. P. and S. L. Pimm. 1986. "Species introductions to Hawaii." In *Ecology of Biological Invasions of North America and Hawaii,* edited by Mooney, H. A. and J. A. Drake, 231–249. New York: Springer-Verlag.

Muñoz-Schick, M. 1980. *Flora del Parque Nacional Puyehue.* Santiago: Editorial Universitaria.

Navas, E. 1973–1979. *Flora de la Cuenca de Santiago de Chile.* 3 vols. Santiago: Ediciones de la Universidad de Chile.

Philippi, F. 1881. "Catalogus plantarum vascularium chilensium adhuc descriptarum." *Anales de la Universidad de Chile* 59: 49–422.

Pysek, P. 1998. "Is there a taxonomic pattern to plant invasions?" *Oikos* 83: 282–294.

Rapoport, E. 1991. "Tropical versus temperate weeds: A glance into the present and future." In *Ecology of Biological Invasion in the Tropics,* edited by Ramakrishnan, P. S., 41–51. New Delhi: International Scientific Publications.

———. 1993. "The process of plant colonization in small settlements and large cities." In *Humans as Components of Ecosystems,* edited by McDonnell, M. J. and S. T. A. Pickett, 191–207. New York: Springer-Verlag.

Raven, P. H. 1963. "Amphitropical relationships in the floras of North and South America." *Quarterly Review of Biology* 38: 151–177.

———. 1973. "The evolution of mediterranean floras." In *Mediterranean Type Ecosystems: Origin and Structure,* edited by di Castri, F. and H. A. Mooney, 213–224. Berlin: Springer-Verlag.

Raven, P. H. and D. I. Axelrod. 1978. "Origin and relationship of the California flora." *University of California Publications in Botany* 72: 1–134.

Reiche, C. 1894. "Estudios críticos sobre la flora de Chile." *Anales de la Universidad de Chile* 88: 55–100.

Rejmánek, M. 1989. "Invasibility of plant communities." In *Biological Invasions: A Global Perspective,* edited by Mooney, H. A. et al., 369–388. New York: John Wiley and Sons.

———. 1996a. "Species richness and resistance to invasions." In *Biodiversity and Ecosystem Processes in Tropical Forests,* edited by Orians, G. H. et al., 153–172. Berlin Heidelberg: Springer-Verlag.

———. 1996b. "A theory of seed plant invasiveness: The first sketch." *Biological Conservation* 78: 171–181.

Rejmánek, M. and D. M. Richardson. 1996. "What attributes make some plant species more invasive?" *Ecology* 77: 1655–1661.

Richardson, D. M. and W. J. Bond. 1991. "Determinants of plant distribution: Evidence from pine invasions." *American Naturalist* 137: 639–668.

Rundel, P.M., M. O. Dillon and B. Palma. 1996. "Flora and vegetation of Pan de Azucar National Park in the Atacama desert of northern Chile." *Gayana Botánica* 53: 295–315.

Scherer, M. and U. Deil. 1997. "Floristiche diversität und vegetations-strukturen in traditionellen und modern kulturlandschaften—undersucht and biespielen aus Chile und dem westlichen mittelmeergebiet." *Zeitschrift für Ökologie und Naturschutz* 6: 19–31.

Schlegel, F. 1966. "Pflanzensoziologische und floristische untersuchungen iiber hartlaubgehölze im La Plata-Tal bei Santiago de Chile." *Bericht der Oberhessischen Gesellschaft für Natur- und Heilkunde zu Giessen. Naturwissenschaftliche Abteilung* 34: 183–204.

Simberloff, D. 1986. "Introduced insects: A biogeographic and systematic perspective." In *Ecology of Biological Invasions of North America and Hawaii*, edited by Mooney, H. A. and J.A. Drake, 3–26. New York: Springer-Verlag.

Simonetti, J. 1997. "Biodiversity and taxonomy of Chilean taxonomists." *Biodiversity and Conservation* 6: 633–637.

Smith, I. (General Editor). 1997. *The State of New Zealand's Environment*. Wellington: GP Publications.

Squeo, F. A., R. Osorio and G. Arancio. 1994. *Flora de los Andes de Coquimbo: Cordillera de Doña Ana*. La Serena: Ediciones de la Universidad de La Serena.

Teillier, S., A. Hoffmann, F. Saavedra and L. Pauchard. 1994. "Flora del Parque Nacional El Morado (Región Metropolitana, Chile)." *Gayana Botánica* 51: 13–47.

Timmins, S. M. and P. A. Williams. 1991. "Weed numbers in New Zealand forests and scrub reserves." *New Zealand Journal of Ecology* 1(2): 153–162.

Villagrán, C. 1998. "Flora ornamental y malezas del Campus Juan Gómez Milla, Universidad de Chile." http://macul.ciencias.uchile.cl/botánica/pag1.

Vermeij, G. L. 1996. "An agenda for invasion biology." *Conservation Biology* 78: 3–9.

Wagner, W. L., D. R. Herbst and S. H. Sohmer. 1990. *Manual of the Flowering Plants of Hawai'i. Volume I*. Honolulu: University of Hawaii Press.

Wiggins, I. L. 1980. *Flora of Baja California*. Stanford: Stanford University Press.

Part IV

Summary

≈

Global Change and Invasive Species:
Where Do We Go from Here?

Harold A. Mooney and Richard J. Hobbs

What did we learn from all of this? Our original proposition that global change elements will exacerbate the invasive species problem appears strongly supported by the chapters in this book. The complexity and implications of this proposition are woven throughout the volume.

What Are the Drivers of Global Change and How Will They Influence Invasive Species?

It is clear that there are a whole series of processes that are changing, driven by human activities, all of which most likely will accelerate the mixing of the Earth's biota and increase the numbers of invasive species. These processes include especially land-use change. As Hobbs notes, not only does degradation due to changing land use enhance the invasive process, but there are also positive feedbacks by the invasives to increase the problem even further. We are, in a sense, by large-scale habitat modification, preparing the soil as a garden to favor invasives. By dissecting the landscape by clearing vegetation, we

are creating highways for their unimpeded movement. Even the processes that deliver the invasives from one continent to another are accelerating, as McNeely notes, through the increase in international trade. The economies of nations are, to an ever-increasing degree, being driven by global markets. These markets are not simply the flow of investment money, but also the flow of goods, including biotic materials, from one region of the world to another. The pressures to increase trade are currently greater than the pressures for precaution in moving biological material across former barriers. Correcting this imbalance is one of the greatest challenges facing us in dealing with invasive species.

Thus land use modification is providing new fertile grounds for invasives, and enhanced trade, the delivery vehicle for them. There are however other important global change elements that will play an increasing role in the success of invasives. These include nitrogen deposition resulting from both the increasing use of fertilizers in agriculture and the increasing use of fossil fuels. Scherer-Lorenzen and co-authors note that nitrogen deposition, an increasingly important phenomenon in many parts of the world, can lead to the success of invasive species. They find in central Europe that most of the successful invasive species are favored by nitrogen deposition. The case is not so clear for the impact of increased CO_2 concentration in the atmosphere. Evidently, higher CO_2 concentrations will create winners and losers, as Dukes notes, and there is no clear evidence that invasives will be favored overall. D'Antonio, on the other hand, notes that with global warming, fire frequency may well increase and in most cases will favor the spread of invasives. In turn, some of the invasive species will further cause an increase in ecosystem flammability and hence result in a positive feedback further favoring invasives. Thus it is rather clear that global change will result in a world with more rather than less invasive species.

How Will the Increase in Invasives Impact Ecosystems?

Of all of the earth's ecosystems, it is probably safe to say that freshwater systems have been most impacted by the activities of humans. There seems to be little in the future that will change this trend, as Kolar and Lodge note. This is because humans divert water to their own uses, they utilize water for transport and the generation of power, they alter the surrounding lands, and they manipulate the biota to "enhance" fisheries. All of these activities have profoundly impacted the biotic integrity of these ecosystems. As freshwater becomes scarcer and the waterways are modified to even a greater extent as their use increases for transport, and as the surrounding lands are modified to even a larger extent for agriculture and other uses, these ecosystems will come under even stronger pressure. There are however some hopeful signs of

greater efforts by some nations to restore freshwater habitats, to clean up waterways, and even to decommission dams. In certain areas, such as the San Francisco Bay Delta, the Columbia River Basin, and the Everglades, huge restoration projects are on the drawing board. The challenges to make these happen in a successful manner are daunting. The new players, or invaders, that have entered these ecosystems since they were disrupted will of course hinder these restoration efforts.

In contrast to the state of freshwater systems, it has been traditionally thought that the open oceans are not subject to invasive species problems since the organisms that inhabit these regions are mobile and the barriers to migration are not so strong. Although this has not been studied to any great extent, it is clear that the intertidal regions are extraordinarily sensitive to invasive species, and the reason for this is, in part, the tremendous loads of live organisms from distant lands that get dumped into the seawater ports. Again, increased trade is exacerbating this problem. However, as Carlton notes, the problem can be addressed by new methods of dealing with ballast water that ensure that live organisms are not released in new habitats. This will take international agreements, but work has already started on this important initiative.

The impact of invaders on terrestrial systems was explored in several chapters. Hobbs indicates clearly the two-way relationship between changing land use and invasions. Changes in land use, degradation, and human disturbance all provide opportunities for invasion, and invading species in turn can force changes in land use or modifications in management. D'Antonio also illustrates a similar two-way relationship between fire and invasion. The use of fire in management can generally increase invasibility of ecosystems, but in turn invasives can alter fire regimes. Some invaders increase the intensity of fires, whereas others totally alter natural fire regimes. These latter cases can result in large-scale alterations of the natural landscape. Global warming has the potential to increase further fire frequency and hence foster the spread of invasives. Nitrogen deposition may also foster the invasion of species, as illustrated by Scherer-Lorenzen, and hence also alter fire regimes.

The Effects of Global Change Elements on Invasives Will Not Be Uniform around the World

It is well known that the problem of invasive species is not uniformly distributed across the globe. Very cold climates, such as exist at high elevations and in the arctic, do not favor invasives. Closed-canopy tropical forests also seem to be free of invasives. Global change may well alter these patterns as tropical deforestation progresses and as temperatures warm. This volume examined a num-

ber of different regions of the world to see how they differ and what the future may bring. Richardson and co-authors describe the tremendous impacts of invasive species on the South African landscapes. What makes South Africa so unusual is not only the numbers of invaders and their tremendous success but that they also include a great number of invasive trees and shrubs. The predictions are that temperature change will have little importance in changing the patterns of invasion that we see today, but changes in precipitation patterns will be a major exacerbating influence in these dry-regions summer.

Modeling predictions indicate that South Africa will have even more problems with invasive species in the future than they have today.

New Zealand is another classic case of a country highly impacted by invasive species. The importance of land-use change as a global change driver is also shown in the fact that self-introductions are increasing as vast expanses of new deforested habitat are created.

The Social Costs of Invasives under Global Change

Accounting for the relative costs and benefits of invading species is a complex process that is still relatively undeveloped. However, chapters by Naylor and Zavaleta indicate how this can be approached. Naylor presents an important analysis of how we are gaining new insights and tools for dealing with the economics of invasions. She proposes some innovative new approaches and outlines the additional complexities of dealing with invasives under global change scenarios. These analyses are difficult but not hopeless, and in order to make progress we need greater collaboration between resource managers, ecologists, and economists. These analyses will be of increasing importance as we have to decide where to invest resources to deal with growing problems.

Zavaleta gives a detailed case study of the economic benefits and costs of *Tamarix,* a woody tree that has invaded the southwestern United States. She makes a compelling case that even today there would be considerable benefits in controlling this very pernicious invader. With global change scenarios of increased demands for water, decreasing precipitation, and increased warming, the benefits of a vigorous control effort become even more persuasive. Such analyses will become increasingly important for deploying limited resources in control efforts. Zavaleta notes that economic analyses are not the only tool that we will use in making decisions relating to control, but they are an important one and will need to cover all aspects of the problem.

Richardson et al. also clearly outline the social and economic dimensions of the invasive species issues, in particular, who gets the benefit and who bears the cost. Currently, the agency or individual involved in introducing species stands to gain significantly in terms of benefits, but is not required to take

responsibility for any future costs, for instance, of subsequent control if the species becomes invasive or of compensation for lost production by other land users.

Several chapters indicate the clear social costs of invasions. McMichael and Bouma show how human activities are significantly changing the risks associated with human disease organisms. They indicate that climate change per se will increase some infectious diseases, including malaria, and that land-use change and greater free trade are also important drivers increasing infectious diseases. The activities of humans in inadvertently decreasing the effectiveness of antibiotics are another growing threat to the vulnerability of humans to infectious diseases.

Clout and Lowe examine invasions in New Zealand, one of the world's most severely impacted regions. The social dimensions of this issue are clearly shown since the impacts are so obvious and detrimental that the public has agreed to draconian measures to eliminate or control invaders where possible, and to monitor and limit further invasions. In this case, there are economic, aesthetic, and conservation issues involved. It is frequently stated that people are motivated primarily by financial considerations, but the New Zealand experience indicates clearly that decisions are not always based on purely economic drivers. Considerations of local identity and preservation of endemic biota, for instance, can be of primary importance.

What Can We Do?

We can't stop global change, and it's unlikely that we will be able to either eradicate all species that are currently invasive or prevent future invasions. Should we then just sit back and let it all happen? One point of view is that the problem is so massive and difficult to deal with in an effective way that it is a waste of time and resources trying to do anything. In any case, some introduced species are actually highly beneficial in terms of their contribution to food or fiber production, or to alleviating land degradation problems, especially in developing countries.

There are, however, many reasons not to give up the struggle for managing and controlling invasive species. Here we differentiate between nonnative species that make up the bulk of our food and fiber production systems and that are largely noninvasive, and those species that have become, or have the potential to become invasive—that is, to become problems in areas where they have been introduced, or to move from their point of introduction into other systems. First, as illustrated in chapters in this book, invasive species represent real threats to all aspects of human life, including human health, food production systems, and water supplies. Invasive species have the capac-

ity to alter the world's ecosystems in unpredictable, and often undesirable, ways. Beyond these fundamental requirements for existence, invasive species also threaten other human values, including those related to conservation and aesthetics, in particular through the homogenization of the world's biota and the loss of locally unique species and assemblages. Invasive species thus stand to affect not only the basic ecosystem services on which human life depends, but also virtually all aspects of life on the planet.

In this sense, the problem of invasive species is truly a global one, which must be tackled at a global level. The recognition of this global dimension has led to the development of an ambitious project named the Global Invasive Species Program (GISP) (Mooney 1999). The components of this program are illustrated in Figure 17.1. The program aims to build on past studies and pull together existing information on invasions, and to feed this into a set of activities that aim to tackle the problem in a comprehensive way, resulting in a series of outputs aimed policy, management, and education arenas. The main components of this program are outlined at the end of this chapter.

It is apparent that not all species introduced to a new environment will cause problems—indeed, most probably won't. However, it has proved excep-

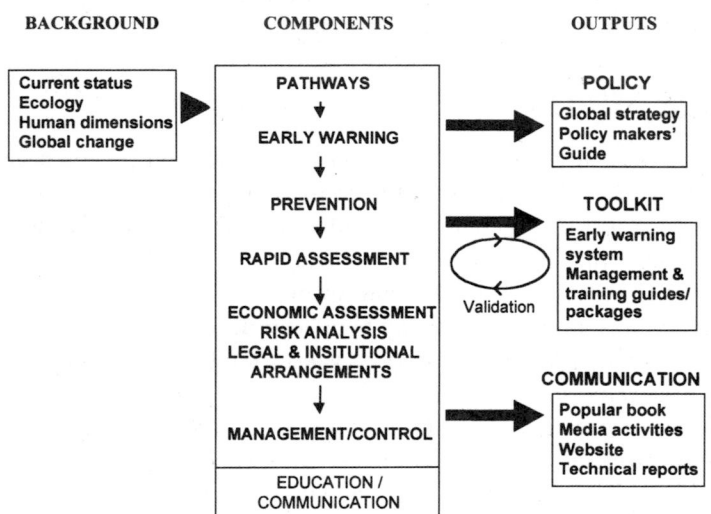

Figure 17.1. Outline of the Global Invasive Species Program, illustrating the three parallel streams of gathering background information, developing a set of program components aimed at tackling the various aspects of invasions, and feeding these components into the policy, management, and communication arenas via a number of products, including policy documents, management tool kits, and popular books and articles. This book forms part of the first and third streams. For more information, see the GISP web site at http://jasper.stanford.edu/gisp/.

tionally difficult to predict in advance which species are likely to become problems. While we are now improving our ability to do this (e.g., Richardson et al., this volume; Richardson et al. 1994; Reichard and Hamilton 1997), it has become clear that it is not just the characteristics of the species that determine the outcome of an invasion, but also those of the ecosystem that the species invades (Hobbs and Humphries 1995). Increasingly, species are being brought into contact with ecosystems that they would never normally have encountered, often, for instance, allowing them to exploit new resources (e.g., as in New Zealand; see Clout and Lowe, this volume). In addition, if the ecosystem is being changed or disturbed in any way, this opens up the possibility of greater levels of invasion, and under these circumstances even species that have not previously shown invasive tendencies can become invasive. This is precisely the scenario produced by global change.

It will thus be exceptionally difficult to make predictions concerning which species will become invasive. We can make a start by highlighting the species that have become invasive elsewhere in the world. The information on this, however, has been scattered and is hard to access. Clearly, one priority is the development of an invasives database that is available for use worldwide. For this to be effective, however, it must be coupled with effective mechanisms for the prevention of transport and introduction of known and potential problem species. This requirement goes against the current moves to free up international trade, and hence has important implications for trade policies. It also requires the strengthening of national quarantine strategies, and the effective policing of species movement. While increasingly effective measures are being put in place in some countries, the overall situation is not good. For large federated countries such as the United States, almost as important as the national approach to quarantine and control of species movement is that adopted between states. In Australia, for example, some plant species are legislated as problems in some states and not in others.

As well as maintaining effective measures to keep known problem species out of countries or states where they are currently absent, we also need mechanisms for assessing the relative risks and benefits of introducing species, particularly those being introduced for commercial purposes, such as forestry, horticulture, or the aquarium trade. While we cannot, and probably should not, aim to completely eliminate purposeful introductions, we do at least need to have effective means of weighing the likely benefits versus the potential costs (both economic and environmental), together with mechanisms for ensuring that those likely to benefit from the introduction also have to bear any costs related to the subsequent development of an invasion problem.

Whether or not we achieve effective measures to regulate the deliberate movement of species between countries and states, there will always continue to be inadvertent movement of species. While this could be limited to some

extent by increased public awareness and altered procedures (as in the case of ballast water—Carlton, this volume), some species will doubtless continue to arrive in new areas and develop into problem invasives. Hence there is a need for effective early warning systems that can detect the arrival and establishment of potentially invasive species. This is a huge task, but not an impossible one. For example, farmers are already well tuned into looking for new weed species, and new pest insects on crops or orchards are detected quickly. The arrival of a saltwater zebra mussel in Darwin harbor was also recently detected relatively rapidly—although it remains to be seen whether the detection was early enough and the control measures effective enough to limit its spread.

These are all weighty policy, legal, and management issues, which will only be resolved if there is enough public and political will to tackle them. This in turn will only come about through a greatly increased awareness of the invasion problem, and this requires a concerted communication effort on behalf of all those with an interest in it. Recent signs are encouraging. Popular books on the invasion problem have appeared (e.g., Bright 1998; Devine 1998). And unlike other global change issues, it is possible for individuals to get involved and actively work on the invasion problem, or at least part of it, in their own neighborhood. For while the invasives problem is undoubtedly global in its extent, a significant part of the solution will have to come from local actions by individuals and groups, especially in terms of early warning systems, eradication and control attempts, and more generally in terms of changed attitudes, increased awareness, and political pressure.

Far from being a hopeless cause that leads people to shrug their shoulders and give up, the invasion problem can and should be tackled at all levels from local to global. An appreciation of the impacts of invasive species may ultimately lead to an increased appreciation of the value of local species and ecosystems and an increased desire to maintain them. The alternative is a vastly more homogeneous world lacking local uniqueness. In our increasingly globalized society, increasing numbers of people see the value of retaining local identity and "sense of place." Invasive species are a severe threat to this identity. This, coupled with the developing body of evidence of the impact of invasive species on ecosystem services, should represent a call to arms for everyone to act now.

Hammond (1998) has presented a number of alternative scenarios for the world in the twenty-first century, which include a consideration of social, political, security, environmental, and economic trends. He illustrated how the world as a whole and particular regions could follow a range of trajectories, but pointed out that it was impossible to predict which scenario was most likely due to the complex and unpredictable nature of the global environmental, political, and social systems. His main conclusion, however, was that we need, collectively, to choose our desired future and aim to shape

things accordingly. Currently, we are blundering blindfold into the future. One bit of that future is the question of invasive species. We have to choose, soon, whether we want to act on this issue, and hence whether we want a future filled with more and more problem invasive species and fewer natives, or whether we want to prevent future problems, ensure the persistence of our food production and natural systems, and ultimately act in a strategic rather than a reactive manner. The challenges are undoubtedly great, but we've got nothing to lose and everything to gain—and not much time to get started!

The GISP program illustrated in Figure 17.1 indicates an integrated approach to the problem of dealing with invasive species. It is operating under the premise that learning about the science underlying the success of invasives and about what the future will bring, the subject of this book, is the foundation from which we can work to solve the problem. However, we must go much further. We need to involve social scientists in helping us understand the considerable social dimensions of this issue by probing the questions of who gains, who loses, who cares, and why. We need economists to help us in many ways in order to build the information base we need to evaluate when it is effective to invest in control as well as prevention. We need to work together with lawyers who are evaluating the laws that govern the exchange of biotic material to see what is working and what is not so we can design better legal instruments to deal with this issue. We need to give managers the most up-to-date information on what to do about invasives once they are in place and how to prevent them from getting there in the first place. We need to have readily available information everywhere on which species present the greatest threat to the functioning and stability of those systems that we are trying to protect, whether they are natural or managed. Most of all, we need to communicate both to the policy makers and to the general public what the nature of the problem is and how we can attack and solve it. The Global Invasive Species Program is due to complete its first phase at the end of 2000, and then there will be pilot operational projects.

The invasive species problem has already attracted the considerable attention of many nations, and comprehensive programs are being formulated or executed to deal with the issue. Further, the Convention of Biological Diversity is paying increasing attention to invasive species and is consulting GISP on how to deal with the issue. So, although the invasive problem is huge and, as noted in this volume, has the potential to get much worse, there is a growing political will to address the issue in a meaningful way.

References

Bright, C. 1998. *Life Out of Bounds: Bioinvasion in a Borderless World.* Worldwatch Institute Report.

Devine, R.S. 1998. *Alien Invasion: America's Battle with Non-native Animals and Plants.* National Geographic Society, Washington, D.C.

Hammond, A. 1998. *Which World? Scenarios for the 21st Century: Global Destinies, Regional Choices.* Island Press, Washington D.C.

Hobbs, R. J. and S. E. Humphries. 1995. "An integrated approach to the ecology and management of plant invasions." *Conservation Biology* 9: 761–770.

Mooney, H. A. 1999. Global Invasive Species Program (GISP). Pp. 407–418 in Sandlund, O. T., P. J. Schei, and A. Viken (eds), *Invasive Species and Biodiversity Management.* Kluwer Academic Publisher, Dordrecht, The Netherlands.

Reichard, S. H. and C. W. Hamilton. 1997. "Predicting invasions of woody plants introduced into North America." *Conservation Biology* 11: 193–203.

Richardson, D. M. et al. 1994. "Pine invasions in the Southern Hemisphere: determinants of spread and invadability." *Journal of Biogeography* 21: 511–527.

Contributors

MARY T. KALIN ARROYO, Departmento de Biología, Facultad de Ciencias, Universidad de Chile, Casilla 653, Santiago, Chile.

SPENCER C. H. BARRETT, Department of Botany, University of Toronto, Toronto, Ontario M5S 3B2 Canada.

WILLIAM J. BOND, Botany Department, University of Cape Town, Rondebosch 7701, South Africa.

MENNO J. BOUMA, Department of Tropical and Infectious Diseases, London School of Hygiene and Tropical Medicine, London WC1E 7HT, UK.

JAMES T. CARLTON, Maritime Studies Program, Williams College—Mystic Seaport, Mystic, CT 06355 USA.

LOHENGRIN CAVIERES, Departmento de Botánica, Facultad de Ciencias Naturales y Oceanográficas, Universidad de Concepción, Casilla 160-C, Concepción, Chile.

MICK N. CLOUT, School of Environmental and Marine Sciences, The University of Auckland, Tamaki Campus, Private Bag 92019, Auckland, New Zealand.

CARLA M. D'ANTONIO, Department of Integrative Biology, University of California, Berkeley, CA 94720 USA.

W. RICHARD J. DEAN, Percy Fitzpatrick Institute of African Ornithology, University of Cape Town, Rondebosch 7701, South Africa.

JEFFREY S. DUKES, Department of Biology, University of Utah, Salt Lake City, UT 84112 USA.

ANDREAS ELEND, Environmental Measurements and Consultants GmbH, Liebknechtraße 51, D-99086 Erfurt, Germany.

STEVEN I. HIGGINS, Institute for Plant Conservation, Botany Department, University of Cape Town, Rondebosch 7701, South Africa.

RICHARD J. HOBBS, School of Environmental Science, Murdoch University, Murdoch, WA 6150, Australia.

CYNTHIA S. KOLAR, Department of Biological Sciences, University of Notre Dame, Notre Dame, IN 46556 USA.

DAVID M. LODGE, Department of Biological Sciences, University of Notre Dame, Notre Dame, IN 46556 USA.

SARAH J. LOWE, School of Environmental and Marine Sciences, The University of Auckland, Tamaki Campus, Private Bag 92019, Auckland, New Zealand.

RICHARD N. MACK, School of Biological Sciences, Washington State University, Pullman, WA 99164 USA.

CLODOMIRO MARTICORENA, Departamento de Botánica, Facultad de Ciencias Naturales y Oceanográficas, Universidad de Concepción, Casilla 160-C, Chile.

OSCAR MATTHEI, Departamento de Botánica, Facultad de Ciencias, Naturales y Oceanográficas, Universidad de Concepción, Casilla 160-C, Concepción, Chile.

ANTHONY J. MCMICHAEL, Department of Epidemiology and Population Health, London School of Hygiene and Tropical Medicine, London WC1E 7HT, UK.

JEFFREY A. MCNEELY, Biodiversity Policy Coordination Division, IUCN, 28 Rue Mauverney, CH 1196 Gland, Switzerland.

GUY F. MIDGLEY, National Botanical Institute, Private Bag X7, Claremont 7735, South Africa.

SUZANNE J. MILTON, Percy Fitzpatrick Institute of African Ornithology, University of Cape Town, Rondebosch 7701, South Africa.

HAROLD A. MOONEY, Department of Biological Sciences, Stanford University, Stanford, CA 94305-5020 USA.

ROSAMOND L. NAYLOR, Institute for International Studies, Stanford University, Stanford, CA 94305 USA.

STEPHANIE NÖLLERT, Max-Planck Institute for Biogeochemistry, Tatzendpromenade 1a, D-07701 Jena, Germany.

LESLIE W. POWRIE, National Botanical Institute, Private Bag X7, Claremont 7735, South Africa.

DAVID M. RICHARDSON, Institute for Plant Conservation, Botany Department, University of Cape Town, Rondebosch 7701, South Africa.

MICHAEL C. RUTHERFORD, National Botanical Institute, Private Bag X7, Claremont 7735, South Africa.

MICHAEL J. SAMWAYS, Department of Zoology and Entomology, University of Natal, Pietermaritzburg, Private Bag X01, Scottsville 3209, South Africa.

MICHAEL SCHERER-LORENZEN, Max-Planck Institute for Biogeochemistry, Tatzendpromenade 1a, D-07701 Jena, Germany.

ERNST-DETLEF SCHULZE, Max-Planck Institute for Biogeochemistry, Tatzendpromenade 1a, D-07701 Jena, Germany.

ROLAND E. SCHULZE, School of Bioresources Engineering and Environmental Hydrology, University of Natal, Pietermaritzburg, Private Bag X01, Scottsville 3209, South Africa.

ROBERT W. SUTHERST, CSIRO Entomology, Long Pocket Laboratories, PMB No. 3, Indooroopilly, Queensland, Australia 4068.

ERIKA ZAVALETA, Department of Biological Sciences, Stanford University, Stanford, CA 94305 USA.

Index